German Gothic Church Architecture

German Gothic
Church Architecture

Norbert Nussbaum

TRANSLATED FROM THE GERMAN BY
SCOTT KLEAGER

Yale University Press
New Haven and London

First published as *Deutsche Kirchenbaukunst der Gotik*
© 1994 by Wissenschaftliche Buchgesellschaft, Darmstadt

Translation © by Yale University 2000

Set in Ehrhardt by Best-set Typesetter Ltd., Hong Kong
Printed in Italy

LIBRARY OF CONGRESS CATALOGING-IN-PUBLICATION DATA

Nussbaum, Nobert.
 [Deutsche Kirchenbaukunst der Gotik. English]
 German Gothic Church Architecture / Norbert Nussbaum;
 translated from the German by Scott Kleager.
 p. cm.
 Includes bibliographical references and index.
 ISBN 0-300-08321-1 (cloth: alk. paper)
 1. Church architecture – Germany. 2. Architecture, Gothic – Germany.
 I. Title
NA5563.N8813 2000726.5'0943'0902–dc21 99-087079

CONTENTS

The Empire, *ca.* 1380, excluding the Italian territories, marking the most important buildings

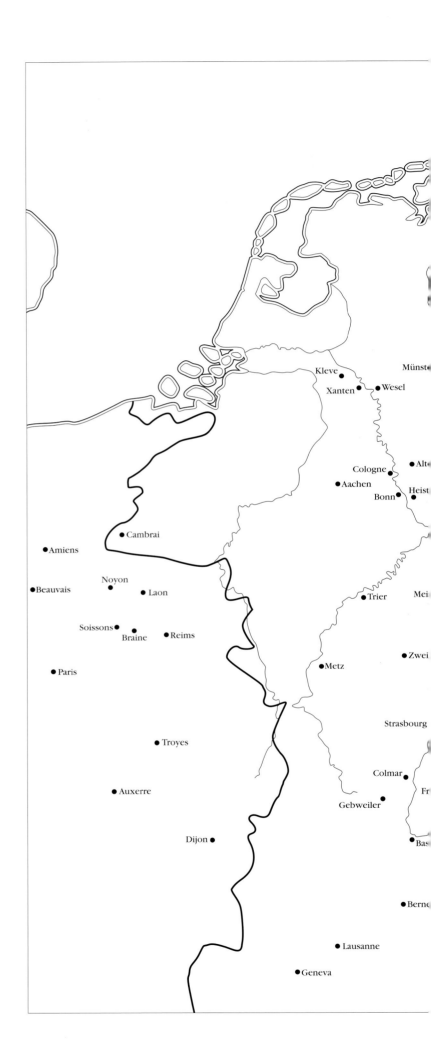

Braunsberg

Danzig
Frauenburg

Marienburg
Pelplin
Marienwerder

Kulmsee

Stralsund
Rostock
Lübeck
Doberan
Greifswald
Wismar

Schwerin
Pasewalk
Neubrandenburg
Stettin
Stargard
Prenzlau

Lüneburg

Verden

Chorin

Minden
Stendal
Berlin

Brunswick
Brandenburg
Frankfurt/O.

Magdeburg

Paderborn

Soest

Halle
Torgau

Mühlhausen
Leipzig

Naumburg
Meissen
Dresden
Görlitz
Breslau

Marburg
Erfurt
Rochlitz
Freiberg
Pirna

ienstatt

Schneeberg
Annaberg
Neisse

aburg
Brüx

ach
Frankfurt/M.

Prague
Kolin

Oppenheim
Karlstein
Kuttenberg

Bamberg

Ebrach
Olmütz

Heidelberg
Nuremberg
Mühlhausen

Wimpfen
Amberg
Brünn

Heilbronn
Schwäb. Hall

albronn
Dinkelsbühl
Regensburg

Stuttgart
Nördlingen
Eichstätt

r Stadt
Esslingen
Schwäb.
Gmünd
Ingolstadt
Krumau

Zwettl

Reutlingen
Ulm
Landshut
Freistadt
Imbach

Augsburg
Passau
Königswiesen
Klosterneuburg

Rottweil
Neuötting
Braunau
Enns
Vienna

Steyr
St. Valentin
Heiligenkreuz

Munich
Lilienfeld

Salem
Wasserburg

Salzburg

St Lambrecht

Kötschach

Bozen

Gothic Architecture

The Changing Focus of Research from the Romantic Period to Modern Times

AS ITS TITLE suggests, *German Gothic Church Architecture* proposes to illuminate a period of German architecture defined by its churches, in an enquiry of a more or less geographical nature. We know what church construction entails, or at least we think we know. Ever since specific building styles and periods of architecture have been identified and delineated, there appears to have been general agreement among scholars as to what "the Gothic" means. And despite the damage done in some cases to the understanding of certain buildings by period classification, such categories remain indispensable in helping to define what we see when we look at a particular structure. On the other hand, how do we define the word "German" in the title? Where *was* Germany in the years 1200 and 1500, those associated with the Gothic period? Should Switzerland or the Brabant region be considered German in 1400 because they belonged to the Holy Roman Empire *Nationis Germanicae*? Given the fact that the empire's nominal political borders – those areas actually controlled by German monarchs or principalities, along with those areas designated as being culturally German – were in a constant state of flux during this time, a certain amount of flexibility is in order when defining an area as "German."

Germany, as the geographical entity we are familiar with today, cannot be drawn on a map of the period with absolute certainty. The extensive nation-state, with its surveyed and fixed borders, did not come into existence until the nineteenth century. It was a product of utopian thought, first proposed by political philosophers who demanded state sovereignty. Medieval Europe, on the other hand, was first and formost feudalistic, where power meant control over persons who lived in the same area, shared allegiance to the same ruler and depended on each other for economic support and military protection. Those living during the Gothic centuries were the first to witness upheavals out of which would come the notion of "territory" as a legal entity based upon a common cultural heritage. In some cases, territories would force the unification of various traditions into a homogenous culture.[1]

The idea of a federation of German territories under one king was maintained, and was reality for many people living on the borders of the German heartland. Yet, because the German crown constantly changed from one family to another, weakening momentum for German cultural integration, there was little impulse to create a nation with a stable succession of monarchs at its head, as was the case in England and France during the same period. The resulting power vacuum at the monarchical level left room for individual territories within the German empire to consolidate themselves and to claim sovereignty. Depending on the situation, these territories swung between loyalty to and independence from the crown, and brought about what O. Brunner calls a "parallelogram of powers" which neutralized each other. In every respect, then, the late-medieval German empire was an extremely variable entity, and when approaching the history of German Gothic architecture geographically we would do well to limit or expand our definitions according to whatever a particular period's situation dictates.

The Romantic period in Germany was a time of unparalleled enthusiasm for Gothic architecture. This enthusiasm was strongly patriotic and inspired some of the first serious research projects in the field. Yet the Romantics were not up to the task of defining exactly what German Gothic is. There seems to have been a general consensus among them that medieval German art reflected the same emotions felt by all

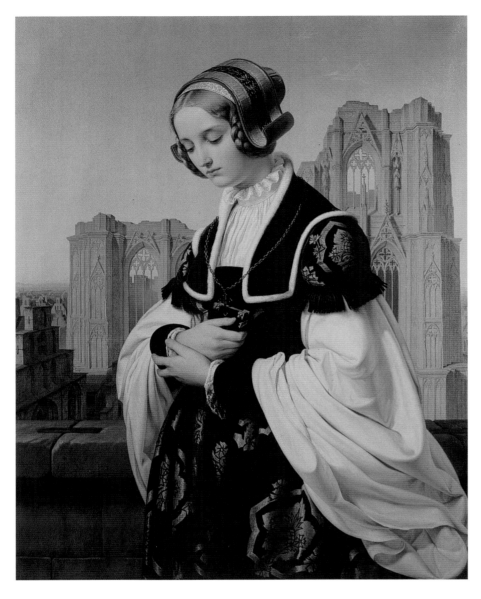

1 *The Church-goer*, by
Louis Blanc, 1837

Cologne Cathedrals, and thus symbolize a rebirth of the fatherland.[3] For the tireless architectural scholar Sulpiz Boisserée (1783–1854) and the publisher/historian Joseph Görres (1776–1848), the as-yet-unfinished Cologne Cathedral would come to represent a torn and divided Germany;[4] and in 1823 Heinrich Heine would dream of a future in which "...people will recognize the incomparable organic cohesion of medieval splendor, and call the Song of the Nibelungen a versified Cologne Cathedral and the Cologne Cathedral the Song of the Nibelungen in stone.[5]" Indeed, the final building stages in Cologne would not begin until 1842 under the patronage of the House of Hohenzollern and would not be finished until 1880. The subsequent celebration, with a festival and parade, would provide an opportunity for the Kaiser to present himself as head of a generous empire.[6] For a patriotic public, Gothic architecture would remain synonymous with German architecture long after art historians had established its French origins.

Closely bound up with this patriotic enthusiasm for Gothic architecture was its rediscovery as an ecclesiastical style, and as a paragon for the articulation of a new and purified art form. Many German Romantics believed that the art of their time was bereft of religious values. In fact, re-establishing religion at the heart of artistic expression – as it had been in medieval Europe – became one of German Romanticism's main objectives. The perfect fusion of religion and art seemed to them to be the microcosm of the Gothic cathedral. This "rediscovered Gothic" was a vehicle for the Romantics' spiritual assimilation of a perceived medieval world, one that was still spiritually unified and anchored in Christian humility. After all, wasn't the German soul characterized through the ages by its meditative seriousness and contemplative piety, characteristics best embodied by the medieval world view?

The strong metaphorical imagery found in some Romantic painting is the result of combining medieval German sentiments with Gothic architecture, then projecting these through feelings of having been "born too late," to create what can only be called a transfigured medieval background perspective. In Louis Blanc's second portrait of Gertraud Künzel, *The Churchgoer*[7] (1837) Cologne Cathedral is once again vehicle for this perspective [1]. Frau Künzel, clothed in late-medieval dress, stands in an elevated position before the western façade of the cathedral. Head bowed, eyes almost closed, hands crossed and holding a small prayer book, she personifies contemplative piety almost too

Germans. They understood medieval Gothic as being the culmination of German history– a time of unity and greatness. The Gothic period was fervently sentimentalized by the Romantics during the Napoleonic wars, and sorely missed during the years leading up to the March Revolution of 1848.

Along with the paintings of Dürer, Gothic architecture had been synonymous with medieval Germany even before the Romantic period. Ever since Goethe, actually, who studied classical architecture extensively and was inspired by Strasbourg Cathedral to speak movingly of "... the great soul of our elder brothers..." In 1773 Goethe announced with certainty that "...this is German architecture, our architecture..."[2] During the Napoleonic wars, Goethe's vision became part of the political agenda. In 1814 the historian and future diplomat Karl Sieveking proposed the building of "a teutonic cathedral on the battlefield of Leipzig..." whose style of architecture would imitate that of Strasbourg and

forcefully. Blanc's clothed portrait can be traced to a drawing by Jan van Eyck from 1437 representing Saint Barbara before a huge, half-completed tower which is zealously being worked on. No one can be seen working on the Cologne Cathedral in Blanc's painting, though. The structure remains incomplete, its half-built towers reflecting an irrevocable loss before a setting sun and red sky.

A revival of the search for God in nature also inspired the German Romantics to study the Gothic period. The inquisitive, emotional members of the Sturm and Drang Movement – along with the aesthetic philosophers of the Age of Enlightenment[8] – were looking to nature for divine truth as early as the mid-eighteenth century. Nature came to represent the sublime, a place to experience the awe of the divine. It became a metaphor for irrationality and mystery. For the Romantics, the most important medium for the expression of religious sentiments was communing with nature, and the Gothic style of architecture was seen as having been derived from nature. In his "Essay on the Origin and Principles of Gothic Architecture" (1779) geologist James Hall theorized that all Gothic forms originated in nature – specifically in the traced and plaited characteristics of ash trees, and the arched branches of willows, which had been translated into stone in the architecture of the great cathedrals.[9] Though scholars did not agree with all the specifics of Hall's theory, nevertheless there was a basic consensus about the plant-like character of Gothic architecture. In his *Grundzüge der gotischen Baukunst*, Friedrich von Schlegel wrote that

> In the conformation of piers, arches and windows that break out in delicate tendrils like tangled branches, in the profusely foliated decoration of the ornaments, and especially in its floral and plant-like quality are found the essential, basic form and peculiar beauty of this style of building, the true origin and primary reason of which are to be sought in the profound German feeling for nature and in fantasy as the dominating spiritual element of that age.[10]

Here again we find Gothic architecture commonly understood to be German, with direct reference to the German Romantic's affinity to nature.

Architectural forms reflecting the natural world had a devotional function and an essence, a heart, that was German – these seemed to the Romantics to be identical facets of a still rather diffuse idea of Gothic architecture. Each facet created metaphors for, and resonated in, the others. The German landscapes of Caspar David Friedrich offer examples, often compressed, of the intermingling of these Romantic metaphors. His background Gothic churches and ruins give the impression of being parts of trees metamorphosed into stone. They are also monuments of a divine presence sanctifying the scene envisioned in the paintings. The nineteenth century created this imaginary synthesis. However, its specific elements are cultural assets the Romantics inherited from the Renaissance, a period to which they remained true despite all these medieval tendencies. In fact, it was during the Italian Renaissance that Gothic forms were first suspected of having origins in nature. In a memorandum to Pope Julius II concerning the Germans, which most likely came from Bramante, we read "This [Gothic] architecture did make some sense, however, as it was derived from trees not yet cut down, whose branches were bent over and made to form pointed arches when tied together."[11] It appears that, even before Vasari rejected what struck him as a monstrous and barbaric architectural style, which he also called "German" (tedesco), the opinion that the Gothic style had come from Germany *and* from nature had already taken root. It was precisely German Renaissance architectural theorists, however, who valued the Gothic as the embodiment of ecclesiastical building style. To them it represented, even at the end of sixteenth century, a powerful and uninterrupted tradition.[12]

Modern scholarship, which began after the end of Romanticism, nonetheless retains the Romantic's awe concerning the emergence of Gothic out of Romanesque architecture, or at least it seems that way. In few other disciplines of art history have discussions about the origins of style been so controversial, and lasted for so long, as they have in Gothic research. In the beginning, it was as if Gothic architecture might only be understood when the mystery of its origins were solved.

The generation of scholars following the Romantic period – specifically Karl Bötticher, Georg Ungewitter and Eugène Viollet-le-Duc – came of age during the dawn of industrialization. It is no surprise that they found exclusively rational sources for the development of the Gothic load-bearing structure.[13] After studying the anatomy of Gothic designs thoroughly, it appeared to them that the advent of the style was a logical outcome of advances in building techniques, with the development of the ribbed vault being the actual moment of its birth. To them the Gothic form was an expression, and

consequence, of structural requirements. Some sixty years later Ernst Gall overturned this thesis, employing a mature theory of style-analysis; not a mastery of construction technique, but an aesthetic sense of form, brought forth the Gothic's main structural elements – ribs and vault responds. The respond existed earlier than the rib, and from this Gall concluded that the rib was not a structural element but developed as a motif, as a related form, to the respond. The rib articulates the vaulting in the same way the respond does the clerestory wall. The actual distribution of load and support was not as important as the way in which the surface articulation of ribs and responds portrayed it.[14]

A further change in methods of Gothic research occurred with the efforts of Otto von Simson, who identified speculations on light-metaphysics by the Neo-Platonists and early Scholasticism of the Chartres School as the intellectual prerequisites leading to the development of the French Gothic.[15] This medieval *Weltanschauung* or world view was important to this particular approach to Gothic research. It resulted, for instance, in the search for analogies between modes of thought and the architectural forms of a particular period. To studies using this approach, focusing on the origins of Gothic church building minimalized the importance of German architecture. With the publication of F. Merten's essay "Paris baugeschichtlich im Mittelalter" in the newspaper *Wiener Bauzeitung* in 1843, German scholars – for whom Gothic was a source of national pride – could no longer avoid recognizing France as the fountainhead of Gothic architecture. They seemed unable to relinquish the idea that it was a German art form, however, and turned their attention to Late Gothic which they called "Deutsche Sondergotik" or "German special Gothic"[16] and which seemed beyond a doubt to be German. At the turn of the century August Schmarsow, along with his students Erich Haenel and Wilhelm Niemeyer, formulated the provocative thesis that German Late Gothic, when viewed correctly, was no longer medieval at all, but a Renaissance style all its own. Its emphasis on spacious Hall structures, rather than decoration, made it analogous to Italian architecture of the same period.[17] Once again this conjures up the German Romantic movement, and specifically Overbeck's painting of the two sisters "Italia and Germania." Sisters yes, but of different temperaments and inspired by different things.[18]

The Romantic school and the technical-rational definition of style only appeared to be different approaches to Gothic scholarship, for

the two schools flowed together during the completion of the cathedrals at Cologne, Ulm, Milan, Rouen and Trondheim in the middle of the nineteenth century. At these construction sites, a picture of the Gothic great-church emerged as an exacting, conscientiously formalist creation. This picture was characteristic of both schools and perhaps typical of nineteenth-century thought in general. The completed cathedral seemed to confirm the Romantic approach, which believed in a unified medieval Christian culture, in a synthesis of life and art that had been lost but seemed now to be recoverable. For the structurally oriented scholars, the cathedral embodied the Gothic system, a system that could only express the logic of its austere and irrevocable harmony through the completed structure. The urgency with which researchers concerned themselves with the cathedral as the "Gothic microcosm" had a decisive influence on the direction scholarship would subsequently take. A general premise took hold, for instance, that Gothic architecture emerged because of the systematic development of a specific architectural language. This was the product of advances that were both aesthetic and concerned with structural soundness, which together formed "a system" that allowed for early stylistic maturity at the classic thirteenth-century Early Gothic cathedrals of Reims and Amiens. All the more destructive, then, was Georg Dehio's judgement in 1900 that there was no uniform system to German Late Gothic architecture whatsoever.[19] The notion of an architectural "system" presumes a uniform development in which the system is revealed, not through sudden changes of form, but through a progression of styles laid down, as it were, one stone on top of another, each contributing to its realization. For Dehio, what followed the High Gothic was at best a graceful variation on a pre-formulated theme, and a style he saw as in decline.

The analyses of Gothic architectural styles made during the first decades of this century, including Karl-Heinz Clasen's "Gotische Baukunst" from 1930, were to recognize the achievements of Late Gothic. The prevalent feeling was that style reflected nature, and that in its development the Gothic reflected the self-evidence of birth, life and death in a natural life cycle that appeared in the flowering and decaying of its designs.[20] This interpretation, as suspect as it seems to us today, is based without a doubt on correct observation. Whenever art historians describe a collective style of architecture in order to understand and categorize a particular period, they specify the directions that style took. If this

were not done, then no works of art could be compared, categorized or dated. This does not mean, however, that the main direction a style took was set from the start, that it moved irresistibly towards its final form as though there were something inherent in it that drove it to fruition – an entelechy similar to Hegel's *Weltgeist*. Such a *Weltgeist* cannot be found in German Gothic, which seems instead to have been the result of individual building solutions. These, though focused and thought-through within the limits of a particular situation, were nonetheless carried out with little thought to creating a definitive character of the Gothic that would transcend a project's own stylistic horizons.

What Dehio asserted about German Late Gothic is accepted by most scholars today concerning German Gothic architecture in general: that it was not the product of a single, recognizable system, but of various systems that influenced each other and brought forth highly individualized buildings. The reasons for this stylistic diversity are as manifold as the buildings themselves. However, two assumptions can be made, at least tentatively, about German Gothic architecture. First, it is a "derivative style," in that it originated for the most part in locations outside of the German empire. This lead to a lively interaction between domestic German architectural traditions, that were extraordinarily rich in surface articulation and in structure type, and the newly imported Gothic style whose assimilation from the very beginning was subject to drastic modification and change. Second – and here we return to the problem of geographical definition touched upon at the start of this chapter – German architecture, even as late as the fourteenth and fifteenth centuries, seems to have been more open to foreign influences than that of either France or England during the same period. This was due to Germany's location in the middle of the European continent and to its political and cultural diversity. And, in fact, we find the German Gothic characterized by far fewer periods in which a consolidation of style took place, than we do periods of experimentation and diversity. If German architecture lacked conceptual unity between the thirteenth and sixteenth centuries, when Renaissance styles became dominant, this does not imply a lack of talent or that architectural forms were deficient, but that there was such rapid and sustained creative innovation that it precluded any chance of style consolidation.

Scholars have since moved away from trying to understand Gothic architecture as being the product of a system. The overwhelming number of different approaches applied to Gothic research in the last few decades testifies to that. This research has cast doubt on the old style-development school of thought. The idea of stylistic unity between separate works of art of the same period is seen today as a postulate of Romantic thought, born out of a Romantic perspective that presented the distant past as being more harmonious and unified than it actually was.[21] Modern Gothic scholarship demands a more pluralistic approach to style development. It loosens the traditional notion that style develops in a straight line, by placing more emphasis on the dissimilarity of contemporary works of art, and the differences and contradictions of a particular stylistic period. Research today is more concerned with describing the composite of forces under whose influence artistic production develops. It does not succumb to the need to categorize an imaginary style according to its single components, but rather emphasizes the individual decisions that determine style, and the absolute necessity of choosing from a constantly changing pool of possible forms that underlie every creative decision – even when a new work revolutionizes the forms it inherits.[22] The push to make stylistic pluralism the preferred approach among art historians who analyze artistic development reflects the proliferation of specialized research itself. The increase in kinds of research approaches can no longer be ignored, even though it makes grasping the Gothic as a whole very difficult.

Perhaps the situation that art history finds itself in today, with its diverse branches and constant doubting of its own premises, is a reflection of a fundamental pluralism governing every part of our lives, the validity of which we accept almost instinctively. Hence the common tendency to understand history as a complicated fabric of interwoven forces and reactions to them. Rediscovering, in the past, those social forces that move our own times helps shorten the distance between the scholar and his subject. Many of today's historians, then, make the past mirror their own society's world view. In Barbara Tuchman's extremely insightful book, *A Distant Mirror*, which concerns the crises and vicissitudes of the fourteenth century, the author proposes the theory that every historical interpretation reveals an unspoken bias because it reflects back to us the image of ourselves.[23]

Against this background it is not surprising that the traditional distinction between Late Gothic, which was still medieval, and early Renaissance has begun to blur, though for other reasons than those put forward by Schmarsow and Haenel. Gothic art was found to possess

so many "modern" characteristics that it did not seem erroneous to push it closer to the present. For Werner Gross, medieval architecture became that of the early Renaissance (Neuzeit) in the decades around 1300. During these years a "purer" Gothic style was able to shake off its medieval affinities through a clarity of form and a consensus of structural application. This allowed the Gothic to develop a "static naturalness" which made possible the anthropomorphic architecture that followed.[24] Arnold Hauser sees the upheavals of the late Middle Ages, and especially the beginnings of urban culture, as having influenced to a greater degree the appearance of modern sensibilities concerning life in general than the intellectual achievements of the Renaissance did. Hauser gives the Gothic a leading role in the process of change from medieval to Renaissance, and hence modern. With the rise of the Gothic "…art experienced one of its greatest transformations. Into a style whose ideal – that its premise is true to natural forms, reflects the deepest human emotions, is perceptive and sensual – is still with us today and had its birth in the late Middle Ages."[25] Admittedly, one cannot help but wonder whether the natural forms of Gothic – if they were even seen as such by the medieval mind – developed out of the same assumptions we have of reality and its representation, or whether they arose out of completely different ones. And the emotions that Hauser recognized in the Gothic – emotions that seemed to strike a chord within him – were they powerful enough to have caused such a transformation? Can we say for certain that they were part of the world view of a distant past that, though available to us in text and illustration, can no longer be experienced first hand?

Be that as it may, the question of whether Late Gothic was medieval or Renaissance has yet to be answered. It is an important question because it influences the way we perceive the past, whether we see it with affinity or distance. If we were to single out one factor that, without reservation, we could say had an impact on all of the facets of the Gothic in Germany, it would have to be the integrative power of Christian culture. Admittedly, it was no longer dominated by the powerful monastic civilization which dominated the early and high Middle Ages and to which the Romanesque period owed its strength. Its power was more and more city-oriented. Even so, the German Romantics were wrong to believe that Gothic was flagship of a unified occidental Christianity. During the

fourteenth and fifteenth centurie, heresy, schism and a continuing crisis of leadership at the heart of the Church, drove Christianity to the precipice of permanent division, which was then sealed by the Reformation. By no means did Gothic art reach all of this estranged *res publica Christiania*. In Rome, for instance – which in the Middle Ages was at times deserted by its Popes – Gothic architecture had very little influence in shaping the face of the city. Gothic influence was all the greater in areas east of the River Elbe, where it made its first appearance together with the structural forms of central European settlements and their legal institutions.

In the development and ultimate acceptance of Gothic architecture, cities played a major role. The city-state did not appear only in Italy. Germany saw the emergence of powerful urban centers as well. In a process similar to that of Lombardy in the thirteenth century, cities found room to grow and prosper in the power-vacuum left by the collapse of the House of Hohenstaufen around 1250. They were no longer hindered by a strong central power, and the effect they had on society in general lead Fernand Braudel to compare them to electrical transformers: "They raise the voltage, accelerate the amount of trade, and drive people to increased activity."[26]

Monasteries remained economically powerful, and had close contacts with towns and cities. They used urban markets to sell their goods: the huge city warehouses of the Cistercians attest to this.[27] It was in the cities that cathedrals, spacious parish churches, buildings of the Mendicant orders, civil oratories and hospitals were built. They were placed in the middle of residential districts and were designed to conform to streets, squares and the surrounding architecture. Cathedral chapters, patrician families, craftsmen and merchant guilds and brotherhoods, all contributed to the financing of church building and to their continued maintenance.[28] With the development of urban institutions, secular Gothic architecture became more important. Town halls, drapers' halls and covered markets appeared alongside the great churches. However, church construction remained the most important kind of building activity long into the fifteenth century, and was the single most influential factor in the development of architectural style. In Germany, church construction was the forum for Gothic architecture, and the criterion by which its greatest architects and builders would be measured.

II

Origins of Style: Gothic and Romanesque

SINCE THE PUBLICATION in 1901 of Dehio and von Bezold's *Kirchliche Baukunst des Abendlandes*, early thirteenth-century German Gothic architecture has been understood as having been in a state of transition:[29] no longer purely Romanesque, not quite Gothic either – in transition from one building style to another. And this is problem which faces us concerning the early thirteenth century.

It is less a question of recognizing in one building or another building the point at which the style changed, or recognizing this or that form as being in the new style and therefore part of early German Gothic. Such questions apply to the origins of every style. In the final analysis they can only be answered with approximation because of the difficulty, generally speaking, of having direct access to the beginning of anything: very seldom do such beginnings manifest themselves abruptly and in a pure form.

Dehio and many scholars after him were hesitant to give dates to the appearance of the Gothic in German architecture. This stems in great part from their difficulty in dealing with the many German buildings that were suspended stylistically between Romanesque and Gothic, when the way seemed to have been paved for a complete change-over to the new style by important structures that had employed French construction methods. If we believe Dehio – and Gross's comprehensive presentation on precisely this question in *Propyläen-Kunstgeschichte* – then the change from Romanesque to the Gothic in Germany took almost a hundred years, during which time architectural forms were in a hybrid state between the traditional and the daringly innovative. Tangible stylistic trends from the period can be identified only now and then.[30] We have Dehio to thank for the first systematic survey of German Gothic's inaugural century,

which is still accepted as the theoretical basis today.[31] He divides the century into three periods according to the degree by which French forms were assimilated. This process assumes a consistent effort on the part of builders to "germanize" the adopted forms and use them in what was, at the time, traditional German architecture. According to Dehio the desire to assimilate, rather than the forms themselves, dominated in the beginning, so that his first "phase of assimilation" was genuinely Romanesque. It was a period in which the Gothic played a passive role: it was conspicuous enough to leave evidence of itself, but not strong enough to influence the architectural forms in which it was imbedded. Based on this observation, Dehio then develops a theory outlining the differences between German architecture and that of England and Normandy where elements of articulated construction – like responds and ribbed vaulting – seemed to develop in a quick, natural progression into the Gothic without late-Romanesque hybridization.[32] It isn't until Dehio's second and third "phases" that German architecture matures and enters a similarly active period, years in which the French Early Gothic of Laon and Soissons and the High Gothic of Reims and Amiens were repeated, though arm-in-arm with an actively developing German architectural tradition.

Dehio's model, based on "phases of assimilation," is sensible and clear. His main thesis[33] – that in France the Gothic style developed *out* of the Romanesque, but in Germany *in opposition* to it – shows him to be a brilliant analyst of architectural style. Surely it will not diminish his merits if later scholars, supported by an expanded pool of sources and research approaches, should venture to limit or disagree with his judgements. His theories will still

2 Great St. Martin, Cologne, view into the east conch

central-European Romanesque wall articulation and spatial design systems, and that it wasn't until the building of the "classic" High Gothic churches of the thirteenth century that the radical break actually came.[36]

Contradictory theories concerning the origins of French Gothic, then, make defining the parameters of German Early Gothic that much more difficult. However, there is some agreement about the similarities between German Romanesque and those first, French Early Gothic buildings whose mixed stylistic character makes them seem so difficult to categorize. This will help in determining more precisely how the new style coming in from the west influenced German architecture during the thirteenth century.

The area between the Loire and the Rhine, together with England and Burgundy, is understood as having been the center of Romanesque architecture in Europe.[37] In these areas, shared methods of structural engineering and organizing inner space had developed which eclipsed all local building traditions. The development of the basilica into a structure with transept, pronounced crossing, and a high central vessel with rich wall articulation and a bay-creating vaulting of the ceiling was characteristic.[38] Furthermore, it was precisely in the heart of these areas – in the Loire and Seine valley, Burgundy, Normandy and in the Rhineland – during the twelfth century, that passageways and galleries played an important role.[39] As zones that dissolved the flat basilican wall and created storied upper levels, passageways and galleries were a decisive factor in the move to three-dimensional articulation.

To outline the relationship these Romanesque centers had with each other would be a complex task. The role each area played in the discovery and dispersion of those architectural forms common to all is, in many cases, uncertain. For example, it is difficult to ascertain the influence Normandy Romanesque (St-Nicholas and Ste-Trinité in Caen and buildings in their style)[40] and the Rhenish tradition had on the Lower Rhine branch of the Staufen apsidal churches (Cologne Romanesque School, St. Gereon and buildings in its style). Another difficulty lies in pinpointing a clear connection between northern France and the western side of the Rhine valley, which experienced such an enormous increase in building activity during the second half of the twelfth century that it can be compared to the Ile-de-France or the centers of the architecture of Normandy and Champagne. Cologne alone saw twenty-eight

provide the framework within which all controversies concerning the origins of German Gothic are disputed.

It is modern scholarship, especially, that wonders whether the Early Gothic structures of the French royal possessions around the Ile-de-France represented, when compared to that which preceded them, a mutation of form and content, or whether the style of these churches might not actually be traceable to the Romanesque buildings from the same areas.[34] The so-called "first Gothic"[35] of northern France from 1140 to 1190 is no longer defined as Dehio defined it. Scholars today no longer see it as a style that, though gradually developing out of the Romanesque, was already a catalyst for a new kind of architecture upon its appearance. Instead, the "first Gothic" is now seen as one of many related directions taken at the time by

new churches built between 1150 and 1250.[41] Here artistic ambition walked hand-in-hand with economic power, for the area between Loire and Rhine saw a marked growth in the population of its cities during the twelfth and thirteenth centuries. Playing a key role was the textile industry. Its importance for the trade centers of Champagne, and for the export centers of the Baltic and Mediterranean, has led economic historians to call the area "the cloth landscape." In fact, this area corresponds for the most part to the principal centers of Romanesque architecture in Europe at the time. According to records of the large textile market in Genoa, towns like Paris and its environs, Chartres, Etampes, Reims, Caen, Amiens, Tournai, Ypres, Cambrai, Liège and Cologne – all of which saw the building of many large churches in the twelfth and thirteenth-centuries – were among the most important cloth and linen producers in Europe.[42]

THE FRENCH BASIS

In the architectural milieu of these towns, Gothic architecture took root at the same time as many buildings of similar stylistic heritage, from which it nevertheless clearly stood out. For example, the conches of Cologne's Great St. Martin's trichora choir (after 1150–72) [2] and the transept conches of Noyon Cathedral (1160–5) [3] are related structures because they share the same prototype. The half-spherical wall augmented by surface articulation behind which niches, passageways and bevelled window jambs draw a spatial and corporeal three-dimensionality from the surface is a common feature, but the means by which this was achieved are quite different in each church. Great St. Martin has blind arcades at ground level set upon powerful three-quarter columns, between which the wall has been deeply hollowed out. Above this is a high wall with a passageway voided by windows, in front of which are pairs of free-standing columns bearing the apse calotte. Separating the two stories is string coursing that runs the length of the apse and makes for an austere bipartite division of its surface. The arcade columns do not stand in front of the wall, but are fused with the first layer of its masonry. The unarticulated spandrels above them act as base for the passageway. The upper columns bear the springing of an apse calotte that looks like the inside of a thick cap pulled down to the top of the windows. Despite this, the conch surface seems tall, due for the

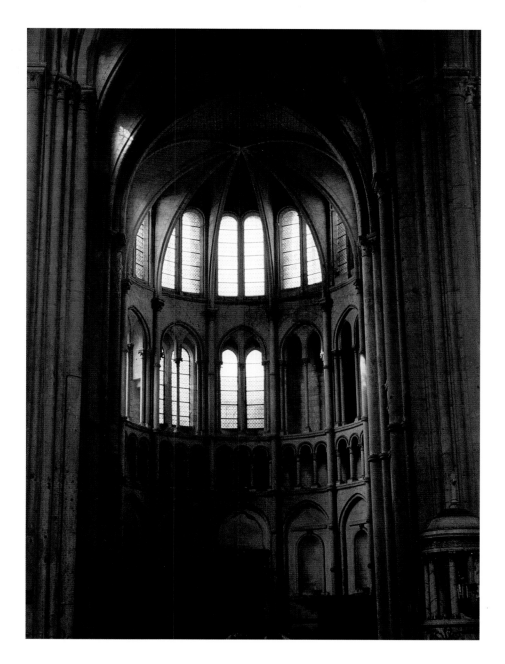

3 Noyon Cathedral, view of the north conch

most part to the extremely thin columns of the passageway, the verticality of which is not repeated anywhere else on the wall surface. The upward movement remains bound to the columns themselves, which seem to hover in the air, positioned on high pedestals, and whose offset polygonal lower sections – despite their elegant contour – give the impression of being column shafts rather than responds. The result is a tense, turbulent wall articulation in which the support element is the individual column, which is not subordinated to an overall framework. The elevations of Great St. Martin's conches do not communicate vertically with each other, but each register possesses its own horizontal rhythm.

Not so the conch-shaped terminations of Noyon Cathedral's transepts, where we find standing in *front* of a four-register wall a cohe-

sive framework of responds and string coursing that ends in breathtaking sail-like vault cells overhead. The ribs of the vault radiate out from between the lights of the clerestory to meet in the center. Circulating behind the responds – whose shafts are fastened into place by string coursing – is a pedestal wall with blind pointed arches, three-arched triforium, a gallery with double openings canopied by pointed arches, and a tall clerestory with bright double lancets cut high into the vault at the top. Especially effective from an aesthetic point of view is the contrast between Noyon's framework of responds and string coursing, and the dissolved wall surface behind it, which visibly increases in height with each register yet is broken up by the framework into a series of compact vertical sections. The columns in front of the passageway at Great St. Martin give the impression of being self-contained elements whose power is carried within, while the responds of Noyon are continuous shafts which seem to channel the thrust radiating out from the vault boss overhead.[43]

So there are major differences between Cologne and Noyon, variations that reflect a divergent sense of form among contemporaries – that of the Late Romanesque, and that of a locally developed northern-French style whose achievements would form the basis for all subsequent variations of the Gothic. Any history of German Gothic, then, must begin in France.

The appearance of the Gothic style in northern France owes much to the fact that in this region there was a continuous modification of the lateral elevations of the nave wall which, when projected onto the transept and upper walls of the sanctuary, created space that was bordered by latticed surfaces of similar form.[44] In the second half of the twelfth century the architecture of northern France was a huge proving-ground for wall-surface articulation, and there are many structures similar to the transept conches of Noyon that attempted to find new ways to equate form with function.

In the richly articulated Rhenish-School Romanesque, the wall manifests itself as load-bearing, space-defining substance. Whatever form the masonry took, however – whether it gave structure to a surface, or presented a system of vault and arch supports – it still remained part of the wall and never lost contact with it, even when placed in front. With the new Gothic style, on the other hand, the structural elements break free from the wall, as if stepping out from the background of a relief, to become part of a latticework that gives the structure form. The wall remains but as a thin foil between or behind

this framework of elements. Ornamental detail becomes functional and aesthetic at the same time. Statically important elements are pushed into the field of vision by a design that differentiates form and emphasizes function, and that searches for new ways to determine the aesthetic ordering of individual forms within a structure that is anatomically laid bare.

While the Romanesque pier was put together out of individual and non-cohesive parts, the Gothic experimented with tightly bundled piers made up of organically related cores and responds. Stylistically, this stripped more and more of the wall-like character from the Romanesque pier. The Gothic architect altered the Greek column's base by compressing it into oblate plates which reflected, literally, the loads they carried. Thin Gothic capitals with plain, almost austere foliage were given a new orientation; they were turned diagonally in relation to the axis of the nave, if the ribs above them indicated that direction. The archivolts of the main arcades and the enlarged wall openings were dissolved into compressed groupings of molded shafts. The vertical elements of the Romanesque, now placed before the wall, were elongated by compound responds which were transformed as they rose into vault ribs overhead. The entire latticework was fastened together story by story through powerful string coursing. Depending on the intention of the design, the coursing either offset the vertical movement and preserved the coherence of framework and wall surface, or it was cut through by responds which heightened the impression of support that the skeleton of ribs and responds lent to the wall.

This major stylistic change was made possible because of a remarkable change in construction technique and engineering.[45] It had been common practice in Romanesque dressed-stone construction to build horizontally: instead of building a single section of wall up to the vault, several sections of wall were built together one layer of stone after another. Apparently, prefabrication and storage of ashlar was seldom done, and the blocks were hewn just prior to being mortared into place. We assume, as a consequence, that not only was the work of the stonemasons limited to the warmer months, but that no stone work was done at all during winter. In this way Romanesque builders avoided damage associated with the freezing of wet mortar and damage to the blocks themselves, which were wetted-down before being used and usually took on extra moisture after they were placed in the wall.

At the huge construction sites of Gothic

cathedrals, however, long winter breaks were not financially feasible. As a consequence, they were organized around serial prefabrication during the cold months, and quick assembly during the summer. Besides efficient preliminary planning, this required standardization of the stonework through the use of templates and measurements, as well as secure, intermediate storage facilities for the completed elements. The stored ashlar and stonework were then put into place according to a stringent assembly plan that ensured the quality of the materials and the fit of jointed and interlocking elements.

This system did not develop overnight, of course. It can be traced, step-by-step, from the beginning of Early Gothic in the middle of the twelfth century to the mature Gothic in the second quarter of the thirteenth century. As the system matured, the complicated joint-cut piers, compound responds and molded cording gradually disengaged themselves from the tiered layers of masonry making up the surface of the wall between these elements. It became common practice for the skeletal elements to be built up beforehand to a certain height, before the wall sections between them were filled in.[46]

This new construction technology changed the role that the structural element played within the texture of the overall architectural design. It seems as if the familiar forms of the Romanesque were transformed into a new physical state – as though they were unified, then animated to ascend. Within the stationary, jointed cubes making up Romanesque architecture, the animated element comes across as isolated and about to break free. In the French Gothic, this animation is the expression of a dynamic architectural concept that seizes the entire building. The individual sections of wall are raised and their linking together corresponds to a series of identical bays set at precise intervals. Because they are placed close together, one after the other, the bays give the impression of a rapidly moving spatial depth that seems to stretch away indefinitely, even if the total space does not extend further than it did in Romanesque times. Gothic spaces resemble fields of vectors that are created by the thrust of interlocking elements. They seem curiously unstable because of this, and strike one as being incomplete, as though they were permanently frozen in the act of being created.[47]

The floor plan of the Gothic church, on the other hand, was governed by a standard model: that of the side-aisle bay which, when doubled, gives the proportions of the central vessel and crossing; or that of the travée used as the structural unit for the high vault and side-aisle bays, including the buttress-work outside, all of which represents a cross-section of the Gothic basilica.

These are the general characteristics of Gothic church architecture. The sum of these attributes results in a kind of ideal type, which is what we imagine the Gothic to be and, for the present at least, will assume it to be. Yet, nowhere was this ideal achieved, not even in the "classic" Gothic cathedrals. Individual churches varied their uses of these fundamental stylistic elements in the most diverse ways imaginable, each making its own choice of which Gothic features it employed.

The speed at which the new style developed can be attributed to the fact that a large part of its vocabulary stemmed from the Romanesque and was "gothicized" through a process of modification. Important ideas for the Early Gothic cathedrals of the royal territories, and large ecclesiastical holdings in and around Paris, came from the areas bordering to the north. Four-register elevations not only appear in Noyon and in the cathedral of Laon (begun around 1150–5), Notre-Dame Paris (begun 1163), Soissons (south transept 1180–1200), Cambrai (nave 1148/50 – around 1180) and in the nave of St-Germer-de-Fly (after 1150); a similar four-register organization also appears in the churches of Flanders and the Hainaut, like Tournai Cathedral (nave begun about 1135/40) and St. Donatus in Bruges (around 1130), which were probably inspired by the churches of western England.[48] There is even a hint of English and Norman influence in the double-shelled structure of the middle register of Noyon's transepts, which were used in older apses at St-Nicolas (1083–93) and Ste-Trinité in Caen (around 1100), in Cérisy-la-Forêt, and in the nave of Peterborough Cathedral (1118–40).[49] Transepts extended to include wide, three-aisle arms – Laon was an inspiration for this – are not only found in the pilgrimage churches of south-western France, but also in the great Romanesque buildings of England.[50] The ribbed vault was introduced to central Europe by the architecture of England and Normandy, before it served Gothic architects.[51]

Early Gothic did not compile these highly developed Romanesque structural elements indiscriminately, but combined them into easily recognizable examples of a new style. This they accomplished with the help of a new vocabulary of form, along with a new sense of unity and consistency in spatial organization. For example, it took a complete restructuring of the

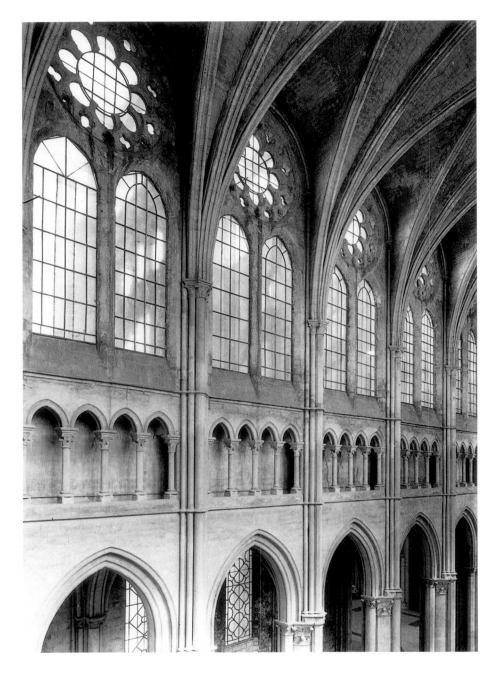

4 Chartres Cathedral,
wall of the central vessel

5 Braine, St-Yved

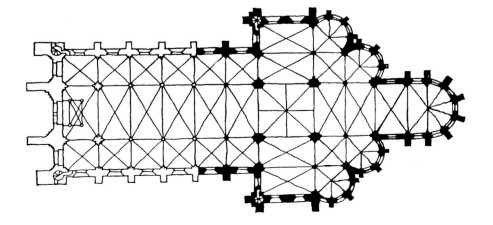

Romanesque ambulatory choir of the type seen in the third abbey church at Cluny, to fuse the chapels and ambulatory of St-Denis (1140–4) into the single luminous spatial unit that it is. It required an aesthetically heightened sense of form to realize the wall-articulation system at Sens (1140–80) where the form of every single element both expresses and fulfills the function it is meant to perform, or to erect the nave of Notre-Dame Paris (1180–1200) as a chain of narrow travées whose static requirements are expressed by open buttressing that surrounds the structure like a cage.[52]

The building of Chartres Cathedral (begun 1194, nave completed 1220) must have seemed like a solution to all of the problems facing builders struggling to come to terms with this completely new vocabulary of form during those first decades [4]. Chartres canonized a method of simplifying the four-story elevation into a tripartite division with huge clerestory openings, equal in size to the main arcade windows, which are broken up into groups of lights to provide support for the glass.[53] Chartres' architect preferred an incredibly flat wall-articulation, and only the triforium achieves any depth at all. In general, its lateral elevations consist of a flat, towering surface of stone and glass. Chartres' monumental central vessel is combined with a lack of sculptured form – except in obvious cases like the clerestory responds, which are fused to the wall in order to express structural continuity optically. The profiling of the mullions in the windows is omitted completely. The clerestory openings sit flat between the vault responds. The window sills are cut at a steep angle, and transform thickness into flat surface. The main arcade pier seems here to have found its form once and for all: through a frontal and lateral placement of four responds on its core, it communicates with the arcade arches, with the transverse ribs of the high vault and the aisle. This forces the lower sections of the inner framework's most important elements to gather around the piers.

There is the tendency to understand the lateral organization systems of the three classic cathedrals – Chartres, Reims and Amiens – as representing the pinnacle of the Gothic articulated framework. By doing this, however, we limit the historical development of the Gothic by placing it into three "perfect" cathedral systems. And, in fact, our enquiry can disregard this attitude, for there is no direct descendent in Germany of the Chartres style of architecture, nor of the second great building of the turn of the thirteenth century, Bourges Cathedral (begun around 1195). Perhaps this is because its

grandiose five-aisle spatial alignment, its steep
main arcading and inner aisles lit by clerestory
windows, demanded a maximum of rich articu-
lation and structural differentiation. In the final
analysis German Gothic, together with much of
the architecture of eastern France, turned to
other buildings whose influence was just as great
as that of Chartres and Bourges.

An example of just such a building is St-Yved
in Braine, a Premonstratensian church of the
Soissonnais that was begun before Chartres and
consecrated in 1216. It employs a flat three-
story elevation and quadripartite vaulting like
Chartres, with a clerestory that is low despite a
high vault springing, and a pier that lacks
respond shafts.[54] This kind of wall organization
was popular in much of France during the early
years of the thirteenth century.[55] The choir
section of St-Yved in Braine [5] would find many
adherents in Germany as well. Characteristic are
its paired chapels placed diagonally between
choir and transept. These are Gothic decendents
of the Romanesque Benedictine choir flanked by
small chapels,[56] and their use in St-Yved surely
came from the desire to simplify the cathedral's
ambulatory choir by reducing the number of
radial chapels to two each side.

On the eastern borders of France, between
the Schelde River area in the north and
Provence in the south, many churches were
built during the whole of the thirteenth century
that used this choir design either directly or as
a springboard for a similar design.[57] It was
through this area that the busiest trade routes
of the High Middle Ages ran: from northern
Italy through Provence, Burgundy, Champagne
and Flanders to England. Economic competi-
tion meant close ties between the cities of the
region, which promoted dispersion of the diag-
onal chapel type.[58] Churches begun in thir-
teenth-century Germany that employed this
type included Our Lady in Trier [29], St.
Viktor in Xanten [48], St. Catherine in
Oppenheim, St. Michael in Pforzheim and the
parish church in Ahrweiler – to name only the
earliest examples.[59] It's perhaps not surprising
that these churches are all located near the
Rhine valley, an area on the eastern edge of the
heart of European Romanesque architecture.
The Rhine valley, it's true, would soon lose its
distinction as a Romanesque center, but it
would gain in importance as a point of assimi-
lation for the new style coming into the
German Empire from the west. The cities of
the Rhine had flourishing architectural tradi-
tions. Because of their location, they had espe-
cially close architectural ties to France.

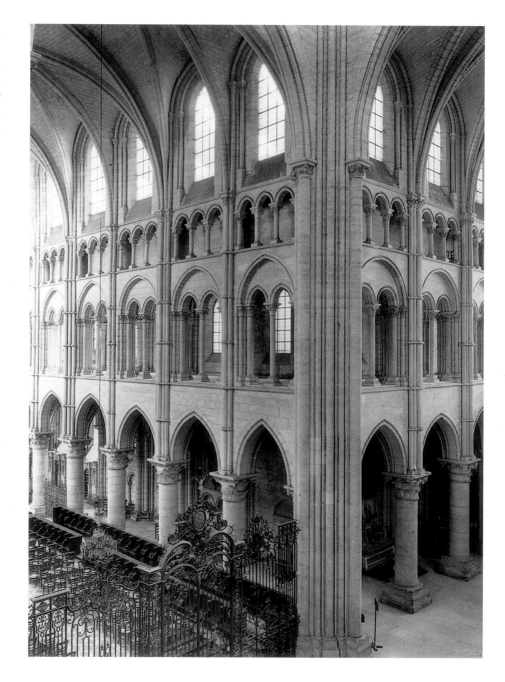

Even more important to German architec-
ture than Braine's reduction of the cathedral
choir was a differentiation of Gothic wall artic-
ulation undertaken in Champagne and
Burgundy. Specifically, the persistent use in
these regions of the double-shelled wall con-
taining spatial volume, instead of the board-like
latticed wall of the Chartres school. A example
of this is found on the northern edge of the
Champagne region at Laon Cathedral [6], with
its impressively thick inner wall that fronts
deep galleries behind. Its low arcade carries
heavy clerestory walls featuring rounded forms,
sculptured three-dimensionally. Resting on
abaci that jut out from the tops of compact cir-
cular piers, are powerful compound responds
whose upward movement is interrupted at close

6 Laon Cathedral, wall
elevation of nave and
transept

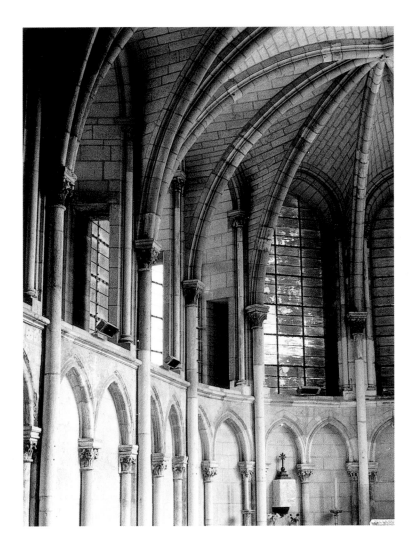

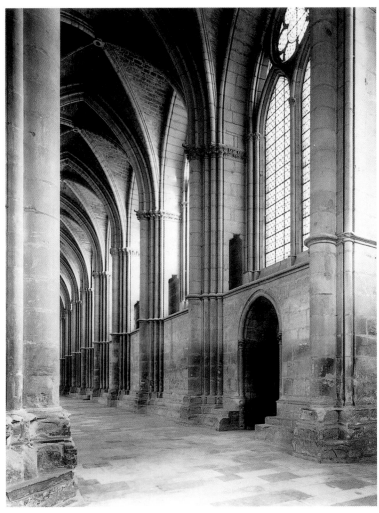

intervals by shaft-rings. There was a break in construction at Laon (1190–1205) and when work began again, the builders did not deviate completely from this wall system in finishing the western section of the nave.[60] For a German architectural tradition used to Romanesque forms, the example at Laon was easier to assimilate than the flattened surface elevations of Chartres.

During the early 1270s, in the heart of the Champagne region, the nave and choir of St-Remi in Reims were built using a highly individualized design with many new structural motifs. One of them would be widely imitated: the triple-bay chapel that juts out at the apex of the sanctuary [7], accompanied by a wreath of radial chapels with engaged piers that create deep window niches. Circulating in front of these window niches is a passageway that cuts through each pier. This same organization of engaged piers cut through by a passageway can also be found in the side aisles of Reims Cathedral [8]. However, here they are part of a powerfully rhythmic line created by huge, spatially promi-

nent compound responds, between which the passageway and the tracery work of the wide windows form a second and third level of depth respectively.

At Amiens and Beauvais the Gothic skeleton is reduced to the point of extreme fragility. The architect of Reims Cathedral, Jean d'Orbais, chose a double-wall construction with deep window spaces separated by rounded respond shafts fused with pier buttresses, which produces a very massive and stable appearance. Compared to this massive layering, the wall articulation of Chartres seems almost two dimensional.[61]

We meet the structure of Reims' side-aisle walls again at the most important Gothic structure in Burgundy, Auxerre Cathedral (begun 1217), but here it has been translated into delicately articulated openwork [9]. Its choir ambulatory wall sweeps back from above the arcading to create room for a passageway in front of the windows. The engaged pier of Reims is reduced here to a bundle of three thin responds behind which the passageway runs, open and unobstructed. The lateral elevations of

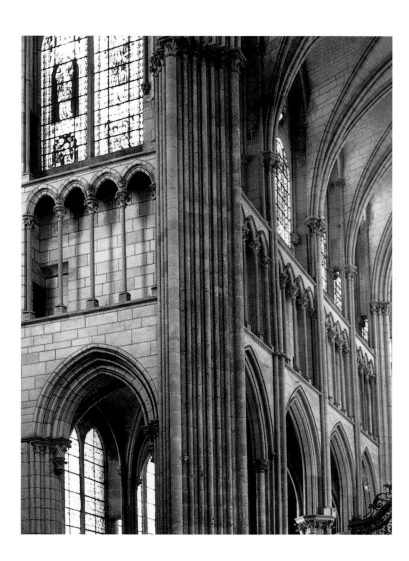

7 Reims, St-Remi, wall articulation of the apex chapel

8 Reims Cathedral, wall articulation of the side-aisle

9 Auxerre Cathedral, choir and transept clerestory

Auxerre's sanctuary seem at first to resemble Chartres: three stories, high clerestory with double lights and oculus openings over them. But there are characteristic deviations from Chartres as well. The arcades of the choir have an alternating system of compound piers and columns, the triforium is very high and its columns create an exceedingly light and elegant latticework that reveals the outer wall as being the actual shell of the central vessel. The upper elevation is enriched by a second passageway in the clerestory, which runs immediately above the triforium.

This multiplication of passageways in Burgundy – St-Martin in Clamency and Notre-Dame in Dijon[62] followed Auxerre's example – is not isolated to this area. Auxerre's clerestory passageway can be traced back to the wall design of the three major cathedrals in the upper Rhône valley at Lausanne, Geneva and Lyon where the Gothic style made its breakthrough shortly before 1200. Further examples can be found in southern England (Canterbury's Trinity Chapel, Exeter, St. Albans),

Normandy (Bayeux, Lisieux); Brittany (Quimper); in Hainaut and Flanders where – as in Lyon – the passageway has been moved outside the clerestory wall. Between 1180 and 1240 these churches, as a group, can be understood to have further developed the tendency of central-European Romanesque to build hollowed-out walls. The Gothic wall retains its spatial depth at these churches, while at Chartres the relief of the lateral surface is so completely flat that nothing remains of the heavy Romanesque wall. This family of churches, with their very different structural detailing, stretched from England to the Rhône valley and forms a wide half-circle on the map around the Ile-de-France.[63] A similar dispersion pattern is formed by the group of churches employing the choir plan of Braine.[64] We will come across the leitmotifs of all these buildings again in early thirteenth-century German churches which, now that our look at the western borders of the German Empire is complete, we can start to scrutinize more closely.

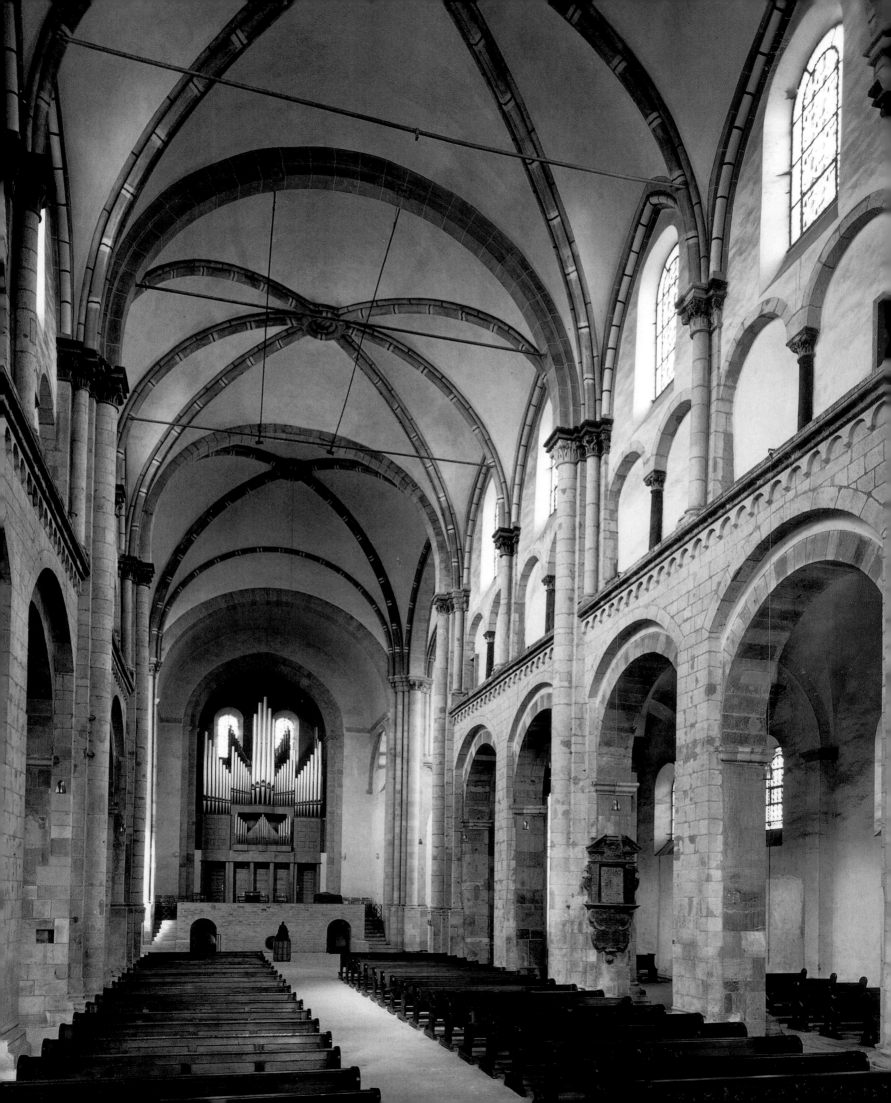

Between 1200 and 1250 the Rhenish School of the lower Rhine region articulated churches with highly individualized forms by tapping the strength of a Romanesque tradition that continued to develop and be important. Many places saw the building of important churches, like Great St. Martin in Cologne, whose architect communicated a joyous profusion of forms without forgoing a physical emphasis of the structure as a whole. Perforating and hollowing-out the wall here did not lead to its absorption or dismantling into intervals of vertical division, as we saw in the Gothic specific to eastern France. Instead, it led to an encirclement of the space in band-like stories set quietly one upon the other.

Nonetheless, the choir of Great St. Martin seems to express a knowledge of Gothic verticality and spatial unity. This has lead some scholars to date it later than the especially wide choir of St. Aposteln, also in Cologne. Just the opposite is true, however. The transformation of Great St. Martin's high conch design into wide, thick-walled, even heavy choir spaces and the setting off of its conches by wide fore-bays (where the goal at St. Martin had been for a narrow fusion of spatial elements) were changes done in a Romanesque style that was barely influenced by the new Gothic style coming in from the west between the years 1150 and 1192.[65]

It was between these two poles, Great St. Martin and St. Aposteln, that stylistic variations would swing during the first decades of the thirteenth century in the towns on the lower Rhine. There followed a series of triple-conch choirs – in Bonn (about 1200), Neuss (1209–20/30), Roermond (1218–24) and St. Andreas in Cologne (begun about 1220) – all built using both the proportions of Great St. Martin and St. Aposteln.[66] These four are closely related to the "storied choir" churches of the Rhenish-Maas school which include St. Clemens in Schwarzrheindorf, St. Gereon and St. Kunibert in Cologne, St. Nikolaus in Brauweiler, St. Kastor in Koblenz and St. Servatius in Maastricht. Also closely related are the choirs built during this time that were influenced by Bonn's transept conches – Sinzig, Münstermaifeld and Boppard. Or those churches with choirs influenced by St. Quirin in Neuss – Gerresheim, Kaiserswerth and Werden. All are characterized by storied outer-wall elevations, whose surfaces are enlivened by blind arches, pilasters, string coursing, and a typical combination of plated friezes and dwarf galleries;

without losing the thick, solid character of the wall. Indeed, many of these churches have choirs with inner passageways running in front of the windows – Neuss, and St. Kunibert in Cologne have them at ground level too – without ever quite diminishing the thickness of the walls. Rather, their heavy arcade arches give the impression of being inner abutments to the apse calottes.

These churches usually possess a short nave, designed as transition space leading to the more extravagant eastern end of the building. They use the double-bay system, which was significant regionally as a general design. In the important churches of the period in Cologne – St. Andreas, St. Aposteln [10] and St. Kunibert – a blind triforium has been inserted between the piered main arcade and clerestory. Possibly they are decendents of late eleventh-century architecture of Normandy (Caen), although the lower Rhine did have an early blind-triforium system at St. Nikolaus in Brauweiler (around 1140). In the naves of Gerresheim (around 1210–36) and Cologne's Great St. Martin (rebuilt 1235–40) we find "true" triforia. In St. Martin there is even a series of travées created by short rectangular nave-bays and side-aisle bays extended longitudinally. But these naves have not made a decisive move to Gothic surface division. Their piers remain four-cornered and squat. The arcade arches – in Great St. Martin they are still rounded – seem chiselled out of the wall and appear to emphasize the masses they carry. In the unarticulated upper elevations, the triforium and windows hover in an unclear relationship to each other. In the clerestory of Great St. Martin, small conch-like niches stamped into the stone next to the windows seem to want to visualize the massive core of the wall. Compare this to the passageways of Burgundy, for instance, where open space, framed by shells of masonry, has replaced the heart of the wall.

In the particulars of these naves one senses a knowledge of French Gothic,[67] but looks in vain for a dynamic treatment of detailing, or for a cohesive system of austere spatial organization. However, it would miss the mark to say that the architecture of the lower Rhine never attempted to copy Gothic forms.[68] Even more inappropriate would be to call it, as Dehio did, a "transitional style" which we addressed at the beginning of this chapter. No style is transformed into another style in these naves, no form is at the point where it is about to change from that which is still Romanesque to that which is already Gothic.[69] Rather, these naves reflect an important synthesis of two dialectically

10 Cologne, St. Aposteln, nave looking west

11 Cologne, St. Gereon, interior of the Decagon

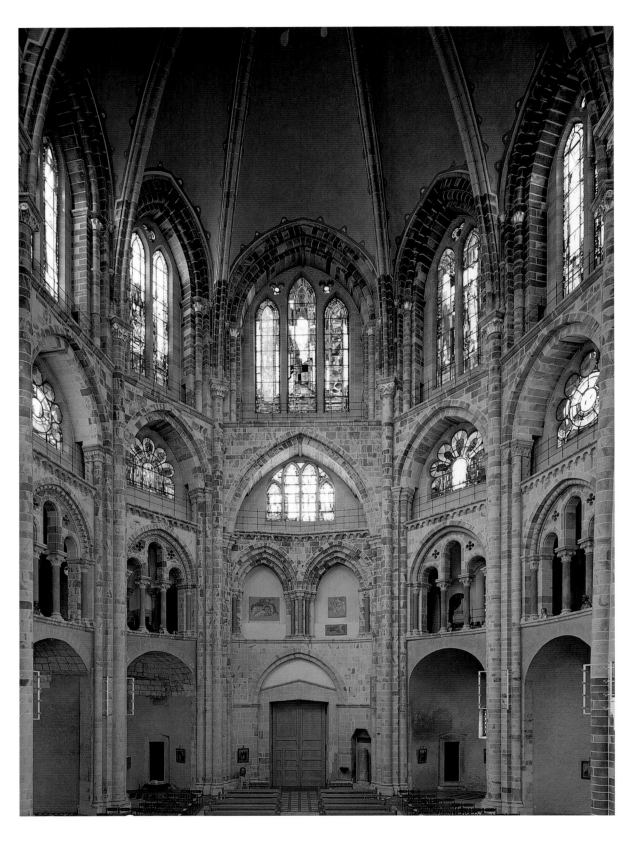

opposed styles built upon compromises between Rhenish Romanesque – anchored in local tradition; whose influence was still powerful and widely accepted – and a French Early Gothic style with only weak affinities to the wellspring of central-European Romanesque that it shared with the Rhenish School. A melding of the two styles created various forms, and each shared

certain common characteristics. For instance, the Romanesque of the lower Rhine takes up Gothic detailing, but in its hands it resonates in a heavier, more single-minded and sober way. Gothic wall articulation and spatial organization relegates itself to a Romanesque attitude towards mass and volume, yet the character of Gothic detailing – with structural peculiarities that are

aesthetically forced to the surface – gives the Romanesque wall onto which they were applied a lighter appearance.

For decades churches were built in this "mixed style".[70] Pointed arches and ribbed vaulting supported by responds were built into spaces bordered by huge structure-supporting ashlar walls that counteracted all lightness in detailing by their massive thickness. Trefoil arches, arches with decorative chevron bands, torus profiling, hanging vault-bosses, sail-like vault cells, fan-shaped windows, peaked gables, rhomboid roofs; all of these were employed to enrich the inner vessels and the silhouettes of multi-towered outer structures. But these motifs were unable, indeed were not intended, to completely relax the severity of the Romanesque structure or to create movement in its stone. What to the Gothic eye seems strikingly a-tectonic – breaking up the rib shafts in the vaulting of Gerresheim's choir, for example, through shaft rings and decorative bosses – was to the Romanesque sense of form a heightening of architectural dignity through the augmentation of decorative elements.[71]

However, Gothic spatial organization did penetrate some of the inner vessels of this diverse family of Rhenish churches. One example is contained in the decagon of St. Gereon (built 1219–27) in Cologne [11]. The ten-sided central structure covered the ruins of a late-Roman martyrium that had itself been rebuilt in the eleventh century and expanded by a choir and crypt. In building the decagon, three new registers were added which rise high above the semicircular niches adjacent to the Roman oval design. The stories are divided into thin vertical sections by large round responds. The gallery, covered by a leaning roof, opens to the middle through twin- and triple-arch arcades topped by a single, blind pointed arch. Above the gallery rises a high, double-register clerestory with double lancets recessed into the wall of its upper level, in front of which are passageways that encircle the whole of the central space. The lower level of the clerestory – with low, wide fan-shaped lights – communicates optically with the ground floor through pier responds that stretch up to receive the archivolts of their window recesses. An abundance of light is provided by the upper clerestory level's Early Gothic lancets and trefoil windows carved into the spandrels of the pointed arches. These openings have a similar effect to the quatrefoils of the gallery's blind arches, in that both give the impression of having been punched through the thin masonry. The main responds rise between the window

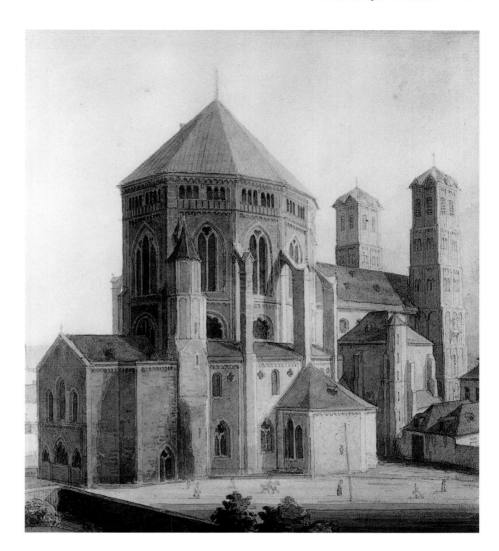

groups, each receiving one of the ten ribs of a domed vault, whose lower edge is truncated by the uppermost window recesses.

To name an exact forerunner for this lateral division would be difficult indeed, although some general prototypes can easily be identified: the recessed wall passageway in the side-aisle at Reims Cathedral, the double-passageway systems in the clerestories of north-eastern France and Savoy (Noyon, Rouen, Geneva, Lausanne), which were adopted in Burgundy at about the same time. St. Gereon's upper-register windows, unadorned and lacking tracery, can be found at Chartres [4] and Soissons.[72] However, all these forms possess the measured severity of the Cologne School, which casts doubt on the notion that a French architect was at work here.

Much remains of St. Gereon's outside wall [12]. The cornice-work of a plated frieze, and the dwarf gallery beneath the eaves, is genuinely Rhenish. It is interesting how the pier buttresses, which support the upper story with short flyers, seem to grow out of the corner lesenes. These are topped, not by tabernacles or pinnacles, but by simple gables like the buttresses of many struc-

12 *Cologne, St. Gereon, View from the South-west*, *ca*.1844, watercolor, Weyer Collection, Stadtmuseum, Graphische Sammlung, Cologne

13 Bonn, Minster, central-vessel wall

14 Bonn, Minster, north side of nave

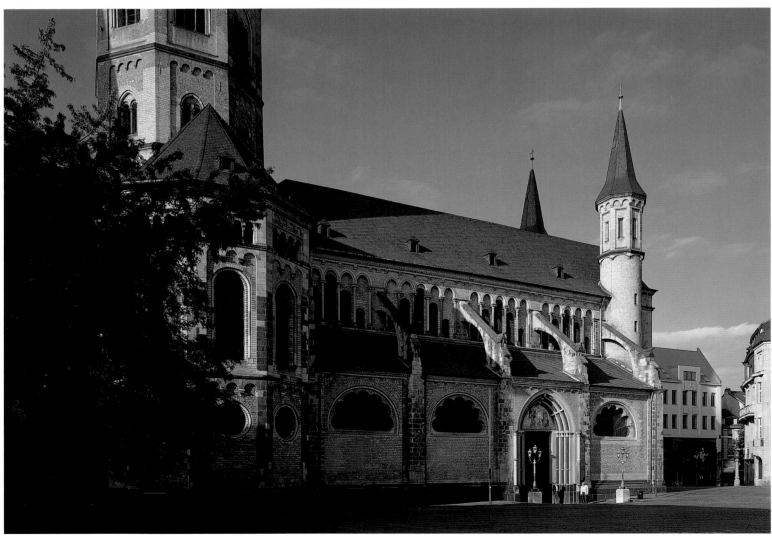

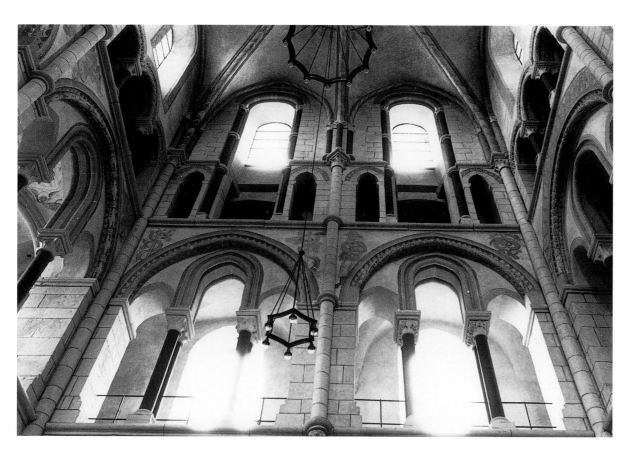

15 Limburg, St. George, view of the gallery register of the crossing

16 Limburg, St. George

tures in eastern France around the year 1200.[73]

Like St. Gereon, the nave of Bonn Minster (1220–30) applied the above-mentioned styles with some differences in detail [13]. Most of Bonn's lateral elevations are Gothic – this time three registers, with triforium and clerestory passageway. The individual forms seem at times Romanesque – its squat goblet-shaped capitals, for instance, the smooth-edged molding on the archivolts of its lower arcades, the pilaster form of the main responds, and triforium piers with rectangular cores flanked by small columns. Some forms seem either Early Gothic, like the slender crocketed capitals of the uppermost stories, or High Gothic, like the rectangular high vaults and the roll-and-fillet molding of their ribs.[74] The most obvious feature indicating an eastern-French Early Gothic prototype for Bonn are the five "stepped" arches of the passageway placed before the windows, which appear in the same form in the nave of the cathedral at Geneva. Bonn's nave also shares Geneva's wide pier placement, and its slightly rectangular high vault combined with longitudinally extended side-aisle bays.[75] Seen from the outside the aisles with their wide fan-shaped windows and flat lesenes, would appear pure Romanesque were it not for the Gothic columned portal in the north wall [14]. Growing out of the side-aisles' roofs, as at St. Gereon, are gabled pier buttresses out of which spring unadorned flyers – clearly an open-

buttress system employed to expand the series of basilican bays of the nave into a complete Gothic travée.

An even more obvious example than Bonn's conscious adaptation of individual Gothic elements can be seen at St. George in Limburg-an-der-Lahn [16]. Whatever western-European churches influenced St. George (begun prior to 1200), they must have also had luxurious ornamentation skillfully incorporated into the surface of a massive wall. Its Early Gothic design was clearly influenced by the Champagne group of cathedrals. It possesses a system of double

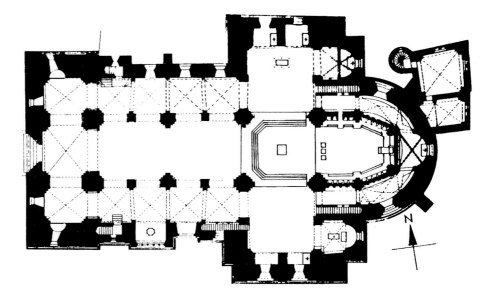

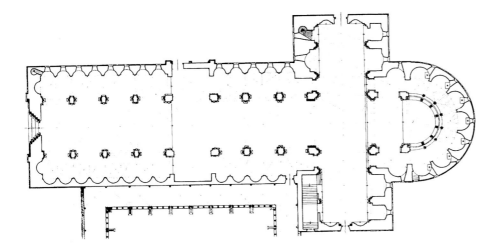

17 Heisterbach, former
Cistercian Church

passageways in the upper registers that encircle the central vessel and transept. It has a two-towered west façade, repeated in reduced form on the transept fronts, that achieves a level of integration in overall design not seen in any French cathedral of its time. Yet this cruciform church has a short nave of Rhenish proportions within a double-bay system that combines a square high vault with two side-aisle bays each half as large (Gebundenes System). Of local origin is the single-bay transept lacking side-aisles, a high crossing with cloister vaulting, and a cramped, archaic-looking ambulatory. St. George's four-register lateral organization is similar to that of Laon's[76] [6], but lacks its thick individual elements. The multi-edged piers of the crossing, rectangular supports, wall surfaces as part of the passageway arcades and squat tri-forium columns with high plinths and abaci, are all standard features of the architecture of the lower Rhine [15].

Accompanying the majestic double towers of the west façade, are small towers on the outer corners of the transept along with a high cross-ing tower – all in all an ambitious group similar to that originally planned at Laon Cathedral but never built. Limburg's architect employed the achievements of Gothic structural engineering very sparingly. The two pier buttresses of the choir are statically useless and are not elements that assimilate into the otherwise cohesive "closed rotunda" system of the apse.

Now to the early Cistercian churches in Germany. Were they Gothic or Romanesque? At first glance, the question seems easy to answer, since we know that the origins of the Cistercian Order were French. Furthermore, the German Cistercians were the product of a general reform movement in the order, and we assume that the structures they built were in the most modern style of the time. Yet, even German Cistercian architecture is stylistically ambivalent, possess-

ing Gothic and Romanesque features either in symbiotic harmony, or tense counterpoint.

Of the monastery at Heisterbach in the hills east of Bonn [17], only picturesque ruins of the choir remain; the structure was almost completely destroyed during secularization between 1809 and 1820. When, centuries before, the monks at Heisterbach, under the leadership of Abbot Gevardus, began building a church and cloister[77] many elements of the Rhenish Romanesque had not yet been developed. Heisterbach would contribute to its development with the building of asymmetrical, triradial vaults over side-aisle bays, circular and rose windows with foils, and the "stepped" triple lights of its west façade.[78] At the time of its consecration in 1237 a chevet had also been built, whose complex tripartite lateral division, with ambulatory and radial chapels, illustrates the Burgundy school of Cistercian architecture [18].

Scholars have thoroughly debated the role the Cistercian Order played in transmitting French architectural forms. The white monks are often celebrated as "missionaries of the Gothic" east of the Rhine. Otto von Simson proclaimed that the Cistercian Order's leader at the time, Bernard of Clairvaux (+1153), along with Abbot Suger, the builder of St. Denis, and Thierry of Chartres, the most influential teacher of early Scholasticism – were the intellectual catalysts of the Gothic movement.[79] And, in fact, Cistercian reform architecture did stem from Clairvaux. As early as the 1120s[80] a basilican nave in the Burgundy tradition was supposed to have been built there, that was covered by pointed tunnel vaulting and connected to a flat choir termination and projecting transept. Off the eastern side of the transept were a series of rectangular chapels that formed box-like spatial units. The choir design of the first abbey church of Clairvaux spread as quickly as the affiliations of the mother church in Burgundy,[81] of which the earliest German Cistercian churches were at Eberbach (founded 1135, construction plan about 1145) and Himmerod (founded 1135, building begun about 1138). The Clairvaux type was conceived as a structure that was extremely sparse in ornamentation, functional and easy to engineer. It was very suitable for duplication by the growing monastic order. Bernard surely con-tributed to its conception, for it agrees with the theme he put forth in *Apologia ad Guillelmum-Sancti Theoderici Abbatem* (1124) which is criti-cal of the complicated architectural and artistic activities of the Cluniac Order.

It is difficult to draw a parallel between the aesthetic architectural ideal of the Cistercians,

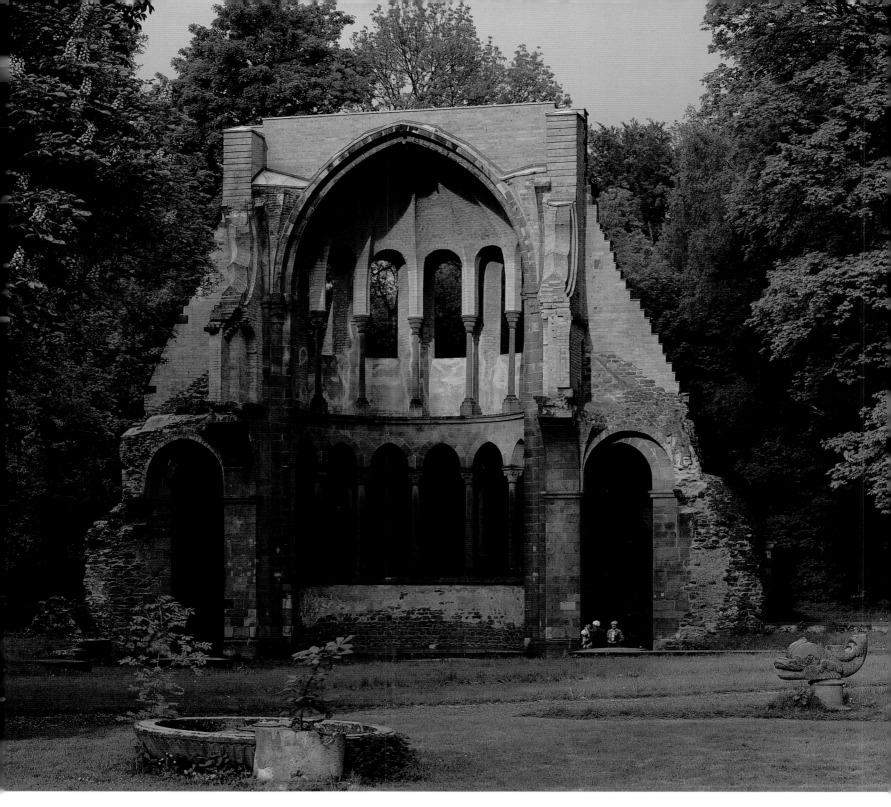

18 Heisterbach, former
Cistercian Church, choir
ruins

19 Villard de Honnecourt, *Sketchbook* (*ca.*1225/35). Floor plan of a Cistercian church

with its avoidance of all forms of ornamentation, and the richly articulated Early Gothic style. At best a parallel can be made based on secondary observations from the drawing board, as it were, rather than the buildings themselves. For both Gothic and Cistercian architectural designs required the most comprehensively thought-through floor plan possible, based on a single modular unit that could easily be reproduced. The smallest unit of design is the square of the side-aisle bay. When its surface is doubled, it gives the rectangular shape of the high-vault bay. When its sides, not its surface, are doubled, it gives the square bay of the crossing. Reduced to this simple design scheme, the floor plans of the Cistercian church at Fontenay (1139–47) and that of Chartres Cathedral look very similar.

It is possible that Bernard's well-documented love for church music[82] and his study of St. Augustine's harmonics contributed to the theoretical fundamentals of Cistercian construction geometry. Transposing harmonic principles into mathematical-geometrical proportions – translating musical intervals into dimensions – was a general habit of the Neo-platonists and can be traced back to Augustine himself. The structural ratio of 1:2, on which Fontenay's ground plan is based, corresponds to the basic whole-tone intervals of the octave, whose absolute perfection, according to St. Augustine, expresses to the human ear the meaning behind the mystery of redemption.[83]

In the final analysis, there is no direct proof that Augustine inspired the geometrically ordered proportions of Gothic and Cistercian architecture, but at the very least there were probably attempts by his contemporaries at

explaining the design of a building *after* it had already been completed. Referring to the authority of the Church Fathers was a common practice among medieval thinkers, and any intentional or accidental correspondence between form and theory gave meaning to architecture in their eyes. Use of the square as basic design module for floor plans reached its peak with the rebuilding of the choirs at the Cistercian churches of Morimond (about 1155) and Cîteaux (about 1140–93). Here the proportions of the Clairvaux type were taken even further, for these choirs possess a right-angle ambulatory with square bays and chapels that were needed to provide more altars for the monastery's growing population of monks. No doubt those familiar with Gothic architecture at the time were impressed by this rational module-based plan, as the study of a Cistercian church [19] in the "sketchbook" of Villard de Honnecourt (1225/35) shows.[84] At what point Cistercians and Gothic came to share more than just a similar design aesthetic is a question that must be answered by taking a critical look at individual elements of the two styles. Serious differences exist, for instance, in the appearance of their outer structures. Where Gothic architecture was enveloped in an open, skeleton-like system of buttresses, the large Cistercian churches of Burgundy retained the modest blockiness of the terraced basilica.

With a growing number of churches spread far and wide, the Cistercian aesthetic of the "ideal building" was influenced by contact with local building styles. It was also influenced by the ongoing structural enhancement of a Gothic style that was becoming more important all the time. Heisterbach's [18] extravagantly articulated inner choir wall – with its high, wonderfully placed pairs of columns – possesses both a clerestory passageway and an ambulatory hollowed-out by niches. It is surely one of the most beautiful choirs in that area of the Rhine. For while it shares with many neighboring churches an inner-wall division of two levels encircling the apse; its handling of form – its interpretation of the double-shell organization – is accomplished with a playful ease. The positioning of the columns – those of the front row sit on a low wall, those in the back on columns – manage quite well without the heavy weight of the Romanesque piered arcades.[85] As though to emphasize this daring highwire act, the double columns are placed in loose echelon with the back elements, raised by their supporting columns, taller than the wall and bases of the front columns. The design plays with the

masonry, dissolving its normal solidity in a purely Gothic way using the motif of movement. The apse calotte develops out of stilted arcading produced by the clerestory columns with their funnel-like vault beginners that cover the back wall and only allow room for the windows. This clerestory is the most open of all the windowed walls in the Rhineland from this period: the variable framework of its lower arcade reflects the up and down movement created by window divisions that are cut extremely high into the vaulting overhead, and the very low vault springing between them. In this way, Heisterbach's Romanesque character is dynamically articulated and its walls carved-out to the point of possessing an almost Gothic fragility.

The entire arrangement at Heisterbach follows that of the rebuilt second choir of Clairvaux (1154, destroyed nineteenth century) which had been built in the style of the third choir of Cluny – with a rounded termination, ambula-tory and radial chapels. This amounted to a relaxation of the austere Cistercian plan in favor of the Burgundian tradition, against which Bernard of Clairvaux had preached. That Heisterbach emulated Clairvaux III is understandable, since it was an affiliate church with direct ties to Clairvaux through its parent cloister at nearby Himmerod. Heisterbach's radial-chapel scheme is the first in German architecture, even though the flat contour of its outer structure reduces the chapels to a chain of wall niches – a structural motif common to the lower Rhine area ever since the construction of the side aisles at Essen Minster (1040/50).[86]

The role Cistercian architecture played in the dispersion of Gothic structural motifs was actually greater in southern Germany than in any other part of the empire. The Romanesque of the upper Rhine region never fully assimilated the lower Rhine's relaxed, decorative surface articulation rich in forms, which were new developments at the time. Instead, the architecture of the upper Rhine valley continued to depend on a contrast between ponderous ashlar-block construction and pure cubic forms inherited from the High Romanesque style of the Alsace School that one sees, for instance, at Rosheim. The polygonal western section of Worms Cathedral (1171–81)[87] is an exception: not the contour of its heavy-handed polygon[88] but the rather un-Romanesque internal divisions of the circular windows in its main story, and particularly the large "wheel" window in the center with a shape closely resembling Early Gothic rose windows.[89] Other than at Worms, the stylistic direction

south-western Germany took was conservative. The great structures of the thirteenth century – the Palatinate churches of Eusserthal and Enkenbach, Gebweiler in upper Alsace, and Breisach in the upper Rhine valley – stuck to the *Gebundenes System* combining a square high vault with two side-aisle bays, each half as large. Even double-choired churches (Mainz, Bamberg) and those with transept-like western sections (Maursmünster, St. Thomas in Strasbourg, St. Paul in Worms) remained true to older Ottonian and Salian designs. It wasn't until the appearance of Cistercian architecture at Ebrach in Franken, and at Maulbronn in Württemberg, that another stylistic direction was introduced – a "mixed style" of architecture comparable to that of the lower Rhine [20, 21].

The choir with ambulatory of the monastery

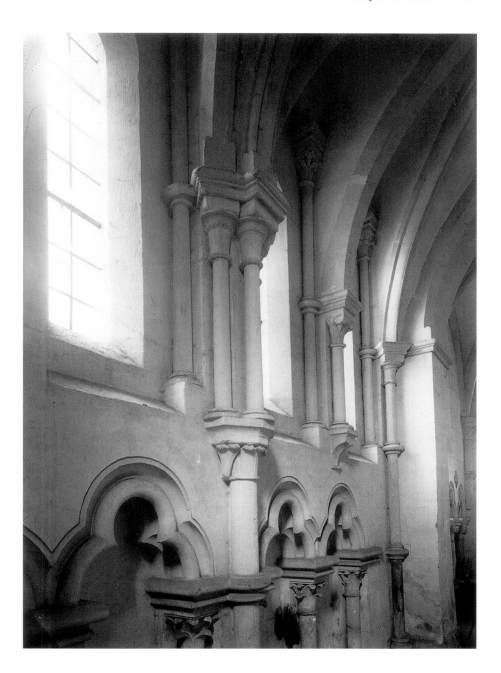

20 Ebrach, former Cistercian Church. Wall articulation of St. Michael's Chapel

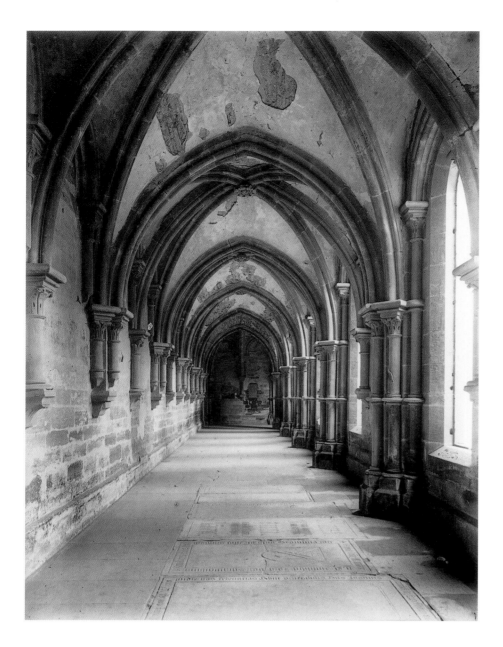

21 Maulbronn, former
Cistercian Monastery.
South wing of cloisters

22 Bamberg Cathedral,
west choir

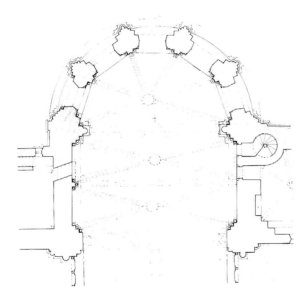

church at Ebrach adopted much of the floor plan of the choirs at Cîteaux III and the parent abbey at Morimond, each of which combines a flat sanctuary termination and a number of small, spatial squares which can be seen as ambulatory bays or chapels set between wall buttressing, and which encircle the central vessel in ways similar to basilican terracing.[90] Ebrach's powerful, closely spaced pier buttresses surround the outside walls of the choir and transept, giving the impression of a robust Early Gothic structure. The cornerstone was laid on 4 June, 1200 and soon after 1239 the choir and most of the transept with its eastern chapel niches were completed.[91] In 1778/91 the interior was re-designed in a style common to that period. The only section untouched was St. Michael's Chapel, a small stand-alone structure with the floor plan of a latin cross placed in front of the north transept, that served both as tomb for the founders of the monastery, the brothers Benno and Richwin and, in the crypt, as charnel house for the monks. St. Michael's Chapel was begun before the building of the monastery church, and had already been consecrated by 1207.[92] Its interior walls are sculptured with compound responds, ribbed vaults sitting on diagonally placed capitals, and blind arcading on the walls typical of the Early Gothic of northern France. More clues as to the origin of this style can be found in the organization of the window walls, whose formerets spring from a point high above that of the transverse arches and cross ribs. A shaft ring encircles the formeret responds at the height of the cross-rib responds. This grouping corresponds to that of the high vault of Laon Cathedral[93] [6]. An even more obvious descendent of Laon is the respond-and-arch structure found in the south wing of the cloister at Maulbronn (around 1220). The formeret respond rises here without a shaft ring, but is overlapped by the profile of the rib respond's abacus. A consistent, systematic framework, in which every element of the vault has its respond, made St. Michael's Chapel and the cloister bays at Maulbronn the most advanced structures of their time in southern Germany.[94]

In the 1230s Strasbourg's large transept was built onto the eastern part of the cathedral, which itself had been constructed during the reign of the House of Hohenstaufen. Each transept arm contains a single-pier vault; that is, one pier carries four vaulted-bays which seem to crown the space overhead at a dizzying height. The south transept, where documents have established the location of a medieval court,[95]

contains the first monumental Gothic sculpture cycle in the German Empire. The south transept, instead of repeating the circular pier in the north, employs a compound pier ringed by canopied figures. The theme of the Last Judgement, widely used in the rich sculpturing of the Romanesque tympanum, has been reduced here to stand-alone figures – arranged around the pier in three garland-like levels – the Evangelists, angels trumpeting-in the Last Judgement, and the second-coming of Christ amidst the Heavenly Host [23]. Freed from the surface relief of the Romanesque tympanum, the isolation of the figures in their new sculptural surroundings lends a fresh plasticity to the masonry of the pier, between whose respond shafts they have been inserted. This symbiosis of sculpture and structural element is a Gothic invention. The almost free-standing figures of Ecclesia and Synagogue at the front of the south transept portal – site of another medieval court at the cathedral[96] – reflect this as well, for they seem to have broken out of the architecture there. The sculptural motif of the slightly turned, standing figure in clothing that is skilfully detailed to reflect thin, finely folded material would have been unthinkable at the time without a knowledge of the sculpturing techniques used at Chartres and Reims.[97] As was so often the case at Strasbourg, the sculpturing was stylistically more advanced than the structure itself, which was subject to ponderous, long-term planning and execution.

The same can be said of Bamberg Cathedral where construction, proceeding from east to west, first betrays the influence of Reims in the sculpturing of the Prince's Portal at the northern side of the nave (built around 1225). It conforms, to an amazing degree, to the south-transept portal at Strasbourg, as shown by its belated supplementation of the Ecclesia and Synagogue theme, but also by the forms of its crocketed capitals and canopies.[98] But it wasn't until building reached the west choir (1227–34) that we see a real display of Gothic structural elements, which includes a polygonal contour [22] and heavy ribbed vaulting. True, the ribs do not meet in the center of the polygon as in other five-sided terminations, but meet instead at a boss placed slightly towards the west. In this way, the apse could be built around a central point, giving it the character of an independent spatial unit. This effect is intensified by the fact that its wall articulation is not continued to the east. Bamberg's polygon seems more a Romanesque apse, than a Gothic chevet whose wall and vault articulation seek visual

23 Strasbourg Cathedral, so-called "Angels Pier" in the south transept

continuity with the adjacent bays of the chancel.[99]

The three upper registers of the west towers were last to be built at Bamberg Cathedral [24]. The basic form, that of structural openwork with aedicules on each corner of the tower, is very similar to the tower flanking the south transept at Laon, the *Tour de l'Horloge*, though in Laon the attempt at a stylistic fusion of the registers was achieved, whereas the cube-like stories at Bamberg seem ponderous and squat by comparison. Research on the structure indicates that the arcades of the corner tabernacles of the north-west tower were originally meant to encircle it entirely. Had this been carried out, the result would have resembled the south-west tower at Lausanne Cathedral.[100]

There are, of course, many other examples of a gradual "importation" of the Gothic into the architecture of southern Germany, but the aforementioned buildings were the most important. It was here that the pool of forms coming in from the west were assimilated and transformed. They took as their models Laon, Reims, Lausanne and the Cistercian floor plans of Burgundy – the very same structures and schools that were so important to the architecture of the lower Rhine region. The architecture of eastern France, then, was the dominant influence in southern Germany as well.

The most important economic forces behind Gothic architectural activity at the time seem to have been cathedral chapters and their bishops, collegiate foundations (in Cologne and Bonn) and the Cistercian Order. No surprise in the case of the first two. Since the end of the twelfth century cities like Cologne, Bonn and Strasbourg – which had developed out of Roman *civitates* – had seen a complete rolling back of the power of the Benedictine abbeys, which had dominated every facet of civic life until then. It was precisely in these cities that territorial and monetary policy, trade and commerce, were conducted at a level of intensity not seen anywhere else. Decades before Gothic expansion, these towns were sites of feverish building activity. Large churches, stone residences and expensive fortifications were built.

The political and economic center of the empire at the time lay in the west. There were three reasons for this. First, the Rhineland garnered tremendous financial benefits from its proximity to the trade centers in Flanders and France. Second, the powerbase of the House of Hohenstaufen was concentrated in the upper Rhine region, despite the fact that the imperial domains also included parts of Franken,

Thuringia and Saxony. And third, the leading figures of the Imperial Electorate bordered each other closely along the Rhine – the archbishops of Mainz, Cologne and Trier, and the Palatinate Count.

It would therefore be logical to assume that the first contacts with the Gothic occurred in the Rhineland, then spread from there to the east, south and north. Much attests to this fact. We find, for instance, wall passageways similar to the Cologne School of St. Gereon [11] in the mid-twelfth century in the Westphalian cathedral choirs at Münster (1250–65) and Osnabrück (1254–77).[101] Also, the rebuilding of the nave and transept of Bremen Cathedral (about 1220—50) where the Westphalian-born archbishop Gerhard II appears to have utilized elements of the Rhenish School in the cathedral's conception and its completion.[102] St. Mary's Pilgrimage Church (begun 1220, demolished 1722) on top of Harlunger Mountain near Brandenburg in the northeast of the empire, seems to have been similarly influenced. The main structure was of crucible design with conches and pinnacled towers in the angles of the cross, a clerestory passageway and ribbed vaulting.[103] And finally – inspired by St. Peters in Sinzig[104] – the choir of St. Mary's in Gelnhausen, Hessen, with its pier buttresses on the corners of a polygonal apse, a crown of gables, and a narrow triforium-like passageway inside.

At first glance, then, the steady movement of the Gothic style from west to east appears to reflect the rapid dispersion of the Cistercian Order, since all the western-German monasteries founded affiliations in the east of the empire. The role western Cistercians played in the crusade to convert the Slavic tribes, a crusade propagated by Saint Bernard, was also important.[105] Yet, it was not a "Gothic" order that settled the east. Most of the monasteries between the Weser and the Elbe rivers (Amelungsborn, Walkenried, Volkenrode, Sittichenbach) were founded before 1150, while the majority of the Cistercian settlements east of the Elbe were founded between the years 1170 and 1200 (Rheinfeld, Doberan, Dargun, Lehnin, Zinna, Dobrilugk and Kolbatz). These monastery churches were built too early to assume that any of them contained Gothic elements, as was the case in the west at Heisterbach, Maulbronn and Ebrach, all of which were built after 1200. It would not be until the early thirteenth century that Cistercian churches in Saxony – Riddagshausen (about 1220–75) and the now-ruined Walkenried (choir begun 1207/9, completed between 1240–53) – adopted

24 Bamberg Cathedral, west towers

25 Lilienfeld, Cistercian Church, ambulatory

style common to the area between Linz and Vienna. Wagner-Rieger calls it "a significant architectural form," that was singled out and promoted by Leopold VI, "to express the independence of his dukedom in architecture which, in a very peculiar way, came to serve his political ends."[107] This all-too-easy interpretation lacks written proof to support it, for neither Leopold nor his successor to the House of Babenberg, Friedrich the Valiant (1230–46), left anything that would indicate they took an active part in determining the form of the church they patronized.[108]

Nonetheless, to walk the ambulatory at Lilienfeld is to walk through a well-balanced Early Gothic structure of astounding unity. The Hall bays move from one to the other without interruption and its smooth-surfaced octagonal piers with their high pedestals look the same from every angle, which emphasizes spatial unity and the lack of a central axis. The transverse ribs of the vaults are molded the same way as the cross ribs, making for a homogenous shell-like ceiling that rests on the corbels of a sparsely windowed outer wall so that the end effect is of a ceiling that hovers overhead in a peculiar way.

The ambulatory at Lilienfeld is reminiscent of Cistercian monastic buildings of the same period, like the monks refectory at Maulbronn (1220) which also possesses an austerely articulated double-aisle Hall with corbelled ribbed vaulting. Yet, it is precisely Maulbronn's advanced structural techniques that stand out when compared to the coarse, stiff forms of Lilienfeld's crocketed capitals and the haphazard direction taken by its vault ribs. Clearly these elements at Lilienfeld were built in what can be understood as a southeastern "outpost" of the Gothic, where there appears to have been a lack of stonemasons who were familiar with the new style.

Questions can therefore be asked, especially in the case of Lilienfeld, about the size, mobility and means of subsistence of a Cistercian lodge. Types of Cistercian floor plans and spatial-organization schemes were often copied – even in buildings far apart from each other. It is not difficult to conclude that there must have been recommended designs, both written and drafted, carried from one monastery to another – in a process similar to the way in which a first set of manuscripts was carried from a parent monastery to a newly-founded one, where they were then copied. The Cistercian Order surely had building specialists at their disposal as well, architects like Achardus from Clairvaux who was sent to Himmerod in the

the Cîteaux III and Morimond choir type as Ebrach had. But they did so without repeating Ebrach's characteristic synthesis of a massive Burgundian Romanesque terraced profile, with Early Gothic construction.[106]

The same cannot be said of the choir and ambulatory of the Cistercian monastery church at Lilienfeld [25] in north-eastern Austria, a church that had been patronized since 1202 by Leopold VI from the House of Babenberg, and which he chose to be the location of his tomb. Lilienfeld's choir (first altars consecrated 1217) is of the Ebrach type. Because of a change in design, however, the inner choir terminated in a polygon, with chapels and ambulatory fused into a double-aisle Hall with octagonal piers. Austrian scholars have written much about this change in design, and in it have located one of the wellsprings of the important Hall-church

Eifel by Bernard. Or Gaufried – also from Clairvaux – who worked on Fountains Abbey in England. Yet, of those who actually carried out the work of building, we know very little. We do know that in 1154 the order was prohibited from loaning their workmen to building sites outside the order's own lodge. And in 1189 lay brothers were kept from being bled – a procedure used to treat and prevent disease in the Middle Ages – if they were needed for construction work. But a newly founded Cistercian monastery, in such a distant location as Lilienfeld, could not have grown fast enough to have built a self-sufficient lodge in just a few years. In such a place, laborers and helpers not associated with the order must have been employed. Furthermore, the nobility was taking over the protectorate of more and more monasteries, which was against the statutes of the order. It was through their help that such building projects were financed, and the workers probably hired to do the job.

It is difficult to find buildings in the eastern regions of the German Empire that were influenced by the Gothic before the middle of the thirteenth century, and of those buildings that were, it is equally difficult to locate their prototypes in the west. There are not nearly enough churches from this period in Saxony, Franken, Thuringia, Bohemia, Bavaria and Austria to show a steady or even slow dispersion of the new style from west to east. That is assuming such a movement even took place, and that it wasn't instead a case of a church here and a church there employing the new style, or of the occasional innovative leap.[109]

Just as far removed from the Gothic centers as Lilienfeld was Magdeburg Cathedral (1209) [26], begun under Archbishop Albrecht to replace a structure built by Otto the Great that had been destroyed by fire in 1207. By the middle of the thirteenth century, an ambulatory choir with radial chapels was completed, and a transept with towers on its eastern flank had been started. Together they represent one of the most striking examples of early German Gothic. Its plan is northern French. The model for its ambulatory with trapezoid bays was probably the destroyed south-transept conch of Cambrai Cathedral (begun 1175),[110] and the towers on the edges of its transept are common to the Schelde River region (Tournai) as well.[111] Magdeburg incorporated a complete Gothic cathedral choir by giving its ambulatory low radial chapels – a daring move if you consider that Heisterbach [18] was settling for enclosed chapel niches at the time, and the start of Reims Cathedral's choir was still two years away. Yet, despite all this,

26 Magdeburg Cathedral

Magdeburg Cathedral would not be a ground-breaking structure emulated by others. The reason for this is two-fold. First, the Elbe River region lacked an architecture rich in tradition that was able to process newly developed Gothic elements, as occurred in the lower Rhine region. Second, crucial elements of the older structure were incorporated into the new cathedral because its builders, in a move common to the Middle Ages, wished to preserve as much of the earlier structure as possible in order to maintain its symbolic value. Both of these factors, then, restricted the potential influence this early attempt in the new style might have had.

Magdeburg's structural forms are pleasantly eclectic. We find antiquated groin vaults in the choir's ambulatory, huge piers, sharp-edged archivolts, rich foliated capitals in the Westphalian or the Rhenish traditions, wide galleries in the Bishop's Aisle (begun between 1230–40), imposts placed at alternating levels, shaft rings, half-circle cross ribs with diamond-pointed rustication similar to that in Maulbronn's "Paradise Building" and monks' refectory. The outer structure reveals the radial chapels, protruding and massive, behind which the weak flyers of the Bishop's Aisle are nearly invisible. Above this is a clerestory with deeply hollowed-out window niches topped by a high, dwarf gallery. This appears to be a distant cousin of the Rhenish storied choir.

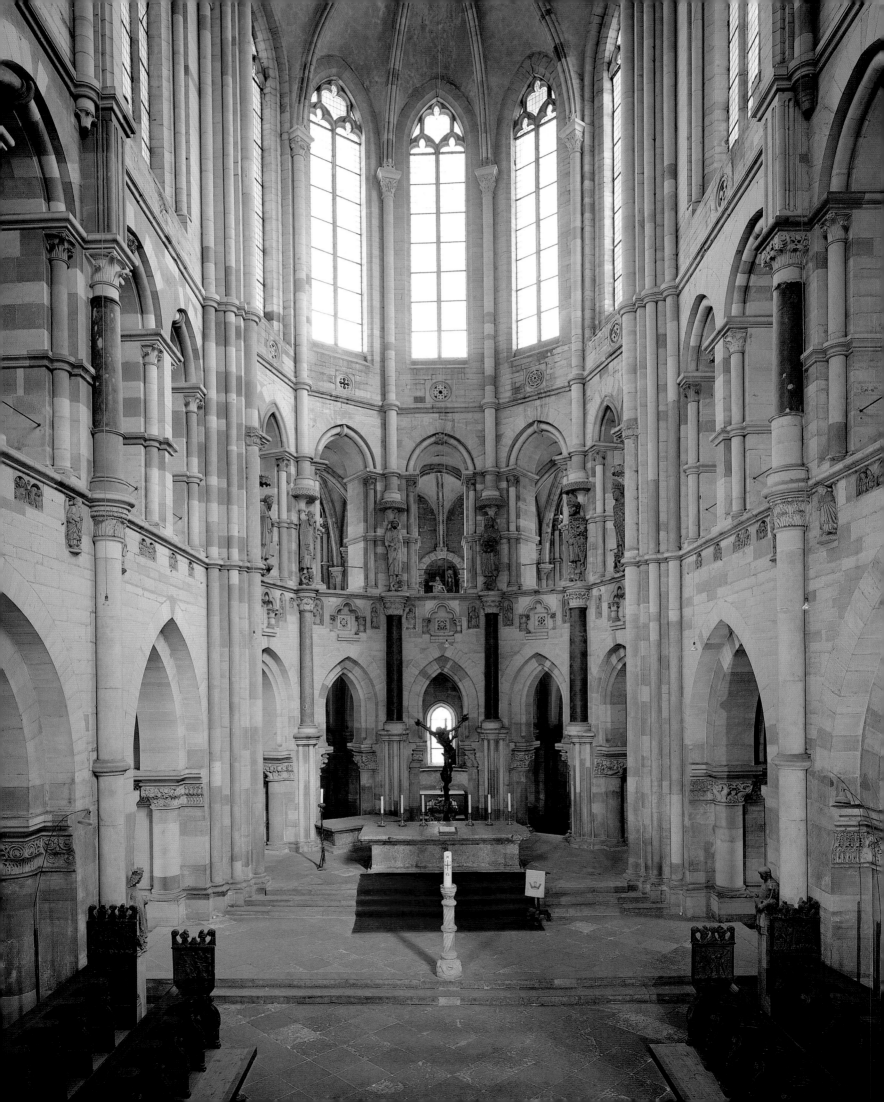

However, the inner choir wall [27] leaves a completely un-Gothic impression and, indeed, seems much more to evoke the imperial *habitus* of the Ottonian, pre-Romanesque structure it replaced. Pressing down on elegant compound responds are powerful columns made of porphyry, granite and marble that Otto the Great had transported to Magdeburg from Ravenna for inclusion in his cathedral, and which were carefully worked into the new structure with austere antique capitals built onto them. Between these columns are trefoil niches housing relics once immured within the Ottonian walls.[112] Above these are oversized, strikingly anachronistic Early Gothic canopied figures. These were intended for a west portal that, had it been completed, would have been the first to possess jamb figures of the French type in Germany. Nonetheless, placed as they are against the wall at gallery level, they form the earliest monumental sculpture cycle in a German choir apse.[113] Proportioning, thickness and horizontal organization give the choir wall a distinctly antiquated feel. Fat or extremely thin columns and responds of various heights are engaged or placed before the wall, resulting in a wall surface that is exceedingly rich in form and three-dimensional movement.

The anomalies of this structure can only partially be explained by its builders having included antique pillars to preserve the rank and importance of the older structure, which housed the seat of a bishop. The dimensions of Magdeburg's choir, and the fact that it took so long to build, also helped determine its contradictory character. Buildings of this size invariably went through different phases of construction, and each phase meant a new beginning. Local architectural traditions, developing slowly, tended to assimilate outside innovations in phases as well, rather than all at once. When these innovations were used in a church like Magdeburg, it resulted in formal discontinuity.[114] And the opposite can also be said. Smaller, quickly built structures were often more precisely articulated stylistically since they did not have to go through this process. In fact, the oldest surviving building from the German Empire to incorporate, pure and untouched, the spatial organization of earlier French prototypes was a small chapel.

27 Magdeburg Cathedral, choir

28 Klosterneuburg, Capella Speciosa. Drawing of inner and outer wall elevations by Canon Prill (+ 1757)

THE FIRST GERMAN GOTHIC STRUCTURES

Drawings of the *Capella Speciosa* [28] – the Palatine Chapel of Leopold VI in Klosterneuburg, Austria, torn down in 1799 by a certain choir canon named Benedict Prill (+1757) show particular structural elements. The drawings reveal outer walls with wide, double windows of the Chartres type [4] above a plain masonry surface, all of which was set between massive, stepped wall buttresses. The lower wall surface inside was enlivened by blind arcading. The upper story was set back behind thin wall responds to make room for a passageway that ran in front of window wells along the long side of the nave, and the five sides of the choir polygon.[115] The west side contained the "Duke's Gallery."

The *Capella Speciosa*, a palace chapel, was consecrated at the early date of 1222, and could have stood in France as well as on the Danube. The motif of blind arcading combined with a passageway can be found in the wall elevation system of the sanctuary chapels at St-Remi in Reims [7] and Auxerre Cathedral, which was the most important Burgundian Gothic structure and built about the same time. Between the building of this chapel and the next Gothic chapel built in Austria is a span of over fifty years

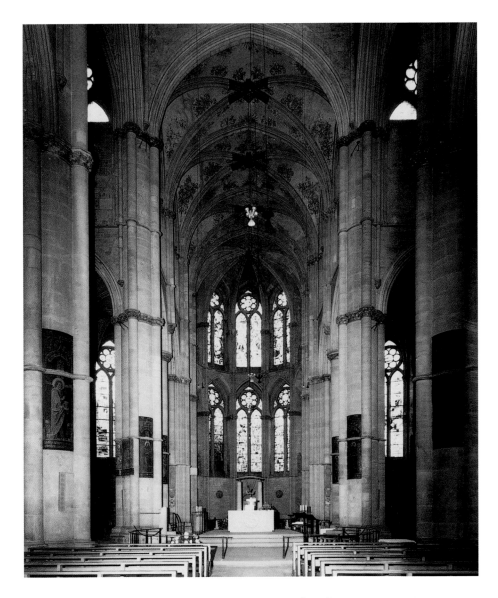

29 Trier, Our Lady,
looking east

30 Trier, Our Lady

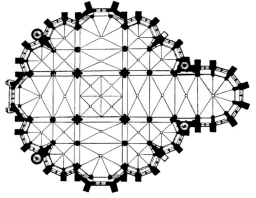

through or combined with a Romanesque tradition that remained important and continued to develop. Our Lady at Trier is a church with an extremely individualized design, that nonetheless remained true to the Champagne school of Gothic cathedrals built in the area around the huge construction site of Reims Cathedral in the 1220s. It was at Reims that the Gothic avant-garde met for over two decades to garner ideas for the unfinished or yet-to-be-built churches in the Picardy (Amiens begun 1220) and around Paris (St-Denis, choir clerestory, nave and transepts begun 1231, St-Germain-en-Laye begun 1238), churches that would soon outshine Reims with their fragile dissolved-wall, shaft and glass construction. The archdiocese of Trier, which included the dioceses of Toul, Metz and Verdun, bordered directly on Champagne. When work began on a collegiate church dedicated to the Virgin Mary just south of Trier Cathedral, the Gothic cathedrals in Toul and Metz were already being built.[117] Our Lady was to replace the ruins of a pre-Romanesque parish church that had been built as part of a late Roman "double church" site. Next to the new cathedral cloister, to its east, it was to be a twin structure to Trier's oft-expanded Bishop's church. This two-poled design, inspired by its Roman prototype, makes it an extremely imposing group of buildings of a type far too seldom seen.[118]

The floor plan of Our Lady at Trier is nothing less than amazing [30], for it employs the Braine-type choir [5] with its diagonally placed chapels, then repeats the organization symmetrically on the west side of the crossing.[119] This simple, yet convincing design results in a crucible-shaped central vessel with low pairs of chapels between the transept arms. Its basic design unit is the square of the crossing, to which are connected the rectangular bays of the transept arms and their three-sided polygonal terminal walls. The choir design employs three bays [29] instead of one and seems to jump out of the otherwise closed contour, with a five-sided polygon forming the apex. In the west polygon is the main portal. Pairs of diagonally set chapels fill the angles of the cross, each pair locked into place by a square bay.

What appears in the description of Our Lady's floor plan as an organized series of spatial elements, one placed next to the other, results in a cohesive three-dimensional unity that, in fact, cannot be fully comprehended at first glance. Entering from the west portal, the view is dominated by the perspective created by the central vessel leading to the choir apse. The nearby transept arms seem to step back, and the lower

– making the *Capella Speciosa* in Klosterneuburg way ahead of its time. Who its builder was, whether a wandering French architect or an Austrian *Baumeister* who had been sent by Leopold to eastern France, is unclear.[116]

It was not until many years after Klosterneuburg's consecration that the first large structure of Gothic design was begun in the west of the German Empire, one that was not filtered

sections of the chapels remain spatially diffuse in their relationship to the crossing of the two main axes. It is not until the center of the church is reached that one perceives the high-walled crossing to be so very deep, sees the role the ends of the transept arms play as illuminated window-walls, and how far away they look – the clerestory here is lit to a much lesser degree and lends the ends of the transept a strangely distant appearance – and finally how the chapels form a circle around the crossing. Trier's choir doubles the Reims apex-chapel scheme, employing two identical windowed stories with passageways. It copies Reims's double-lancet tracery with six-part foils – at Reims they sit on two foils, at Trier one – and impost friezes on the sides of the window niches. The lower passageway circles the entire space, including the diagonal chapels, the polygons of the transept and the west end. The upper passageway is interrupted in the clerestory where the windows are closed all the way up to the tympanum, but then continues in the walls of the polygons. The compound piers of the crossing, with their four respond shafts, pick up the double-storied motif of the choir. They possess impost friezes both at arcade and clerestory level, as though the same pillars had been placed on top of each other.[120] The arcading of the crossing is extremely high. The crown of its arch is the same height as the windows of the lower level of the choir, which are placed on a high wall pedestal. Serving as piers are extremely elegant round columns, which have little in common with their Early Gothic precursors at Laon or Paris.

The walls outside are organized rhythmically into vertical sections made up of double-windowed walls resting on a high ashlar pedestal. These sections are locked in place by pier buttressing at the edges. Only the choir steps out of this wreath-like outer structure. The walls of the clerestory rise out of the diagonal chapels. The chapels have roofs that cover part of the clerestory's windows, and topping it all off is the dominant form of the crossing tower with its round-arch biforia. The crossing tower stands in the center of the building and everything seems to radiate out below it.

Numerous structural details at Trier can be found at Reims. Some appear to have been obtained from the choir of the cathedral at Toul (begun 1221).[121] The most intriguing thing about Trier, though, is the form of its central plan. A modern theory has proposed that its design was a project of the archbishop of Trier at the time, Dietrich von Wied. In choosing as his model the forms of Reims Cathedral, the coronation church

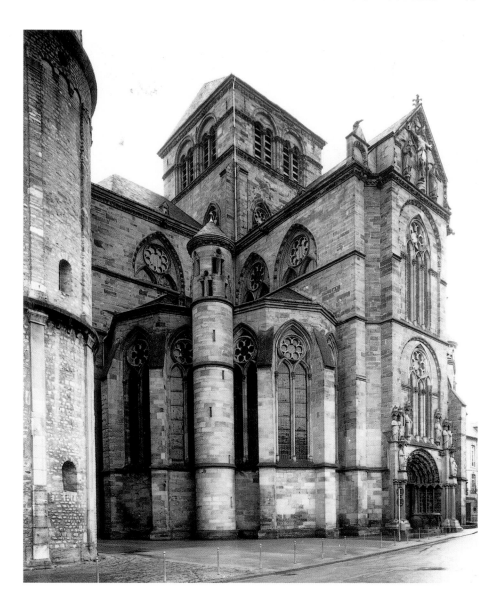

of the Capetian kings, Dietrich was striving to build a church in Trier that would carry associations of imperial grandeur equal to Charlemagne's Palatine Chapel in Aachen, the traditional coronation church of the German kings. This, of course, would have lent more weight to Trier's claim to crown the emperor, a right also being claimed by Cologne at the time.[122] However, there is far too little of Aachen in Our Lady at Trier to support this theory. True, the double-register ambulatory of Aachen's Carolingian octagon is repeated at Trier, but only as narrow passageways. The doubling of the crossing piers at Trier is delicately articulated to correspond to that of the sanctuary, but it does not result in a doubling of the entire structure like at Aachen. As mentioned above, only certain elements are doubled, with everything else being determined by basilican terracing. To identify the spatial organization of Our Lady at Trier with Aachen's Palatine Chapel, then, is a real hallmark of conceptual abstraction.

31 Trier, Our Lady, view of the north-west exterior

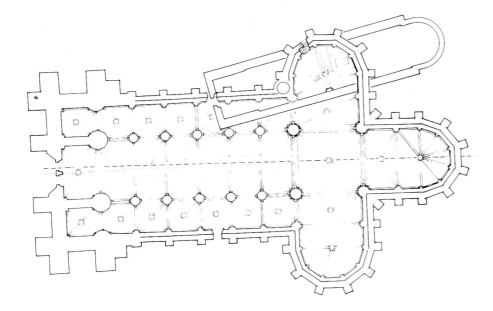

32 Marburg, St. Elizabeth

just such a structure stood within Trier's electorate diocese – the Romanesque church of Our Lady in Metz, a structure that had been integrated into the western sections of Metz Cathedral and was mentioned in the year 1207 as "Beata Maria rotunda." The church was dismantled in the thirteenth century and rebuilt as a bayed area with four supports which melted in with the Gothic renovation of the cathedral's nave and side-aisles. The successful fusion at Trier of a cathedral with a centrally planned Our Lady church was not a new idea, then. The fact that the very best jurassic limestone from the Metz area was used for the more difficult stone carving during the early phases of construction – before changing to cheaper grey-green sandstone, no doubt for financial reasons – is enough of a coincidence to suspect Metz as one of the inspirations for its plan.[125]

A connection between Trier and St. Elizabeth in Marburg (cornerstone laid 14 August 1235) has always been made and, in fact, St. Elizabeth was built using the so-called "Trier foot" as its basic unit of measure.[126] For Gothic scholars of previous generations, St. Elizabeth came to be equated with an ideal or pure German Gothic church, a role lost by Cologne Cathedral after its French elements had been identified. St. Elizabeth's combination of a trichora plan with a Hall nave – from the Rhenish and Westphalian tradition, it was thought – was seen as having been a call to arms against the French cathedral style.[127] Its austere ornamentation and concise articulation was supposedly due to a specifically German unwillingness to compromise one's own traditions.[128] Today, however, scholars agree that the only parts of Marburg to have stemmed from the German Romanesque are its west front and two massive towers (completed mid-fourteenth century), since the two towers grow out of the ground to enclose a thin portal zone between them, whereas French towers sit on rectangular façade blocks.

Marburg was a small fortified town in the thirteenth century, tucked away in the east on lands belonging to the Count of Thuringia – not exactly a location in which we might expect to find one of Germany's earliest Gothic great churches. But St. Elizabeth owes its construction to the cult that grew up around Elizabeth, Countess of Thuringia after her death in 1231. This cult was used for political gain by both her brother-in-law, Konrad, Count of Thuringia, and the Teutonic Order. It wasn't long after Elizabeth's death before a church was standing over her grave, which was near a hospital she had founded during her lifetime, one of her many

The Romanesque appearance of Our Lady's west portal [31], with its round arches flanked by small staired turrets, has even *less* in common with the high, niched wall of Aachen's western sections. It could well be that Our Lady's west front is related to the façade of nearby Trier Cathedral. Perhaps its, shall we say, tentative design was due to its function: the French Gothic offered no prototype for a west façade that had to reflect a centralized space behind it.

Even more questionable is the notion that Dietrich von Wied consciously attempted to use what were then modern forms of the coronation church in Reims, to strengthen his claim to crown German kings. The prototype for the general organization of Our Lady is Braine, not Reims.[123] Only an art historian could recognize Reims Cathedral, which offered a source merely for Trier's detailing, as being a model for Dietrich's aim to create a new Aachen. Demonstrative allusion could not have been accomplished by the repetition of subtle detailing alone, it would have had to be done through the employment of essential architectural characteristics. Furthermore, how much influence did Dietrich actually have on the construction of Our Lady, which was the collegiate church of the cathedral chapter in Trier, and not his own archbishop's seat?

Its rotunda design probably stemmed ultimately from the Madonna Patrozinium. The Pantheon in Rome was consecrated in the year 610 as St. Maria Rontonda in honor of The Virgin and All Martyrs. One of the most celebrated of ancient buildings, it became the prototype for a tradition of centrally planned Our Lady churches that was centuries-old.[124] In fact,

charitable works. Her confessor, the papal inquisitor Konrad von Marburg, used all his considerable power to get the Church to pronounce her a saint at a time when her life was quickly becoming interwoven with spectacular events and legends of all kinds. Just three years after her death, Konrad, Count of Thuringia, along with the head of the Teutonic Order, Hermann von Salza, managed to obtain Elizabeth's hospital and make it home to the Teutonic Order, even though the powerful Archbishop of Mainz had opposed the move.

Evidently the two men formed an alliance to realize mutual territorial ambitions east of the Elbe River – especially in East Prussia which the Pope had invested to the Order in the same year – an alliance that was sealed when Konrad became a Teutonic knight. In May that year (1234) Elizabeth was proclaimed a saint and named patron saint of the Teutonic Order, thus giving the political alliance between Konrad and Hermann von Salza the appearance of sacred legitimacy. Reason enough for the House of Thuringia and the Order to build a large sepulchral church in honor of Elizabeth in the most modern style of the day in the little town of Marburg. The coalition between the House of Thuringia and the order would, in fact, play an important role in the politics of the German Empire as a whole. When Elizabeth's remains were placed in the church on 1 May 1236, it was in the presence of Emperor Friedrich II. According to the *Cologne Chronicles of the German Kings*, Friedrich took off his crown and placed it upon the saint's head, thus making the activities of the alliance his own and tying its interests to that of the Empire and the House of Hohenstaufen.[129] In just a few years, indeed unexpectedly, Marburg had become the scene of important diplomatic activity.

The centerpiece of the new church was its conched trichora [32, 33]. The vault of the north conch covers the tomb of St. Elizabeth, the south conch has served as tomb for the Counts of Thuringia since 1274.[130] Dominating the outer structure is a powerful framework made up of closely placed pier buttresses whose upward movement is terminated abruptly by a well-defined roof cornice. Not a single pinnacle rises above the eaves. Outer ornamentation is extremely restrained and held firmly within the overall design. As at Trier [30], the lateral elevations inside are organized into two registers, each with tracery double lancets. In the apex of the conches, these possess six-part foiling at the top. Its Trieresque passageways have been placed outside and form a straight bridge between the

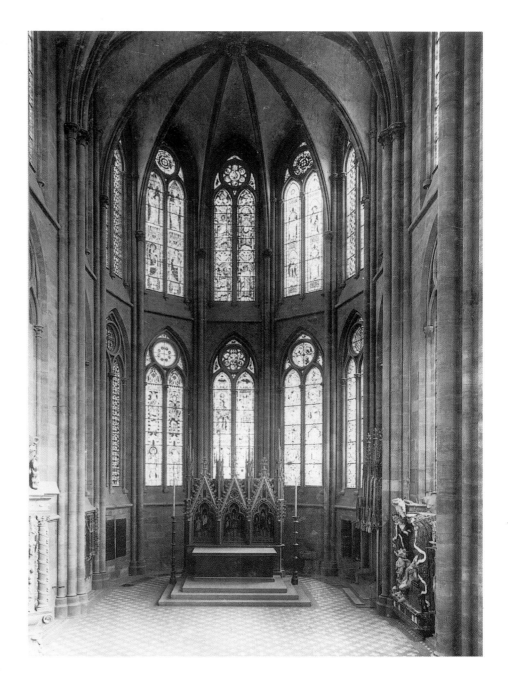

33 Marburg, St. Elizabeth, view of the east conch

pier buttresses.[131] The detailing is, like at Trier, dominated by forms inherited from Reims,[132] though Reims's rich ornamentation is toned down considerably in Marburg to a minimal amount of sculptural relief work. Marburg's two-register lateral surfaces consist of extremely thin, windowed-wall sections. Triple-shaft compound responds, unbroken by any horizontal breaks, rise between them to form a thin framework for the whole.

Exactly how far Marburg deviates from the not-much-older Rhenish trichora termination plan can easily be read on its windowed walls. In the east conch, much of the original glazing has survived and surrounds the room with a thin, transparent sheath of light. Compare this to the Rhenish conches of St. Quirin in

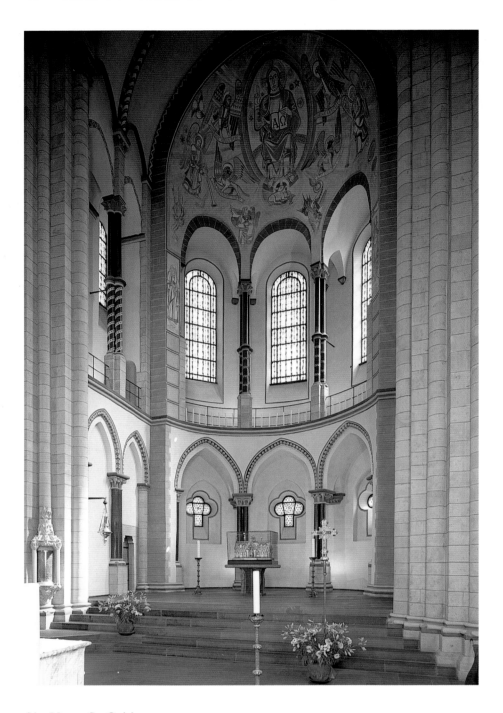

34 Neuss, St. Quirin, view of the east conch

35 Marburg, St. Elizabeth, nave looking east

for a centralized floor plan, or whether it was influenced from afar by the four-part conch design of the Teutonic Order church in Tartlau/Siebenbürgen (about 1222–3). The building techniques, and the reasons assumed to have been behind Marburg's representation scheme, leave many questions unanswered when coming to naming its predecessors.[133] If we focus only on style, we find a nave – whose eastern sections were already roofed by 1248[134] – that continues the Reims tradition. Its three aisles form a six-bay Hall onto which the tower bay is coupled, in a very open way, to form a seventh bay. Its square side-aisle bays are half as wide as those of the central vessel, which is framed by a powerful phalanx of arcade piers of the type seen in the nave of Reims Cathedral, but here they are higher and carry the vaulting directly on their shoulders.[135] As at Reims, leaf foliage on the pier imposts encircles the responds. They are in the ornamental style of Reims up until the third bay from the east, but the remaining bays possess triple-lobed, deeply fluted foliage of the more fluid type found at Amiens, rather than the heavier, three-dimensional foliage of Reims.

St. Elizabeth's nave [35] (completed no later than consecration in 1238) introduced the Hall church to German Gothic, though the form would transcend its immediate successors.[136] The importance of this development will become clear once we take up the architectural works of later generations of German builders, who would employ its formal structure as the basis for their most inventive designs. The Westphalian Romanesque Hall church – wide, domed bays on low supports that form aisles of nearly the same width[137] – played no part at Marburg. The dominating central vessel – a common feature of the French cathedral – was achieved at Marburg in spite of its Hall design. Its bulky piers are so tall that they replace the basilican clerestory and they are placed so close together that they nearly prevent a view of the tall, narrow aisles. The central vessel receives a dim light from the sides, diffused off the piers. The cylindrically shafted arcading is the only articulation of the inner vessel. All in all a memorable reduction of the Gothic to its basic structural elements.[138]

Trier and Marburg represent the final churches in this first phase of German Gothic, for which the French areas bordering the German Empire provided most of the prototypes. In fact, some of these areas were French-speaking members of the feudal tenures of the German Empire, like Hainaut and Burgundy.

Neuss (1209–20/30) where every window stands alone, has its own axis surrounded by wall, and is a single well of light in a wall continuum made up of registers each proportioned differently [34]. Not so Marburg's windowed clerestory, the masonry of which is limited to the bare essentials and which provides support for the glazing only, so that light can stream in, filtered through stained glass.

In the final analysis, it cannot be determined with certainty whether the Gothic conches at Noyon, Soissons, Cambrai and Chaâlis were prototypes for St. Elizabeth, whether the example of Trier's polygonal transept arms was its predecessor, whether its function as memorial and sepulchral church suggested to its architect the need

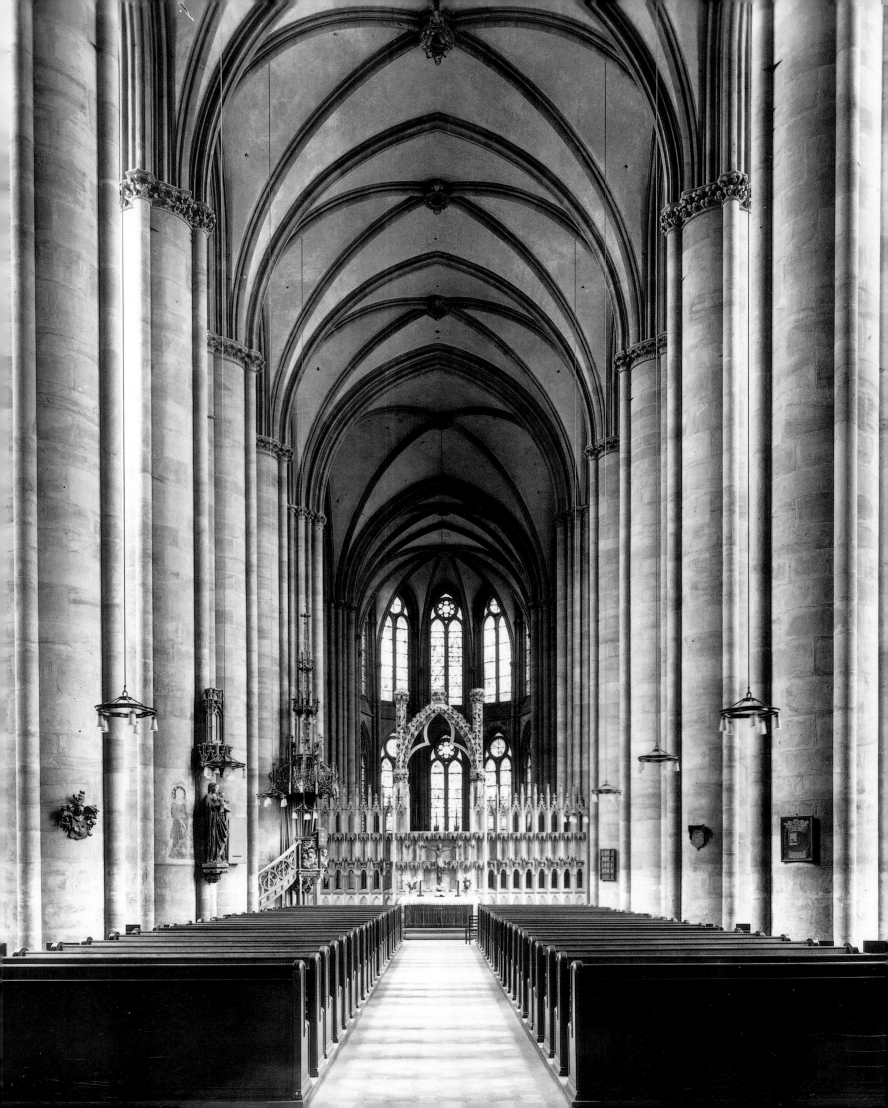

Dehio divides this period into two "phases of assimilation" but the facts only partially support this. Indeed, Laon and Soissons set the stage for the appearance of St. Gereon in Cologne, the nave for Bonn's Minster, St.George in Limburg, for Ebrach, Maulbronn and Bamberg. Reims Cathedral was the inspiration for the style of Trier and Marburg, yet, the sheer variety of other prototypes blows a big hole in this all-too-easy constellation. Furthermore, the years during which St. Gereon, Bonn, Limburg or Bamberg's eastern sections were built correspond very closely to the first years of construction at Trier and Marburg. Even the Palatine Chapel at Klosterneuburg would fit into Dehio's first phase, though stylistically it does not belong there.

Dehio's "phases of assimilation" seem to be consepts based mostly on various *types* of assimilation, rather than periods, types that came about because of the interests and tasks of architects and their patrons as they dealt with the French Gothic – either in open or uncompromising ways. Many of the structures belonging to Dehio's first phase were part of large churches begun in the Romanesque style. For formal reasons alone, perhaps, a complete departure from the old style would not have been deemed desirable.

The variety of the buildings constructed during this period is amazing. Missing, however, is that clear line the scholar needs to locate a "style of the period." The reasons for this do not lie with the retirement of the House of Hohenstaufen from medieval German politics, and the subsequent collapse of the imperial dynasty.[139] German Gothic was not, nor would it ever be, a monarchical style. In fact, to call the great bishop churches of Capetian France "royal cathedrals" represents a dubious abbreviation of historical fact.

If the Gothic can be seen as being *the* representative architectural style of its time, then it was a "modern" style that appeared suddenly. Like all things novel, its appearance must have been spectacular. It wouldn't be long before this spectacular effect would inspire, and serve, those with the means to finance a structure articulated by costly stone carving. When the financial means were lacking, help came via a simplification of construction technique and material.

The Development of Gothic Architecture in Germany

"OPUS FRANCIGENUM"
THE LARGE CATHEDRAL LODGES
AND THEIR ENVIRONS

"RICHARD FROM THE town of Ditersheim on the upper Rhine having torn down the old Minster it being in a most dangerous state very near collapse did summons a stonemason recently come from Paris in France and well-versed in the art of building, and ordered the construction of a church of hewn stones in the French style (opus francigenum)".[140] What Burckhard von Hall so blandly relates in his "Chronicles" about the new collegiate for church in Wimpfen (1269–79) is characteristic of German architectural development in the thirteenth century as a whole. The process of coming to terms with the constantly changing forms of the French building style was now beginning all across the German empire. Lateral wall elevation was, and would remain, the single most important element in this process. With its transformation, a new kind of spatial organization would be realized, and the development of architectural forms would lead to the "glass shell" structure built entirely from elements made of thin shafts and luminous walls.

During the building of Metz Cathedral, this concept ran into older, more thickly proportioned forms resulting in a peculiar tension between its central vessel and side-aisles. The latter are compact, heavily articulated and possess a passageway common to the nearby Champagne region in France. The main arcade seems too low because it bears a clerestory wall – consisting of a tall glazed triforium and huge tracery windows – that is twice as high as itself. This glazed wall is of extremely fragile construction and of such huge dimensions that it relegates the arcades to the role of pedestal.[36]

Work on this glass structure went on long into the fourteenth century, but it was part of Metz's design no later than 1280 or 1290.[141] What lead up to its being included in the design?

An architect whose name we do not know created a design for the lateral wall elevations of the sanctuary of Troyes Cathedral (1229), and again for the choir clerestory, nave and transept of the abbey church of St-Denis (1233) [38], which combined the quintessential characteristics of the latest developments from cathedral lodges active at the time in France. He designed the wall backing the triforium to be a surface of colorless glass. In the nave and in the chancel, he ran the mullions of the quadripartite lancets down to the bottom of the triforium and made what had always been the middle register part of the window zones.[142] He visually separated the two larger "rosed" lancets by making the center mullion compound, consisting of two or sometimes three shafts, then divided each of these into four smaller lancets using single-shaft mullions. Because this hierarchy of shafts overlaps the glazed triforium, the motif of the window mullion determines the form of the entire clerestory, transforming it into a unified, structural framework of graduated forms. The responds follow the same principle, for they appear only in groups – as compound wall responds or as trim for the free-standing compound piers, either thicker or thinner depending on their function. The architect of Troyes and St-Denis was concerned with illustrating architectonic values. He did this by a cohesive organization of the surface through a step-by-step movement from the smallest to the next largest element, which developed the clerestory – now made almost completely of glass – into an unbelievably open and transparent structure.

These, then, were prototypes for the clere-

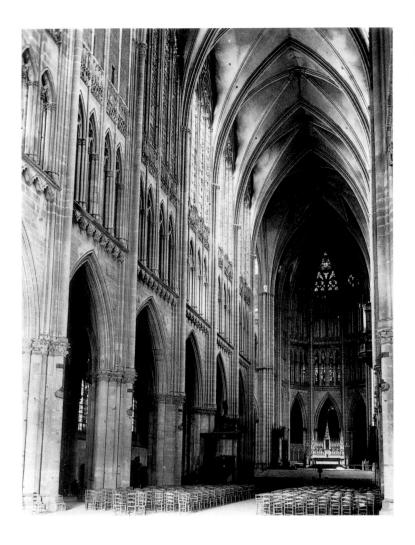

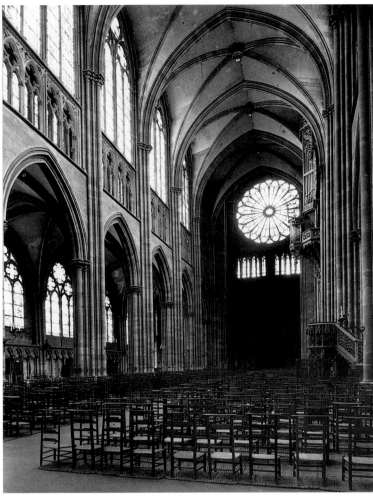

36 Metz Cathedral, nave looking east

37 Strasbourg Cathedral, nave looking west

38 St-Denis, abbey church, elevations of the central vessel

story wall at Metz. The huge discrepancy in size between its main arcade and clerestory is truly one-of-a-kind.[143] This style is called "rayonnant" after the two most impressive examples of the new focus on glass construction: the transept roses of St-Denis and Notre-Dame Paris [45] whose tracery radiates out from the center.

Apparently the new emphasis took hold in Strasbourg even earlier than it did in Metz. The nave of Strasbourg Cathedral [37] (begun 1235, completed with brick vaulting 1275) leaves the pool of forms employed in its somewhat older transept far behind. The articulation of its central vessel closely resembles that of St-Denis. Compound piers and a glazed triforium can be found here, together with quadripartite tracery windows which have been extended so much in height and width that the vault webs framing them on each side are but thin, vertical extensions behind the diagonal ribs. They do not begin to curve over to the vault crown until above the window imposts, at which point they bend sharply inward.[144] Characteristic for Strasbourg are piers surrounded by smooth, unbroken shafts – some fat, some thin – and a

triforium dissolved into open tracery that is framed in boxes created by window mullions that pass through them, and string coursing above and below.[145]

It is almost as if light were the principal building material in the large glass walls of Troyes, St-Denis, Metz and Strasbourg. If we choose to see this as significant, then it's easy to conclude that Gothic "light architecture" was the result of new construction techniques, and that it was related to the light metaphysics of neo-platonic Scholasticism which itself was the reflection of a new medieval world view. Evidence of such a connection abounds. Known as *forma prima et communis* in the ontological writings of the Scholastics, light was the symbol of the *forma perfectionis corporis*.[146] That which is cast in light is beautiful. Through light, that which is good is manifest. Through it, divinity is made visible.[147] Ulrich von Strasbourg witnessed the building of Strasbourg's nave and was inspired to write in his *Summa de bono*: "Because light's form-giving dignity lends shape to all form through its radiating, form illuminated by light is the true good (bonitas) of each thing."[148] Light dignified all

matter, and only through its power was the architecture of the church beautified and consecrated. In short, there might have been aesthetic and theological reasons for opening the church windows up as wide as possible – in order to fill with light the House of the Lord as symbol of His rank as Holiest of Holies.

There is proof that the builder of the first Gothic choir, Suger of St-Denis (1081–1151) shared, indeed lived, this world view. The books he read are known to us, most important of which were the writings of Dionysius Pseudo-Areopagite who made the theories of the neo-platonic writers Plotinus and Proclus palatable to Christian philosophy. Dionysus Pseudo-Areopagite introduces the concept of "emanation of Divine Light" as the way human intellect can transcend the illumination of corporeal forms to reach the "true light" of God. To build an appropriate receptacle to house the soul during its spiritual preparation for its ultimate rise from the material to the immaterial world (latin *anagogicus mos* literally "the method that leads upward") was for Suger the most important function of his new abbey church. His vision of how the finished structure should look speaks for itself:

> the dimensions of the old side-aisles should be equalized with the dimensions of the new side-aisles, except for that elegant and praiseworthy extension, in [the form of] a circular string of chapels, by virtue of which the whole [church] would shine with the wonderful and uninterrupted light of most sacred windows, pervading the interior beauty.[149]

He wrote this in the twelfth century. Unfortunately, similar writings from the thirteenth century do not survive and it is difficult to estimate when Suger's light metaphysics became a convention, a concept that lived on as mere institutional opinion among the teachers of late Scholastic aesthetics. As a consequence, it is hard to know when his light metaphysics were no longer consciously translated into the design of new churches.[150]

Statements like Suger's have prompted scholars, including those in disciplines outside architectural history, to search other forms of medieval cultural expression for the effects of, and analogies to, light metaphysics.[151] What semantic scholars often carefully formulate as a question, has for years been accepted as the single most important cultural characteristic of the thirteenth century – that it was a time people felt themselves to be in a state of "illumination."

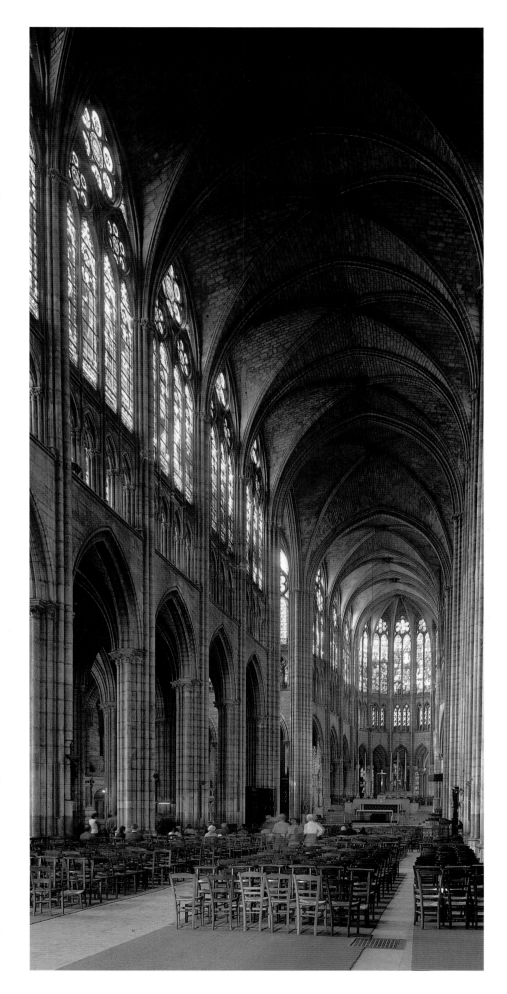

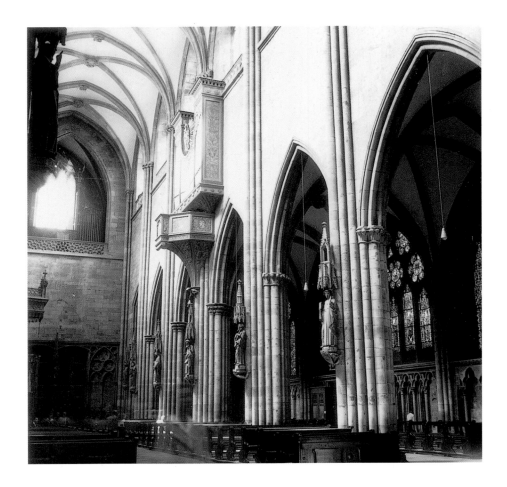

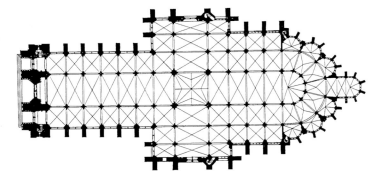

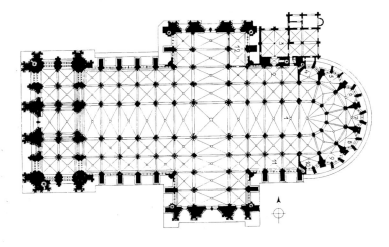

The idea that there was an irresistible movement towards glass-wall Gothic architecture which reached its fruition in the thirteenth century, is a concept of modern Gothic scholarship, one that has helped support many a theoretical construct in its day. As a result, the years between 1180 and 1270 have been celebrated as a "classic" period of cultural history during which all phenomena of human endeavor came together in a rare show of cultural cohesion to form a medieval *Zeitgeist*.[152] In reality, the oft proclaimed "spirit of the Gothic" is an all too pure distillation of a wide spectrum of medieval intellectual and artistic activities that were just as rich in alternative forms as any other period in history.

The light aesthetic that determined the form of Strasbourg Cathedral's nave, for example, was not met with general acceptance in the German empire, and remained more the exception than the norm. When building the nave for the new parish church at Freiburg-im-Breisgau [39], which like nearby Strasbourg was built onto an older eastern structure, architects did remain for the most part true to Strasbourg's detailing[153] but left out completely Strasbourg's complicated, box-like triforium, and limited the clerestory to small windows. Did medieval Freiburg, a town barely a hundred years old at the time, not possess the means to finance a complicated skeletal construction and its expensive glazing? Was its architect unable to master the static problems inherent in such a structure? Or did the builders in Freiburg consciously choose a more traditional design? Possibly a lack of experience in working with Gothic structural engineering played a decisive role here. The clumsily worked features of the eastern bays of the nave (begun shortly before 1240) indicate that there was some difficulty in employing Gothic forms. There was, at this point in time, no open buttress system intended. Perhaps masons who had worked on the Romanesque sections of the older church were now working on the new church.[154] Freiburg's high, unarticulated wall surface above the main arcades [39] perched between heavily molded arches and clerestory, Dehio called "reductionist Gothic" since a bare wall replacing a triforium seemed like an omission when compared to the "classic" Gothic tripartite elevation system.[155] Freiburg's concept is altogether new

39 Freiburg Minster, nave looking west

40 Amiens Cathedral

41 Cologne Cathedral

42 Cologne Cathedral choir

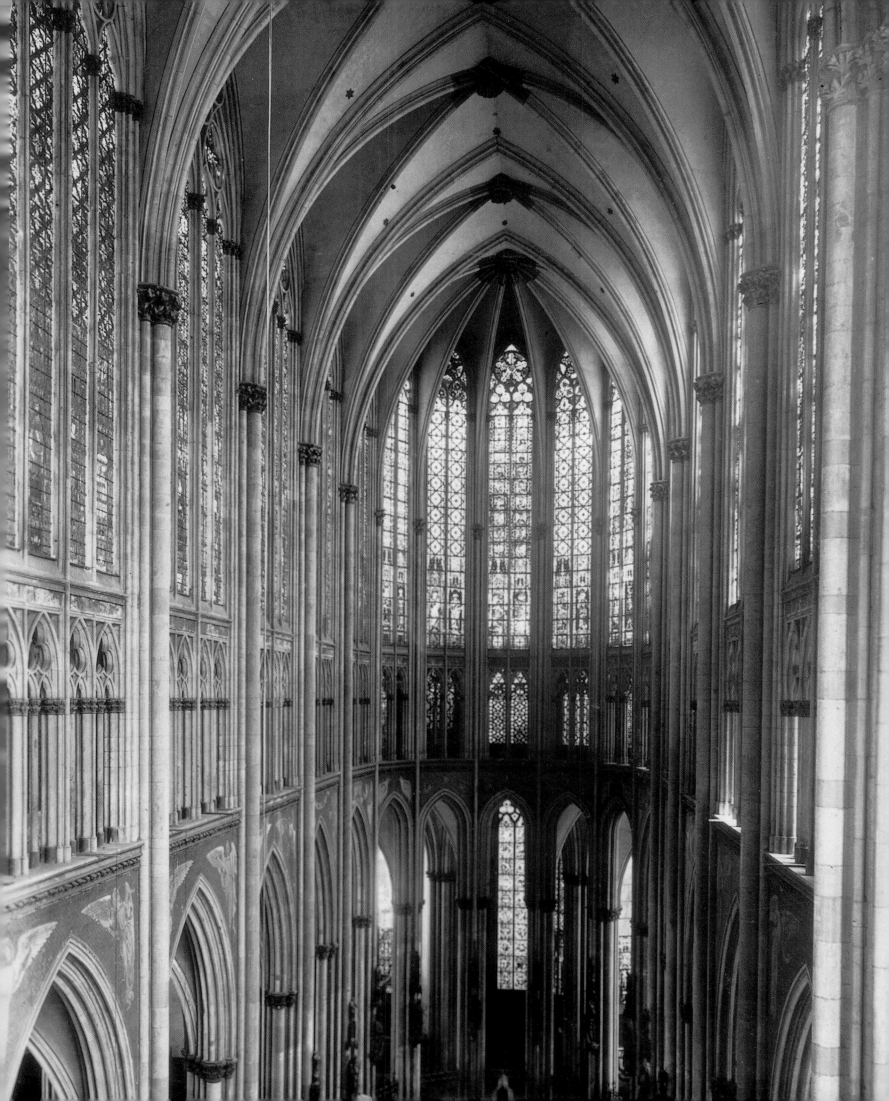

and cannot be compared with the not-much-older walls of Trier's transept, where blind window zones placed directly over the crown of the arcade arches prohibit a strict separation of arcade and clerestory like at Freiburg. Just a few decades later, the nave of St. Lorenz in Nuremberg would follow Freiburg's example.

Besides Strasbourg, Cologne was the second most important place in Germany where the Gothic style of Troyes and St-Denis not only made its greatest inroads, but was also combined with new forms coming out of the cathedral construction sites at Amiens and Beauvais. The rich aristocratic cathedral chapter in Cologne – the German empire's most populous and prosperous city – set about in 1247 to rebuild its pre-Romanesque cathedral which had been damaged by fire. No cost was too great. The cathedral chapter believed they had resources enough to finance a cathedral whose size would make it greater than any built before it. The choir alone required the services of three architects before being consecrated in 1322: Meister Gerhard (1248 to before 1270) who no doubt is responsible for the cathedral's overall plan, followed by Arnold (prior to 1270 to prior to 1308) and his son Johannes (prior to 1308–31).

Arnold Wolff calls Cologne Cathedral "the youngest, and because of this perhaps the most beautiful, of all the sister-churches in the family of French cathedrals"[156] – indeed a judgement based on taste, but not an arbitrary assessment by any means. What sets Cologne apart is a confidence of design, a compelling structural continuity that was fully aware of how to utilize the experience of its older French "sisters." The architecture of Cologne's choir is of such a polished elegance, in fact, that it has been wrongly called "dryly academic." Indeed, more than once it has been accused of representing a superficial decadence in design.

As prototype for his choir Meister Gerhard used the ambulatory and radial chapels of Amiens Cathedral's choir [40], which were already standing by 1248. Cologne's seven-sided chevet [41], the trapezoidal bays of its ambulatory, the five-sided termination of its chapels and its four-bay, double-aisled sanctuary are all quite similar to those of Amiens. Only by virtue of Cologne's lack of a protruding apex chapel does it resemble Beauvais Cathedral (begun 1225). Beauvais's design was clearly based on sketches from Amiens, even though the choir at Amiens was probably completed later since it was built from west to east and its nave stood first.[157] Gerhard broke ranks,

however, when designing Cologne's transept and nave. The three-aisle transept arms he covered with four bays – one bay deeper than at Amiens, and of the same length as Cologne's sanctuary – and made the six-bay nave shorter to make room for two tremendous towers in the west. Thanks to an extension of the choir's double side-aisles into the nave, and the spectacular resolution of the five-aisle traveé in the bays under the towers, Cologne is the first cathedral with western sections that rival the choir, whose complex arrangement had always made it the center of attention in French cathedrals.[158] Add to that a wide transept that spans the space between these two equal poles without completely separating them, and you have a floor plan characterized by balance and uniformity.

For its vertical organization, Cologne owes more to St-Denis [37] than it does to Amiens. It shows a preference, like St-Denis, for the compound pier with thick groups of molded elements overlaying the pier surface in a seamless, wave-like movement, while sending long responds, unbroken by coursing, up the wall [42]. The triforium's framework, hollowed-out as high as the spandrels of its arches, is backed by a windowed wall and formally communicates with the clerestory lights above it. These lights consist of four lancets in the sanctuary, and two thin lancets in the polygon sections of the termination in order to maintain clerestory symmetry throughout. Cologne's clerestory is even more thinly articulated and taller than at St-Denis. Canopied figures of Christ, the Virgin and the Apostles placed at the piers of the choir show that the masons' lodge at Cologne was familiar with one of the most outstanding French structures of the mid-thirteenth century, Ste-Chapelle in Paris (1241–48), built to hold the religious relics owned by the kings of France.[159]

Cologne's choir has a double-register outer structure [43] that reflects the inclination of its designer towards monumentality. The outer walls of the chapels and the side-aisles, unarticulated and strengthened by smooth pier buttresses, create a massive base for the framework of fliers above. Hidden behind these are the ambulatory and equally tall aisles on each side of the choir which, despite their considerable width, are hardly visible from the outside. Two rows of upper pier buttresses – front forked, back cruciform, with the back placed between the chapel roofs – along with the sheathing of clerestory windows that possess steep triangular gables, are reminiscent of Amiens. Yet,

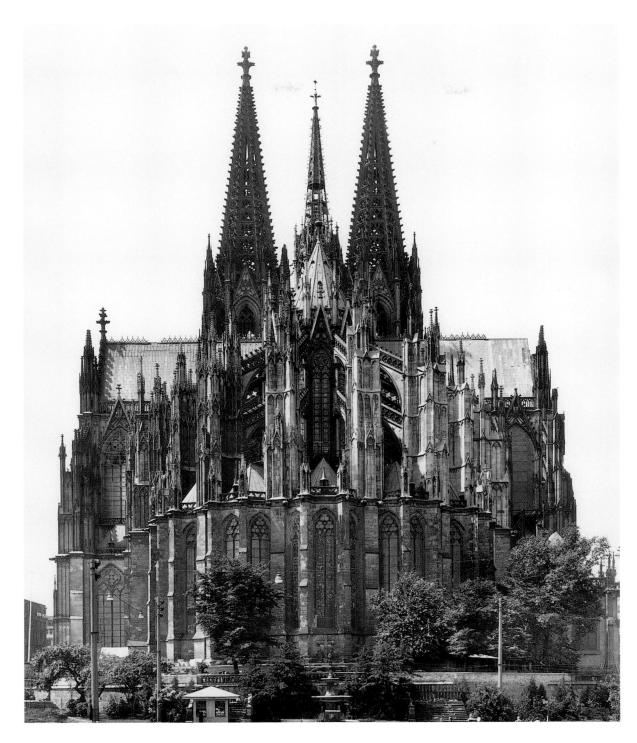

43 Cologne Cathedral, choir as it looked before today's structures were built around it

Cologne's tendency towards structural stability allowed its builder room for a dazzling display of forms. Enriched by a fine blind tracery, the upper two rows of pier buttresses are nearly melded together, the back row jutting tower-like above the crown of the inner vaults. The flyers are doubled, with combs made up of tracery quatrefoils and crockets.[160]

No other thirteenth-century German structure has as many French Gothic prototypes as Cologne Cathedral's choir. The lodges in Amiens, Beauvais, St-Denis and Paris are just its main sources, and there is every reason to believe that the final form of its detailing had not been agreed upon in 1248, and that Cologne's architect continued to learn and profit from the building of its only slightly older French prototypes.[161] Gothic scholars have given Cologne's stylistic demeanor, and not without reason, the name of "normative." This is an attempt to put the older judgement, that it represents a lifeless eclecticism, in a more positive light.[162] It was the nature of a Gothic cathedral to break new ground. A Gothic cathedral pushed the limits in every sense of the word, for not only did its height put it somewhere between heaven and earth, it also tested the limits of what was possible in architectural

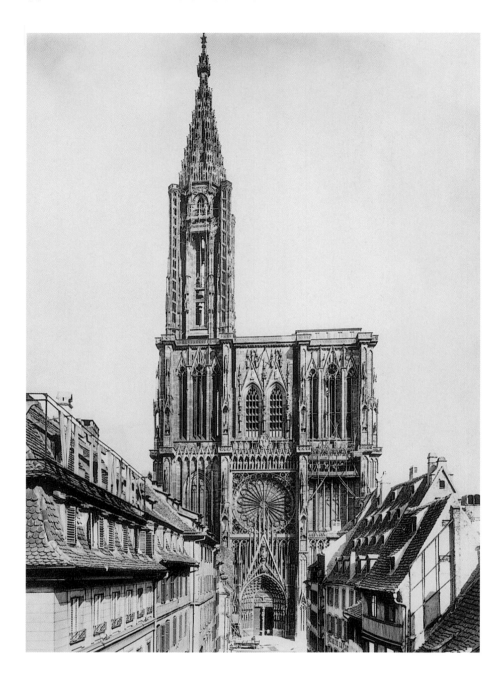

44 Strasbourg Cathedral, west façade

until his time, done their best to ignore the Gothic aesthetic:

> I was no better than people who called the world outside themselves barbaric, when I called everything that does not fit into my system Gothic – from the pretentious, colorful dolls and picture work with which our noble bourgeois decorate their houses, to the more somber examples of older German architecture which I – on occasion of seeing some overdone filigree – had also agreed was "completely overwhelmed by decoration!" So much so that I dreaded, as I walked, to must see a misshapen, bent and bristled monster. But oh, what unexpected joy greeted me as I raised my eyes! A flood of sentiment filled my soul, for though it consisted of thousands of harmonizing details for me to perceive and enjoy – but which I neither recognized nor could explain – it revealed in quiet premonition the genius of the master builder. "You are astounded," he whispered to me. "All this massed stone was necessary, for do you not see the same on all the older churches of my city? But their arbitrary shape only I was able to raise to correct proportions. How, over the main portal which rules two smaller side entrances, the wide circle of the window opens to answer the inner vessel of the church, a window that otherwise would only have been a hole. How the belfry demanded smaller windows. All this was necessary, and I formed it with beauty".[165]

This eulogy is surprising for the way Goethe has his master builder, Erwin, emphasize the necessity of converting previously built churches of "arbitrary shape" to one of "correct proportions." Indeed, Strasbourg's west façade challenges us to compare it to what was achieved in Cologne, and the impression one gets of a standardized, cohesive style common to both cannot be ignored. What Goethe called "thousands of harmonizing details" – the sheer variety of which was beyond his considerable ability to describe – is still difficult to grasp completely, even after two hundred years of Gothic scholarship.

For years, only the west portal and the register that includes the rose window (enclosed by gallery 1340), were seen as having been achievements of the thirteenth century due to the problematic history of the design's development. Intensive research conducted on medieval sketches of the façade indicates that

organization, technology and art.[163] It pushed the limits of what was financially possible as well, for by the year 1322 the coffers in Cologne were empty, and the choir remained the only usable section of the cathedral until the nineteenth century.

No less an undertaking than Cologne's choir was Strasbourg Cathedral's west façade [44] which employed – from when construction began in 1277 to the completion of the north tower in 1439 – six master architects: Erwin von Steinbach, creator of the famous "Sketch B," Erwin's son Johannes, a certain Meister Gerlach, Michael von Freiburg, Ulrich von Ensingen and Johannes Hültz from Cologne.[164] The huge west façade's collection of articulated elements so impressed a young Goethe that he sharply criticized scholars of classic humanism who had,

Strasbourg's first architect, Erwin von Steinbach, probably planned tower bases for the second upper level, along with the "Apostle Gallery," and for an intermediate tower level above that. These features were carried out at a much later date and the builders stuck to the original façade design from 1277, the year the cornerstone was laid, only making changes in detailing according to the tastes of each new generation.[166] The lower registers of the façade were finished around 1340 with the completion of the gallery above the rose window. Here thin pier buttresses, articulated with blind tracery and open tabernacles, create a severe division of the surface. The three walls of the portal area, the large rose and the window walls to its sides, are set off from each other like flat panels between these buttresses. Stretched in front of these mostly unarticulated background surfaces is a fabric of open tracery, like a thin veil of stone that only partially conceals the back wall. These are the famous "harps" made up of thin mullions – sometimes in compact rows, sometimes loosely combined – which limit and contrast the sections of smooth wall between the pier buttresses. If spatial depth was achieved in

the façades at Reims and Amiens through a dynamic front-to-back movement of chasm-like porches, shadowed window niches and pier buttresses of massive proportions placed between the portals;[167] then at Strasbourg the whole façade surface was elegantly refined by string coursing, thin piers, and the play of fibrous open tracery work across it.

Between the façade of Amiens and Strasbourg stand the transept façades of Notre-Dame Paris, both of which – the north (about 1246) [45] and the south (1258) – were begun by Jean de Chelles. Reduction of material and a playful joy in the effects of surface articulation make them the epitome of the Rayonnant style.[168] The tri-angular gabled portals of Reims have here become flat "panelled forms"[169] flanked by pinnacles and blind tracery that resemble portals, and that barely protrude from the wall surface. Above these, a gallery arcade functions as transition to the huge rose, which radiates out across the entire surface of the square upper register.[170] This arrangement is repeated in the middle register of Strasbourg's façade, even though deviations from an older design dispensed with the gallery arcade between rose and portal, and

45 Paris, Notre-Dame, north transept façade

46 Strasbourg Cathedral, main portal and rose of the west façade

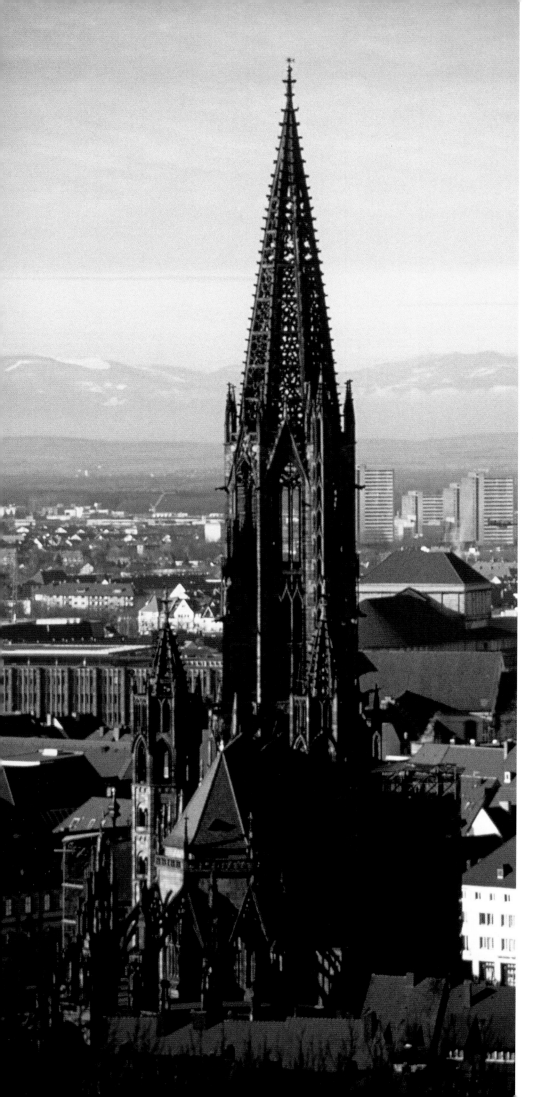

placed the rose considerably lower[171] [46]. However, the triangular gables of the Paris portals have been converted at Strasbourg into skeleton-like centerpieces on which spear-shaped pinnacles sit. The tracery in the spandrels of Strasbourg's rose is disengaged from the surface of the rose itself. These spandrels engage a graceful hoop which encircles the deeper-set rose so that it appears to hover in the air when seen from a distance. Remaining true to its Paris prototype did not hinder Strasbourg's Meister from reintroducing the third dimension, not in its traditional role as depth, but as a layer of empty space set between, and parallel to, tracery ornamentation and the window wall.[172]

The relationship between ornamentation and load-bearing wall will become one of the focal points of German Gothic architecture from this point on. Lying dormant in the role tracery played as structural ornamentation was the seed of its emancipation into an independent, consciously applied decorative element. The inclusion of the decorative element in a cohesive overall system of interweaving forms opened up a completely new compositional medium to architects. The applications of tracery could be redefined with each new building. It could be applied in equal increments over a surface, or concentrated in one area. It could be articulated into forms of fantastic variety, or used to repeat the same motif over and over again. It could veil the static form of a structure, or emphasize the tectonics of a less expressive design.

One of the most outstanding examples of the use of open tracery from the period is the west tower of Freiburg Minster[173] (begun before 1280) [47]. Its hollowed-out spire with octagonal lower level sits like a crown upon a large tower base made up of smooth cubes of masonry. Its stepped pier buttresses at the corners, and small windows with deep concave molding, were placed in front of the central section of the newly built nave. The resulting contrast between closed and open registers is comparable to Cologne Cathedral's choir [43]. Much points to the fact that the open-tracery upper tower at Freiburg owes its form to a plan from Strasbourg's lodge.[174] The octagon sits on a twelve-sided gallery of open tracery work, behind which spike-shaped pier buttresses placed in front of the chamfered sides of the octagon descend to the square lower level.

47 Freiburg Minster tower

Similar to Strasbourg are Freiburg's open taber-
nacle figures on spiked piers, its perforated tri-
angular gables over the high windows of the
octagon, and fragmented or melted forms of the
foiling in the tracery work of the spire.

Freiburg's stone spire is a paragon of Gothic
structural articulation, even though its impor-
tance has been overshadowed somewhat by the
number of neo-Gothic spires built in the nine-
teenth century.[175] The surfaces between its
crocketed and elegantly curved spars have been
completely dissolved into tracery, the pattern of
which changes with each register as it rises. This
skeletal stone structure is everything but protec-
tion against wind and weather. It was meant to
be a self-contained work of art without struc-
tural function, one that expresses a tendency
towards boundless abstraction and its technical
realization in stone.

What Strasbourg was for the architecture of
the upper Rhine, Cologne Cathedral was for that
of the lower Rhine and the regions bordering it.
The cathedral lodges of these two ancient
Rhenish centers had a decisive influence on
ashlar stone construction until the middle of the
fourteenth century. They retained their reputa-
tions as the chief workshops in the west of the
German Empire until the very last years of the
Gothic period.[176]

Characteristics of the floor plan of Cologne's
choir [41] can be found in the Dutch cathedrals
of Utrecht (begun 1254) and 's Hertogenbosch
(begun 1280), and its architectural sculpturing
can be found on many churches of the
Rhineland.[177] The foliage work of Cologne's
piers – oak and leaves, ivy, maple, thistle and
other local leaf forms [84] – are finely articu-
lated, deeply recessed and arrayed in two rows
around the nucleus of the capital. The same
foliage work embellishes the impost zones of the
collegiate church in Xanten [48]. Like Cologne,
this structure consists of five aisles locked into
place by a framework of fliers possessing long
spans. Xanten's cornerstone was laid in 1263 by
Provost Friedrich von Hochstaden, brother of
the archbishop of Cologne at the time, Konrad
von Hochstaden. The cross-section of its arcade
piers [49] – part of the nave was completed in the
sixteenth century – the vine-scroll-pattern
friezes under its clerestory passageway, and the
cornice of its outer structure are Cologne
inspired. The Trieresque plan of the choir, with
a two-register wall organization, takes the
Braine-inspired [5] reduction of the basilican
choir with ambulatory and makes it its own,
using fewer resources to achieve the same effect.
Nonetheless, even this choir design nearly

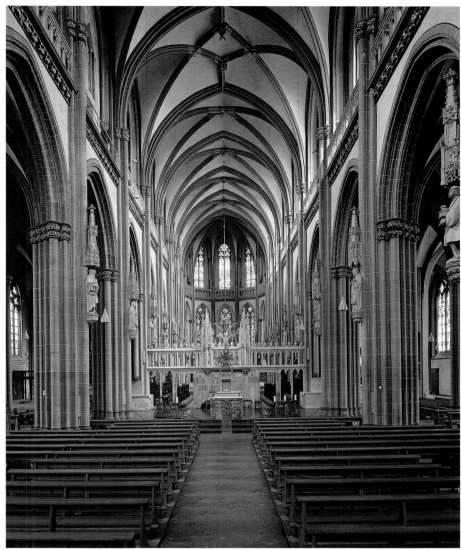

48 Xanten, St. Viktor,
nave looking east

49 Xanten, St. Viktor

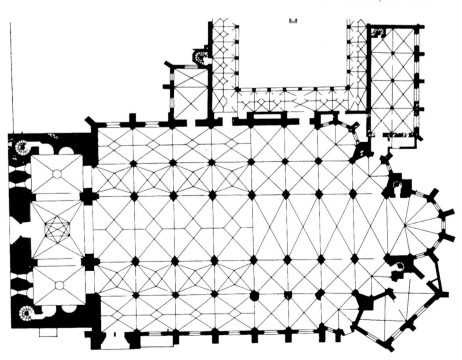

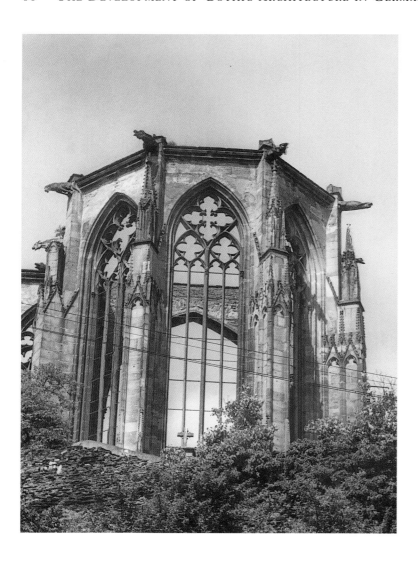

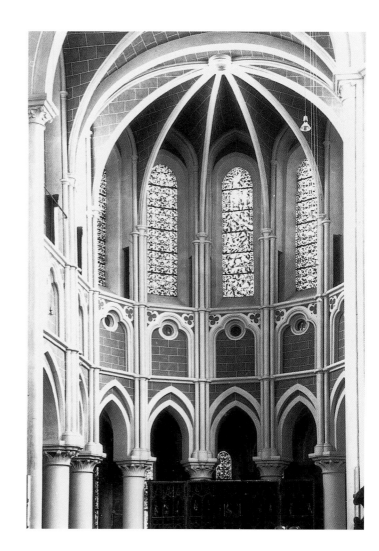

50 Bacharach, ruins of
the Werner Chapel

51 Marienstatt, choir of
the former Cistercian
Church

exhausted the finances of the collegiate founda-
tion. Construction continued until 1437 and the
nave, which served as Xanten's parish church,
wasn't erected until sometime between 1438 and
1519. Despite this, the original design was
adhered to, with the builders tenaciously dedi-
cating themselves for over two hundred years to
realizing a design that, as the church approached
completion, was no longer modern. The result is
an extraordinarily unified and cohesive building.

The floor plan of the Werner Chapel in
Bacharach, in the central Rhine region, might
also be of the Trier type. A beautiful building on
a hill high above the Rhine valley, it was men-
tioned in many a Romantic's travel diary, and is
dedicated to the memory of a boy called Werner
who was reportedly murdered by Jews in 1287,
and thereafter honored as a martyr. The chapel
was built over his grave [50]. Of cruciform
design, it has three, five-sided conches and a
shorter west-transept arm possessing a straight
termination, all organized around a square cross-
ing. The east conch features a small fore-bay.
Whether this simple arrangement was garnered
from the trichora system of the Cologne School,

or can be understood as a reduction of the spatial
organization at Our Lady in Trier, is not clear.
As at Xanten, spatial concepts from older
sources were added to the newest forms coming
out of the lodge at Cologne Cathedral. Among
these are thin wall responds inside, the trefoils
and quatrefoils of its wide windows, and the
blind tracery work of its tall pier buttresses.[178]
The Werner Chapel received preliminary conse-
cration in 1337, but was not completed until
1437. Most of the north and west sections were
destroyed when nearby Stahleck Castle was
blown up in 1689. It has stood as a picturesque
ruin overlooking the river ever since.

Xanten and Bacharach's Werner Chapel are
representative of a new architecture environ-
ment in the Rhineland, the prerequisites of
which had been established by the choir of
Cologne Cathedral. The development of this
new architectural milieu can be traced in the
choirs of the Cistercian monastery churches at
Marienstatt [51] and Altenberg. Marienstatt
(cornerstone probably laid between 1225–7)
stands on the edge of the Westerwald, a large
forested area southeast of Bonn. Its parent

monastery was Heisterbach. In 1324, after nearly a hundred years of work, the choir, transept and parts of the three bays of the eastern nave were standing. The floor plan of its choir – a seven-sided sanctuary with ambulatory and radial chapels – resembles very closely the French Gothic Cistercian choirs at Longpont (1200–27) and Royaumont (1228–35), even though the rounded outer walls of Marienstatt's radial chapels lack pier buttresses. The flyers above the chapel roofs are of the type seen on the decagon of St. Gereon in Cologne [12] and Bonn Minster's nave [14]. The vertical elevations of its sanctuary walls exhibit the eastern French/ Rhenish "mixed style" at its most elegant. The flat, crocketed capitals of its round piers each carry smooth arcades topped by blind arches. Rising from the piers' wide abaci are triple-shaft compound responds with annulets and chalice-shaped capitals. Trilobed arches make up the blind triforium, over which the clerestory opens into thin lancets with the obligatory passageway in front.

Research fingings helped restore the original polychromy of Marienstatt's inner choir wall – vault and wall surfaces in red brick with white joints, articulated elements set off in grey. This is uncommon for the "mixed style" during the first half of the thirteenth century, and can be attributed to the late completion of the choir. Prior to 1250 it was common practice in both the Rhineland and the buildings of rural France to corporeally accentuate the wall surface using heavy, double-jointed rustication in white, while setting off articulated elements in different colors to create a lively surface pattern with a variety of decorative motifs.[179] It wasn't until years later, after experience had improved the techniques of applying the articulated Gothic style, that the color scheme as we see it at Marienstatt took root and was used to emphasize the characteristics of Rayonnant Gothic; namely, the wall and vault surfaces remain nearly monochrome, its rustication – except for a thin white strip between the stones – held to a minimum. The intended foil-like character of the wall is thereby emphasized. All the elements of the articulated trellis are one color as well, brighter than the wall behind it, and presented as a tightly cohesive and unified framework.[180] Marienstatt's choir makes it clear just how effective the use of polychromy can be in accentuating style. On no other structure of the "mixed style" do Gothic components dominate as they do here.

While the parish church in Marienstatt owed its financial basis to a bequest from Heinrich III Count von Sayn, the Cistercian abbey at

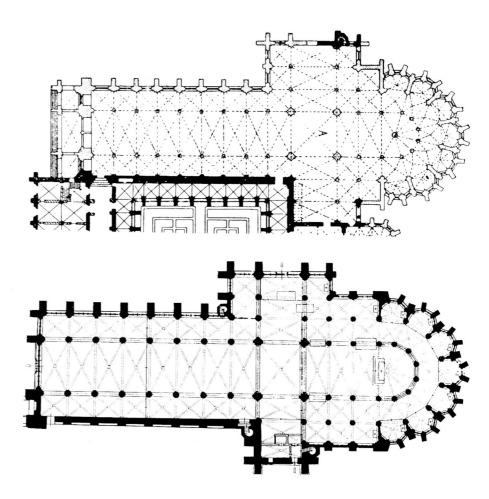

Altenberg – some twelve miles northeast of Cologne – was founded by the Counts von Berg on the family's ancestral land (latin: vetus mons). Monks dispatched from Morimond, who first settled on von Berg land in 1133, soon moved the monastery to a location in the Dhünn River valley where the first monastery church was consecrated in 1160. This was torn down in 1259 to make room for a new church, the choir consecration of which, in 1276, led many to believe that the rest of the structure would be finished not long after. However, it was not until the end of the fourteenth century that the church was completed, when the unadorned west front was closed with a huge tracery window. The floor plan of the choir [52] is almost identical to that of Cologne Cathedral's [41] and the choir to that of the Cistercian monastery church in Royaumont [53] (destroyed 1791), though Altenberg has one less chancel bay than Cologne and one more than Royaumont. Altenberg and Royaumont testify to a standardization of the French floor-plan type that took place around the middle of the thirteenth century. They also bear witness to the fact that Cistercian architecture had entered the

52 Altenberg, Cistercian Church

53 Royaumont, Cistercian Church

54 Altenberg, Cistercian Church, ambulatory vault and piers of the choir

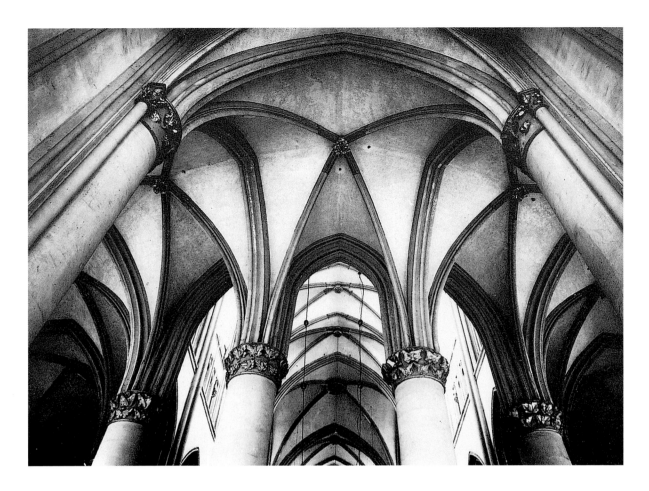

mainstream of Gothic cathedral building.

Indeed, the builders of Altenberg might have been familiar with Royaumont. The French royal family was Royaumont's main patron and some members were interred there. The Counts von Berg were interred in their own monastery church at Altenberg, even though the order forbade it. It was, lest we forget, an ancient Benedictine tradition. Details such as the trefoil tracery of Altenberg's windows, the profiling of its transverse ribs, its main arcades, the pedestals of its piers and its triforium mullions [54] all point to the dominant influence of Cologne Cathedral.[181] This, despite the fact that Altenberg possesses a smaller transept, whose south arm is narrow due to its connection to the cloister, and that the luminous five-aisle spatial organization at Cologne has given way here to a scant three-aisle design of almost sobering effect. Altenberg's piers – their capitals unarticulated except in the choir where they are foliaged – have a plain, round contour and seem strangely severe in the cold, colorless light of the graisaille windows, many of which have survived intact. The same holds true for the mullions of its clerestory and triforium, the latter of which opens onto dark lofts above the side aisles. A partial collapse, combined with years of neglect after secularization, has left the building nearly

empty and in such a fragmented state that there is a strong sense of spatial emptiness that was surely unintended.

Of course, not every German choir was to copy the expansive spatial organization of the cathedral choir via a terraced sheathing of the sanctuary through ambulatory and radial chapels. More often than not, the preferred form was an independent chevet lacking all auxiliary rooms whatsoever, whereby the German tradition of the chapel-less apse no doubt promoted the dispersion of the French bishop and royal palace-chapel choir design. The "one room" sanctuary, however, is not by any means a form specific to German Gothic.[182]

This has to be taken into consideration when looking at Naumburg Cathedral choir [56], a structure that to this day is thought to be an example of Staufen architecture, the main reason for which being the donors statues placed in front of the passageway at the base of the high windows [56]. In the past, nationalistic pride – that didn't care to look all that closely – idolized these statues as being equal to any French cathedral sculpture, so that their outward appearance and the characteristics they infer have been "transported with such vehemence into the present" that "no German can confront them today in a state of innocence".[183] Besides

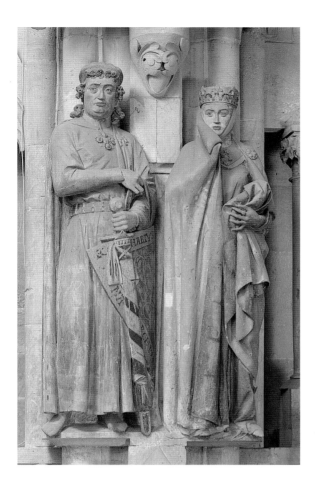

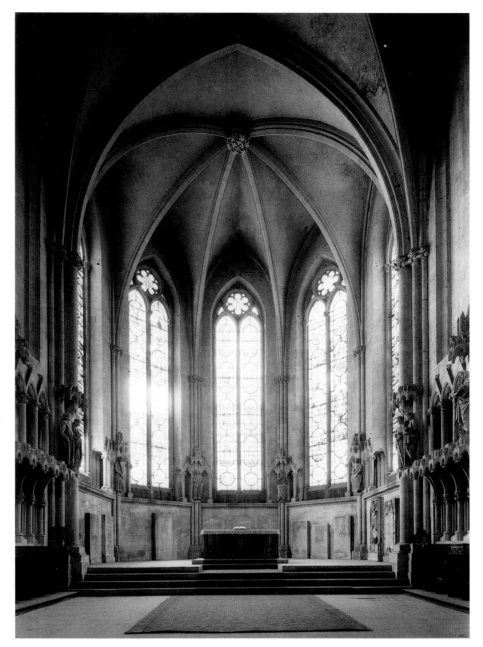

Margrave Hermann von Meissen and his brother Ekkehard, whose bequest allowed the bishopric of Zeitz to be transferred to Naumburg, there are figures obviously representing members of the aristocracy who supported the cathedral as *donatores* or as *advocati*. The form given to the figures represents a lifestyle common to the French cultural elite at the time. Motifs such as holding the knot of the belt, gathering up the mantel and the gracious smile, were widely used at the time. Yet, the almost classical treatment of what were for the most part medieval garments – evident in the soft, deeply molded folds of the material, and a contraposto-like straightening of the knees of the figures' free legs – betrays a style reminiscent of the transept sculpture of Reims Cathedral.[184]

Like a "Mirror for Magistrates" in stone, these figures adorn a slightly stilted, five-sided polygonal choir, on whose windowless side-walls there are stone choir stalls where prayers were said. A high chancel-screen closes the area off from the nave. Prototypes for the *passage rémois* motif of its passageway, and its doubled lancets with "standing" six-part foiling, are more than likely the same as those of the choir terminations at Trier [30] and Marburg [33] – the most important being the apex chapel at Reims Cathedral.

The German art historian Willibald Sauerländer believes that Naumburg's sparse employment of molded elements indicates its lodge was working with limited resources from the moment construction began.[185] Except for the planar framing of the windows, this observation seems incorrect. Sculptured articulation and wall surfaces of smooth masonry are carefully balanced here, like the side-aisle walls of Reims Cathedral, and a modest height insures tranquil proportioning. Everything considered, Naumburg's "donors choir" belongs to those German structures that preferred and assimilated the forms of the lodge at Reims Cathedral, then employed them in a fresh way. A lack of any surviving primary sources justifies placing the choir's construction before or sometime around 1250.[186]

55 Naumburg Cathedral, west choir, donors statues of Margrave Eckehard II and his wife Uta

56 Naumburg Cathedral, west choir

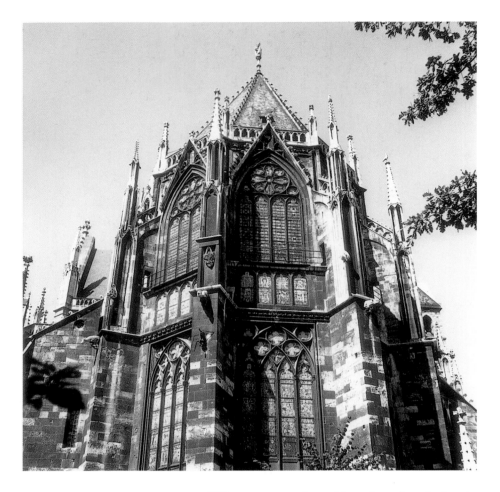

57 Regensburg Cathedral choir

forward because it sits upon the inner triforium arcades.

The glass surfaces outside rise between the pier buttresses and are separated by thin horizontal planks of masonry. They move progressively more inward with each register: the lowest level of windows sits on the wall base, the glazing of the triforium is set back from that, and the upper windows are placed so far inside the triforium arcade that the offset space can contain a passageway. The second passageway outside pierces the pier buttresses at the pedestal level. The hollowed-out tops of the pier buttresses and triangular gables over the windows are characteristic of the second half of the thirteenth century.

Which of the similar group of choirs at Troyes, St-Urbain (1262–6) and St-Sulpice-de-Favières (around 1250–60) was the prototype for Regensburg is academic, since Regensburg's choir represents a slightly later variation of their vertical organization systems.[188] The complete reduction of high wall intervals to shafts and glazing introduced at St-Denis [37] and Troyes has now, a mere four decades later in an area far removed from the Gothic heartland – and such was Bavarian Regensburg in the late thirteenth century – been completely assimilated and technically mastered, despite the comparably rigid and heavy handling of its mullions.

HALL CHURCH ARCHITECTURE
GOTHIC TRANSFORMS A REGIONAL TRADITION

The Hall church developed beyond its regional roots to spread across the German empire in just a few decades. It was an oft-employed alternative to the basilica, which since late Roman times had been the most widely used and popular type of ecclesiastical structure. Besides a few Hall structures in medieval Bavaria, Westphalia was the location for most of the Hall churches built after the dawn of the eleventh century. From there the Hall experienced a modest degree of dispersion – as far south as Siegerland, as far north as the Weser River basin.[189] The Hall type adopted by St. Elizabeth in Marburg was followed by the building of similar structures in Hessen, the area north of today's Frankfurt-am-Main.[190] The transformation of the early thirteenth-century's ponderous spatial organization into the Gothic Hall was accomplished suddenly in Wesphalia, without a transitional "mixed style." A more intense synthesis of style was not possible here because the region lacked a rich local tradition, one with a full repertoire of malleable forms that could be successfully employed to contrast

When comparing Naumburg's choir in distant Thuringia with the choir of Regensburg Cathedral in Bavaria (begun after a fire 1273, finished around 1310) [57], the major differences in style between Cologne/ Strasbourg and Trier/Marburg are confirmed, differences that can be traced to Germany's confrontation with the French Rayonnant style in the decades after 1250. What's striking about Regensburg is its collection of passageways both in front of, and in, the wall, which determine the position of the window surface in relation to the wall of each register. Evidently this system provided the opportunity for a free hand in dissolving the surface into an open tracery work of many contrasting forms. This was hung onto a structural framework that is similar – although of a different part of the building – to that which distinguishes the façade style of Strasbourg Cathedral [44,46]. One of the inner passageways is placed above a high wall base and runs in front of windows that fill the entire wall space. These windows are not lancets, but sheets of glazing pulled into the shape of standing rectangles between the pier buttresses. Above the front of this passageway is an arch whose spandrels consist of open tracery. It supports the glazed triforium over which the window surface suddenly juts

those of the Gothic canon, as happened in the Rhineland.

Characteristics of the Westphalian Hall visible in the nave of Herford Minster (begun around 1228) are nothing short of archetypal. They were uniformly applied for the first time here to a space of large dimensions. Herford's floor plan consists of three aisles of three nearly square bays each. The imposts of its warped, eight-webbed domical vaults are placed half-way between floor and vault apex, creating a calm spatial division from bay to bay.[191] The compact massiveness of its graduated, cruciform piers with responds is repeated nicely by the thick, sparsely windowed outer walls.[192]

The four-bay Hall nave of Paderborn Cathedral [58] should be mentioned in the same breath as Herford Minster, despite widened spatial proportions that are reminiscent of Early Gothic Hall churches in western France. Begun after completion of the west transept (before 1231), Paderborn's Hall nave lacks Gothic artic-ulation except for foliated capitals on the eastern piers, and tracery windows. Its entire physical structure – heavy cruciform piers with three-quarter shafts, groin vaults whose domical apexes are higher than their surround arches, graduated transverse and arcade arch profiles – continues the Herford style without further developing it.

Truly Gothic Hall churches did not appear in the area between Westphalia and the Weser River basin until after 1250. Simultaneous with the first Marburg-type structures[193] in Hessen and the central Rhine region, was the building of Minden Cathedral nave (1267–90), whose inner structure had to be rebuilt after severe damage in the Second World War [59]. Minden possesses a narrow bay acting as transition to the older west section of the church, yet its floor plan is typical of the short Westphalian Hall–church design – three aisles of three bays each. Like at Herford, the imposts are placed half-way between the floor and the top of the vaults, making for an extremely low springing of the vault ribs.

The cells of the high vault were mistakenly rebuilt after the war using ringed webbing, which is common to Romanesque Hall-church vaulting of the Weser River basin (Our Lady in Bremen). It does not, however, correspond to the original webbing at Minden. Today the cross-ribbed vaults rest on stilted transverse and arcade arches. Because these are molded to a far lesser degree than those at Herford and Paderborn and are barely distinguishable from the vault ribs, there is a strong sense of spatial

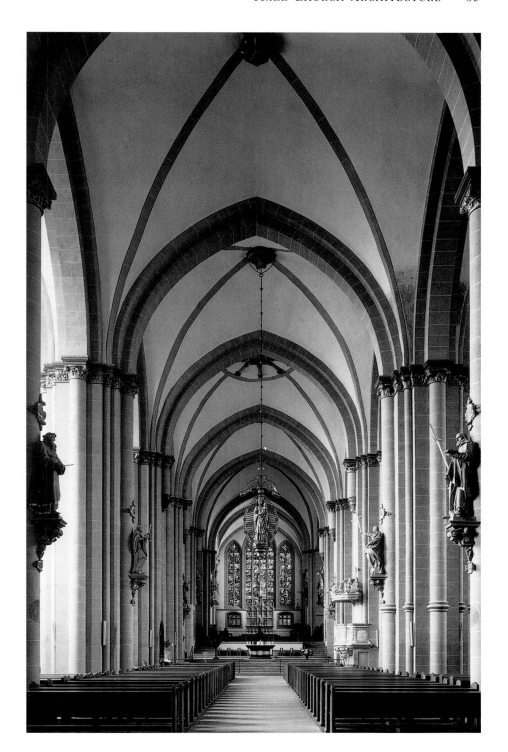

58 Paderborn Cathedral, nave looking east

59 Minden Cathedral,
nave looking east

60 Minden Cathedral,
tracery windows of the
nave

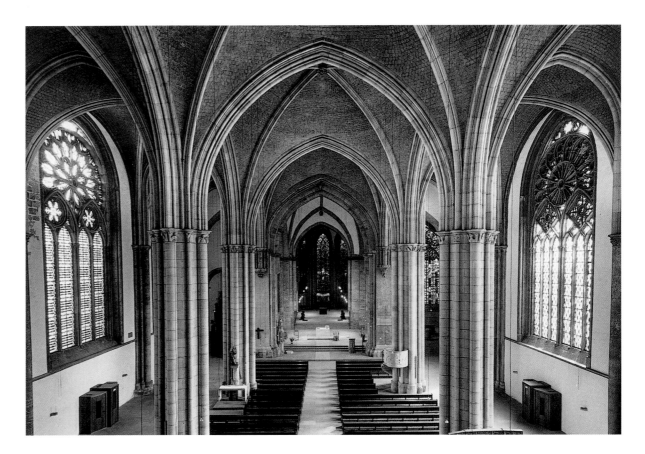

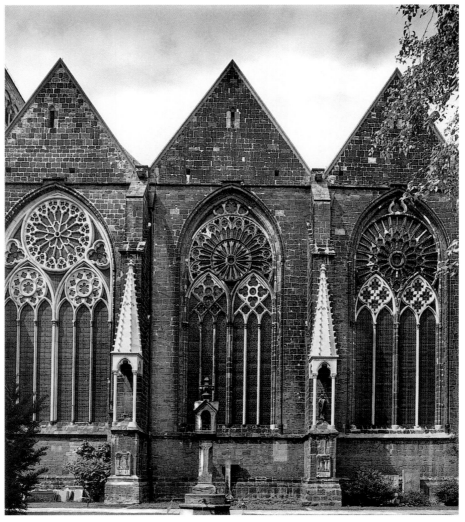

cohesion between the individual bays. Round, compound piers – with powerful axial, and thinner diagonal shafts – are no less sculptured than those at Marburg, but because there are only four of them, the deep trestle-like effect created by the rows of Marburg's piers [35] is not repeated. The distance between Minden's piers is much greater than at Marburg too. The molding of the arcade arches has been reduced to that of the transverse arches. In this way, similarly articulated spatial elements in separate parts of the church are formed into a unified whole.

For the prototype of Minden's compound piers we need look no further than the Hall-like side-aisles of Cologne Cathedral's choir. The matching of transverse and arcade-arch molding also comes from there.[194] To Minden, then, we can trace the first stage of the dispersion of Cologne forms to the north and east, over the Weser River.[195] In fact, the "Minden pier" became an almost standard motif of the Hall churches in the Weser River basin and Münsterland during the early fourteenth century.[196]

The architect of Minden's nave went his own way, however, when designing the side-aisle windows[197] [60]. Each window is placed, like many northern-German Hall churches, in the middle of a gabled outer-wall section that corresponds to a bay inside. This unifies the bays with the outer structure, the effect of which is heightened on the outside by the placement of saddle-back roofs over the side-aisles at right angles to the outer wall. The couronnements of the windows at Minden are filled with magnificent tracery roses. Double lancets that cut into their lower sections from below give the roses the appearance of open fans, a feature not found in other structures of the period. Minden's conscious adoption of the extravagant rose window – the dominant tracery form in the terminal wall of cathedral transepts – was intended to stylistically enrich its modest row of gables and to awaken in the observer the sense of looking at a sequence of opulent transept fronts. Minden's function as cathedral evidently required the representation of a cathedral façade, however abbreviated the elements might be.

Due to a growing demand for large churches with multiple-aisle sanctuaries, it was only a matter of time before the Hall-nave design was expanded to include the choir. The first Gothic Hall choir to be built with ambulatory[198] was Verden-an-der-Aller Cathedral (between 1273–1313), the spatial possibilities of which would captivate the most important German

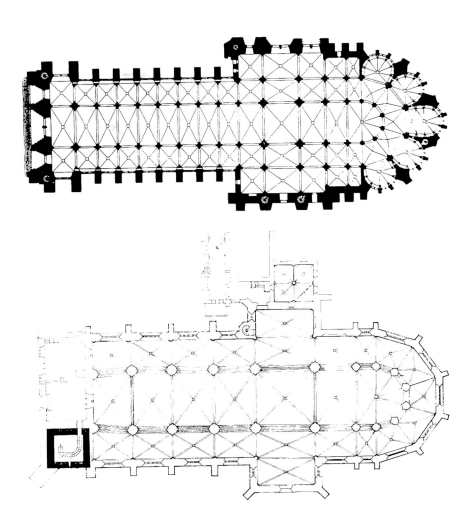

architects of the fourteenth and fifteenth centuries. The floor plan of Verden's choir is oriented towards that of Reims Cathedral [61,62] as both possess the characteristic half-bay transition between chancel and polygon,[199] but Verden's unified bay height and its abandonment of radial chapels results in a completely new spatial feel. At Reims Cathedral the chapels protrude outside. At Verden the outer ambulatory walls are large surfaces bent to conform to the sides of the polygon, and which encircle and clearly define the limits of the chevet [63].

The shafts separating the inside-wall sections at Verden are thin, conspicuously so, as if the architect wanted to hide as carefully as possible the positions of the joints in the continuum of the wall. The wall surfaces beneath the tall windows of the choir are unarticulated and function as a bordering foil. There are no clerestory walls. Spatial division is allocated to thick cylindrical piers in two rows unified by the half-circle they make around the apse. The shafing that articulates these piers seems insignificant compared to the distended volume of the pier core. Unusually wide and heavy arcade arches, nearly

61 Reims Cathedral

62 Verden Cathedral

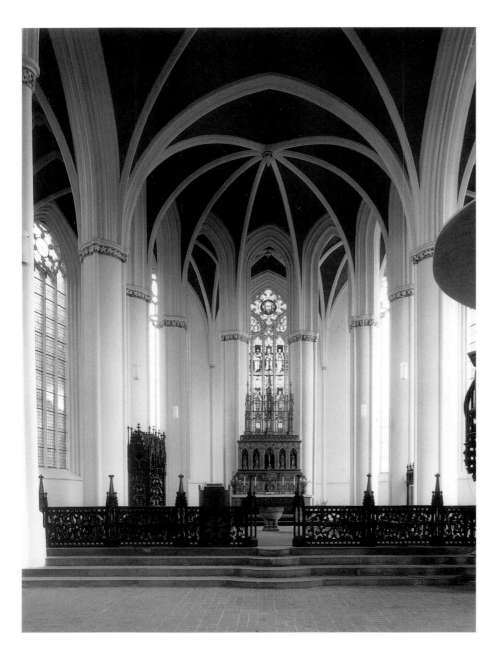

63 Verden Cathedral,
view of the choir

64 Verden Cathedral,
five-lancet tracery window
of the choir

65 Verden Cathedral,
four-lancet tracery window
of the choir

66 Heiligenkreuz,
Cistercian Church, Hall
choir

as big around as the piers upon which they sit, are profiled by innumerable roll-and-fillet, concave, graduated and echinus moldings. The arcade arches are extremely stilted between the narrowly placed supports of the polygon, where they form a splendidly opulent relief that encircles the sanctuary like a wreath. Here, then, was a conscious effort to contrast the dynamic "action" of free-standing elements in the inner vessel with the calm, wide framework formed by the smooth surface of the outer wall. Verden-an-der-Aller is yet another example – after Strasbourg's west façade [44,46] and Regensburg Cathedral choir [55] – of a new-found freedom in the application of Gothic articulation.

Besides being the earliest Hall church with an ambulatory,[200] Verden's choir was also a depository for a variety of Cologne and Strasbourg-type detailing features. For our pur-

poses, a look at the window tracery will suffice [64,65]. The cloverleaf rosettes with lily-bud cusping in the windows of the polygon are obvious descendants of those in the clerestory of Cologne's choir[201] [43]. On the other hand, the pointed arch of the window couronnement, whose haunches stand upon the crowns of the lower lancets, is a slightly altered version of a belfry-level tracery figure in "Sketch B-1" – a working design of the façade elevations of "Sketch B" – that was used around 1300 by the lodge at Strasbourg Cathedral.[202] In just a few years this motif must have been communicated to Verden, far to the north of Strasbourg, and indicates an active exchange of information among German architects and lodges over a large area. Unfortunately, little is known about this exchange. Verden garnered the inspiration for its floor plan from Reims Cathedral. Other than

67 Heiligenkreuz,
Cistercian Church

to communicate with each other to an even greater degree than in the nave of Minden Cathedral [59]. In cross-section, the piers are stereometric with an indefinitely shaped core. Their surface is made up of a lively interplay between roll-and-fillet molding, round shafts, sharp edges and shallow concave molding. Not only is the Rayonnant compound-pier motif handled here in a very creative and ground-breaking manner, the structure as a whole is one of the Gothic Hall tradition's most extraordinary churches.

MENDICANT–ORDER GOTHIC — PLANNED ANTITHESIS TO CATHEDRAL ARCHITECTURE

The churches of the Medicant Orders form their own branch of Gothic architecture. Generally speaking, the outer structure was modest. It had pier buttresses placed along the side-aisle and choir walls, a smooth gabled front, and saddle-back or leaning roofs over the central vessel and side-aisles. By the year 1300, Mendicant churches could be found in every large town. They were urban churches for a variety of compelling reasons, and if they had not yet settled in a city, then their appearance there was only a matter of time.

The Spaniard Dominicus founded the Dominican Order for several reasons: the deplorable social conditions of Medieval Europe, a neglect of religious values among the population, a decline in the education of the clergy, and the powerlessness and incapacity of Church institutions to deal effectively with the pressing problems of heretical lay movements. The order was officially ratified by Rome in 1216. In 1220 the "fratres minores" of Francis of Assisi received its precepts, and in 1245 the Carmelites were founded. Also founded at this time was the hermetic branch of the Augustinian Order, though they would not be officially recognized until 1567. Convents were in existence within all these orders as early as the thirteenth century.

Medieval society was in the midst of a deep spiritual crisis. The Mendicants set clear goals in response to this crisis: they were to preach the Gospel and provide spiritual guidance for the masses, instead of the traditional tasks of manual labor and serving at mass at the monastery. They renounced ownership of land and made an unconditional commitment to having a positive impact on the lives of as many people as possible – a commitment not steeped in monastic tradition. This made settling in towns unavoidable. Only there could the monks

that, hardly any French forms can be found here that didn't first pass through the large lodges at Cologne and Strasbourg. In Verden, then, the first contours of a Gothic style with a domestic German genealogy are visible.

The choir of the Cistercian church at Holy cross monastery [66, 67] in northern Austria (construction underway 1288, consecrated 1295) is much taller than the German Hall churches of Münsterland and the Weser River basin. Its three-aisle Hall connected to a Late Romanesque transept and its square plan are reminiscent of the choir and ambulatory at Lilienfeld [25]. However, Holy cross's arcade arches, which have a somewhat heavier profile than its transverse arches, run all the way to the east wall so that no chevet with ambulatory was ever built, but rather a group of three parallel aisles with a flat termination. Its vaults, flatter compared to northern-German Hall churches, are fused together to form a large shell-like ceiling similar to Lilienfeld's ambulatory vaults. The torus profiling of its arcade arches prevents the intended effect of bay separation that was achieved at Verden [63]. In order to facilitate a seamless movement from one vault compartment to another, the cell ridges were made almost horizontal. Making up the walls are very thin windows sitting upon a high smooth wall base. These windows are quite tall and reach high into vaults. The molded shafts of powerful compound responds spring up between them, forming a tall framework uncut by horizontal articulation. The tremendous height of this Hall is accentuated by the rapid exchange and contrast between glazing and three-dimensional wall shafting. Wide placement of the thin, extremely tall piers dissolves the border between the separate aisles, and allows the individual spatial units

live among those they exhorted to return to the Faith, among those most in need of God's word, the "pauperes" of an unsettled and fragile social order. In town the monks also hoped to awaken in the rich urban classes a renewed sense of responsibility based on Christian values, through which they hoped to restrain lay power, and solicit its support.

The Mendicant movement was incredibly successful. A stirring, electrifying style of preaching mobilized the masses to such an extent that Mendicants were soon at odds with the Church establishment. As early as 1240 the "barefoot monks" were banned from entering city churches. They responded by building their own church. It usually stood right on the edge of the street and lacked an esplanade or any open spaces whatsoever. It was aligned with, and was the same height as, the homes around it, with the monastery buildings placed towards the back of the lot. There was no better way to visually emphasize the order's commitment to their own goals than this type of structure,[203] which acknowledged the urban citizenry and its living conditions, and proved that the monks' words were not just empty rhetoric. Mendicant churches were open to the people of the town. They were a site for all kinds of legal activities, from arbitration between conflicting parties to public announcements and reports. In Braunschweig and Frankfurt the Franciscan monastery, in the town of Krems the Dominican church, served as the meeting house for the town council and artisans guilds.[204]

At a general chapter meeting of the Franciscan Order in 1260 in Narbonne, specific guidelines were drawn up for the order's architecture. They were very similar to those of the Cistercians, and ultimately ineffective in controlling what style or type of design was to be used since, except for prohibiting towers and limiting the use of vaulting to the sanctuary, the guidelines were not followed. A lack of towers – with the exception of small, staired towers and turrets with bells – is common to all Mendicant churches of the period. Many Franciscan naves have flat ceilings, though there are major regional differences in this.[205] The choir served chiefly for common prayers, with its function of celebrating individual Mass, as stipulated by Benedictine precepts, playing a secondary role. It was therefore natural to dispense with a choir ambulatory and transept with spaces meant for auxiliary altars where these masses would have taken place.

As a result Mendicant churches are, almost without exception, of an uncomplicated spatial organization and divided according to a two-fold function: the sermon was usually given in an unvaulted nave, with the monks choir – the so-called *Langchor*, a tall and narrow chancel – separated-off from the lay area. This separation was common to all monastic churches from the very beginning, but it was applied in Mendicant churches in a new way.[206] The caesura between the two areas was often emphasized by a low triumphal arch, before which chancel screens were raised (especially after 1260) that could be extended through three-aisle churches to form high spatial-barriers.[207] The various types of Mendicant naves conform to the dominant thirteenth-century architectural traditions of the region in which they were built. This was due to the fact that the new orders lacked an architectural tradition of their own, and that building was not carried out by their own artisans, but usually by those available in the cities.[208]

It is difficult to determine whether, and to what degree, German Mendicants were dependent on older Italian churches of the same order, since the possibility of comparing architectural forms – the preferred method of style derivation – proves to be very limited with objects whose major characteristic is a *poverty* of form. Necessity is the mother of invention, however, and scholars have made up for this by comparing types instead of forms. Even then, the question remains whether the Italian "Ur-types",[209] like St. Francesco in Cortona, were really a necessary prerequisite for the building of such plain structures as the long, flat-ceilinged, one-room structures of the Franciscans (1220s in Eisenach) and those of the Dominicans (1235/40) in Thuringia. They were, after all, structural types that were still common in the late thirteenth century.[210] Ever since Krautheimer's research, scholars have believed these rooms, bereft of art, to be representative of higher architectural concepts whose wellspring it was assumed was in the radical beginnings of the Medicant orders in Italy; that the central role of the sermon directly influenced the form of these one-room churches where priests and laity would gather in spiritual harmony around the chancel.[211] But there is no proof of this. In fact, there are more plausible reasons for the Mendicant's building in a style bereft of art: their vow of poverty, and the order's indifference to architecture in the beginning. They needed little more than a roof over their heads, and even in later years a tendency towards makeshift structures was characteristic of Mendicant Gothic. Asymmetrical spatial organization, axial shifts, building according to immediate needs,

68 Regensburg,
Dominican Church, nave
looking east

that Würzburg was the first Franciscan monastery in Germany (1220/21) and was settled by Italian monks, this conjecture is probably not incorrect.

In those places where Mendicant architecture – with its structural aesthetic of employing limited materials to build simply formed structures with clearly defined spaces – came together with the ambition to use and reinterpret Gothic forms, the results were extremely impressive. A look into the central vessel of the Dominican church in Regensburg (choir with side-apses begun 1245/48 completed with west front 1310–20) reveals high, smooth walls on both sides into which pointed-arch windows are placed far overhead [68]. These windows have slanted jambs, are cut into the formeret wall and are part of the vault zone. Between these and its low, compressed-looking arcades, are wide flat surfaces broken only by respond shafts. Except for the semi-circular shape of the responds, the profiles of all the other elements – including the plain, graduated molding of the arcade arches – are cut from the wall and do not project out of it as individual three-dimensional forms.

Here we see the major difference between Mendicant Gothic, and that of the usual thirteenth-century system of a dynamic clerestory wall made out of thin, rounded elements that form a relief-like framework that actually denies having a defined plane. The Gothic articulated style has been reduced at Regensburg's Dominican church to an essential interplay between wall responds and ribbed vaulting that forms an inner framework whose surrounding surfaces are pulled tight as if by tent posts. The antithetical nature of the relationship between framework and wall surface, sublimated with all available materials and methods at Strasbourg and Cologne, is candidly brought to the fore at Regensburg. The only elements that come close to lessening this effect are the extremely thin windows of the choir. A flattening of the responds into horn-shaped profiling in the area of the choir stalls gives the peculiar impression that the inner framework hangs in the air at that point, and that the elements placed towards the bottom are only temporarily fastened to the wall. Regensburg's high vaults are flat, with horizontal ridges in their transverse cells that border the clerestory with thin wall ribs. The vaults do not appear to sit on the upper wall, but seem to be lifted and spread out by wall responds that resemble tall canopy posts. In contrast to Romanesque domical vault construction, Regensburg's nave wall comes across as unen-

non-proportional additions – all these are surprisingly common.[212]

Early in their history, the Mendicants of northern Italy tried to model their own architecture on that of the Cistercians. Many of their thirteenth-century churches not only have a projecting transept, some of the larger ones followed the Cistercian habit of including rectangular chapels in the eastern transept walls.[213] This type of Mendicant church cannot be found anywhere in Germany, even though various individual motifs seem to point to a connection with Italy. It has been suggested that the Franciscan church at Würzburg (nave about 1257–90) possesses characteristics – including an previously-constructed flat ceiling, a clerestory kept low in favor of a high nave arcade, and squat round piers that had flat abaci – to be found in the flat-ceiling basilicas of Tuscany.[214] In light of the fact

cumbered by weight from above – more a bordering foil than a load-bearing structure.[215]

Regensburg's original polychromatic colour scheme is well known. Its walls were painted a white eggshell color and, except for a red horizontal line running below the windows, completely without contour. The window jambs were set-off from the white surface in red. The appearance of the responds is not known, but we do know that the ribs were highlighted by painted joints and lines running lengthwise on both sides. Thus the color scheme was intended to emphasize the spatial characteristics of the architectural style.[216]

This type of wall framework was incredibly influential because it offered the possibility of "building Gothic" at less cost and fewer materials. Instead of a dissolution of the wall surface into a latticework of articulated elements, it projected the latticework's essential structural element – the wall respond – upon an unarticulated surface. The ambulatory walls of Verden Cathedral [63] are an early example of how eagerly builders seized upon this principle. This was not, as Kubach thinks, a harkening back to Late Romanesque massive-wall construction[217] for it required a reduction and re-interpretation of the Gothic system of vertical organization. It may be true that certain details at Regensburg's Dominican church are to be found in Italian and German Cistercian structures[218] – such as the extremely high placement of the windows within the formeret wall, or the abstract-stereometric forms of the pedestals, consoles and capitals – but their use within an overall pictorial space is a creation of the Mendicant orders.

Around 1250 the Mendicant order in southern Germany introduced three motifs into their architecture that would play an important role in the new emphasis on wall surfaces that delineate space. One of these is the smooth, octagonal pier without responds (Franciscan church in Constance begun 1250) a type of pier that had been used now and then by the Cistercians[219] and which allowed the arcade support to appear as if made of flat surfaces. Another new development involved the impost zones of the piers at the Franciscan church in Rufach (begun 1250). Here the profiling of the original arcade arches disappears into the piers[220] as if to demonstrate that support and wall arch were part of the same mass of stone, whose forms penetrated each other and did not require connecting joints. The supports formally grew into the wall. And finally, the vaulting of the Dominican churches at Regensburg and Esslingen (1250/55–1268) possess the oldest

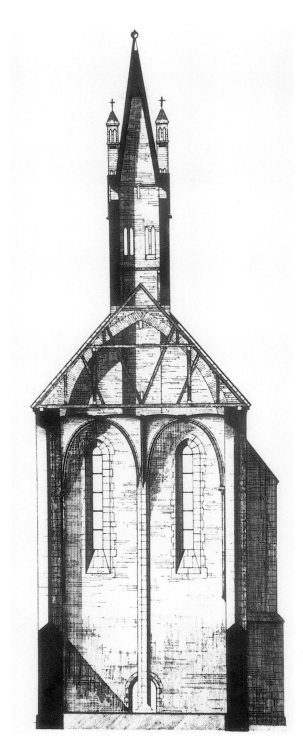

examples of ribs with plain concave molding which in cross-section resemble a thin I-beam. This form of profiling exhibits much less relief work than the rich roll-and-fillet molding of the ribs usually seen during the period, and reduces the rib work to a fine interplay of lines. Here we see the principle of the "Mendicant wall" dominating the vault as well; for the more muted the three-dimensional articulation, the greater the effect of the vault cell as a smooth, enclosed surface.

Concave molding of the ribs, arcade-arch profiling that disappears into the pier, and octagonal piers, would all be indispensable ele-

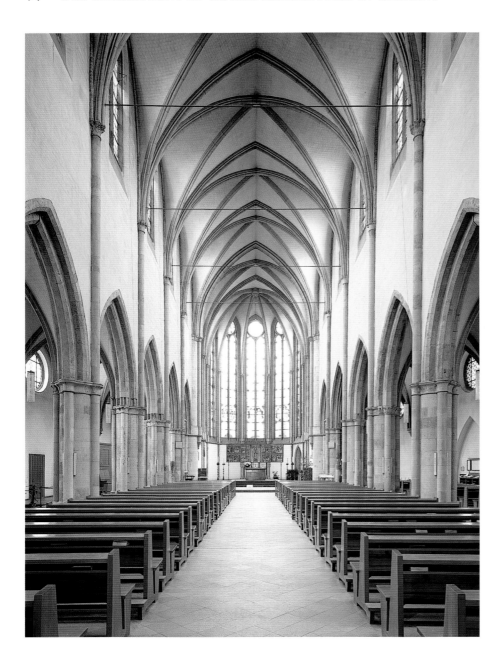

70 Cologne, Minorite
Church, nave looking east

71 Cologne, St. Ursula,
view of the choir

72 Cologne, Minorite
Church, nave from the
south-west

Westphalia and northern Germany. An interesting parallel to Imbach can be found in Toulouse in the so-called Jacobin Church (choir rebuilt 1275–92, nave 1325–35) a Dominican Hall which is similar in height and has two aisles.[221] Research has shown that Toulouse's northern aisle was reserved for the monks of the order, the southern for the laity.[222] This same functional division of space into two sections – whether it inspired the design or merely suggested itself later – was probably not employed at Imbach, as there was a large gallery above the west bays reserved for nuns' prayers.

The clearly formulated Mendicant structural aesthetic found at Regensburg and Imbach is not to be found everywhere. Mendicant churches often approached, without completely emulating, the articulated style of differentiated elements from the lodges of the larger cathedrals. An example of this is the seven-sided choir of the Minorite church in Cologne [70] that possesses almost as much mullion work as the nuns' collegiate church of St. Ursula [71], also in Cologne. Both are single-register structures with a passageway running in front of the windows outside, making them similar types but with noticeable differences in style. The Minorite choir has double-lancet windows crowned by a circle, along with the shape of the choir, which are both essential features of Our Lady at Trier's choir [30]. Begun in 1248, the year the cornerstone was laid for Cologne Cathedral, and consecrated in 1260, this Minorite sanctuary remained untouched by the Rayonnant style. Not so the choir of St. Ursula (assumed consecrated 1287) whose more modest five-sided termination one would have expected to find in a Minorite church. The reduction of the polygon to five sides allowed for triple and quadruple lancets whose mullions pierce the window sills and run through the wall base below forming a kind of blind panelling,[223] the prototype for which is surely Cologne Cathedral's choir. Also from Cologne are the double rows of foliage on its wall respond capitals, whose leaves shoot out from a chalice-like nucleus.

The differences between these two sanctuaries surely do not indicate a stylistic direction specific to the Minorites. Rather, the year construction began on St. Ursula's choir, which has yet to be determined with certainty, will have to be dated later. It was not until the building of the basilican nave[224] of the Minorite church [72], whose west window-tracery indicates a date of around 1350, that the Mendicant aesthetic was more emphatically expressed.

ments of German architecture in the following two centuries.

The Mendicants developed a style all their own in the Hall church tradition. The double-nave Hall church of the former Dominican convent at Imbach (after 1269) [69] – which together with the choir at Holy cross [66] introduced the Hall to northern Austria – is so tall that the height of its aisles is four times its width. In its scant four-bay inner vessel, thin windows have been positioned above a high wall base. The concave-molded ribs of the vault spring seamlessly – similar to the main arcades in Rufach – from the surfaces of the octagonal piers whose rows occupy the main axis of the nave. The chasm-like height of its two aisles, and the concentration of it sparse formal materials into large, clearly arranged proportions, make the structure quite different from the Halls in

The total array of its forms was increasingly simplified from east to west: the impost bands of the squat piers lost their foliage decoration, and the molding of the archivolts of the main arcade took on a sharper edge. As at Regensburg [68], the only articulation of the wall surface above the arcades is via semi-circular responds, and there are small round windows in the aisle walls. However, its open buttress system and the proportions of the spherical quatrefoils in its clerestory betray the proximity of the lodge at Cologne Cathedral, even though the effect of Cologne's fine ornamental openwork has been completely removed from them. In the nave of this Minorite church, then, we see an attempt to find a balance between the Mendicant style and cathedral Gothic. Evidently when its choir was being built, Mendicant architecture had not yet developed its own pool of Gothic forms in Cologne, for the sacristy in the north corner of the choir was done up completely in forms from Trier.[225]

Like the early Cistercian churches – which can be understood as having been an alternative to Burgundian Late Romanesque, with its richness of form and spatial differentiation – German Mendicant architecture has to be understood as having stemmed from a conscious program undertaken to reform Gothic in its own (Mendicant) image. Its austere construction concentrated on simplifying the complex spatial and articulation systems of the High Gothic, and on recapturing the homogenous nave which leads those who enter in the west to the east without any intersecting structures or auxiliary rooms. It focused on relinquishing the cathedral's extensive structures in the west and the choir, and on flattening the Gothic wall relief. To what degree German Mendicant architecture adopted the articulation systems of the large cathedral lodges can be clearly seen in the nave of Cologne's Minorite church.

It is impressive to see just how far the Mendicant's were willing to go to "correct" the Gothic canon. Scholars believe these measures were inspired by a Mendicant "world view based on reason".[226] Because of its poverty of form, they impute to Mendicant architecture an "absolute functionalism....a complete disassociation from subordinating itself to standards that had become sacred through tradition and authority." From this they conclude that the style's creators would have "rejected and worked against every form of pictorial and symbolic architectural presentation".[227] The notion that an architectural aesthetic, one that was con-

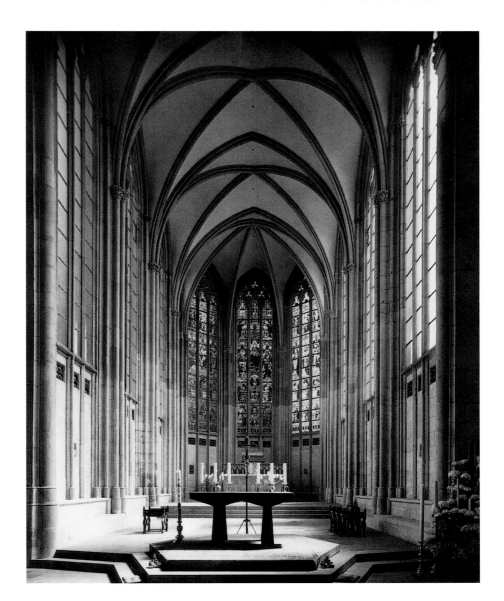

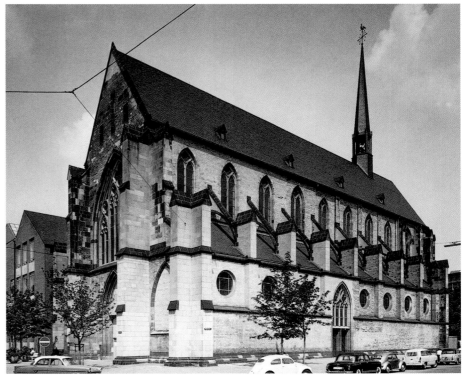

73 Chorin, Cistercian Church, view from the south

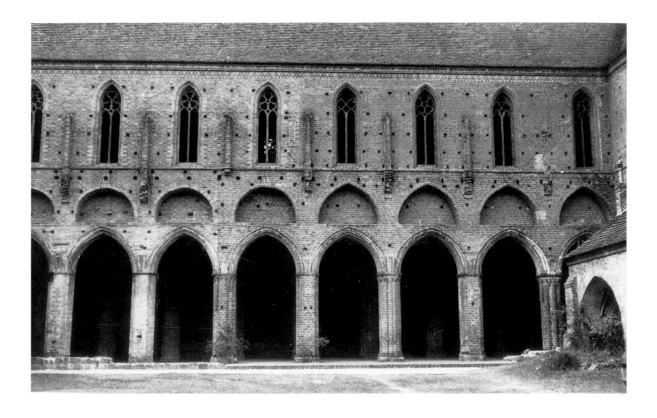

sciously opposed to artistic presentation, could be based on a pragmatic and functionalist mentality, appeals to us inheritors of the Bauhaus tradition. But such a conclusion is deceptive, since wall painting in Mendicant churches often took over the teaching and narrative role of Gothic's three-dimensional Biblical representations.[228]

BACKSTEIN GOTHIC − THE EFFECT OF MATERIAL ON FORM

There is no ashlar to speak of in most of northern Germany, the Netherlands, Flanders, the Baltic coastal regions, Silesia and the alpine foothills of Bavaria. In these regions Backstein, or red brick, was used for construction after the twelfth century. This was a revival of sorts, since Backstein had been the most commonly used building material in the provinces of Rome for centuries, but after the fall of the empire it remained confined to the Mediterranean. In the thirteenth century the centers of German Backstein construction were in the north, and lay east of the Elbe River: on the plains of Brandenburg, Mecklenburg and Pommerania, the coastal regions of the Baltic Sea between Holstein and the "state" of the Teutonic Order east of the Vistula River. The Teutonic Order "state" was a region that had been conquered during the later years of the reign of the House

of Hohenstaufen, and held thereafter with varying success. In these areas Backstein Gothic became associated with what can only be termed as pioneer settlements, for it was the architectural style of western Europeans who gradually settled in the east over a period of years.

Backstein is characterized by an enlivening of the wall surface, an effect achieved more often than not through the pattern created by its masonry bonding.[229] The walls are usually of filled, double-wall construction. The outer surfaces of these are covered in red brick laid down in a course of "stretchers" (their long sides visible) and a course of "binders" (their short sides visible). The two most common masonry-bonding systems were the "Gothic" or "Polish" bond, consisting of a simple pattern of stretchers and binders in one course, and the "Brandenburg" or "Wendish" masonry-bonding system consisting of one stretcher followed by two binders in one course.[230] In later years it was common practice to mix both bonding systems in order to break up the repetitive pattern of cross joints. As early as the beginning of the thirteenth century glazed bricks of brown, green and black were used in many buildings to achieve color contrast and an articulation of the surface.[231] Expensive molded or cut bricks each costing as much as ten surface bricks[232] were used for molding, piers, friezes, corbels and every kind of ornamentation. In the early years these were carved out of partially dry clay. In

later years they were cut with a wire tool called a *Schneidedraht* while the clay was still wet and soft. Sometimes sandstone or plaster was used instead.

Compared to articulated ashlar structures, the "small parts" construction of the Backstein Gothic wall limited the architect's latitude for varying detail. Whereas the technique of ashlar structures tended towards an elegant duplication of forms in ornamental openwork and a complete three-dimensional articulation of the wall surface, Backstein Gothic maintained calm, homogeneous surface values and sharp, block-like contours. The properties of the material itself required a limitation and simplification of plastic detailing which, in many respects, makes it related to the Mendicant style.

The oldest Romanesque Backstein churches on the plains of northern and eastern Germany bear witness to a mass migration of people from the western territories of the empire, who had been forced by economic hardship and a booming twelfth century population to move east.[233] This mass migration was supported by the aristocratic houses of northern Germany and, for reasons that would be to their advantage, directed into those regions east of the Elbe controlled by Slavic tribes. Heavily involved in this were two men. The first was Albrecht the Bear from the House of Askania, the holder of extensive lands in the Altmark of Brandenburg west of the Elbe and who had inherited all of Brandenburg. The second was Heinrich the Lion, Duke of Saxony, who founded new diocese in the east in Holstein, Ratzeburg and Oldenburg. Both were major players in the so-called "German colonization of the east" a harmless-sounding name for an undertaking that was anything but harmless. Colonization east of the Elbe was completed in two phases that can be differentiated as to when they occurred and the methods that were employed. In the twelfth century an unsystematic and at times brutal acquisition of land took place that was morally sanctioned by the Christian ideal of "converting the Gentiles," in this case the Slavic tribes. After 1226 the Teutonic Order adopted the same methods. The resulting political situation and altered cultural climate made the development of a dynamic infrastructure possible on a provincial level[234] and paved the way for prosperous mercantile activities in the thirteenth century.

During the second phase, the House of Askania used the strength of three ambitious Christian orders, one after the other, to economically and culturally develop their new possessions. The Pramonstratensian Order – which would remain important into the eighteenth century and was based in their church of St. Mary's on Harlunger Mountain – did most of the missionary work and organized the church's administrative apparatus under Albrecht the Bear.[235] The Cistercians had already been called to settle in the east by Margrave Otto I by the year 1180, and played a major role in the domestic colonization of the area after 1250. As the agricultural experts of the period, they supported the provincial rulers in what was still an area with very few towns or cities.[236] The Cistercian foundations at Lehnin, Chorin and Himmelpfort were nothing short of house monasteries for successive Askanian margraves who inherited parts of those vast holdings from their predecessor. Soon thereafter, the Mendicant orders settled in the towns which had gradually appeared.

One of the oldest Gothic buildings in Brandenburg is the Cistercian monastery church at Chorin [73]. Like the church of its parent monastery at Lehnin, Chorin held tombs of the House of Askania, specifically the branch founded by Johann I (ruled 1225–66). At Johann's request, Cistercians monks from Lehnin settled on Lake Paarsteiner in 1258. The monastery at that location was abandoned in 1273, however, and moved to Chorin. The eastern section of the new church – an almost semi-circular, seven-sided polygonal choir with fore-bay, and a transept whose eastern walls possess rectangular chapels with separating walls that fill the angles between the choir and transept – was already sketched out in Romanesque forms at Lehnin. Traditionally, the ashlar choir of the Cistercian church at Schulpforta in Thuringia (begun 1251) is seen as the prototype for the thin, single-register elevation of Chorin's choir.[237] No prototypes from the Backstein region seem to have survived. The flying buttresses of Chorin's basilican nave are covered by side-aisle roofs, a feature that probably came from Schulpforta as well. The ruins of the monastery, which was abandoned in 1542, allow us a view into the church's structural anatomy. Now visible, where they were once hidden under side-aisle roofs, are deep pointed-arch niches, which bear the weight of the clerestory wall above, and deflect it from the graduated, rectangular-profiled arcades of the central vessel below. Backing these niches is a layer of bricks which is part of the high, smooth wall inside the central vessel between the crown of the arcade arches and the windows placed far above. It would have been possible to open the niches up by not having backed them with a wall. Instead,

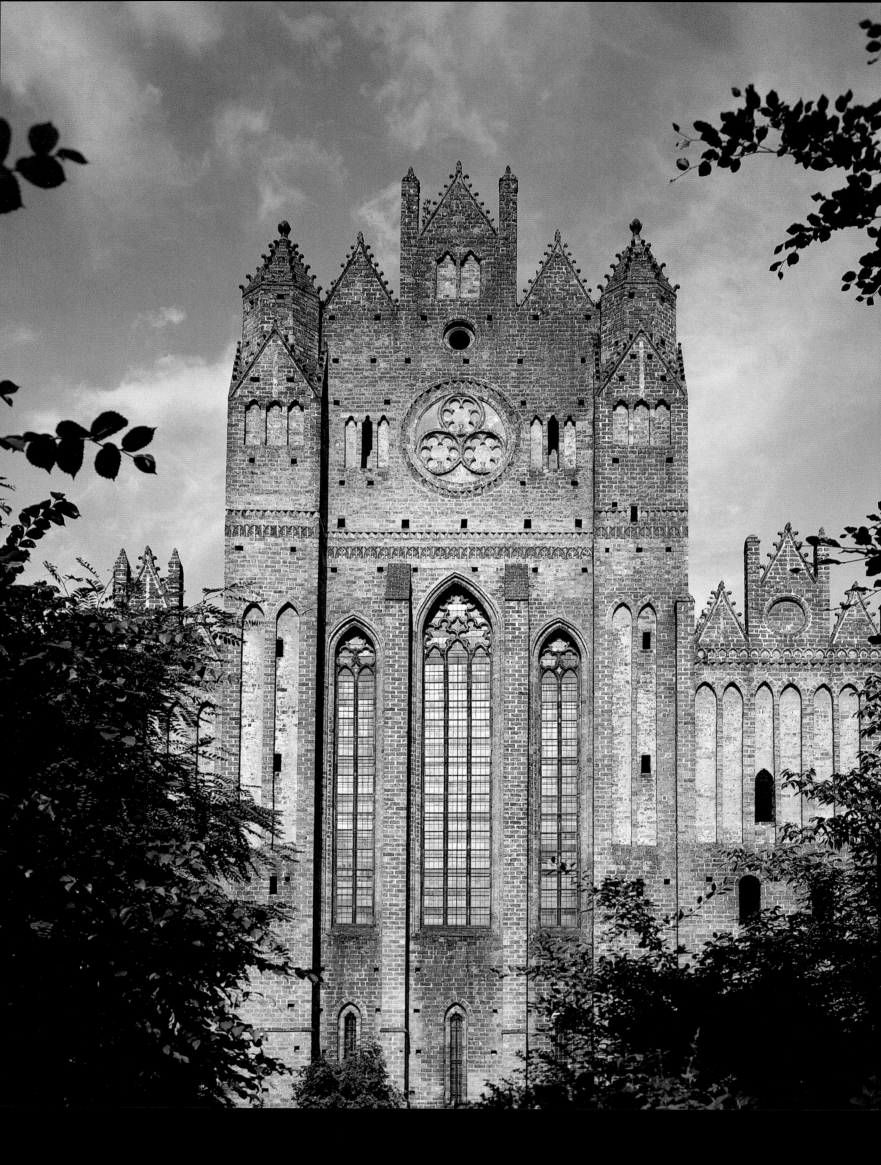

the builders decided upon lateral elevations made up of tall, smooth surfaces inside. This wall system is fundamentally different from the skeletal structure of the Gothic cathedral wall, and seems even more closely related to the style of the Mendicant orders.

Chorin is famous for its west façade [74] which takes the Cistercian motif of the gabled front and turns it into a splendid, monumental three-part surface display that is much taller than the aisles behind it. At first glance, it looks like a tall, military structure which warrants but a single entrance through a door in its southern flank. Even though the wall fronting the central vessel is outfitted with large windows, its lower registers are bricked closed, as are the façade's lateral walls which are unarticulated except for small windows and flat, blind lancets. It isn't until we get above the string coursing, made up of arched and dentil friezes, that the mass of masonry is broken up by ornamental gables articulated by crockets and pinnacles. Combined with main pier buttresses that have been expanded to staired turrets, the whole is more reminiscent of a crenellated fortress than the cross-section façade of a Cistercian monastery church.

Chorin's façade was built by provincial rulers of the House of Askania as a monument to themselves. Through the single portal the margrave entered a two-aisled, vestibule-like hall placed at a right angle to the façade, which contained fireplaces and frescoes. Having returned, the margrave would be greeted in his own private monastery by wall paintings of Biblical themes – still intact are the Adoration of the Magi and the Judgement of Solomon – the obvious intent being to impress him with examples of God-fearing rulers. This room offered easy access to a spacious gallery reserved for the margrave's family at the west end of the central vessel, onto which opened the three large windows of the middle façade section. Thus the spatial organization behind the façade (probably completed before 1319) was tailored to the wishes of the church's founder. It was no doubt meant to be a monument to aristocratic power.[239]

The Baltic coastal cities of eastern Germany are rich in Gothic structures. In the town of Wisby in 1161, Heinrich the Lion helped found the Guild of German Maritime Traders or the *universi mercatores imperii Romani Gotlandiam frequentantes*, the members of which developed a wide range of lucrative business ventures as traders in the Baltic region. The guild organized the trading of raw materials from the north and east – mineral ore from Sweden, fish from Denmark, furs from Russia – for finished prod-

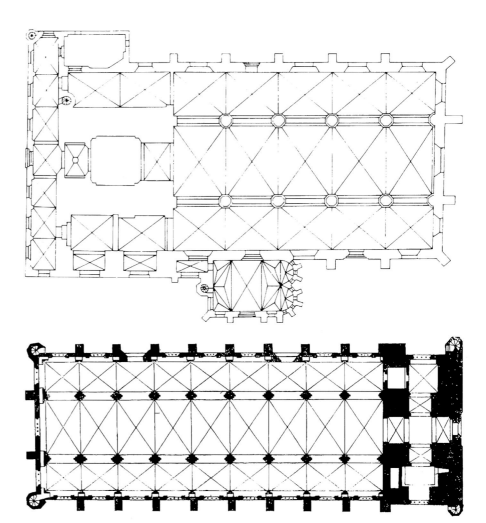

ucts from the west. Leadership and administration of the guild soon moved to the harbor cities where wandering merchants had settled, and a rich mercantile class controlled the town councils. These large commerical outlets attracted numerous artisans to process and work the raw materials, and in a short time there were prosperous communities, each with its own economic infrastructure. In the thirteenth century this Baltic "trading zone" gradually grew westward to include the North Sea where traders from Cologne, Bremen and Westphalia were already active. The merchants of the Baltic coastal cities opened trading offices at the large textile markets in Flanders, the Netherlands and England, operating closely with the cities of Westphalia. They not only brought commercial products back with them; the architecture of these western countries would eventually also make its way east and be copied in Backstein.

Westphalian prototypes, for instance, were used to build the shortened Hall churches of St. Nikolai in Rostock and St. Mary's in Greifswald (begun about 1260) [75]. They were built with compound piers set far apart,[240] and in a varia-

75 Greifswald, St. Mary's

76 Neubrandenburg, St. Mary's

74 Chorin, Cistercian Church, south wall of the nave

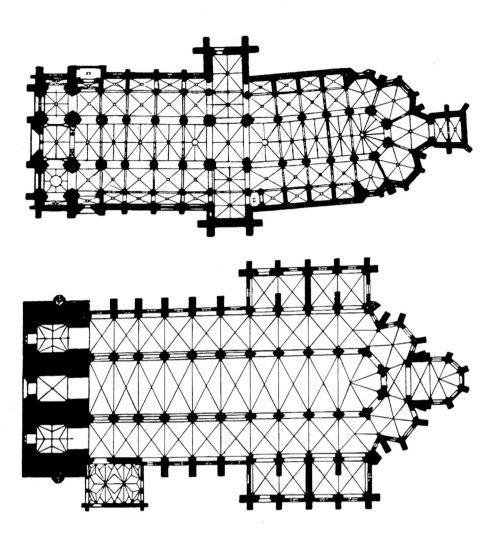

77 Quimper Cathedral

78 Lübeck, St. Mary's

79 Lübeck, St. Mary's,
nave looking east

trade organization that would include a hundred and sixty member cities by the fourteenth century. Many of the German Hanseatic cities chose for their major churches the most expensive and difficult to build of all Gothic building types: the three-aisle basilica with transept, choir and ambulatory. Economic competition carried over into the ambitions of the merchant elite to build great churches as a way of showing neighboring communities the superior rank and prosperity of their home cities. It was not by chance, then, that the *mater ecclesia* of these Hanseatic churches stands in Lübeck, capital of the league, which Emperor Freidrich II proclaimed an imperial city in 1226, freeing it from provincial rule and taxation.

Construction began on Lübeck Cathedral's new choir with ambulatory in 1266. Its singular floor plan, obtained from northern France via the harbor cities of Flanders, fuses ambulatory and radial chapels into six-sided spatial cells [78]. In each of these, the side opening towards the sanctuary is formed by a choir arcade, the sides to the left and right open onto cells bordering it, and the three sides behind protrude outward to form window walls. Planned as a basilican structure, Lübeck was redesigned during construction as a Hall (completed 1334/35, consecrated 1341) resembling that of Verden Cathedral choir. Ribbed, sexpartite vaulting covers each chapel, making each seem like a separate room. This fusion can be traced back to the choir of Soissons Cathedral (completed 1212) after which it was developed in Brittany at Quimper Cathedral [77], Tournai Cathedral and in Gent (Vrouwkerk St. Pieter's, St. Nicholas) into the form that determined Lübeck's floor plan.

Once the new bishop's seat was completed, the townspeople of Lübeck decided to enlarge their main parish church, St. Mary's. Its nave had been a Hall structure since the 1250s, a condition of short duration as it turned out, since in about 1280 a renovation of the choir was begun that would involve the entire structure and last well into the fourteenth century.[242] The floor plan of the new choir follows that of nearby Lübeck Cathedral choir. Specific to St. Mary's, however, is the positioning of the west pair of radial chapels which, because the Hall nave was already standing, were integrated into the row of side-aisle bays.[243] The same chapels at Lübeck Cathedral are positioned radially, like all the others, and in the same way as those in the structures of northern France and Flanders of the same period. The western radial chapels in buildings that employed St. Mary's as prototype

tion that was, however, already dispersed throughout the east in Mecklenburg and Pommerania – three-aisles terminating choirless in a flat eastern wall, whose gabled outer structure was often enlivened with blind ornamentation, frieze work and other surface decoration.[241] New standards for this style were set towards the end of the thirteenth century at St. Mary's in the town of Neubrandenburg [76], which is a nine-bay Hall whose rectangular high vaults are separated from its almost square side-aisle bays by wide arcade arches that are strikingly similar to the accented arcade arching of the Hall choir at Verden, built about the same time. An inner passageway runs in front of all windows and through every engaged pier.

At the end of the thirteenth century the rich trading cities of the "Wendish District" in eastern Germany – Lübeck, Stralsund, Rostock, Schwerin and Wismar – formed the *Stade von der Dudesche Hanse* under the leadership of Lübeck. This organization formed the basis of the Hanseatic League, a powerful merchant and

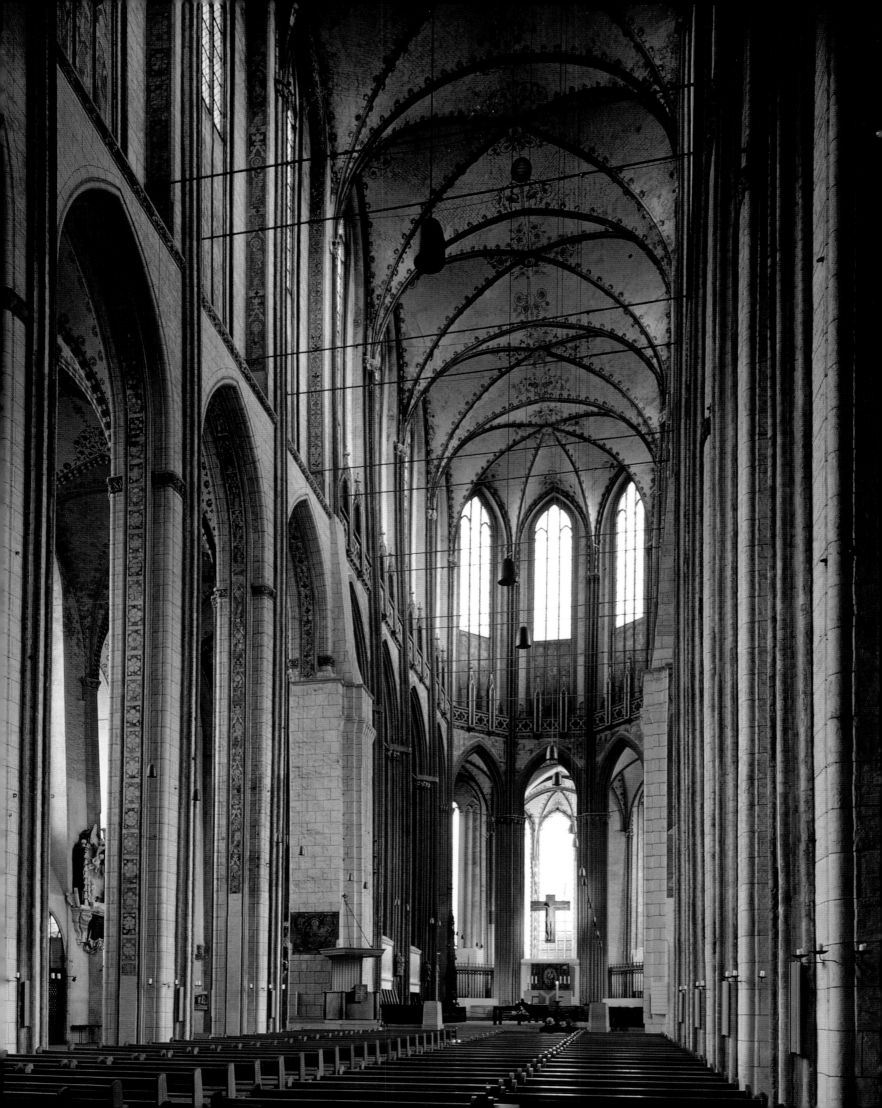

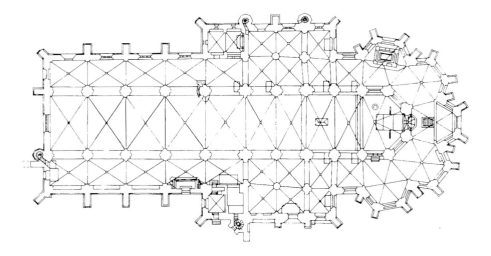

80 Doberan, Cistercian
Church

for their design follow, almost without exception, the Flanders type.[244]

St. Mary's huge west towers were started in 1304. About ten years later a basilican nave [79] (completed 1330) was begun that would connect the towers with the choir and replace the thirteenth-century Hall nave. Between the pier buttresses of the new nave are chapels – financed for the most part by rich families and completed between 1328–73 – that required a doubling of the flyers outside. Under these are steep, lean-to roofs over the chapels and side aisles rising to a Backstein clerestory wall. The plain tracery of the pointed arches framing the windows is reminiscent of Flemish Backstein churches.[245] The stepped triple-lancet tracery of the windows themselves, however, corresponds closely to that of the north section of Cologne Cathedral's sacristy (consecrated 1277, torn down 1867). The eaves of the choir chapels are joined together by strainer arches. On these rests a large, semi-circular roof that sits atop the chapels and the ambulatory.[246] The large, flat surfaces of St. Mary's massive structure make it appear rather block-like, despite its open system of flyers. However, the flyers provide magnificent contrast to the ponderous, untapered cubes, and the sparsely windowed storeys of the group of towers in the west.

The choir is two-register on the inside. It was a product of the latest developments in French cathedral construction at the time (Le Mans, Coutances). Compound piers with limestone capitals carry main arcade arches that are very narrow, a motif that is repeated by the thin window niches of the clerestory. These windows possess blind tracery in their bottom halves to supply support to the roofs of the ambulatory and side-aisles, which lean against them at that point. A tracery balustrade with projecting pinnacles, normally a feature employed on the outer

structure, restricts the passageway under the windows inside. The similarity of the roll-and-fillet and concave molding of St. Mary's arcade arches, to those of Cologne Cathedral's is interesting. St. Mary's lancet arches also emulate the plain tracery of Cologne's sacristy, so it seems that the Cologne arcade – which uses profiled groups made up of a series of similar elements – was especially suited for translation into Backstein whose repertoire tended, for reasons having to do with material prefabrication, to repeat fewer forms.

The forms of the nave piers are different than those of the choir. Fused to the corners of the square pier-core are thin shafts, which rise to become outer profiling for the arcade arches. Groups of very thin wall responds rise to the vaults overhead. The inner sides of the pier have flat, oblate, ribbon-like bands in the Flemish style[247] which begin low at the base and rise to form intrados on the underside of the arcade arches. They pierce narrow impost zones that are so flat they barely protrude from the pier surface. The solid, compact contour of these supports is in complete harmony with the sharp-edged surface of the high Backstein wall, whose core still manages to retain its integrity as secure, load-bearing mass.

The medieval builders wanted to present the illusion of a large ashlar wall here. They covered the piers and wall surfaces with white plaster and painted red joints on them. This formed a kind of surface grid that was set-off against wall paintings and ornamentation which could be found next to the vault ribs, on the surfaces of the nave clerestory, in the spandrels of the choir arcade arches, in the jambs of the windows and the main arcades. It was as if the builders wanted to make up for the lack of three-dimensional sculpturing through the application of colorful painting.[248] The belief that Gothic architecture was a product of the aesthetic of the "unadorned stone" structure – a notion inherited from nineteeth-century scholarship that is still with us today – has been shown here, and wherever recent restoration has brought the original spatial characteristics of the Gothic surface to light, to be an indefensible fiction.

Soon there were many churches being built with Lübeck-type choirs in the cities of the Wendish District, and in the inland areas of Mecklenburg. Coastal areas saw a renaissance of the basilican style, which quickly replaced most of the older Hall churches. It was not the Hall choir of Lübeck Cathedral, completed at a much later date, that provided the prototype for these choirs. It was the basilican variation of it at St.

Mary's. In fact, St. Mary's choir became nothing less than a trademark of the area's principal urban churches.

The oldest dated structure with a Lübeck choir-type is the Cistercian monastery church [80] at Doberan (rebuilt after fire 1291) which, it is now known, was earlier than Schwerin Cathedral. Both churches have a protruding transept. St. Nikolai in Stralsund also appears to belong to this oldest group of churches – those started before 1300.[249] St. Nicholas's superstructure – lacking a transept and encircled by skeletal buttress work, with a huge two-tower west front and heavily articulated choir columns – makes it quite similar to St. Mary's in Lübeck, though of wider proportions. After St. Nikolai came St. Mary's in Rostock, for which no dependable dates concerning its construction have survived. And finally Wismar's single-towered churches, the building of which lasted far into the fourteenth and fifteenth centuries: St. Mary's (choir 1339–53) and St. Nicholas (begun 1381, consecrated 1459). St. Mary's in Stralsund [189] with its magnificent west structure and choir, is another variation on the Lübeck design, like all the churches on this list.

German Gothic seldom witnessed such conformity of architectural type, as was seen in these cities with their geographical proximity and close economic ties. Only two elements determined each structure's limited claim to individuality: the spatial proportions and the shape of the support element, which is often the only part of the large-scale wall structure that achieves a differentiation in three-dimensional effect. Their stylistic conformity is a reflection of the shared cultural attitude that developed within the parameters of a politically and economically competitive region.[250]

THE FIRST STELLAR VAULTS

The area of the Teutonic Order "state" saw the development of a rich Backstein architecture as well. Its geographical center lay near the Vistula River in western Prussia where the order's Grand Master had his residence. Though the large cathedrals in Marienwerder and Frauenburg belong to the late fourteenth century – a period which saw the Teutonic Order reach the peak of its power and saw the expansion of its capital Marienburg into an imposing residency – there were in fact major Gothic buildings started in the thirteenth century, namely the Cistercian church at Pelplin and Kulmsee Cathedral.

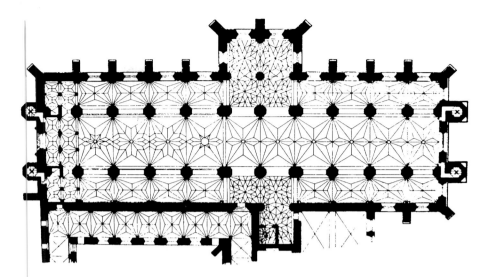

81 Pelplin, Cistercian Church

Built after 1276 and founded by monks from Doberan, the church at Pelplin is supposed to have been the first ecclesiastical building on the European mainland to possess stellar vaults completely covering the ceiling [81]. This innovation literally set the forms of Gothic ceilings all across the empire in motion. Its dispersion was probably due to the Cistercians, who by this time had founded monasteries in all corners of Christian Europe and kept up a variety of contacts with each other. Pelplin's elongated, basilican floor plan, articulated externally in large clear forms, is amazingly simple. A rectangle pierced by a transept, it is divided into a three-aisle structure by two rows of piers. The cross-section of this plan is reflected at the small ends of the rectangle – the east and west termination walls – where its three aisles are separated by staired polygonal towers. Ornamentation on its completely smooth outer walls is limited to richly decorated gables. Projecting out of approximately the middle of the long sides of the basilican rectangle is the transept, whose south arm is fused with the cloister area and whose north vault, like its parent church at Doberan [80], is supported by a centrally placed pier. The three-aisle nave and choir areas form near-symmetrical poles on each side of the transept. The rectangular choir is as long as some Cistercian choirs in England (Fountains, Jervaulx, Rievaulx).

Even more obviously influenced by English Gothic is the choir's vaulting, which we now know was built in the thirteenth century.[251] The vaults of the rectangular north-aisle bays have an unbroken longitudinal ridge-rib running through their crowns. Passing through this are transverse ribs and, stretching from one corner of the bay to the other, diagonal ribs, which together form the basic framework for a row of

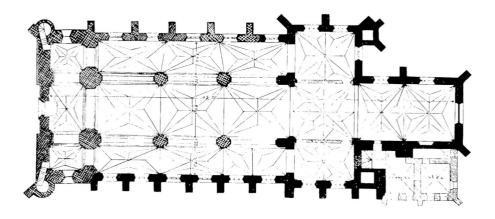

82 Kulmsee Cathedral

cross-ribbed vaults. Triradials are placed in the transverse cells of these vaults.[252] The two longer ribs of the triradial spring from the corners of the bay, while its middle and shorter rib connect to the vault boss. In the longitudinal vault cells, two pairs of liernes rise from the piers to the longitudinal ridge-rib at the vault crown. These liernes, combined with the triradials, create a four-pointed rhomboid star, with each point divided in half lengthwise by diagonal ribs. A pair of liernes remains outside the star next to each transverse arch.

These vaults bear a striking resemblance to those of the high vault of Lincoln Cathedral's nave (1233) where, however, there is no second pair of liernes. Chronologically, they fit nicely into the development of the English Decorated Style (around 1250 to about 1350), during which time the number of liernes employed in vaulting greatly increased. The Pelplin vault resembles very closely that of the aisle vaulting directly before the south-transept tower at Exeter Cathedral (begun ca.1270). In fact, the plans of the bays are nearly identical.

In the south aisle at Pelplin choir there is no unbroken longitudinal ridge-rib connecting all the bays at the vault crown. The six-point rhomboid stars of its high vault, which were begun later, do possess this longitudinal ridge-rib but there are no liernes like in the side-aisle vaults. The large stellar figures are constructed entirely of triradials which divide each vault cell into three parts, bordered by transverse, diagonal and longitudinal ridge-ribs. For English stellar vaults, this system of triradial vault-cell division is completely atypical. On the other hand, it is characteristic of subsequent vault development in the architecture of the Teutonic Order "state." In the three stellar vaults of Pelplin's choir one sees a steady movement away from the traditional habit of copying English lierne stellar

vaults: the north-aisle vaults are completely English, those of the south have already lost the longitudinal ridge-rib, while the stars of the high vault are a complete departure from the English type. German Gothic was already moving towards a specifically "Vistula type" vault here, with its clearly contoured rhomboid star inscribed into the rectangle of the bay with no auxiliary ribbing outside the stellar figure.

Assuming that the two rebuilt stellar vaults (after 1422) of the rectangular choir of Kulmsee Cathedral [82] are the same as the originals, then it is very possible that they were constructed before the vaulting at Pelplin. In any case, the first vaults at Kulmsee would have to be dated before 1291 when two lights were donated for the main altar area. Whatever their chronological relationship to Pelplin,[254] they resemble more closely the lierne stars of the Lady Chapel at Exeter Cathedral since, like these, they possess two pairs of liernes in their transverse cells, an arrangement that cannot be found anywhere in the vaults at Pelplin. If the vaults at Kulmsee Cathedral are exact copies of the originals, it appears the oldest stellar vaulting in the Vistula River area settled by the Teutonic Order is related to the English lierne vaulting in Exeter, which was the newest of that time.

Suddenly the use of simple cross-ribbed vaults, which for centuries had been the only form of vaulting used in the ceilings of large multi-register churches, came into question. That the catalyst for this seemed to have come from a colonial area far to the east of the German heartland, should not surprise us. Besides the Cistercian connections mentioned above, the lively trade relationship between the Hanseatic League and England probably played a decisive role in communicating such vault forms.

A few comments are in order here concerning patterned vaulting, which wouldn't replace the simple cross-ribbed vault in Germany until almost a century later – and in some regions never. Clasen's emphasis on the patterned vault as a "decorative form"[255] – which is taken as basis for understanding this kind of vaulting in general – stems from the questionable assumption that the cross-ribbed vault deflects thrust from above through its ribs to the responds and pier buttresses below, and therefore functions as a part of the overall load-bearing structure. This is based on an older static model of vaults which has not proved to be correct in modern calculations.[256] Scholarship today emphasizes the shell-like character of the masonry vault – that thrust is deflected in most cases throughout the entire surface of the webbing, and that individual

groins are not subjected to all that much pressure.[257] It seems unclear, then, whether or not vault ribs were perceived by those who built them as statically functional.[258] On the other hand, their aesthetic function was, and is, obvious. They give the Gothic skeletal framework its logical conclusion overhead by concentrating the upward-stretching respond shafts, arching these across the shell of the vault, then sinking them into their counterparts on the opposite wall. The visual and ornamental function, rather than the structural, was always the most important characteristic of the vault rib.[259] This did not substantially change with the introduction of the patterned vault, which inherited from the cross-ribbed vault the space-defining function of being a bridge between two walls. Yet, because its main function was to establish aesthetic cohesion, like its forerunner, it was more than just decoration. Furthermore, compared to the simple cross-ribbed vault, the patterned vault's concentrated trestle-like structure is inexhaustibly variable and offers the opportunity to alter the character of a space through the subtlest articulation.

By the end of the thirteenth century, German architecture had taken great strides towards emerging from the shadow of French Gothic. The importance of the lodges at Cologne and Strasbourg Cathedrals, and the influence they had on other regions of the German Empire – the singular inventiveness of Freiburg Minster's tower, new kinds of spatial organization created by German Halls and Mendicant churches, and the special forms produced by the material characteristics of Backstein Gothic – all show that the close and fruitful ties to French forms that had been built up over a long period were gradually loosening, but had not broken completely. The way was open for a process of "pluralization" of the fundamental elements of Gothic style. This process can be observed in other European countries as well, where French Gothic had run into various local traditions as it had in Germany, which then lead to a breaking up of the Gothic form-canon into numerous specialized features. German Gothic seemed to have already been influenced by these particular forms just when the dominance of French forms subsided – the Italian motifs of the Mendicant Gothic and English vaults in the Vistula region's Backstein churches being the most important examples of this.

The Gothic style of building was a European style by 1300. It no longer possessed even the tendency towards centrifugal dispersion that it once had. The French centers remained stylistically important, but next to these were now a number of other significant architectural centers connected by a loose network of stylistic affinities which would become stronger over time.

STYLISTIC PLURALISM IN THE FOURTEENTH CENTURY

STORMS AND ARCTIC cold ushered in the four-teenth century. In the winter of 1303 and again in 1305–6 the Baltic Sea froze solid and took so long to melt in spring that grain could not be cultivated. Icy rivers made it difficult to supply the cities, and widespread famine was the result. Then in 1315 it rained for so long that there were crop failures all across Europe. This was made even worse by the fact that agricultural produc-tion, despite increases in the amount of arable land and improved farming methods, had not kept pace with a European population that had been steadily growing during the previous two centuries. Recently settled villages and newly cultivated farmlands in central Germany were abandoned, and a period of desolation set in after many years of prosperity. And Germany was not alone; malnutrition caused by wide-spread famine, followed by periodic and lethal outbreaks of the Black Death after 1347, con-tributed to a rapid decimation of the population of central and western Europe as a whole. At the start of the fifteenth century only half as many people lived in France, England and the Holy Roman Empire as had a hundred years earlier. It was a catastrophe of continental proportions that would not burn itself out until roughly 1440. Wars of survival, along with civil wars fought by newly forming nation-states, shook the founda-tions of the old order, the most infamous of these being the Hundred Years War between the royal houses of England and of France, whose agricultural economy was devastated. War, pillage, ruined economies, and let us not forget the long-drawn-out conflict of the Great Schism, all combined to create a climate of turmoil and political instability, and to make the fourteenth century go down in history as a time of crisis.[260]

Despite all this, there was hardly a let-up in building activities. High mortality rates and the desolation of rural areas lead to a disinte-gration of much of the medieval tax base, including farmlands and their products. Among those groups capable of financing con-struction projects, the monasteries were the hardest hit. At the same time, however, the drastic drop in population caused a concentra-tion of individual wealth, and resulted in a general improvement in the standard of living for those in cities who had survived the ravages of the plague. The introduction of government taxes filled regional and city coffers, and lined the pockets of those merchants involved in raising taxes or in the business of loaning money to finance public debt. Here we see the foundations being laid down for the appearance of a new architectural clientele, individuals and communities who would compete for sponsor-ship of the larger parish churches in the Empire. Among them were the "burghers," rich bankers and merchants whose financial support for architectural activity – since classi-cal antiquity the domain of the aristocracy – was employed to increase the prestige of their name in higher circles.

This development has long been misunder-stood by historians as symbolic of a gradual per-meation of what had been for the most part ecclesiastical arts, by a system that reflected the values of the burgher class.[261] And while it's true that the kinds of people involved in the patron-age of architecture did change, the challenge to create art and the messages it conveyed altered little. Furthermore, the new faces who stepped forward to either directly finance or donate money for a building project, did so in the same manner as bishops and aristocrats before them, but with the expressed aim of raising themselves above the social class to which they belonged.

THE ARTICULATED STYLE: FORMS OF
THE HIGH GOTHIC

The fragmentation of European architectural styles in the fourteenth century has often been attributed to war, plague, famine and the advancement of the Turks to the borders of central Europe.[262] As outlined in the previous

chapter, however, the groundwork had already been laid down for the development of diverging stylistic directions in the Gothic. It wasn't the century's many crises that caused the development of so many different forms; but rather a particular style's adaptation to many different construction projects, the characteristics of the materials used, or a style's dispersion over a large geographical area during the long years of Gothic assimilation in Germany. Art historians have never been able to reduce the various forms of the fourteenth century to a common denominator anyway. And it is an especially difficult undertaking in the case of the Holy Roman Empire, placed as it was at the crossroads of Europe where numerous architectural traditions came together. Seldom has a scholarly attempt been made to impose conceptual cohesion upon this tangle of forms. As a consequence, the critical basis for the study of a German High Gothic has never been laid down in any concrete way.

Gross attempted it, assuming after 1300 an *a priori* "shared sense of form" that was based on two criteria: a new aesthetic aimed at clarity of form and a manifest design of the outer structure, along with a reduction and pacification of what he calls the "over-stretched" statics of the structurally articulated Gothic building.[263] This theory concerns itself mostly with groups of forms as they relate to the structure as a whole, but for the source and inspiration of individual motifs it is not very helpful. This deficiency is all the more grave since much of the development of style in Germany during the fourteenth century played itself out in smaller formats, once certain main types of buildings had emerged.

The tracery style of the period from 1300 to just after 1350 is often termed "doctrinaire Gothic" which refers to a certain hardening and rigid formalization, but also to a complete exhaustion of the repertoire of Gothic forms inherited from the thirteenth century.[264] On the other hand, scholars have emphasized the ascetic character of the structures built in the first half of the century. They have often linked them to mundane, as opposed to ecclesiastical, values due to their conscious relinquishment of large, representative forms.[265] Both extreme poverty of form and elaborate plastic decor were prescribed in the archetypal Gothic structures of the thirteenth century. These were the two basic stylistic options open to the new generation of German architects whose interest was focused not on the development of new structural types, but on a refinement of detailing: its harmonization and integration into the architecture of the outer structure, and its function as spatial border.

Even the French buildings of this period are far less interesting typologically. They are famous for their high formal standards, for that tightly controlled and extremely refined system of articulated detailing which is the Rayonnant style.[266] The perceived "doctrinaire" relationship to form clearly indicates a mature use of whatever style was employed, and that it was carried out with the greatest confidence and skill. This seems to indicate that the use of these structural forms was, at least to a certain extent, a routine matter for builders. In such an atmosphere, it was easy to forget the symbolic significance of older forms. The aesthetic values determining the architectural motifs of a new building would tend toward that which was accessible to its builders. An example of this might be early French rose windows, into which complicated pictorial systems were inserted that represented the cosmos through circular shapes. However, in the large roses of the Rayonnant (Reims, west rose; Paris transept roses, and those done immediately after) we see a loss of symbolic cohesion between pictorial system and the architectonic framework in which it was placed. Design and division of the rose's tracery work was no longer subjected to the greater pictorial theme of the glazing as a whole, and the rose as a tracery structure lost its original function as symbolically meaningful form. After that the focus was on the exhibition of refined and elegant shaft work.[267]

A similar phenomenon can be observed in the development of Gothic foliage work. Originally a form reflecting nature, it stood in almost dualistic contrast to tracery work, which was non-representational and purely ornamental. The plants represented on the foliage friezes and capitals at Trier [30], Marburg [33] and in the west choir of Naumburg [55] are exact copies of botanical species in both leaf-form and fruit. They were obviously meant to represent forms as they are found in nature, and by no means give the impression of a symbolic ornament *representing* a plant [83]. The link to scholasticism, which taught that the existence of God is revealed in His creation, is obvious here and the exact rendering of natural forms in structural ornamentation of churches can be understood as the attempt to emulate holy creation.[268] However, on Rayonnant structures such as the west façade of Strasbourg Cathedral and Cologne Cathedral choir [84] the foliage work begins to buckle and swell in a way that is not found in nature. Around 1290 we find foliage forms on the high alter of St. Elizabeth in Marburg [85] which are good examples of the fluted and tensile motifs of the

83 Naumburg Cathedral, capitals on the west lectern with mugwort foliage work

84 Cologne Cathedral, capital of a choir pier

85 Marburg, St. Elizabeth, foliage-leaf finial of the middle gable over the high altar

sculptural style common to the period – the leaves wind around a central post, they bend, sprout from a common base, take on lobed, wrinkled or feather-like shapes. Instead of rendering natural forms, we now see free invention for which nature was merely inspiration. By around 1300, a new level of abstraction in the use of representational ornamentation had been reached, with the natural, iconographically meaningful form hardly employed at all.[269]

Perhaps there is a simple explanation for this. The aesthetic quality of individual form was more effective in the fourteenth century Gothic structure than it had been in the half-dark of an Early Gothic building. The colors of stained glass became more brilliant during the last decades of the thirteenth century and the windows of the churches built during this period let more light in. Builders had moved away from the deeply resonating tones of the older style of Gothic glazing and now preferred lighter, brighter colors which, when combined with single-tone grisaille windows, made for a lighter and brighter interior. At about the same time, the older, more colorful wall surface was replaced by fonds of white or grey, for the most part, against which articulated elements of different colors were set off,[270] like we saw at the Dominican church in Regensburg [68] and St. Mary's in Lübeck[271] [79]. It seems this period had an especially strong influence on us, since many scholars today believe that Gothic inner spaces were well-lit and colorful.

Of major importance to the development of

the articulated style in the fourteenth century was the design and execution of Cologne Cathedral's west façade [86], even though work on the structure would come to a sudden halt after a century of work, and it would remain incomplete for over four hundred years. Building began with nothing between the west façade and the east choir (completed 1322).[272] It would turn out to be the biggest building project in the Middle Ages. Its design was based on a large, detailed sketch of the façade's vertical elevations done on parchment (the so-called "Plan F" of Cologne Cathedral's workshop archives) which more than likely was drawn up shortly after 1300 and probably combined several previous planning stages into the version as we have it. This was the version used to complete the cathedral in the nineteenth century.

In fact, the façade appears to have spent years in the planning stage. The work itself was carried out under the direction of four successive architects of whom few primary sources speak – Johannes (before 1308–31) Rutger (after 1331), Michael (at the latest 1353–after 1387) and Andreas von Everdingen (before 1396–before 1412). Archeological excavations of Cologne's west front recently unearthed a medieval coin, a sensational find because the date on the coin proves that the upper sections of the fifteen-meter-deep façade foundations were not filled until after 1357.[273] The only sections to be completed over this huge tower base were the lower two registers, which encircle a space equal in volume – at almost 40,000 cubic meters – to all of Altenberg or Our Lady in Trier. Yet, as big as it was, it represents but a fifth of today's completed west façade.[274] We know this because there are only a few elements of the central section and north towers that belong to the Middle Ages.

So there could not have been much of the portal zone standing by the middle of the fourteenth century, since the foundations were just being completed at that time. How, then, can we explain the fact that by the middle of the fourteenth century many other church lodges had already adopted forms from the Cologne west-façade type? If its style was already a major source of innovation in German Gothic by the first decades of the fourteenth century, then this influence must have been exerted through design plans alone, which were dispersed far afield. This sheds light on the growing importance of working designs to Gothic architecture in general, and on the process by which ideas were exchanged among cathedral lodges.

The *Leitmotif* of the façade is its two huge

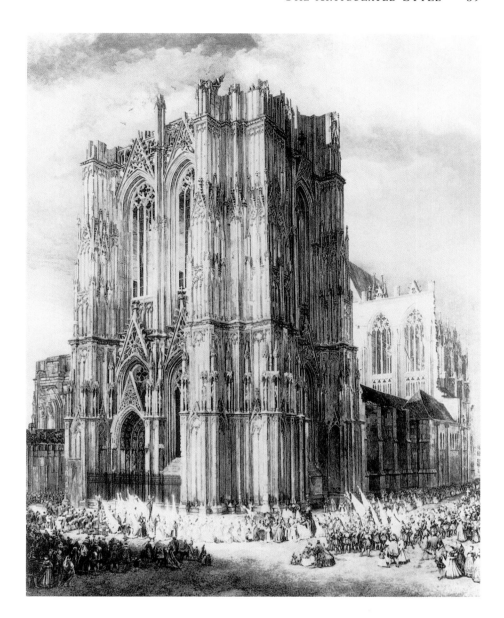

open-tracery towers with pier buttresses at the corners, framing a gabled middle register that is placed before the high vaults of the central vessel. Next to the corner pier buttresses are secondary buttresses that divide the tower surfaces into two sections. Elegant string coursing runs around the entire façade structure, dividing the massive stone into two block-like registers on which rest two free-standing tower levels that gradually transform into octagons as they rise. The corner pier buttresses rise with the towers, forming groups of pinnacles as the towers move inward. The division of surface into extremely high and slender fields, in which the motif of the window arcade with triangular gable is repeated in the same shape in parallel rows, is completely new for its time. Unlike French Gothic cathedral façades, Cologne's west front makes do with this single large form, varying it only in width. Even the large window of the façade's middle register – usually reserved for a tracery rose – terminates

86 *Cologne Cathedral, South Tower of the West Façade*, steel engraving by W. von Abbema, 1846

87 Oppenheim, St.
Catherine, south nave wall
ornamental façade

in a pointed arch, its form corresponding to that of the triangular gables over the windows to its left and right. The points of the gables are above the string coursing at the base of the next-highest register. Older designs had five portals piercing the tower's tremendous base.

Despite their dizzying height, the three portals carried out according to "Plan F" seem almost low under the mass of stone towering above them. The wall relief here is smooth and uniform, consisting of repeated groups of motifs made of lancet arches and tracery gables that are only seldom placed in front of the tower surface in a way similar to the "harps" of Strasbourg's façade [44, 46]. Most of the articulated elements of Cologne's façade cling to the surface and are intertwined into a network of forms made of small elements. Because of this, the façade as a whole appears more stable and solid than the façade in Strasbourg. In fact, partial alterations to "Plan F" during construction – like a renunciation of tabernacle figures and a setting back of the main pier buttress at the top of the second register – indicates that at Cologne there was a general effort to depart from the openwork façade style of Strasbourg in favor of a solid bonding of all façade elements.

The tracery forms – six-part foiling, six-spoke wheels accompanied by rounded triangles, three- and four-pointed stars and foiling with pointed-leaf ends – are all typical for the first third of the fourteenth century, and can partially be traced to the clerestory of Cologne's own choir. Great effort was put into varying the placement of individual forms. Seldom do we find similar motifs placed near each other, but forms complement each other due to the symmetrical way they are organized on the facade.[275] Especially interesting is its preference for respond shafting and jambs whose profiles match the archivolts above them, so that they melt into each other as they rise. Neither the framework of the portals and windows, nor the compound piers of the high-tower halls, possess capitals or impost friezes. Arches and vertical elements are unified into a smooth, single form. This motif, which could be found on the articulated elements inside Cologne's sacristy, was widely used around 1300, and is clearly indicative of a continuing emphasis on line and abstraction in the Gothic system of articulation.[276] All jointed elements are now rejected in favor of a smooth-shaft flow of stone delin-eating a uniform "arcade movement".[277] In both its design, and what was actually executed, Cologne's west façade shows itself to be one of the most advanced architectural undertakings of its time.

Its cathedral lodge played an important role as a center for building innovation even earlier than previously thought and surely long before the south tower rose above its foundations in the middle of the fourteenth century.

By the year 1275, an architect employing Marburg forms was working on a choir of a similar type to Braine [5] in the town of Oppenheim. In its transept and nave, which were built with several design changes in the 1290s, the majority of articulated elements have Cologne motifs.[278] After the church was promoted to collegiate church in 1317, nave chapels were built, along with a major expansion of the nave's southern outer wall. This wall was originally meant to receive a five-bay tracery façade, the design for which was probably ordered from Cologne Cathedral's lodge, at that time under the direction of Meister Johannes. The tracery forms of its windows were to change with each bay, in a manner similar to the system of gables with alternating forms at Cologne Cathedral's choir clerestory and west façade. But in 1322 the builders changed their minds and decided to retain the west towers, which were to have been demolished. They then shortened the nave design to four bays. The design from Cologne's lodge was dropped and preference given to Freiburg, Strasbourg and central-Rhine tracery forms. The majority of the central vessel and south side-aisles were subsequently completed in 1328, followed by the more modest north aisles in 1340.

Oppenheim's south façade is magnificent [87]. Its clerestory consists of a row of gabled windows set between richly articulated pier buttresses, two rows deep. Each register below the clerestory is set farther out than the one above it and the lowest of these is a wall base covered with tracery work. Each of its side-aisle bays possesses a large window in a different form. The surfaces over the window arches are clothed in panel-like blind lancets. This panelled shaft work – which, like the blind-tracery work on the fronts of the pier buttresses, is framed in rectangles and possesses tripartite foiling in the tips of the lancets – can be found in the same combination on the pier buttresses at the top of the second register of Cologne's south tower. Other Cologne forms include the large rose of its westernmost window whose "pedals" are made up of three-point stars and lancets with inward pointing crowns (gable of St. Peter's Portal at Cologne), the quadripartite foiling of the roses in the couronnement of the clerestory windows (window gables, lower-tower register at Cologne) and the three-point stars of the middle

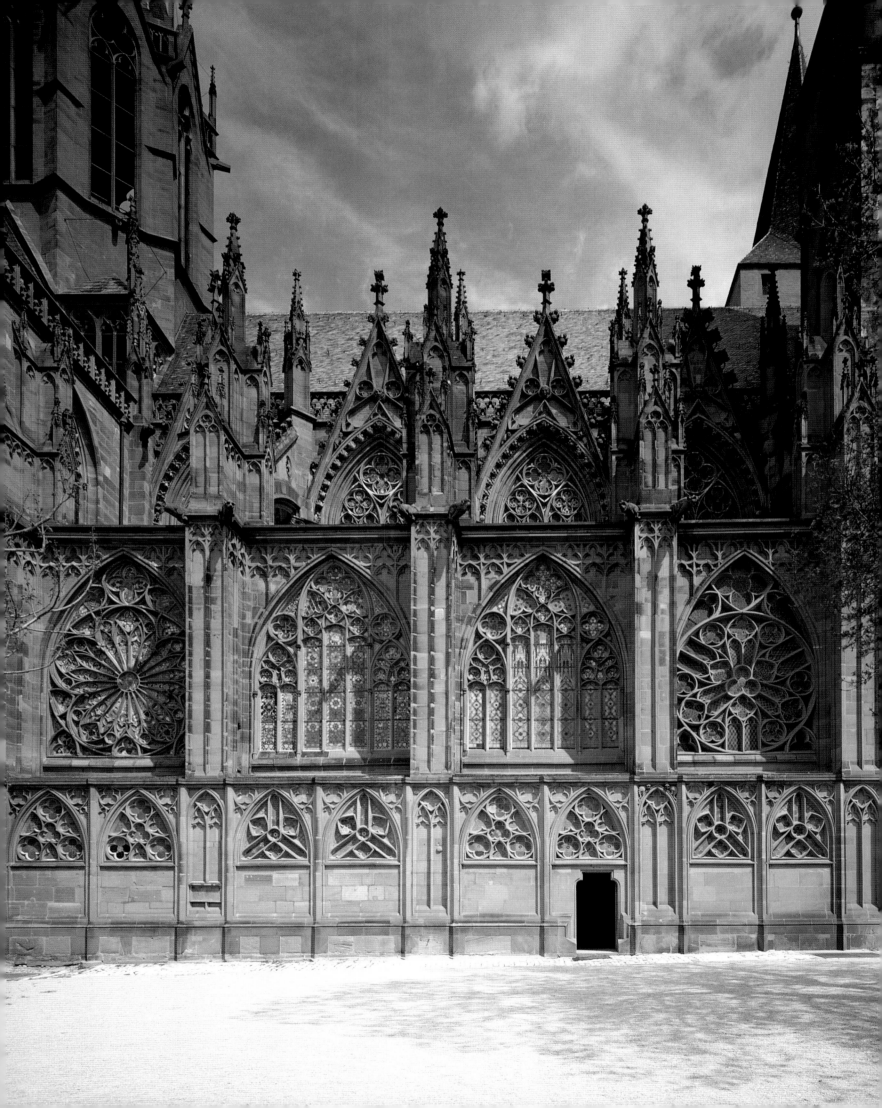

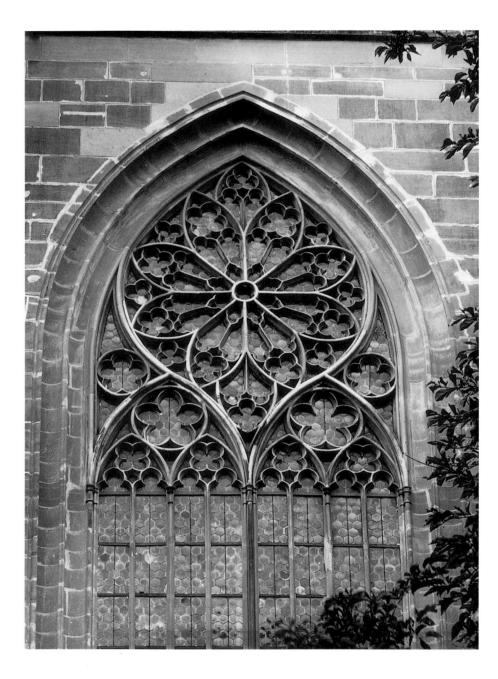

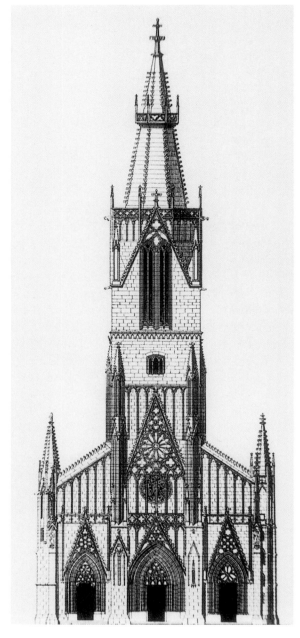

88 Salem, Cistercian
Church, window of north
transept

89 Reutlingen, St.
Mary's, west façade

two clerestory-window gables (Cologne choir
clerestory). The façade's centerpiece is the large
rose of the eastern window, which consists of
pedals that radiate out from the center, and
which can be traced to one of the façade roses at
Strasbourg (lower register, north side).

The motifs of the two middle windows
are characteristic of the window tracery of
Freiburg Minster's tower – round and seg-
mented arches terminating the lancets and a
three-point star sitting on one point. And finally,
the pointed ogee arches of the eastern clerestory
window can be found in the central Rhine
region, specifically after 1280 in the windows of
the north chapel at Mainz Cathedral, and around
1289 in the south corner window of St. Nikolaus
Chapel, part of Worms Cathedral.

The magnificent façade of Oppenheim's nave

wall combined the newest tracery forms in
western Germany at the time. The total effect is
one of vivacious movement created by a display
of alternating, avant-garde motifs. It is a clear
example of just how differentiated and varied
Gothic forms had become.

Cologne and Strasbourg continued to have the
leading construction lodges in the western parts
of the German Empire, with Strasbourg's façade
style playing a decisive role in tracery form-
development in the southern Rhine basin and
the areas bordering it. A good example is
southern Swabia at the Cistercian church[279] in
Salem (1297–1311) which was outfitted with
transept terminal walls distinguished by a rich
array of tracery work. The tall window of its
north transept [88] is embellished by a large,
eight-petal rose. The variety of this window's

articulated elements is no less impressive than Strasbourg's. Salem's free-standing tracery framework owes a lot to Strasbourg as well, placed as it is before the north gable and made up of stepped, double lancets. Transoms – horizontal connecting elements that would become very popular and varied in the next few years – have been hung inside lancets here.[280] They are formed by opposing trefoil arches that lean against each other.

Another offshoot of "Strasbourg Gothic" in Swabia is the west façade of St. Mary's in Reutlingen [89] (more than likely designed after 1300, completed 1343). Like at Freiburg, the west end of Reutlingen nave[281] terminates in a high tower. Unlike Freiburg, however, the builders incorporated the tower into the nave itself. This allowed a tangible display of forms across its entire west front, forms that seem to move inward from the sides and reflect the direction taken by half-gables shooting upward and inward to the base of the tower. Reutlingen's builders succeeded in creating an elegant synthesis of Strasbourg's three-portal system [46] with the single-tower front at Freiburg [47]. The individual forms of the gabled portals, of the tracery in the gables, and of the large window in the center of the tower, can all be traced to Strasbourg.[282]

Many outer structures during this period, then, were articulated in a style that evolved out of the German Empire's two largest lodges in the west, which would provide continuity in the architectural concepts governing cathedral construction beyond even the most radical changes in style.

NEW TYPES OF HALL STRUCTURES

Another development of the thirteenth century that continued to be important into the fourteenth century was Hall Gothic. It was important for the process by which it evolved into a "single room" structure, which scholars for years have understood as being the most important development in German architecture in the fourteenth century. Gerstenberg's well-known study of the "German special Gothic" describes the "single room" Hall as having supposedly developed out of a reduction in the longitudinal depth of the Gothic central vessel and its expansion side-ways to include the aisles. This created a wide, squarish nave in which the normally dominant longitudinal movement towards the choir was reduced by movement to the sides, so that what resulted was a sense of open space, of

freedom of movement in all directions.[283] Gerstenberg was one of the first scholars to link this "single room" concept with the Mendicant order's specific needs – their desire to provide the laity with a wide and, as far as possible, undivided space in which the lectern was visible from just about everywhere in the nave, and the priest's sermon could be heard by everyone present. Because this spatial organization was also adopted by the rich burghers for their city churches, Gerstenberg concludes that the "German special Gothic" Hall was an expression of mundane, non-ecclesiastical values in architecture.[284]

So many scholars have since agreed with Gerstenberg's thesis that it is now widely accepted. Hamann believed the Hall character of a structure was more pronounced the more it resembled a squarish, non-ecclesiastic civic hall. "In place of the demands of the [monastic] cult," he writes, "was now a space within which a freedom of movement reigned that was no longer controlled by the litany, but was as profane and open as the town market."[285] Scholars in the German Democratic Republic took this a step further, seeing in such Hall churches the embodiment of the democratic spirit of community while the basilica, with its spatial hierarchy of a tall central vessel and shorter side-aisles, was the epitome of a "feudalistic" building type.[286]

Such reflections, regardless of how tidy and balanced they may seem, are not by any means confirmed by fact, for we find both the basilica and the Hall as bishop, monastery and parish churches. There is little proof of builders choosing a particular type of church for ideological reasons, and a classification of churches based on this assumption is really not worth doing.[287] Not only that, squarish Hall structures with no movement whatsoever indicated by elaborately articulated travées had been around from the very beginning of the Gothic period in Germany – the nave of Minden Cathedral [59], for instance, and the choir of Heiligenkreuz [67]. From the earliest to the latest period of the Gothic there were Halls that articulated a specific direction, and those that possessed depth via the division of space by elements like thick arcade profiling or narrowly spaced piers – for example Marburg [35] Verden [63] and Neubrandenburg [76].[288] Between these two poles, there were numerous mixed types.

Examples of longitudinally organized Halls would be the early fourteenth-century naves of Saxony and Thuringia which possessed wide central vessels following the Marburg

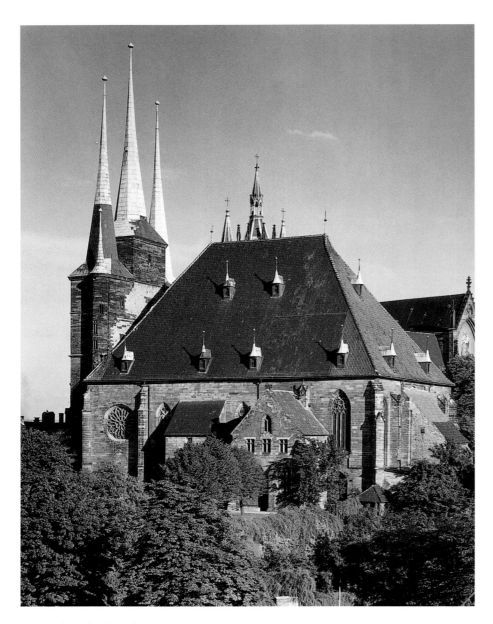

90 Erfurt, St. Severi, south-east exterior

91 Soest, Maria-zur-Wiese

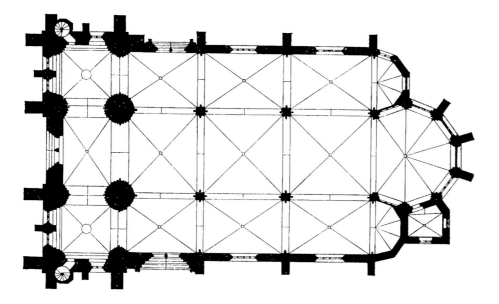

type. These include the Cistercian church at Mariastern (around 1270–90), Halle Cathedral nave (about 1280–1330), Meissen Cathedral nave (under construction 1298), and the nave of St. Mary's in Mühlhausen (after 1300).[289] The Benedictine monastery church at Nienburg near Saale (nave 1280) seems at first glance to be of the Marburg type – with round piers covered by respond shafts and thick arcade arching. Nonetheless, it achieves a different spatial organization through a wide pier placement and extremely deep side-aisles. Even more of a departure from this Marburg system so successful in central Germany is St. Severi in Erfurt (nave around 1275–1330/40), a five-aisle Hall whose inner piers have square cores in cross-section with round respond shafts at the corners. Providing contrast to these are the columns separating the side-aisles, which are much thinner and carry elegantly profil arcades that matched the cross ribs, making for a seamless arching movement throughout the bays. The outer structure of St. Severi [90] – a simple cube with a huge roof – looks like a Late Gothic Hall church way ahead of its time.

Westphalian architecture, which had been producing Hall churches in its own stamp throughout the thirteenth century, gradually began to be influenced by the regions bordering it. It's hard to overlook Minden Cathedral's [59] dependence on detailing from Cologne Cathedral, for instance. A few years later the Minorite church in Soest would follow Minden's example, combining nearly square central-vessel bays and oblong aisle-bays with very thin arcade arches that resemble the profiling of the transverse arches. On the other hand, Soest's individual elements – like the tracery of its windows – reveal a close connection to Cologne Cathedral's choir.[290] The Franciscans built a Hall church in Münster at the same time (today's Holy Apostles, Hall design 1261, completed 1284) which had a double-aisle nave for many years, until the building of the north side-aisles (before 1508). It was the first church in Westphalia to possess rectangular cross-ribbed vaults over the central vessel flanked by square side-aisle bays. The form of its short, stocky pier, its combination of rib-sized transverse arches with very thick arcade arches, can probably be attributed to the Minorite church in Cologne.[291]

These two mendicant churches, then, heralded a Westphalian type of Gothic Hall, a type that lost its special regional characteristics the more it was swallowed up by the widening sphere of the Hall style. For this reason, Münster's collegiate and parish church of Our

Lady (today's Überwasserkirche) deviated very little from the Halls of the Marburg type to be found in Saxony. In both churches, narrow side-aisles border a wide central vessel, with the division between them maintained by round piers with respond shafts and powerful arcade arching.

Of the large number of surviving Halls, the parish church Maria-zur-Wiese in Soest stands out because it combined older forms with a new sense of spatial arrangement to achieve a magnificent whole [91]. The short-nave type, consisting of three rows of three bays each, is classic Westphalian; the combination of a square central vault with oblong side-aisles is known from Minden Cathedral. Missing, however, is the typical thirteenth-century Hall transept like those of Herford, Paderborn and Minden, a reduction that we have seen already in the Minorite churches of Soest and Münster.

Maria-zur-Wiese's Hall choir – whose plan includes chapels in echelon and a large, seven-sided apse at the apex – can be traced to Soest's St. Petri (1272–1322).[292] But the structure over this floor plan is very different from all other churches of its kind. Extremely tall piers, whose profiles are a fusion of sharp-edged respond shafts, carry vaults that are much flatter than most other early Westphalian ceilings. These compound piers have square cores which are turned diagonally in order to de-emphasize their role as elements dividing central vessel from side-aisle. Like those in Cologne Cathedral's tower halls,[293] Maria-zur-Wiese's responds lack imposts and are transformed smoothly into ribs above. The profiles of these and of the transverse arches reach all the way down to the pier base below. This gives the Hall its spatial structure, its characteristic breadth and clarity of form, which invites the eye to look diagonally into the side-aisles.

The ideal type of a "unified" Hall structure imagined by Gerstenberg seems to actually take shape here [92]. Quatrefoil-tracery transoms run through the lower third of the windows and ring the inner structure like a porous ribbon. Except for that, no other horizontal elements break the vertical impetus of the windowed walls. Maria-zur-Wiese's green marl sandstone, with its lively play of different shades, was originally covered by a layer of grey-green chalk, on both pier and wall alike. This smoothed out the wall surfaces and was probably intended to optically fuse with the tall windows to create as much as possible the impression of a spatially unified foil.

An inscription in the choir names a

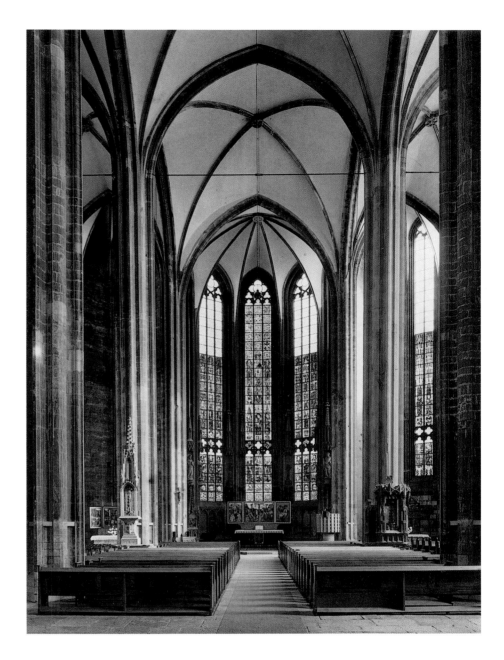

certain Johannes Schendeler as architect, with 1313 as the date construction began.[294] We know the choir was completed in 1355, the southern side-chancel and the Hall's eastern bay in 1376, but the outer wall of the nave was not finished until the early fifteenth century. This was before lodge master Johannes Verlach began building the western section of the church in 1421, with its two huge piers bearing the west towers and galleries. It was planned as a smaller version of Cologne's two-towered west front and, like Cologne, not finished until the nineteenth century.[295] The free-standing piers and the vaulting of the Hall bays to the west were built in the second half of the fifteenth century, but follow closely the forms of the fourteenth century bays to the east, except that the vault compartments are more warped.

The most important Hall structure in Austria,

92 Soest, Maria-zur-Wiese, nave looking east

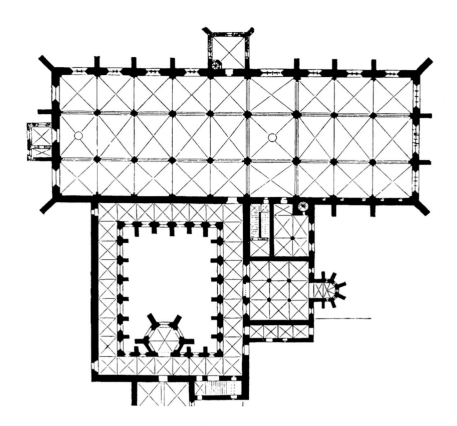

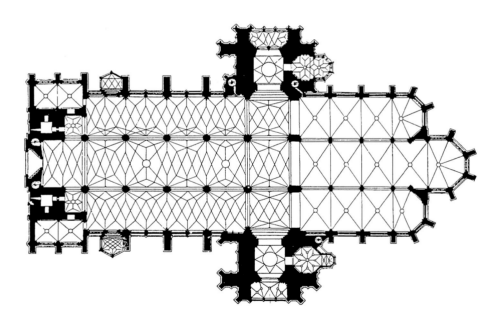

93 Neuberg-an-der-
Mürz, former Cistercian
monastery

94 Vienna, St. Stephan

after Imbach [69], was the choir of the Cistercian church at Heiligenkreuz monastery [67]. The church of the Cistercian monastery at Neuberg-an-der-Mürz, in the Austrian province of Steiermark (begun after 1327), was founded by monks from Heiligenkreuz who employed the forms of their parent monastery there: a three-aisle choir with flat termination, whose forms are repeated in the five-aisle nave [93]. The only elements indicating a liturgical separation between choir and nave are the somewhat wider bays of the non-protruding transept, which are separated from the neighboring bays by the transverse arch only. The outer structure is a long rectangle surrounded by pier buttresses.[296] Other examples of three-aisle Hall churches built on rectangular floor plans are the former Salzburg hospice church (first half of the fourteenth century, today's parish church of St. Blasius), the parish church in Laufen, Bavaria (1330–8), the "Herrenkapelle" at Passau Cathedral (first record 1323) and the hospice church Holy Spirit in Ingolstadt (around 1330–50). These churches would have been unthinkable without Austrian Cistercian prototypes.[297]

Viennese architecture, visible symbol of the growing power of the House of Habsburg in the fourteenth century, applied the Hall concept in a more independent way than the Halls described above. The second rebuilding of St. Stephan in Vienna (consecrated 1263 by Ottokar II of Bohemia) produced the structure as we know it today. It served as ducal church for the Habsburg dynasty, for whom the gallery of the double-towered Romanesque western section was reserved. St. Stephan's choir (planned 1304, completed 1340) which Albrecht I induced the citizens of Vienna to build, was intended to add weight to the Habsburg demand to have their capital declared an episcopate. Such a declaration would enhance the value of their own possessions and make the Habsburg name more important politically. As a consequence, they continued to expand St. Stephans, of which the 1340 choir was just the beginning, even though Vienna would not become an episcopate until 1469 [94].

The new choir project connected to, and was just as wide as, St. Stephan's Romanesque transept. This created a Hall choir of three aisles terminated by three chancels in echelon, each of which is five-sided. The central apse projects out from the two chapels an either side by the depth of one bay. The outer structure is articulated with simple, stepped pier buttresses crowned by gables with leaf-like crocketing. A gallery, punched through by small pinnacles, runs

around the base of the roof just above eaves that are held up by monstrous gargoyles. The wall surfaces between the pier buttresses have triple-lancet windows.

On the inside, compound piers that carry cross-ribbed vaults rise out of square bases turned diagonally. Canopied figures decorate the piers and wall responds. The organization of the choir's five-sided polygons is the same as that of Regensburg Cathedral. On the other hand, its detailing – like the cubed pedestal of the compound piers, and arcades with benches running along the walls – can be attributed to Austrian mendicant Gothic.[298]

The striking thing about almost all of these buildings is the rectilinear nature of their floor plans. Either the transepts do not project out of the box-like nave, or there are no transepts at all. The same can be observed in the Backstein Halls of northern Germany during this period. St. Mary's in Prenzlau, Brandenburg (under construction 1325, badly damaged in the Second World War)[299] has a Hall nave lacking transepts [95] with pronounced arcade arches between the aisles, and a passageway at the base of the windows that lines the inside structure with pockets in the wall. This is similar to St. Mary's in the town of Neubrandenburg [76], but here the motif has been expanded to include three chancels at the end of the nave and the aisles. Each of these aisle chapels is terminated by a pier buttress outside – not a new motif, but one not seen very often.[300] The effort by the builders to integrate the outside wall into a single large form can be seen in their treatment of the choir walls, where strainer arches form a bridge between the pier buttress and the window walls of the chancels in order to carry the flat eastern-façade wall. It was designed to be a magnificent multi-register tracery gable which was built after a change of plan in the second half of the fourteenth century. The load-bearing structure beneath this eastern gable is reminiscent of the system of strainer arches that bridge the choir chapels and round off the eaves of St. Mary's in Lübeck.

The Lübeck choir form and the Neubrandenburg and Prenzlau nave type, were combined to create very original designs. A good example might be the Hall church of St. Mary's in Pasewalk, Pommern (begun prior to mid-fourteenth century).[301] Here the easternmost bays of the side-aisles, whose walls are outfitted with passageways and niches in the base, are each fused with two chapel-like spatial cells of different polygonal shapes, which in turn flank the five-sided termination of the central vessel.

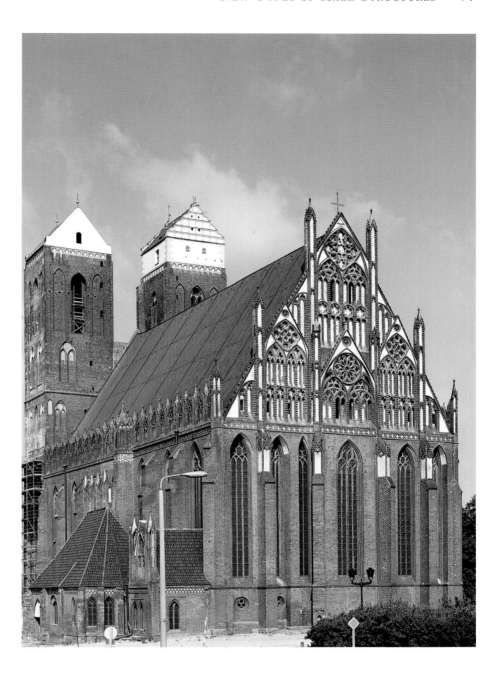

This is a rudimentary variation of Lübeck's "chapeled" basilican choir, translated into a Hall form which does away with the complicated ambulatory motif in favor of a simpler spatial organization.

Gross' concept by which Gothic buildings achieved "a clarity of form and a tangible design of the whole structure" and which he ranked as the most important development in German architecture after 1300, can indeed been seen in the development of such designs.[302] Northern Germany seemed to have been particularly involved in this, since the forms the process called forth were suited to the material characteristics of Backstein. In fact, this development can be observed not only in the overall structural design, but in detailing as well. Starting in the late thirteenth century single-

95 Prenzlau, St. Mary's, east wall

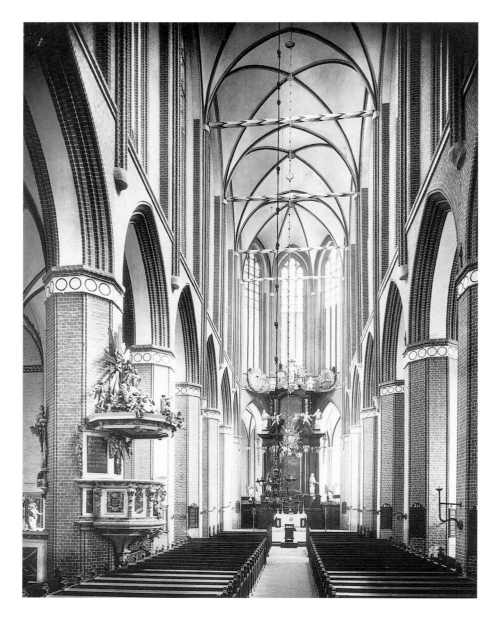

96 Wismar, St. Mary's,
nave looking east

Germany after 1300, then we should be able to find evidence that articulated elements were being "profiled down" in ashlar structures as well, but this is difficult to find. In building the thin, free-standing columns of the Wiesenkirche in Soest [92] or the squat, massive piers of St. Mary's in Wismar [96] there seemed to be a concerted effort to break out of what had been a harmonious interplay of Gothic pier elements by emphasizing some aspects or leaving others out altogether. But the Backstein pier is stylistically much closer to the older, prismoidal pier of the mendicant orders, than it is to the complicated pier cross-section of the Westphalian Hall tradition.

BACKSTEIN CHURCHES IN THE
TEUTONIC ORDER "STATE" AND IN SILESIA

The fourteenth century saw a flowering of the Backstein tradition in the Teutonic Order "state," in what is now northeastern Germany and western Poland. After Prussia was conquered by the order between 1280 and 1290, and then Gdansk-Pommerania in 1308, settlement accelerated to the point that by mid-century all the area's cities were founded and the largest castles of the Teutonic Order built.[303] By the end of the fourteenth century there were eighty-five towns in Prussia, Gdansk-Pommerania and Kulmerland including six members of the Hanseatic League, and the majority of their population was made up of German settlers from the west.

The large city churches and cathedrals of this area do not wilt in comparison to the aristocratic military structures and palaces of the Teutonic Order. In fact, for several decades the vaulting of these churches could claim to be the most modern on the European continent.[304] The floor plans of their naves are similar to those of the northern-German Hall tradition (Neubrandenburg, Prenzlau). They are arranged longitudinally, have arcades as thick as the piers below them, and shallow side-aisles. Most of them terminate in choirs with only a single chancel, and there are some pseudo-basilican solutions to Halls as well.

The high vaults of Kulmsee Cathedral (completed shortly after 1350), and those over the tall and narrow chancel and low Hall nave of Frauenburg Cathedral (around 1350) adopted the stellar figures of the Cistercian church at Pelplin [81] and the figures of Kulmsee Cathedral's choir. The triradial is the basic form of these rhomboid stars, and there are diagonal

piece profiled elements, that were occasionally carved out of expensive ashlar, were gradually replaced by pieces with more block-like profiles and sharp, not rounded, edges. At the very least they were carved with profiles that were flatter in cross-section than was usual for an earlier date. For example, during construction from west to east at St. Nikolai in Stralsund, and during the building of St. Mary's in Greifswald, there was a gradual "profiling down" of articulated elements in which specifically the oblated and slightly rounded pier forms used earlier were replaced. This was a process similar to that which we saw earlier at St. Mary's in Lübeck. The number of respond shafts was reduced too. The huge octagonal piers of St. Mary's in Wismar possess flat, completely unarticulated impost zones, along with responds that have been reduced to extremely thin shafts, one to a corner.

If there was, as Gross said, a "shared sense of form" permeating all stylistic tendencies in

ribs traversing the entire vault, like in Pelplin's central choir-bay. However, the English lierne has been dropped completely, with only a few of the area's structures possessing the vault-linking longitudinal ridge-rib. One of them is Frauenburg Cathedral's nave with its six and eight-pointed stars. In fact, Frauenburg's rich vault forms became the prototype for the larger churches of the diocese of Ermland, the building of which offered the opportunity for even more elaborate vaulting [97]. The vaulting of Braunsberg parish church (1346–81), one of Ermland's oldest churches, is very complex, its design possessing more fine detailing than Frauenberg's stellar figures [98]. Each bay at Braunsberg is covered by four rhomboid stars whose points touch at the tips.

In the narrow side-aisles of Marienwerder Cathedral (a pseudo-basilica, around 1350) [99], stellar figures have been cut in half leaving triradials in combination with a zigzag figure. This required the adding of an additional support element in the middle of the side-aisle wall. As a consequence, the pier buttresses have been doubled and each side-aisle bay has two windows. The central vessel at Marienwerder is taller and wider, with huge octagonal piers and bays covered by a single eight-pointed rhomboid star. It seems peaceful and calm compared to the tense and turbulent spaces to its sides. A singular dissonance between side and central spaces is the result, brought about solely by the vaulting. Marienwerder Cathedral seems to present us with the clearest example, among all these Teutonic Order "state" churches, of how builders were exploring new and exciting ways of articulating space via the ribbed-figure vault.

Silesia was also an area settled by Germans in the fourteenth century, with the majority of its aristocrats, the *Piasts*, allied with the King of Bohemia during the years 1327–9. In 1335 the Bohemian royal house persuaded the King of Poland, Kasimir the Great, to drop his claim on Silesia, which quickly opened up east-central Europe to international trade via the Hanseatic League. This had, of course, a positive effect on Silesia's economy. Trade routes from Lithuania, the Teutonic Order "state," Bohemia and Hungary crossed right through the area. The majority of people living in Silesia's cities were German settlers, as was the case in Prussia. In its largest city, Breslau, the reins of political and economic power were in the hands of rich German merchants. Six large churches were built inside its walls in the fourteenth century,[305] more than in any of the architectural centers of the west during the same period.

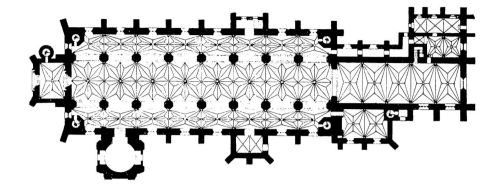

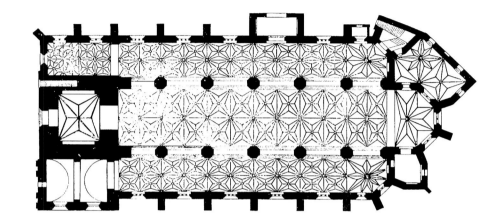

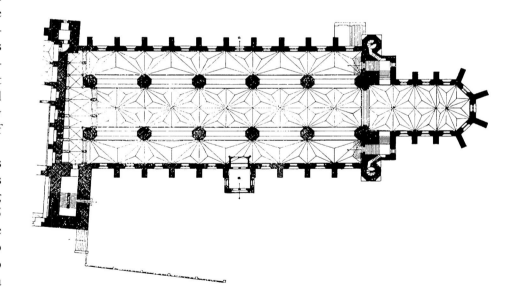

Backstein was also the most popular building material here. Often, however, it was combined with articulated elements made of ashlar. Silesia's longish, rectangular floor-plans are reminiscent of the architecture of the Teutonic Order "state." They lacked a transept and achieved separation of the narrow side-aisles through the use of thick arcade arches cut out of the wall surface. The dating of most of the area's churches is too vague, however, to allow for an architectural correlation to be drawn between

97 Frauenburg Cathedral

98 Braunsberg, Parish Church Frauenkirche

99 Marienwerder Cathedral

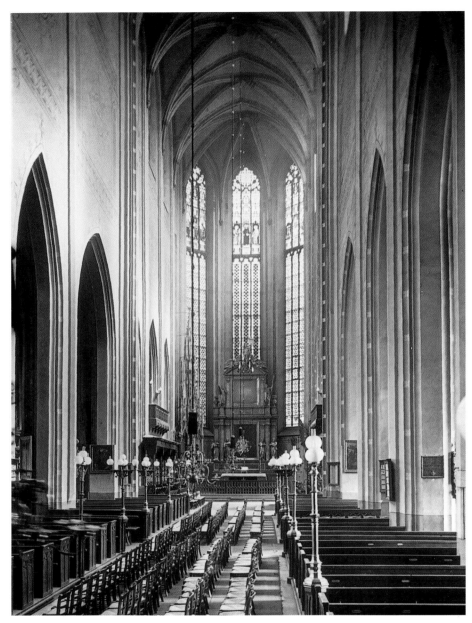

100 Breslau, St. Elizabeth, looking east

101 Breslau, Holy Cross Collegiate

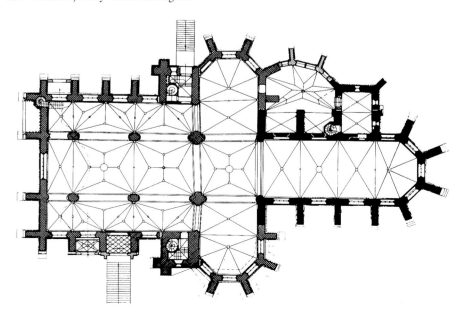

the two regions.[306] Stylistically, the churches of Silesia were not linked to the Baltic region exclusively. A preference for triple-chancel choir terminations seems to be traceable to Bohemian and Bavarian prototypes to the south and close political ties between these states seem to confirm this. The presence of conched transepts in Breslau, at Holy Cross Collegiate (1288, completed before 1371) and St. Matthias (expanded to a trichora east termination after 1450) indicates that the building type of St. Elizabeth in Marburg was known and employed in the easternmost areas of the Holy Roman Empire. This was probably due to the personal initiative of the founder of Holy Cross Collegiate, Duke Heinrich IV of Breslau, who was a relative of St. Elizabeth of Thuringia.[307]

A typical medieval parish church in Breslau would be St. Elizabeth (eastern section consecrated 1357). A long basilica lacking a transept, it has tall and narrow side-aisles and a triple-apse choir system [100]. It possesses a certain southern-German Mendicant flavor brought about by the contrast between its high-windowed choir walls, the almost barren wall surface of the central vessel, and by its renunciation of capitals in favor of a smooth transformation of pier shafting into wall arcading.

Breslau's monastic churches are also important for being some of the earliest to have been built with figured vaulting. The oldest of these can be found in the Hall churches of Holy Cross Collegiate [101] and the Augustinian canon church St. Maria-auf-dem-Sande (1334–69, aisle vaulting 1386–95). The four-pointed rhomboid stars over the crossing and the high vault of Holy Cross differ in one major respect from those of the Teutonic Order "state." They lack the obligatory diagonal rib dividing the point in half longitudinally. This is surely a vault characteristic that is specific to Silesia, since the triradial vaults of Breslau Cathedral's pseudo-transept (before 1351) and the westernmost bay of its so-called "small choir" (designed 1354, completed 1369) also possess irregular rhomboids lacking diagonal ribs. The basic form of the groups of triradials at Breslau Cathedral results in a zigzag vault figure like those found in the side-aisles of Holy Cross. Here they do actually possess diagonals of the kind found in the aisle vaults at Marienwerder. There is only sparse data concerning the building of these churches in Breslau, but it is possible that their zigzag vaults were built before those of the Vistula River basin. At the very least we can assume that Breslau Cathedral was the prototype here. The triradial vault motif – the basis of a

kind of vault construction that had supplanted the older English vault in the Teutonic Order "state" – appears to have been rapidly assimilated and transformed in Silesia. Now and then we also find the Vistula River vault employed without changes.[308]

The figured vault is the most important form of expression in spaces with very little articulation, like those at Breslau Cathedral and the churches of Holy Cross and St. Maria-auf-dem-Sande. It appears that the traditional Gothic way of defining space, through an interplay between support elements and walls articulated by shafts and tracery, had shifted to the vaults in these churches, where it concentrated a collection of lively forms. These bear little relation to the load-bearing structure of the ceiling itself but nonetheless influence the character of the entire space – from above rather than from the bordering walls. In cross-section, the piers of these churches are elongated octagons placed longitudinally, their flat surfaces giving the impression of having been cut out of the wall and their wide arcade openings the product of some gigantic breach above.

THE MOVE TOWARDS ASCETICISM IN MENDICANT ARCHITECTURE

There had always been close ties between German Backstein Gothic and the style of the Mendicant orders, and during the fourteenth century the two styles mixed more and more. As it became more popular in the areas where Backstein was used to build elongated structures that lacked a transept and had a simple choir – structures on which detailing typical for the previous century continued to be developed into more modest stereometric designs – a type of Backstein structure came into general use that was amazingly similar to the Mendicant church. The northern and eastern German Mendicant structures of the same period – typical examples being the Franciscan churches in Lübeck, Angermünde and Stralsund – can be characterized by a categorical renunciation of massive towers, use of a rood screen between central vessel, aisles and choir, and by the at times gigantic *Langchor*, the high and narrow chancel that can be found accross the entire German Empire.[309]

One of the largest Mendicant churches of medieval Germany, and one that took the longest to complete, is the so-called Barfüsser Franciscan church in Erfurt. Its choir was begun after a fire devastated the town in 1291, and completed in 1361 using an older design that dictated a five-sided termination with four choir bays. Work then began on the basilican nave, a twelve-bay affair that incorporated the west section of the previous church (begun 1231)[310] and the building of which lasted into the early fifteenth century. The choir and central vessel are united by a single saddleback roof. Just as antiquated in appearance as the choir termination, are the crucible piers with responds on their corners and sides. The whole structure seems particularly unaware of the usual Gothic travée organization, indicated by the fact that each bay is divided in half by a transverse arch with one cross-ribbed vault on each side.[311]

The Mendicant orders came into money and property during the fourteenth century. The rich and powerful donated to the "barefoot monks" because they believed they were uncorrupted by money. Surely their prayers would have the most effect on their behalf in Heaven. Mendicant monks became trusted advisors and chaplains at court, whereby they were able to acquire some of the most valuable properties of the Middle Ages, becoming very wealthy in the process. This paradoxical turn of events had no visible effect on their construction aesthetics, though, which continued to demonstrate an emphasis on the renunciation of elaborate forms and a vow to poverty.

The Dominican churches of Alsace travelled further than most down the road of radical form reduction paved by the Medicants in general. The flat-ceiling naves of the Dominican churches in Gebweiler and Colmar achieved spaces exhibiting a minimum of form, set between bare walls with windows smooth in profile. Their only articulation were large, austerely presented pier arcades.

The cornerstone of Gebweiler's choir was laid in 1312. A few years earlier, probably in the year 1306, construction had begun on a tall, narrow basilican nave.[312] Short, round piers fuse with the arches above them to form wide arcading, over which the completely bare surface of the clerestory rises. Pointed-arch windows are placed at the top. A single, slender window in the west wall lets light into the central vessel, while the northern aisle wall has no windows whatsoever. A rood screen, drawn from one outer wall to the other and made up of five vaulted chapels, separates the nave from the more richly articulated choir area. The arcade piers are the only forms not part of the wall surface. Even the pier base is nothing more than a square block providing support. The side-aisle walls are sparsely articulated too; because of the flat roof, they

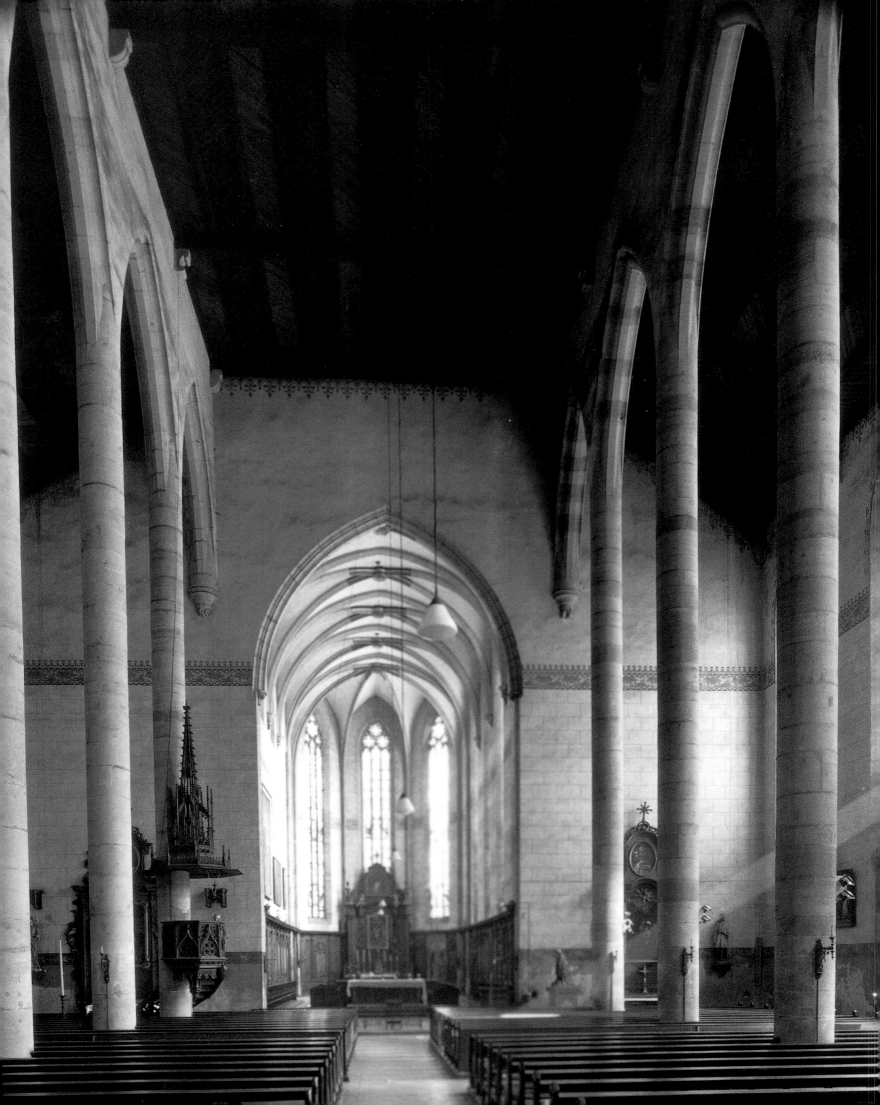

possess neither wall responds nor pier buttresses. This is more than just an abbreviated version of the Gothic space, since only a few elements of the Gothic's individual characteristics remain. The overall austerity was softened somewhat by surface painting from the late fourteenth century, which can be still seen in many parts of the church today. The twelve Apostles painted on the consoles between the arcade arches were obviously meant to take the place of the sculpture cycle in the tradition of Ste-Chapelle and Cologne Cathedral and creeping vines with flowers were painted onto the extrados of the arcade arches and on the window jambs, giving those sections a rich, plastic character reminiscent of ashlar construction.[313]

Perhaps the most drastic abstraction of the Gothic church form is embodied by the nave of the Dominican church in Colmar (choir 1283–91; nave second quarter of the fourteenth century) [102]. The only interior form of this large, three-aisle space is the arcading separating the two side-aisles from the central vessel. The walls above the arcade arches are incredibly fragile structures that resemble thin boards. The pointed arches punched into them are perched upon shaft-like piers of stone.[314] The arcading and its piers seem almost temporary, as if they were stage scenery. Yet they were strong enough to carry, on consoles, the wooden ceiling, which falls at a sharp angle over the side-aisles like a lean-to roof. The south walls have some windows, the north walls almost none. The so-called "Triumph Arch", the arch in the chancel that opens to the choir, seems to have been sawed out of wood. The entire nave with its side-aisles is nothing more that a box-like space with a minimal amount of interior division, almost as if it were abandoned in the middle of construction. It is hard to imagine a more audacious antithesis to the cornucopia of forms being employed at Strasbourg Cathedral's façade, which was going up at the same time as Colmar, and not all that far away either.[315]

In no other phase of the German Gothic, which had always possessed a wide spectrum of stylistic possibilities anyway, were contrasts as pronounced as here. Were I to try and pinpoint basic characteristics of the German Gothic style during this phase of its development, characteristics that despite obvious differences would eventually fuse into a single style, then the criteria for comparing individual forms would have to be very general indeed. Perhaps it makes more sense to understand the period's stylistic directions as valid precisely because they were so different, and that these sometimes polar differ-

ences represent an important chapter in the stylistic development of German Gothic in the first decades of the fourteenth century.[316] Seen in this light, the oft derided "stylistic fragmentation" of the period was nothing more than a reflection of the limited influence exerted by newly developed forms. These remained isolated from each other, which invariably lead to stylistic dead ends rather than to a process by which contrasting styles might converge.

It is tempting as a historian to see the divergent architecture of this period as reflecting the time in which it was popular; that it tended to express the intellectual, social and political disorientation of a fourteenth-century society in upheaval. But this impression is not entirely true, for the rich variety of architectural styles in the fourteenth century did not come about overnight, but evolved gradually out of that which came in the decades before it. There was no sudden change, as there had been in the weather at the start of the century, and neither was there a genesis into a common Gothic "system" in Germany, by whose collection of styles later churches could be interpreted. Forms were being shared and passed on, at the same time that wildly different forms were being developed.

SMALLER VENUES AS SITES FOR TESTING NEW ARCHITECTURAL IDEAS

One of the most interesting architectural phenomena in the years after 1300 was the large number of chapels added to great churches, and their increasing importance as small, extremely artistic structures in and of themselves. Just like in France during the same period, more and more of them appeared next to the side-aisle walls of Germany's urban churches – as family chapels, chapels of brotherhoods or guilds, elaborate tombs for magistrates, chapels in honor of special church events or to house city courts and administrative functions. They decentralized liturgical space, whose focus had been the choir, dividing it up to be shared with spatially isolated cells on the sides that were meant for private or collective worship.[317] Chapel construction would play an important role in architectural history in general during the years after 1300 in Germany, since much of what would become repertoire for the great churches to follow was first tried out on smaller structures, some of them fundamentally different and distant from each other.

All changes of individual forms came about because of a process in which architectural

102 Colmar, Dominican Church, nave looking east

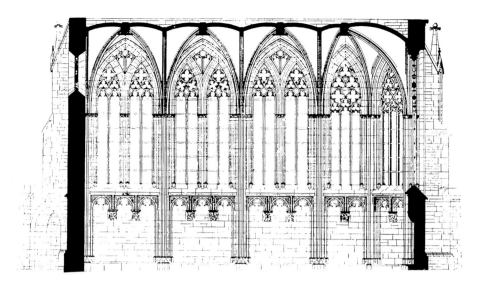

103 Imbach, Dominican Church, wall elevations of St. Catherine's Chapel

104 Erfurt Cathedral, so-called Triangle of north transept

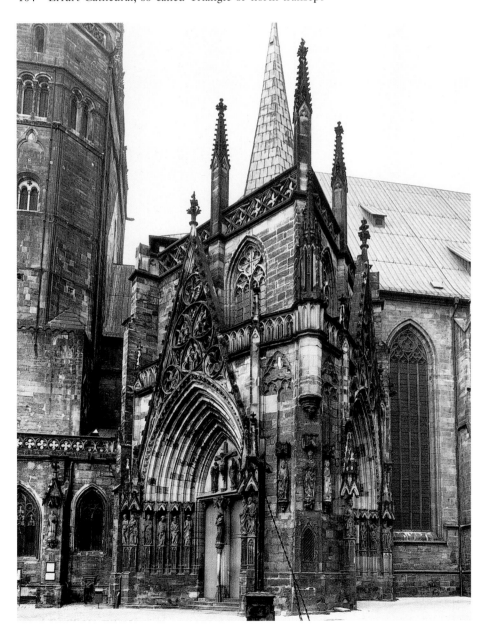

priniciples, relevant up to that point in time, were completely rethought. This was true whether it involved tracery forms that diverged from the usual stereometry, clashing vertical divisions of the wall, a new solution to applying a portal to the front of a building, vault types that dissolved the row of bays; or whether it was a virtuoso combination of tracery and vault ribbing. It would not be until half a century later that these experiments would be brought together and used in larger projects.

St. Catherine's Chapel on the north side of the former Dominican convent church in Imbach, Austria [103] is a three-bay structure terminating in a five-sided polygon, whose elaborately windowed walls represent a radical departure from the modest outer walls of the Mendicant church in general. A partially legible gravestone in the floor of the chapel indicates it was built as a sepulchre; its donor is not known.[318] No primary sources concerning its construction have survived, but it should probably be dated in the second quarter of the fourteenth century.[319] At the very least, the extreme height of the tracery windows' pointed arches speak for this date, as does the sharp-edged profiling of the blind arcades in the wall base below them. Compound responds of three shafts each articulate the wall between the triple arches of this blind arcade. Very early examples of mouchettes can be found in the window tracery of the chapel's north side; they fill the upper field of the window arches, are arranged in pairs and stand on their "tails." One would expect to find them at the edges of window spandrels at this early date,[320] not as the main motif of the couronnement. These mouchettes are examples of how organic tracery figures were gradually replacing earlier geometric tracery forms in a process that saw a softening and enlivening of what had been austere patterns.

Also of interest at St. Catherine's Chapel is the dissonance between wall base and window register. On the long side of the chapel, each tracery zone of the wall base consists of three arches, while the window over it is quadripartite. In the curve of the polygon the ratio is 2:3. This slight deviation – the upper tracery figures sit upon gaps in the tracery work below them – breaks up the vertical impetus of the elevation, something seldom seen in a church of the Rayonnant style in which the seamless vertical connection between wall elements of different registers would normally be a dominate feature.[321] Such vertical shifts were popular in the architecture of the late fourteenth century and were employed to achieve an element of con-

trast or to make structural articulation more ornate. Here we find evidence that the Rayonnant's cohesive, harmoniously articulated style was disintegrating at the very moment of its maturity in the cathedral lodges at Cologne and Strasbourg.

German builders had now solved the technical and formal problems presented by the Gothic style. Seen in a positive light, its "doctrinaire" character – that is, the widespread acceptance of its basic repertoire and the doctrines behind it – presumes a high level of confidence and skill in dealing with the style. This in turn was the foundation for the use of detailing, for it was confidence in the stonemason's ability to handle the various forms of ornamentation effectively that offered the architect the opportunity for a greater freedom of design.

This is best seen in the example of the small structure. For instance, the tracery style employed in the porch of the north transept at Erfurt Cathedral is nothing new in and of itself, but its unusual floor plan makes for a charming design nonetheless. Portals of the High Gothic period were usually restricted to the front of a structure. They were subordinate to larger design principles which dictated they be an element or substructure parallel to, and centered on, the wall they fronted. Erfurt Cathedral's porch, however, is a triangular structure [104] with one of its sides against the transept terminal wall, and the other two sticking out like a wedge. Its two large portals, each topped by a high triangular gable, are set at oblique angles to the transept, so that the frontal symmetry usually associated with the Gothic portal is rescinded. The entrances are turned away from each other, which shifts the center of the structure to the corner where the two free sides meet. The axis indicated by the transept is thereby split in two, and with it the relationship between inner and outer structure is organized in a completely new way. A fine artistic understanding for the arrangement of façades was at work here. It appears that a lot of effort was being put into designing multiple-sided structures, and that architects were well aware of the surprising relationships and angles resulting from them. This characteristic makes the "Erfurt Triangle" (shortly after 1329) way ahead of the similar portal structures that followed.[322]

Tracery work, originally a form of window division, began to cover more and more of the Gothic structure in the fourteenth century. In the façades of Cologne and Strasbourg it served as surface decoration, in Freiburg Minster tower as an elegant solid tracery to fill the space between the spire's load-bearing elements. In the first quarter of the fourteenth century, tracery unexpectedly appeared in the vault zones of smaller structures, where it was employed for purely ornamental purposes. One of these smaller structures was the "Tonsure" built in front of the south transept portal at Magdeburg Cathedral [105]. It is a chapel-like, eight-sided polygon of unknown function. Below its flat roof is a vault consisting of "flying ribs" with no masonry webs whatsoever between them. The spandrels between ribs, wall and ceiling are filled with tracery figures. Like at Freiburg, where the open tracery of the spire did not fulfill the function of roof, Magdeburg's "Tonsure" vaulting cannot be called a variation on a ceiling. Rather, by dissolving the surface webbing between the ribs, the ceiling is transformed into a kind of lattice work, the vaulting itself into a work of art as open as a garden trellis.[323]

105 Magdeburg Cathedral, cloister, tracery vault of the so-called Tonsure

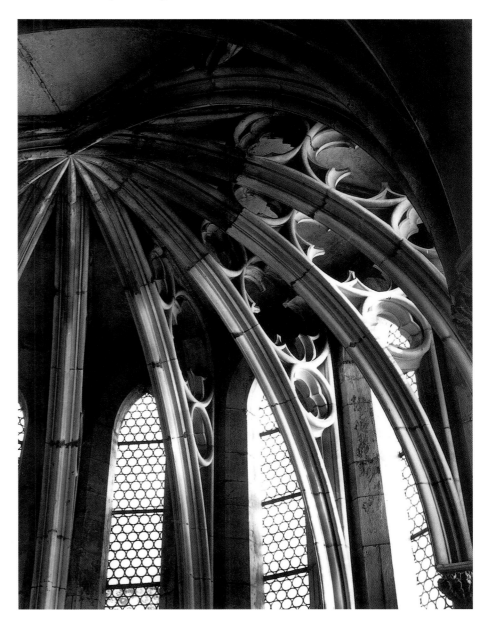

As early as 1300, then, there were signs that much of Gothic style development would concern vault construction in the future. Roughly contemporary to the stellar vaults of eastern Prussia and Silesia were the first German "umbrella vaults" of the English chapterhouse type, a kind of vault construction that differed fundamentally from the ceiling forms used up until then. Most vaulted spaces had been created by running ribs up from the four corner points of the walls bordering it. The springers of the vaults rested on top of the corners of the spatial cells below, and in multi-aisled structures on top of piers. In both cases, the illusion was maintained of a canopy-like ceiling made up of vaulted bays connected to each other.[324]

The umbrella was the only kind of Gothic vault that diverged fundamentally from this basic design principle, and that was capable of creating its own kind of spatial feel. It was built on top of a free-standing support placed in the center of a room. From the top of this single support, the vault opens up in an umbrella-like manner, with ribs on all sides arching up and over the vault zone, then down the other side to form a zigzag pattern against the surrounding walls. It may well be that the edges of the umbrella vault share some characteristics with other ribbed-vaulting systems constructed around a central point – the up and down movement at the vault edge of the formeret arches, for instance, or the bundles of ribs between these and the corners that bend inward as they rise. The function of the individual rib as a "spoke" of an umbrella skeleton becomes obvious only when the vault figure is seen as a whole. In fact, the linear plan of some umbrella vaults matches that of a stellar vault almost exactly. But the three-dimensional spaces they create are very different. Whereas the boss at the zenith of a stellar vault visually focuses the inward/upward movement of both volume and space, the center of an umbrella vault, anchored in the middle by its central pier, creates a *vertical* axis of symmetry around which articulated space spreads out in all directions.[325] The free-standing support, and the chalice or funnel-shaped "rod" of the umbrella sitting on top of it[326] claim for themselves, as sculptured elements, all of the space in the center. Umbrella vaulting, then, does not create a calm and cohesive spatial entity, complete in and of itself, but rather one with compartments that communicate laterally with each other over a mass-filled space. Standing under one of these vaults, one is struck by the feeling of being pushed out of the center, which is already occupied,[327] and by the impossibility

of seeing the room as a whole. As you turn and look at the vault – regardless of where you begin – each section you see is covered by a spoke of the umbrella bending inward towards the central pier, which dominates the middle like a monument.

The spatial organization of the umbrella vault was, it's true, always close to that of the polygon, but some of the umbrella's characteristics can also be found in older, square rooms with single supports. Romanesque – and also many Gothic spaces – possessed central piers that supported four cross-ribbed vaults. This was the simplest kind of ceiling for a double-aisled area that shared a single pier. High Romanesque spaces of this kind are characterized by heavy, cupola-like cross-ribbed vaults that seem, because they are separated by transverse arches, to possess a dynamic that is isolated to each individual bay. The French-dominated High Gothic vaults of this kind are characterized by the often steep cut of the transverse vault ridges, which are orthogonal to the surrounding walls, a form that could not give rise to the idea of a central pier around which the axis rotates.[328]

Not so the umbrella-vaulted space, whose chalice-shaped center is formed by ringed layers of masonry so that it resembles the seamless, homogeneous curvature of a cupola. But the ribs of the umbrella vault, shooting up from this central axis like a fountain, gives the convex part of the vault shell a very different contour to that of a cupola. Only after the ribs have reached far out from the center and over to the concave-shaped web compartments near the walls, does the vault seem pushed opened from below by the ribs. Only then does the observer associate it with the image of an umbrella.

The earliest surviving umbrella vaults date from the thirteenth century and can be found in the chapterhouses of English cathedrals and it is here, in these centralized spaces, that we must look for its origins. As early as the twelfth century, in fact, English chapterhouses were being built as elaborately articulated, free-standing polygonal structures which served as assembly halls for the monks within the confines of the monastic buildings. The rich cathedral chapters of the thirteenth century employed this type of structure all the more willingly, rather than staying with the stricter monastic tradition, which would have put the chapterhouse off the east wing of the cloister where the more worldly clerical society spent little of their time. Having a chapterhouse separate from the monastery also offered the canons, who often held high public office, the opportunity for a tangible demonstra-

tion of the power and prestige of their cathedral chapter.

It was here, at the festive assembly of canons, that it was believed the miracle of Pentecost was repeated, that the chapterhouse was a location where the Holy Spirit once again descended upon the Apostles of God. Within this context, the chapterhouse was seen as "the workshop of the Holy Spirit where the sons of God assembled".[329] Nothing could have been nearer to this interpretation than the choice of a centralized structure. In fact, beginning in Carolingian times, illustrations depicting the miracle of Pentecost represented Mary and the apostles gathered in the middle of a room with the Holy Spirit being poured down upon them from above.[330]

The oldest surviving chapterhouses with umbrella vaults are in London – Westminster Abbey (begun 1246, wide-ranging restoration 1866–73), Lichfield (1239–49) and Salisbury (1263–84) – and these were clearly the prototypes for the largest of the German umbrella vaults. All three consist of triradials with ribs radiating out from the center that divide the points of their rhomboids in half longitudinally. All are extremely tall and of the finest elegance. A variation on this design is embodied by the umbrella vaults of the chapterhouse at Lincoln Cathedral (around 1230–5) and Wells (vaulting completed before 1306 on an older structure). The oldest, Lincoln, presents an enriched vault configuration, the main motif of which would reach mature expression at Wells, whose umbrella is made up of a thick array of no less than thirty-two ribs shooting up like a fountain. Wells chapterhouse differs sharply from earlier vaults of this kind because it lacks triradials altogether.

On the European mainland the umbrella vault developed in a different direction. In the early years, builders stayed with simpler triradial configurations. Only grudgingly, and only in certain regions, did they follow the English and increase the number of ribs. In the Holy Roman Empire, the first umbrella vaults to appear in a space with a central pier were in the crypt of St. Stephan (1270–80) in the town of Kourim, in the old parish church at Brüx in Bohemia (begun around 1273) and in the "Silver Chamber" at Worms Cathedral (1270–80). Whether or not the builders consciously used the English chapterhouse vault as the prototype for their umbrellas is unclear.[331] What we do know is that Kourim and Brüx introduced to German Gothic the one variation of the vault that we subsequently see over and over again: either it has (Brüx) or lacks (Kourim) the diagonal rib running longitudinally down the point of the rhomboid.

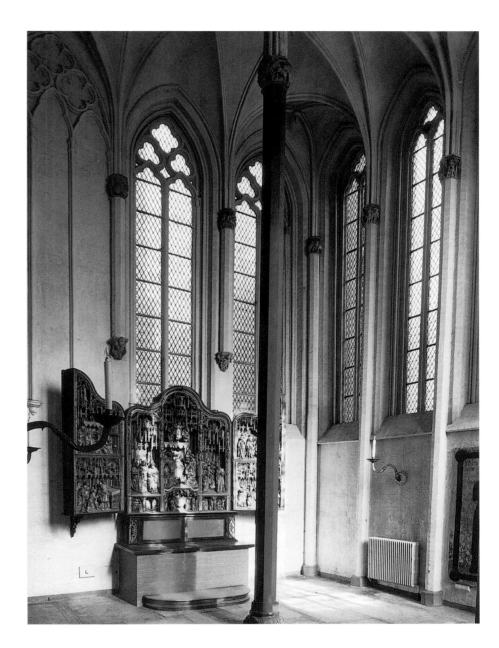

106 Lübeck, St. Mary's, Letter Chapel

A vault similar to the early Bohemian triradial umbrella vault can be found over the crypt of the Franciscan monastery church in Neuenburg in western Prussia (beginning of the fourteenth century). In fact, many crypts underneath choirs would employ this type[332] because it offered an adequate ceiling form for the centralized sepulchre, which itself had developed out of memorial and martyrium structures.[333]

It was typical for the Hanseatic League cities, and the areas around them, to build umbrella vaults in combination with two or sometimes three columns in one row, which allowed for double-aisled spaces. The tall, thin pier so typical of the area's churches attests to English influence. In 1310, the "Letter Chapel" was added to the west end of the south aisle of St. Mary's in Lübeck [106]. It owes its name to the medieval scribes who plied their trade there. It is positioned exactly where the two chapels flank-

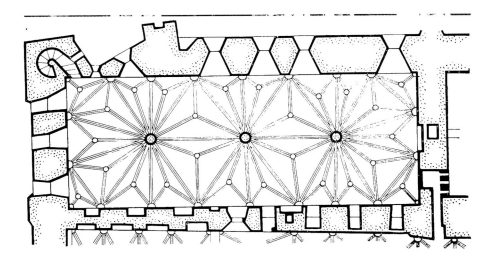

107 Marienburg,
Chapterhouse

108 Maulbronn,
Cistercian monastery,
chapterhouse

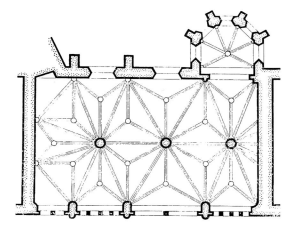

109 Eberbach, former
Cistercian monastery,
chapterhouse

ing the two west nave bays of Lincoln Cathedral are, a fact that seems to indicate a direct stylistic link between the two.[334]

The "Letter Chapel" is divided into aisles by two free-standing piers. However, the aisle division is not repeated overhead because the two rhomboid stars there are intertwined. The octagonal piers are tall and thin and carry two umbrella vaults, whose diagonal points are warped by the attempt to maintain visual correspondence between pier placement and wall responds. This was achieved by slightly bending each rhomboid over a diagonal rib. The tips of the spokes barely touch the surface of the surrounding walls, and the intertwining of the stellar figures goes all but unnoticed overhead.

Despite the centralized placement of the piers, the "Letter Chapel" seems to have no central axis whatsoever. The only element of its vault to indicate an aisle/bay spatial organization are the ribs – introduced into the system of triradials that divide the rhomboids – which are either perpendicular or parallel to the main axis of the chapel. These contribute what little sense there is of a rectangular bay organization. The walls surrounding the chapel form a two-

dimensional envelope that holds the vault's solidly three-dimensional forms. These spread out in all directions to create a ceiling that dominates everything below it.

Many umbrella vaults outfitted with magnificent ribbed figures can be found in the Vistula River area, in what was the extreme northeast of the Holy Roman Empire. Here the Teutonic Order constructed large rooms – like the chapterhouse and refectory of their castle at Marienburg (around 1320–30) [107]. They were double-aisled, with two or three piers in a row covered by umbrella vaults. The builders obviously adopted the forms of the "Letter Chapel" of St. Mary's,[336] but enriched the type by employing additional diagonal ribs in all points of the rhomboid.

The vaulting of Marienburg's large refectory contains small lierne-like ribs in the seams of its umbrellas – a descendent, surely, of the chapterhouse vaults at Lincoln and Wells, and a humble one at that. It wouldn't be until later – in their summer and winter refectories at Marienburg (1385-ca.1400) – that the Teutonic Order would achieve more complex ribbed figures over single-pier, umbrella-vaulted rooms. The longitudinal and transverse ridge-ribs of these would spring from all four sides of the central pier, and possess richly articulated bosses. With their squat proportions and massive individual forms, they seemed to have gone even further in this direction than the English.

The first large-scale umbrella vaults in the west of the empire were at the chapterhouses at Eberbach (vaulted 1345) [109], Maulbronn (second quarter of the fourteenth century) [108] and the summer refectory at Bebenhausen (1335). As was the case east of the Elbe River, it was Mendicant architecture – Cistercian, not the Teutonic Order – that had the most influence on vault type in the west.[337] While the umbrellas covering Eberbach's chapterhouse sit on single, rather powerful, central piers, the umbrellas of the Cistercians further to the south in Swabia were built over double-nave structures divided by a single row of three piers, a form we also find in the chapterhouse and refectory at Marienburg [107].

There is, however, a characteristic difference between the umbrella vaults built in the west and those of northeastern Germany. In the northeast they possess transverse rhomboids whose wall supports are placed exactly opposite the central pier. Western German rhomboid umbrellas in Maulbronn and Bebenhausen – six-point, rather than eight – possess wall supports that are staggered to correspond to a position on the wall

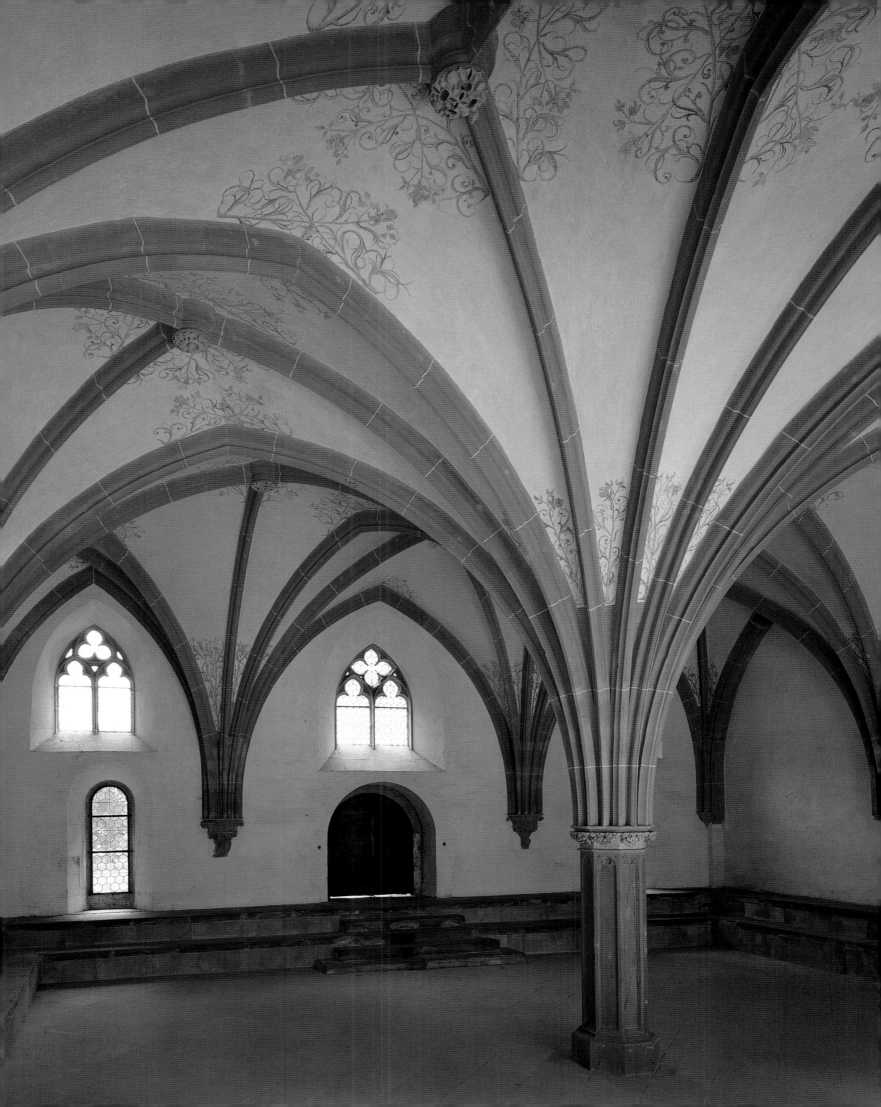

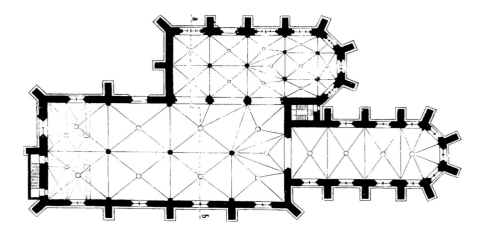

110 Enns, Minorite
church

bold manipulation of the statics of the ribbed vault would be difficult to find anywhere in the Holy Roman Empire.

A final note about triradials. They are the motif out of which both stellar and umbrella vaults are made. Their use allowed builders to experiment with different pier placements, which in turn allowed them the freedom to come up with new ways of organizing space. A noteworthy example of this is the chapel built onto the north side of the Minorite church in Enns, southern Austria [110], which was built as a family tomb by the House of Wallseer around 1343.[341] The west half of the chapel has two free-standing piers which create a two-aisle space. It's in the choir area, however, that we find a very intriguing placement of four piers. These surround the altar like the posts of a ciborium, setting it off from the rest of the choir inside a separate square enclosure. The small bays behind and to the sides function as a kind of ambulatory. The intersection of nave and choir is formed by a triangle of piers, connected in the vault by a triradial. In fact, the triradial is the only Gothic vault form that could allow the connection of such a pier configuration. Through the use of these simple elements, a small Hall structure was created which emphasizes the altar's liturgical importance by placing it inside what is, in effect, a *baldachin*.

Smaller spaces like those in Marienburg, Lübeck, Strasbourg and Enns were harbingers of a fundamental stylistic change that would not gain momentum until after the middle of the fourteenth century. At first, this change would not encompass large structures, and the vehicle for its dispersion throughout the German Empire would be chapel, crypt or chapterhouse. With their new understanding of vaulting as a shell to be formed into a variety of shapes, German builders now focused their creative efforts on the ceiling – as an element that can facilitate the creation of a single artistic expression which both encompasses, and articulates, the space below it. As many new structures were engulfed by vaulting, the handling of articulated wall elements became rather unspectacular. Walls were nothing more than a frame inside which the interaction of vaulted figures and their supports was played out. No longer limited by the fixed shape of the cross-ribbed vault, German church builders were now free to create a host of new spatial compositions.

that is between the piers. Under this system, every pier corresponds to a single wall section that resembles a window because it is framed on each side by the arching responds of a rhomboid. The last visages of the Gothic travée system – the axial correspondence of wall responds and free-standing piers – was renounced in these western German structures, and transformed into an intense zigzagging interplay of pier and wall respond.[338]

The dispersion of umbrella vaulting in the west was accompanied by an increasing number of stellar figures in general. The decorative possibilities of the star were magnificently explored in a chapel added on to one of Europe's greatest cathedrals. Between the years 1331 and 1349, the Bishop of Strasbourg, Berthold von Bucheck, had a double-bay chapel built on to the cathedral in the angle between the nave and the south transept, and dedicated it to St. Catherine. Its original vaulting – which collapsed in 1546 and was replaced with a vault in the style of that period – consisted of two, eight-pointed rhomboid stars which were separated by an arch.[339] An inscription in the chapel says that at one time there was a "hanging vault" there. The medieval chronicler Sebald Büheler was amazed by what he called the "hanging and artistic vault in SA's Catherines Chapel".[340] Obviously, both stellar figures had bosses in the middle of the vault hanging down into the chapel. It is difficult to imagine a more artificial vault in Germany at such an early date. Perhaps the vault bore witness to both the power and prestige of the chapel's builder, the Bishop of Strasbourg, and to the excellence of the city's cathedral lodge. Be that as it may, an earlier example for such

Architecture in the Time of the Parlers

AFTER A CHAOTIC first forty years, the fourteenth century saw political activity in the Holy Roman Empire gradually begin to center once again on a single, powerful individual. Charles of Mähren, successor to the House of Luxembourg, was proclaimed German King in 1346, then officially crowned Emperor of the Holy Roman Empire as Charles IV in 1355. During his reign, decades of political turmoil within the empire would come to an end. His leader-ship ushered in the beginning of a slow re-consolidation of imperial authority which would bring many semi-independent principalities back into the empire. Charles IV was the greatest *realpolitiker* of the fourteenth century, and as such is a figure that fascinates contemporary historians. A collections of essays published in 1978 on the occasion of the 600th anniversary of his death took as its subtitle "Diplomat and Patron",[343] and it is precisely these two facets of his activities as ruler that are of great interest to the architectural historian.

Charles was forced to practice diplomacy, instead of war, because of the relatively weak position of the monarchy which, after long years of strife concerning the rightful heir, had lost much of its ancient prestige.[344] But prudence in political decision-making, coupled with a charismatic personality which most contemporary accounts speak of, would characterize his career as statesman and change those perceptions. Born in Prague, raised in Paris, Charles was proficient enough in five languages to have wooed and married daughters of the most important families in Germany, France, Hungary and Poland. He was adept at staging impressive public appearances, and possessed the ability to out-manoeuver his political opponents, achieving what could not have been achieved militarily through impressive imperial gesture alone. He adored, even worshipped, Charlemagne. As a young man, he had changed his given name from Wenceslaus to Charles in honor of the Carolingian emperor which, as many have speculated, was probably due to youthful exuberance

rather than rational impulses. It should be pointed out, however, that after his second coronation – a memorably opulent event in Aachen[345] – this name-change turned out to be a brilliant poli-tical move, since the suggested connection between his own regency and that of his royal "ancestor" could be applied quite effectively as a propaganda tool.[346] And this connection involved more than just symbolically binding his reign to that of Charlemagne's. Charles was able to create the *Karlshof* Foundation in Prague to finance Castle Karlstein, which housed Charlemagne's *Reichskleinodien*, or the imperial treasure of the Holy Roman Empire, which would be displayed on a yearly basis there.

Obviously, Charles was especially keen on a public display of the glory of his reign. To achieve this, it became necessary to build a suitable architectural framework for his activities. And so it came about that the German monarchy took over the patronage of many new structures during the years between Charles' coronation and his death in 1378. For the first time in the history of the Holy Roman Empire, Gothic architecture came to symbolize a court culture that in many respects was similar to the role it played for the kings of France. At the same time, however, the first steps toward a genuine German Gothic with its own character-istics were taken. This German Gothic was a flexible kind of architecture. It developed out of the conditions that had formed the Hall tradition and, due to its location in the center of Europe, was open to new methods of organizing space. A single family of outstanding architects would play a major role in its development – the Parlers.

Even if we disregard the myths and legends surrounding their name, the range of their influence established by primary sources is still amazing. Family members held leading positions in medieval construction lodges at Schwäbisch Gmünd, Strasbourg, Freiburg, Basel, Vienna and Prague – *the* most important architectural centers in the empire at the time.

111 Prague Cathedral,
bust of Peter Parler in the
choir triforium

112 Schwäbisch Gmünd,
Holy Cross, west front

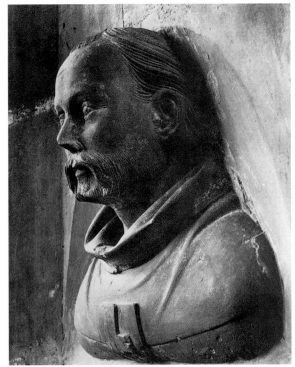

With the Parlers, we see the advent of a genera-
tion of Gothic architects about whom we know
more than only their names. The rich fund of
contemporary sources allows us a glimpse into
the conditions under which they lived and
worked. For art historians, then, this period rep-
resents the first time in German history when an
architect stepped out of the shadow of the build-
ings he designed.

SCHWÄBISCH GMÜND AND THE DEVELOPMENT
OF THE HALL CHOIR WITH AMBULATORY

A bust of Peter Parler in the triforium of Prague
Cathedral choir [111] bears an inscription indi-
cating that here is the son of Heinrich Parler
from Cologne, who was master at Schwäbisch
Gmünd.[347] The inscription goes on to say that
at the age of twenty-three, Peter Parler was
summoned to Prague from Gmünd by Charles
IV in the year 1356. There he completed the
cathedral choir, along with All Hallows church
on the Hradschin, and the Moldau Bridge. It
also says he began the choir of the church in
Kolin-an-der-Elbe, and that he died on July 13,
1399. We also know that Peter's first wife,
Gertrude, was the daughter of a stonemason
living in Cologne.[348] Like his father Heinrich,
Peter Parler must have had close connections to
Cologne Cathedral's lodge.

About Heinrich Parler we know far less. An
entry in the *Anniversarienbuch* at Schwäbisch
Gmünd names a certain *magister hainricus
Architector ecclesie*.[349] This, along with the
inscription at Prague Cathedral, seems to indi-
cate that Heinrich Parler, at least for a time, held
the position of lodge master at Holy Cross in
Gmünd. It is not known for sure which sections
of the church he was responsible for, a question
of some weight since Holy Cross is one of the
most important structures of the fourteenth
century.

The citizens of the town of Gmünd, in
Swabia, began a major rebuilding of their parish
church in 1315 with the raising of a towerless
west façade [112] which was to front a three-aisle
basilica. In 1330, however, with the western bay
immediately behind the façade only half com-
pleted, the basilican design was dropped in favor
of a Hall plan. Evidence of this design change
can be found on the façade's lower pier-buttress
articulation, and the rich display of its blind
tracery work in a "staggered lancet" system in
the gable register that is reminiscent of the east
façade of the Cistercian church in Salem and St.
Mary's at Reutlingen [89]. Further evidence of

the change can be seen in the façade rose windows in the sides of the upper wall sections, which seem to bear no organic relationship to the rest of the structure whatsoever. They appear excessively large compared to the small rose in the center and no doubt owe their existence to a raising of the Hall side-aisles behind them.

Holy Cross was probably the first Hall ever built in Swabia.[350] The decision to go with a Hall instead of a basilica has been attributed to a change in lodge masters, and the second nave master at Gmünd is assumed to have been Heinrich Parler.[351] Whoever the new architect was, he inherited a nave plan whose parameters included pier placements, as well as two Late Romanesque towers from an older church which flanked the seventh bay of the central vessel [113]. His solution was to build a Hall structure with rectangular central-vessel bays combined with square side-aisle bays, that were separated by round piers whose impost zones were wreathed in foliage work. Gmünd's nave has been studied closely for details common to Cologne Cathedral in order to prove that Heinrich Parler, who we know had come to Gmünd from Cologne, was indeed the nave's architect – so far without success. Several details at Gmünd – like the concave molding at the bases of its portal and windows mullions, the crocketed pier buttressing of its west front, its three-sided figured tabernacles, or the fusion of trefoils and quatrefoils in its tracery work – can no doubt be traced to prototypes from the upper Rhine region (Strasbourg, Salem, Freiburg) and this has raised questions about Heinrich Parler's authorship.[352]

The nave appears to have been roofed before the Plague struck Gmünd in 1347/48. Nonetheless, workers were able to lay the cornerstone for a Hall choir in 1351. It was designed to correspond to the dimensions of the nave and, in fact, the rows of cylindrical nave piers are continued for three bays beyond the Romanesque towers. The arcades of the choir polygon are the same width as those of the sanctuary. The last pair of piers in the east are placed more towards the middle, making the three sides of the inner choir arcade approach three-fifths of a pentagon. However, the outer polygon has seven sides which creates an ambulatory with adjacent low chapels. These appear pocket-like between the outer wall's pier buttresses, which have been pulled inside.[353]

Gmünd's choir represents a decisive move away from the usual High Gothic cathedral choir, the ambulatory wall sections of which always corresponded in number to the arcade

113 Schwäbisch Gmünd, Holy Cross

sections of the sanctuary, with every arcade interval connected outward to a trapezoidal ambulatory bay and a radial chapel. Now and then, as at Notre-Dame in Paris, we find trapezoidal ambulatory bays divided in half by columns. But in every case, the spatial organization of the inner-choir structure radiates outwards in a uniform manner. At Schwäbisch Gmünd, however, we do not find a radially articulated design. The width of the chancel's central vessel arcades is exactly the same as the distance between the wall responds of the outer polygon. As a result, the individual spaces of the main choir do not fan out from a central point. Instead, a terse correlation between inner and outer wall has been created that is based less on a controlled geometric floor plan, than it is on free composition. Dominated by the outer choir walls, Gmünd's inner wreath of pier arcades seems to have been added as an afterthought, as though it were of secondary importance to the space as a whole. Seen from the middle of the chancel, the choir arcade isolates the ambulatory, which appears as an irregularly shaped extension of the sanctuary.[354] The floor plan [113] gives the appearance of extreme simplicity, not the least of which is brought about because of its decimation of the usual wreath-like placement of inner ambulatory piers. Yet despite this simplicity, the renunciation in plan of a strict geometry in favor of free composition actually makes the three-dimensional structure built over it more complicated, not less.

Rudiments of the "Gmünd choir type" as it is called, can be found in earlier buildings, but it has no prototype as such. There are earlier examples of sanctuary structures whose arcades do not correspond numerically to their own outer polygon – Le Mans Cathedral (1217–54), for example, and some High Gothic Cistercian choirs. But all these churches have an outer ambulatory wall that is a doubling of the number of arcades on the inside, a design brought about by alternating square ambulatory bays with

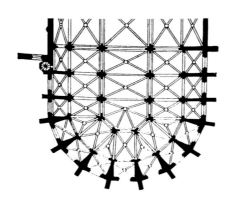

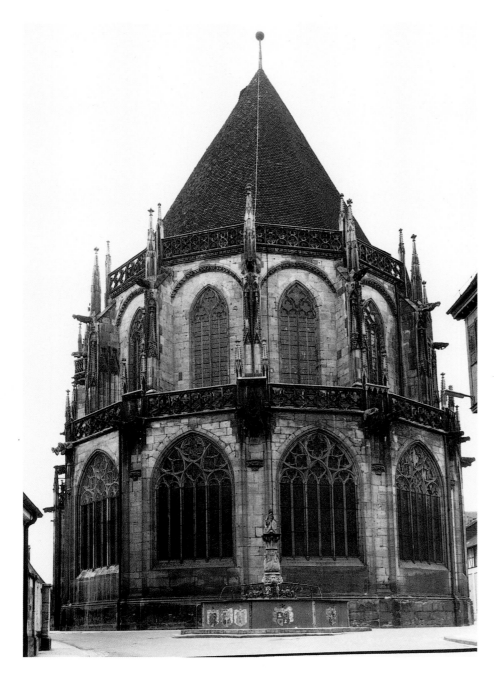

114 Zwettl, choir of the Cistercian church

115 Schwäbisch Gmünd, Holy Cross, view of the choir from the east

116 Schwäbisch Gmünd, Holy Cross, view of the Hall choir

triangular bays.[355] The closest design we have to the Gmünd choir type is the Cistercian church in Zwettl, Austria (1343–83) mainly because the pier buttresses of its polygonal outer wall are also pulled inside to form walls between the chapels[356] [114].

Work on Gmünd's choir was interrupted in 1377. The altar was finally consecrated in 1410, with its ceiling still incomplete. The mesh-like stellar vaulting that we see today over the choir was built by Aberlin Jörg (after 1491) [116]. The vaults over the nave were also renewed at this time, after the Romanesque towers – which had been weakened by the building of the nave – collapsed and caused serious damage to the upper registers.

We would know more about the intended effect of the interior design, had a vault plan from the fourteenth century survived. However, springers of the vault ribs in the ambulatory zone, those from the time the choir was built, have survived, and from them we can infer that the original vaults were a combination of triradial stellar figures. This would have suited the design well, as they correspond nicely to the impost placements. This, of course, could not have been done in the trapezoidal bay at the apex of the choir.[357] The wide arcade arches, which are nearly as wide as the pier placements below them, surely belong to the fourteenth century. The arcades have cylindrical piers which lend the whole a three-dimensional plasticity reminiscent of the Hall ambulatory at Verden [63]. Unlike Verden, however, Gmünd's outer wall is more than simply a smooth membrane-like structure: running above the wall surfaces between the pointed-arch chapel openings, and the window register above them, is a thick lintel-like molding. This springs outward over the compound wall responds and towards the observer at an acute angle, giving the wall a rhythmic relief. It circumvents the articulated elements of the choir in a thick ring and it not only functions to stabilize the outer wall, but lends it the shape of an elegantly carved receptacle.

Outside, the choir and ambulatory are covered by a cone-like roof, with the lean-to roofs of the chapels encircling it halfway down from the top. The outer choir structure [115] is enlivened by the contrast between these two registers, each of which is crowned by a high eaves gallery. The only thing visible of the pulled-in pier buttresses are the outlines of their flat outer surfaces. These are accentuated only by pairs of arris-shaped elements running up each side, between which is a shallow niche wide enough

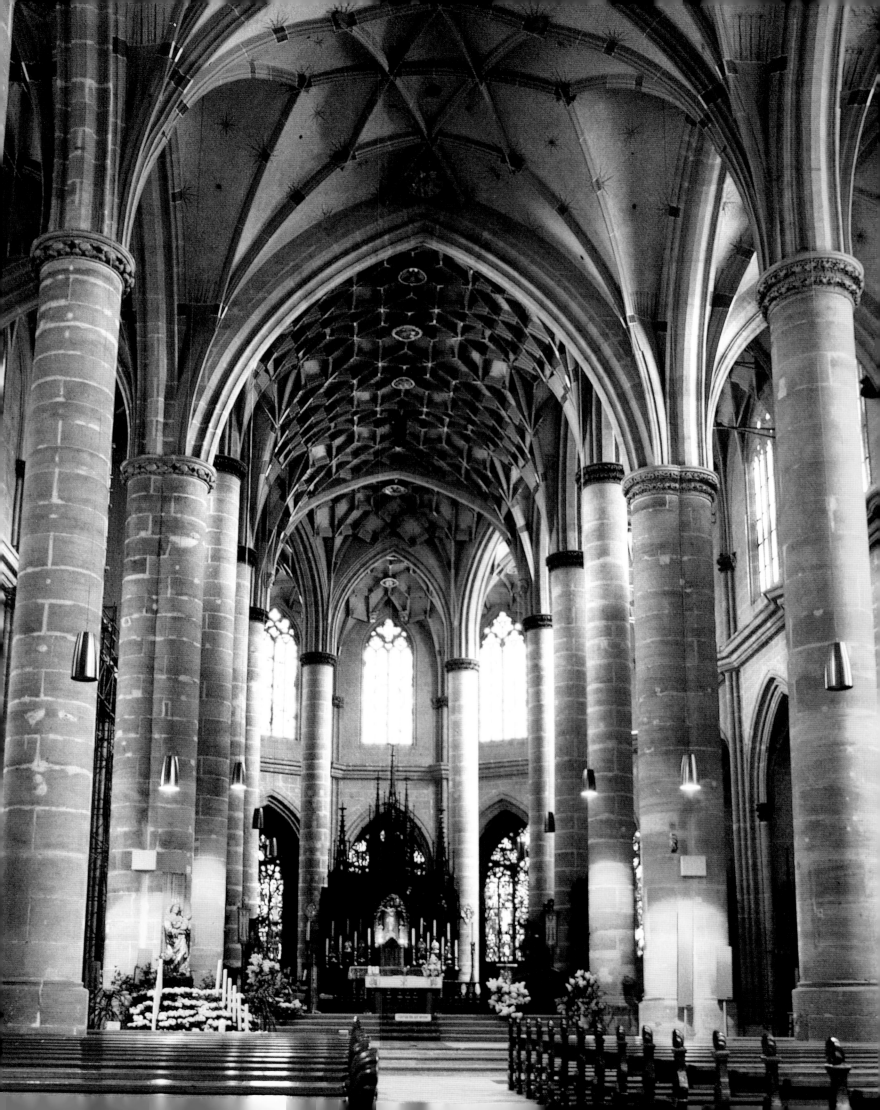

117 Colmar, St. Martin, choir

118 Colmar, St. Martin, view of the choir from the east

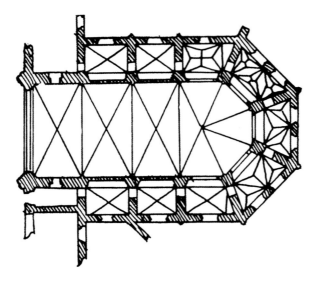

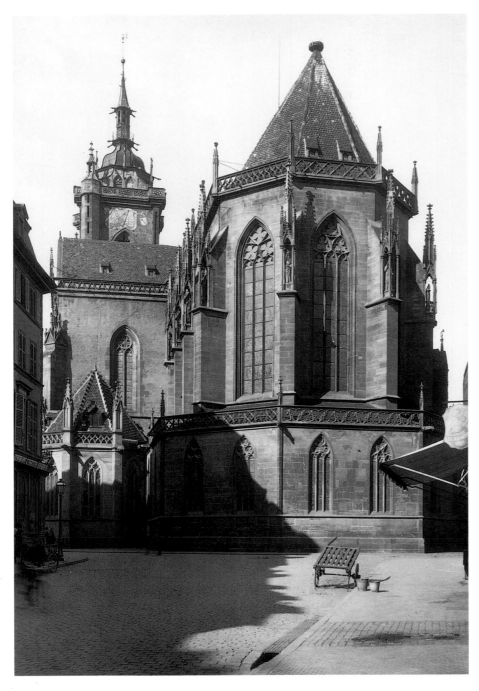

for a sculptured figure. Thus, in a method similar to the choir renovation undertaken at Notre-Dame in Paris (1296–1318/20) the flattening of the surfaces facilitates a "filing down" of the outer choir structure so that it approaches a smooth half-sphere. Placed between these arris-flanked niches are wide tracery windows sitting upon high window sills.

The calm and closed contour of the wreath of chapels at ground level stands in sharp contrast to the more open construction of the upper register, where the pier buttresses above the chapel roofs rise in a rich display of pinnacles and three-sided tabernacles. The windows are smaller here and topped by round arches decorated with leaf foliage.

This "filing down" or tightening of the usual Gothic protruding choir-chapel system is one of the main goals of Gmünd's choir design. Buttressing and chapels disappear behind an even surface that provides a solid outer wall for the inner structure. The principle of a compact outer structure of simple block-like elements that surrounds an inner structure of complex organization was to find many adherents in southern Germany.

If there are doubts about the nave of Holy Cross being Heinrich Parler's, there is no doubt about his having designed the choir. Most revealing is its similarity to buildings documented as having been built in Bohemia by his son Peter. The tracery forms of Gmünd's choir windows can be found in a slightly varied form in Prague Cathedral, and Gmünd's singular lintel-like molding that jumps at an acute angle over the inner ambulatory wall elements can be found in Prague's triforium zone. Peter Parler took Gmünd's unmistakable chapel design as the prototype for his choir at Kolin. The style of Prague Cathedral's funerary sculpture and structural ornamentation harkens back to the figures found in the portal and pier buttress niches of Gmünd's choir, whose sculptural style is now referred to as "cubic stabilization".[358]

Gmünd's choir was probably much cheaper to build than a traditional basilican choir with ambulatory – surely more than just a passing concern of the citizens of Gmünd who financed it. Structurally, Gmünd's Hall ambulatory could easily be built in place of a system of open buttresses. Its ambulatory vaults, in combination with outer-wall pier buttresses pulled inside, created a system easily able to deflect the thrust of the wide vaults of the sanctuary. Not only do the wall buttresses carry load, they also function as side walls for the chapels. Because of this, the chapels need no auxiliary support. A reduction

in the number of free-standing piers in the sanctuary must have saved the builders money too, since piers were made exclusively out of prefabricated elements in ashlar and were some of the most expensive parts of a Gothic church.

Besides aesthetic concerns, this cost-efficient use of materials was perhaps the most important catalyst behind the astounding number of experimental designs to appear in German choir solutions after 1350. However, Heinrich Parler's choir, despite its originality and the innovative character of its design, does not by any means deserve the central importance that is often ascribed to it in relation to the choir systems that followed.[359] Rather, an entire generation of architects active at this time seemed to have been concerned with simplifying the structure of the cathedral choir with ambulatory into a new form that was both artistically impressive and could be employed in smaller structures. In fact, other choirs built at roughly the same time had just as much influence in this respect as Gmünd.[360]

The choir of St. Martin's collegiate church in Colmar (after 1350) is one of these. Here we find, in basilican hierarchy, radial chapels grouped around the sanctuary. The side chapels are rectangular while those forming the polygon are trapezoids [117]. Both the inner arcade and the outer walls of the polygon have five sides. Thin gaps pierce the walls separating the chapels from each other, but they are too small to open up the chapels' almost cell-like isolation. The trapezoidal chapels of the polygon are covered by triradial vaults like those assumed to have

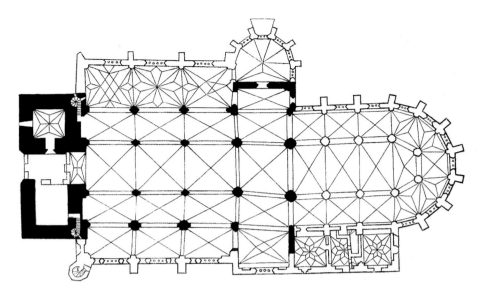

covered the ambulatory at Gmünd. The chapel-wall sections of the outer-choir structure are similar to those in Gmünd as well [118]. The only articulation of the edges separating the smooth double-window sections of Colmar's lower register outside are single, finely formed arrises. The flat chapel roofs here are hidden behind an eaves gallery. Colmar's inner polygon is higher than Gmünd's and ringed by powerful pier buttresses each decorated with open tabernacles. The choir was probably inspired, like Holy Cross, by the renovation in Paris and the choir ambulatories of the Cistercians. It is attributed to Wilhelm von Marburg who died in Strasbourg in 1363 or 1366.[361]

Construction on a choir with ambulatory at St. Mary's in Frankfurt-an-der-Oder [119], a

119 Frankfurt-an-der-Oder, St. Mary's

120 Choirs with Ambulatories from the northern-German Backstein region (after N. Zaske)

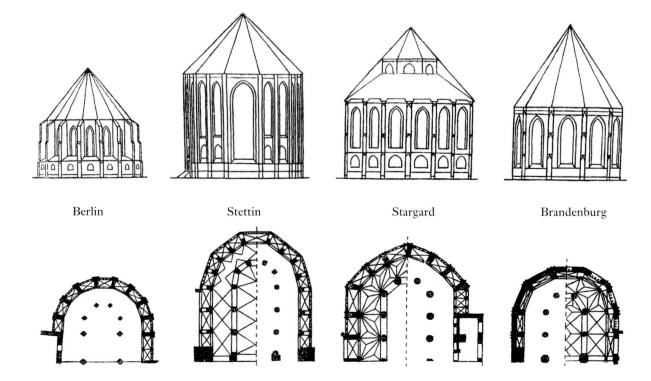

Berlin Stettin Stargard Brandenburg

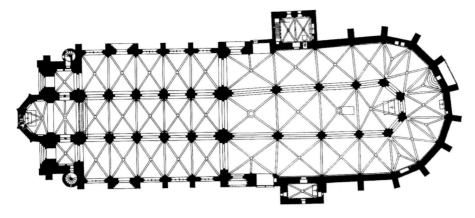

121 Nuremberg, St. Sebald

122 Nuremberg, St. Sebald, choir

piers are staggered rhythmically in relation to the elements of wall division behind them: the wall piers of the outer polygon are placed to be seen between the free-standing piers of the arcades in front of them. Once again this system offered the chance to introduce triradial figures in the vaulting over the ambulatory. The renunciation of chapels allows for the stepped pier buttresses to be visible outside. The typical "filing down" of the outer choir surface characteristic for Gmünd was not achieved here.

The floor plans of the Hall choirs of St. Nikolai in Berlin (under construction 1379)[364] [120] and St. Sebald in Nuremberg (1361–79) [121] follow the organization put forth at Zwettl [114]: a five-sided inner polygon combined with a nine-sided outer terminating wall.[365] The individual structural elements, on the other hand – with the exception of alternating triangular and hexagonal bays in the ambulatory – have been formed in completely different ways. Berlin's Backstein choir is rather low and, like its prototype at Zwettl, has "wall" chapels

Hall lacking chapels, also began in the mid-fourteenth century.[362] Built onto an older nave, the choir termination is a seven-sided Backstein wall articulated outside by pier buttresses. The inner polygon arcade consists of four piers that form half of a hexagon.[363] The contrasting ratio of outer-wall sections to inner arcading is handled in a way similar to that of Gmünd's choir. The result is a system whereby the choir

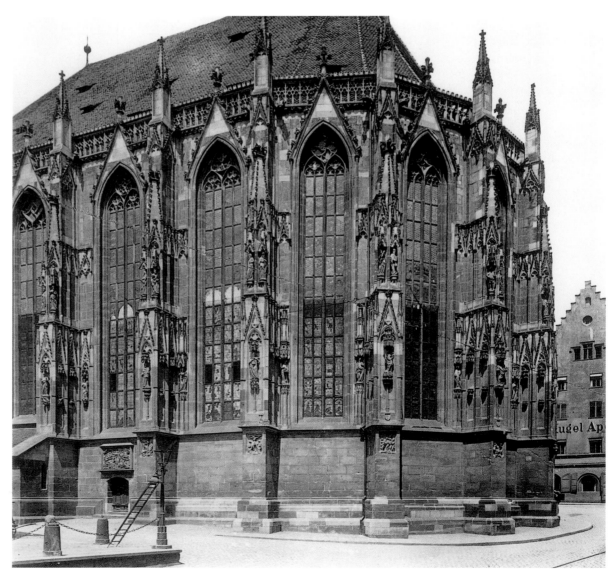

set between pier buttresses, the first example of such a system in the architecture of Brandenburg.[366]

The much larger choir of Nuremberg's St. Sebald, on the other hand, has no chapels whatsoever. Despite this, it was the most extravagant ambulatory choir of its time, possessing an outer polygonal structure [122] decorated with lavishly articulated pier buttresses, tall tracery windows crowned with triangular gables and placed inside a finely profiled framework. At the apex of the polygon is an eaves gallery decorated by delicate ornamental tracery, between whose sections the finials of the pier buttresses rise. Gross called this structure a "choir façade" and rightly so. Its collection of forms sets forth the façade style of Rouen, Mantes and Cologne,[367] weaving motifs developed at those lodges into a rich ornamentation that lends the polygon a decorative plasticity. What sets St. Sebald's choir apart, then, is its new and effective combination of decorative motifs, not its architectonic design.

The inner structure's free-standing piers – with bevel-edged cores, round responds running from floor to vault and no capitals [123] – reveals a debt to the nave of Our Lady in Esslingen, one of Swabia's earliest Hall churches.[368] St. Sebald's use of free-standing piers, and pier buttresses that are heavily articulated is impressive, and comparable to the new sculptural style of Heinrich Parler's choir at Gmünd. The individual pier elements are no longer exclusively subservient to verticality, but have been worked in such a way as to emphasize the corporeal and textural quality of the stone itself.

Perhaps the most independent-minded of all the new choir forms developed during this period was that built at St. Lambrecht's Benedictine church in the Steiermark region of Austria (choir under construction 1386[369] [124]. It is a three-aisle Hall, whose arcading continues right up to the edge of a five-sided polygon in the east. This is a principal feature of the Austrian Cistercian choirs at Holy cross and Neuberg where, however, a flat termination was employed.[370] St. Lambrecht's easternmost arcade arches are turned slightly towards the center of the structure in order to connect with the narrow placement of the two wall piers at the apex of the choir. The eastern side-aisle bays of the choir are oblique due to the curvature of the outer wall of the polygon, and possess vaults built around two triradials each. The wide, and round chevet of St. Lambrecht's choir appears to be a Hall choir with ambulatory, but it is no more so than its Cistercian prototypes. Obviously, the goal

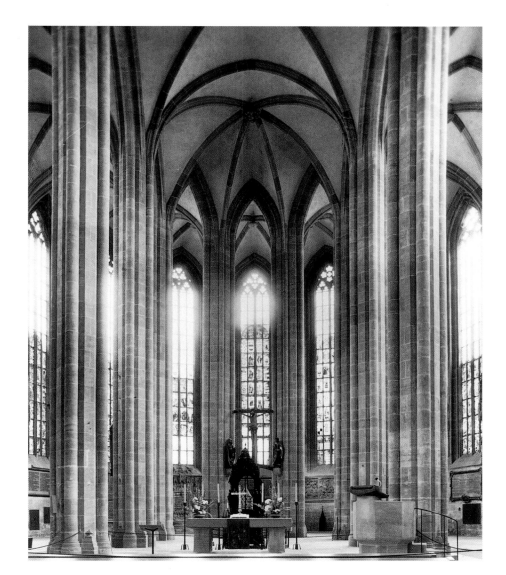

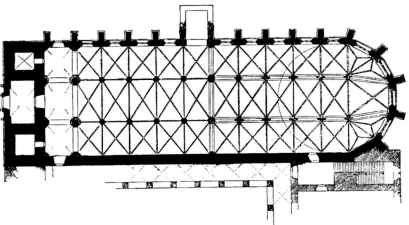

of its design was to achieve the illusion of a Hall ambulatory with limited means.

Despite differences in the kind of stone used, and the degree of structural sculpturing, all these choirs have certain characteristics in common. First, they are witness to a widespread acceptance of the Hall as a way to articulate space. Second, in almost all of the choirs the ratio of inner and outer polygons diverge, with the older system of five or six-sided sanctuaries having been replaced by

123 Nuremberg, St. Sebald, view into the Hall choir

124 St. Lambrecht, Benedictine church

125 Freiburg Minster,
choir

126 Augsburg Cathedral

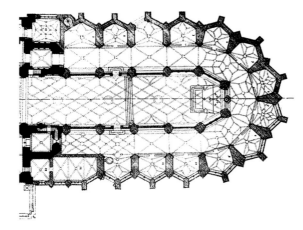

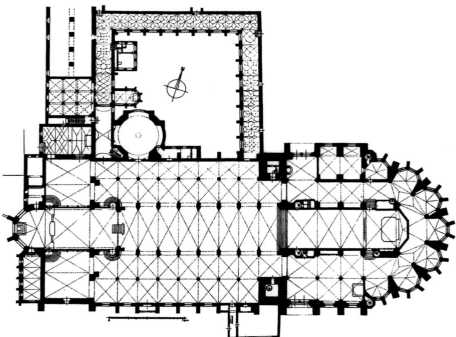

less popular. The richly articulated French chevet inherited from the thirteenth century – a traditional choir solution that was seldom achieved on German soil except at Cologne Cathedral, and the Cistercian churches at Marienstatt and Altenberg – was revived during this period at Freiburg Minster and at the cathedrals of Augsburg and Prague. Admittedly, though, even these church choirs also possess clear variations on the form.

In the year 1354 the cornerstone was laid for a new choir with ambulatory at Freiburg Minster [125] to replace an older Romanesque choir. Work stopped sometime between 1370 and 1380, however, and was not be taken up again for a hundred years. A conflict in 1368 with Count Egino III, ruler of the area surrounding Freiburg, had forced the town to purchase its way out of his protectorate, and to join that of the House of Habsburg in Austria. The town was subsequently forced to pay heavy taxes to help finance the Habsburg's war against the Swiss Confederacy, and the ambitious choir project – which had been entrusted to Freiburg's lodge master Johannes of Gmünd – came to a halt for lack of funds. Johannes "of Gmünd" was clearly a member of the Parler family. The common medieval habit of taking one's place of birth as one's last name indicates this, as does the mason's square pictured in his seal.[371] Like Peter, he seems to have been a son of Heinrich Parler. Besides being master at Freiburg, Johannes was also in charge of rebuilding the choir of Basel Minster which had been badly damaged in an earthquake in 1356.[372]

For a hundred years, then, the choir of Freiburg Minster stood incomplete at only half its planned height. Though the surviving sections from the fourteenth century give no indication of what kind of sanctuary termination was planned, or how high the ambulatory was to be, enough was built to reveal a design that is strikingly different from the traditional cathedral choir form. Its chapels, for instance, have two outer sections instead of the usual three. Each chapel section is framed by pier buttresses that project out in arrises, giving the terminating wall around the choir a rhythmic zigzagging line. One of the wall buttresses in this system assumes the position of the apex chapel. The "Lady Chapel" motif, which in earlier churches was often the stage for a rich profusion of articulated forms, has been renounced at Freiburg's choir in favor of a pacification and simplification of structural contour.

Augsburg Cathedral choir (1356–1431) [126] possesses double side-aisles like Cologne [41]. New developments in choir forms appear not to

three or four-sided design forms; that is if, like at St. Lambrecht, the inner polygon was not done away with entirely. When the interior design includes a wreath of chapels (Colmar, Berlin) these chapels are always backed by flat walls, so that they resemble niches embedded like low pockets between pier buttresses that have been pulled to the inside of the terminating wall. And finally, triradials are employed individually or in combination to solve the problem of vaulting the complicated ambulatory structures such designs created.

Of all these new interiors, Heinrich Parler's choir at Schwäbisch Gmünd stands out because it is particularly successful in fusing these characteristics. Whether or not Gmünd was in reality the prototype for the others will be difficult to prove so long as the dating of when construction began at Berlin, Frankfurt and St. Lambrecht remains unclear.

The appearance of these new kinds of choirs did not mean that the older cathedral choir, with its wreath of polygonal chapels, was

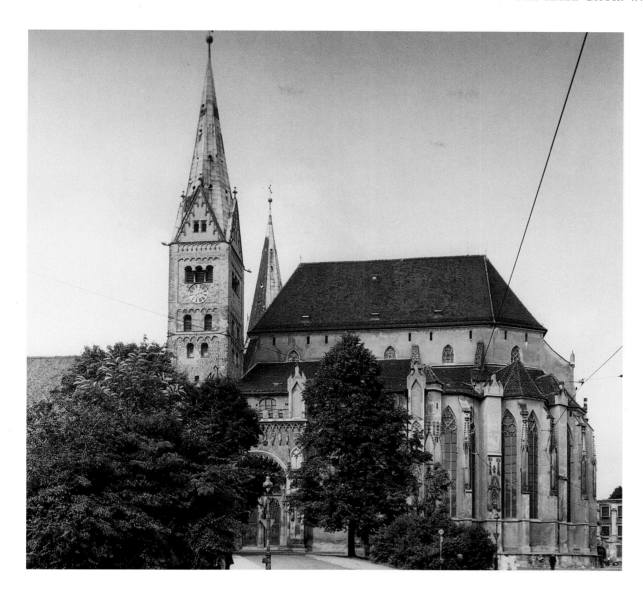

127 Augsburg Cathedral, east choir seen from the south-east

have played a role in its radial-chapel organization, which is rather traditional, but instead to have manifested themselves in the interplay between sanctuary and ambulatory. The easternmost sanctuary bay is trapezoidal, and positioned so far east that it functions as central bay to the ambulatory, which is placed immediately in front of the apex chapel. Sanctuary and ambulatory, like those at St. Lambrecht, have been submitted to an intimate fusion. In Augsburg, however, we find a staggered organization of the inner structure: the low ambulatory rises suddenly at the apex of the choir to the same height as the central vessel. Outside, the inner polygon has been pushed towards the east to engulf all the spatial cells below it. It rests upon the two apex chapel pier buttresses that have been raised, in full depth and width, to clerestory height [127]. The strange way in which the choir's easternmost bay cuts into the ambulatory may have been the result of a change in design. Evidence of this is attested to by many incomplete forms in the choir's inner structure that do not seem to fit together. Only Augsburg's stringent floor plan allows for the assumption that it was derived from Cologne's choir plan. There is little reliable information, however, about the originally intended form of its vertical elevations, and the reasons behind the change in design.[373]

AACHEN, NUREMBERG AND PRAGUE: THE EMPEROR AS CHURCH BUILDER

In building the choir at Ausgburg, the architect obviously sought to preserve the "classic" Gothic choir type, an architectural convention that the church would of course seek to emulate as the seat of an archbishop. The rebuilding of Aachen Cathedral choir during the same period, however, offered the chance to imitate a specific building, rather than a type. The cathedral chapter financed renovation beginning in 1355, although it is possible that building began a bit earlier than this date. The choir was consecrated in 1414.[374] Though we do not know for

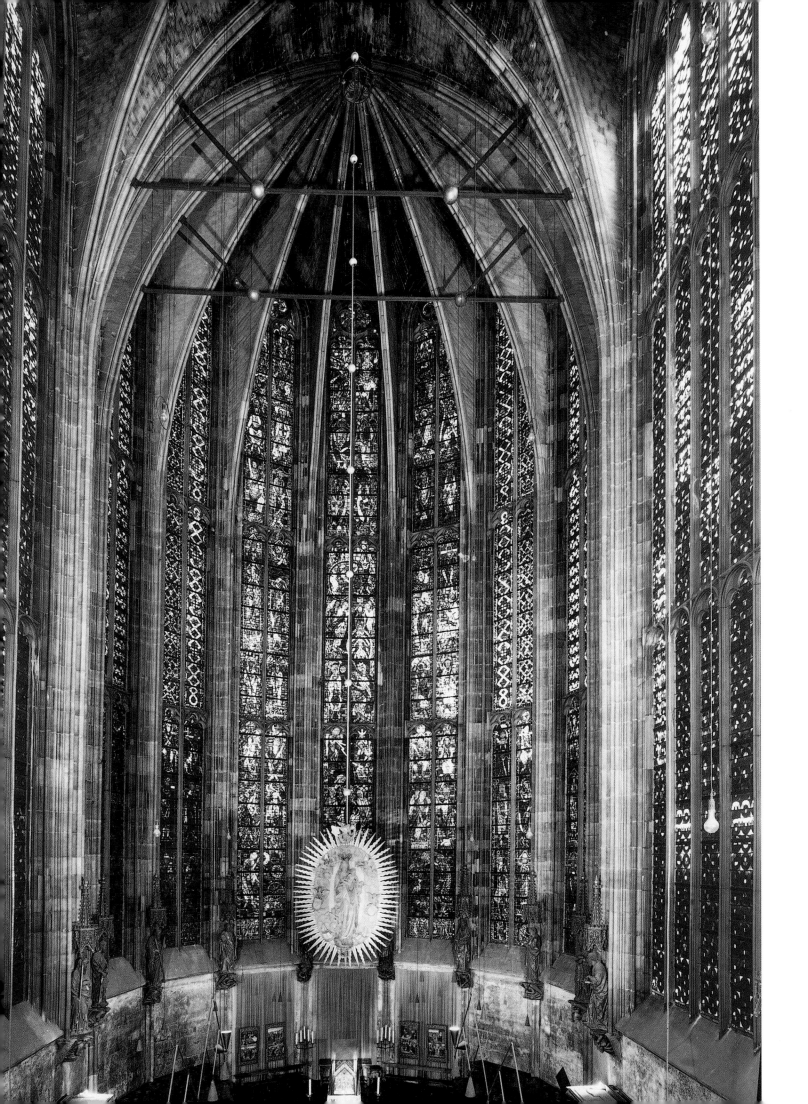

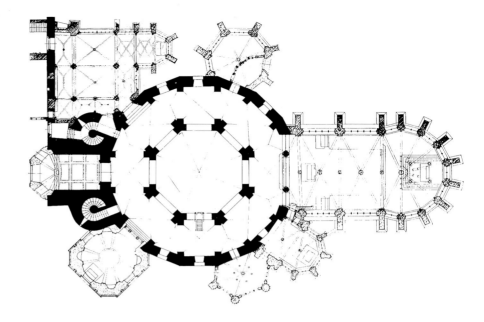

sure if Charles IV participated in the project, we do know that the choir bears witness, monumental witness, to a rebirth of the cult of Charlemagne[375] which swept through the empire during these very years, a cult that was intimately tied up with Charles IV's political ideology. Roughly concurrent with Aachen being confirmed as official location for the coronation of German kings, the cathedral chapter there decided to replace the carolingian apse with a large "glass house," as we call it today, in order to be better equipped to handle the increasing number of pilgrims visiting the cathedral, as well as future coronation ceremonies.[376] The prototype for Aachen's tall choir [128] with its profusion of windows, was obviously the upper section of Ste-Chapelle in Paris, which had been built a hundred years earlier by Louis the Holy to house a huge shrine containing the Crown of Thorns relic, which a French king had obtained from the Emperor of Byzantium. Ste-Chapelle expressed, better than any other building, the sacred character of the French monarchy.[377] Charles IV patterned his government after that of Louis the Holy and Philip the Fair, and one can probably assume that a building like Ste-Chapelle, which Charles surely knew having grown up in Paris, must have awakened in the emperor the desire to build a similar structure in the Holy Roman Empire. Like Ste-Chapelle, this church should express the historical legitimacy, and the sacred right, of his newly established monarchy.

To facilitate this, the westernmost bay of the new, two-bay sanctuary [129] was the location of the coronation and contained St. Mary's Shrine, which had been drawing pilgrims to Aachen for centuries. The polygon itself would hold the "shrine" to Charlemagne, which was sacred to the cult of the carolingian kaiser. The choir polygon consists of nine sides of a fourteen-sided figure, which creates a kind of centralized space that is greater than half a circle. Its walls are outfitted with statues of the twelve apostles, like at Ste-Chapelle, with Charlemagne and St. Mary added as the patron saints of kaiser and empire[378] respectively. Angels playing musical instruments hover at console level, both supporting the compound wall responds and symbolically lifting the entire inner structure into heaven. A globe of gold supporting an eagle with spread wings once sat atop the steep saddleback roof outside as tangible symbol for the imperial importance of the church.[379]

The choir is an unbelievably tall *capella vitrea*[380] that appears to be made entirely of glass, and which owes its stability to a five-

part Gothic ring-anchor system that locks the window tracery in place.[381] It represents a most elegant example of the Rayonnant style. The choir is attributed to a certain *magister Johannes*, the second architect to direct the building of Aachen's town hall (begun several decades earlier), and a man with close ties to the Netherlands.[382]

Aachen's choir is one of those structures that can be characterized as representing imperial architecture of a type that had not been achieved in Germany since the reign of the Hohenstaufen many years before. It can be categorized as having been conceived and built to represent a political ideal. The same can be said of the Church of Our Lady in Nuremberg, built at almost the same time. Before Charles IV had even assumed the imperial insignia and treasure (*sanctuaria sacri Romani imperii*) he had already given the order to level the Jewish Quarter in Nuremberg (on November 16, 1349) so that he might replace the synagogue with a church in honor of St. Mary.[383] The Church of Our Lady in Nuremberg, for which there are primary sources referring to its construction (1352) and consecration (1358), was designed to face the main market square of the town, where large groups of people might gather before its west façade. The church consists of a simple polygonal choir in combination with a square Hall nave of three rows of three bays each, carried by four circular piers. The central nave bay is accentuated by a ringed boss in the vaulting. The rest of the nave bosses have sculptured heads, all of which are positioned to look at the central boss [131]. A porch was added to the west front, probably after the church was consecrated in 1358. Its upper register contains a small chapel-

129 Aachen Cathedral

128 Aachen Cathedral, looking into the choir

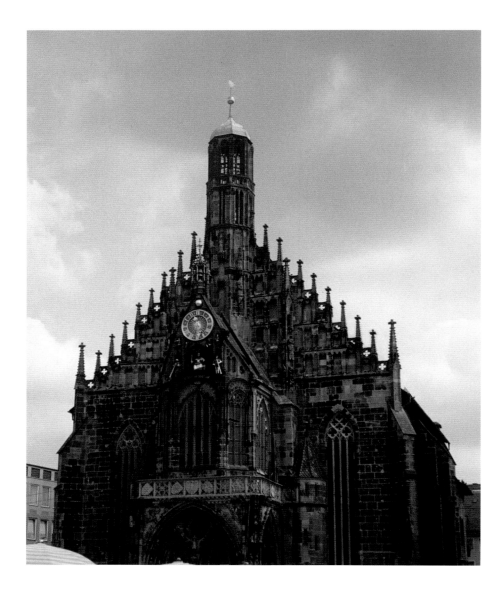

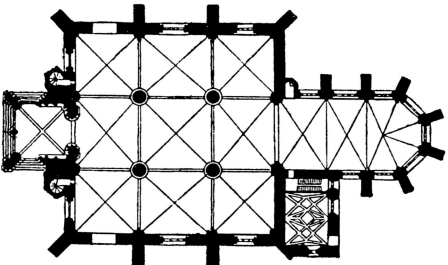

130 Nuremberg, Our Lady, view of the south-west

131 Nuremberg, Our Lady

like structure, the so-called "St. Michael's Oratory," which is surrounded on three sides by a balcony accessible via two staired tourelles on its sides[384] [130].

In an endowment written on July 8, 1355 Charles IV explained that he "built, founded and created the new church or chapel in honor of his reign as Kaiser, to honor the glorious Virgin Mary, Mother of God, and to insure salvation for himself and his ancestors, in his imperial city of Nuremberg".[385] In a function similar to the west tower with gallery at Aachen where St. Mary's Reliquary was displayed, Nuremberg's "St. Michael's Oratory" was the location for the showing of the imperial treasure once a year. The balcony balustrade has representations of the imperial eagle, Rome as the site of the emperor's coronation, as well as the arms of the imperial electorate. These are clear indications of the sacred and political importance of the site as a reliquary for the imperial treasure.[386] Nuremberg was Charles IV's favorite residence outside Bohemia. As an imperial stronghold between Bohemia and Frankfurt, home of the royal electorate, it was of the greatest political and territorial importance to him. He honored the town by entering it into the *Goldene Bulle*, a code of laws established at that time similar to the Magna Carta, which stipulated Nuremberg as the site for the meeting of the *Reichstag* after the election of each new king. After Aachen and Frankfurt, Nuremberg was the third most important city in the newly codified Imperial Disposition, and the Church of Our Lady a tangible symbol of its rank.

For years scholars have accepted the notion that Peter Parler took part in the construction of Our Lady at Nuremberg. He had been summoned to Prague to complete the cathedral there in the year 1356[387] and was already in service to the court of Charles IV when Our Lady was under construction. The boss sculpturing has been attributed to the Parlers, along with the nave's circular piers and the richly articulated west front whose lively detailed porch, oratory and gable stand in stark contrast to the smooth wall of the nave. Individual elements appear Parleresque as well: the blind half-circle arches over the windows of "St. Michael's Oratory" which are very reminiscent of the architecture in Gmünd [116]. Nonetheless, serious doubts remain about the authorship of Peter Parler here, for at the time construction began in Nuremberg he was not even twenty years old and probably too young to assume leadership of a lodge that was building a structure of such importance.

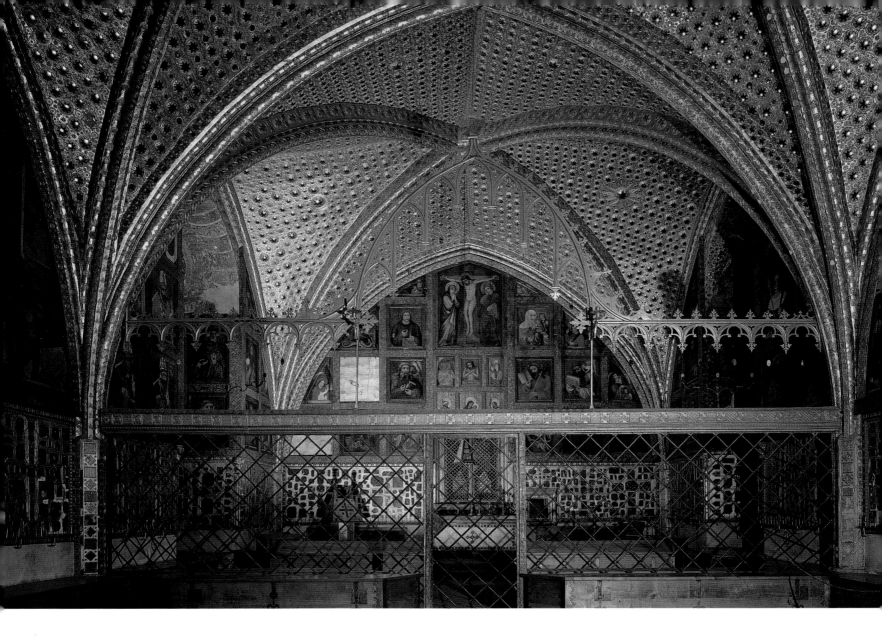

By the time Peter Parler appeared on the scene, Prague had become the focus of Charles IV's efforts to represent, through architecture, the power and prestige of his reign. Under his auspices, it became the first truly imperial residence of the Holy Roman Empire. A Bohemian town of only minimal importance, both geographically and politically, Prague suddenly found itself at the center of power in central Europe. Its path to greatness had begun a generation earlier, in 1341, when Charles's father Johann von Luxemburg donated a tenth of the revenue from the royal silver mines to the collegiate foundation of Prague for the building of a new cathedral. In 1344 the town was named archdiocese, and building promptly began on a new structure that would fulfill a three-fold function as the national cathedral of Bohemia: to honor the country's patron saints St. Vitus and St. Wenceslaus; to serve as royal mausoleum for the House of Premysliden, an earlier dynasty, and for the new dynasty of the House of Luxembourg; and to be coronation church for the kings of Bohemia.

Four years later, in 1348, Charles IV founded the University of Prague and the Neustadt. This was followed in 1360 by another expansion of the city by two large quarters, one on the left side of the Moldau, the so-called "small side," and one on the Hradschin behind the royal residence. After Rome and Constantinople, Prague had become the third largest city in Christendom[388] in just a few years.

Like Nuremberg, Prague became a pilgrimage destination for the "cult of the empire." The imperial treasure was displayed every year on St. Wenceslaus and St. Vitus's day in the Neustadt. This took place atop a large wooden platform at the market square furthest from the city center until 1382, after which it was displayed in a stone church.[389] The Kreuzkapelle, a chapel at Castle Karlstein near Prague (begun 1348), would eventually serve as permanent home to the *sanctuaria sacri Romani imperii*. This structure surpassed all previous reliquary chapels in its sheer Byzantine ostentatiousness [132]: its windows are not glazed, but set with translucent semi-

132 Castle Karlstein, Kreuzkapelle

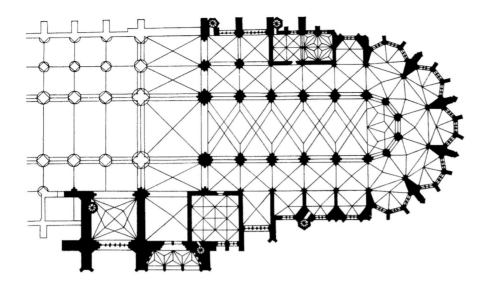

133 Prague Cathedral, choir

134 Prague Cathedral, view of the choir from the east

through art the vision of the heavenly city of Jerusalem from the Apocalypse of John:

> Having the glory of God: and her light was like unto a stone most precious, even like a jasper stone, clear as crystal...and the foundations of the wall of the city were garnished with all manner of precious stones ...And the twelve gates were twelve pearls, every gate was of one pearl; and the street of the city was pure gold, as if it were transparent glass...And the city had no need of the sun, neither of the moon, to shine in it, for the glory of God did lighten it and the Lamb is the light thereof. (Revelation 21, verses 11, 19, 21 and 23).

precious stones. The vault ribs are inlaid with gold, the vault bosses made of silver and decorated with gems. The surfaces of the vault webs are a texture of crystals on a gold background that gives the illusion of a starry firmament overhead. The walls are covered, as high as the impost zones, in jeweled tiles formed into crosses. A rhythmic pattern formed by Charles's initials–crown and eagle on a gold background– further decorates the chapel walls. Just below the formerets are the busts of saints and imperial ancestors of the kaiser. They seem to have dropped by from heaven for a look at the altar below, and at the blue, star-studded niche holding the sacred imperial treasure just above that. These heavily decorated walls form a kind of iconostasis made of jewels,[390] a luxurious and stately shrine for the empire's most precious possessions that combines jewelry and architecture in near perfect symbiosis.

The same kind of synthesis can be found in St. Wenceslaus's Chapel, placed between the choir and south transept arm of Prague Cathedral [133] and which was more than likely begun under the direction of the cathedral's first architect Matthew of Arras[391] in 1348, the year the relics of the saint were recovered. In 1358 Charles IV ordered a tomb made for the saint and that it be decorated with gold, engraved gems and precious stones. In 1372–3 the walls of the chapel were inlaid with semi-precious stones and encrusted with gold. Like the Kreuzkapelle, here too the jewelled walls resemble the outer sides of a shrine[392] – a strangely exotic housing for a saint's tomb perhaps, but intended to remove all earthly associations from his name through the colorful glistening of precious stones. Once again we see the attempt, so common in the High Middle Ages, to express

Even more important than this elegant allegorical presentation of heavenly light, which must have seemed to medieval pilgrims to rival the sumptuousness of Byzantine court art,[393] was its more mundane function of representing the power and prestige of Charles IV and his imperial city. Besides the walls of the reliquary chapels, there is also a large mosaic *de opere vitreo more greco*[394] that was financed by the House of Luxembourg in 1370/71 on the south-transept terminal wall. It depicts the Last Judgement with the figures of Bohemian patrons and the imperial founders of the cathedral. The ancient genre of "imperial art" was resurrected here to add weight to a retrospective ideal of sovereign authority, and to employ the power of tradition to validate newly founded prestige.

The hierarchical arrangement of the monuments and sculptures of the new choir in Prague was also intended to be a presentation of monarchical continuity and the sacred right of kings. Placed lowest in the choir chapels are the tombs of the dukes and kings of the House of Premysliden. Above them, in the triforium, are busts of members of the House of Luxembourg including those honored for their service to the building of the cathedral – archbishops, architects and clerical building administrators. And finally at the highest level, placed between the clerestory windows in gaps in the outermost piers, we find Christ, the Virgin Mary and the eight patron saints of Bohemia. Here the historical is placed side-by-side with the sacred in order to consecrate the present.

PETER PARLER AND PRAGUE CATHEDRAL

For the building of his cathedral choir – the cornerstone of the nave was laid in 1391, and not completed until 1861–1929 – Charles

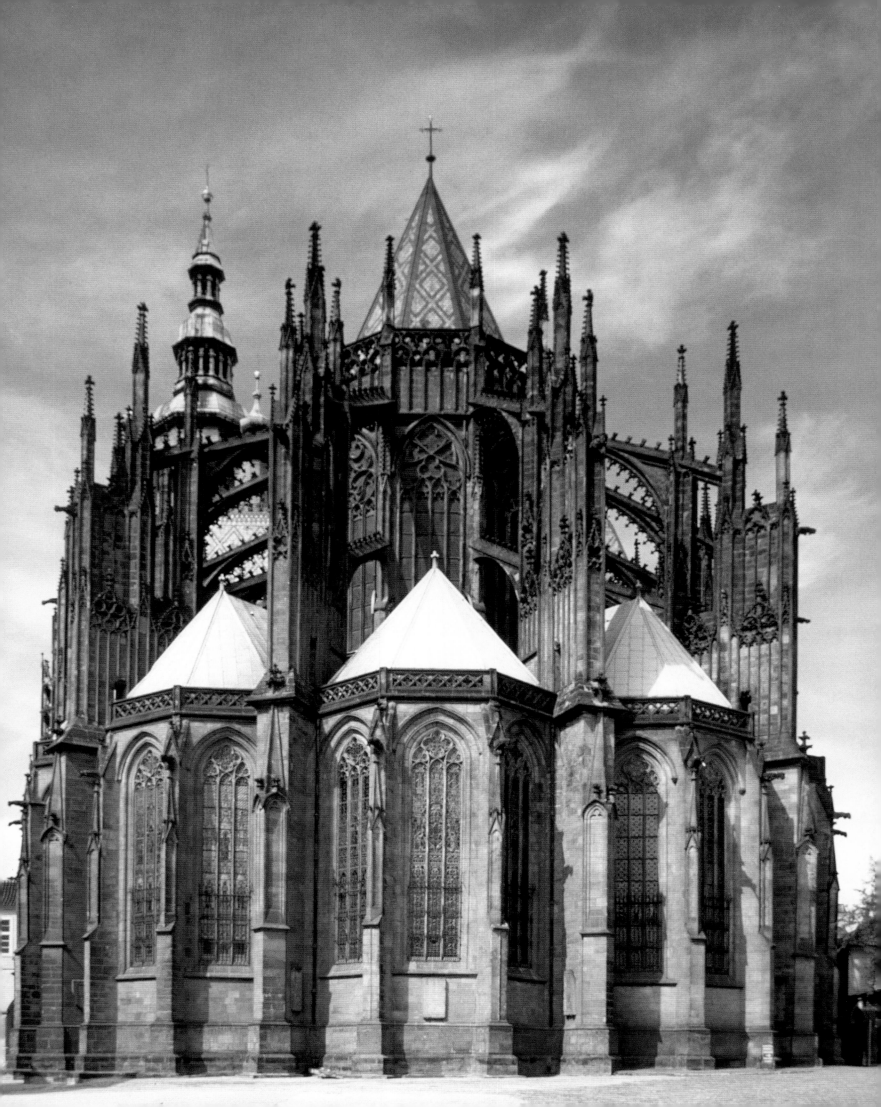

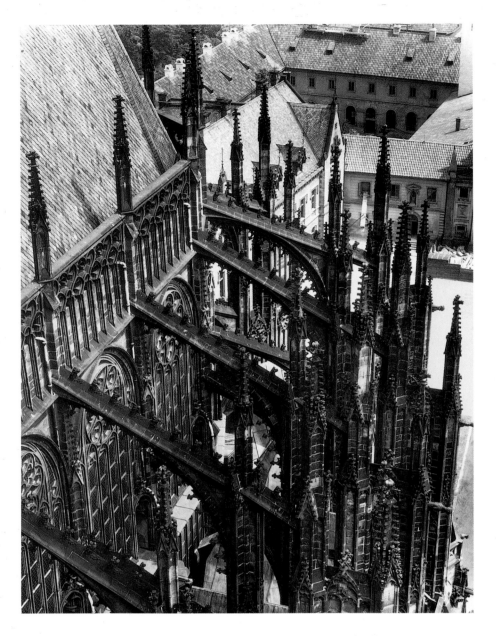

135 Prague Cathedral, flying buttresses of the choir

136 Prague Cathedral, a view into the choir

the chapel window frames in the polygon, along with a certain brittle sharpness of all its forms, are easily traceable to southern-French Gothic.

Matthew of Arras died in 1352 leaving behind a wreath of chapels, ambulatory and the sanctuary arcades almost completed, with nothing above them. Peter Parler took over the lodge four years later and completed the choir in such a brilliant way that it turned out to be one of the most important structures of the fourteenth century. Like few other architects then or now, Parler so completely comprehended the stylistic tendencies of his own time that he was able to reforge them into a cornucopia of new motifs and forms which would provide an inexhaustible source of inspiration for generations of architects.

There are many similarities between the upper registers of Prague's choir and the Decorated Style of western England, which might lead us to conclude that Peter Parler spent a year of his stonemason's apprenticeship on a study tour of England.[396] However, no primary sources have survived to confirm this, and much of what recent scholarship has been quick to label the "anglicized" characteristics of Parler's work can just as easily be attributed to continental prototypes or to individual creativity.[397] There is precious little agreement about this matter among art historians. One thing is clear, though, and that is that Parler must have been the recipient of an exhaustive and detailed education in all facets of medieval architecture.

This education must have included an intimate analysis of Cologne Cathedral's choir [43], for Parler knew it well enough to paraphrase its flying buttress system in his choir at Prague. Here pairs of buttresses shoot up between Colognesque radial chapels. They are placed one behind the other and connected to the clerestory by two elegantly arched fliers [134]. At Prague the forms seem even more graceful, the surface shaft work more elegant, than at Cologne. The upper fliers of the choir are sheathed in hanging tracery work[398] in a manner similar to the formeret arches of St. Wenceslaus Chapel. The blind tracery of its window gables are either pointed or – a form that was new at the time – in the shape of ogee arches.[399] Prague's wide clerestory windows are without Cologne's display of tracery gables. Instead, the gallery level outside has been extended downward to cover the window crowns. This creates a sheath of tracery work dominated by shafts, which encircles the top of the outer wall of the inner polygon in a panel-like coping.[400]

Yet, despite all its references to Cologne

brought the Frenchman Matthew of Arras with him from Avignon, where he and his father had been to negotiate with the curia concerning the elevation of Prague to archdiocese.[395] This was 1344. Prague's floor plan was inspired by the thirteenth century French cathedral choir type, a traditional ambulatory design with a polygonal array of chapels. And this it accomplished at a time prior to the building of the choirs at Freiburg-im-Breisgau and Augsburg. That such a design was chosen can probably be attributed to Charles's French education and the reputation of the French cathedral as a "royal church." Unlike Freiburg and Augsburg, the eastern structure at Prague is closely related to western-European prototypes; probably the cathedral choirs of Narbonne, Rodez and Toulouse. Prague's five-sided sanctuary termination, its thin and square-profiled arcades which cut into a high wall, the flat profiles of

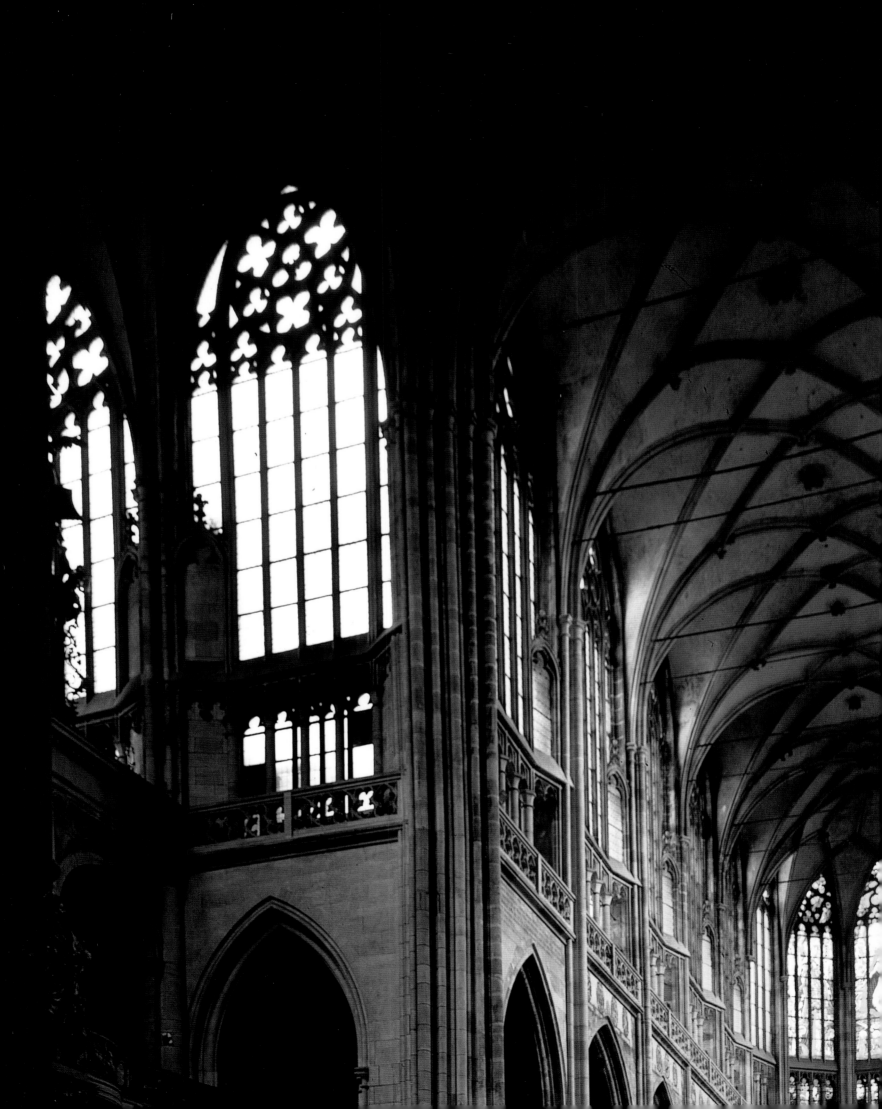

137 Prague Cathedral, clerestory and vault of the choir

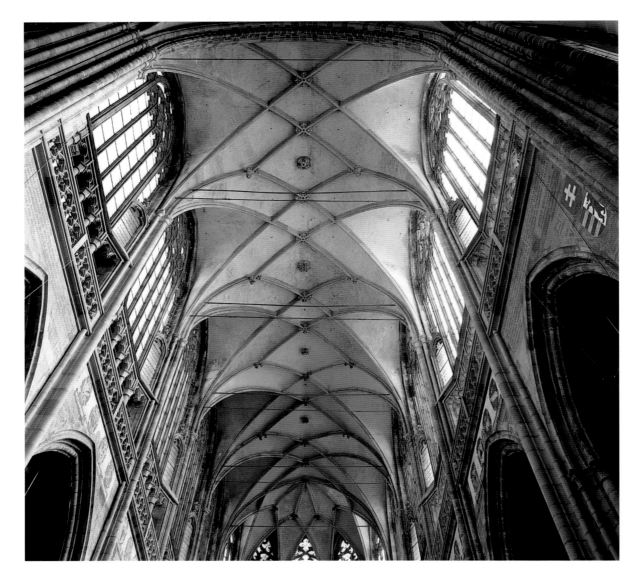

Cathedral, Prague's interpretation of structural decoration and how it functions as articulating element is fundamentally different. The strict grouping of elements on the outer structure at Cologne into systems of similar forms has been relaxed here. Parler grants more freedom of expression to the articulation of individual form. Instead of Cologne's repeated rows of forms visually linked by their similarity, Prague's choir exhibits a system of conscious variation, and an intimate architectonic fusion of individual elements. For instance, much importance is placed on the exchange between type and width of blind tracery arching on the pier buttresses. In the upper registers, mullion work is employed for contrast: the five mullions of the triforium glazing and upper wall panels contrast nicely with the four-shaft upper window sections of the clerestory.[401] Diverse elements of the choir's outer structure are fused together in an elegant and surprising manner. The pinnacles of the pier buttresses between the chapels pierce the weathering at eaves level, with their finials rising above it. The

pinnacles of the inner row of pier buttresses at clerestory level pierce the combs of inner fliers that are fused with the outer buttresses [135]. A new direction has been taken in sculptural articulation here. Individual elements are not placed next to each other, but literally grow into each other as if they were organic material.

Also amazing is the variety of its tracery forms. These are constantly recombined in a different way, which makes for a lively, almost restless surface articulation of the upper registers of the choir's outer structure: fused blind and open foiling are contrasted with rounded triangles that seem to tip to one corner,[402] and with lancet arches cut in sickle-like shapes. Tracery mouchettes, arranged in thick array, are combined to form rotating figures or, when placed on their heads or tails, transformed into "twin mouchettes".[403] These only remotely resemble the original mouchettes of the Decorated Style from the early fourteenth century. The French Flamboyant mouchette, developed at about the same time Prague's choir

was built, is more closely related to the Decorated Style.[404] It appears that Parler possessed the ability to project his own sense of form through the vernacular of English Gothic archetypes.

The upper registers of the choir interior [136] are clearly distinguishable from the lower sections by Matthew of Arras. In the long and narrow chancel, the triforium springs in a sharp point over each bundled compound respond, thus breaking out of its usual straight line and into a rhythmic articulation of the chancel as a whole. This is a motif similar to the crocketed cornice of Schwäbisch Gmünd's choir, which also springs over the wall elements [115], but at Prague it has been intensified to a panel-like back and forth movement of the choir wall. Tellingly, the motif is not continued in the choir polygon where it could not have had the same effect due to the curvature of the choir wall.[405] The chancel's sexpartite clerestory windows, their slanting sills atop the triforium like lean-to roofs, are transformed into triptych-like structures[406] by the outer lancets of each light, which follow the line below and are slanted inward. Ogee arches articulate their window-heads, so that they form what has been termed a "window within a window".[407] The result of all this is that a wave-like movement seems to engulf the entire clerestory wall on the sides of the choir [137]. But only there, for it stops when it reaches the polygon.

Besides breaking up the surface of the clerestory wall, Parler was also concerned with parallel shifts that would dissolve the Rayonnant Gothic system of linear verticality. As we have seen, the shaft work of the triforium's outer wall does not correspond to that of the outer blind arcading nor to the windows. The number of columns of the *inner* triforium is not the same as the number of mullions in the glazing behind them either. In the choir polygon, for instance, the triforium possesses three small shafts, the windows behind them four. The front shafts are placed to stand between the mullions of the glazing behind, which creates a lattice-work of shafts when seen from the nave.[408] Such methods are strongly indicative of an architect striving to employ every possible means to enliven what was, by that time, a dogmatic orderliness governing the vertical organization of articulated stone construction, inherited from the thirteenth century. He employed dissonance and altered forms, yet did so without breaking completely out of the stylistic parameters set forth in the lower register by Matthew of Arras.

This choir "rejuvenation" process finds resolution overhead in a brilliantly conceived vault. Optically, it can be understood as having developed out of the form of the cross-rib vault over a transversely placed rectangular bay, but its construction is completely different. Here is a Gothic vault superstructure that is no longer based on a series of intersecting pointed-tunnel vaults divided into cross-rib bays by transverse arches, but rather a tunnel vault long enough to span the entire ceiling of the choir, which in cross-section is semi-circular due to the acute angles created by the low formeret vault webs that penetrate it on each side. This construction is a necessary prerequisite for its system of rib figures, which is essentially a doubling of the Gothic cross-rib form, but without transverse arches. It is a "parallel rib vault" that forms two distinct figures, both at the same time: it can be seen as open scissors straddling the transverse borders of each bay, or as shifted pairs of parallel ribs that spring in nearly opposite directions from the tops of the responds, and whose crossing at the crown of the vault forms a chain of large and small rhomboid figures. In the choir chevet, this net vault breaks into a half star that is formed by overlapping triradials.

As though he wanted to prove the stability of his new vault construction, Parler placed huge foliage bosses at the crown of the webs precisely where they would have no ribs whatsoever to support them. Because they are at the *edge* of each bay, rather than in the middle, these boss structures contribute aesthetically to the breaking up of vertical delineation. Parler's system of overlapping vault figures breaks the mold of the Gothic vault and its system of rhythmic rows of bays. The vault also contributes to the process by which the choir is fused into a cohesive articulated space. He does this by employing the basic tunnel-vault form, then shifting the center of its bays in relation to the vertical delineation below through a brilliant employment of parallel-rib vaulting, a design that probably could not have been achieved without a knowledge of western-English prototypes with similar vault solutions – like the choir vaults of Wells Cathedral (1329–45) and at Ottery St. Mary (*ca*.1337–42).[409]

Before the choir vault was completed at Prague Cathedral in 1385, Peter Parler had already built the square bays and vault of the sacristy (1362) [138] and St. Wenceslaus Chapel (consecrated 1367). He had already vaulted the porch of the south transept (1367/68) [139,140] as well as the gate of Altstädter Tower (1370)

138 Prague Cathedral, "hanging vault" over west bay of the sacristy

139 Prague Cathedral, vault over porch of the south transept portal

[141] at the end of the Moldau Bridge. These smaller vaults are no less innovative than that of the high vault of Prague's choir. All of them bear witness to a breakdown of the vault webbing into small fields, which facilitated a shortening of the distance the ribs had to span and allowed for a very high impost placement. This resulted in an increase in height of the space below the vault.[410]

The vaults over the sacristy and Wenceslaus Chapel each form two different shapes within the same vault, in a manner similar to the choir vault. They are built around a ribbed figure, turned on its axis 45°, which overlaps a figure that is not turned. Over the west bay of the sacristy, a square rib-figure is turned to overlap four small cross-rib vaults. In the east bay, a four-point rhomboid overlaps a figure that creates two sets of opposing triradial pairs. In both of these vaults, the ribs split off near the crown in a kind of free fall, then come together – perhaps in a way similar to the collapsed vaulting of St. Catherine's Chapel in Strasbourg[411] – to form skeletal hanging pendants. In Prague's Wenceslaus Chapel two cross figures, each made up of parallel ribs one turned 45° in relation to the other, are projected onto the vault.

The south-transept porch and the Altstädter Bridge tower possess vaults consisting exclusively of triradials, and are therefore more closely related to the type of vaulting that had developed out of chapels, crypts and chapter rooms during the first decades of the fourteenth century.[412] The south-transept porch is a good example of that typical Parler habit of presenting contrasting elements in a single vault structure. The two piers of the triple-arch outer portal [140] and the single trumeau pier of the double-arch inner portal form the corners of an equilateral triangle. Above the two outer piers are half-rhomboid umbrellas whose spikes overlap and seem to fill the entire space, which is funnel-shaped in plan. Pushing against these are the flying ribs of the trumeau, over which the rhomboids of the outer umbrellas shoot up to the crown of the inner portal arch. The flying ribs of the trumeau's umbrella – projected as they are directly into the star-like figure created by the two umbrellas above it – form a structure closely resembling a stellar figure with a hanging pendant. Here, then, is a textbook example of a vault solution that consists of contrasting figures, the umbrella and the star, fused into a single vault by the motifs that they share.

The vault over the gate of the Moldau Bridge tower [141] is a doubling of the thirteenth-century "jumping vault" system, which consisted of pairs of rhomboids created out of triradials set

in a mirror image to one another. A doubling of the figure here causes the rhomboid pairs to touch at the crown of the funnel-shaped vault shell, thus forming two rows of figures in a continuous zigzag pattern similar to the choir vault of Prague Cathedral. Together with the choir's parallel-rib configuration, this "jumping rhomboid" vault would form the basis of many of the lierne vaults to follow, whereas the staggered umbrella and stellar motifs of the south-transept porch would be the catalyst for the development of stellar nets and umbrellas with staggered impost and pier positions. In fact, Parler's designs would supply all subsequent central-European Gothic net vaults with prototypes. From this moment on, German vault *constructeurs* would try to outdo one another in designing complicated, multi-figure net vaults. Such a healthy atmosphere of competition could never have come about, had it not been for the practically inexhaustible pool of ribbed figures available to architects during the Late Gothic period.

If we look at all the advancements introduced by the young court architect at Prague Cathedral, an "enlivening" of the traditional Gothic building type via contrast and an expressive variation of its parts seems to be one of the most important.[413] The fusion of disparate elements in the flying buttress system, the various kinds of shaft and tracery work, the "triptyched" clerestory wall, axial shifts and the motif of the staggered rib figure in the vaults. These reveal a joy in the manipulation of form, a hankering for the artistic presentation of contrasting elements and a desire to modify tried-and-true motif combinations, while now and then playfully intensifying certain of their architectonic values.

At the eastern edge of Prague's south transept [139] is the culmination of Parler's emphasis on freedom of design, for here we find a functioning stairway built into the one of the corner buttresses. The hollowing-out of the buttress mass in order to insert a stairway resulted in a surprising symbiosis of two completely different structural elements. Because the corner buttress is "stepped", that is each register as you rise is smaller than the one below it, the three separate stairway levels do not rise straight up, one directly over the one below, but each level is placed slightly inward. The stairs, along with the tracery staircase holding them, were made to change directions with each new register. Parler designed the entire staircase around this threefold break in both the vertical axis and in the axis of ascension. The result is optic destabilization that was probably meant to emphasize the tower's already fragile appearance.

Thus the humble stairway – until then a functional element only, and one that the orthodox canon of Gothic façade construction would never have considered important enough to emphasize – plays a major aesthetic role in the form of one of the most visible sections of Prague Cathedral. Parler courageously altered the traditional Gothic hierarchy of structural elements here, reflecting in a brilliantly unconventional way on the relationship of form to function. It was a well-versed variation, characteristic for a new "Parlaresque architecture" which was no longer exclusively concerned with representing the principles of scholasticism

140 Prague Cathedral, view from the south

141 Prague, vault of the gate of the Moldau Bridge Tower

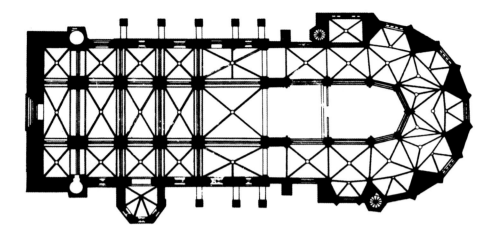

142 Kolin, St. Bartholomew

through the catharsis of architectural metaphor. Instead, it served a structural and secular *Symbolik* that found expression by divesting structural elements of their sacred context, then placing them in a new kind of architectonic environment so that the traditional values they invoked seemed to find their voices in a different language.

Peter Parler's work in Prague can best be characterized, then, as being highly individual. To his fellow medieval architects, his structures must have verged on the exotic. Regardless of this, or perhaps because of it, his influence, especially on the architects of southern and central Germany, would be tremendous.

Yet Parler was equally up to the task of employing more modest stylistic designs. He was able to adapt his own individual pool of forms to whatever building he happened to be working on, regardless of its function or size. An example of this can be seen in the parish church of St. Bartholomew in the town of Kolin-an-der-Elbe, whose choir Peter Parler built in the years 1360–78 onto a three-aisle Hall nave[414] [142]. The rich variety of forms employed at Prague cannot be found in Kolin, regardless of how hard one looks at its detailing. In place of Prague's complicated wall structure, Parler gave Kolin a modest double-register elevation system, very simple profiling and cross-rib vaulting. The floor plan can be placed on the list of that mid-fourteenth century family of choirs with ambulatory, in which the number of sides of the inner polygon differs from those of the outer polygon, and whose chapels appear like niches between the pier buttresses of the terminating wall.

Kolin's angular spiked piers, the "filing down" of its outer choir wall and the fact that its pier buttresses are pulled completely inside to form the walls of the chapels, can surely be traced to the choir at Gmünd. Other than that, the structure is a complete departure from the

first Parler building in far away Swabia, for basilican hierarchy is retained in the elevations of its sanctuary, ambulatory and chapels. The chapels themselves terminate in the polygon with three sides each, sides which are not visible in the outer wall because the space between each chapel is filled by the wide side of a triangular pier buttress. The outer sides of these are unarticulated and form surfaces between the chapel windows that are even smoother than the closed outer-choir wall at Gmünd. Kolin's outer choir communicates a more massive and stable construction because of it.

The inner sanctuary terminates in a single pier that is placed exactly at the end of the nave's longitudinal axis [143], just like the radial-chapel termination of the choir at Freiburg Cathedral, built by Peter's brother Johannes[415] [125]. The geometrical relationship of this "choir-terminating pier," and the eastern-wall piers of the ambulatory, is quite similar to the triangle of piers in Prague's southern transept portal [140]. Parler seems to have taken the opportunity in Kolin to employ the same vault form as the south portal, without the flying ribs. It is also slightly warped due to the angle of the ambulatory. The motif of the "choir-terminating pier" is the most important development to appear in Kolin. It would soon be employed to excellent effect in the work of Hans von Burghausen, one of Bavaria's greatest architects.

The second half the fourteenth century saw the culmination of Gothic choir building in Germany. In most cases these choirs were not part of a completely new structure, nor did they come about at the end of a long building project from west to east. Most of them replaced older choirs and were built as terminations to naves and transepts that were already standing.[416] This is an indication of how much importance medieval builders gave to the choir as *sanctuarium* of the church. Were financial resources available for a large renovation, the money was often used to renew the most important section of the church. That more and more parish churches were equipped with ambulatories can be attributed to the growing power of the burgher classes, whose donations often financed chantry priests to celebrate mass, and whose memorial epitaphs were intended to display the family name as close to the main altar as possible. Choir aisles offered enough room for the honoring of such donors. That is why we find complicated choir extensions – whose designs were often independent of the forms of the rest of the church – being built during the second

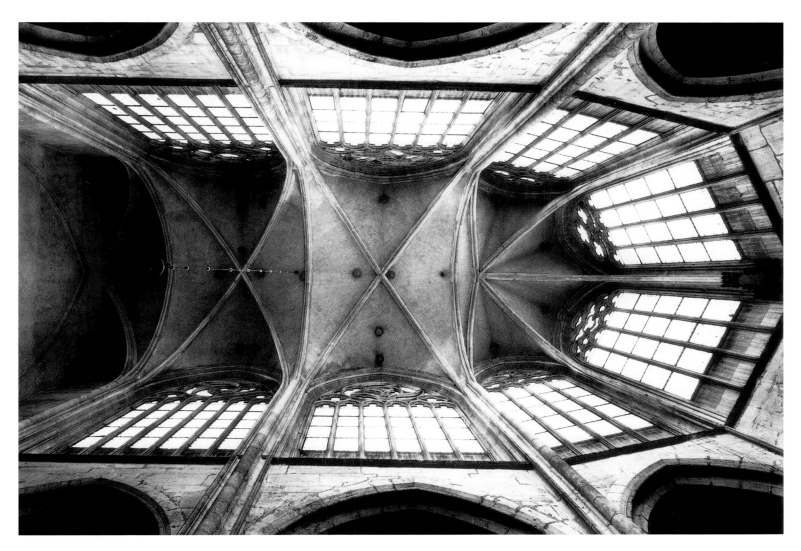

143 Kolin, St.
Bartholomew, choir
clerestory and vault

half of the fourteenth century. The choir with ambulatory, because of its nearly inexhaustible variety of possible forms, would remain one of German Gothic's most important architectural undertakings.

There were large tower projects during the late fourteenth century as well. Town halls in Flanders, the Netherlands and the lower Rhineland received huge towers at this time. Single-tower parish churches, most of them in the western parts of the empire, soon became pet projects for the elite burgher classes. This occurred years before the Ensingers and the third generation of Parlers undertook the gigantic tower projects (after 1400). Freiburg might have provided inspiration for many of these structures,[417] yet many towers – and not only those in the Backstein region, which had expanded far to the south by then[418] – were built with little reference whatsoever to the elegant filigree style developed by the great lodges at Freiburg, Strasbourg and Cologne. A good example would be the west tower of Überwasserkirche (1363–1415) [144] in Münster; it expresses the Flemish-Dutch practice

of tectonically fusing different articulated styles, which is easily comparable to the stabilizing wall articulation found in the choir systems of Gmünd [116], Colmar [118] Berlin or Kolin.

Überwasserkirche's square tower consists of five individual cubes which, for lack of extensive ornamentation, are not fused into a whole. Slight modulation is achieved by its hollowed-out blind tracery work which, however, does not sufficiently diminish the structure's square and block-like contour. Only the belfry, articulated by small corner turrets, diverges from this scheme. The only sculptural details are canopied figures placed before the west wall and the belfry level, and which frame the windows. Canopied figures can be found between the windows on the same sections of the town hall façades in Aachen (1300–70), Bruges (completed 1387), and on the tower of Cologne's town hall (1407–14).[419]

It is interesting to note that groups of canopied figures appeared about the same time in the repertoire of Strasbourg Cathedral lodge, the administration of which had been in the hands of the town council for several decades by

144 Münster, Über-
wasser parish church,
view from the south-east

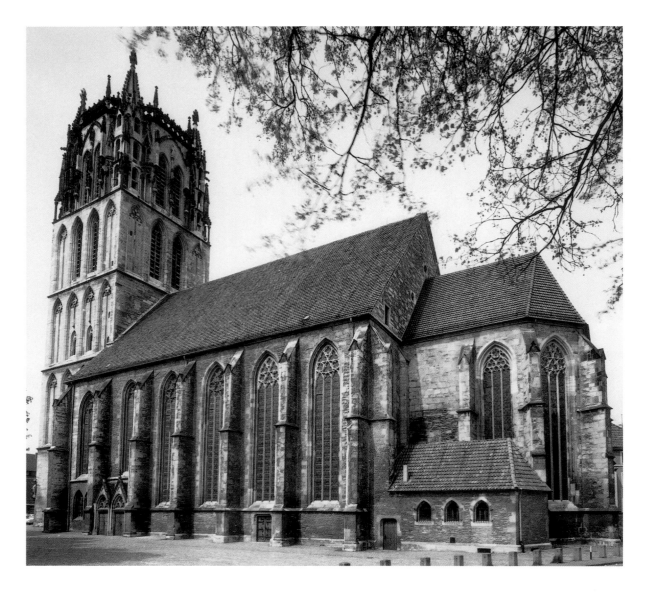

then. Designed no later than 1365 and completed under another Parler, Michael of Freiburg[420] in 1383, the canopied figures of Strasbourg's belfry register are placed on the sides of the two large triangular-gabled windows between the tower bases, lending a stable, even powerful contour to the upper-middle register of the façade.[421] The façade style of the belfry level diverges from the older façade sections below it, its smooth unbroken wall surface possessing neither free-standing nor attached tracery work. On its blank surface, and on the equally smooth surfaces of the window spandrels, are sculptured figures from the Last Judgement that appear to be clipped on to the tower without a secure base. In contrast to the registers below it, the sculptural program here steps out of the façade's usual shadowy niches and hollows. The three-dimensional representation of the human figure has once again appeared in front of a closed surface background. The closest example of this phenomenon is Prague Cathedral's south transept, which retains a smooth, unadorned wall surface

as background for a planar style of art – a mosaic representation of the Last Judgement.[422]

This, then, was a period dominated by the Parlers. It can be characterized as having contributed, not only to a process that strove to perfect the strict precepts of Rayonnant Gothic (Aachen Cathedral choir) and its free interpretation in a variety of formal structures (Prague Cathedral), but also as a period that witnessed the rediscovery of the wall surface as an aesthetically valuable element in and of itself, or as a background for artistic display. Even the lodge at Strasbourg – that guardian of a pure tracery style – set off briefly in this new direction when the belfry register was built. With it, the oft-employed method of evoking contrast by dissolving and consolidating the wall surface, by filigree articulation and clarifying simplification was not only continued, but raised to a higher level of complexity as well. For the architects to follow, this very creative phase of German Gothic provided once again a rich source of diverging styles to chose from.

The Fifteenth Century

LATE GOTHIC

I SHALL NOT even attempt to date the advent of the High Gothic in Germany. Opinions are so divided on the subject that there is no consensus whatsoever. Stylistically, the earliest Gothic structures in Germany have French prototypes like Reims and Amiens, and are thus High Gothic. On the other hand, many of these same churches are difficult to define chronologically because they were under construction over a long period of years that stretched from the Late Romanesque to the Rayonnant period. Even Dehio's "flexible" period chronology, with its three phases of Gothic assimilation, is singularly incapable of giving a clear picture of the advent of High Gothic in the empire. At most, Dehio is helpful in differentiating various *types* of assimilation. Gross's concept of a "purified" Gothic that appeared around 1300 – which he defines as a "Renaissance-like" style – contributes just as little to clarifying matters as Swoboda's differentiation of a "heroic" Gothic of the thirteenth century and an "ascetic" Gothic of the fourteenth.[423] Generally speaking, the large number of buildings constructed during the period preceding the Parlers makes classification difficult. Most attempts to do so have failed, and the concepts that stem from them are not very enlightening.

On the other hand, scholars are pretty clear about when the Late Gothic began in Germany. Of course it took years of debate, but they seem to have agreed on a date of around 1350. This date comes from an older theory having to do with the appearance of the German Hall church. It proclaims Heinrich Parler's choir at Gmünd as the pivotal building of a clearly definable epoch, one that German art historians early this century called the "Nordic Renaissance" and set next to the Italian *quattrocento* in importance.[424] Among these, Kurt Gerstenberg delivered the most impressive analysis with his *Deutsche Sondergotik* (German special Gothic), a concept clearly tainted by the author's nationalistic impulses,[425] for it was his expressed goal to locate and define a specifically German architecture that stood out from the rest of European Gothic.

His work had a great impact on subsequent Gothic research, even though the core of his interpretation – that the Late Gothic Hall was dominant over all other structural types, and that it represents a golden age of a Germanic "race" – was long ago discredited as being one-sided and culturally chauvinistic. The terminology Gerstenberg used in describing the development of the Hall as a specifically German style seems almost expressionist to me when I read it now – he writes of spatial delineation as if it arched or flowed, of profiles that are blunted, of subtly toned spaces, even of interiors with the atmosphere of a painting. Many of these expressions have since become standard terminology for Late Gothic scholars writing in German. Even Ullman, who consistently argues from the opposite ideological standpoint as Gerstenberg, is not able to escape the use of his terminology. Ullman not only has the same date for the end of the German Late Gothic, he also adheres to Gerstenberg's concept of the teleological development of the Hall into a "unified space".[426] But Ullman fuses it with another concept, namely that Hall development moved towards a more naturalistic kind of art in a time that was "early burgher, pre-Reformation and pre-revolutionary," and thus reflected a move away from a theocentric to a more anthropomorphic world-view.[427] Ullman seems to have taken the old definition of the Late Gothic as "Nordic Renaissance" and projected it through his own historical materialism.

The date accepted by almost all scholars today

for the advent of the Late Gothic in Germany, 1350, is based on a study of questionable merit that was conducted on the development of the Hall church. This study encompassed a huge span of years in the history of architecture, and those reading it for the first time will be surprised to learn that a 150 year-old architectural style already in its late phase continued in that phase for another 150–200 years, as though it remained "old" for 350 years! Gothic scholars have struggled to conceptualize and define such a long span of years as a congruous entity.[428] The subject also groans under the weight of a huge collection of period definitions, which have been bandied about like attributive paraphrases[429] in the struggle to classify the German Late Gothic as a style all its own. The first studies that attempted to do this were undertaken in the nineteenth century, when love for Gothic architecture first surfaced in the modern era, and the Romantics sang praises to the Gothic in their poems. The nineteenth century interpreted the architectural forms from the fourteenth and fifteenth centuries in a variety of ways: as symbolic for a general cultural decline (Schlegel 1805, Schnaase 1834, Ruskin 1849, Renau 1862), and as a "Nordic Renaissance" (Schmarsow 1899, Haenel 1899, Niemeyer 1904). In this century it has been defined as the first phase of European Baroque (Riegl 1905), as earthy "burgher's realism" (Clasen 1937), as a decorative prosthetic dynamism (Weise 1932, 1943, 1949, 1950), as Mannerism (Grodecki 1947); as royal, retrospective, realist and anti-realist (Krautheimer 1925, 1956, Panofsky 1933, Swoboda 1939, Heydenreich 1937 respectively).

None of these concepts is completely off the mark, and yet all of them elucidate but one facet of the total picture of the period after 1350. Taken together, they leave one a bit overwhelmed and indeed, this very characteristic lead Dehio to state that the Late Gothic in Germany reflects no systematic development whatsoever.[439] However, he was lead to this by his own stylistic model, which understood the history of German architecture up to 1350 as paralleling a step-by-step unfolding of a Gothic "system." If, however, in place of Dehio's uniform stylistic parameters one sees the period as having developed pluralistically, then the multiplication of "systems" after 1350 – which resulted in the very different stylistic directions taken by the Late Gothic – is less difficult to understand.

However, this proliferation of styles has understandably befuddled scholars of German Late Gothic. It inspired Fischer's ironic statement that "on the middle Rhine everything grew into everything else" which was a subtle reference to Dehio's notion that Württemberg was the "clipped and cultivated garden of the Late Gothic".[431] Indeed, the very concept that there were pure stylistic characteristics during the first decades of the fourteenth century – exemplified by the articulated style of Cologne and Strasbourg, and in the reduction of form in the box-like rooms of the Dominican churches in Colmar and Gebweiler – cannot be applied to what was being built just a few decades later. Obviously, the traditional pool of Gothic forms became larger and more complicated during these years. Surely this can be attributed to the fact that older stylistic characteristics were never completely rejected by German builders, but gradually became part of local architectural traditions and were compiled into newer styles. Any scholarly attempt at understanding the Late Gothic that ignores traditionally defined stylistic period delineation runs the risk of being even *less* successful the further it gets into the fifteenth century. Stylistic development, normally brought about through the exchange of older for newer forms, occurred much less than would normally be expected during these years. The catalyst for change came about through a process of expanding the existing pool of forms that were available at that particular moment, and in the materials used to express them. As a consequence, German architects had a wide spectrum of suitable modes of expression available to them.

Robert Suckale revealed the inherent fallacy in projecting the work of medieval architects through our modern notion of the "unified personal style," the notion that we see an architect's "handwriting," his "style," in all the structures attributed to him. Peter Parler, for instance, applied many different modes of expression in his work. He seems to have possessed the ability to find a suitable form for his structures, not out of a well of personal invention, but in the tradition out of which that type of structure sprang.[432] The same architect to cultivate a full-bodied sculptural style in the clerestory of Prague Cathedral [137] and who stopped at nothing to set the fusion of these forms into a dynamic movement, also built St. Wenceslaus Chapel as an architectonic shrine that bears witness to the calming spatial effects of a filigree, almost crystalline style. At the choir at Kolin [143] he softens the pathos of Prague's clerestory by simplifying its opulent use of forms and renouncing completely its virtuoso display of detailing. His design for All Hollows Chapel on

the Hradschin is steeped in the tradition of the royal palace chapel set down by Ste-Chapelle. The Altstädter tower on the Karlsbrücke employs elements of traditional medieval fortification construction. Parler's structures – catalyst for architectural innovation in southern Germany in the fifteenth century – not only pointed architects in a specific direction, it also gave them the confidence to go their own way.

If I were to boil down German Late Gothic to a common denominator, it would probably be "stylistic pluralism." I do not mean to imply that all types and forms drifted apart in a process without rhyme or reason, for there were in fact identifiable phenomena that determined what occurred in certain regions. Chief among these were structures of a polyphonic, fifteenth-century stylistic "avant-garde" whose achievements can be seen in the radical departure of their designs from traditional late-medieval artistic practices. The greatest impetus to innovation was the buildings in Prague built by Peter Parler. Their systematic program of terse relationships, expressed through a virtuoso application of the articulated style, became a central theme of Late Gothic design in Germany. Its most important modes of expression would be axial shifts or splits, a fusion of hitherto disparate structural elements, the staggered and surprising placement of structural elements, fragmentation, and a purposeful blurring of prototypic reference. With the implementation of these modes of expression, a genuine metamorphosis of Gothic attitudes took place that was at times radical, and at times barely noticeable. What had been a reproducible system of abstract and interchangeable forms expressed in ashlar, now became a system that emphasized free invention and the individual interpretation of form. One of the main reasons stylistic development in the German Late Gothic went the way it did, was the architect's readiness to emancipate his plan from the restrictions of a stereometric design geometry that had, for years, been determined by established rules.

A large number of Late Gothic sketches have survived and are in the collections of today's cathedral lodges, and it is possible to trace the step-by-step evolution of building designs from the period. A large body of at times very different workshop and pattern books has also survived. All of these bear witness to the steady refinement and virtuosity of Late Gothic technical drawings that supplied the two dimensional basis for entire construction projects.[433] After studying these collections, many neo-Gothic scholars from the Romantic period were con-

vinced that the entire Gothic church – from the proportions of the ground plan and vertical elevations, to the smallest of details – was based on a complex and proportionally uniform geometric system that was standard in all Gothic churches, and which was kept a guarded secret by the masonic construction lodges across Europe.[434] This theory has not stood the test of time, of course, but there can be no denying that – besides simple arithmetic calculation of proportion, form and mass – common geometric figures like the square, triangle and circle also played a role in Late Gothic design.[435] Manuscripts like Hans Schmuttermayer's *Fialenbüchlein* (around 1485), Matthäus Roriczer's *Büchlein von der Fialen Gerechtigkeit* (1486/88) or Lorenz Lechner's *Unterweisung* written for his son Moritz (1516) testify to a highly developed culture of artisanship, of simple men using construction techniques founded on the collective knowledge that centuries of experience had amassed. On the other hand, we look in vain in these manuscripts for theoretical reflections.[436]

NEW PATRONAGE AND THE LATE MEDIEVAL CONSTRUCTION INDUSTRY

Any summary of building activity in the empire between 1350 and 1550 will have to consider a large number of structures. The number of churches to have survived increases the closer we get to 1550 and, in fact, the majority of Germany's Gothic structures come from the period. Of primary importance to the period was the growing economic power of the cities and that the majority of great churches built in this 200-year period were parish churches, mendicant or *Kartäuser* churches built in cities and towns. Some were city hospice churches, or churches built by charitable foundations. Patronage for these came, for the most part, from an increasingly prosperous and ambitious merchant class. This is not to suggest that the aristocracy was no longer influential in collegiate foundations or cathedral chapters, or that they were not members of the urban ruling class. They were, of course. Rather, the reasons behind the design and building of great churches – whose display of forms continued to offer the opportunity for representing selected ideals and beliefs – were now those of the city.

This was a time before local government as we know it, and the parish church served not only for the reading of Mass, but housed the institutions of local rule as well. Some churches held municipal courts and served as a meeting place

for the town council. Some stored official documents, hosted the local market,[437] were used for important diplomatic functions and for the festivals of local guilds.[438] Church galleries housed libraries.[439] Church towers were landmarks. They kept time with the ringing of bells and served as a fire watch. In those eastern cities founded relatively recently by the Teutonic Order, both church and market square were built in the center of town. In northern and central Germany we find basically the same thing, with the church most often facing the market square and the town hall always near by. In southern Germany, on the other hand, a block of houses usually separates the church from the marketplace, creating a separate site for ecclesiastical activities. Both these constellations clearly show that the late medieval town understood its communal function as being both economic and spiritual.

These two functions met, as it were, in the parish church where we find epitaphs and tombs of the town's growing merchant class. Church space was used to display altar donations as well, and parish churches with forty or even fifty altars were not uncommon – altar donations were a favorite way to raise money for church construction.[440] A large and richly decorated house of God increased the reputation of a city. In fact, churches were the measure by which towns were compared to each other, and were a symbol of economic and political independence. There are many primary sources expressing this facet of the late medieval world-view. Paradigmatic would be the 1488 tract written by Brother Felix Fabri concerning Ulm Minster:

> It did rise, the structure, under the work of their hands and in 111 years, namely from its foundation in 1377 until now 1488, there appeared a church which will inspire all peoples and times to amazement and wonder. Nay, even more than the wondrously huge structure itself, the observer will wonder at the nobility and audacity of them who conceived it. For in this small town they have dared – without seeking support from outside, without help or the need to beg – to erect a building whose incredibly tall bell tower riseth this very day to the honor and glory of the majesty of God, as though it seeketh to reach heaven. First, it be a larger parish church than any other parish church; for it is neither a collegiate church nor a Bishop's seat nor an abbey church, but a simple parochial church, larger than many cathedrals and

more beautiful than the seat of a Patriarch Second, this church is more beautiful than all others; perhaps not in wall decoration, or flooring, stone sculpturing, its wall painting or woodwork. Nay, its beauty be much more in the glory of its light. Verily, I have seen many churches which are more beautiful in their artistry and the quality of their materials, but no church that I have seen has such a flood of light and be as bright as this one. For here are no gloomy corners, no angles covered in shadow, no musty dark spaces common to other churches. Neither does Ulm have hidden chapels, for they are all accessible and bright. Third, it has more altars than any other parish church, namely fifty-one, each with sufficient sponsors and funds, but not from amongst princes or dukes or foreign dignitaries, but from the good people of Ulm itself. These are both patrons of the church, and collegiate of the altars. Some altars have three, four or even five sponsors.[441]

Even more impressive than the number of new urban churches were the number of parish, monastery and pilgrimage churches built – sometimes astoundingly large – in rural areas of the empire. In the fifteenth century only ten to fifteen percent of the population lived in the three thousand towns and cities within the imperial protectorate. Of these towns, only two hundred had more than a thousand residents.[442] So many rural churches were built in the fifteenth and sixteenth centuries that they comprise the majority of sacred architecture to this day.[443] The building of a Gothic church was often the first example of stone construction in that area. Gothic was the first architectural style of the Middle Ages pervasive enough to reach into the farthest corners of the empire, in the process turning almost every village into a construction site. Surely this explosion of build-ing activity promoted the spread of cultural "centers" in some regions. Yet *why* the countryside was developed to such a degree architecturally remains a mystery, considering that the labor pool was constantly being depleted, as much of the population moved from the countryside to the cities due to a series of bad harvests.[444] It would be a mistake to ignore the influence rural church construction had on the general development of architectural style, especially in southern Germany which played an important role in the history of figured vaulting.

This increase in building projects caused

what was in effect a reshuffling of the entire building industry.[445] Until the Late Gothic period, medieval construction lodges had grown up around great cathedrals and monastery churches. Most of these were managed by high-placed clergymen who directed the full time activities of stonemasons, smiths and carpenters. Nevertheless, most lodges depended on seasonal laborers, who early on were organized into town-based guilds. With the number of new churches, there was a strong demand for experienced, unskilled laborers and it was not long before the entire medieval construction industry in Germany had been organized according to skill and social position, a system that was not always free of artistic disputes and power struggles between the lodge management and the workers guilds.[446] The lodges were a lucrative source of income for the masters of the guilds, as they were called. Lucrative building projects were often secured through the town council, where sat many a guild member. In fact, administration of many construction lodges eventually fell into city hands. Between 1332 and 1402 the stonemasons of Strasbourg Cathedral formed a guild with men of the town who were skilled bricklayers, after which the lodge and the city's artisans guild were in reality the same organization. A similar thing occurred in Regensburg where stonemasons of the cathedral lodge joined the local bricklayers and masons guild in the middle of the fifteenth century. However, such fusions of artisans and skilled laborers into a single guild seems to have been the exception, and stonemasons seemed to have been able to retain a relative independence from local organizations. As specialists able to sculpt pieces of ashlar prior to placement in the wall – either according to a large stencil-like form or freely composed – they usually found temporary employment, and only at those work sites using ashlar and in need of representative sculpturing. And not only that, such costly projects were plagued by financially lean times, which caused long breaks in a stonemason's work schedule.

The average medieval stonemason, then, was forced to migrate from one project to another for his entire life, whereas the guild-member bricklayer was usually a journeyman only for the last year of his apprenticeship, after which time he settled in a town and entered the service of a master. That is why the stonemasons were organized into an inter-regional "brotherhood." This organization was similar to the guilds. It controlled questions of training and work conditions, and dealt with problems that might come up between members. Through the raising of membership fees and fines the Brotherhood of Stonemasons, as it was called, was able to support the more needy among the rank and file, and even provided money for proper burial.[447] The first written record we have of this organization is from 1459, on the occasion of a meeting in Regensburg for all members in the Holy Roman Empire, but it was surely founded much earlier than that. They called the meeting a *Hüttentag*, or conference of lodges. The main point of discussion appears to have been the freedom of movement for stonemason apprentices, which evidently was threatened. Indeed, mobility, along with a difficult five-year apprenticeship, characterized this class of artisans. Surely they were the main catalyst for the wave of new structures built during the period, and for the astounding quality of decorative workmanship that we find even on small rural churches far from the highly populated centers.

Investment in ecclesiastical architecture was on the rise. This allowed practicing architects, themselves stonemasons and leading members of the brotherhood, an incredibly wide field of possible activity. *Donatores* of even the most humble buildings needed, or felt they needed, the services of a master stonemason. This was especially true when it came to vault construction. This master was an expert at all the skills of his trade. If anyone could avoid static mistakes, he was the one. The step up to a permanent construction lodge – always a major financial and administrative undertaking – was not always taken at temporary or otherwise limited construction projects. It was usual for a lodge to have a pay-by-day system, but in the Brotherhood Regulations of 1459 we also find rules governing payment for individual pieces of work and projects. It seems to have been common practice to issue written contracts that included a precise naming of the work to be done, the date it was to be completed, a description of the work therein and the legal consequences for non-fulfillment of terms. In fact, many bills for the payment of completed projects have survived, payments not only to architects but stonemasons and other artisans as well.[448] Some primary sources also indicate that Brotherhood regulations prohibited an architect from being absent or otherwise neglecting the responsibilities at a building under his direction in order to accept other contracts, unless the owner of the said building gave him permission. The later of these two options was

probably the norm, since at a much earlier date than 1459 Peter Parler was building in Prague and Kolin at the same time, his brother Johannes of Gmünd in Freiburg and Basel. Two of the most talented architects of the generation following the Parlers, Ulrich von Ensingen and Hans von Burghausen, were constantly moving from one project to another. Ensingen was director of construction lodges at Strasbourg and Ulm, while erecting the tower of Our Lady in Esslingen. While under contract at Ulm, he made his famous, if unsuccessful, sojourn to Milan in 1394. Hans von Burghausen managed six large construction sites at Landshut, Straubing, Salzburg, Wasserburg and Neuötting. He was a large-scale contractor in the modern sense of the word, one who surely allowed his lodge foremen, the *parlier*, to make many decisions at the local level.

As was the case with the guild masters, a son would often follow in the footsteps of his architect father. He would inherit the wealth of his father's experience – hands-on knowledge that could have only been taught by working together on a personal level – in order to then carry on the great construction projects his father had been involved in. Peter Parler's son, Johannes, built Prague Cathedral's south tower and was director in Kolin while it was still under construction. Whole dynasties of Ensingens, Böblingers, Roritzers and Prachatitzes – families that were in some cases related by marriage – continuously provided masters for construction lodges in southern Germany, under whose leadership the lodges earned great reputations.

At the 1459 meeting in Regensburg, the Brotherhood was organized into four major regions within the empire, each bearing the name of that region's most important cathedral lodge – Strasbourg, Cologne, Vienna and Bern. This honor was probably more a reflection of these lodges' historical reputation, and the fact that they were regional centers and politically important, than the role they were playing at the time in artistic development.[449] The lodge in Cologne, for example, had recently decided to complete the slow-rising west front of the cathedral according to its original design. The lodge had tentatively agreed to employ new Gothic forms in this, and there was a new emphasis on unifying the forms of different sections of the façade. Like many churches of the period, this project was not commissioned by Cologne's rich collegiate foundation, as they always had been in the past, but by private patrons. Yet this change was in *imitation* of similar contractual agreements at other loca-

tions, rather than a ground-breaking move by Cologne's lodge.[450]

The cultural center of the empire in the thirteenth and early fourteenth century had been in the west. This domination at last came to an end, and was replaced by a complicated network of cultural centers interacting with each other and in a constant state of flux themselves.[451] This was a direct result of political developments which had seen the dominance of the Rhineland gradually broken, and a shift of political power to principalities at the edges of the Holy Roman Empire – in the east the Imperial Electorates of the Elbe River basin, in the south-west the Houses of Habsburg and Wittelsbach – all of whom knew how to take advantage of the power vacuum left by the decline of the west.[452]

There have been many attempts to identify a definitive artistic style for the years around 1400. Some of these have sought to translate the obvious pan-European character of the period's sculpture and painting onto German Gothic architecture. Much research in this direction has looked to identify examples of English, Dutch and Burgundian motifs in the architecture of Westphalia, the Lower Rhine, Cologne and Aachen; and in the buildings of Ulrich von Ensingen, Madern Gerthener and Hans von Burghausen.[453] Many of these ignore the fact that, culturally, the German-language regions of Europe formed a relatively homogenous entity in which there was a lively exchange of domestic artistic forms. Those Franco-Flemish or English Gothic forms to actually make it to Germany were quickly assimilated. German architects were highly thought of outside the empire too. After going through several French architects, Milan Cathedral lodge hired Hans von Freiburg, then Heinrich von Gmünd, Ulrich von Ensingen and finally Wenzel von Prague to either conduct tests on the cathedral's design or as masters of the lodge in the years around 1400. Johannes Niesenberger from Strasbourg, along with fifteen other artisans of his lodge, migrated south to Milan in 1438.[454] *Meister* Gierlach from Cologne built the cathedral choir in Linköping, Sweden around 1400, and Hans von Cologne built the tower spire of Burgos Cathedral between 1442 and 1458. And while it's true that stonemasons from Poland, northern Italy and the Netherlands did work at Prague Cathedral's lodge under Peter Parler,[455] contacts with foreign architects and artisans were sporadic; and the influence they had on German architecture – by this time with its own extensive pool of Gothic forms – is barely traceable at best. Later than in France and England, but richer in its stylistic

diversity, German architecture now began a period of development that had as wellspring a church from its own Gothic tradition – Prague Cathedral.

THE GREAT TOWER PROJECTS

No later than 1392, the year in which the foundation of its nave was laid, a decision was made to give the south façade of Prague Cathedral (facing the imperial palace) an asymmetrical design [139]. Building a huge, square tower in the angle between transept and nave that dominates the entire south front? This was a decision of the cathedral lodge at a time when Peter Parler was still active. It proves once again his love of the unorthodox, even courageous design.[456] Peter would die a few years later, however, and his two sons Wenzel and Johannes would take over the lodge. The structural forms employed in the three lower registers of the south tower, as well as those of the transept clerestory above the portal porch next to it, can be attributed to them.

The precise characteristics that define Peter Parler's decorative style – a purposeful ambiguity of prototype and an almost irritating joy in fusing forms in new ways – is continued in the upper register of the transept. The line of an eaves gallery spans the space over the wide transept window, for instance, but is overwhelmed by a layer of blind tracery work that rises out of the window spandrel below. This blind tracery work consists of a series of short half-circle arches opening upward and placed to overlap each other exactly half way through each arch. They are fused into a single layer of tracery work. The illusion is created of two concave half-gables with a whole gable in between, their curving sides articulated in crockets which end in pinnacles on rounded bases. The gallery itself can only be glimpsed now and then behind all this.

As was the case with Peter Parler's vaults, this "combed" tracery work, as it is called, is made up of various individual forms weaving in and out of each other. They do this so perfectly that it's all but impossible to recognize (let alone put into words) a single overriding feature or figure to describe the whole.[457] Nonetheless, it seems clear that its figuration is held together by the varied and rich associations created by its individual forms. Earlier styles of decoration express a similar attitude. On those parts of a building, for instance, where decoration was absolved of its sheathing, load-bearing function, it often expresses a greater freedom of design. Canopies, monuments inside a church, fountains, pulpits, rostrums and model architecture of liturgical use all bear witness to this. However, we hardly ever find such a purely decorative piece this big, and almost never on the outside of a structure.

The rest of the tracery work on Prague's south façade tower is not as aesthetically functional, nor as filigreed, as it is on the eaves gallery. Most of it consists of a stiff, tightly woven tracery net placed close to the tower surface and through which much of the wall is visible. It is thicker and more sheath-like on the huge corner buttresses. The tower itself has a very tall, three-register base with a single horizontal division in the form of a balustrade at the top of the porch level, which runs around the entire body of the tower. The two upper-most registers are visually united by a texture of long shafts articulating the corner buttresses. These gradually become thinner and more fragile as they rise. The eaves gallery on the transept jumps over to cross the face of the tower next to it. The large corner buttress covers the point of transition between the two structures, so that when the eaves gallery reappears on the tower, it is transformed into a strip of blind tracery work between the upper and lower windows at the top of the tower base. It barely touches the core of the tower at that point and leaves the window spandrels completely untouched.

The pier buttresses sit upon high, unarticulated bases, both at ground level and at the bottom of the gallery. This lends the corner tracery work a monumental and statuesque solidity. No gables crown the window archivolts, which sit in the wall without any framework whatsoever. The two windows at ground level are topped by blind, round arches that seem to visually emphasize the mass of stone resting upon them.[458] A sheath of tracery work on the pier buttresses rises high into the air, ending in open tabernacles placed before the terminal surfaces of the buttresses on the second register. This sheath remains securely fastened to the wall surface, while lending the tower cube a fine relief that enlivens its contour without overwhelming it.[459]

In contrast to the frantic movement that Peter Parler imposed upon the staired turret on the south-west corner of the façade structure, and on the choir's triforium, here we find a calm vertical articulation. As on the choir's flying buttresses, the forms of the arches and gables are different here – including the new type of gable described above with "inward sweeping" sides on the finials and tabernacle roofs. The fusion of

these has a calm overall effect. Other than these, the only thing reminiscent of the unorthodox play of forms on the choir structure are the canopied gables topping the open tabernacles in the second register. These seem to have slipped down from where they should be, and to have been hung haphazardly into small corner shafts. These small shafts rise above them, with their capitals sticking up like flag poles. A wreath of finely articulated triangular gables surrounds the corner pier buttresses about half way up. Another wreath, consisting of single gables, is above this. Each gable is in a niche placed in front of the concave section of the corner buttress.

Here, then, is evidence of a gradual "calming" of that dynamic movement characteristic of Peter Parler's work, in the work of his sons Johannes and Wenzel (transept gallery and south tower in Prague, respectively). This, of course, has not gone unnoticed. Erich Bachmann saw it as representing the transition to a "soft style," which as a term is similar to those used to define types of Late Gothic painting and sculpture. Bachmann describes the process of transition as having come about through an inversion of recognizable motifs, through formal repetition, employing "curving" gables with concave sides and using unbroken vertical articulation.[460] The notion of a "soft style" Gothic in German architecture around 1400 has been accepted by most art historians.[461] The theory also "identifies" stylistic unity between the fine arts during the period. Using this concept, the art historian Ernst Petrasch organized architecture of the fifteenth century according to three large period delineations, all of which had been used to such good effect in defining painting and sculpture: the Soft Period (1400–30), the Sharp-edged Period (also known as "Realistic Gothic" 1430–70) and Baroque Gothic (1470–1520).[462]

This phase-delineation system forms the basis of defining German architecture fifteenth-century to this day.[463] It is, of course, far from perfect, especially concerning the first two periods which are antithetical. "Soft" forms, for instance, will not be found on a smooth, unarticulated wall surface, which means it's only possible to differentiate "soft" from "sharp-edged" forms on buildings sheathed with sufficient tracery decoration. The model's greatest weakness, though, is that it is based on the evolution of how clothing was represented in Late Gothic painting and sculpture.[464] Petrasch defines the transition of "soft" detailing to "fragile-creased" detailing, as a move to a style made up of small parts with an almost "metallic sharpness." But

he doesn't stop there. He goes on to say that this transition reflects a move towards the renunciation of structural decoration in general, which lead to a kind of cubism of the lateral elevation.[465] Unfortunately, this process was not widespread in the fifteenth century, and surely not prevalent enough to base an entire theoretical model on. Rather, the period saw a continuation of what had begun with the first churches of Mendicant Order Gothic and the Backstein tradition, namely that richly decorated buildings were being built at the same time as those possessing very little detailing at all. What determined the style for a particular church was the pliability of the materials used, the various ideals to be formally represented and naturally the costs involved. Especially hard to follow is Petrasch's characterization of "soft" and "sharp-edged" interiors as expressing typical or ideal types, the description of which is carried out using an associative vocabulary, based on his own subjective impressions and projected via rather unclear metaphors. As a result, Petrasch sees the "painterly disposition" of German Special Gothic interiors (Gerstenberg) as an example only of the "soft style.[466]

Bachmann's motif definitions for the forms of Prague's south façade are helpful in understanding the "soft style" as a type of decoration, since these same motifs can be found on many structures built around and after the turn of the fifteenth century. These, however, were mixed with motifs common to older traditions. Like those motifs of Prague's south façade, they would be assimilated into a domestic repertoire of forms that continued to expand long into the Late Gothic period. Because of this, an art historian who seeks to impose cohesion on the period by ignoring or excluding any of the phases of stylistic development in the fifteenth century does so at his or her own risk. The evolution of architectural style during this period depended less on the replacement of older forms by new, and much more on expanding the available pool of forms and materials, and on procuring the funds to build. Many of the motifs of this period can only be dated according to the year or approximate years they first appeared. The mouchette, for example, cannot be a motif of the "soft style"[467] if it appeared in the choir clerestory at Prague Cathedral [134] and was employed unchanged *after* 1430, when the "Soft" period had supposedly already ended. Furthermore, Prague's "twin mouchette" motif was employed in many churches late in the fifteenth century,[468] while the sickle-shaped arches of its choir windows remained popular forms for

newly built churches in Austria and Saxony after the turn of the sixteenth century.[469] The actual pool of architectonic forms and types in the fifteenth century appears to have been much more complex than the accepted stylistic models of the period would have us believe.

By the time the Hussite War broke out in Bohemia in 1420, the Parler lodges in Prague and Kolin had long since broken up[470] and numerous stonemasons had migrated to find work in neighboring principalities. They are easiest to trace in southern Germany, where ashlar masons were in great demand at the time. Here tower projects dominated great church architecture, for which the west tower at Freiburg Minster (finished 1320) supplied much of the impetus.[471] No doubt Parler-trained stonemasons were involved here as well, since the majority of the forms used in these towers can be traced directly to Prague.

In Vienna Duke Rudolf IV and his wife Duchess Katharina von Böhmen, daughter of Charles IV, laid the cornerstone for the nave of St. Stephan's Cathedral in 1359. Built west of the older Hall choir, it included two transept-like high towers immediately west of the choir section. With this construction project, Rudolf IV was continuing the efforts of his predecessors to make St. Stephan's the seat of Austria's own episcopate. But surely he also wished to give the church the rank of *capella regia Austriaca* in a manner similar to that in which his father-in-law, the kaiser, had bound his own cathedral in Prague to the Bohemian royal House of Luxembourg.[472] St. Stephan's is a so-called *Staffelhalle*, a three-aisle nave whose windowless central vessel is a bit taller than the aisles in cross-section. Work on Vienna's *Staffelhalle*, which is covered by a huge roof, continued until the middle of the fifteenth century.

Foundations for a south tower were put down at about the same time (1359) as the cornerstone of the nave, and perhaps a bit later. These were allowed to set for a period of years, after which the tower was carried out and completed in 1450. Then work began on a north tower, which would remain incomplete. Records indicate that the first lodge master to work on the nave and south tower probably came from Klosterneuburg in Austria, and that he is the same man named for the first time in 1372 as *Chunradus murator*.[473] He was followed in 1392 by the architect of the south tower, Ulrich Helbling, then by a certain *Meister Wenzla* who has been identified as the son of Peter Parler previously active in Prague.[474] He was followed in 1404 by Peter von Prachatitz and then by his brother Hans.

St. Stephan's south tower [145] is an extre-

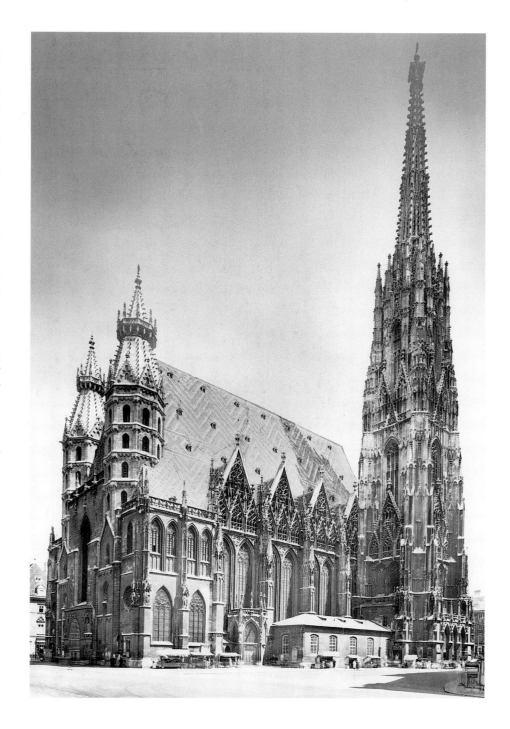

mely thin structure with a silhouette that gradually narrows as it rises. Its base register has a portalled porch and a St. Catherine's chapel. The two registers above that have square floor plans, while above that is an octagon on which sits a needle-like tracery spire. Although each register is different, they are nonetheless fused into a unified whole via a process by which the four angle buttresses – their extensions shrinking as they rise – are transformed, first into diagonal buttresses, then into giant finials at octagon level. As a result, the third register seems much higher than the more massive registers below it. Placed before the lancet windows here are huge, blind triangular gables that echo the motifs of a row of

145 Vienna, St. Stephan, view from the south-west

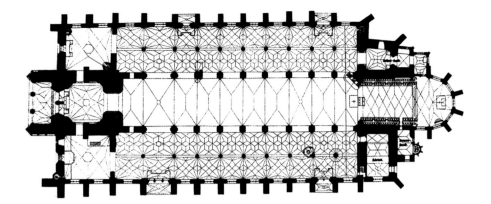

146 Ulm Minster

heavy, traceried dormers on the nave.[475] Beginning at the roof there, they run over to encircle the whole tower. Two further triangular gables, whose inner sides intersect, stand at the base of the octagon. Behind their points, the buttresses at the edge of the octagon are visible rising into the air. Their finials are just as tall as the pinnacles of the huge corner buttresses. Together they make for a richly articulated, zigzagging, crown-like structure at the base of the spire. The tracery spire itself is extremely thin and has the smallest possible floor plan. Its ribs bend slightly inward as they move upward, lending the spire even more vertical impetus.

Pier buttress decoration on the nave is similar to that of the lowest sections of the tower – especially the finials with their canopied figures – and reflects a severe clarity that harkens back to the older pier style found in the lower registers of Strasbourg Cathedral's façade [46]. However, this same register exhibits a strong Parleresque flavor as well: the opening to the tower porch "funnels" inward like at Prague Cathedral – three doors outside, two inside – and we even find flying-rib stellar vaulting of the octagonal St. Catherine's Chapel.[477] Moving higher, we find that the form of the pier buttresses above the window sills of the first register are near copies of the south-tower pier buttresses at Prague Cathedral[478] [139], even though a diagonal "turning" of the pier mass is emphasized in Vienna and the pier surface more thickly modulated. Vienna also places more importance on fusing the pier buttresses to the surface of the tower. At belfry level, for instance, the wreath of gables – rows of ogee, triangular or concave shapes – are fused to the walls to such an extent that they reach over to connect with the window archivolts. Rows of triangular gables surround the tower structure, which is permeated by long shafts of tracery work. The Prague style has been greatly enriched here. Its formal fusion of corner pier buttress and tower core has been achieved by a repetition of forms.[479] Perhaps in

the process by which the tightly woven tracery shell of Vienna's belfry level gradually opens up in the octagon and spire, we can imagine how the upper levels of Prague Cathedral's tower might have looked had they been completed. Despite the complicated history of its construction, St. Stephan's in Vienna possesses one of German Gothic's most formally coherent towers. Its complicated and opulent sheath of filigree tracery forms makes it one of the most magnificent as well.

The most important "tower architect" in southwestern Germany at the time was Ulrich von Ensingen. With designs for towers in Ulm, Strasbourg and Basel, and at Esslingen's Our Lady, he secured for himself the largest and most lucrative contracts in the southern Rhine region and in Swabia. His sons made names for themselves on structures that he began. Ensingen's works contain forms from Strasbourg and Freiburg mixed – to an even greater degree than we saw at Vienna – with new forms from Prague. The fact that his projects were located nearer these western lodges played a major role in this.

The town of Ulm was able to hire Ensingen to head their lodge in 1392. A new parish church had been begun there in 1377 under the direction of two lodge masters named Heinrich – supposedly members of the Parler family – as a Hall with a polygonal choir as wide as the central vessel.[480] But before Ensingen took over the reigns in Ulm, the Hall plan was discarded in favor of a basilican form [146]. The choir was not yet vaulted and the nave built to only half its height, when work was taken up on the huge west tower. Obviously, the city fathers were interested in demonstrating the town's political ambitions with a great show of power the building of such a structure required. Ulm was leader of the *Schwäbische Städtebund* (Swabian Confederacy of Cities) which had suffered a serious military setback at the hands of the forces of Eberhard von Württemberg near the town of Döffingen in 1388. The builders would surely have felt the reputation and political patronage of Ulm depended on the success of the project.[481]

The most important document among the many primary sources to have survived concerning the history of tower construction is "Sketch A" which can be found in the City Archives at Ulm. The design, from Ulrich von Ensingen, is probably the first planning stage of the tower from the year 1392. "Sketch A" was not only to inspire the subsequent designs of Ulm's lodge, but became a design prototype for many tower solutions in southern Germany

during this period. Ulm's decorative style can be traced back to motifs from Prague Cathedral under Peter Parler,[482] as well as motifs built later in the upper sections of Prague's south façade.[483] Perhaps this is because "Sketch A" shared the fate of many tower designs from the period: during long years of actual construction, many of its forms would be modified to please contemporary tastes.

In a manner different from Freiburg, but similar to St. Mary's, Reutlingen [89], Ulm's west tower [147] is part of the nave behind it. Its façade is flanked by the outer walls of the west side-aisle bays. The striking effect achieved by Reutlingen's side-aisle fronts is totally lacking at Ulm, however. Ulm's Hall portal has a lean-to roof, combining three outer openings with two on the inside and, like the tower portal at St. Stephan's in Vienna, was inspired by Prague's south porch [133,140]. Rising above this are the two, square lower registers. These are crowned by a gallery that circumvents all four tower faces. The only part of the tower completed before Ulrich von Ensingen's death in 1419 was the portal register. In the following decades, Ulrich's son-in-law Hans Kun and his son Caspar, Ulrich's son Matthäus Ensingen and finally Matthäus Böblinger (+1483) attempted to complete the tower following as best they could the formal characteristics as they found them in Ulrich's designs. Ulm's squarish main pier buttresses are reminiscent of those at Strasbourg [44] as is its profuse tracery work, whose shadows lend both window registers considerable spatial depth. Spiral staircases occupy the angles between the pier buttresses[484] and divide the decorative fields between them and the wall surfaces. This prevents a fluid transition between the tower's core and its corner buttressing like we saw in Vienna. Rather, the corner buttresses form a solid framework for the tower's vertical-shaft articulation in a way similar to Strasbourg.

The octagon and spire were not finished until a final building phase from 1885–90. They were completed using a sketch from Matthäus Böblinger. As early as Ulrich von Ensingen's "Sketch A" there were plans to use staired turrets as open tracery piers in the octagon level. Böblinger adopted this motif and did not diverge much from the first stages of the tower's design, which already included an elegant inward curve to the tracery spire along with the so-called "masthead" motif – a ring of finials just below the tip of the spire.[485]

Ulrich planned a nearly identical pyramid spire for the north tower of Strasbourg Cathedral where he was lodge master beginning in 1399.[486]

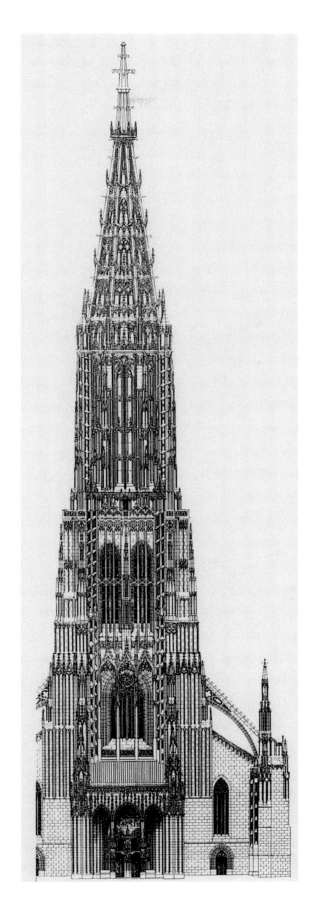

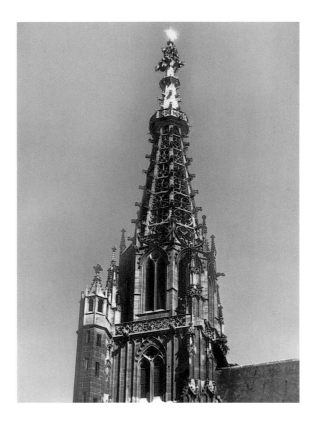

His design from 1414 for the north tower of Basel Minster, which had been damaged by earthquake, is similar to Ulm's even though the "masthead" of the spire was not employed. The only part of Ulrich's design carried out in Strasbourg was the octagon [44] where a punched out, cage-like core structure articulates a tracery crown that sits upon tall lancet windows. This tracery crown is pierced by finely articulated triangular gables in a way similar to Prague Cathedral's transept gallery [139]. Four spiral staircases are placed a good distance in front of the tower core until they reach the upper structure, where they then connect to the core by small bridges. In a way not achieved at either Prague or Ulm, the staircases here step out of the shadows on the inside of the structure to formally accent the tower's outer composition.

Johannes Hültz's tracery pyramid (1437) completed Strasbourg's single-tower west façade. The "dignified staircase" motif is a major feature of this structure, with staircases replacing the usual massive ribs of the spire. These rib-replacing staircases are made up of single units, each hexagonal in cross-section. As the tower rises, each unit is placed inward in relation to the one below it by a distance of half its own radius. The steps within the staircase unit change direction with each new landing. The individual staircases eventually converge in pairs as they rise into four box-like structures. Above these, the point of the spire takes the shape of a lantern. It could not have been Hülz's intention to make the spire accessible via these stairs. For that, a single stair-

way would have sufficed. Instead, he interpreted the "staired turret" literally here, taking Prague's "offset stairs" to their logical conclusion. Using a tracery spire as receptacle, Hülz created what amounts to an apotheosis of the stairway.

Ulrich von Ensingen's smallest tower can be found over the west section of Our Lady in Esslingen (begun 1395) [148]. Its lower registers have square floor plans and possess simple articulation. Accompanying these massive stone blocks is a closed, laterally placed staired tower. The tower itself does not exhibit any tracery work until it reaches a spot above the half gables of the side-aisles. Little more than the first register of this structure stood at the time of Ulrich's death, and work continued slowly under the direction of his two sons Matthäus and Matthias. Octagon and spire were, once again, the work of a member of the Böblinger family of architects – this time Hans von Böblinger who was still quite young when he began work in Esslingen in 1439. His son Matthäus von Böblinger took over at Ulm from the Ensingens. Upon the death of Hans in 1482, two other of his sons, Marx and Lux, together with his son-in-law Stephan Waid, picked up the work and completed the tower in the year 1494.

The upper stories from Hans von Böblingen betray a strong debt to Ulrich von Ensingen. The tracery spire crowning the octagon not only resembles very closely the spire of Strasbourg's octagon register [44] it also possess a "masthead" at the top. This time, however, the ribs of the spire do not bend slightly inward as they rise. Esslingen's octagon is not lacking a staircase either, even though Böblingen made do with only a single little tower. This tower does not visually continue the staired tower below, but enriches its silhouette by virtue of its placement opposite the stairs, at the outer edge of the tower.

The building of Regensburg Cathedral came at a middle point in the history of great church building in the Late Gothic period in southern Germany. It was also located in the middle of things geographically. This is reflected by the at times complicated course the building of the west front (begun after 1341) and the south tower took. Its nave, which had not been completed at this date, along with the lowest register of the south tower, were built in the Rayonnant style, a style unchanged since the older choir had been built. Yet during the last decades of the fourteenth century, during the building of the rest of the cathedral, we find forms influenced by the great lodges in Nuremberg, Prague, Vienna and Strasbourg. Primary sources indicate that a certain Liebhart the Mynnaer was

Regensburg's lodge master in 1395. From 1415 to 1514 the office was sinecure, as it were, of the Roriczer family, who probably came from the southern-Rhine region.[487]

It is more than likely that the so-called "double-tower sket:ch" of the cathedral façade [149] – a plan of the middle sections of the façade and the north tower up to the base of the spire – is from Liebhart.[488] It is characterized by a uniform network of canopies, finials, triangular gables and tracery panels placed across its surface. The overall effect is one of a large structure made up of a myriad of small parts – there are no large window gables, for instance – which reminds one of Prague Cathedral. The large number of tracery mouchettes and a literal copying of one section of Prague's window couronnement in a window over the side portal[489] indicates that there was an exchange of design information between Regensburg and the lodge in Prague during the reign of Charles IV. But Liebhart was also familiar with the Strasbourg façade style, and covered the window of the third register of his tower with a veil-like lattice work of free-standing tracery. The wreath of blind tracery that engulfs the rose window, along with the gable above it that has been extended by a small tower, indicate a knowledge of the west front of St. Lorenz in Nuremberg (built in the 1460s). Groups of motifs, like the interlacing arches over its canopied figures and its tracery "combs" indicate an intimate familiarity with the lodges in Vienna and Ulm, making it quite probable that the "double-tower sketch" was drawn up around 1410.[490] Despite an almost overly passionate love of decoration, the "double-tower sketch" still manages to compile these most different prototypes into a masterful whole. Major reductions were made during the process of carrying out this design, yet even the simplified version would only reach the third level of the tower during the years between the laying of the north tower's cornerstone (1398) and the early sixteenth century. Both towers would finally be completed in the Neo-Gothic style.

The mid-fifteenth-century "single-tower sketch" – probably from Konrad Roriczer, in which forms from Ulm and Vienna's tower mingle – is difficult to date since two towers had already been decided upon by that time anyway. The only part of the "single-tower sketch" to show a section of the façade actually carried out was the triangular main portal (1390–1499) which is similar to the Erfurt Triangle [104] and juts out at an obtuse angle from the plane of the façade.

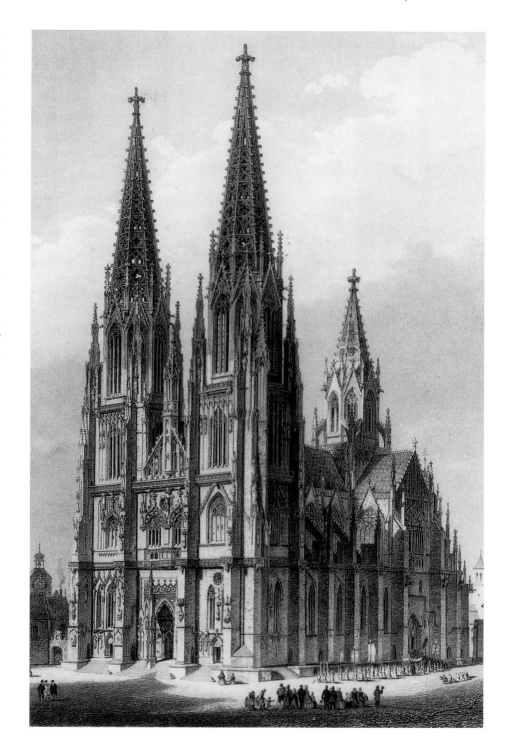

149 "Regensburg Cathedral, View from the South-west," steel engraving by Franz Habutschek

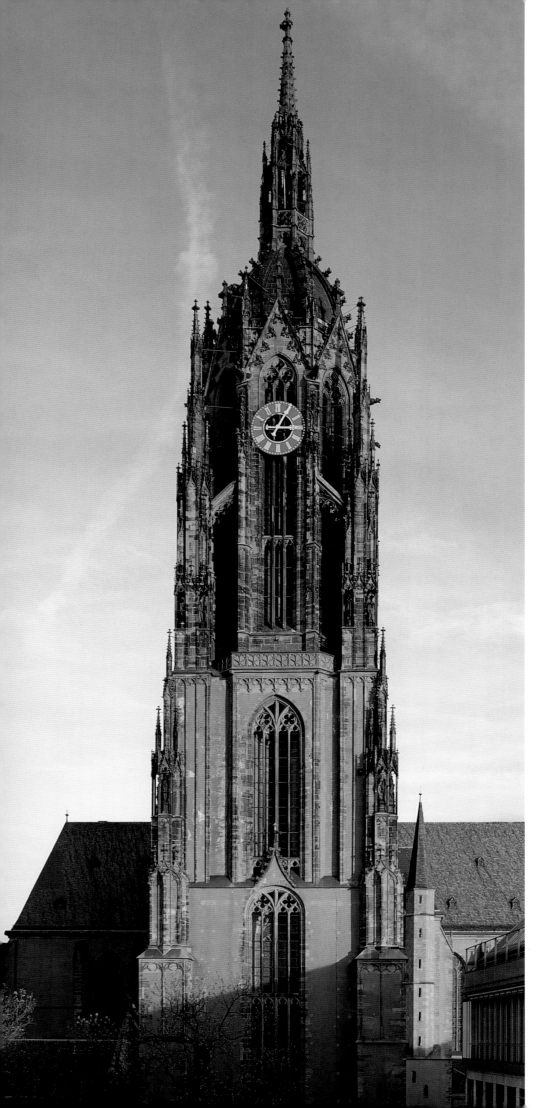

The collegiate church of St. Bartholomew in Frankfurt [150] – for centuries the town where the German electorate met to declare a new monarch – received a tower worthy of such an important church in the year 1415. The tower base is a huge cube with entrances via two side portals on the south and north. It fronts a Hall nave that ends in a wide transept that was still being built at the time the tower went up. Both the town and the collegium were involved in financing the construction project. A manuscript from 1409 names Madern Gerthener from Frankfurt as lodge master of the Bartholomew Collegium, a position that was to bring Gerthener fame and fortune.

Most of the squat, double-register tower base is unarticulated. This section of the church was hidden by the surrounding buildings of medieval Frankfurt, and perhaps that is why practically no structural decoration can be found until the second level of the tower base. The articulated elements gradually increase in number as you go up from that point to the octagon, which is surrounded by thick bundles of pinnacles. The shell-constructed dome that sits atop the octagon is very rare in German Gothic architecture. Work on the tower stopped in 1514, and the shell dome was not built until 1870. Besides a few minor changes, it was built according to the original design set forth in Frankfurt's "Sketch A" from the year 1420.[492] Compared to the thin verticality of the spire pyramids of southern-German Gothic that seem to shoot into the sky, St. Bartholomew's spire seems heavy and monumental – a suitable crown to the tower's massively proportioned lower registers.

The two porches of Frankfurt's tower [151] contain magnificent examples of post-Parleresque vaulting. They are funnel-shaped niches and, like Prague's south porch [133,140] covered by triradial figures.[493] Because the outside opening consists of a single wide arch, its triradials do not form umbrellas, but half-stellar figures placed beneath the vault web as it sweeps outward and upward. The vaulted star of the north portal resembles a rose bud: it is carried out in arch-ribbing filled with tracery that is outfitted with curved quatrefoils whose cusps stick out from the vault surface. Madern Gerthener created Germany's first "tracery vault" here, perhaps the first on the European continent, a

150 Frankfurt-am-Main, St. Bartholomew, the west tower

decorative form that had been known in England a hundred years by that time. From this point on "tracery vaulting" would become more and more popular in central-European chapels, sacristies, treasure chambers and other smaller ecclesiastical rooms.[494] At the same time, it is one of the first arch-rib vaults and one of the earliest forms of the "looping" stellar-configuration vault that would appear in the late fifteenth century.[495] The arches of the porch's side walls are articulated by so-called "branch work",[496] a tracery form characteristic of Gerthener in which the outer shafts of the foiling and the mouchettes coil around each other like branches, and out of which grow small sheaves of foliage work that end in buds. Gerthener repeated this "branch work" in the tracery curtain of the Memorial Portal of Mainz Cathedral (around 1425). Evidently this was done to strengthen the portal's two round arches, which come together in a hanging capital.[497] The main motif of this tracery curtain consists of two intersecting circles made out of twirling mouchettes. These "whorl rosettes" were, along with Peter Parler's "twin mouchette," some of the most popular tracery figures of the fifteenth century.[498]

PORTALS, ORNAMENTAL GABLES AND CHOIR FAÇADES

Compared to the great towered façades, towerless west façades played a minor role in German Gothic architecture. It is not difficult to understand why. Even the smallest village parish church required a tower for the ringing of bells, which was the only method of keeping time in the Middle Ages. Furthermore, the nave cross-section façades of Cistercian and Mendicant churches were seldom planned with aesthetic effect in mind – the exceptions being those in Chorin and Salem, as well as some transept structures. Many fifteenth century towers were placed in an angle of the choir, or sometimes in the eastern sections of the nave in order to make room for a sacristy at ground-level. This gave many churches at least the opportunity to build ornamental western sections.[499] Yet decorative gables such as that at Holy Cross in Schwäbisch Gmünd [112] were few and far between, even in southern Germany. All the more surprising, then, to find a west façade like St. Maria-am-Gestade in Vienna that fronts an aisle-less nave (1394–1414) and choir (begun 1332).

The structure stood on a cliff above the banks of the Danube during the late Middle Ages. In 1391 it came into the hands of the royal steward

of Duke Albrecht III, a man named Hans von Liechtenstein-Niklosburg, via an exchange with the episcopate of Passau. He chose to found a collegium there and decided to renovate the church. After laying the cornerstone in 1394, however, Liechtenstein-Niklosburg's entire possessions along with the patronage of the church were confiscated by Albrecht III. Then in 1398, with ducal assistance, work finally got underway. The architect and director was more than likely *Meister Michael* from Wiener Neustadt, who was Austrian royal architect until Albrecht's death in 1404.[500] In 1409 ownership of the church once again changed hands, back to the episcopate of Passau, and the nave was probably completed under the direction of the lodge of St. Stephan's in Vienna in 1414.

St. Maria-am-Gestade's façade is a tall structure with elongated articulated elements [152]. Its high base, fine sculptural decoration and small pinnacle towers flanking a pointed gable

151 Frankfurt-am-Main, St. Bartholomew, north porch of the tower

are from the Ste-Chapelle façade type. Steps lead up to a deep portal over which a stone, cupola-like roof seems to hover in the air. The portal vault is a warped, canopy-like hexagonal rhomboid star. Above the portal is a large window and on each side of this window, the wall surface is covered by fragile paneling made up of long mullions. At the top is a gable decorated with canopied figures and a tracery gallery. It is cut through at the sides by pinnacle towers that pick up and continue the mullion work of the wall surfaces next to the window below.

There were several richly decorated choir chevets built in the last decades of the fifteenth century. The polygon of St. Sebald in Nuremberg [122] was surely the first of these, but it was in Saxony that most choir chevets were built during the period. While St. Sebald's details are more attuned to the stylistic norms set down by western-European cathedrals (Rouen, Mantes, Cologne), the "choir façades"[501] of Saxony, as they have been called, were strongly influenced by the pool of forms set down by Prague's cathedral lodge. The first such choir chevet in the eastern provinces of the empire was that of Moritzkirche (begun 1388) [153] in the town of Halle on the Saale River. Work on the church was often interrupted and ended up lasting until 1557.[502] It is a "stepped choir" structure with polygons at the ends of the side-aisles and a main apse[503] whose prototypes can be found in the Teyn and Emaus churches in Prague. The outside of its northern sections and main apse were finished in 1420. The choir itself, however, was not consecrated until 1472 with its vault still incomplete.

At the church we find an inscription which names "Conradus in Einbecke natus" as one of two "rectores structurae" in 1388. Whether Conrad von Einbeck was actually the architect in charge of building the choir, as has always been assumed, is doubtful.[504] The sheathing of Moritzkirche's massive pier buttresses with their rows of concave gables, its ogee arches, panels of tracery work above windows that cut into the pier buttresses, as well as hanging-tracery work placed before the window couronnements (most of which has been lost) are all leitmotifs of the lodges at Prague and Freiburg.[505] These very same motifs could be found on the choir of Holy Cross in Dresden (built around 1407/10, destroyed 1760), a church whose pier buttress articulation was the same as that of All Hallows

152 Vienna, St. Maria-am-Gestade, west façade

Chapel in Prague. The same holds true for the choir of the palace church built by the Landgrave of Meissen in Altenburg, Saxony (first decade fifteenth century) which exhibits a turning of the pier at different registers[506] so characteristic of the small Parler structure on the Hradschin. Churches of this group to have been built at a slightly later date include the five-sided polygon of St. Mary's in Bernburg (1420–40) and the Hall choir with ambulatory of St. Nikolai in the town of Zerbst (1430–47), both of whom more or less follow Halle's decoration system. In the choirs of this group built in towns further up the Saale River basin (Weissenfels, Naumburg, Freyburg) the decorative system is limited principally to the pier buttress.[507] Only a few of the combined details from Moritzkirche's "stepped" choir were adopted by choir façades in the town of Magdeburg (St. Petri) and in the Harz region (Oberkirche in Burg, Marktkirche St. Petri in Quedlinburg).[508]

Related to this "Saxony choir," but very creative in its use of form, is the south side of St. George (begun 1437) which faces the market place in the town of Schmalkalden, Thuringia. An opulent display of mouchettes, and tracery forms that are round, framed by spheres or teardrop shaped, modulate the window couronnements and the decoration of the pier buttresses of St. George's outer structure. A finely articulated blind transom divides the panel-work tracery of the upper wall zones into two sections. The thick ogee framework of the windows is a clear indication that St. George's belongs to the Bohemia-Saxony school.

Ogee articulation, filigree tracery work of the panels above the windows and a modulation of triangular, concave and ogee blind gables on the pier buttressing can also be found at the choir of Münster's St. Lamberti[509] (begun 1375, chapel 1425–48) and on the south side of its nave (1450–60) [154], all of which indicates that the architect was quite familiar with the architecture of the Parlers.[510] St. Lamberti's richly decorated outer structure is a rarity in Westphalian Gothic. Its profusion of windows, in which Prague's twin mouchettes are fused into magnificent whorl rosettes, contain some of the most beautiful Gothic window tracery to be found anywhere.[511]

Hans Krumenauer's Passau Cathedral choir (begun 1404, roofed no later than 1444) seems to have been just as idiosyncratic to the Gothic architecture of medieval Bavaria, as St. Lamberti's choir and southern nave wall were to Westphalian architecture. The choir of St. Martin in Landshut can probably be attributed to Krumenauer as well,[512] even though its walls are constructed with unadorned Backstein and do not give the slightest hint that they were

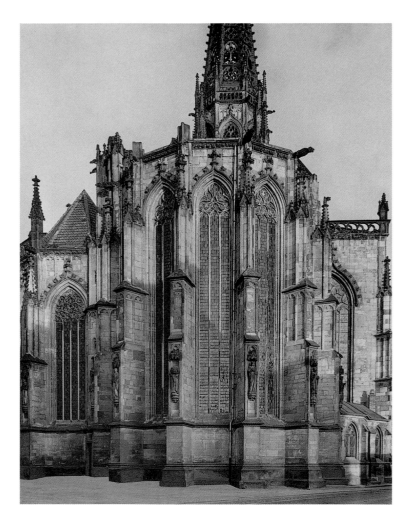

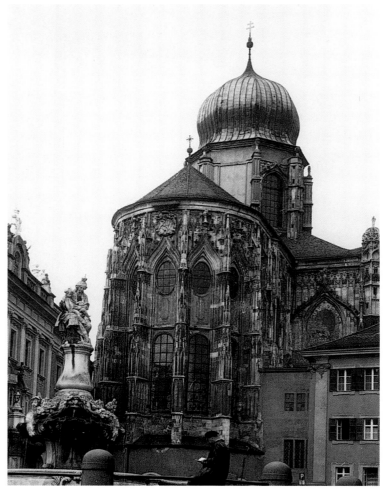

154 Münster, St. Lamberti, choir from the east

155 Passau Cathedral, choir from the east

erected by the same man who built the thick sheath of blind tracery at Passau's choir. In fact, these two choirs are worlds apart, and exemplify just how flexible Gothic architecture was: it was the preferred style for a cathedral lodge in Passau eager to stay abreast of the latest Gothic forms coming from neighboring diocese in Prague and Regensburg, and it was the style chosen for a parish church in the city of Landshut.

A wide-ranging renovation of Passau Cathedral in the Baroque Style left only the outer Gothic wall intact, and even its windows and eaves were not left untouched [155]. What survives exhibits striking similarities to the first Saxony choir façades and their prototype in Prague: rows of blind concave gables around the pier buttresses, ogee arches over the windows, and blind panel tracery below the eaves.[513] Nonetheless, Passau managed to diverge considerably from the Prague south-façade style. Its rows of ogee-arch window frames are employed to almost monumental effect. They grow out of the sides of thick pier buttresses and encircle the whole choir with a powerful wreath of stone arches. Passau's choir was something truly new for its time. Krumenauer renounced the façade style of Peter Parler's sons – whose goal was the

homogeneous overall effect of a balanced pool of motifs – to create a dynamic all his own. He sets the upper registers of the windowed walls in motion to such a degree that even bands of thick pier buttresses can't break it up. In his choir wall we see an early example of autonomous expression in structural articulation, a design tendency that would not become characteristic for German Gothic until its latest phase. The forms of the choirs in Halle or Münster are laid upon the wall core to clothe them in a festive ornamental mantel. Passau's "garland of arches",[514] however, actively forms the wall mass and is not a structural ornament placed upon it. Prague cathedral offered textbook examples for both these methods of ornamentation: in the blind tracery placed close to the wall of its south tower, and that of the free-standing tracery figures above the transept gallery.

In fact the relationship between decoration and wall core changed in the Backstein structures built during this period in northern Germany as well. Backstein is a material that is too brittle for filigree mullion work in the windows, but is quite suitable for the use of stone tracery work in heavy ornamental façades. During the last decades of the fourteenth

century, the great Hall churches with straight terminations in Pommerania and Mecklenburg received magnificent eastern gables. They followed a long line of austerely ornamented country and town churches of the same area that had been built – starting in the second half of the thirteenth century – with the gable surfaces of the choir opened up by blind tracery work and friezes. The ornamental gable of St. Mary's in Greifswald (completed before 1382) is divided into vertical strips by thin buttresses. These rise from the gable's top edge and are covered by white plaster, into which the simplest of blind tracery work with no ornamental detailing is carved. The wall is everywhere visible and retains its value as supporting core for the blind tracery. We find a similar gable at St. Mary's in Gransee. Its buttresses are placed more towards the middle of the gable, however, which transforms vertical elements into thick bundle-like shapes.

Not so St. Mary's in Neubrandenburg [156] and St. Mary's in Prenzlau [95], both in the same region. They contain a latticework of free-standing tracery placed in front of an over-abundance of triangular gables, rose-shaped tracery motifs, along with a spatial articulation of the wall zones[516] all of which is reminiscent of Strasbourg Gothic. This free-standing tracery style reached its peak with Hinrich Brunsberg's dwarf gables that top the two side-chapels added to Brandenburg's St. Catherine (1387–1411) [157]. Here rows of narrow gable sections rise above the line of the roof like palisades.

While the examples of tracery work found in Brandenburg, Prenzlau and Neubrandenburg possess round or basket-arch lancets – like their contemporaries in southern Germany – they hardly ever possess mouchettes.[517] The material characteristics of red brick, which was prefabricated in large quantities, make it easier to form into geometric shapes, than into distended organic shapes like the mouchette. Obviously, Backstein tracery work tended to consist of a unified series of smaller, communicable parts. Thus we find a pattern-like structure, not unlike the weaving of thick carpet, on the portal wall of Brandenburg's north chapel that is made up of one motif – the quatrefoil.

156 Neubrandenburg, St. Mary's, seen from the south-east

157 Brandenburg, St. Catherine, tracery gable of the north chapel

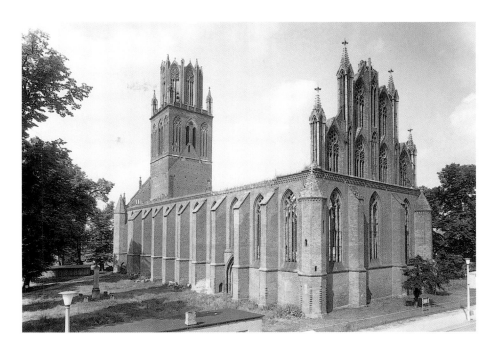

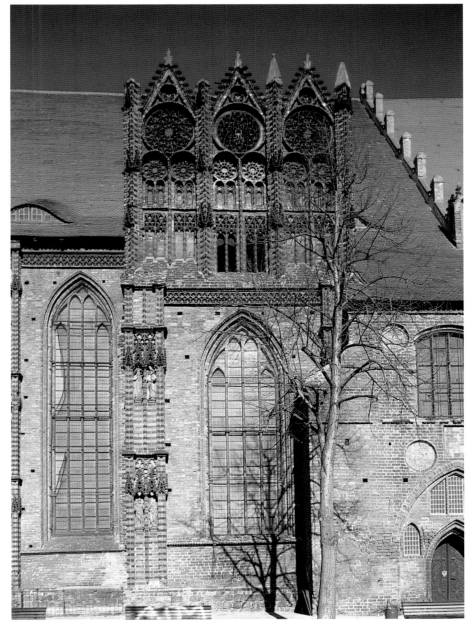

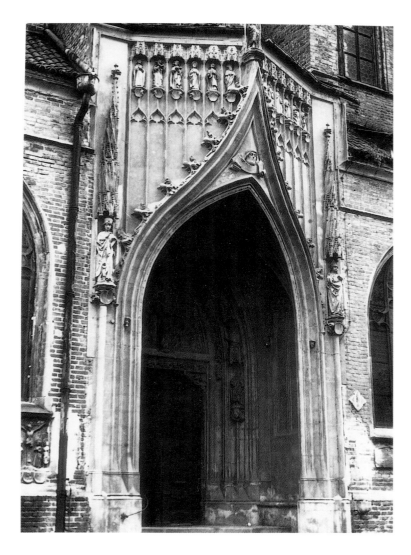

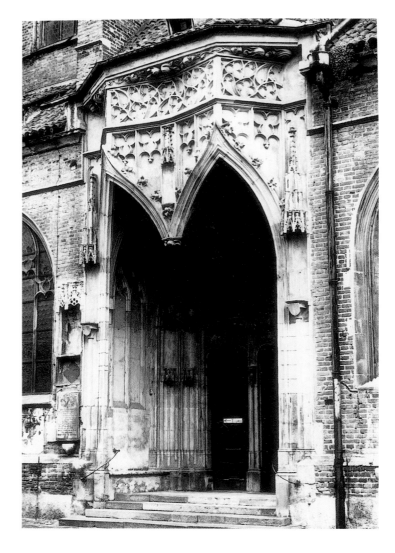

158 Landshut, St. Martin, nave portals

On the outside of most churches built in the fifteenth century, however, we find precious little ornamental articulation. In the middle of their large blank wall surfaces, the portal was often a last enclave of structural decoration. A good example of this might be St. Martin in Landshut (built 1429–32) [158] where individual small-scale portals in ashlar have been inserted into the naked Backstein nave wall.[518] They open up to narrow lanes that run along both sides of the church. All four of these portals fulfil a function similar to the Triangle Portal in Erfurt [104], namely to provide access to the church from the sides. They are in the shape of ogee arches that seem to rise out of the surface of the long side of the nave, their tracery set at an oblique angle to the axis of the portal opening. They possess two types of canopies: one is a single, pointed-arch opening framed by a large ogee arch. The north portal takes this form. It is decorated with small rows of canopied figures, along with two larger figures at the edges of the portal, each held up by a wall respond topped by a spiral brace. A similar portal on the nave's south wall is kept a bit more simple.[519] The two remaining portals

possess even more complicated canopies of two ogees, projecting out above pointed-arch openings, that are divided down the middle by a hanging boss.[520]

The four side-portals are placed so that both types of canopies can be found on each side, but in reverse order. Formal variety and planned asymmetry gain in importance as compositional values here. Landshut's canopied portals – along with the west-portal canopy of St. Maria-am-Gestade [152] and the porches of the tower portal in Frankfurt [151] – are examples of a joy in experimental design that had flourished without a break since the time of Peter Parler, and that was based on a virtuoso articulation of individual sections of a church so that they stood out from the rest of the structure.

No clear lines of development emerge from a survey of the formal systems found in the complicated outer structures that were built up to the mid-fifteenth century, in the wake of the Parler revolution. Again and again we run across the influence of Prague motifs which, however, are hardly ever presented in exactly the same form as the prototype. The Saxony

choir façades from the early fifteenth century can be seen as a homogeneous group of structures in which a few rather unspectacular motifs from the Parler Gothic repertoire were canonized and conserved, as it were, through decades of regional assimilation, with other stylistic sources having had little or no influence at all. In the churches outside the Saxony group we find an efficient "editing" of the Parler family's polyphonic form vocabulary, in a process that played itself out under different conditions, and for different reasons, in each case. On the drawing boards of the great architects of the southern and central Rhine regions there was a fruitful symbiosis that combined the Parleresque style with Swabian, Frankian, Austrian and upper Rhenish forms, and the results would become important in their own right. Playing a decisive role in this was the advancement of a class of European architects to the level of specialized entrepreneurs. Hans Krumenauer, for example, whose choir at Passau Cathedral occupies a special rank in this period because of how its flamboyant-like decorative style set into motion the calm forms of the "soft style." Equally important was the façade of St. Maria-am-Gestade, on which a certain *Meister Michael* worked to express architectural values that are reserved and minutely attuned to the overall structure. In the tracery gables of northern Germany we find two kinds of tracery work: one that betrays a joy of free-standing ornamentation and one closely fused to the wall surface. In both cases, the tracery forms themselves remained conservative.

All these developments occurred more or less concurrently with each other, and at separate locations. Of course there were churches built in similar styles and with similar forms, but there was nothing like a unified stylistic development. In fact, many churches are characterized by their highly idiosyncratic designs, and naturally they tended to implement new forms to a greater degree. The complicated structural ornamentation of the great tower fronts and façades – not counting the Saxony school of choirs which expresses a certain uniformity – does not provide a wide enough basis by which to organize the majority of churches built during the period in a coherent whole. Most of the outer structures, on the other hand, seem to represent recognizable types in tangibly articulated forms. In fact, architecture itself was gradually becoming synonymous with the renovated space. The art of spatial design was becoming the main goal of

construction, and the medium of expression for creative fantasy.

THE CONCEPT OF GOTHIC "UNIFIED SPACE"

Our picture of ecclesiastical architecture in southern Germany during the early and mid-fifteenth century is one of the wide Hall church with ambulatory, of which there were a large number in the region. As formulated by Gerstenberg, this type of church reached the height of its popularity as a church type around 1500 in Upper Saxony with the development of the Hall into what he terms a "unified space".[521] In fact, many of these Hall churches are counted among the greatest buildings of their time, and many of their shared characteristics have been identified in brilliant, and influential, treatises by scholars of the German Hall. Yet, these theories have extremely narrow parameters. As a consequence, some important structures have been excluded from the overall picture. For instance, there were just as many great Hall churches in the south of the empire built *without* an ambulatory as with – not to mention the basilican and *Staffelhalle* structures which admittedly were in the minority. Gerstenberg chooses churches that express a "unified Hall space," a choice based on the concept of the idealized "special Gothic" Hall. Structures or spaces that fall short of this ideal picture are reduced to being merely a phase in its linear development.[522] Then, of course, there is the linearity of this concept: that great church construction developed in a single direction and towards a logical end-phase. However, this falls apart the moment those structures, supposedly outside the ideal, are accepted as representing valid alternatives. Ironically, the best way to understand how many important churches lie outside the ideal of a "unified Hall space" is to understand the narrow parameters set down by Gerstenberg's thesis.

He begins by identifying, as a major phase in the development of the unified Hall space, the move towards renouncing the transept, which no doubt is right on target when it comes to church building in the entire fifteenth century. But this renunciation was *not only* brought about by the aesthetic desire to "file down" the outer structure, as Gerstenberg theorizes. There also were very practical reasons for it. Since the late thirteenth century, for instance, there had been numerous mendicant and urban parish churches built that lacked transepts. The complicated crossing structures of cathedrals and monastic architecture served both aesthetical and liturgical functions, but they brought with them the

need for three, instead of only one, façade and were therefore costly undertakings. Furthermore, the premium on space in a crowded medieval town often, though not always, made the construction of a transept extension impossible. In fact, the more a church was to be used for city functions, the more often it was built without a transept.

Gerstenberg – assuming architects of the period desired to "file down" and tighten the line of Gothic lateral elevation systems – goes on to describe the unfolding of the "unified Hall space" as having occurred through a combination of the following factors:

1. Wider pier placement to create the illusion that the church interior had been shortened.
2. Extending the depth of the side-aisle bays to match the width of the central vessel.
3. Attenuation of the height of the interior. An emphasis on the horizontal through the use of string coursing, cornices and galleries.
4. A breakdown of bay separation by discarding arcade and transverse arches in the vaults, and by introducing large, ceiling-covering net vaults.
5. "A consistent reduction in the pointed contour of the nave as a whole"[523] through a flattening of the vault arch in cross-section.
6. Stabilization of the wall surface as spatial border, by flattening it and smoothing out its articulated elements. An emphasis on unifying space through the employment of a simple pier with a stereometric cross-section that "gives the same [axial] value to all directions."[524]
7. Architectural space, thus unified, is enclosed through a complete "filing down" of the outside wall and the building of a large roof, under whose eaves the entire structure, in homogeneous extension, rests.[525]

If we look closely at the great Hall churches built south of the Main River during this period, we find that many of them contradict Gerstenberg's criteria:

1. Churches with wide pier placements that cause the usual transversely placed rectangular, high-vault bay to approach the shape of a square, or pier placements that are so wide they turn the high vault into longitudinally placed rectangles – a traditional bay form in Westphalia, by the way – are clearly in the minority during the entire fifteenth century. Furthermore, those churches that do reflect Gerstenberg's criteria in this cannot be categorized as representing a clear line of development. Instead, most of them can be organized according to two prototypes: St. Stephan's in Vienna (begun 1359), a *Staffelhalle* [94] whose system of combining slightly rectangular central-vessel bays (place transversely) with square side-aisle bays was very influential in Austria and Moravia;[526] and the choir of the former parish church (now Franciscan) in Salzburg [178] (begun by Hans von Burghausen after 1408) in which the central-vessel bays are square and the side-aisle bays only slightly rectangular (placed longitudinally). Structures with Salzburg as prototype are easily recognizable by the centralized apex pier in the choir.[527] With the exception of this particular group, few other fifteenth-century churches south of the Main River possess pier placements that are as wide.[528] This is because in most Hall churches the piers are so close together than their central vessel bays must, to a greater or lesser degree, be transversely placed rectangles. Conspicuously narrow, in fact, are the pier placements of the inner arcades in all other Hall churches built by Hans von Burghausen.[529] The attempt at spatial fusion in Salzburg's choir was the absolute exception in Burghausen's *Œuvre*.[530] Later Hall churches in Medieval Bavaria stuck to the rectangular bay form.[531] The great churches built later in Franconia, Swabia, Bohemia and the Upper Palatinate region hardly deviated from the form either.[532]

2. Extending the depth of the side-aisles to match the width of the central vessel can only be found among the churches in the Vienna group, at Salzburg's Franciscan choir and in the nave of Schwäbisch Hall. The choir of Schwäbisch Hall, however, is built in proportions that match the usual choir size common in Swabia fifty years later. Almost all of the Halls south of the Main River that have transverse rectangular central-vessel bays possess square side-aisles – a constellation that can be traced back to the beginnings of the Gothic. It is precisely in those Hall churches with high vaults approaching a square, that the side-aisles appear especially narrow. Placing the piers wide apart stretches the central bays longitudinally. Matching them in the side-aisles could not have been in order to make them deeper, but longer.[523] Furthermore, had the true goal of the architect been to create a "directionless space," one that unfolds equally to all sides, then all the great churches built in southern

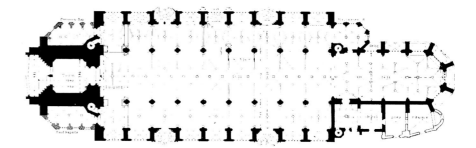

Germany during the fifteenth century would have resembled – much closer than most of them do – Our Lady in Nuremberg, whose Hall nave is based on the repetition of square bays [130].[534]

3. Most of these church interiors no longer ascribe to the dizzying heights of Rayonnant Gothic. In this, Gerstenberg is right. Central vessels with a height three times its width (St. Martin in Landshut) [159] or even those with a height two and a half times as wide (Frauenkirche in Munich) [199] are exceptions. Usually, the high vaults are twice as high as the width of the central vessel. However, an emphasis on horizontal articulation, as Gerstenberg says, is not the rule. In fact, just the opposite is true. String coursing at window sill level, quite common in the fourteenth century, disappears completely from many of the Hall churches built during this period, and in those where it doesn't, the coursing is cut through by wall responds.[535] The division of the wall into two distinct registers through string coursing that springs out over the responds (Schwäbisch Gmünd choir) [115], over galleries (St. Lorenz in Nuremberg choir) [182] or through lofts placed between pier buttresses pulled inside (Salzburg, Amberg and the Halls of upper Saxony) [179, 183, 211, 235, 236] came about because "chapelled extensions" had been built at the edges of the nave.

4. There was indeed a breakdown of bay delineation in the vaults of a *single* aisle, but it hardly ever occurred *between* aisles. If development moved towards integrating the vault bays of separate aisles, as Gerstenberg maintains, then why do almost all larger urban churches from the period have thick arcade arches articulating longitudinal movement of the bays within a single aisle? There are only three churches that did *not* channel the vault longitudinally via thick arcade arches: Salzburg, Meran and St. Martin in Amberg [183] and the last two followed Salzburg's lead at that. However, and this is telling, although Salzburg is the only church to utilize a renunciation of the arcade arch to create a motif-based weaving of the figured vault [178] that encompasses the entire inner structure in an irregular stellar net, it nonetheless *retains* the bay-dividing transverse arch in its side-aisles – albeit in the thinness of a vault rib. The inspiration for this might very well have been the Bavarian preference for covering the side-aisle bays with a four-pointed stellar figure, obviously

a form well suited for vaulting square or nearly square spaces. But the four-point star requires the employment of transverse arches, and is precisely the kind of arch that cannot be broken down into the smaller motifs of a net vault.[536] It is precisely in this group of churches that we find central vessels with rib-work net vaults lacking transverse arches. Obviously, their architects chose to unify only the central vessel, because the side-aisles do not participate in the process of vault fusion at all.[537] Perhaps the combination of vault forms was meant here to emphasize that the central vessel was the most important space in the church. Outside medieval Bavaria, on the other hand, most churches do in fact have side-aisles with net vaults. This is probably due to their having been built, most of them at least, at a later date in the Gothic period.[538] It might also be due to the artistic and cultural traditions of the area in which they were built. In Swabia, Franconia, Austria and Moravia we find some Hall churches with net vaults lacking transverse arches, which cover the entire nave.[539] Others possess transverse arches that cross through the net vaulting and retain, however slightly, bay delineation.[540] In Swabia, both kinds of net vaulting can be found in the same church.[541] So it appears that the goal of breaking down bay delineation into an all-encompassing vault system was realized in far fewer of the great Hall churches in southern Germany in the fifteenth century than Gerstenberg's theory would allow. In fact, a clear marking of the borders of the bays was the rule. Arcade arches, for instance, are found in nearly all of these buildings, and the vault figures of the central vessel and the aisle are different from each other in most cases too. Only within the row of bays making up the central vessel, or an individual side-aisle, do we find a reduction in bay delineation in varying degrees.

5. Unfortunately, there are not enough reliable vault measurements to prove whether there was a continuous process by which the vault

159 Landshut, St. Martin

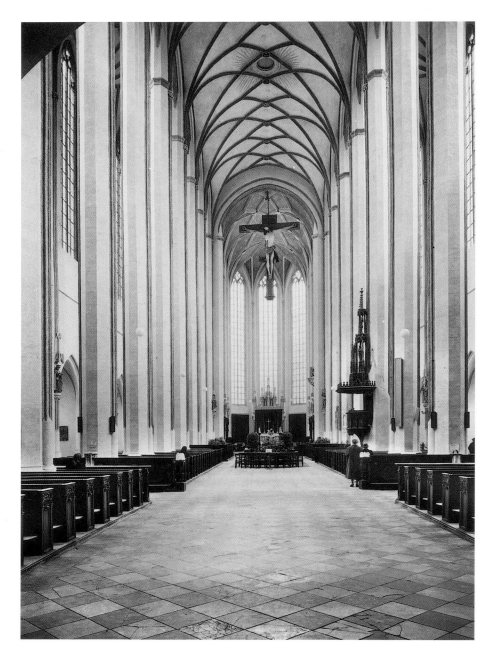

160 Landshut, St. Martin, view of the nave looking east

in the center of the bay in order to allow the star to be more visible from below.[546] The numbers of rib figures available to architects resulted in a huge variety of possible vault shapes, and made their appearance all but inevitable.

6. Without a doubt this period saw a certain amount of stylistic convergence when it came to renouncing the skeletal and lattice-like relief of the Gothic wall surface – an achievement of Cathedral Gothic that had always been limited to regions of Europe where ashlar was readily available. Even in these areas, though, there was movement early on to simplify this complicated wall-articulation system, especially among the mendicant churches. Wall relief in the fifteenth century was usually limited to the recesses and corbelling of vault responds, which often stood in front of whitewashed surfaces. In many cases the respond was little more than a small piece of corbelled stone set against the wall. Only a few great churches achieved a logical fusion of wall and articulated element – when, for instance, an older design was carried out at a later date, as was the case with the nave of St. Stephan's in Vienna. Only in cases such as this were cathedral lodges able to provide churches in the surrounding areas with a richly decorated wall structure, as St. Stephan's Cathedral lodge did for the single-aisle nave of St. Maria-am-Gestade in Vienna. In hardly any other churches of the period do we find such a homogeneous and seamless fusion of window framing and compound wall responds. Seldom do we find naves with such a fine cut, such a nuance-rich relief, to the molding and shaft work between the windows. Stereometric pier shapes that do not have one primary axis, but many, and to which Gerstenberg attributes what he calls a "spatial filing-down effect," are admittedly quite common to fifteenth-century German Gothic. Round and octagonal piers were the most common, neither of them creations of the fifteenth century. New pier forms were developed, however, and not only the octagonal pier with concave edges that Gerstenberg sees as the special Gothic's own.[547] There was also the longitudinally-extended octagonal pier core with bundles of responds on its broad sides, which was employed at St. Martin in Landshut [159, 160], and later in the choir of St. Lorenz in Nuremberg. This kind of pier form is not, by any means, directionally neutral, but helps emphasize the longitudinal movement of the central vessel as a

cross-section was flattened out during the fifteenth century. Many vault structures seem to be based on the semi-circular barrel vault of Prague Cathedral [137] although we find elliptical and pointed-arch vault cross-sections as well.[542] On the other hand, we hardly ever find a raising of the line of capitals that would result in a basket-arch vault, like the curved-rib vaults of Upper Saxony on which Gerstenberg focuses his whole theory of vault development.[543] We also find vaults whose longitudinal ridges are curved, and others whose longitudinal ridges are flat. The mesh-like net vaults common to Halls in Swabia and Franconia possess, like Prague, a smooth vault surface behind the ribs that lacks any and all bay delineation.[544] Stellar-figure net vaults, however – and bay delineated stellar figures[545] – are sometimes domed

whole. The articulated elements placed upon its surface are organized according to the requirements set up by the vaulting.[548] Often a similar longitudinal emphasis was produced by extending thickly profiled arcade arching to the foot of the arcade piers.[549]

7. The "filing down" of the outer wall, like the fusion of the aisles into a "unified space," was not by any means common to all types of Late Gothic churches. All we can say for certain is that those churches to "file down" their outer walls were either small churches, or great churches where the pier buttress had been pulled inside to form small rectangular "wall chapels" like we saw in the choir termination of Schwäbisch Gmünd [116] and in Kolin. On the other hand, those choirs and naves without chapels almost always retained a framework of pier buttresses visible on the outside of the structure.[550]

Taken together, the above observations concerning individual motifs make it clear just how little use Gerstenberg's thesis is in drawing general conclusions about the development of spatial articulation in German fifteenth-century Gothic. Precious few of the great churches he dealt with diverged from earlier kinds of nave-bay delineation systems, yet it is on just such a change that he bases much of his work. In reality, the general focus of spatial delineation was the vault – as it had been in most buildings since the middle of the fourteenth century. The play of lines in the vault figure ensures that the ceiling is in a constant state of flux: a person entering a Late Gothic Hall church for the first time will automatically look up. Gerstenberg correctly recognized that the vault seemed to move within the interior, and that it could be grasped as a whole, as one would an individual motif. He also correctly saw that the individual vault figure was difficult to recognize as a motif, and that it disappears into the overall rib-work.[551] The process by which most naves were lowered brought the rib-work closer to the observer, who would not have been able to comprehend – especially from a diagonal view – what role the single vault figure played in the ceiling's complicated net. Erasing the usual central vessel/side-aisle borders in the vaults, which was not a new idea by any means, appears to have been employed in only a few of the great three-aisled Hall churches with longitudinal bay orientation. Vault figures – regardless of whether they were stellar, or parallel-rib or thick nets – were almost always organized according to the axis set forth by the central vessel and the side-aisles.

It is precisely in vault and bay delineation that many smaller country churches differed from larger city churches in Bavaria and Austria during this period. In smaller churches – often two-aisled or with a nave shortened to one room with four piers – the tendency for an all-encompassing vault unifying the space below it actually did achieve a certain amount of popularity. It was much easier for them to achieve this, than it would have been in a three-aisled Hall with its dominant central vessel. If a "unified space" was achieved *at all* in structures prior to the appearance of the Upper Saxony Hall, then it was in smaller churches that Gerstenberg only touches lightly upon.

TYPES OF URBAN CHURCHES BUILT IN THE FIFTEENTH CENTURY

Gerstenberg's attempt to unify structural forms of the fifteenth century into a "special Gothic" ideal type fails because regional variations of that ideal dictated, to a great degree, the overall picture. Architectural development took place within narrower geographical parameters than he allows, as many regions already possessed their own large repertoire of Gothic forms, and it was very probable that an active exchange of information existed between neighboring construction lodges.

The most common form of urban church built in fifteenth-century Bavaria was not the Hall with choir and ambulatory, as Gerstenberg's model suggests, but the triple-aisle Hall nave with choir polygon terminating the central vessel. In 1407 lodge master Hans von Burghausen began building a Hall nave onto Hans Krumenauer's choir at St. Martin in Landshut[552] [159, 160]. This nave is bright and unusually tall, with two rows of extremely thin inner arcade piers, and an outer wall that seems paper thin and which is but slightly articulated by elegant responds. St. Martin's in Landshut is also the first nave in the Danube region to have chapelled extensions in the outer nave wall. The wall buttresses are completely pulled inside, and the chapelled extensions so low and niche-like between them that the side-aisles are four times as high. Outside there are no arrises articulating the surfaces of the wall piers of the choir, like at Gmünd [116] and Kolin [142]. Except for the four portals described earlier, the outer walls of the chapels create a smooth Backstein base for pier buttresses that are visible above the slope of the roof. The only surface decoration outside is a tracery frieze painted onto the plaster that runs

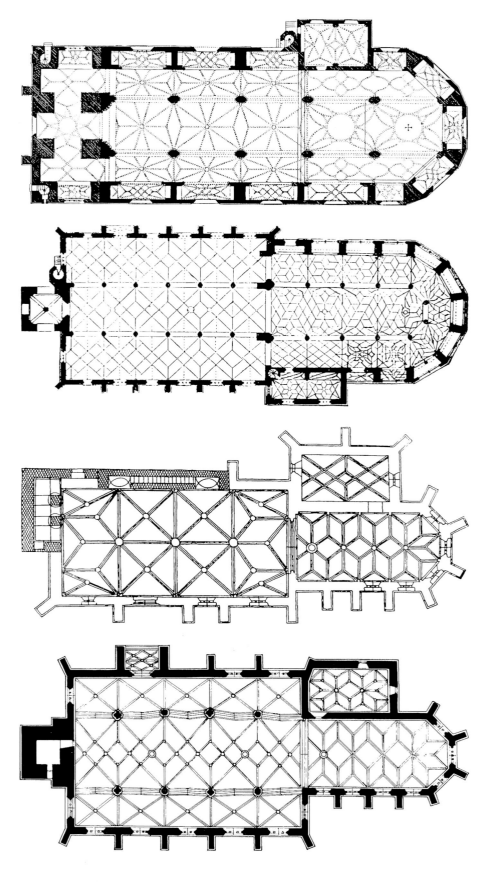

161 Wasserburg, St. Jakob

162 Schwäbisch Hall, St. Michael

163 Mühlhausen/Southern Bohemia, St. Ägidien

164 Krumau, St. Vitus

around the structure under the eaves of the roof. This monumental Hall had few, if any, descendants in the area around Landshut, which did not see much building activity until the last thirty years of the fifteenth century.[553]

Landshut was the seat of a duchy and tensions between the town's rich burgher class and the duke, stretching over a period of many years, slowed down work on St. Martin's considerably. While his project there continued in fits and spurts, Hans von Burghausen began parish churches in the towns of Neuötting and Wasserburg. With these projects, the main center of great church construction in Lower Bavaria shifted to the region around the Inn and Salzach Rivers. The naves of both these churches repeat the concept of St. Martin's in a smaller format [161, 165]. It is not until the building of St. Stephan's in Braunau (begun 1439) – a *Staffelhalle* on which Stephan Krumenauer, son of Passau lodge master Hans Krumenauer, worked[554] – that the chapelled extensions in the nave wall were finally built as high as the side-aisles and the central vessel, and that we at last find an inner structure of unified height. The chapel niche has finally developed here into a true chapelled extension, one just as high as the side-aisles. In subsequent decades, both the Braunau *Staffelhalle* type with chapelled extensions, as well as the one-aisled church – also called the "wall-pier church type" due to its interior pier buttresses – would become the most popular kinds of church structures built in the Danube River basin of Bavaria and Austria.[555] A *Staffelhalle* type lacking chapelled extensions in the nave would also become a popular form at about this time in the Duchy of Bayern-Ingolstadt (Höchstädt, begun 1442; Donauwörth, begun 1444).

In Swabia builders were not limited to a single nave type either. In those southern-Swabian towns belonging to the Imperial Protectorate, where the first fifty years of the century saw feverish building activity, we find numerous types of structures. These include basilican churches (Geislingen parish church, begun 1424), Halls lacking chapels (St. Michael in Schwäbisch Hall 1427–56 [162], St. Kilian in Heilbronn, change of the basilican design around 1450) as well as *Staffelhalle* structures (Überlingen Minster, begun 1424).[556] The only great church built during the period in the possessions of the Count of Württemberg was the collegiate church at Stuttgart (begun 1433) whose *Staffelhalle* nave was designed by the earl's own architect Hänslin Jörg and whose vaulting was carried out by his son, Aberlin.

Stuttgart's six-bay floor plan, with the lower registers of its west tower built as part of the central vessel, had Our Lady in Esslingen as prototype. New at Stuttgart were the tall proportions of its *Staffelhalle*, with a truly *raised* central vessel lacking windows, as well as chapelled extensions in the nave's outer wall. These would be copied by many structures built at a later date in the area around Württemberg.[557]

After the Parlers left Prague and Kolin, the focus of architectural activity moved to southern Bohemia and the permanent court of the Rosenberg Dynasty in Krumau. The Rosenbergs gradually began to play a more pivotal role in Bohemian politics as well, as Prague lost some of its importance and prestige after the death of Charles IV. In a way similar to what the House of Luxembourg had done a generation before, the House of Rosenberg attempted to promote and support the canons of the reformed Augustinian Order, which was in the process of building double-aisled Hall churches in Wittingau (begun 1367) and St. Ägidien in Mühlhausen (around 1390); which probably took as their prototypes Austrian mendicant churches (Dominican convent church in Imbach, Minorite church in Enns [110]). Both churches possess cross-rib vaulting, both have simple triradial vaults over the end of the nave of the kind that can be found in other double-aisle Halls in southern Bohemia.[558] The vaults of St. Giles's choir in Mühlhausen (finished 1409) [163] and that of the Hall church of St. Vitus in Krumau (1402–39) [164] possess vaults similar to Peter Parler's "double springing-rhomboid" vault in the bridge tower at Prague and the "parallel rib" vault of the cathedral choir. They would become the most popular vault figures in the principalities bordering the Danube River.[559] In Bohemia, vault technology did not manage to evolve beyond these Parler prototypes,[560] at least in the beginning. No doubt the Hussite War arrested its development, but the fact remains that there was little impetus to come up with new vault forms anyway.

Churches built during the period in the Danube River basin in Austria, and in Moravia, were influenced by Vienna's cathedral lodge. The Hall choir and the nave of St. Stephan's [94] were finished prior to 1467 and found numerous adherents in these regions. Many three-aisled Halls, both *Staffelhalle* and plain Halls, were built in eastern Austria after 1400.[561] The parish church in the town of Steyr (begun 1433) [166] and St. Mauritius in Olmütz, Mähren (nave 1433–53, choir 1454–83) [167] have Vienna-type choirs with chapels in echelon. They even have

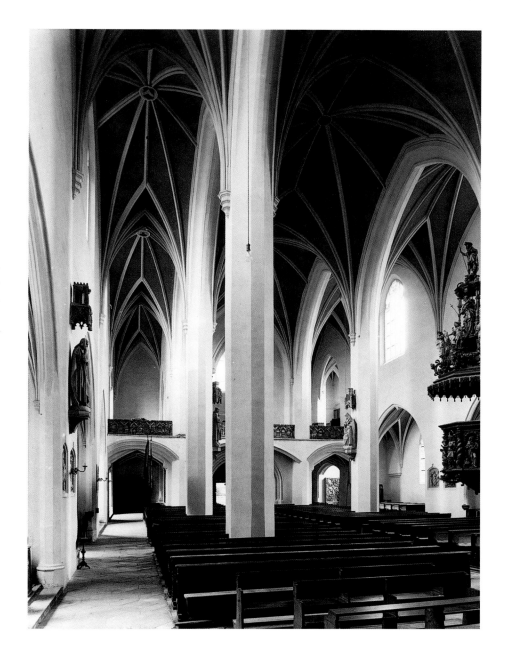

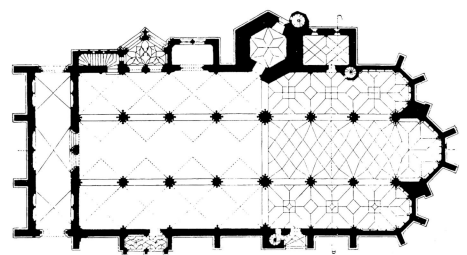

165 Wasserburg, St. Jakob, nave looking west

166 Steyr, Parish Church

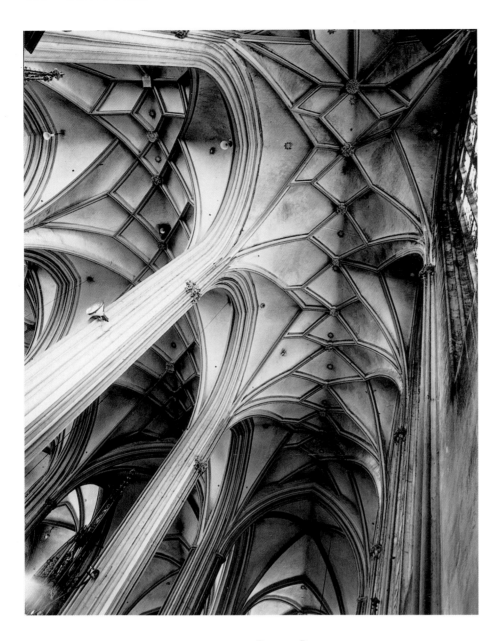

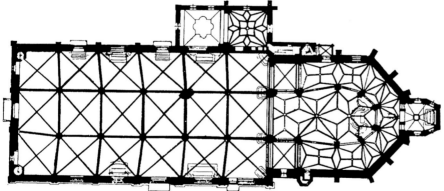

167 Olmütz, St. Mauritius, nave

168 Bozen, Parish Church

similar detailing – both possess richly articulated compound piers, for instance, with foliage-work capitals. Hans Puchsbaum, whom records show was working in Vienna beginning in 1446, not only designed Steyr's parish church as a copy of St. Stephan's, he even employed the same canopies over his pier statues. In Olmütz, pairs of windows between the wall piers of the nave are reminiscent of Vienna. It's tempting to interpret these forms – and especially the old-fashioned Vienna School pier form – as remnants of a centuries-old style, and their employment as a kind of tired decadence, were it not for the fact that the increasing power of the House of Habsburg had made medieval Vienna a political and cultural center by this time, and its more traditional style Gothic the most important within the borders of Austria.

Most of the Gothic churches in the more sparsely settled areas of the Austrian Alps were not built until after 1450. A few great churches were built earlier, but only in the silver and salt-rich areas of northern Tirol. Narrow side-aisles are typical for the Hall churches of the area. The nave of the parish church in the town of Hall (1434–6) for instance, delegated precious little space to its side-aisles. The side-aisles of the parish church in Meran (begun prior to 1450) are reduced to passageways whose eastern ends terminate in slanting walls.

Gerstenberg's linear development is missing from this list of structures. The sheer number of new churches built surely must have made it difficult for architects to be familiar with them all. There were too many different solutions – solutions to local requirements and needs – for them to have been of much use anyway. In the midst of such variety, it must have been almost impossible for a particular type of spatial organization to rise above its place of birth and become a prototype for other buildings.

In fact, in the early and mid-fifteenth century there were even more choir types than there were nave types. Because of its association with the great cathedrals, the choir with ambulatory was, and would remain, *the* most important medium for architectural expression. Types inherited from the time of the Parlers were developed into a wide variety of choirs. The standard solution for a chapel-less choir with ambulatory was the 5/8 inner polygon, that is five-sides of an octagon, combined with a five-sided outer choir termination. St. Ägidienkirche in Braunschweig [117] and St. Martin in Colmar [118] had already employed just such a choir form in the mid-fourteenth century. We find the type – in combination with a basilican nave (Marktpfarrkirche in

Osnabrück, second quarter of the fifteenth century) and a nave approaching Hall width (St. Catherine in Unna, 1389–96) – concentrated in the area influenced by Westphalian architecture.[562] This area includes the Hall choirs of St. Lambertus in Düsseldorf (renovated 1380) and St. Peter's in Rheinberg (begun 1400), both of which possess austere Rhenish cross-rib vaults.

Those choirs built in southern Germany with five-eighths inner polygons had as their prototype St. Martin in Colmar, where triradial vaults had been used only sporadically over the ambulatory. This would now change, as entire ambulatory vaults would be built of triradials. Choirs terminating basilican structures, like Our Lady in Worms (being built 1381), were rarer. Much more common was the Hall choir. The most important exceptions to this were Holy cross in Heidelberg (1398–1498) and the priory church in Bozen (around 1380–1420, more than likely a design by Augsburg architect Martin Schiche) [168]. In both structures, the choir arcades swing to the north and south, giving the inner choir an oval shape.[563]

St. Jakob's in Brünn, Bohemia is usually thought of as the first choir with a five-eighths inner polygon to have received triradial vaulting over the ambulatory. However, this structure could not have been built in the fourteenth century, as many believe, since primary sources indicate a construction date of sometime between 1456 and 1473. Crucial to dating St. Jakob is its detailing. Shaft work passes through the window jambs, it has compound piers, and figures with intersecting ogee-arch canopies on the wall responds, all of which is indicative that St. Jakob's architect had a thorough knowledge of forms from the lodge at St. Stephan's in Vienna[564] during the time Lorenz Spenning was master there.

Not only do Bozen, Heidelberg and Brünn [169] have the same kind of ambulatory vaults, their wall articulation is similar too: the three outer-polygon sides of each church have two windows divided in half by a small pier buttress. From the middle of the west end, the easternmost piers of their arcades stand in front of the windows and disperse their light[565] – an effect common to choirs with a centralized apex pier (Kolin). However, to understand this organizational system as a conscious instigation aimed at a "painterly" effect (Gerstenberg) whereby the body of the pier de-materializes and the space around it becomes more luminous and beautiful,[566] is an over-interpretation caused, perhaps, by a modern sensibility and a way of seeing that has been conditioned by the importance of cen-

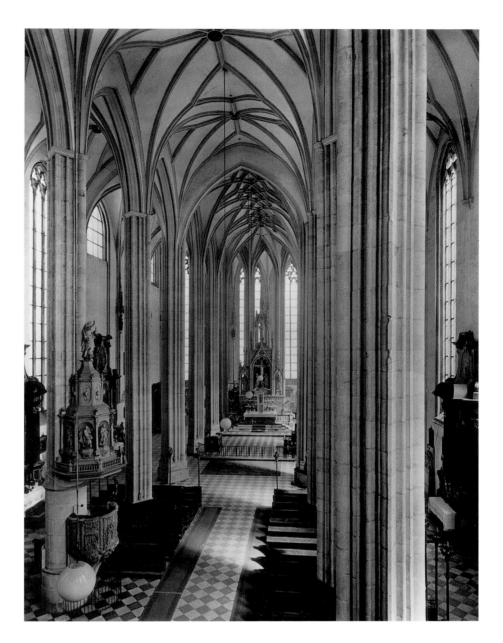

169 Brünn, St. Jakob, nave

tralized perspective. It is an interpretation of the effects of decoration that is probably more studious than medieval builders were. It is achieved, after all, from only one spot in the church almost as if it came about by accident.

Of an even simpler construction than these, were those Hall choirs built without a curving wreath of inner columns. Instead, the inner choir terminates in a right angle, that is, the two easternmost free-standing piers are not placed inward, but remain in line with the rest of the piers. With few exceptions, this type of choir is found south of the Danube. Due to the simplicity of its construction, it is not surprising that we find these choir solutions in village parish churches in western Austrian villages like Pischelsdorf (1392–1419) in the Inn River basin. About the same time as this church was built, Hans von Burghausen was employing a similar termination in St. Jakob's in Straubing, where

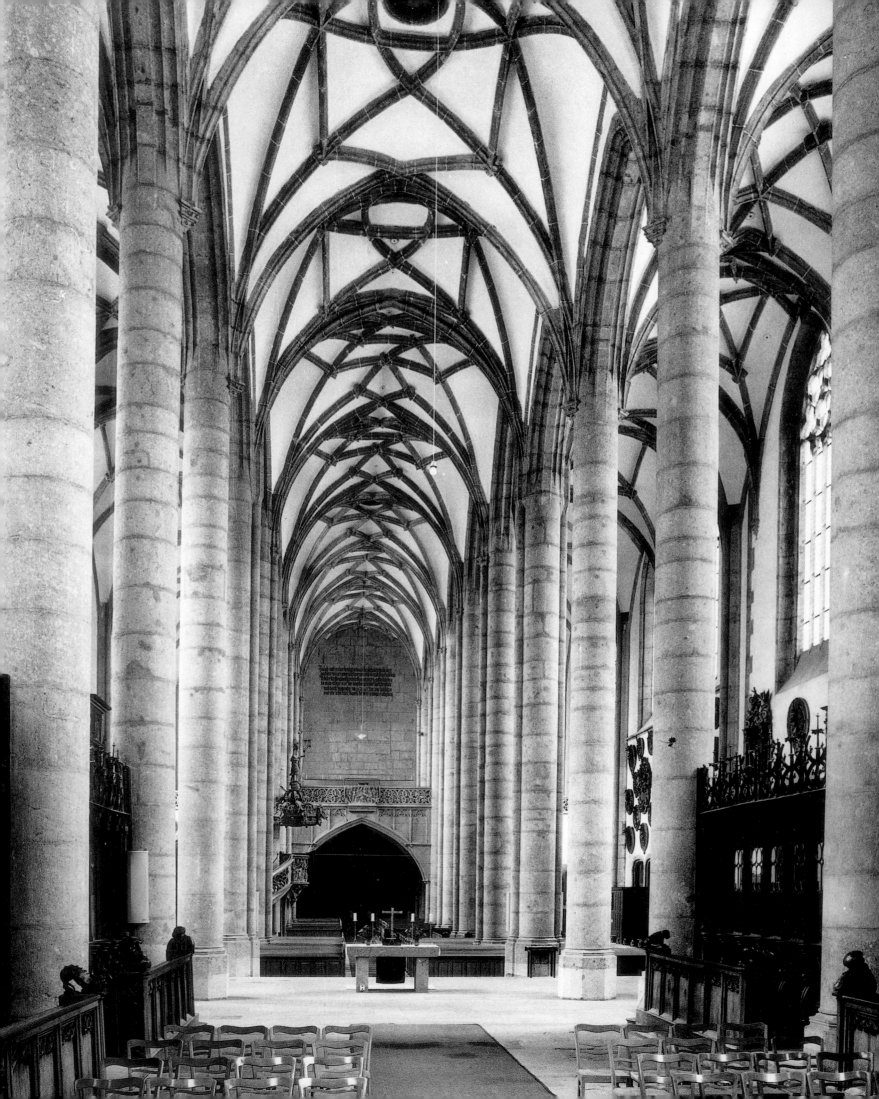

the easternmost piers of the choir hardly move inward at all.[567]

A similar type of choir can be found at St. Lambrecht in the Steiermark region of Austria [124] whose arcades were built right up to the outer wall of the polygon and, naturally, prevented the building of an ambulatory. Stephen Krumenauer's choir at St. Jakob's in Wasserburg (begun 1445) [161] expanded the form by adding wall chapels, by then a common motif. He did this by continuing the chapelled extensions of the nave – built by Hans von Burghausen – around the chevet. The vaults of these wall chapels he raised so high that they're almost as tall as the side-aisles. As a consequence, they merge almost without a break into the diagonally placed chapels of the outer polygon.

In Swabia, the only choir of this type is that of St. George in Nördlingen [170, 171], a church whose huge, elongated roof and tall west tower easily dominated the skyline of the walled, imperial town around it. Under the local management of Konrad Heinzelmann, Hans Felber and Hans Kun began building the huge, twelve-bay Hall in 1427. In 1442 Nicolaus Eseler the Elder took over as director of the project, and by 1451 the choir had reached far enough to the west that a few altars could be consecrated. The St. Lambrecht choir type was reduced to three sides of an octagon here, like at Wasserburg. Chapelled extensions, already introduced to Swabian architecture in naves at Stuttgart and Überlingen, are missing here and as a result, the three-aisled Hall appeals to the eye as a simple, clearly defined space of generous proportions.

Construction of the "classic" High Gothic chevet system – which is centered on a single point of axis around which space is divided symmetrically and in which the inner arcading radiates outward to resonate in the articulation of the outer wall – was no longer attempted in choirs built during the fifteenth century. The exception to this rule was the group of choirs that terminate in five-eighths polygons, with inner structures and ambulatories consisting of five sides of an octagon. But the centrifugal effect created by this type was reduced considerably by triradial vaulting in the ambulatory, which was used often and to good effect in southern Germany. Generally, there were two kinds of choir solutions. In the first, one of the two polygons (inner or outer) had an angle – formed by the meeting of either two walls or arcades – at the longitudinal axis of the central vessel, with the other polygon a wall or an arcade. In the second, the number of sides of the outer polygon was chosen so as not to be divisible by

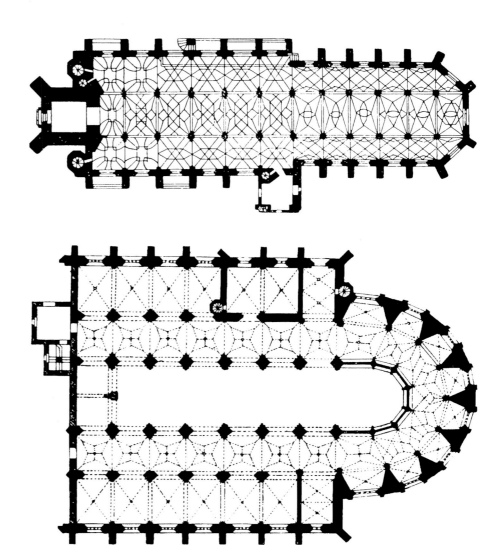

the number of sides of the inner polygon. The Parlers had developed a distinctive type for each of these choir solutions, types that were now ripe for variation. The renunciation in the mid-fourteenth century of radial floor-plan geometry in favor of free design could now bear fruit.

The choir system of Freiburg Minster [125], designed by Johannes von Gmünd, was an early structure with a seam of the outer polygon visible at the eastern apex of the choir. This choir type was subsequently adopted in 1388 at St. Barbara in the Bohemian town of Kuttenberg [172,173] from a design that may have come from Peter Parler's son Johannes.[568] While Kuttenberg possessed the cathedral system's five-sided inner polygon, the architect of St. Jakob in Neisse, Selesia (1401–30) [174] chose to build a three-sided inner polygon that he then surrounded with six ambulatory walls lacking chapels. Here too a pier buttress, placed in the seam of two walls in the outer polygon, stands at the apex of the choir. Its "parallel-rib" high vaults, and the fact that its ambulatory vault is made up of triradials placed in opposition to

171 Nördlingen, St. George

172 Kuttenberg, St. Barbara

170 Nördlingen, St. George, nave looking west

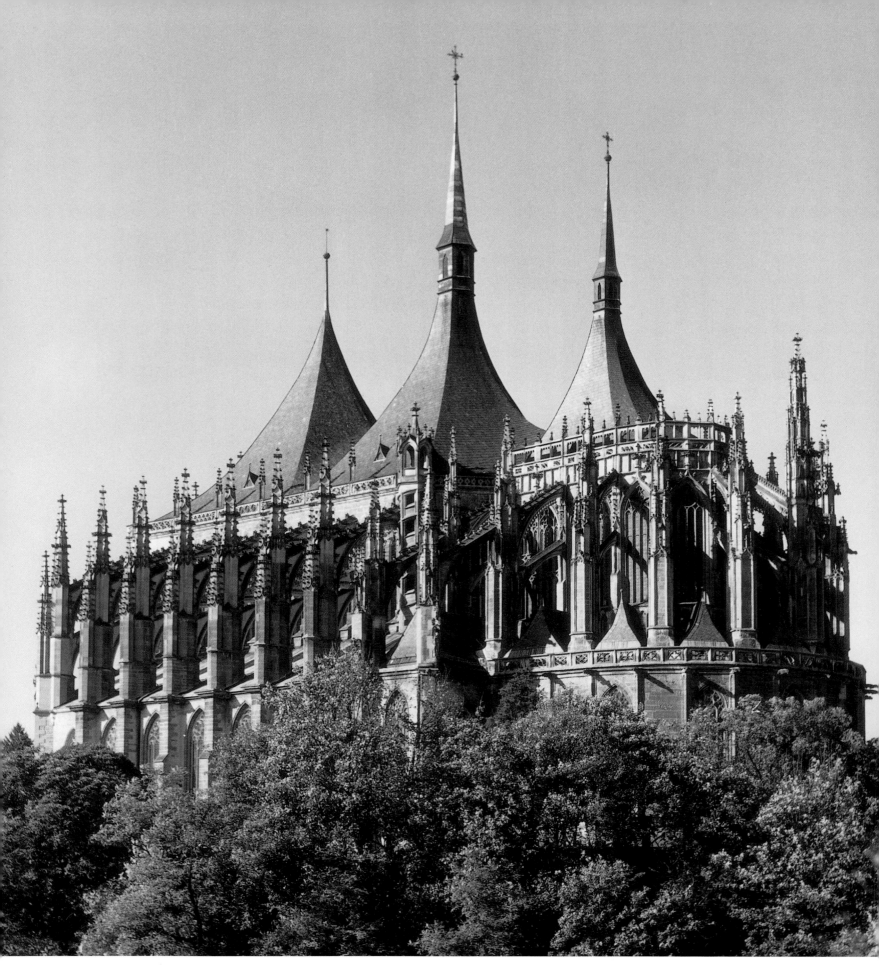

173 Kuttenberg, St.
Barbara, from the south-
east

each other, leave no question that this is a choir type directly out of the Parler tradition. St. George in the town of Dinkelsbühl (begun after 1448, vault completed 1499) [175] which was built by Nikolaus Eseler, whom we saw earlier in Nördlingen, and his son of the same name, possesses exactly the same floor-plan disposition, with the exception that its inner polygon is formed by three sides of a hexagon. A reduction of Kuttenberg's wreath of piers, and the renunciation of basilican organization, has the effect in Dinkelsbühl, like it does at St. Jakob in Neisse, of spatial unification.

Placement of a central pier at the apex of the inner polygon, rather than the outer choir wall, was an invention of Peter Parler at Kolin [142]. This "apex choir pier" would become a *leitmotif* of the work of Hans von Burghausen and clearly shows that he had an intimate knowledge of Bohemian architecture, and was perhaps even schooled there. Burghausen's first choir of this type, at the hospice church Holy cross in Landshut (begun 1407) [176], translated the Parler prototype into the Hall tradition. He isolated the apex choir pier to an even greater degree by leaving the two nearest piers in line with the arcades. The wreath of chapels is also renounced. Hall churches, choir arcades with a high springing line that open up adjacent spaces, along with a renunciation of chapels, characterize the first descendants of both Parler choir types – that of Kuttenberg and of Kolin.

As is always the case in structures by Hans von Burghausen, the structural forms of Holy cross in Landshut are quite simple. Modest round piers lacking capitals, a distinct separation of aisles, vaults made up of four and six-pointed rhomboid stars[569] and alternating three and four-sided vault compartments in the ambulatory, all combine to form an especially harmonious spatial effect, one that was not by any means unusual for the time in which it was built. What is unusual, and surprising, is how exposed the centralized apex pier is and how absolutely alone it stands at the east end of the choir [177]. It manages to dominate the middle of the choir, even though it is connected to its two neighboring piers via thick arcade arches. Perhaps this is because a large umbrella vault grows out of its top and spans the entire chevet, which in turn seems to focus the flow of articulated movement back into the body of the pier.

The next important church interior from Burghausen was done for the parish church in Salzburg (now Franciscan). Sometime after construction began in 1408, the original plan of a Hall nave and choir was dropped, and it was

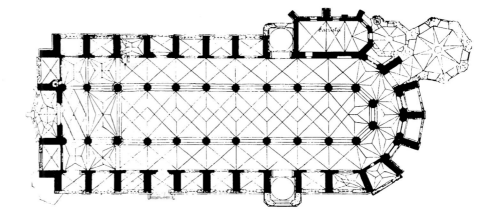

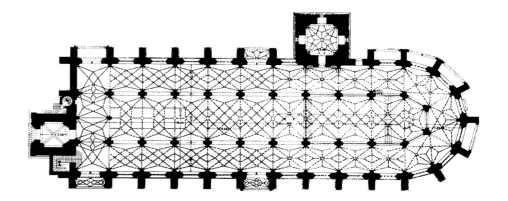

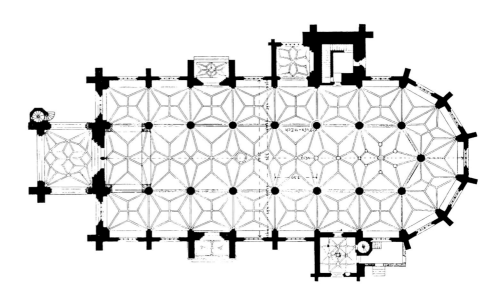

174 Neisse, St. Jakob

175 Dinkelsbühl, St. George

176 Landshut, Holy Spirit

decided to build a choir, with apex pier and ambulatory, onto the old Romanesque nave already standing [178, 179]. The choir-wall buttresses have been pulled inside here. And though the spaces between them are as tall as the high

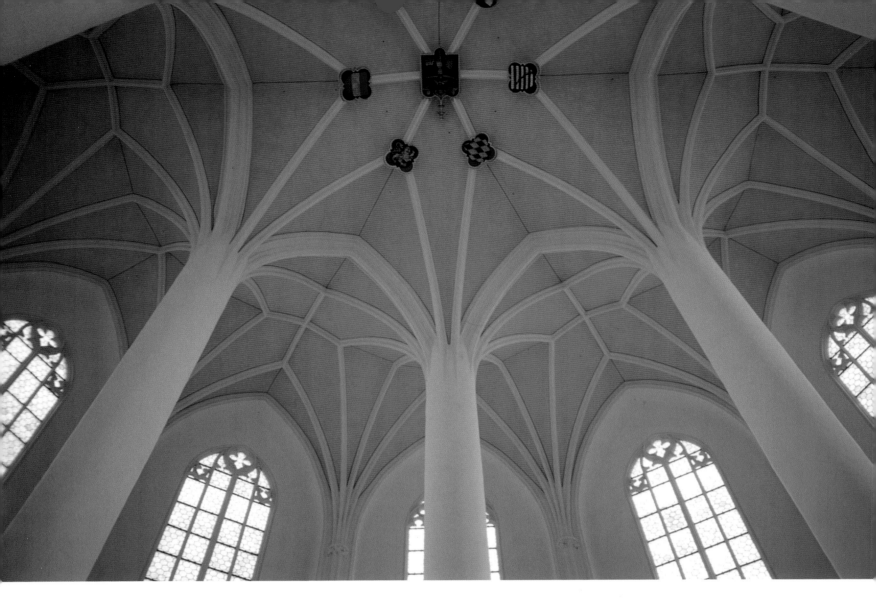

177 Landshut, Holy Spirit, umbrella vault of the central pier in the choir

178 Salzburg, Franciscan Church, choir

vaults, a gallery runs through their lower sections, making them appear like a row of low chapels. As at Holy cross in Landshut, the outer choir polygon is five-sided and its free-standing piers cylindrical. The apex choir pier is placed so far to the east, however, that it is nearer to the responds in the terminating wall than to its neighboring pair of piers. The division of the interior into a triple-aisled structure assures that

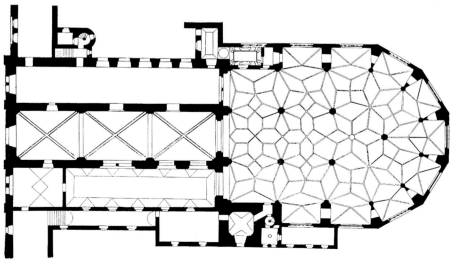

the spaces near the outer wall do not seem separate at all. The ambulatory seems, indeed, to circulate the altar at the same depth as the nave and side-aisle, when it is actually not as deep. With the location of the centralized apex pier, combined with an extremely wide placement of the remaining piers, the choir seems to relax the usually strict rules of Gothic geometry. The cylindrical piers look like they've been placed haphazardly around the room. The side-aisle and ambulatory vaults are incorporated completely into those of the nave, with the points of their rhomboid umbrellas meshing like gears in relation to each other. This forms irregular, inter-bay stellar figures whose rhythmic up-and-down arching creates a spatially homogenous vault landscape, bathed in sunlight from windows placed high in the walls of the chapels. Extending the chapels to such a height effectively opened up the formeret walls. They appear, along with the vaults (finished 1450), to have been the work of Stephen Krumenauer who took over here from Hans von Burghausen like he did at Wasserburg.[570]

Despite sharing the choir centralized apex pier

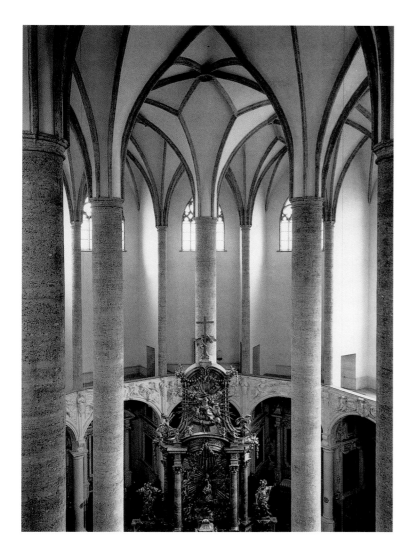

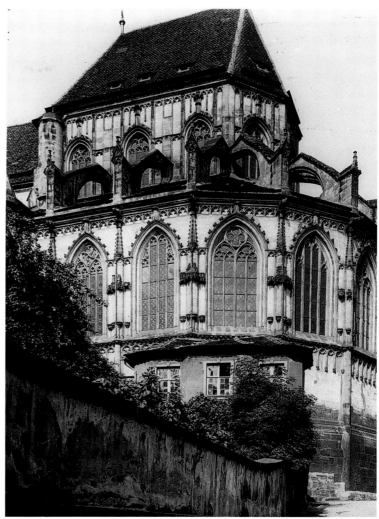

motif, there are important differences between the choirs designed by Burghausen. At first glance, the way he altered them from one structure to the next seems to confirm Gerstenberg's thesis of a linear development of the "special Gothic" Hall into a unified space.[571] But in reality Burghausen's structures in Landshut and Salzburg were anything but linear in their development. They represent choir solutions developed at two separate locations, that were arrived upon at roughly the same time. Both choirs were contemporaneous to one another even though the vaulting at Landshut – the earlier of the two designs – was finished after Salzburg's vault. And we should not overlook the fact that Salzburg is one of the few, if not the only, Hall choir with ambulatory from the period to successfully apply the concept of spatial unity.[572]

These choirs – possessing $\frac{5}{8}$ polygons with ambulatory, arcade arches that do not step inward to the center of the choir to form an inner polygon, with pier buttresses or a free-standing centralized apex pier – can be traced back to a Parler prototype. The same goes for those southern-German choirs with an inner-to-outer polygon ratio of 3:5 or 3:7, whose prototypes were the Parler choirs at Schwäbisch Gmünd [113] and St. Sebald in Nuremberg [121]. Though they do possess different inner-to-outer polygon ratios, all of them adopted the Gmünd wall chapel which we seldom see in the other three types of choirs outlined above. A widening of the side-aisles in the polygon to match that of the nave, another characteristic of Gmünd, did not become all that popular.[573] As a result, the ambulatory was either as wide as the nave and side-aisles (Amberg, Ingolstadt, Bamberg) or much narrower (St. Lorenz in Nuremberg, Munich, Schwäbisch Hall), the latter being a type that can hardly be interpreted as expressing an advanced form of spatial fusion.

St. Sebald in Nuremberg introduced the 3:7 choir type – with three inner and seven outer polygon sides – to the region of Franconia. The citizens of Bamberg chose the same choir form for their Upper Parish church (choir 1392–1431) [180], but decided to enrich the design through the use of rectangular wall chapels. Their intention, no doubt, was to build a structure to rival the church in Nuremberg. The choir's outer

179 Salzburg, Franciscan Church, a view of the choir

180 Bamberg, Upper Parish Church, choir from the south-east

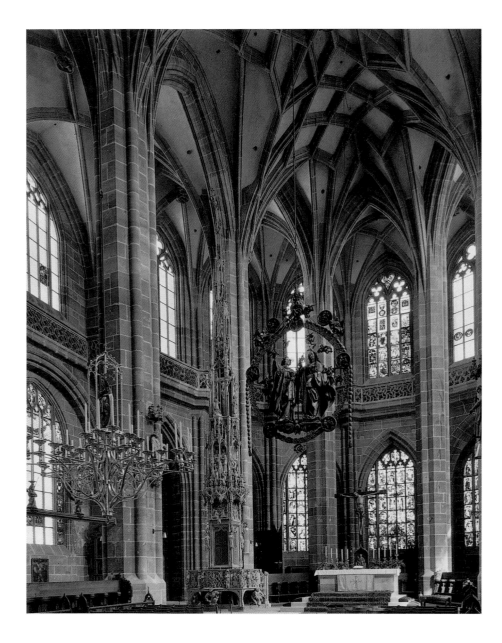

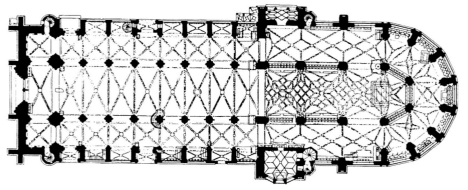

181 Nuremberg, St. Lorenz, view of the choir

182 Nuremberg, St. Lorenz

structure was to receive ornamentation and had it been completed, it would have been magnificent. Ogee window frames, pier buttresses with crocketed pinnacles and panel tracery work on the walls were carried out according to the original plan – in forms oriented towards the Bohemian churches of Peter Parler. Parleresque as well is the basilican hierarchy of inner vessel and ambulatory which, however, was given a ceiling of alternating cross-rib and triradial vaults similar to Nuremberg.

The builders of St. Lorenz in Nuremberg (1439) also adopted the spatial organization scheme of St. Sebald's choir. A Hall designed by Konrad Heinzelmann, St. Lorenz expands the type to include wall chapels which, however, break off at the side-aisles of the sanctuary [181]. Heinzelmann became lodge master at St. Lorenz in 1456 after the death of Konrad Roriczer, who had also headed Regensburg cathedral lodge. Heinzelmann adopted St. Sebald's system of alternating triangular and square-shaped vault cells in the ambulatory, but was also inspired by Franconian, Swabian and Bavarian traditions. He paraphrased Gmünd's choir in his use of trapezoidal chapels. He gave the pier buttress pairs outside niches with sculptured figures in them, a Gmünd motif that Heinzelmann surely knew from his work in Ulm and Nördlingen. The role played by the cornice in register delineation, as we saw at Gmünd, is played by a passageway here. Heinzelmann's Gmünd-type forms, however, are usually limited to individual motifs so that the overall spatial feel they create is completely different than that of Gmünd's. No doubt this can be attributed to the articulated elements, whose magnificent plasticity gives the choir a special place in the group of German choirs built during the fifteenth century [182].

St. Lorenz's piers are longitudinally placed octagons with sharp contours, similar in form to those of St. Martin in Landshut, but heavier. They carry more thickly profiled arcade arches as well. This gives a more solid, heavily proportioned feel to the interior, one appropriately topped by the heavy rib-work of a woven net vault (from Jakob Grimm after 1464). The prominent cornice at the gallery level of the ambulatory fronts a passageway with an open tracery-work balustrade that springs pulpit-like over the wall responds. The room-encircling wall passageway at gallery level has been revived here. It is a motif that would eventually develop into the choir loft. The fragile mullion work of the chapel windows is reminiscent of the Perpendicular style.[574] However, the tracery work of St. Martin in Landshut is somewhat

comparable as well, and similar to the southern-German habit of running mullions almost to the top of the window head and isolating the mouchette there.

The space depicted by the Hall church of St. Martin in Amberg (1421–83) in the Pfalz region [183] seems softer and rounder than at St. Lorenz. Amberg employed Gmünd's five-sided outer ambulatory wall for its choir, but articulated its lateral elevations with forms from Salzburg: round piers lacking capitals and vaulting with no arcade arches that nonetheless retains a strong aisle delineation. But most important is Amberg's use of Salzburg's wreath of tall, thin wall chapels cut through by a gallery that encircles the entire church.[575] The triangular arrises on the pier buttresses of Gmünd's choir are lacking here, however. Instead we find, like at Salzburg, an enclosing wall that apparently had no further need for representation than a lone cornice.[576]

Like so many other choirs built during the time of the Parlers, the Gmünd choir form found adherents even in the late fifteenth century,[577] which proves once again that the years between 1350 and 1380 were pivotal to the genesis of "Southern-German Gothic." Whatever forms became part of the standard repertoire at a later date, even for some naves – variations in nave hierarchy, for instance, and communication between separate aisles; a new type of wall chapel combined with the smooth outer wall; the use of figured, ceiling-encompassing vaulting – all came from choirs built during this thirty year span of the fourteenth century.

Compared to southern Germany, stylistic development in the west of the empire seems to have been a rather stunted affair during the fifteenth century. The numerous new churches built during this period in the Rhineland were unable to emulate Cologne Cathedral's articulated style successfully. Furthermore, starting in the early fourteenth century there were more and more churches built in Backstein, often covered in tufa from the eastern Ardennes region and with articulated elements made of trachyte or sandstone. We find the same materials being used in the Low Countries and Belgium, whose architecture had always had close stylistic ties to the Rhineland. Dutch influence on the Backstein Gothic of the Rhineland can be seen in the tall west tower with surfaces articulated by blind arching, in tall basilican schemes, Halls and *Staffelhalle* designs[578] and in the propensity for building a single roof over both central vessel and side-aisles, even of the Halls. The most

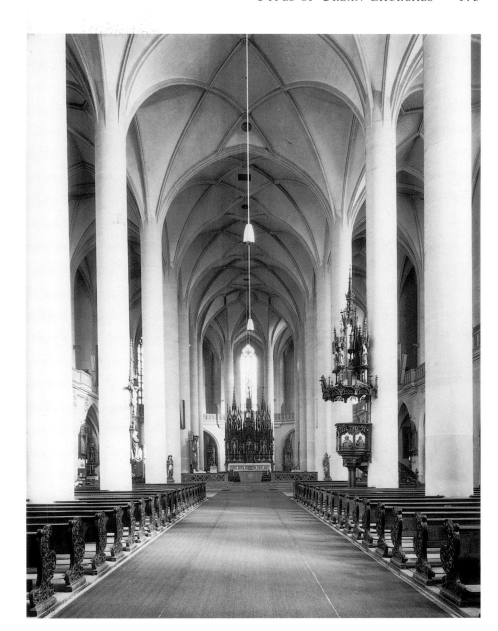

183 Amberg, St. Martin, nave looking east

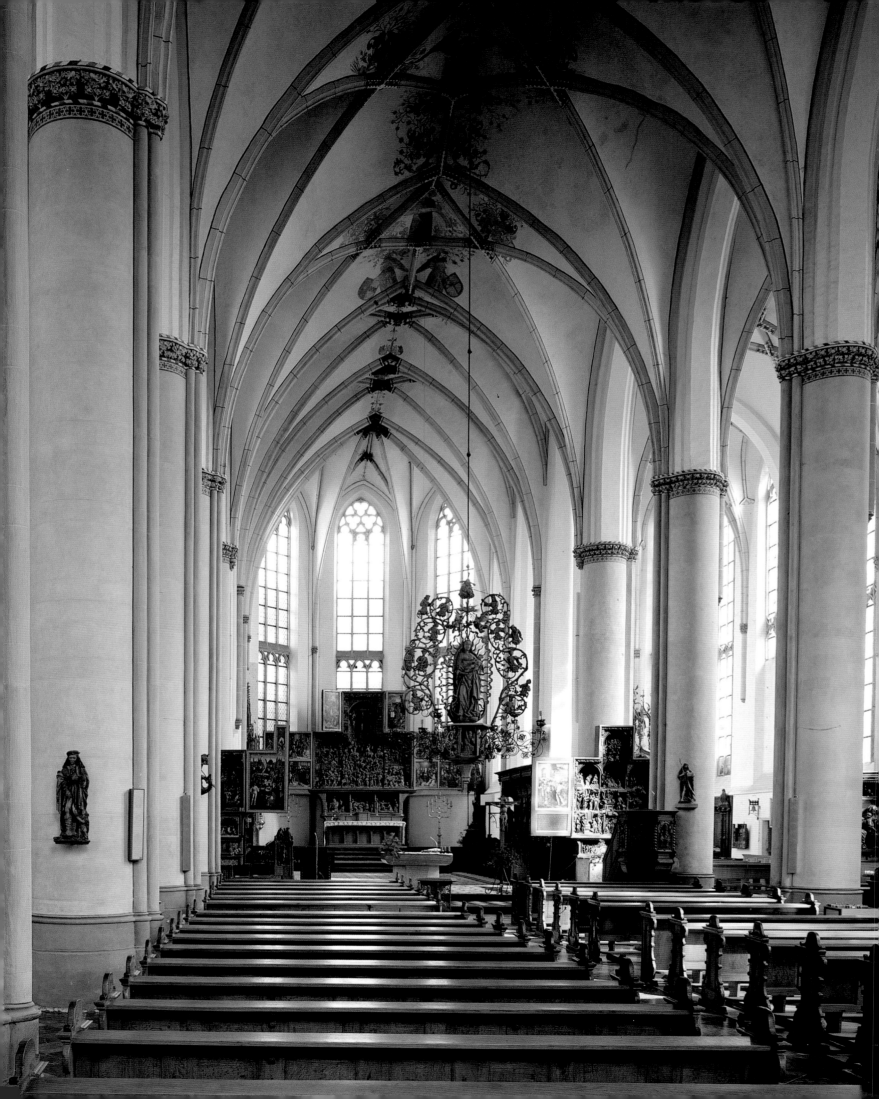

common choir form of the area was the five-eighths polygon system, followed by the triple-apse *Staffel* choir and the triple-chancel choir. A high-vault form common to the Rhineland would be that of the parish church of St. Nikolai in Kalkar [184] with rectangular bays (placed transversely) and arcade arches with sharp-edged moldings. The window tracery at St. Nikolai, also typical for the period, consists of muted quatrefoils and trefoils, and capitals with a stereotyped, dryly executed foliage work.

We find few net vaults in the west of the empire, like we do in the Low Countries of this period. Those few churches to receive a stellar figure, retained a strong bay delineation. Simple cross-rib vaulting was the norm and complicated and expensive structures, like the double-tower façade of the collegiate church in Kleve (1341–1426; prototype Xanten) were the exception. Lower Rhenish Gothic, it seems, had long ago passed its zenith by this time.[579]

The architecture of Westphalia was also conservative compared to that of southern Germany. The fifteenth century continued to see the building of three or four-aisled Halls in this region, which was a traditionally Westphalian type. Most of the churches built after 1400 were village churches of at times very diverse size, especially in height. Smooth cylindrical piers and extremely warped cross-rib vaults were the norm for new structures. As a whole, however, building activity was rather slow, and didn't really take off until after 1470.[580] Only a few stellar vaults were built here in the fifteenth century: in the choir of St. Reinoldi in Dortmund (begun 1421), St. Christophorus in Werne (around 1450), and in the parish churches of Haselünne and Lengerich (end of the fifteenth century). Not until the sixteenth century did stellar figures, combined into simple net vaults, appear in Westphalia, in places like St. Lamberti in Münster (nave vault around 1525) [185] and its descendants – the collegiate church in Nottuln and the parish church in Bochum. This late appearance is a bit surprising in light of the fact that the net vault had been in use for decades in the lower Rhineland and in southern Holland.

The short Westphalian Hall type, on the other hand, can be found as far east as the Lausitz region of Saxony. There were many Hall churches of this type built in the Hannover-Oldenburg region[581] and, beginning in the fifteenth century, further east in Saxony-Anhalt, usually in conjunction with a four-bay space with octagonal piers lacking capitals and terminating in a polygonal choir as wide as the central

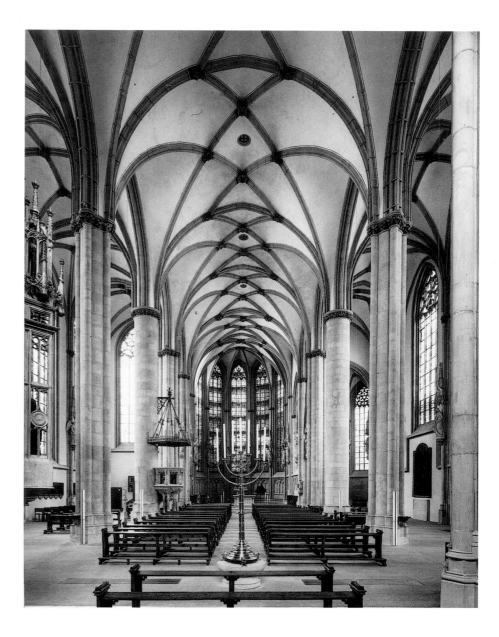

vessel.[582] The Westphalian Hall type, in its Upper Saxony and Lausitz forms, sometimes had noticeably long choirs.[583] Also of interest are the group of Halls built in the towns of Braunschweig and Magdeburg, which have naves up to seven bays long and side-aisle bays each with its own saddleback roof.

Of the churches built in Saxony, only a few employed new vault forms, at least for most of the fifteenth century. One of the very few which did was St. Nikolai in the town of Herzberg in Saxony-Anhalt. The vault in the eastern section of the church (probably built around 1415) is one of the first descendants of the "double parallel-rib" scheme first used in the choir of Prague Cathedral.[584] We also find the "double springing-rhomboid" vault from Prague's Altstädter Bridge tower in the choir of the parish church of St. Michael in Jena (choir vaulted 1442) in Thuringia. Besides these examples, the

185 Münster, St. Lamberti, nave looking east

184 Kalkar, St. Nikolai, nave looking east

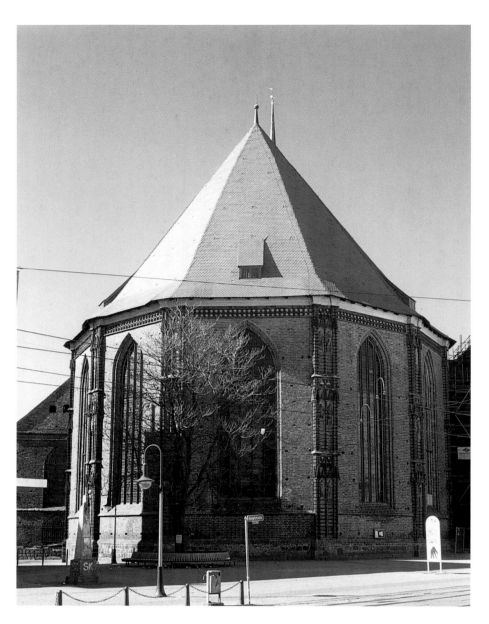

186 Brandenburg, St. Catherine, choir seen from the east

St. Nikolai in Berlin. The Hall choir with ambulatory at St. Nikolai in Spandau was built before 1400, as was St. Mary's in Beeskow (after 1388, in ruins since the Second World War) whose central vessel possessed stellar vaulting, and whose side-aisles and ambulatory combined cross-rib and triradial vaulting like many southern-German choirs built during the same period.[585] While St. Mary's in Frankfurt-an-der-Oder influenced these choirs to a great degree, the Berlin motif of a low wreath of chapels surrounding the choir was not without its adherents in Brandenburg and Pommerania.[586]

Shortly after 1375, builders surrounded the choir polygon of St. Jakob's in Stettin [120] with an ambulatory of the same height, then broke the old choir walls into arcades[587] and placed small, two-story chapel niches between the pier buttresses. These chapels were consecrated between the years 1380 and 1387. The chapelled extension, it appears, was introduced to the architecture of Pommerania decades before it was in southern Germany. The lateral elevations of the chapels are double-register inside. This resonates in the articulation of the outer wall via a window system made up of pointed-arch lancets – a high one directly on top of a low one, the so-called "piggyback system" – with the apex chapel lit by a huge, single window.

One of the few Gothic architects of northern Germany whose name is known to us is Hinrich Brunsberg. An inscription in Corpus Christi Chapel at St. Catherine in the town of Brandenburg indicates that the structure was begun by "Hinrich Brunsberg from Stettin." Indeed, nothing confirms Brunsberg's Stettin roots more clearly than the architect's preference for the chapelled extension, which we find in all three structures attributed to him (Königsberg, Brandenburg and Stargard). Another motif common to all three churches, and an even clearer example of a Brunsberg design, is the pulled-in choir pier buttress, articulated outside by three decorative zones – each consisting of a pair of figures tucked into niches and crowned by a pointed gable – stacked one on top of the other [186]. And while this pier form seems amazingly similar to the gabled niches with figures on the pier buttresses of Gmünd's choir [116], they are not of Swabian descent. Rather, they are based on wall piers found in the cloisters of the Teutonic Order stronghold at Marienburg (second half of the fifteenth century).[588] They can also be found on the southern chapels of Stettin's nave, which was rebuilt when the choir was renovated. Hinrich Brunsberg's pier buttress decoration, made as it

architecture of central Germany remained pretty much untouched by the revolutionary developments in southern-German Gothic into the last third of the fifteenth century. Later, of course, developments in the Hall tradition of Upper Saxony would usher in a late flowering of Gothic vault construction.

Fifteenth century Backstein Gothic east of the Elbe River evolved, as it did in most places in central Europe, parallel to the development of the choir with ambulatory, while nave design had long since settled on the typical Hall type and offered little that was new. Besides the Lübeck choir type from the Baltic coastal cities of the Hanseatic League, there was also a Brandenburg choir type. This first appeared in the mid-fourteenth century in churches like St. Mary's in Frankfurt-an-der-Oder [119], which had an inner-to-outer polygon ratio that was the same as Zwettl [114] and St. Sebald [121], and was surrounded by wall chapels in a manner similar to

is of small articulated sections of stone, is in stark contrast to the austere Backstein Gothic east of the Elbe River. The tracery façades of the two chapels at St. Catherine's choir in the town of Brandenburg[589] [187] are further evidence of his joy in decoration.

Around 1400 Brunsberg began the choir of St. Mary's in Stargard, Pommerania,[590] with double-register window walls reminiscent of those at Stettin's choir [188]. The ambulatory and chapelled extensions at Stargard are lower than the chevet. In a style similar to the Baltic choirs of the Lübeck type, half of the clerestory is covered by a steeply pitched lean-to roof. A pier buttress is placed in the outer polygon at the longitudinal axis, indicating a debt to St. Jacobi at Neisse [174] and through it a knowledge of Bohemian architecture. The inner choir possesses a true triforium. Below this are octagonal piers with canopied figures in niches covered by pointed gables that look like they're right out of the ashlar tradition. Once again we are confronted with Brunsberg's love of sculptural detailing that was, for the most part, alien to Backstein Gothic.

For the spatial disposition of the Hall choirs at St. Mary's in Königsberg (1389–1407) in the Neumarkt region, and at St. Catherine in Brandenburg (1387–1411) [120][591] Brunsberg

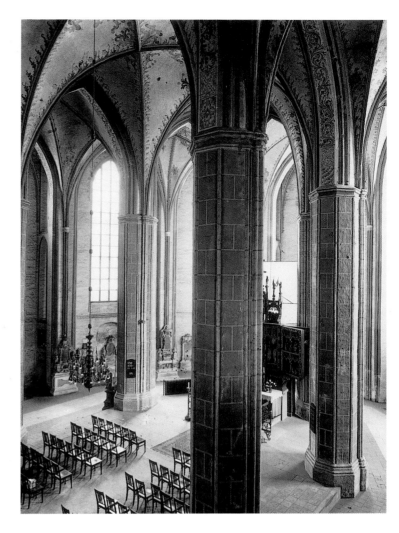

187 Brandenburg, St. Catherine, view of the choir

188 Stargard, St. Mary's, view of the choir

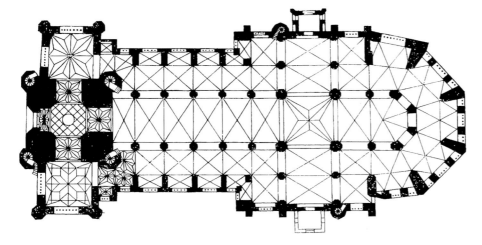

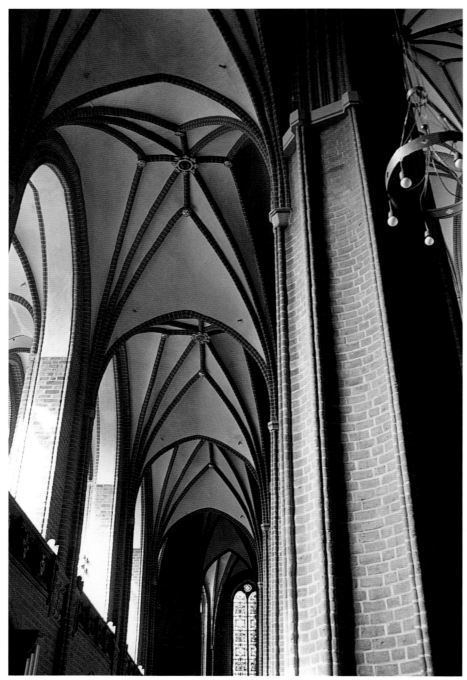

189 Stralsund, St. Mary's

190 Lüneburg, St. Nikolai, side-aisle vaults

followed many of his contemporaries and employed forms from St. Mary's in Frankfurt-an-der-Oder. Königsberg possesses stellar vaults over the sanctuary like those we find in Spandau and Beeskow. Brandenburg's ambulatory vaulting is quite similar to Frankfurt's[592] but narrower because the outer choir polygon, which has five sides of a decagon, is flattend in the apex, and its chapelled extensions are very narrow. The pulled-in pier buttresses, however, are broken through so that they appear at ground-level to consist of two free-standing supports. A strainer arch is the only connection the inner part of the hollowed-out pier has to the outer choir wall. Instead of individual chapel spaces, then, a kind of second ambulatory has been formed here, similar to what we saw in the early Hall naves in Prenzlau and the town of Neubrandenburg. Brunsberg adopted an old motif of the Backstein Gothic and with it created a second row of piers made up of "opened" buttresses. This stands out as one of the most impressive, and spatially differentiated solutions among the many conventional choirs with ambulatory built in the north of the empire during this period.[593]

In the Baltic coastal cities, choirs developed in a different direction. Trade with the major harbor cities of medieval Holland and Flanders, whose architecture had developed little beyond French Rayonnant during the fourteenth and fifteenth centuries, helped insure that most new buildings in the area were retrospective stylistically, and that they were much influenced by local materials and traditions. For the Hanseatic League, it was a time of social and political stagnation. Rich merchant families – who had become wealthy through League activities and were able to finance great-church building – must have felt conventional forms to be the best way of representing the values they chose to stand for, since the most popular type was the basilica with transept, which still possessed the aura of the great cathedral housing the seat of a bishop. Paradigmatic of this would be St. Mary's in Rostock – one of the churches descended from the Lübeck type. After a major collapse in 1398, it was rebuilt with large transept arms, a floor plan disposed towards Doberan, and detail forms closely reminiscent of Lübeck.

St. Mary's in Stralsund (begun after 1382) [189] was also built as a three-aisle basilica with transept. It possesses a huge crossing structure in the west (1416–78) with large windows. The tall rooms flanking the west tower are very spacious, almost as if the builders decided to translate the Cologne/Strasbourg "towered hall" into the heavy forms of the Backstein tradition.[594]

Connecting to its five-bay nave with chapelled extensions, is a three-aisle transept and choir with ambulatory. A wreath of six chapels of the Lübeck choir type was fused to a five-sided eastern wall with irregular shaped pier buttresses pulled inside.[595] A filing-down of the outer choir wall, and the chapelled extensions in the wall of the nave, were concessions made by Stralsund's architect to the new structural forms from the German regions further inland. On the other hand, the vault – including the stellar figures of the west ceiling that were built much later – remained conservative.

St. Nikolai in Lüneburg (1407–40) [190] also features a "Baltic" wreath of three protruding polygonal choir chapels very similar to the Lübeck type. The church managed to creatively combine old and new elements of northern-German architecture. In fact, at first glance, this tall, and narrow basilica – with its single-column crypt beneath the sanctuary – seems rather old-fashioned for the time it was built. But the fact that the church lacks a transept gives a tight spatial feel to its rows of vaulted bays, and the nave is enriched by double-register chapelled extensions. Vaulting the bays are stellar figures with diagonal ribbing of the east-Prussia type. The molding of the arcade arches is made up of numerous thin fillets and round shafts that are just as thick as the piers below them. This constellation can be found in the *Staffelhalle* of St. Johannis in Lüneburg (before 1289–1310) and in many other structures of the same type between Hannover, Hamburg and the lower Elbe River basin – a "Lüneburg motif" if you will, that continued to be popular into the late fifteenth century.[596]

After making major contributions to vault development in the fourteenth century, the easternmost areas of the empire – Silesia and the Teutonic Order "state" – ceased to play an important role in the development of German Gothic. The exception was in the city of Gdansk where, despite the collapse of the Teutonic Order in the mid-fifteenth century, the city managed to build one of the largest churches of the Baltic coastal area. The original design for St. Mary's in Gdansk (begun 1343) foresaw a nine-bay basilica lacking transept with a straight choir termination [191]. This design was dropped by Hinrich Ungeradin[597] who had been put under contract as *magister structure* in 1379. He replaced the flat choir termination with a wide, triple-aisle transept and a three-aisle Hall choir built onto it. This huge cruciform eastern termination was finished in 1446, including the gables which are made up entirely of individual turrets

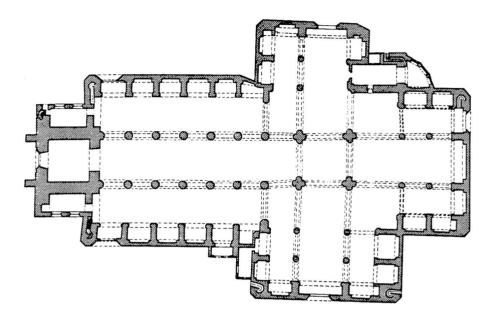

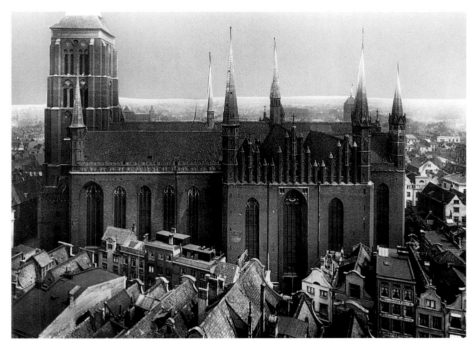

in staggered heights that rise above the terminating walls. Between 1454 and 1466 the upper registers were erected. The western sections received their Hall form via a widening of the side-aisles between 1484 and 1498, then the entire inner structure was vaulted (completed 1502).

The block-like outer wall of St. Mary's [192] with its huge flat surfaces and beveled corners, betrays little of this change in design or the unorthodox way in which it was built. The rhythmic placement of tall windows – which possess tracery in the choir and transept only – are the only elements to cut into its flat, otherwise unarticulated outer wall. The pier buttresses have completely disappeared inside to form chapels. Long saddleback roofs, corners

191 Gdansk, St. Mary's

192 Gdansk, St. Mary's, from the south

with smallish polygonal towers and pointed spires on them, ornamental gables above the choir and transept terminal walls – reminiscent of secular, patrician architecture – are all dwarfed by a massive belfry tower. Inside, the octagonal piers of the nave are covered in a thick layer of chalk. They belong to the basilican floor plan which was followed until 1379. The supports of the eastern sections of the church are thinner, with the exception of the massive crucible-shaped piers of the crossing. Surrounding this mostly unarticulated Hall space are chapelled extensions as high as the side-aisles, and over which the ribs of a finely spun stellar net vault branch out. St. Mary's in Gdansk is a powerful monument to the monotony of the unadorned Backstein wall. With it, two hundred years of Baltic Backstein Gothic came to an end.

THE FIGURED VAULT

Prague Cathedral provided Peter Parler with a venue in which to employ a variety of different vault figures. These vaults were to provide basic patterns for the sheer inexhaustible pool of individual variations of them that soon followed. Until Parler's lifetime, cross-rib vaults were the most popular form of ceiling, stellar and umbrella vaults being in the minority. With him began a period in which the vault became the focus, if not the *main* focus, of great church architecture.

As the number of vault forms multiplied during the fifteenth century, the more architects there were who specialized in building them. In the manuscripts from medieval construction lodges,[598] and in stonemason and sketch books of the fifteenth and sixteenth centuries,[599] we find so many vault drawings and vault cut patterns, so many sketches of arches, that they make up the majority of the collections. The kind of ceilings we are discussing here could not have been built without extensive geometrical design-aids, and one cannot help but get the impression from these sources that architects of the generation after

Peter Parler competed against each other to come up with the most audaciously drawn vault designs as proof that they could safely be translated into stone. Perhaps the reason why Late Gothic vault construction entered its "golden age" in Germany was because, more than all other disciplines of the articulated style, it lent itself best to geometrical experimentation, which had always been a strength of German architects.

Yet, creative vault figuration was not a characteristic of all regions of the Holy Roman Empire, and not all regions shared equally in its development. Many areas remained true to the cross-rib vault until the advent of the Renaissance.[600] Once again it was southern Germany that first adopted Parler's vault patterns. It is here also that we find the greatest number of new vault forms built during the years between Prague and the advent of the great spatial designs at the end of the Gothic period in 1460/70.

The first step taken beyond the vaults of Peter Parler can be seen as early as the work done by his two sons in Prague. The stellar vault that once hung over the ground floor of Prague Cathedral's south tower [133], for instance, possessed a large apex ring on which the four points of the stellar figure broke in a zigzag pattern.[601] Over the chapter room to the west of this, the vaulting consists of so-called "creased-rib stars" whose zigzag forms proceed out of a central rhomboid.[602] By the early and mid-fifteenth century, both of these had become standard vault motifs of the lodge at Vienna: stellar figures with an apex ring can be found in the tower registers of St. Stephan's, while "creased-rib stars" with an octagonal central figure hang over the nave of St. Maria-am-Gestade [193] and actually span two bays of the western parts like a dome. Here the ribs radiate outward in small compartments from bundles of richly profiled wall responds to hold up the large ring at the vault apex.[603] Around the middle of the fifteenth century the "creased-rib stars" of St. Maria-am-Gestade were transformed into a ceiling-encompassing rhomboid net configuration at Vienna's St. Stephan's[604] built by Hans Puchsbaum and Lorenz Spenning [194]. They retain the compartment-like rib structure and dome-like curve of the original, but are fused at the apex of the vault to create a row of identical rhomboids turned transversely. Each net figure receives additional support above the crown of every second arcade arch, where a rib-structure branches out like a fork in search of the formeret wall. In the choir vaults of St. Martin in Landshut [159] (probably built by Hans Krumenauer) we find the same rows of rhomboid figures[605] but turned longitudinally. They do not,

193 Vienna, St. Maria-am-Gestade

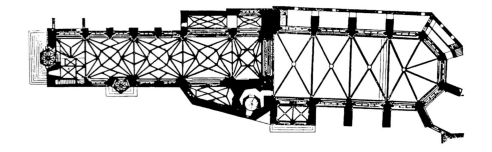

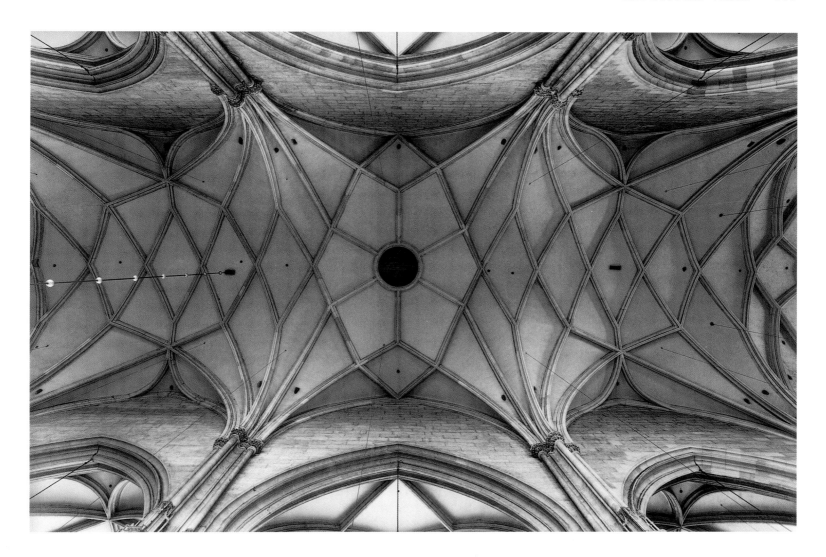

194 Vienna, St. Stephan,
central vessel vault

as they do at St. Stephan's in Vienna, develop out of stellar figures, but are spanned between "springing rhomboids".[606]

Through the work of talented architects like Hans Krumenauer, medieval-Bavarian architectural design was focused on the curved vault by the first half of the fifteenth century. Another of Bavaria's important architects, Hans von Burghausen, copied Prague's St. Wenceslaus Chapel [133] and had s-shaped ribs radiate out from a central ring-shaped vault boss[607] in the sacristy of Holy cross in Landshut [176]. St. Catherine's Chapel (donation 1411) on the north side of Holy cross, has a vault made up of a single, eight-point star whose middle ribs are curved.[608] The star over the church's south-portal porch also has curved ribs. These were built before the fork-like rib structures of St. Stephan's and were the first curved ribs, inconspicuous though they are, since Madern Gerthener used them in Frankfurt's tower portal [151]. Nothing was done to develop these small-venue vaults for decades, until Stephan Krumenauer took the bold step of basing the vault of his choir at St. Jakob's in Wasserburg

(1445–8) on the curved rib, creating German Gothic's first large-scale rib-arch vault. The four-point stars of the choir's central vessel are similar to the vault system at Prague's tower, but curved only slightly by Krumenauer to form four-leaf blossom shapes. Like many of the vaults to follow in southern Germany, the ribs at St. Jakob's are formed out of stucco.[609]

Eastern Bavaria, which bordered on the important lodges at Landshut, was one of the most important areas for vault construction in the first decades of the fifteenth century. Besides historically important architects like Stephan Krumenauer, there were many other "vault masters" active at the time. Their names are all but unknown to us, but they nonetheless managed to build original vault designs that have survived the centuries. A good example is Konrad Bürkel, about whom we know little more than that he built a triple parallel-rib vault over the central vessel of the monastery church in Seeon (renovated around 1430). Here we find a thickening of the double parallel-rib structure from Prague Cathedral's high vaults. It creates rhomboid figures at the apex of the vault, thus multi-

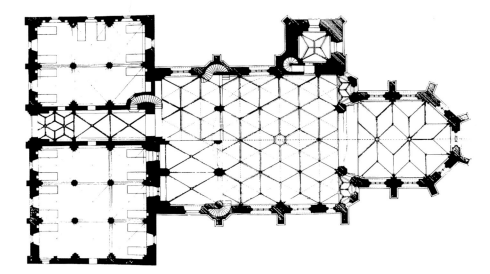

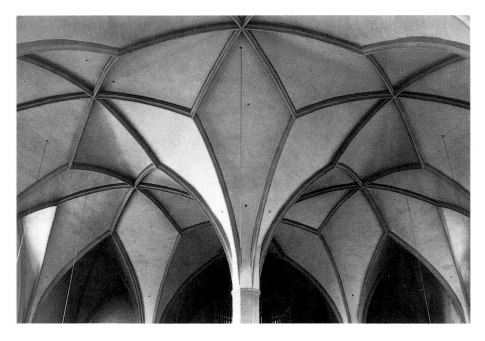

195 Braunau, hospice church

196 Burgkirchen-am-Wald/Oberbayern, St. Rupertus, vault over the three-column nave

nave wall. The two easternmost piers are also the supports of the triumphal arch. Every pair of piers in the wreath formed an equilateral triangle with the central pier. The arrangement of columns in Prague's southern porch [140] is, of course, the prototype here – projected onto a large space and expanded to all sides.

What appears in the two-dimensional floor plan as a homogeneous stellar net-vault made up of identical rhomboid shapes, is in reality separate umbrella vaults that have been fused together. This vault is not a canopy-like structure spanning a space between two walls and resting on corner supports. Neither is it a space formed into parallel aisles running longitudinally and made up of rows of bays. Strategies that had determined the designs of ecclesiastical architecture throughout the Middle Ages have been overturned here, for Braunau's vault has no aisle delineation whatsoever. Instead of the usual rapport between supports placed exactly across from each other, here we find the design concept of "infinite" pier-placement stretching to all sides. Its seemingly endless expanse of umbrellas appears to have been broken off at the outer walls, then forced into a rectangular nave.

Many so-called "three-column churches"[611] in medieval Bavaria and Austria would copy this structure, and there would be numerous double-aisle and single-column variations of it built, especially for country churches in the region. The employment of rhomboid umbrellas resulted in a complete dissolution of aisle-delineation in the vault, even in double-aisle churches, because the umbrellas of the central row of piers radiate out equally in all directions.[612] Here were the first steps towards that spatial fusion achieved at a later date with the development of "looping" stellar vaults in Bohemia and Upper Saxony. The closest any great church came during this period to the three-column type was the Franciscan choir in Salzburg [179] with its bay-dissolving umbrellas. When seen from the west, the central pier of Salzburg's choir interacts with its neighboring columns to form a similar, spatially dominating constellation.[613]

The vault's importance in Gothic spatial delineation can be seen in the development of polychromy, which moved from the walls to the ceiling during roughly the same years we are addressing here. By the fourteenth century, piers, responds and ribs were already painted bright colors, and set-off from white or light-orange wall surfaces and vault webs. Now and then surfaces had ashlar joints painted on them, or the material character of rib crossings were enriched by manschettes painted to look like

plying the number of elements that transcend bay delineation.[610]

A completely new kind of spatial organization was achieved in the nave of the hospice church in Braunau (1417–39) via the employment of a rhomboid umbrella vault [195]. Free-standing piers were arranged inside a longitudinal space so that they formed the corners of a equilateral triangle. The two west supports, with a gallery hung halfway up between them, form a line that is parallel to the west wall of the church. The third pier, which unfortunately was removed in 1687, stood in the middle of the nave at a spot between the west gallery and the eastern nave wall, so as to be exactly between the two western piers. The free-standing piers in the west also formed two corners of a six-cornered wreath of piers that swept around this central support. The two lateral supports of this wreath are articulated by thickened compound responds in the

marble. White surfaces with articulated elements set-off in color became more popular as the century wore on, developing parallel to the gradual process by which the Gothic window was being developed to let in more light. Architects sought a lighter, brighter polychromy for their interior designs, which had the wall surface placed like a foil behind a trellis of unified support elements and vault ribs.

Then, sometime around the end of the fourteenth century, the color of articulated elements became duller. There were many churches built, especially in the south, with articulated elements in gray monotone.[614] Shortly after the turn of the fifteenth century, however, foliage work began to appear, painted across the surfaces of vaults in many small churches of a more intimate character. All areas in Germany witnessed the phenomenon of "botanical vault painting," and it took various and quite different forms. Often sheaves of vines were painted growing out of rib crossings and vault bosses, or passing under the path of the vault ribs. Frequently a blossom in the shape of a chalice grows out of the vault springer, or a vine twists around a rib as it rises.

Before this development, vault webs had often been treated to look like ashlar or were covered in stars.[615] Its replacement by painted foliage work indicates that a new variation of celestial iconography was at work in the minds of vault-builders. No longer was the vault to be stonework representing the Heavenly City of Jerusalem, or holding the stars of the firmament. Now it represented the Garden of Eden. Indeed, painted vines now entwined ribs of the net vaults like real vines do through the trellis of an arbor.[616] No doubt this development was related to the *hortus conclusus*, a new subject in panel painting of the same period. In many churches, apex rings or circular vault openings, framed by flames or angels, articulated vault cells and were meant to allow the Holy Spirit to descend into the church. These are the so-called *Heiliggeistlöcher* [197], holes through which a living or wooden dove was hung during the Mass at Pentecost. In passion plays celebrating the Resurrection and Holy Ascension, actors playing the part of Jesus and the angels would rise and disappear into them.[617]

Less common than botanical vault painting was sculptural foliage work, a motif that would become especially popular – next to the usual

197 Kalkar, St. Nikolai, high vaults with the Heiliggeistloch, or hole through which a dove was dropped during the Mass at Pentecost

capital decoration – during the last third of the fifteenth century.[618] Early examples of sculptural foliage work in vaulting are the foliage bosses[619] at Prague Cathedral [137] and Peter Parler's Altstädter Bridge tower, along with the foliage crockets that articulate the path of the vault ribs over Prague's St. Wenceslaus Chapel and Ulm Minster's "Besserer Chapel" (1414). Generally speaking, those few cases where sculptural foliage work was employed after Parler – in Saxony, Franken and Austria – it remained conservative in design.[620]

Like foliage decoration, vault tracery work was an exotic form of ornamentation, and thus restricted for the most part to smaller formats. Madern Gerthener's tracery vault rosettes on the north-tower porch at Frankfurt [151] are the first examples. Around the mid-fifteenth century a man named Moyses von Altenburg was decorating small aristocratic chapels in Saxony with vault tracery work. The Prince's Chapel at Meissen Cathedral (vaulted 1443–6) [198], which Margrave Friedrich the Valiant had built as his tomb in 1423, has a parallel-rib vault construction, with quatrefoil rosettes at the apex whose cusps end in lilies. Even more impressive is the tracery that fills the webbing

of the palace church in Altenburg (built in 1444 after a fire), whose forms correspond to those of the tracery used on the cathedral's choir façade.[621]

These were some of the few churches to receive articulated vaults with painted botanical motifs, or abstract and botanical tracery figures. Nonetheless, they heralded in the most important development in German Late Gothic, a period during which magnificent designs would raise vault construction to a high art. Once again, forms tested on smaller venues would be developed at a later date into important features of great churches – this time warped, stellar and branch-work vaults.

In the wake of the creations of the Parlers and the special regional types they inspired, the pool of forms and structural types characteristic to German Gothic architecture was, by the middle of the fifteenth century, richer than it had ever been before. The following half-century would see the survival and variation of the complete repertoire. It would be applied at various levels of expertise, in a process that saw the conscious application of individual architectural values that were intensified and transformed, which resulted in completely new kinds of structures.

MOVEMENT IN STONE: A LATE GOTHIC METAMORPHOSIS

MANY FORMS OF the fifteenth century were in use for a long time, and a kind of general architectural language built up over the years that did not change much, even after the epoch (and fictitious) break in the year 1500. The standardization of types and motifs, that could be copied almost verbatim, increased as more and more new churches were built. As is the case with all highly developed artistic styles at the end of their historical cycles, many great churches of the Late Gothic period were neither spectacular nor particularly innovative. Many churches, especially in the south, bear witness to this phenomenon: an extremely high level of workmanship executed rather conventional forms, conventional considering all the stylistic options open to builders at the time. There were new and important developments, of course, but not in larger forms like lateral elevations or structural articulation systems. Once again, change came in a smaller format, in ornamentation and especially vaulting which was having more and more of an impact on the spatial articulation of great church interiors. Vaulting, in fact, would bring about the last transformation in Gothic architecture, with the southern and central regions of the empire – their ruling families investing heavily in new church construction – being at the center.

CHURCHES BUILT AFTER 1470
THE IMPORTANCE OF SAXONY AND
SOUTHERN GERMANY

The list of figured vault-types available to Gothic architects was expanded during the first fifty years of the fifteenth century to include curved-rib, foliage-leaf and tracery configurations. By the second half of the century, the sheer number of different vaults was staggering.

The same cannot be said of floor plans, nor of lateral-elevation types or outer structures. Evidently, as vault manipulation became more popular, architects lost interest in developing more complex systems to articulate space from the surrounding walls. Outer structures built during the period exhibit, for the most part, scant ornamentation. Magnificent towers and façades, among the most important construction projects in the decades before 1450, were now few and far between. Thus simplified, the outer structure of the great Gothic church took on more and more the function of protective shelter for a resplendent interior.

A typical Late Gothic structure, one that characterizes this process in Bavaria, is Munich's Frauenkirche (begun 1468 by Jörg von Halsbach) [199]. The major patron of the project was Duke Sigismund, and the church was to serve as tomb for his family, the powerful House of Wittelsbach. The duke's patronage is probably why Frauenkirche was completed in such a short time – church consecration was in 1494. As the last of the Bavarian royal residences to receive a great church, Munich stood at the end of a long line of magnificent Donau Gothic Halls that includes Burghausen, Landshut, Straubing and Ingolstadt.

Frauenkirche's completely uniform contour outside is created by huge roof surfaces and a smooth Backstein wall with chapelled extensions that are articulated with nothing but flat lesenes [200]. Two towers rise in the west. Their compact cube-like lower registers, combined with a double-register polygon, remind one of Gothic towers in eastern Bavaria.[622] The towers' onion domes set on tambour bases represent the earliest Italian Renaissance motifs in the German Empire. This form of tower must have epitomized the classical tower for Germans of the Late Middle Ages, since

199 Munich, Frauenkirche

200 Munich, Frauenkirche, seen from the south-east

similar structures appear as background architecture in a historical painting by Hans Schöpfer the Elder.[623]

Frauenkirche's floor plan is of the type we saw at St. Lambrecht, Nördlingen and Wasserburg – a triple-aisle Hall with polygonal choir and no separate ambulatory. The arcade arches of the central vessel continue through the choir to the apex chapel of the eastern polygon. The last pair of piers is placed just a hair closer together than the others. Only at the very end of the church do they step inward from the long and straight lines the arcades form. The individual octagonal piers, massive and unadorned, are so close together that they seem to fuse into a wall as they run away from the eye towards the east. This dramatically emphasizes longitudinal movement through the nave. Further emphasis is provided by the stars over the side-aisle vaults, which are rotated towards the central vessel and make each side-aisle bay seem to flow inward. Tall chapel windows in the outer wall reach clear up to eaves level, and let a lot of light in. The church's reconstructed polychromy – white surfaces with ocher rib work – makes for a bright yet serene spatial feel throughout the interior [201]. Frauenkirche's spatial disposition, unlike other Hall churches of this period, is not determined by a wide expanse of vault overhead. The overall effect is not one of movement, but of monotony created by stiff masses of piers and unadorned outer walls.

The influence the House of Wittelsbach had on the construction process at Frauenkirche was symptomatic for a general trend, which saw powerful ruling houses in many principalities within the empire taking a more active part in great-church construction. In late medieval Swabia, for instance, work on a new residence for the Württemberg dukes in the town of Urach around 1470 made that town a veritable magnet for architects from the Palatinate and upper-Rhine regions. Swabia was ruled at the time by the Duchess Mechthild in place of her son Count Eberhard im Bart who was still a child. Born in the Rhineland, the Duchess appears to have used the opportunity to appoint artists from her childhood home.

The most important of these were architects of the Urach School. They included Peter von Koblenz, who was hired by the Württembergs around 1470 and designed the monastery church at Blaubeuren (begun *ca.*1482) and the basilican collegiate church in Urach (under construction 1478, finished 1499); Hans von Landau and Peter von Lanstein who designed and built St.

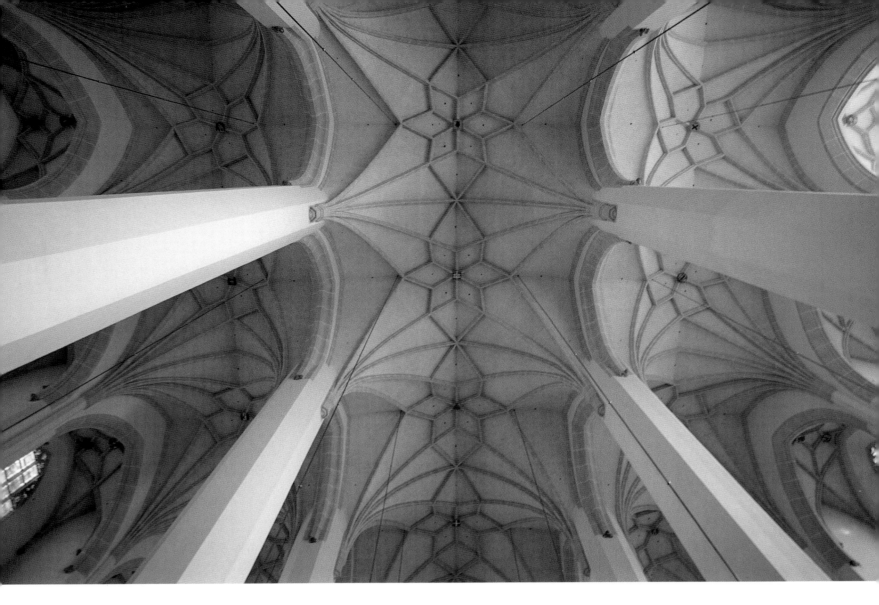

Michael in Waiblingen (a *Staffelhalle* begun 1475); an unknown master, the *Urach Meister*, who built the collegiate church in Tübingen (begun 1470) and the parish church in Weilheim (begun 1489) [202]. Furthermore, records indicate that a group of artisans replaced workers from Stuttgart who were building the parish church in Schorndorf designed by a certain Jakob von Urach.[624] The floor plans for all of these churches are pretty much the same. They all have four to eight bays, triple-aisle naves terminating in single-aisle choirs, and occasionally chapels in the outer nave wall (Schorndorf, Urach, Tübingen). Typical for the Urach Masters[625] is their occasional use of thickly woven reticulated net vaults and stellar net vaults.[626] Their buildings are renowned for the quality of their structural sculpturing, as well as for their pier figures, console busts, baptismal fonts and pulpits.

By as early as 1494, before the death of Count Eberhard im Bart, some architects and master stonemasons called to Württemberg must have left the region for work in the imperial cities of Swabia for we find tightly woven

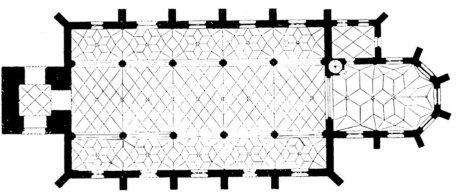

201 Munich, Frauenkirche, nave vaults

202 Weilheim, Parish Church

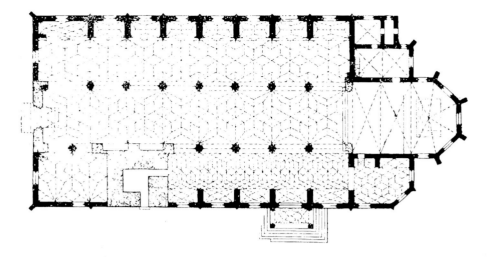

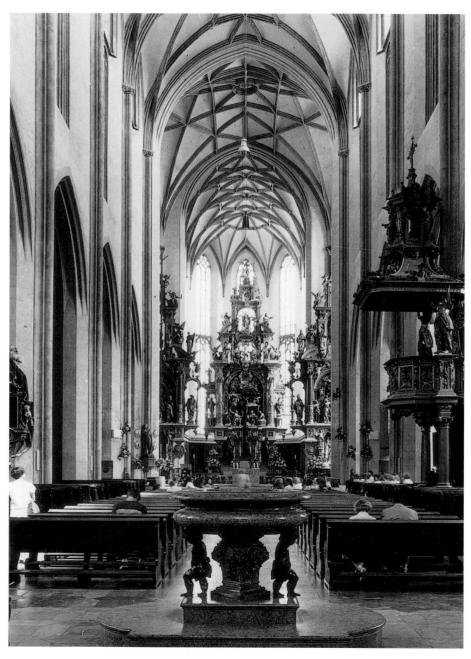

203 Rottweil, Holy Cross

204 Augsburg, St. Ulrich und Afra, nave looking east

"Württemberg" vaults over the nave of Holy Cross in Rottweil [203], (south-aisle vaults finished 1497, the other vaults 1517) and over the choir of the parish church in Weil-der-Stadt (1519). Perhaps the most breathtaking Late Gothic vault in Swabia is the one over the choir at Holy Cross in Schwäbisch Gmünd (begun 1491) built by Aberlin Jörg, probably working with Hans von Urach. Schwäbisch Gmünd [115] was a structure a hundred and fifty years old at the time, but its tightly woven and lattice-like Late Gothic vault does not seem out of place there. The removal of a triumphal arch caused the Romanesque transept towers to collapse during these same years, which initiated the renovation of the nave vault as well. Evidently, completion of Holy Cross's choir inspired the building of a Hall choir with ambulatory at St. Michael in Schwäbisch Hall (begun 1495) the work being carried out under the direction of Jakob von Urach and his brother Hans. The vaulting here (1560s) represents a late compilation of several Swabian Gothic net configurations [163].

In 1478 Burkhard Engelberg replaced Valentin Kindlin as director of construction at the monastery church of St. Ulrich and Afra [204], which was being built at the site of an older structure that had burned down in 1474. A basilican nave with a huge clerestory, protruding transept and towers flanking the choir – of which only one was completed according to a later design – are motifs from a much older Gothic style, but which probably seemed appropriate at the time for a church of the Benedictine Order.[627] The vaults, on the other hand, were state-of-the-art. Asymmetrical rhomboids cover the side-aisles (1489) and are similar to the rotated stellar figures in Frauenkirche's side-aisles. The stars of the high vaults, enriched by rhomboid figures at the apex, were Aberlin Jörg's prototype for the vaults of Gmünd's nave.[628]

When looking at the rich vaulting of these Swabian great churches it is easy to forget that many smaller, single-aisle naves built at the same time had simple flat ceilings.[629] And expensive vaulting that covered the entire ceiling of a church was not by any means the norm in rural Swabia. This was not the case everywhere in the empire, however. Complicated vault forms can be found in many rural churches built in Austria during these years. These churches were much more innovative, and ultimately more important historically, than rural church building in medieval Swabia, with its numerous cities. We have already observed the tendency of Austria's

"three-column" churches toward spatial fusion and, in fact, this appears in an amazing number of churches built after 1470.

Asymmetrical five and seven-point rhomboid stars, so popular in eastern Austria, offered architects another method of fusing Gothic space. By employing either of these two stellar configurations, an architect could weave a net vault overhead without having to worry about transverse or arcade arches. Each star would have one point resting on a single free-standing pier, and two points connected with the wall opposite this, creating a formeret web and frame for a window. The next star would be a mirror image to this, with two free-standing piers and one wall contact. The traditional parallel organization of a pier-to-wall buttress was overthrown here by a pier-to-window/pier-to-wall arrangement that seems to "jump" back and forth [205]. Nearly all double-aisle spaces resemble the "three-column church" in this regard [195]. Both types renounce bay delineation. Both have vaults whose only elements are either intersecting stars or rhomboids, and these actively form a homogeneous structure overhead.[630]

There were numerous double and triple-aisle churches built without arcade arches as well. We find many of them in the areas surrounding the lodge of Steyr in eastern Austria, in Kärnten and in the Steiermark. Here we find smooth, umbrella-like stellar configurations – radiating chalice-like upward from the tops of free-standing piers – and parallel-rib nets that no longer seem part of a single aisle.[631] Despite the variety of these particular vault designs, the ceiling designs for most rural churches in this region were from the first half of the fifteenth century.

Swabia, the Danube River basin and the Habsburg holdings saw much building activity, but it was in Saxony that architectural culture would bloom its brightest during the second half of the century. Southern Saxony is rich in minerals and by 1450 the House of Wettin was one of the wealthiest dynasties in the empire.[632] Much of the construction activity in Saxony in the 1470s can probably be attributed to their patronage.

In the year 1471, the House of Wettin hired Arnold von Westfalen to expand the ducal residence in the town of Meissen. He was also to complete the west façade of Meissen Cathedral [206] where work on an block-like, unarticulated tower base had been going on since 1315.[633] Arnold von Westfalen – who probably did not come from Westphalia but was a member of the rich Westfal family from Leipzig[634] – built a high

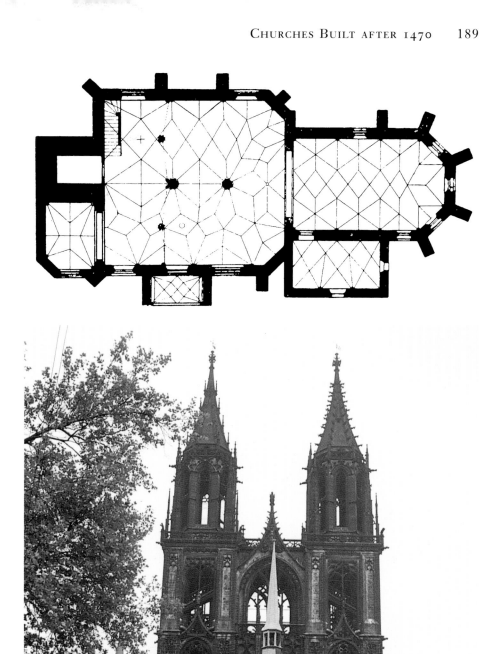

205 Rüstorf/Upper Austria, Parish Church

206 Meissen Cathedral, west façade

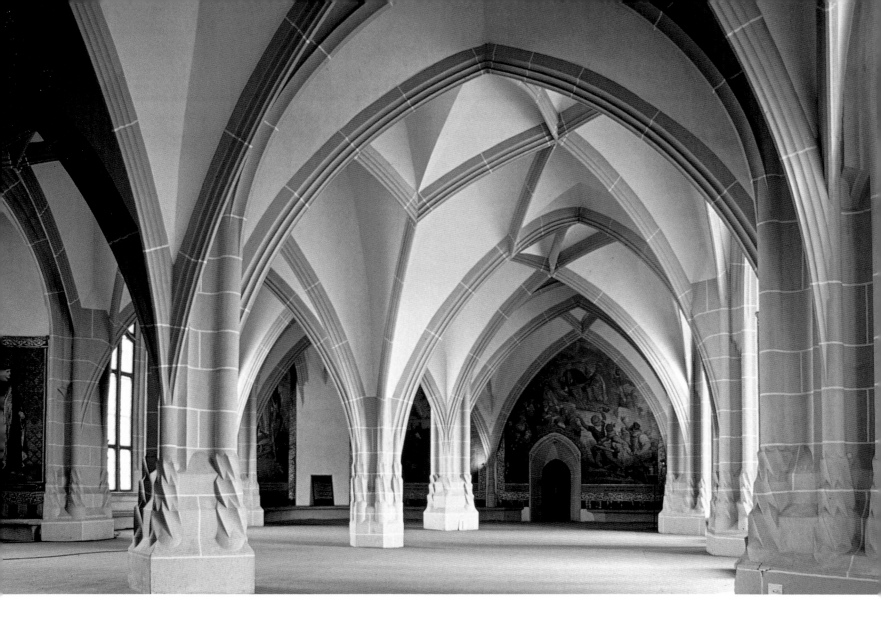

207 Meissen,
Albrechtsburg, Great Hall

window register over this base in the years
1471–81. Everything above that, including the
spire, would not be completed until 1904–1909.

The wide, hollowed-out Gothic cathedral
front was varied one last time in Meissen,
although Arnold kept the middle section of the
structure closed and articulated it with panel-
like blind tracery work. The cubes of the towers
to the left and right of this middle section are
articulated by four corner buttresses, which
possess lightly niched tracery work. Between
these are the windows. They are two layers deep
– a front layer of hanging tracery and a back
layer, which is the actual window, partially
covered in blind tracery. Placed between these
two layers is a staircase, which runs diagonally
through the window on its way to the middle
section of the façade. As was the case with
Johannes Hülz's spire at Strasbourg [44], here is
a tower with a staircase at center stage. It pro-
vides a certain boldness to Arnold's design. As a
motif, it has not been fused at all into the formal
system of the façade's articulation, and seems to
pop out from the mass of stone unexpectedly.

While he was working on the cathedral,
Arnold directed the expansion of Albrechtsburg
[207], which stands on a high hill above the
city and for which the Margraves von Wettin
had invested an inordinate amount of money.
Albrechtsburg is the first castle-like residence
built in the Holy Roman Empire to renounce the
traditional martial and protective function such
structures had always fulfilled, in favor of repre-
senting aristocratic power and prestige. Surely it
had Dutch and French prototypes in this. In
designing the castle façade – which is dominated
by spiral staircases on its outer tower surfaces,
the so-called "Wendelstein," and boasts compli-
cated window and vaults over the main halls
inside – Arnold von Westfalen revealed the full
power of his genius. His style, which is charac-
terized by the at times jarring contours produced
by the juxtaposition of very different forms,
would play a major role in ecclesiastical architec-
ture in Saxony in the coming years.

This can be seen best in the Great Hall at
Albrechtsburg itself, a double-aisled interior
with a low vault that represented a completely

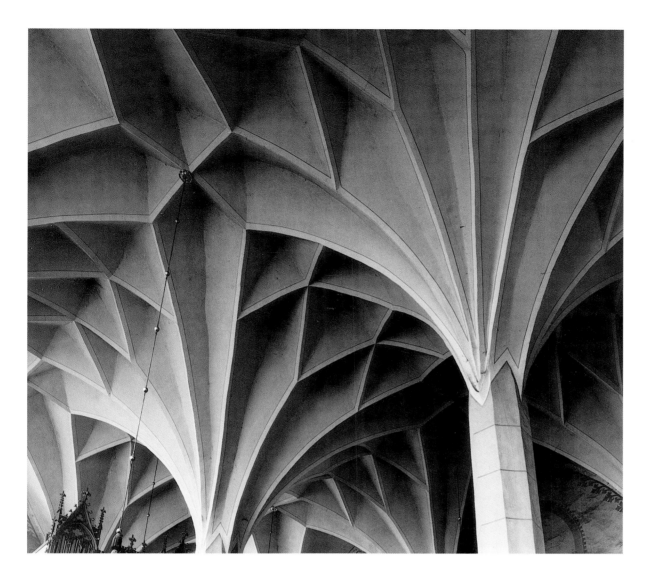

208　Soběslav/Bohemia, folded vault of the Parish Church

new kind of ceiling structure for its time. Its unusually heavy webs, for instance, reach so far down that the vault ribs fuse with the piers at a spot just barely above the pier base. Sometimes this spot is a bit higher, depending on pier placement and, especially, on how much the ribs above could be warped. The pier cores are fluted, that is hollowed-out by concave molding. Rising above the responds without any break whatsoever, they seem to grow into the vault web above. The small bases supporting the vault responds are also fluted. They are articulated into three separate parts, each of which is turned so that together they appear to screw up and into the bottom of the respond shaft. This process of sharp contours rotating into each other, combined with fluted surfaces, is repeated in the vaulting overhead.

Not all the vault groins overhead are articulated with triple concave-molded ribs. At certain places they have been left naked, as it were, without ribbing and unwarped. Folds separate the webs at this point and form deep, almost prismatic niches. Here for the first time in

a larger structure we find the so-called *Zellengewölbe* or "folded vault" which would be copied many times in Saxony and other regions in the east, where we usually find it as a squat-proportioned ceiling with little rib work, sculptured in rough-hewn forms.[635] In Saxony, the folded vault would be used almost exclusively in non-ecclesiastical architecture.[636] However, it would play an important role in great-church construction in Bohemia beginning in the 1490s, where it was often employed in conjunction with stellar figures[637] [208]. Around 1500 folded vaults were being built in eastern Prussia as well, but with much smaller cells than those further to the west in central Germany. Heinrich Hetzel's elegant, almost filigree vaults for St. Mary's in Gdansk (1498–1502), for instance, reveal little of the sober thickness of its Saxon prototype.[638]

With his appointment to the Wettin Court, all ducal structures, including many parish churches patronized by the duke, became Arnold von Westfalen's responsibility. Duke Friedrich II had already decreed in writing in a *Schutzbrief* of 1464 that all his structural pos-

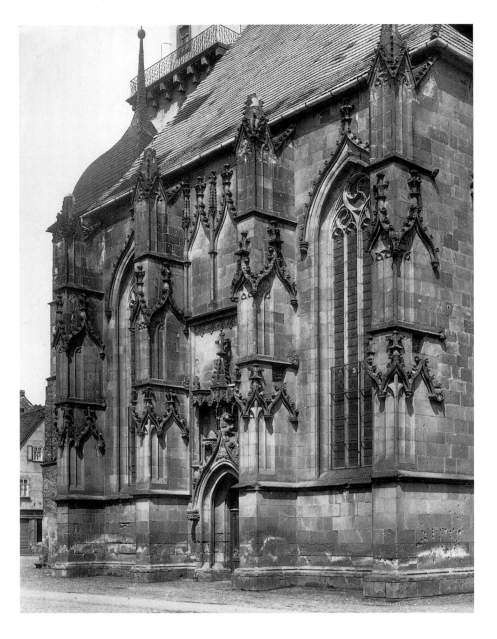

209 Rochlitz, St. Kunigunde, south side of nave

210 Freiberg Cathedral, view of the nave

"Special Gothic" simply because they stand out a bit less dramatically from traditional forms in other regions of Germany.

Somewhere between older architectural traditions in Saxony and the great churches built there during the late fifteenth and early sixteenth century, is St. Kunigunde (1476) in the town of Rochlitz [209]. Its floor plan – a three-aisle, three-bay Hall nave that opens onto a single-aisle, seven-sided polygonal choir – is right out of the older "short Hall" tradition of central Germany. The outer structure is made of Rochlitz red porphyry tufa and possesses structural detailing of especially high quality – motifs like wreaths of crocketed gables around its pier buttresses and opulent ornamentation over its windows and portals. A joy of decoration, already seen in older choir façades in Saxony, experienced a rebirth of sorts here. Rochlitz's St. Kunigunde – along with the outer decoration of St. Mary's in Mittweida (1476 – beginning of the sixteenth century) and the nave of St. Mary's in Zwickau (1506–37) – is a rare but nonetheless characteristic stylistic variation of Saxony Gothic.

Similar to what we saw in the Great Hall at Albrechtsburg, Rochlitz's thin piers are fluted by concave molding in an effort to optically reduce their mass and enliven their surface by contrasting light and shadow. Parallel-rib and stellar vaults, not separated by any arcade arches at all, are free to dominate the spatial character of the interior here, in a way similar to many smaller Austrian churches further south. Admittedly, the vaults in Rochlitz do not rest on top of the pier in a chalice-shaped web construction, like in Austria. Rather, the vault ribs flow into the pier at different heights depending on the radius of the arch they make, just like at Albrechtsburg. This constellation can be found in many Saxony Halls built after 1480. With them, one the major achievements of the High Gothic – the unification of impost height for all arches resting on free-standing piers – is renounced in favor of a complicated intertwining of articulated elements. And though this is reminiscent of Early Gothic construction, here it was employed exclusively for aesthetic reasons: to inject motion into the vault shell that was not there before.[640]

Other examples of churches built without arcade arches would be the vaults over the southern aisles of St. Mary's in Mittweida, or the parallel-rib and creased-rib vaults in the Hall nave of St. Thomas in Leipzig (vaults by Konrad Pflüger from Swabia 1482–96), or the extremely spatially fused reticulated and stellar net vaults over the nave of Merseburg Cathedral (Johann

sessions be placed in the hands of court administrators and stewards for safe-keeping and upkeep. With this, we see something similar to a central building authority in late medieval Saxony.

While it's true that as architect to the Court of Wettin, Arnold concentrated on palace architecture,[639] his style would nonetheless inspire ecclesiastical projects in Saxony. Many churches here employed one of the characteristics of his style – weaving the contrasting forms of support and vault together. This specifically "Saxon" motif would become a mainstay of the famous Erzgebirge Hall tradition which, of course, would not only have prototypes from Saxony, but also be influenced by Austrian Gothic. This motif is also characteristic of a much larger group of central-German Gothic Hall churches. Unfortunately, these have been overlooked by scholars eager to sing praises to Saxony's

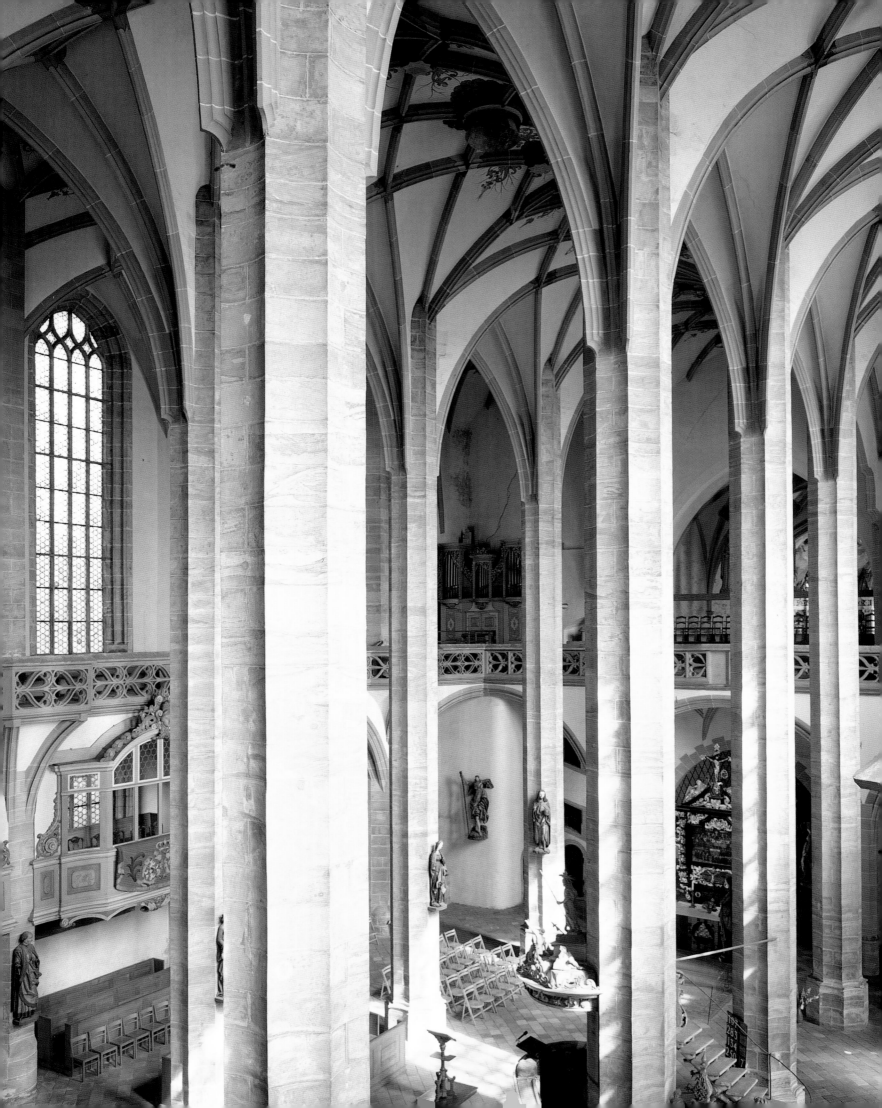

211 Passau, St. Salvator,
floor plan and cross-
section

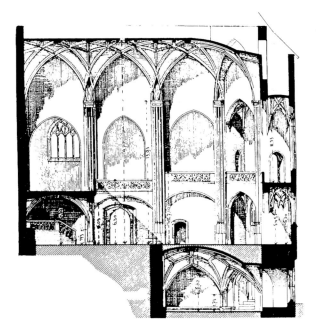
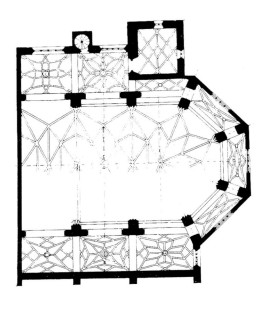

Moestel 1514–16).[641] The renunciation of arcade arching, and the employment of octagonal piers lacking imposts whose sides are fluted by concave molding, were mutually dependent forms, obviously, since surfaces that intersect and are molded to a lesser degree would not be particularly suitable to receive the springers of arcade arches. At the most we find simple, spatially unobtrusive ribs articulating the curve where the arcade *should* be. In this respect, the naves of Freiberg Cathedral (begun *ca.*1488) [210], St. Mary's in Zwickau (1506–36, from Peter Harlass and Caspar Teicher) and St. Nikolai in Leipzig (begun 1513 by Benedikt Eisenberg)[642] are all closely related. Also of note are St. Peter and Paul in Görlitz (vault 1495–97 built by Konrad Pflüger, Urban Laubanisch and Blasius Börer)[643] and Bautzen Cathedral (completed 1497),[644] two great churches in the holdings of the House of Wettin in the Oberlausitz region that possess simplified arcade ribs that help open the aisles up to each other.

Besides a breakdown in aisle delineation in the vault, another leitmotif of the Saxony Hall during the last decades of the fifteenth century was a gallery between the wall buttresses of the side-aisles, that circumvented the entire interior. We find a lot of these in churches built after 1480, which was more than likely due to the growing influence of southern German and Austrian Gothic on construction lodges in central Germany. We have already seen – at the Franciscan church in Salzburg [178,179] and St. Martin in Amberg [183] – how the "wall-pier church" with double-register chapelled extensions developed into a specific Hall type with

gallery. This type of disposition would be assimilated and transformed by many churches. The architect of St. Salvator in Passau (1479) [211], for instance, cut deep niches between the buttresses of the outer nave wall in order to create gallery spaces that not only communicate with each other but wreathe the entire three-bay structure as well. At Amberg the upper registers of the chapelled extensions were reserved, at least most of them, for the *Donatores* of the chapels directly below them. At St. Salvator in Passau, on the other hand, crowds of pilgrims were directed through the gallery for a view of the holy relics in the sanctuary below.[646] The first large-scale Late Gothic gallery structure was in silver-rich Upper Saxony, in the town of Freiberg. Freiberg's architect obviously utilized Bavarian and Upper Palatinate prototypes for the conception of this roomy nave gallery. It is stretched between the wall buttresses, spans the entire church, even in the east where it terminates the single-aisle choir in a kind of rood screen. In the west, the gallery opens up to a wide rostrum. All three of Freiberg's aisles are fenced in by this raised spatial zone, but with the distinction that – in contrast to Amberg or Passau – we have yet to discover what its function was.[647]

We have also seen, at St. Lorenz in Nuremberg[648] [182], a balustrade running over wall piers, which gives it a polygonal shape at that point and frames the upper window, giving it an oriel-like feel. The form taken by Freiberg's chapels, on the other hand, are very similar to that of the window niches in the Great Hall of Albrechtsburg [207]. As there, the walls are

slightly niched, and as a consequence, the apex of the vault over the gallery is a bit higher along the formeret wall than it is on the nave side, and the vault shell falls a bit toward the aisles. This allows more light from the windows to reach into the chapels and aisles. Once again, the ribs of the net vault[649] here flow into fluted octagonal piers at different heights, but this time the difference is more pronounced than at either Albrechtsburg or Rochlitz. Those webs cutting into the vault shell from where the arcades would have been are very low. They are in sharp contrast to the longitudinal movement set up by those webs forming the barrel vaults of the three aisles, so that an intense movement of the ceiling zone results. Above the gallery, the wall buttresses and wall surfaces lack responds and the ribs seems to crash into them at that point.

Freiberg's vault is formally segregated from the rest of the building. With painting at the apex, bosses of brass formed into patrons' coats-of-arms, it seems to live a happier more colorful existence than the scantily articulated structure carrying it. Indeed, from this point on Late Gothic churches in Saxony would be characterized by wide, expansive vaults that barely communicate with wall and pier, and by galleries that encircle the entire inner structure below.[650]

ORNAMENTAL VAULTS IN
THE WEST OF THE EMPIRE

In a process similar to that which occurred in Saxony, the ruling patrician houses of the central Rhine region invested heavily in new church construction during the late fifteenth century. Ludwig the Black von Pfalz Zweibrücken, for example, financed the building of a palace church in the town of Meisenheim-am-Glan (1479–1503) [212] which served not only as court church, but as parish church for the town and as convent church for the local Order of the Knights Hospitaller as well. Its high west tower fronts a rather unimaginative, three-aisle Hall nave with modest round piers. In the east, a square bay with side rooms fronts a centrally placed choir polygon whose seven sides form three-quarters of a circle. These two structures – tower and choir polygon – are the centerpieces of the church.

The tower is paradigmatic for how post-Parleresque structural forms from southern Germany, by then almost a hundred years old, continued to influence architectural style in places as far away as western Germany. The tower's diagonal corner buttresses with slightly

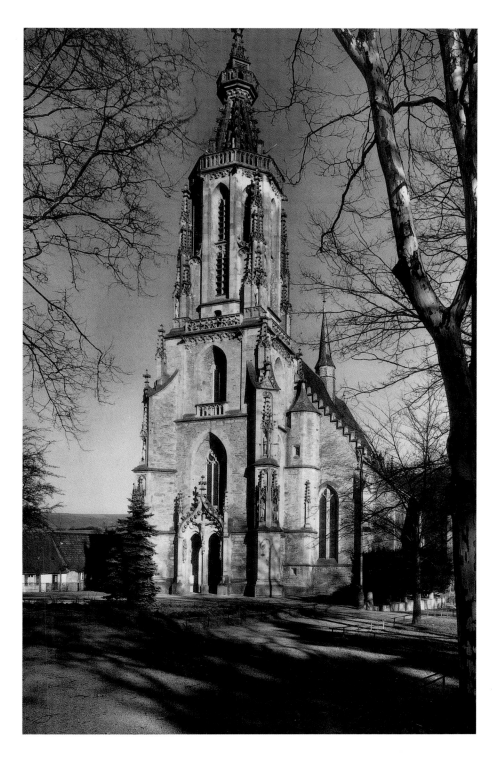

concave roofs, its tracery curtain, mouchettes over portal arches, figured tabernacles on the piers, its galleries and belfry openings, all belong to decorative systems developed in the cathedral lodges of the southern-Rhine region and the Danube basin around 1400. For Meisenheim's spire, with its slightly concave spars leading up to a "masthead," we need look no further than the tower projects of the Ensingers [147,148]. Its choir chevet is one of the last centralizing polygons of the Gothic period. Its ceiling is a stellar vault overlaid with trefoil tracery figures. A white dove symbolizing the Holy Spirit hangs

212 Meisenheim, Palace Church, view from the south-west

213 Meisenheim, Palace Church, vault over Duke Ludwig's Tomb

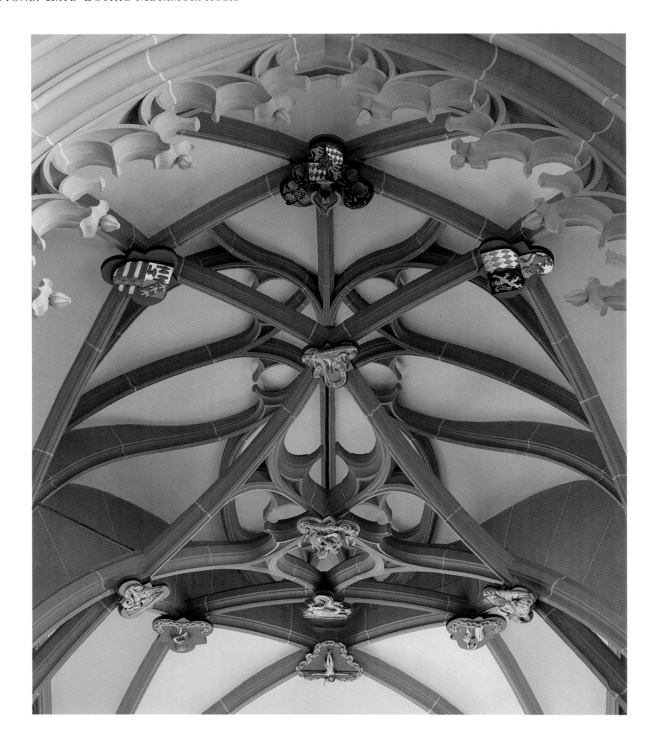

from the vault boss. Grouped around this, at the rib crossings on the edges of the figure, are busts of ten Apostles. The cycle is completed by the two remaining Apostles over the triumphal arch. The theme here is the descent of the Holy Spirit during Pentecost, which in many illustrated manuscripts from the Middle Ages was portrayed as having occurred in a similar, centralized environment.[651] Whether or not the seven-sided choir structure somehow fits into the iconographical symbolism set forth overhead is not known.[652] The head over the square bay in front of the choir is of St. John the Baptist, and might indicate that the choir was reserved for the

celebration of Mass by the Order of the Knights Hospitaller.

Hidden away in a room south of the choir's square forebay is the tomb of the patron of the church, Duke Ludwig. The ceiling over this space is a double-layer vault [213] with a design similar to Peter Parler's south-porch vault at Prague Cathedral [140]. Though employed but rarely after Parler's death, this type of vault would become more popular during the late fifteenth century, and would be constructed out of intertwining and daringly artistic forms. At Meisenheim, the vault's central octagon is placed extremely high up in the vault zone. Its

webs are decorated with rosettes made of mouchettes, which is reminiscent of Madern Gerthener's tracery vaults over the north portal of St. Bartholomew in Frankfurt. A second tracery rosette opens up at quite a distance below this. It is made of flying ribs on whose ends are bosses articulated into trefoils, with each "foil" painted with either a Biblical scene or a coat-of-arms. The architect responsible for this ornamental vault, and for the entire structure, was a certain Philipp von Gmünd, who built a similar tracery vault over the choir of the parish church in Monzingen (begun 1488).

Philip von Gmünd also designed the Alexanderkirche (1492–1507, mostly destroyed in the Second World War) in the western-German town of Zweibrücken [214] as palace church and tomb for Duke Ludwig's son Alexander, who surely sought to emulate what his father did in Meisenheim. When I first entered this church, it felt as though I was stepping into a large Saxony Hall: its three-aisle nave has low segmented arches carrying a circum-venting gallery, and an overall vault system that fuses its aisles into a single ceiling structure. But the nave itself is not very tall and its round piers lacking imposts provide a soft, calm spatial disposition that avoids the sharp profiles common to the Halls in Saxony.[653] The point at which the vault ribs flow into the piers here is pretty much the same from pier to pier, and not at different heights like we saw in Saxony. The few vaults to have survived (over the apse, easternmost central vessel bay and north porch) reveal Philipp von Gmünd's love of combining straight ribs in a net construction and then filling the spaces between them with rounded tracery forms.[654]

Vaults with tracery mouchettes within a trellis-like frame of flying ribs belong to the very last years of the Gothic period in the western regions of the empire. Either there were not many of them built or not many have survived. There seems to be a formal connection between the work of Philipp von Gmünd and the hanging vaults of the Salvator Oratory (around 1510) at St. Leonhard in Frankfurt-am-Main. Here too we find an elegant, fragile-looking vault structure enriched by tracery cusps and heraldic bosses which immortalize the patrician family Holzhausen who financed the building of the church. A figure representing the Scourging of Christ leans against the short round shaft that connects the large boss with the apex of the vault shell above it – one of the very few examples we have of figured sculpturing in a German Gothic vault. Up to that point sculpturing had been limited to bossing, but now figured sculpturing

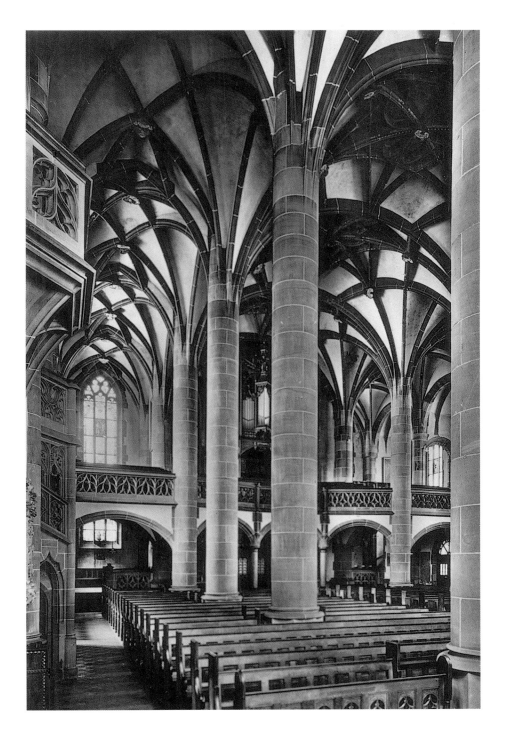

214 Zweibrücken, Alexanderkirche, view of the nave (mostly destroyed in the Second World War)

would become more common along with vault painting, and both in places they had never been before.

Of the few ornamental vaults in the Rhineland that were as creative and expensive as those in the south and east of the empire, those over the choir side-aisles at Willibrordi Church in Wesel [215, 216] rank among the most breathtaking. In the year 1498 a certain Johann von Langenberg was hired to build a choir onto Willibrordi, a structure that had been under construction for decades by that time.[655] Langenberg had moved through the ranks at Cologne cathedral lodge and was master stonemason at Xanten when he came to Wesel. Now he was to work on a church

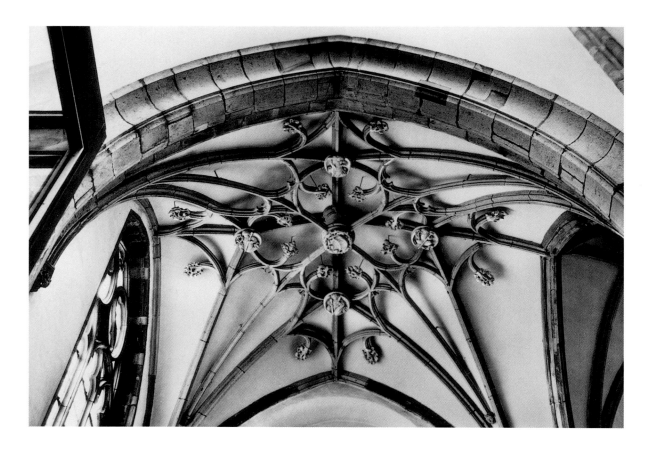

that, like so many others, would not be com-
pleted until the nineteenth century. His son or
nephew, Gervin von Langenberg, would eventu-
ally build the vaults over the Alyschläger Chapel
on the north side between transept and sacristy,
and the Kreuzkapelle in the outer of the two
southern side-aisles of the choir. The quality
workmanship of these vaults seems to indicate
that the stonemasons here were from Cologne
Cathedral lodge. The vault over the Alyschläger
Chapel (donation 1510) [215] was built in 1512.
Six years later, Gervin's son Johann completed
the vault over the Kreuzkapelle [216].

The differences between these two vaults
are illuminating. The primary flying ribs of the
older vault are straight, and form a four-point
rhomboid star. Inside this frame is an intertwin-
ing figure of foils that end in foliage-cusps, all of
it hung in such a way that the sharp contour of
the stellar frame is still visible from below. The
younger vault over the Kreuzkapelle is a true
"looping-rib" vault in which all individual ribs
form loops. They move in and out of each other
to form blossom motifs at the apex of the vault.
This complicated double-layered structure –
with two and four-point blossoms offset in rela-
tion to each other by 45°, with the lower free-
hanging blossom filled with rich tracery work –
could only have come at the end of a long period
of vault development that began with Donau
Gothic's curved-rib arches and, as we now see,

were not employed in northern and western-
German architecture until much later.[656]

BREAKDOWN OF THE ARTICULATED SYSTEM AND THE MOVE TOWARDS ORGANIC SHAPES

The simple looping-rib vault was just one of
many new architectural forms to be brought
forth by German Gothic in the last decades
of the fifteenth century. Anything but simple,
the looping-rib vault was basically an enrichment
of the opulent curved-rib vault figure, and it
is not surprising that some scholars have called
the style that appeared around 1500 "Baroque
Gothic".[657] Though the combination of two
major stylistic periods into one concept does jar
a bit, this term nonetheless conveys something
of the variety of design options open to archi-
tects and master stonemasons at the turn of the
sixteenth century. This was especially true when
it came to sculptural decoration. When com-
pared to the Late Gothic styles of other coun-
tries, southern and eastern-German architecture
stands out for the variety and creativity of its
decorative designs. In these regions, ornamenta-
tion was freed from the tenants set down for it at
the beginning of the Gothic, which had always
dictated that it articulate particular parts of a
church. Ornamental forms now broke loose
and began to express themselves with little or no

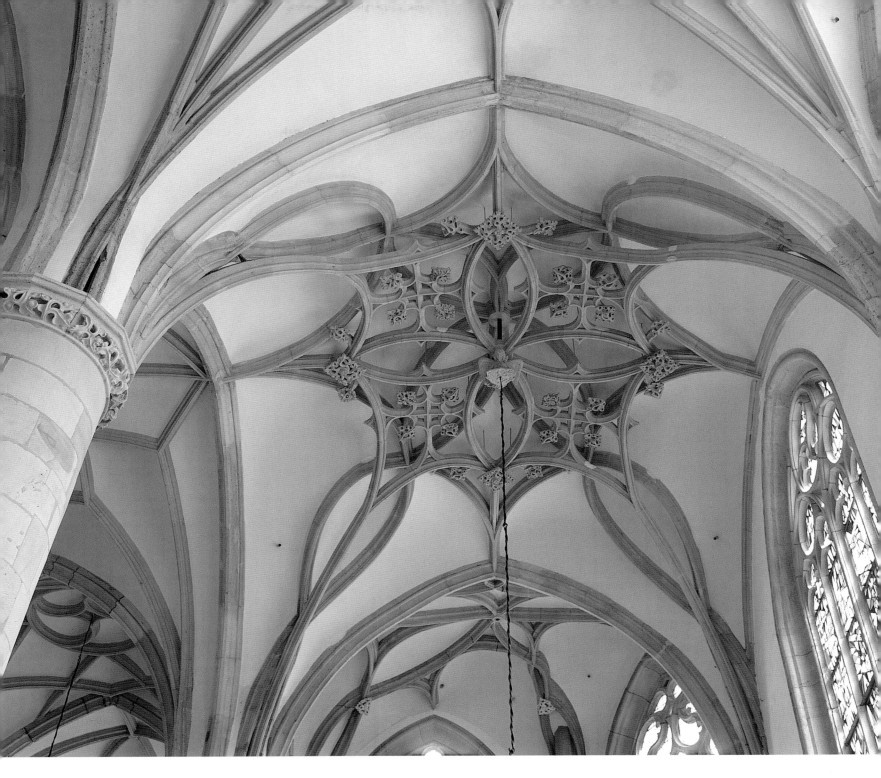

reference to their traditional function, injecting into the interior of the church a growing unrest and intense movement. Dissolved was the tried-and-true Gothic system of communicating articulated elements. Yet, this allowed another of the style's characteristic attributes to be expressed all the more magnificently because of it: namely, that the Gothic church now separated itself completely from being a tangible space unfolding within a predictable tectonic organization. While dizzying heights and translucent walls opened up new spatial dimensions for earlier Gothic builders, now architects focused on the free design of individual form. In doing so, they were not interested in presenting an inner design

that was more comprehensible. They seemed instead to want to focus on an irritating, at times fantastic metamorphosis of those architectural motifs that were most efficient at delineating space. Admittedly, this change of focus concerning decoration cannot be seen in all the churches built during the period; in only a few would it actually change the style in an important way.

Significantly, this new focus first appeared in small-scale architecture of stone and wood, along with objects of liturgical use like pulpits and baptismal fonts in which sculpturing, wood carving and the goldsmith's art were free to express themselves alongside highly refined structural techniques. The period after 1460

216 Wesel, Willibrordi Church, vault over the Holy Cross Chapel

was the golden age of Gothic small-scale architecture, and many of its motifs would later be employed in large structures.

Since the beginning of the Gothic period, designs for objects used in the liturgy – ciboria, reliquaries and monstrances – had been architectonic in form. For centuries there had been a kind of "micro-architecture"[658] in most churches – fine, ornamental objects whose construc-tion followed purely aesthetic rules that were free from the statical problems of great church construction.[659] In the late fifteenth century, however, idealized small-scale architecture developed into a reputable artistic genre all its own, one that allowed much more freedom in creative designing than other Late Gothic genres. In fact, we find designs for miniature structures of all kinds in the cut-pattern books and design collections from the period.[660]

If an architect wanted to create something new with sculptural detailing, then the Late Gothic pool of forms offered him two options. First, he could take abstract forms of structural ornamentation, which by this time had a large and complicated inventory, and make them even more intricate through new ways of form integration and fusion, which would entail a complete and exhaustive knowledge of geometric design techniques. Or he could concentrate on non-abstract botanical shapes, those developed

for vault ornamentation in the previous decades. These were the two options open to the Late Gothic architect, and they stood in diametrical opposition to each other: the one entailed developing abstract forms into more and more creative combinations, the other developing the abstract into more botanical forms without actually copying specific natural forms. Interestingly enough, these two divergent architectural values were often employed together in one object, evidently in order to use the juxtaposition of different forms to heighten the formal tension within the object itself.

A good example of the interweaving of complicated abstract forms would be the amazing shaft work done on pier buttresses and crests of altars; as well as the pedestals on sacrament houses, baptismal fonts or even pulpits. These were often built with a variety of forms placed at staggered heights[661] [217]. Stone vault responds and their pedestals were twisted into screw-like forms, given a downy surface or rusticated with diamond shapes as though they were carved wooden objects.[662] In northern Germany, where there was little or no easily workable ashlar, this "stone carving" technique would remain isolated for the most part to a single liturgical object. In central and southern Germany, on the other hand, we find parallels to micro-architecture in the sculptural articulation of large interiors at a very early date,[663] to which Arnold von Westfalen's pier pedestals at Albrechtsburg in Meissen [207] surely count. The first cable molding – thick shafts that twist around a pier – can be found in the north side-aisle of Braunschweig Cathedral (main altar consecrated 1474). The direction the cable molding takes changes with each pier, and results in a vista of columns rotating towards the ceiling in opposite directions that, needless to say, is rather irritating. We find an even thicker array of cable molding on the south pier of the Mortuarium at Eichstätt Cathedral (by Hans Paur 1489–95)[664] [218].

Many fluted piers were "twisted" during these years as well. Donau Style Gothic brought forth a large collection of different pier forms after 1480,[665] from piers with stellar zigzag cross-sections, to fluted and cable-molded piers, even piers with surfaces ornamented in rhomboid-like segments.[666] Donau Gothic produced strangely shaped impost zones as well. Now and then we find square imposts that clamp the crowns of their pier like a hand vice, or – like those at the parish church St. Valentin (around 1522) in eastern Austria [219] – they form tall, box-like shapes on whose sides prematurely terminated

217 Esslingen, St. Dionys, base of the rood screen

vault responds look like they have been glued or fastened with dowels, as though the builders were using wood.

Interesting shaft work can be found in many churches, like the habit of sticking one shaft through another at a 45° angle, like wooden pegs. This motif was very popular at the turn of the century, and we find them in all conceivable forms. In the south, shaft work made up of tightly bundled torus-molding holds up portals. These are the so-called "shaft portals" which were placed up against the flat surface of the outer wall of a church to frame the opening at a right angle.[668]

About this time, Late Gothic tracery style dissolved the symmetry common to mouchette configurations and their tear-drop shapes began to intertwine, their "tails" hook together (window of the choir chapel at Freiburg Minster 1471–1513), or they were replaced by "broken" circles in order to create more brittle tracery patterns (side-aisle windows of St. Ulrich and Afra in Augsburg 1474–1500) [220]. The mouchette itself, traditionally a smooth and elegantly flowing motif, was deformed into a swollen club-like shape (west window of the

218 Eichstätt Cathedral, Mortuarium

219 St. Valentin/Lower Austria, Parish Church, nave looking west

220 Augsburg, St. Ulrich and Afra, tracery of a side-aisle window

north side-aisle at Pirna 1502–46) or bent (south side of Freiberg Cathedral after 1484) or inflated into near circles that were placed atop lancets in lower window sections (Böllenborn, the Palatinate 1489).[669] It appears tracery forms that harmonized with each other were avoided in favor of individual motifs with an at-times affected extravagance.

The second option open to Late Gothic architects, namely that architectural forms become more plant-like, had been around ever since the appearance of the post-Parleresque painted vault motifs of bushelled leaves and vines. Starting in the middle of the fifteenth century, we find more and more liturgical objects of various sizes and functions, like carved altar pieces decorated with botanical forms or with sculptured branch and leaf work on the frames.[670] These can still be found in many great Gothic churches. Examples would be, among many others, the baptismal fonts at Strasbourg Cathedral (1453 from Jodoc Dotzinger) and at Severikirche in Erfurt (1467), the Eucharist shrines at St. Mary's in Lübeck (1476) and St. Lambertus in Düsseldorf (1479) [221], the sculptured canopies over figures on the gallery piers at the hospice church in Stuttgart, or the small sacrament houses at St. Dionys in Esslingen (Lorenz Lechner 1486–9) and St. Lorenz in Nuremberg (Adam Kraft 1493). Looking at these objects chronologically reveals a process by which the amount of branch work increased and gradually became detached, in varying degrees, not only from the stone surface but from any traditional articulated function as well.[671] Piers were transformed into gnarled stumps, shafts into twisted and intertwining vines, finials into thorny stems rolled up at one end.

The process by which abstract forms were transformed into botanical shapes can clearly be seen when comparing two smaller objects with a similar basic design. The "Music Oratory" at St. Martin in Landshut (around 1430) [222] is a raised rostrum attached to the choir wall. This rostrum has a balustrade with wave-like corbelling underneath. The corbels are pierced through the middle by a hollowed-out wedge whose thin sides form an ogee arch that projects outward in a way similar to the portal openings in the nave wall of the same church. This fragile ogee arch, the dovetail-like shapes of the inter-

221 Düsseldorf, St. Lambertus, Tabernacle of the Sacrament House

222 Landshut, St. Martin, "Music Oratory"

223 Prague Cathedral,
"Wladyslaw Oratory"

secting ribs of the small vault under the wedge, the elegant tracery cusps of its formeret arches, and the thin panels of the wedge wall; all these stand in sharp contrast to the fully sculptural style, and heavy substructure, of the tracery balustrade. The aesthetic of contrast was at work here, one fully aware that the integration and fusion of contrasting individual forms would heighten the effect of dissonance. Peter Parler's dynamic Prague style was further developed here in an idiosyncratic way.

The "Wladyslaw Oratorium" (Benedikt Ried 1490–3) in honor of a Bohemian king, was built into one of the southern choir chapels at Prague Cathedral [223]. It too is a raised rostrum structure with a vault underneath that has a wedge-like centerpiece sticking out the middle. Unlike Landshut's "Music Oratory" which is placed flat against a wall surface, this oratory has been hung into the pocket of a chapel, and is wider and more massive.[672] The vaulting opens up towards the side-aisle in two

intersecting pointed arches, the center of which hangs so far down that its knob-like pendent – with the initials and coat-of-arms of Wladyslaw – is almost half way to the floor. Underneath the pulpit-like wedge in the center of the balustrade hangs a similar knob-like pendent. What makes this oratory so special, though, is not its design but its breathtaking ornamentation, to which the "Music Oratory" pales in comparison. All of the vault ribs have been articulated into thick, bending boughs with

short branches growing off them that look like they've been chopped off with an ax. The vault webs are filled with branches twisting in strange ways. An even thicker array of branch work covers the balustrade. Behind the coats-of-arms of those principalities ruled by Wladyslaw, are short rough-hewn branches in a thick, intertwining mass that seems to have been forced inside the framing cornice. Despite its branch-like forms, however, the stone retains its value as a non-botanical material.

Combined with its emphasis on nodular stumpiness, the overall effect is far removed from anything natural.[673]

Perhaps the greatest example of botanical fantasy in a liturgical object is the "Tulip Pulpit" at Freiberg (Saxony) Cathedral (Hans Witten 1508–10) [224]. Made entirely of porphyry tufa, the pulpit was carved to resemble a goblet-like tulip blossom growing out of a thick stem. It is woven all around by leafy foliage and vines. Between the vines of the stem putto play, while the Church Fathers peak out from between the leaves of the pulpit. Carved into the sounding board above the pulpit is a Virgin and Child *in gloria* placed above the symbols for the four Evangelists. A rich floral symbolism had developed by this time in late medieval church architecture and it offered various representative options. Especially numerous seem to have been the floral forms that symbolized St. Mary who, as flower of the Tree of Life, represents the fulfillment of the new life in Jesus Christ proclaimed in the Word of God by the Evangelists and the Church Fathers. At the same time, the goblet shape of the pulpit itself, the grapes growing on the neck of the stem and in the Christ Child's hand, symbolize the Holy Eucharist.[674]

The "Tulip Pulpit" is accessible via a winding stairway that, like the tulip-shape of the pulpit itself, is meant to look botanical, in this case like a structure made of rough-hewn wood. The edges of the stairs sit upon the branches of three tree-trunk posts. On the tallest of these, a man sits whittling with the upper section of steps resting on his shoulders. At the foot of the stairs is a figure accompanied by lions, perhaps meant to represent the prophet Daniel. This would not make much sense considering the symbolism of the rest of the pulpit, but then this is a puzzling structure anyway – a stone pulpit that seems all the more irrational due to the illusion it presents of being made of botanical forms.[675]

Besides decorative objects of liturgical use, the 1470s also saw the appearance of sculptural branch and leaf-work ornamentation in large-scale architecture. This began with the vault ribs and free-standing piers. For instance, the round shafts in the west bay (built 1471) of St. Willibald's choir in Eichstätt Cathedral are decorated with branch stumps and flat leaves.[676] In the north wing of the cloisters (begun 1473) of the monastery at Himmelkron, Upper Franconia a leafy vine "grows" along the longitudinal-ridge rib at the top of the vault, and the window arches are articulated with branch work. We have already seen the south pier of Eichstätt's

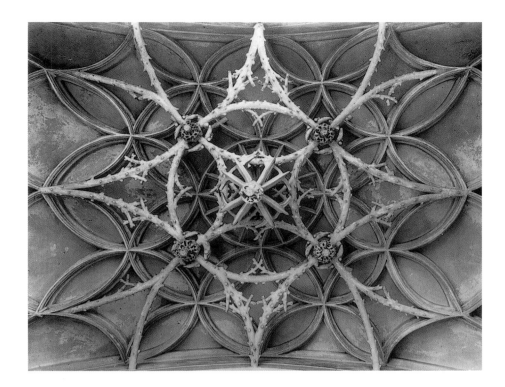

Mortuarium (Hans Paur 1489–95) [218]. The pier next to it is also twisted round by cable molding, but it possesses much more foliage work. Here is a good example of how abstract and botanical stone work might compliment each other in one object.

Because smooth shafts might easily be replaced by branch work, imposts and window tracery were transformed as well.[677] Still, this decorative transformation is most visible in the vault and, indeed, the focus of structural sculpturing had by that time moved to the ceiling. An iconographical program is most visible overhead as well. In the western chapelled extensions of the parish church in Ingolstadt (Erhard Heydenreich, around 1520) we find a kind of tracery vault made of arched branches spanned beneath the vault shell. The branch-work shafting here consists of small sections of intersecting curved ribs whose sides are covered with the stumps of smaller branches chopped off [225]. This "thorny rib work," as it is called, grows out of the net vault behind it in large loops, in the center of which is a crown-like hanging pendent as vault boss. Once again here, only a *part* of the vault has been transformed into botanical forms. However, the workmanship and filigree elegance of this one part, which is basically a flying-rib structure, is without peer.

Instead of employing thorny branch work like at Ingolstadt, Bartlmä Firtaler chose to cover the vaults he built in Kärnten with thin, smooth saplings modelled out of stucco.[678] At the parish church in the town of Kötschach (1518–27) the

225 Ingolstadt, Our Lady, vault of a nave chapel

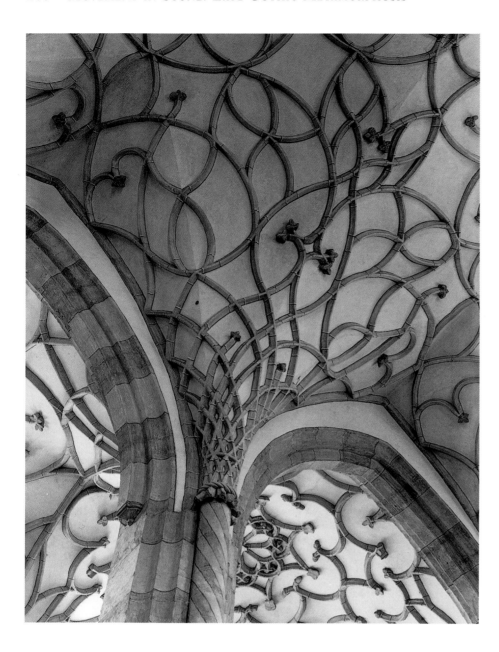

226 Kötschach/Kärnten, Parish Church, nave vault

ings and collections of Late Medieval sermons make plain. Among the allegorical symbols for "church" that we find in the *hortus conclusus* of the fourteenth and fifteenth century, two of the most common were the "garden of the virtuous" and the "heavenly garden".[680] These allegorical constructs also belong to the rhetorical repertoire of late medieval sermon literature, especially popular at church consecrations. In a collection of sermons given at Nuremberg in 1496 we find the following: "Ecce basilica, sive ecclesia divinae hortus conclusus est".[681] The concept of a heavenly garden where the souls of the saints gather for devotion and hymns of praise to God, seems to have been visualized directly in the painting of those vaults where saints appear in among the plants of the webs. Now and then a saint's head will grow out of goblet-shaped blossoms so as to present a kind of Tree of Jesse figure.[682] The saints themselves were seen as the fruit of the heavenly garden, as a *Expositio hymnorum* published in Cologne in 1494 indicates: "Sicut lapides in muro sunt aedificati, ita animae sanctorum sunt ordinatae in paradiso".[683]

This kind of botanical architecture with its own vault iconography is one of the most interesting artistic phenomena of the years around 1500, and its appearance coincides with the naturalistic paintings of the Altdeutsche School and Dürer. And, in fact, painting and sculpture were combined during this period in many carved wooden altars.[684] However, the reality presented by these works of art cannot be understood as having been meant as a descriptive presentation of natural objects or of the "world as it is," nor should we confuse the illusion they present of nature with some kind of archetypal vegetation, as some have done.[685] Neither should we allow the expressive power of these spatial depictions, whose complicated structures made them almost exclusively limited to small churches, blind us to the fact that the vast majority of new churches built during the period possessed only a minimal amount of branch work and botanical painting. To speak of a transformation of architectural iconography into botanical forms during the late fifteenth century would be a wild exaggeration, even concerning southern Germany,[686] for most spatial dispositions from the period continued to express conventional medieval symbolism in traditional ways. We continue, for instance, to find busts or statues of the prophets and Apostles in typological order (*sub lege – sub gratia*) gathered around the main altar in the sanctuary. Windows continue to offer space for the representation of

vault ribs are fastened together at the top of the responds like the withes of a basket [226]. From this point, they seem to branch out in a seemingly random way to grow across the entire vault zone. Not a single line in this vault delineates the warped bay's superstructure. Instead, the perfect illusion of an arbor trellis wound through by vines has been realized.

Obviously, such vault designs were intimately linked to a general trend in Late Gothic architecture to build more colorful interiors that included thicker botanical ornamentation. Up until now vault painting had presented the illusion of a sheath of vines behind the ribs that grew out across the webs in all directions and surrounded the architectonic framework of the inner structure[679] [227]. This presented the "natural character" of the Gothic space through branch and vine work, or botanical painting, but it was more than that too, as ecclesiastical writ-

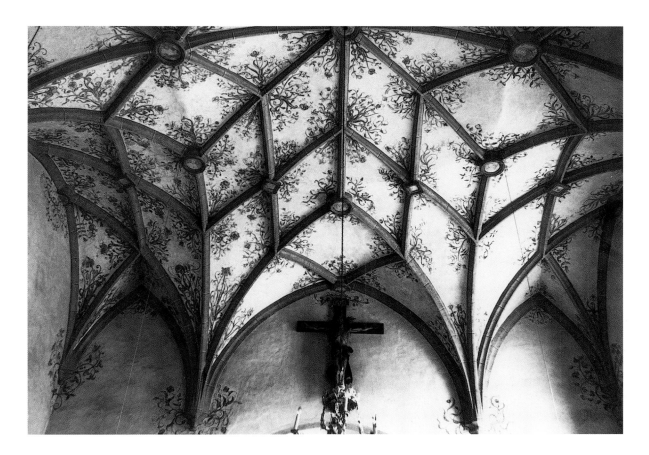

227 Berg/Kärnten,
Parish Church, nave vault

Biblical scenes and the lives of the saints. Christ enthroned as the head of the Catholic Church continued to be depicted on vault bosses.

To look for a universal Catholic iconographical system in a Late German Gothic church, however, is to look in vain. Instead, we find pictorial references simplified, even accompanied by banderoles or inscriptions. As more and more liturgical objects like carved altars were paid for by indulgences, it should not surprise us that they received the lion's share of iconographical presentation. As richly sculptured and painted "replacement architecture," their main function seems to have been to represent pictorially the often complicated *Symbolik* that was newly configured with each new liturgical object. Evidently, Late Gothic spatial iconography was unable to emulate the universal cycles presented by the High Gothic cathedral. Individual works of art were created to be thematically expressive in and of themselves, and hardly ever do we find a fusion of such separate objects into a pre-planned, theological program.[687]

BENEDIKT RIED AND THE GREAT HALL CHURCHES OF THE ERZGEBIRGE REGION

That stylistic and iconographic development was now focused on those parts of the church best at depicting space, and that there was a huge inventory of forms available to achieve this, clearly indicates that Late Gothic architecture was quickly becoming synonymous with the art of spatial design. This was especially true in southern Germany, where most of the artistically important lodges were located. The appearance of Late Gothic spatial design has been described, rather vaguely, as having represented a retreat to devotional space. Various concepts have attempted to explain the phenomenon, most of them based on the assumption that late medieval attitudes had changed – the notion, for example, that a "subjectivity of piousness" developed during the Late Gothic period, or a new *Innerlichkeit* of religious experience, or the need for protection from a belief that the world was about to end. These only partially explain the change in architectural values around 1500[688] since such attitudes were not by any means specific to pre-Reformation Germany. Expressions of individual devotion in the form of altar and chapel donations did abound during the period. No doubt these were indulgences made to ensure the mercy of the church. However, private funding almost always concerned objects of liturgical worship inside the building. Not the tangible shape or design of the church, then, but the spatial ambiance of the interior was now the focus. The altars and epitaphs built would naturally want to reflect the importance of an individual or group within the community of

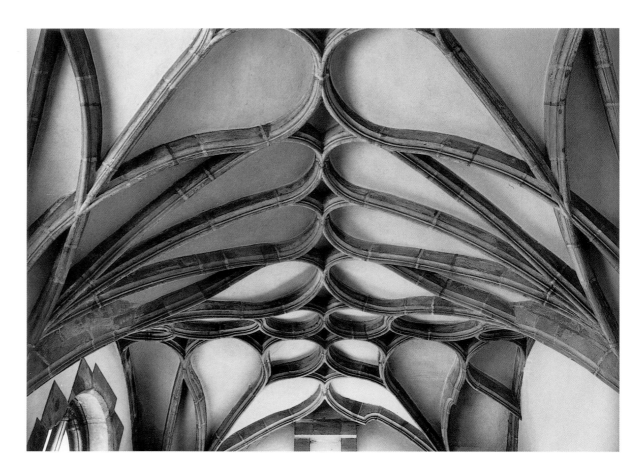

worshippers. Social changes must surely have contributed, then, to the process by which Late Gothic architecture became the art of spatial design, and it would be difficult to separate social values from the works of art themselves.

The devotional enthusiasm with which Germans conducted their religious activities amazed travelers visiting the empire during this period. An Italian who accompanied Cardinal Luigi d'Aragona on his travels through central Europe in 1517 wrote:

> They [the Germans] exert much effort on the reading of Mass and on their churches. So many new churches are being erected here, that when I think of how Holy Mass is celebrated in Italy and how many poor churches there are in a state of total disrepair, I do not envy them any less, and in the innermost folds of my heart I suffer much pain concerning how little religion can be found at home in Italy.[689]

The crowning achievement of Late Gothic spatial design was the vault. Curved rib work – out of which both the west German curved-rib configurations (Frankfurt, Meisenheim, Wesel) [213, 216] and the branch and vine-work vaults of southern Germany [225, 226] are constructed – would also form the structural basis for

numerous looping-rib vaults, both simple and stellar, that appeared at the very end of the Gothic period. This last generation of Gothic vault forms came about, once again, when geometrical vault figures metamorphosed into organic forms: rhomboid stars, stellar nets or rhomboid umbrellas were transformed into flower-like configurations that seem to sprout across the entire ceiling. In an act of linear acrobatics, ribs were intertwined to such a degree that entire vault zones were set into motion. Most of these curved-rib configurations were built in Bohemia, Austria and Saxony and were disposed towards a type of spatial fusion based on freely designed ceiling forms undisturbed by transverse or arcade arches. No wonder Late German Gothic architects preferred the soft contours and "seamlessness" of rows of umbrellas over almost all other vault forms.

The curved-rib configurations of some Late Gothic vaults in Nuremberg (Augustinian church 1479–85, Ebracher Hof Chapel 1483; probably both from Heinrich Kugler) [228] resemble palm fronds that are tied in sheaves around the top of the piers. They are very similar to the umbrella-vault forms we saw earlier, but in place of the rhomboid are large, round loops. "Ring ribs" in groups of four cover the small spaces between the umbrellas at the apex of the vault.[690] The looping-rib stars over

the south gallery at St. Salvator in Passau [210] might have been designed at around the same time as those in Nuremberg. If so, they represent the earliest example of what would later become a large group of curved-rib configurations brought forth by Donau Late Gothic. The majority of these vaults were built to the east of Passau, however, near the towns of Steyr and Freistadt. Curved ribs, piers with zigzag and rhomboid cross-sections, capitals that look like twisting boxes [219], are the characteristic leitmotifs of a Donau Late Gothic whose rich repertoire of forms was without parallel in Germany at the time.

The start of the period saw Donau Gothic experimenting with circular rib segments in the vault, some of them overlapping. They were still connected to the imposts by straight ribs that formed compartment-like web structures.[691] These same circular segments were used in rebuilding the nave vault at the parish church in Steyr after a fire in 1522. However, in the choir of the parish church in Freistadt (built 1481–1501, renovated 1507–16) the compartment-like rib structures over the impost zones were curved, and the ribs allowed to run along the inverted cone of the umbrella above the pier. From here this curved-rib vault type would be expanded to completely engulf the ceilings of multi-aisled structures such as the parish churches in Weistrach and Königswiesen (both around 1520) [229].

Weistrach is interesting for how, in place of the usual triumphal-arch piers, we find huge pendants hanging down like heavy stalactites from the ceiling.[692] Its vault ribs grow smoothly out of the top of each fluted pier, "dovetailing" in opposite directions as they rise. This sheaths the inverted cone above the pier in a network of loops and intertwining arches. The looping configurations of the rest of the vault seem to be made up of a single rib, turning and twisting back and forth upon itself. Directly in the center of each vault-shell bay is a blossom-like form that is difficult to pick out of the confusion of lines.

In contrast to, say, Bartlmä Firtalers' mesh of thin, elegant rib work in the Kärnten region [226], the ribs of the Donau curved-rib vault are much thicker, so thick that they dominate everything around them and literally form the church, giving it a kind of sculptural gravity. Although not all of the technical details were solved here, nevertheless the fact that such breathtaking vaults were built in villages emphasize once again just how vital rural church construction was to Late Gothic style development. They

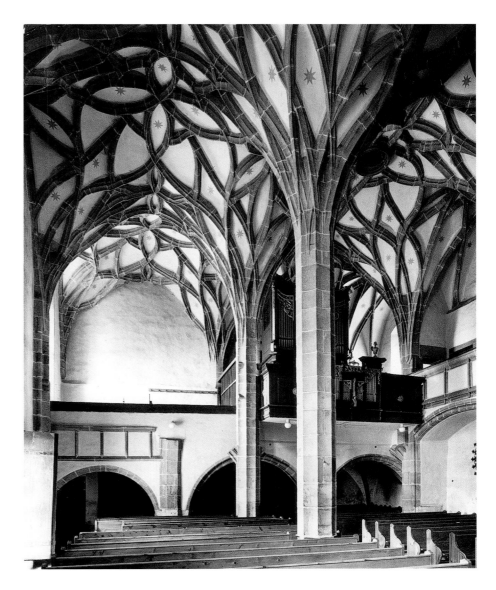

represent a magnificent end to Gothic vault construction as it developed into an aesthetic form that delineated and dominated spatial design.[693]

The Donau Style had a decisive influence on the work of Benedikt Ried, an outstanding German architect working at the turn of the sixteenth century. His efforts would breathe new life into Bohemian architecture, which in the wake of the Hussite War had sunk into obscurity. Indeed, during his lifetime Bohemia would once again be a region where important churches were built. Ried would provided groundwork for the famous Erzgebirge Halls built after him, the same churches that would inspire the concept of a "German Renaissance" in some scholarly discussions about the period.

Primary sources indicate that Benedikt Ried's career began with major renovation projects at Prague's Hradschin, work he carried out for the newly crowned King of Bohemia, Wladyslaw from the House of Jagiello in Poland. Like Peter Parler and Arnold von Westfalen before him, Ried was a court architect. He was urged to

229 Königswiesen/ Upper Austria, Parish Church, nave looking west

230 Prague, Hradschin, Wladyslaw Hall

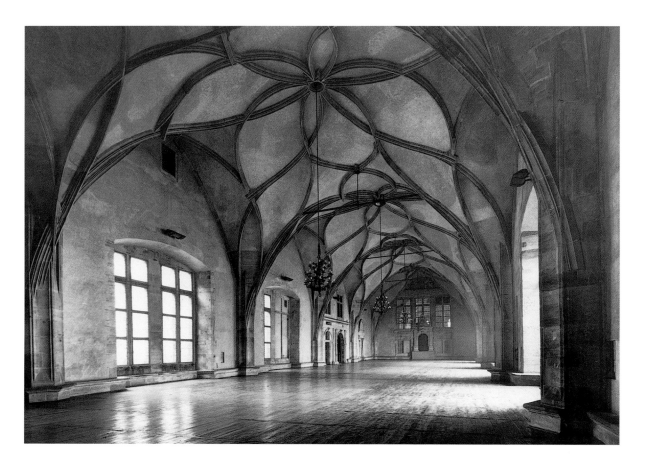

create the most expensive and extravagant examples of his art, with the goal of building structures that reflected the power and prestige of his monarch. The "Wladyslaw Oratory" [223] – an early testing of his ability – is the work of an architect at the forefront of the decorative style of his time.

Ried's *opus magnum*, however, was "Wladyslaw Hall" at the Hradschin (1493–1503) [230], a throne room of such huge proportions that not only does it encompass the entire upper story of the *Palas* built in the time of Charles IV and Wenzel IV, it is big enough to have hosted jousting tournaments as well. At sixty-two meters long and sixteen meters wide, and covered by five dome-like vault bays, it gave new meaning to the term "great hall." Each of its bays is crowned by a large star whose points are formed by looping ribs. Thin vault responds climb up from the wall piers and touch their tips. This vault form can also be found in Donau Late Gothic, but in none of the structures there does the ceiling seem as heavy and ponderous as here. Surely this is the result of very low impost zones, like we saw at Albrechtsburg, and the fact that the inverted cones above the piers protrude a good distance into the middle of the room as they rise. The fluted piers – with their alternating impost heights and the way in which they seem to grow into the vault – come directly from

Albrechtsburg [207] and Freiberg Cathedral [211][695] in Saxony. The ribs dovetail as they rise out of the low impost zone. They are organized so a single vault rib grows out of the central flute of the pier, crosses over and pierces the concave molding on the other side. The heavy vault arches seem, as a consequence, to hang precariously between the wall piers, and the net of ribs seems far too fragile to deflect any of the thrust of the thick vault shell.[696] The effect this structure has on the space below it is overwhelming and far more intensive than any of the other churches in the Albrechtsburg group. In answer to Arnold von Westfalen's sharp-contoured folded vaults made up of small sections of ribs, Benedikt Ried employed looping-rib stellar motifs that had just been developed in the Danube region. However, he made the vault shell larger so the loops are more graceful and smooth, and the ribs flow into one another in a more natural way across a space supported only at the sides.[697]

As was the case with the sculptural architecture of Arnold von Westfalen, Benedikt Ried's propensities quickly found adherents in great church construction. The first step in this direction was taken by Ried himself at Kuttenberg, where he was hired as director of construction at St. Barbara in 1512 [172, 173]. Kuttenberg was a rich mountain city and a member of the royal

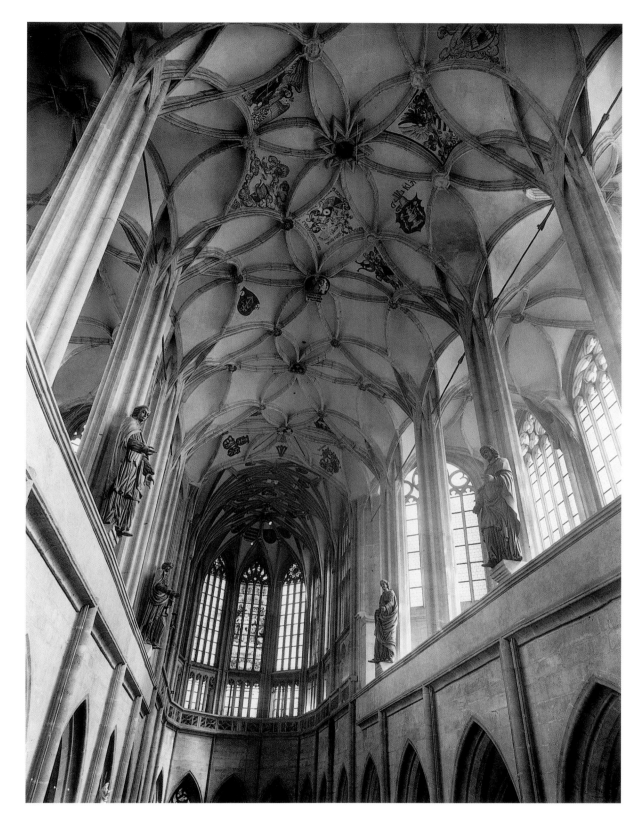

protectorate. By the Late Gothic period it pos-
sessed the financial wherewithal to finally finish
St. Barbara (probably begun by Peter Parler's
son Johannes). No work had been done on the
church at all between 1420 and 1481, when work
was taken up again on the choir, which was even-
tually vaulted in 1499 by the Prague architect
Matthias Rajsek. Plans were then made to build
the nave. Once Ried was hired, he chose to build

a six-bay Hall with side-aisles divided into two
registers. The lower register has chapelled exten-
sions and is poorly lit, while the high gallery
zone above it is wide and bright [231].

Ried's nave renounces the basilican organiza-
tion of Kuttenberg's Parleresque choir. Diag-
onally placed window walls act as a transition
between the narrow clerestory of the sanctuary
and the outer wall of the nave, which has huge

232 Kuttenberg, St. Barbara, vault rib extensions atop a wall buttress of nave gallery

windows between pulled-in buttresses. Standing on top of the arcades are the thick, compound piers of the gallery. The looping-rib stellar vault – covering gallery and central vessel – seems to hang precariously on top of these piers, similar to the way it does at "Wladyslaw Hall." The vault configuration here clearly bears Ried's signature, even though the stars are turned a bit, the encircling play of lines around them more tightly woven and the individual ribs thicker. The ribs barely touch the surface of the vault shell and stick out like boards placed on their thin sides. The courses are elliptical and they submerge into the flutes of the piers. The piers themselves seem to grow naturally into the inverted vault cones above them. The collision of support and springer forms – that oft-varied Parler motif of staggering fused articulated elements that were once locked together in ever-predictable ways – has been pushed to the limit here.

A good example of a Ried motif is Kuttenberg's wall buttresses, where a vault rib crosses through a respond to stick out the other side [232]. And it is precisely this spot that reveals what is new at Kuttenberg – an extremely flat vault shell. The prototype for this did not come from "Wladyslaw Hall" in Prague, but from Freiberg in Saxony [211]. At the top of the impost zones, the vault's flat cross-section forces the shell to jump back as it rises so that the intrados of the springers are revealed. They gradually re-submerge into the webs higher up.

As a result, the ceiling seems to float in the air above its supports. The substance of the vault shell is literally carved back from those spots where pier meets vault, which creates shadowy spaces between the ribs that converge there.

The conspicuous funneling of vault thrust into support elements – for centuries the main method of visualizing the load-bearing structure of the Gothic space – seems to have been reversed here. Visual clues as to which elements function to hold the whole structure together is no longer offered. At the most, nave stability is communicated only partially, since the lively movement of the huge vault shell hides those elements that actually bear the weight and thrust of it all.[698] This vault was not built until 1540–8, long after Benedikt Ried was dead, and is classified as one of the latest in the Bohemian/Saxony Gothic style. Surely its design, and the materials to be used, had to have been decided upon at a much earlier date, since it influenced other vault structures in the region.[699]

While its interior was one of the most advanced of its time, the form of its outer nave structure – not including its detailing – looks amazingly like that of a thirteenth century Gothic cathedral with a thick array of open buttresses. Ried must have incorporated the concept of his predecessor Rajsek, who had based his design on an earlier sketch for the church from the fourteenth century. On the other hand, Ried's roof design of three tetrahedrons was avant-garde for its time. Two of these are crowned by lantern-like structures made of wood. This was a very original solution for a Gothic roof, but Ried had practical reasons for employing it. Wind pressure exerted on such a roof, for instance, is much less than on a conventional saddleback roof. Also the truss of such a structure required fewer wooden beams to construct.[700]

Ried used the same roof form on the parish church St. Nikolaus in Laun (1520–38). Inside we find the major characteristics of his style, if in a somewhat smaller format [233] since its three-aisle, triple-apse Hall is of medium height only. That he used concave-fluted octagonal piers is further proof that he was intimately familiar with the architecture of Upper Saxony. Once again the springers are placed at varying heights, and in the middle of each bay is a four-point looping-rib star. This time, however, the loops are "capped," that is the ribs are severed before they can come together to close the outer point. This makes the looping-rib motif seem more fragile and wood-like.[701]

The designs of Benedikt Ried combined the

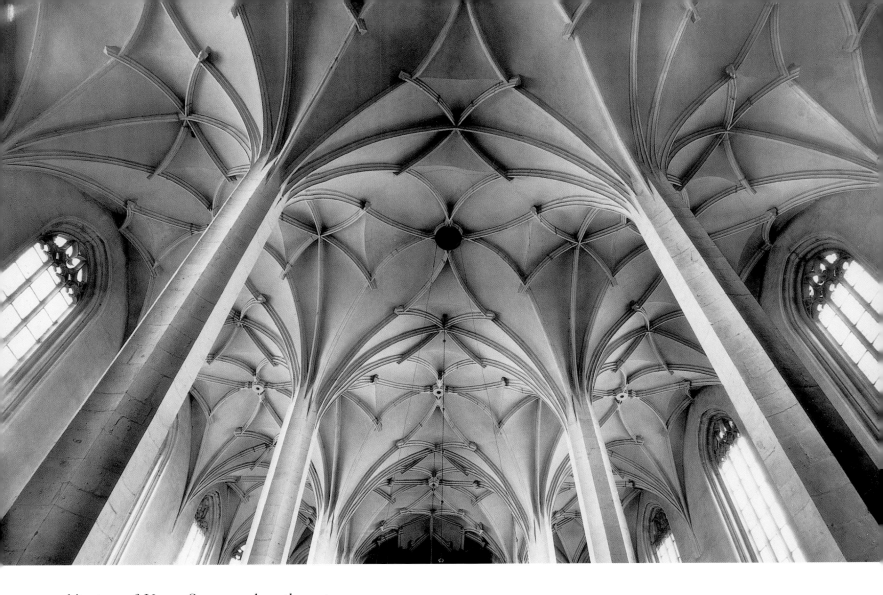

architecture of Upper Saxony and north-west Bohemia into a single style that transcended the geographical characteristics of both. It was a cross-fertilization of styles, if you will, since his work in Bohemia not only owed much to Albrechtsburg and Freiberg Cathedral – both in Saxony which is just north of the Erzgebirge region – it also had a strong impact on spatial design in Saxony even during his own lifetime. The dukes of Saxony had been, and would remain, committed to financing new churches. Indeed, they had always seen such investments as being in their own political interests. They hired and fired architects, made funds available, viewed designs and wished to see specific things included in them.[702] It is not surprising that Dukes Georg, Heinrich and Friedrich of Saxony, together with a member of the clergy, were all present at the laying of the cornerstone for St. Ann in Annaberg in the year 1499 [234] which, at least in the beginning, was to be based on much of what was traditional to the architecture of Saxony. Its design was more than likely provided by Konrad Pflüger, whom records show took over at Albrechtsburg after Arnold von Westfalen's death in 1481, and

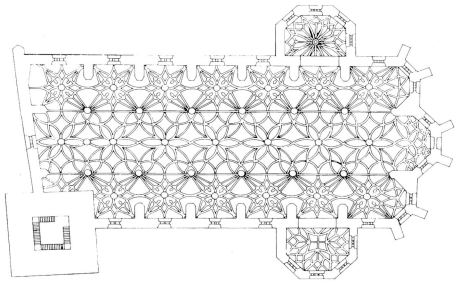

233 Laun, Parish Church, vault

234 Annaberg, St. Ann

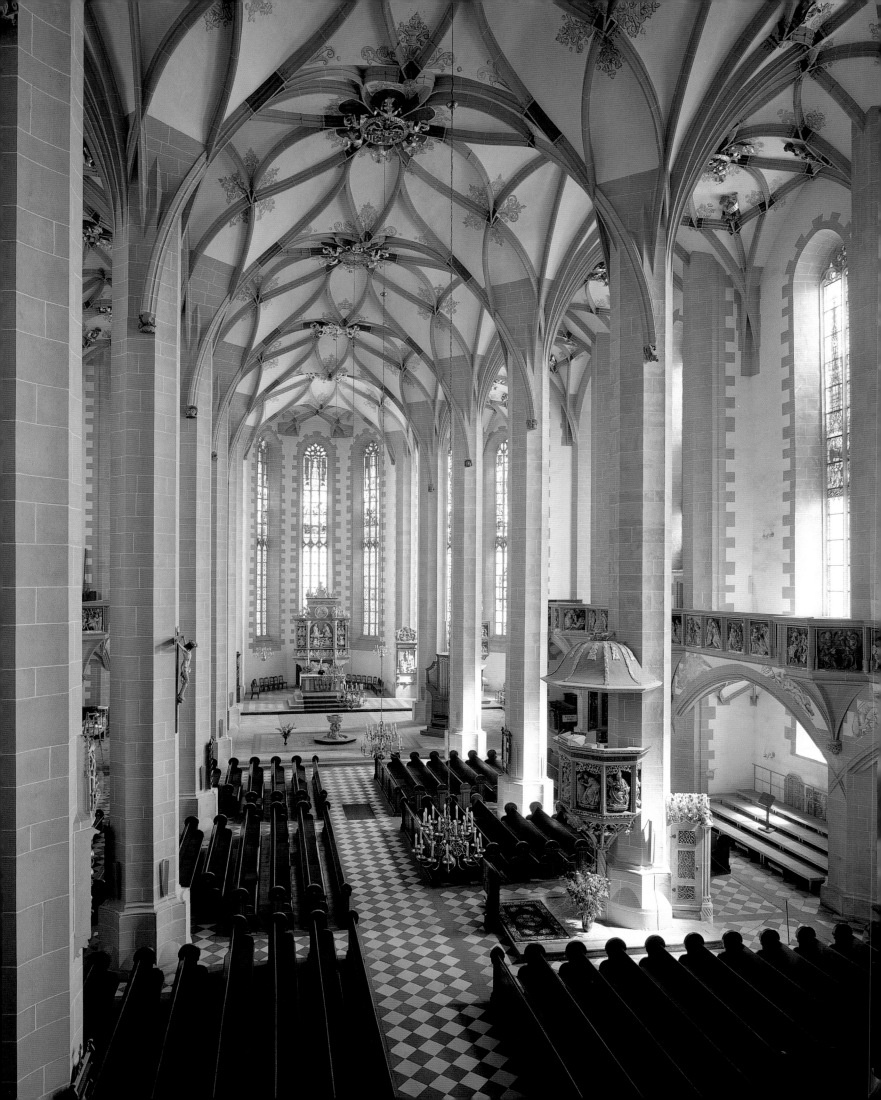

thereafter was contracted to direct the building of several palaces and churches.[703] Annaberg's design called for a triple-aisle Hall with a staggered-apse choir structure, an oft-employed form in central Germany during the Late Gothic period.[704] After Pflüger, who was often absent from the project in Annaberg, Peter Ulrich was appointed *Baudirektor*. Evidently he was building St. Mary's in Pirna at the time. In the year 1515 these, and other master stonemasons mentioned in the at-times contradictory sources concerning Annaberg's construction,[705] built an ogee-arch saddleback roof over the entire Hall. At that point the only parts of the church completed were the closed, cubical blocks of the lower tower register; the unworked-stone outer wall covered in white plaster, the tall and thin lancet windows, and the pier buttresses surrounding the choir.[706] On the inside were the usual concave-fluted freestanding piers and wall buttresses, around which a small gallery would be built at a later date and which would jump over the wall buttresses in pulpit-like structures similar to those we saw at Freiberg [211]. The rectangular ground-floor register of the sacristy on the north side of the choir had also been completed.[707] At this stage, then, St. Ann promised to be another church immersed in the Saxon tradition.

But then Peter Ulrich died, and Duke Georg of Saxony appointed the architect Jakob Heilmann to take his place. Heilmann is probably the same man who records indicate worked as *parlier* for Benedikt Ried at Kuttenberg. This is more than just probable, since Annaberg's looping-rib stellar vault is just as flat in cross-section as Kuttenberg's. It covers three aisles, each the same depth, and reaches clear into the niches of the choir. The vault ribs seem to touch the tops of the piers almost by accident here, the exception being the main ribs of the central-vessel bays which communicate with the pier directly and frame the top of the support in scissor-like forms opening downward [235]. The wide arching shape of these "rib scissors" seems to twist the inverted cone above the pier slightly, giving it a movement that breaks gently on blossom-like stellar figures at the top of the vault. For Gerstenberg, the ceiling-encompassing vault at Annaberg – with its persistent, yet calm movement – represented the purest example of the "Special Gothic" space.[708] While the lower register of Kuttenberg's gallery has the overall effect of narrowing the nave at the sides, at Annaberg the Hall is left to expand freely into the side-aisles.

Jakob Heilmann was also responsible for designing the high, conch-like polygonal level of the north sacristy and then for building its twin on the south side of the choir. The upper registers of both are wide, and both open to the sanctuary. The northern structure is the sacristy, the south holds the church's reliquary. The upper level in the south offered room for an organ and choir, the north's upper register probably served as oratory for the duke.[709]

Cracks appeared in the outer church wall during work on the southern annex. An official appraisal concerning the danger these cracks presented for the as-yet unfinished vault – undertaken by the architects Benedikt Ried, Hans Schickentanz and Hans von Torgau for Duke Georg of Saxony – has survived from 1519. In it, the architects write that the vaulting is carried, not by the outer wall, but by the free-standing piers which they felt were capable of withstanding twice the weight that would eventually rest upon them.[710] It seems the basic static principles governing Gothic architecture had changed little over the centuries, though the articulated forms themselves were quite different by now. Even vault ribs, which are still interpreted as having been purely decorative motifs in the eyes of their Gothic builders, were in reality seen as fulfilling a structural function, at least during the building of the vault. A document from the year 1520–1 states that in building the ceiling, a rib "skeleton" was erected first. After this was completed and seen to be stable, the figuration was then "braided with cut stone".[711]

Many churches built in Upper Saxony and northern Bohemia after 1500 were influenced, to a greater or lesser degree, by St. Ann in Annaberg (completed 1525). The most important of these churches were designed by architects who were active at Annaberg themselves, and who brought the knowledge they gained there to new projects. For example, in 1517 Jakob Heilmann laid the cornerstone for the parish church in Brüx [236] which was consecrated in 1544.[712] Like at Freiberg and Annaberg, Brüx is a triple-aisle Hall with fluted piers. It has a gallery that passes pulpit-like over pulled-in pier buttresses, and a looping-rib stellar vault overhead that closely resembles the configuration we saw at "Wladyslaw Hall" at the Hradschin. Like there, the pedals of Brüx's stellar blossoms overlap and the outer points are capped. Even though the ribs of the inverted cones are not turned like they are at Annaberg, Brüx's configuration seems richer by comparison: the net is more thickly woven, ornamented with flying

235 Annaberg, St. Ann, nave looking east

236 Brüx, Parish
Church, view from the
gallery

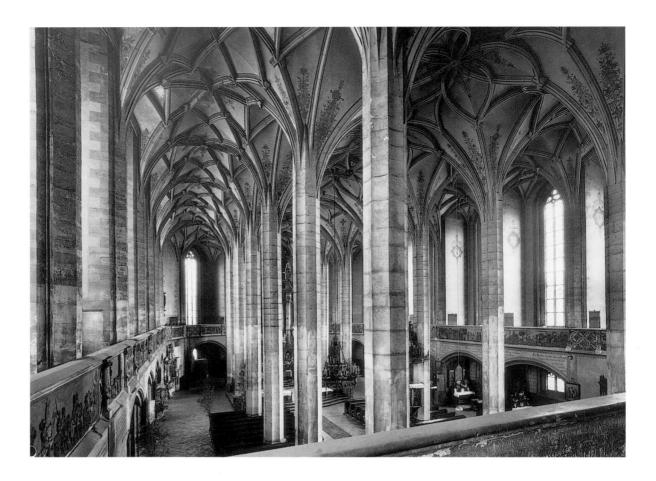

236 Brüx, Parish
Church, view from the
gallery

237 Schneeberg,
Wolfgangkirche

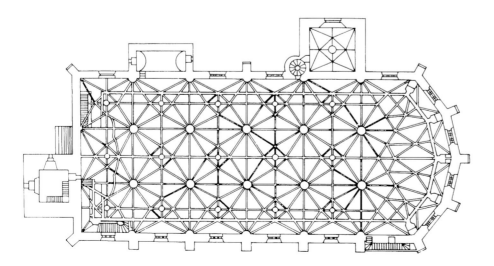

ribs, there are pendants hanging on its blossoms and colorful web painting.

St. Wolfgang in Schneeberg (begun 1515) represents a major step beyond the school of Halls we have been talking about.[713] It is by Hans von Torgau, one of the architects called in to vouch for the stability of the vaults at Annaberg in 1519. Though the church does possess fluted piers and a small gallery hung into the wall buttresses, the fusion achieved by its overall spatial disposition surpasses even that of Annaberg. There is little or no difference in the depth of its three aisles, for example, and the eastern termi-

nation consists of a single polygon circumvented inside by the gallery. With his vault design, however, Hans von Torgau decided against the new curved-rib motif and employed instead a more traditional configuration with each bay delineated by a transverse and arcade arch and covered by a four-point creased-rib star.

Peter Ulrich designed other churches *before* working at Annaberg. In 1502, six years before being called there, he began the parish church of St. Mary's in Pirna according to a Hall design. Its three aisles are the same depth and its staggered-apse has a near non-protruding profile – both characteristics of Konrad Pflüger's floor plan for Annaberg. Pirna's vault shell (1539–46) is also quite flat in cross-section. Beneath the vault shell of the central vessel is a thickly woven rhomboid net configuration that transforms without a break into a pattern of elegant circular shapes over the choir – a vault that some have called a "surface grid".[714] Figurative sculpturing plays a major role in this ceiling, with its figures integrated so well that they appear to be in their natural habitat. Two hairy creatures climb upon tree trunks that rise out of the wall buttresses at the eastern apex of the church [238]. Twelve more of these "wild men" could be found until 1791 on similar buttress extensions in the choir and nave. A wild horde of troll-

like beings populated forests in medieval folklore and were responsible for all sorts of mischief (with the help of the forces of nature).[715] Surely their inclusion in a church interior was apotropaic, for they were to help protect the House of God from all dangers without.[716] There is also a winged dragon on one of the ribs in the choir, as well as a snake slithering through the vaulting over the south choir – symbolic of demons whose power has been taken away by consecrated ecclesiastical space.

Iconographical figures such as these had been part of the repertoire of structural sculpturing since the early Middle Ages. They were employed in one of the last great spatial designs of German Gothic with no loss of expressive power whatsoever. All the efforts by Marxist art historians to define the architecture of Upper Saxony during the early sixteenth century as "realistic", a kind of proto or para-Renaissance that reflected the intellectual and social upheavals of an early "burghers' revolution"[717] seem totally off the mark in light of the irrational medieval system of beliefs presented by the images in this church.

Be that as it may, there is clear evidence that liturgical space was gradually divested of its mystical character during these years. It wasn't the clear and tangible conception of the Hall space, as Gerstenberg thought – in this respect, the Saxony Hall is easily comparable to older structures like the St. Maria - zur-Wiese in Soest [92] – but the way in which these later Halls let light in that allowed structural elements and other objects in the room to appear clearer and nearer. This might be an indication that art and its perception had become less mystical. Because it had hardly any stained glass windows, the Saxony Hall – along with many other churches of the period – was very brightly lit. Now and then we find a single pane of stained glass isolated within large transparent glass surfaces. In place of the glowing window-walls of Cathedral Gothic, we now find smaller openings that, however, allow more unfiltered daylight into the nave than ever before. Instead of glowing with an inner light, the Late Gothic window illuminated the objects in the nave, and in doing so approached once again its original function.[718] This development was not lost on late-medieval writers, nor was it always met with acceptance. Around 1485 a monk in Chemnitz by the name of Paul Niavis complained that churches had become too bright, while the older darker churches were better suited to awaken devotion in the worshippers. The new fashion for lighted churches, he wrote, allowed lovers the enjoyment

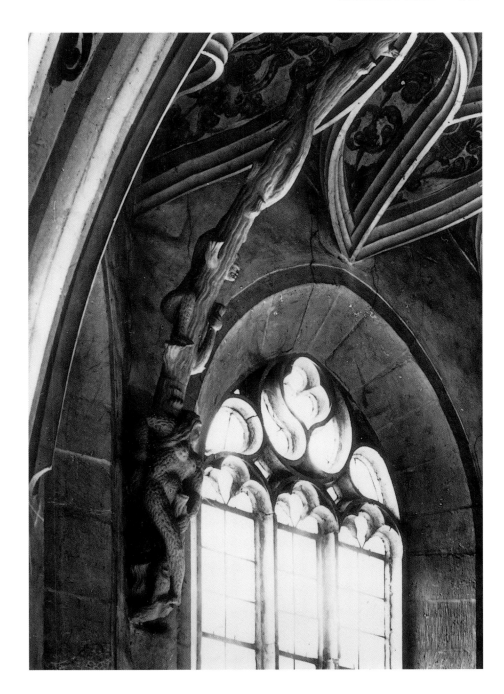

of seeing each other (at Mass) and did not promote a submissive attention to the sermon.[719]

After the end of a strict construction aesthetic that saw a filing-down of the wall relief, the transformation of abstract structural decoration into botanical forms, the neglect of entire groups of structures – like west façades, choirs with ambulatory and transepts – this change in the function of the window can be seen as having been only one Gothic metamorphosis among many, changes that surely were accumulative. The Saxony Hall structures built in the Erzgebirge region during the Late Gothic belong to those structures whose overall spatial dispositions were most affected by these changes. For this reason, they have always embodied the ideal type of the German "Special Gothic"

238 Pirna, St. Mary's, "Wild Men" at the springers of the choir vault

church for scholars. During Gerstenberg's time they were understood as representing a German Renaissance with its own special forms. In light of how far they diverged from the High Gothic canon of types and forms; Annaberg, Brüx, Schneeberg and Pirna represent a spectacular final act to German Gothic architecture. No other church in the empire built after 1530 deviated from the Gothic canon as much as these. Architects continued to build in the Gothic style, but the repertoire of forms available to them froze where it was in 1540–60 or where it had been a few decades earlier.

The generally accepted date of around 1520 for the time when German Gothic became part of the Renaissance – which is also seen as the moment medieval Europe became early-modern Europe – is based on a fictitious curve that reflects how far architectural style deviated from the Cathedral Gothic system. This date is a product of the eminence of the Gerstenberg model, which loses much of its validity when seen within the total picture of German architecture around and shortly after 1500. Without a doubt, the process by which interiors were expanded, fused and injected with motion in the vault was realized to a great degree in the Halls of Upper Saxony. Yet it is precisely the exceptional character of these churches that makes them seem all the less characteristic among the varied forms and types of Late Gothic concepts in general. These spatial designs were not the final product of a linear process either. They resist the teleological approach that historical models of style development have imposed upon them. Such structures as these – whether seen as a last flowering of the Gothic Style or the first of the Renaissance – are simply unable to provide the parameters within which the change from one epoch to the next might be defined. German Gothic architecture, because of its multiformity, is simply unable to define when exactly the Gothic ended and the Renaissance began.

VIII

Gothic and Renaissance

NO OTHER PERIOD of years has been as widely debated as those during which late medieval Europe became early-modern Europe. At the heart of the discussion is the concept of the Renaissance, whose definition determines which dates are important and which are not. For years it was believed – adamantly so by scholars – that the appearance of early-modern Europe coincided with the great discoveries made around 1500. However, when detailed research compiled over the years by historians and scholars of literature began to contradict this, many medievalists were incited to renounce the concept altogether. This was the so-called "revolt of the medievalists"[720] who rejected the notion that the two periods were antithetical. The Late Middle Ages, they said, laid the groundwork for much of what characterizes the Renaissance. Furthermore, early-modern Europe was a period during which many medieval phenomena continued to exist for years. And a closer look reveals that even the most radical of changes in style or form during the period did in fact possess traditional elements that transcended both epochs and exhibited a certain amount of permanence. At what point, then, was medieval Europe irrevocably early-modern? Today scholars tend to see this point as not having occurred abruptly around 1500, but rather as a gradual transition that ran its course between 1300 and 1600 AD.[721]

When the medievalists first revolted, few architectural historians agreed with them. Compared to other disciplines, medieval architecture enjoys the luxury of having actual objects to study, objects whose different characteristics are for the most part clearer and easier to delineate and organize, than the abstractions scholars of medieval literature, institutions or ideas must study. At the very least, the forms of central-European Gothic are discernible from those of the Renaissance in the buildings themselves. But

even so, an individual form alone is not enough to delineate an entire period of architecture, let alone characterize the dissolution of one epochal style into another – especially a style that supposedly continued to change, become more complex, and to influence numerous churches within a large region. In fact, this is precisely what did *not* happen in German ecclesiastical architecture of the sixteenth century. An epoch "renaissance" simply did not occur here.

Perhaps this should not surprise us. German architecture had been evolving further and further away from the forms of classical antiquity ever since the appearance of Pre- and Early Romanesque imperial styles during the reigns of the Ottonian and Salian emperors. Yet, as different as Late Gothic forms were from classical forms coming from Italy during the sixteenth century, there was nonetheless a distinct period of years when German architects employed them. They did so tentatively and were, as usual, concerned first and foremost with stability and how to get stonemasons trained in the Gothic style to carry them out adequately. At the beginning, then, the new style was employed almost exclusively in structural decoration and detailing. The Renaissance style would never become a truly epochal style in Germany, not in the sense that it would affect the entire structure. Instead, it was one of many sculptural styles used in Late Gothic interior design and decorative structural articulation. This is all the more telling, because the values of harmony and proportion in the entire mass of stone played a central role in Italian Renaissance architecture in general.[722]

Evidently the need for non-ecclesiastical structures requiring new and expensive designs was not as great in Germany as it was in those regions of Renaissance Europe where demand precipitated a stylistic breakthrough.

239 Prague, Hradschin,
"Wladyslaw Hall", portal
to Landoechtsstube

240 Heilbronn, St.
Kilian, upper registers of
the tower

The French kings, for instance, sometimes took a court architect with them on military campaigns through Italy during the early sixteenth century. And, in fact, great Renaissance chateaux were built in Blois (begun 1515), Chambord (1519), Fontainebleau (1528–40) and the west wing of the Louvre (1546–59) after campaigns south of the Alps. All of these structures were intended to visibly represent the epicenter of an established monarchy on whose architectural forms many French aristocratic houses would model their own chateaux. A similar situation did not arise in the Holy Roman Empire and such structures were never built. The Italian campaigns of Maximilian I and Charles V did not have any effect on architectural style. It wasn't until the construction of the *Ottheinrichsbau* (1556–9) at the Palatinate ducal residence in Heidelberg – a structure financed by a regional power rather than the emperor – that we find anything similar in Germany to what occurred during the same years in France.

Fifty years before the Renaissance façade in Heidelberg, the same Benedikt Ried who had created some of the most daring Gothic ceiling-arch systems had already built Renaissance motifs into the governmental wing of the Hradschin [239]. These motifs included the double windows of "Wladyslaw Hall" – partially embedded between wall buttresses, or cut into the naked wall surface – and the portals of the Bohemian Chancellery and the "Reiterstiege". All of these are very simple and based on fluted pilasters and columns, or beams and rounded classical arches. Due to their statuesque calmness, they seem strangely out of place in a dynamic Gothic environment. Occasionally, however, they seem to have been "infected" by Gothic movement. The pilasters on the large east window of "Wladyslaw Hall" are twisted in the longitudinal, for instance. Those siding the portal leading into the *Landsrechtsstube* are twisted in a way similar to how Late Gothic "spiral piers" were twisted in the cathedrals at Eichstätt [218] and Braunschweig.

In Saxony, that hub of German church building in the sixteenth century, the portal now became the preferred test-venue for the new style. This was partially due to the influence of Ried's designs in Prague, and partially to the fact that sculptural style in Saxony had been influenced by that of southern Germany, where Renaissance forms were adopted at a very early date.[723] The portal zone provided them with just enough space for the implementation of an order of columns, however abbreviated. It was the location for some early attempts at employing

the strange new motifs which were readily accessible in the form of popular ornamental copper engravings from Italy. Nevertheless, none of these portals were integrated into the structural articulation systems of the churches where they were built.[724]

Now and then Renaissance details replaced an individual form or two in a particular church's Gothic articulation system. Sometimes the new style was used, like branch-work had once been used, to distort an entire section of a church. In the cloisters at Regensburg Cathedral (probably by Erhard Heydenreich 1515–20) we find parts of columns, small candelabra columns, acanthus foliage and pieces of classical entablatures stamped into the arches of the window walls. These replaced Gothic archivolts, and frame the tracery figure in the center of the window. Even less Gothic in appearance is the tower crown of Heilbronn's Kilianskirche (Hans Schweiner 1513) [240]. An octagonal structure with stairway and thin lancet openings, it can be traced to earlier German Gothic spires. But in place of the usual pyramid with vertical spars running top to bottom, we find four separate octagonal levels stacked on top of each other, each one smaller than the one below it. The entire structure, which includes Gothic gargoyles, is otherwise decorated with forms derived from the Renaissance style. Everything, even structural sections like piers and balustrades, is covered in classic ornamentation and thick foliage work which gives the whole a form difficult to categrize. It is covered in a decorative sheath of swollen, grotesque plant forms that intensify the fantastic element of the structure's geometrical tectonics, so that it seems like something from another world. Similar to the botanical decoration of the Late Gothic style, these plant forms seem to indicate, at the very least, the desire of its creator to present a Gothic tower.

As spectacular and exotic as they were at the beginning of the period, Renaissance forms no doubt quickly became the preferred vehicle for demonstrating the worldliness and "modernity" of those people wealthy enough to finance the building of a new structure. The most important banker and businessman in the Holy Roman Empire at the time, Jakob Fugger, had a homogeneous spatial design built in the Renaissance style, which was something entirely new north of the Alps. The Fugger Chapel was built opposite the east choir into the western bay of the nave at St. Anna in Augsburg (Jakob Zwitzel, design probably by Sebastian Loscher and Hans Burgkmair 1509–19). With

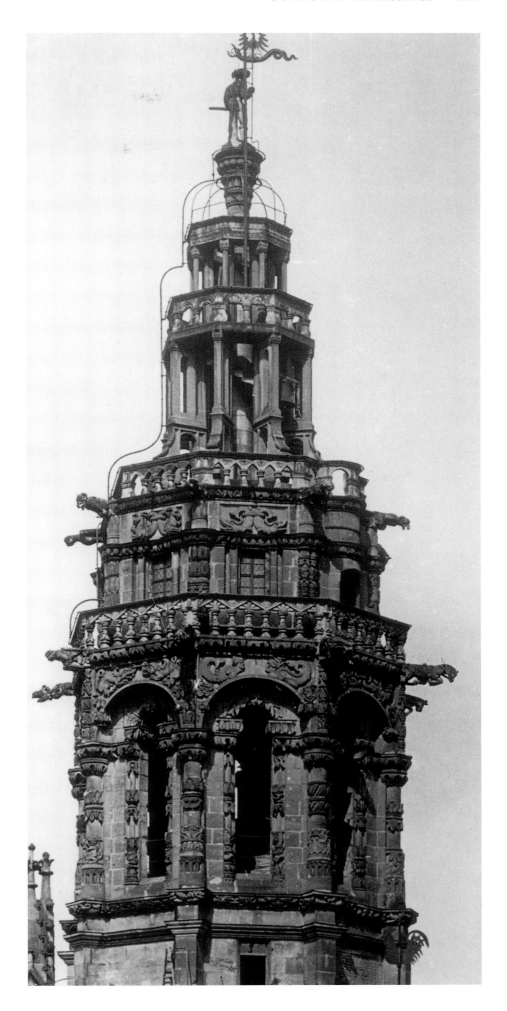

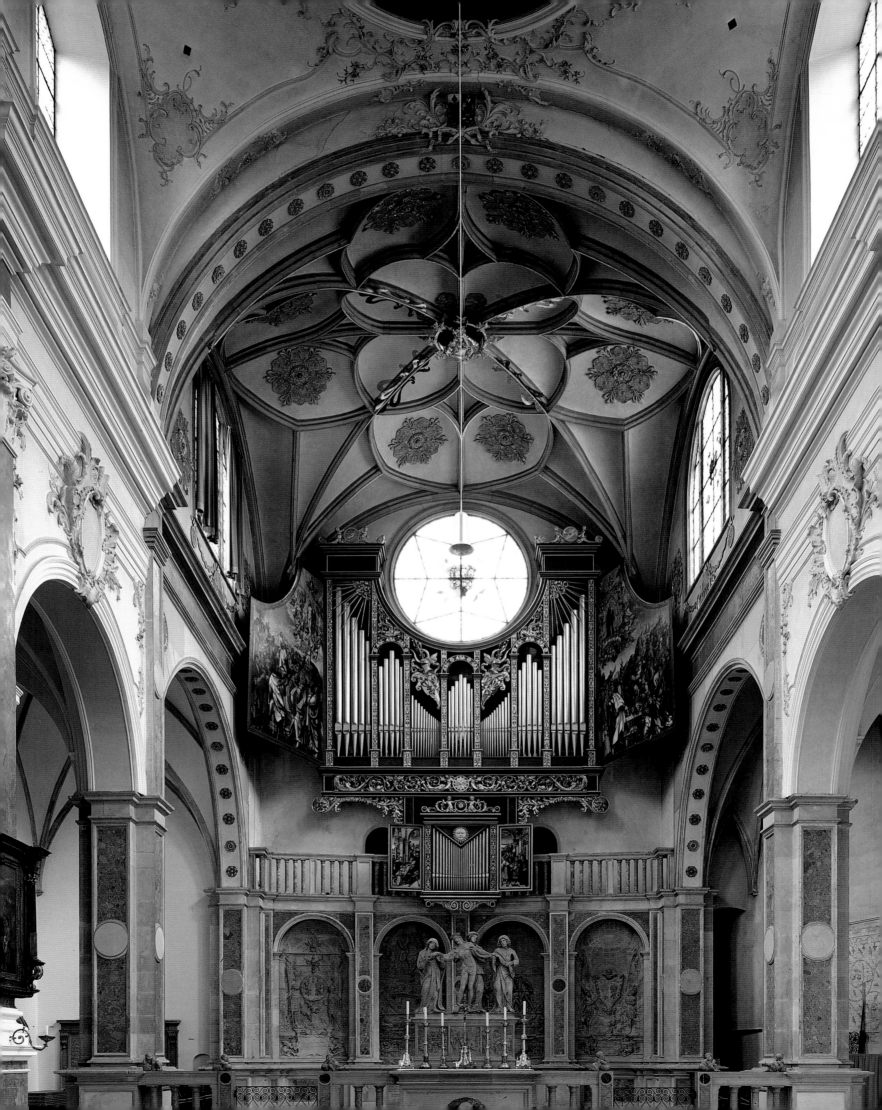

four family tombs, it is as fastidious as any Romanesque ducal west choir [241]. As to who was responsible for the spatial ensemble, nothing has survived. Among many possible candidates is Albrecht Dürer, who was in Augsburg in 1505 on his way to, and again in 1507 on his way back from Italy. It is more likely, however, that a man named Hans Hieber carried out the design. He built Regensburg pilgrimage church at a later date, a structure whose detailing exhibits an intimate knowledge of the Fugger Chapel.[725] The square west bay of St. Anna at Augsburg was very different from the rest of the Gothic basilica, which was still standing at the time. The Fugger Chapel there is made up of only a few architectonic forms – a large transverse arch to the east with decorative intrados rosettes, round arcade arches to the sides and entablatures placed high on the wall – which are directly out the Venetian/Lombardy school. Surely Jakob Fugger was familiar with such forms from his travels to northern Italy. In front of the west termination at St. Anna is a huge ornamental wall. An order of five pilasters frame the four tombs (the two in the middle designed by Dürer) each of which is decorated with a relief panel topped by a round arch. Above this is a narrow organ gallery. The altar, the sculptured Corpus Christi group, an elaborate stone railing separating the chapel from the nave, putti above and intarsia stone floor below, along with painted organ "wings;" all combine to form a homogeneous ensemble that unified the arts. A decisive last step to a purely Renaissance space, however, was not taken. Evidently, it was felt that a large curved-rib vault overhead was essential to give the monument the sanctity it needed as a church chapel. Nevertheless, the Fugger Chapel is rightly understood as having been the earliest example in Germany of an ornamental interior with an inventory of forms designed specifically for it, in a way that the Gothic would never have done.[725]

If there was a sixteenth century design that truly reflected a transition or "mixed style" between Late Gothic and Renaissance then it was Hans Hieber's design for the *Schöne Maria* in Regensburg [242]. A pilgrimage church dedicated to St. Mary, it was begun on the site of a Synagogue that had been destroyed in 1519. The humble form in which it was completed has little in common with Hieber's original plan, an ornamental wooden model of which has survived and can be seen today at Regensburg Stadtmuseum. The original design (from 1520) foresaw the fusion of a large hexagonal central structure with a tall and narrow, single-aisle chancel flanked by

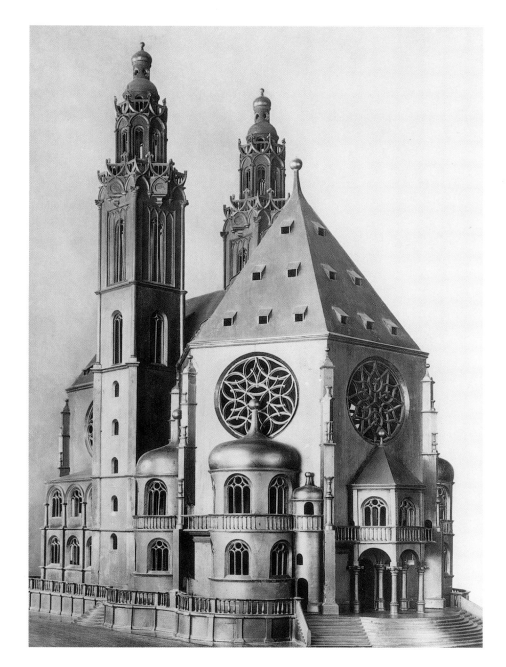

two towers. There were no prototypes for this combination in German Gothic, but several in northern Italy of the early Renaissance period, even though the central structure of these always formed the choir.[726] The small, double-register conches with blind balustrade articulation on three sides; along with some individual motifs like round knobs atop the distended conch roofs and the towers[727] are Italian as well. On the other hand, the rhomboid umbrella vault over a central pier, a steeply pitched roof in the west, window tracery with rounded arches above them, huge roses in the clerestory walls, ogee-arch crests over the tower galleries and pier buttresses at every corner are all purely Gothic. Add to these its tall proportions and structural organization, then the building would probably have qualified

242 Regensburg, Town Museum, wood model by Hans Hieber for the "Schöne Maria"

241 Augsburg, St. Ann, Fugger Chapel

243 Torgau, Palace
Church

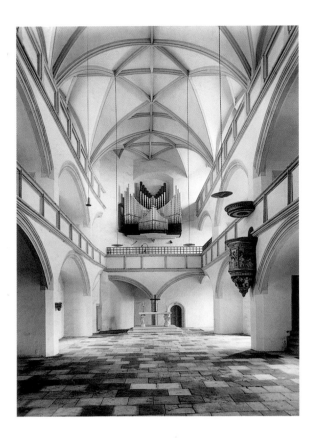

cities of Swabia after 1530, for example, Saxony continued to see many new churches built after 1550 – despite the huge Hall structures begun at a slightly earlier date[729] – and it would be interesting to know what kind of forms these churches took.

The first ecclesiastical structure in Germany to be completely free of Gothic forms, but which also exhibits some early Baroque characteristics of Vignola and della Porta, is the Jesuit Church of St. Michael in Munich (1583–97). A "wall-pier" church similar to Il Gesù in Rome, it was designed by Friedrich Sustris to have a barrel vault resting on pairs of pilasters, semi-domed side-aisles and a façade brimming over with Italian forms. It is a very singular structure that bears witness to the Catholic stronghold that southern Germany was, the effect on the region of the Counter-Reformation, and how open architects there were to the Italian style and especially that of the architecture of Rome which was the most influential of its kind at the time. In Bavaria, Swabia, Austria, Bohemia and Moravia – precisely those areas where a rich and creative Baroque ecclesiastical architecture would develop at a later date – Renaissance forms gradually got the upper hand in the years leading up to 1600, after which Gothic more or less disappeared. Such clearly definable structures as St. Michael in Munich would remain the exception.[730] It should be pointed out, however, that beginning in the early 1500s there was little overall change in the kind of style used. Gothic motifs continued to be employed in many new churches, even in the regions mentioned above. Outside of those areas, that is in most of Germany where the Renaissance played a minor role in ecclesiastical architecture, Gothic forms such as ribbed vaults, pointed-arch windows and portals were indispensable all through the sixteenth century and after.

We can say with little hesitation, then, that Gothic forms continued to make up most of the inventory for architects working in the ecclesiastical style in Germany.[731] The phenomenon of its decades-long survival has earned a stylistic delineation – the post-Gothic.[732] This concept naturally entails flexibility in defining when the Late Gothic period ended, since that which characterizes the stylistic development of the post-Gothic – the gradual but irrevocable rejection of Gothic structural forms – can be observed much earlier. In the fifteenth century, for instance, the Gothic outer structure lost its importance as a zone of representation in favor of the vault, and applied decoration focused on

the *Schöne Maria* as a Late Gothic church, one whose outer structure exhibits a dynamic movement. It owes this to its use of diverse Gothic motifs in combination with extremely large roses, and the addition of an early Renaissance conch type from northern Italy.

In contrast to the strong Renaissance effect achieved by the Fugger Chapel, the tower at Kilianskirche and the original design for Regensburg's *Schöne Maria* were, in the end, so idiosyncratic in their adaptation to Italian forms that the resulting conglomeration could hardly have provided sixteenth-century German ecclesiastical architects with distinct types to develop in the same direction. Structures similar to these were not built, and it appears German ecclesiastical architects were under no contractual pressure to employ the Renaissance style in their designs. Why was this the case? The assumption has always been that the rate of new church construction during the sixteenth century stagnated while the huge construction projects of the Late Gothic were completed.[728] And there seems to be historical evidence for this: the earliest major structures with markedly visible Renaissance forms can be found before or around 1520, then in the decades that followed nothing of a similar magnitude was attempted. But, in fact, a closer look shows that there were marked regional differences in building activity. While church construction came to a near standstill in the

specific parts of the church leaving bleak wall surfaces behind. During the post-Gothic's main phase of development, which supposedly lasted until the mid-1600s, typical Gothic forms of the outer structure – finials, triangular gables and crockets – disappeared from the repertoire in Germany altogether, though admittedly these had not changed much at all since roughly 1580. Figured vaulting, window tracery and pointed arches over portals and windows, however, continued to be employed until about 1700 when the last Gothic motifs were replaced by Baroque forms.

If I were to construct a standard post-Gothic church interior, then it would more than likely be a Hall with pointed-arch tracery windows, ribbed vaults, cylindrical or octagonal piers and a polygonal choir termination – a conventional type of church of which there were already examples in the fifteenth century. Renaissance forms would be limited to structural decoration on walls, portals, ornamental gables and gallery balustrades and the new style would play little role in the disposition of floor plan or structure. There would be, of course, regional differences in this standard, based on how a particular local Gothic tradition had been modified over the centuries. We would find – and do find – many opulent figured or curved-rib vaults in the central-Rhine region, in the Alsace, Franconia, Bohemia and Saxony built after 1550.[733]

Architects must have understood the post-Gothic as an ecclesiastical style first and foremost, since it was employed by both denominations after the Reformation. Yet, despite the period's sharply different views concerning the sanctity of the church structure, liturgical questions and the role art should play in religion, the early years of the Reformation brought forth no style or type of church specific to the Protestant faith.[734] By the 1640s, however, an ecclesiastical type of interior had emerged – usually placed inside a system of pulled-in buttresses and a circumventing, often multi-register gallery – that was especially suited to the Protestant service with its focus on the sermon. The prototype here was without a doubt the Late Gothic Hall, and it was no accident that the first interiors of this type, most of them palace chapels, were built in Saxony.[735] After the building of the palace church Hartenfels in Torgau (from Nickel Grohmann 1543/44) [243], there followed the chapel in the north wing of the castle in Dresden (Melchior Trost after 1550) then a few years later came the earliest structures of the type in other Protestant territories.[736] Despite possessing an

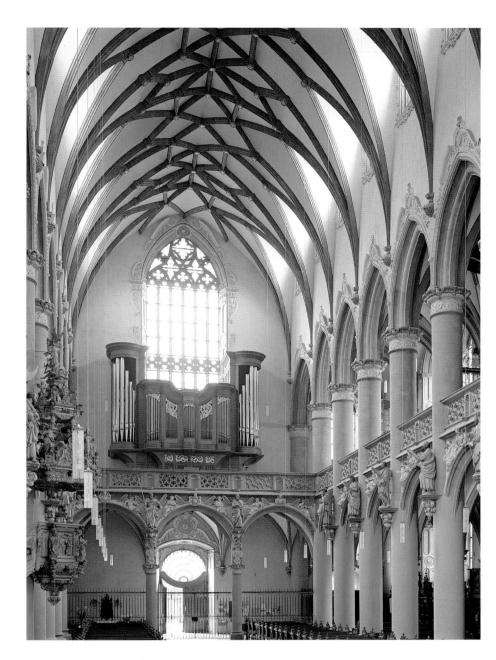

at times strong Renaissance flavor,[737] all of these structures exhibit post-Gothic elements. The large Protestant Halls with gallery built at a later date – in Neuburg-an-der-Donau (begun 1607 as Lutheran court church, completed 1614–16 as a Jesuit church), in Dillingen (parish church 1619–28) and Dachau (parish church renovated 1584–6, nave 1624) – would remain true to Gothic spatial concepts, even though their structural decoration was completely Italian.[738]

The important role the post-Gothic played in churches of both confessions is not particularly good news for the popular theory that there was a Jesuit-style Gothic during this period,[739] especially since even the most important Jesuit churches of this type – in Molsheim (1615–17) and Cologne (Christoph Wamser 1618–78) [244] – are large galleried basilicas with round columns and figured vaults, and can be

244 Cologne, St. Mary's Ascension, nave

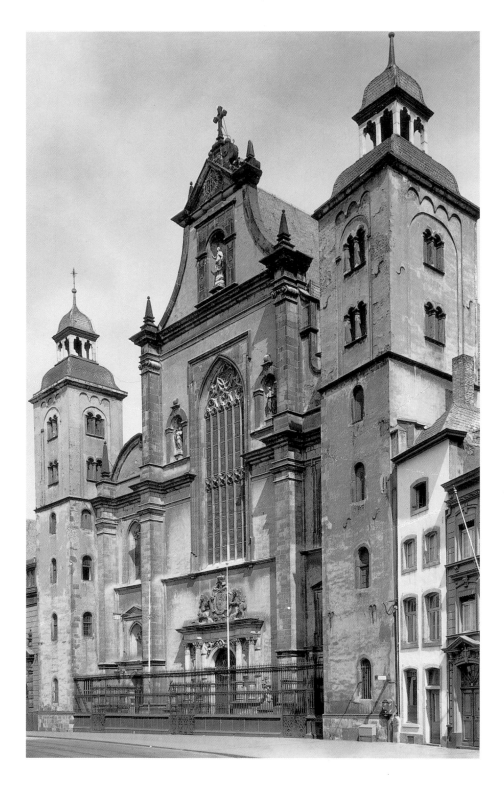

245 Cologne, St. Mary's Ascension, west front

destroyed by the Huguenots, and were heavily involved in the plan of Jesuit Father Hermann Crombach to complete Cologne Cathedral.[741] Supported and financed by the great dukes of Catholic Europe, the order was free to express architectonic values in structural programs that were consciously retrospective. Paradigmatic for this was the west façade of the Jesuit church in Cologne, called by archbishop Ferdinand von Bayern a *monumentum Bavaricae pietatis* and paid for by the House of Wittelsbach to the tune of 150,000 Talers.[742] A large tracery window was inserted into the church's Early Baroque façade [245] placed between two cube-shaped flanking towers of Romanesque form. The window and towers were meant to be recognizable historical motifs. As such, they contrived to symbolically anchor the Kingdom of Bavaria and the Jesuit Order in the pious orthodoxy of the Middle Ages.

The Gothic forms at the church of St. Mary's Ascension took on the added significance of historical reference only when they were placed between Romanesque motifs, a mix not usually found in post-Gothic churches. Those living at the time, however, were well acquainted with this mix of Gothic forms and new "foreign" motifs. Its seeming lack of unity was first formulated by architectural historians at a much later date. German humanists saw the Renaissance as relatively unimportant to German history, a history that they imagined had developed undisturbed by outside elements.[743] Architectural writers of the sixteenth and seventeenth century did not see the appearance of classical forms as representing a change in ecclesiastical construction values either. For Walter Rivius, publisher of the first German translation of Vitruvius (1548), for Strasbourg's town architect Daniel Specklin (after 1577) or Josef Furttenbach author of *Architectura civilis* (Ulm 1628), the post-Gothic style was not anachronistic. It was expressive of an architectural tradition rich in forms and therefore a suitable method of church construction, one that did not lose its validity even as Renaissance architecture became more and more important.[744]

After a while, of course, the distance between post-Gothic and the structures of the Middle Ages became too great. By the seventeenth century, Gothic architecture was a historical style in the minds of architects, a style that was as strange as it was amazing. Perhaps it should not surprise us that Goethe understood Strasbourg Cathedral less with his mind, than with his heart. But Goethe was not the first German to see this particular building as a symbol for

seen as post-Gothic structures.[740] Nevertheless, the Gothic style seemed to become more important in the spatial programs of Jesuit churches of this period. As a product of the Counter-Reformation, the Jesuit Order must surely have seen Gothic architecture as an ecclesiastical style that symbolized unified Catholicism prior to the Reformation. They did, in fact, spend much time and effort in sustaining it. The *Societas Jesu* insisted, for instance, on a stylistically correct rebuilding of Orleans Cathedral which had been

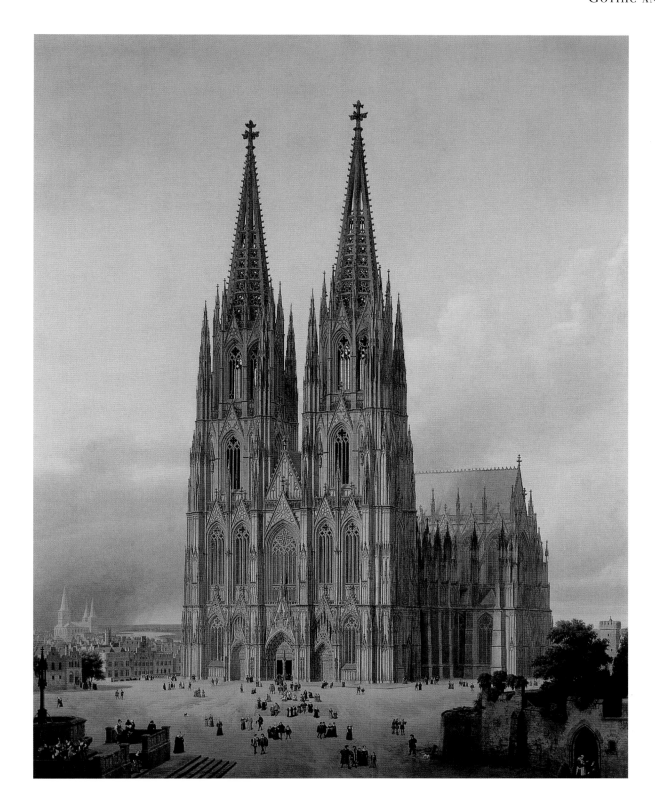

246 *Cologne Cathedral*, idealized view from the south-west, by Carl Georg Hasenpflug 1834–6, Kölnisches Stadtmuseum

medieval art and faith. Poetic eulogies to Strasbourg's west façade were common during the seventeenth century and they have that same reverential, patriotic tone that the Romantic movement would use so well two centuries later. A good example would be Johann Wilhelm Zincgref of the Heidelberg circle of poets, who warned visitors to Strasbourg Cathedral in 1624:[745]

You err, observer, to look upon
This magnificent tower, the eighth wonder
Of our world, and higher than all the hills.
It raiseth itself because wonderfully built
Unto the very clouds; and thereby you wish
 to complain
That it lacketh one thing, namely, that the
 tower base
Which standeth nearby, be but half complete.

Oh, let not your soul despair upon this
 great mystery!
For nature did arrange that next to this
 tower,
No other should standeth as pleasing unto
 the eye,
That the one tower rise alone, most
 beautiful and highest
And have no rival in this wide world.

In the eighteenth century, with Goethe's redis-
covery of German-ness in the Gothic style –
which he had held in disdain for years – Stras-
bourg once again became the paradigm of a
national German architecture. Schlegel, on the
other hand, turned Zincgref's amazement for the
"eighth wonder" into deeply religious sentiments.
In doing so, he recognized the Gothic as one of
history's greatest ecclesiastical styles, whose
buildings expressed exactly what the Romantics
hoped to achieve by resurrecting the medieval
world. The assumed genesis of Gothic forms out
of nature seemed to Schlegel to be the source for
the style's anagogical effect, an effect that set it
apart from all other architecture. To him, the
Gothic church was nearest unto God.

Schlegel would reflect on Gothic archi-
tecture while looking at Cologne Cathedral, that
structure Romanticism would make the quintes-
sential example of German medieval architecture,
a distinction it has retained unto this day [246][746]:

if the entire outer structure is not unlike a
forest when seen from afar, with all its
countless towers great and small, when
seen closer up the whole surely resembles
the innumerable shapes of Nature in crys-
talline form. In a word, this wonder of
artistic achievement is like unto the works
and products of Nature itself due to the
organic bounty and endless variety of its
forms.... The heart of Gothic architecture
can be found, therefore, in the bounty and
endless variety of its natural forms inside,
and the richness of its floral decorations
outside. Hence the unremitting and innu-
merable repetitions of the same decorative
embellishments, and the botanical forms of
these which are not unlike the flower-buds
of plants. Hence the quiet, spiritually
moving mysteriousness of it all. The
joyful, charming, invigorating effect that
the amazement of its size bestows upon
the observer. Gothic architecture is more
than important, it is most important: for
while painting has to make do with weak,
unclear, confusing and distant allusions to
holiness; architecture on the other hand –
thought out and applied like it is here – is
able to give the Infinite an immediacy by
merely copying the bounty of Nature, and
without ever having to allude to the ideas or
mysteries of Christianity. ...

NOTES

Abbreviated references are cited in full in the Selected Bibliography

1 The standard on this subject is still Otto Brunner's *Land und Herrschaft – Grundfragen der territorialen Verfassungsgeschichte Österreichs im Mittelalter*, 6th edition (Darmstadt 1970).

2 *Von Deutscher Baukunst*, originally an anonymous essay from Goethe's Sturm and Drang period published in "Von Deutscher Art und Kunst" (Hamburg 1773) newly edited in *Schriften zur Kunst, Schriften zur Literatur, Maximen und Reflektionen*, commentary Herbert von Einem, 9th edition (Munich 1981) *Goethes Werke*, vol. 12 (Hamburger Ausgabe).

3 Reiner Dieckhoff, "Vom Geist geistloser Zustände. Aspekte eines deutschen Jahrhunderts," *KDV*, 63–105, here 78.

4 *Supiz Boisserée*, M. Boisserée ed. (Stuttgart 1862, reprint Göttingen 1970, 2 vols.) vol. 1, 117 and 165ff. Also Joseph Görres, "Der Dom in Köln," *Rheinischer Merkur*, No. 151, 20 November 1814.

5 Heinrich Heine, "Über Polen," essay 1823, quoted by Jochen Stremmel in "Der deutsche Dom und die deutschen Dichter," *KDV*, 169–89, here 178.

6 Georg Germann, "Der Kölner Dom als National-denkmal," *KDV*, 162, 166.

7 In the Rheinisches Landesmuseum in Bonn, oil on canvas, 115 × 84cm. The first version of the painting is in the Niedersächsische Landesgalerie in Hanover, dated 1834.

8 The effect of Edmund Burke's treatise *A Philosophical Enquiry into the Origin of our Ideas of the Sublime and the Beautiful* (1757) was especially interesting.

9 See also Jan Pieper, "Steinerne Baüme und künstliches Astwerk; Die gotischen Theorien des James Hall (1761–1832)," *Bauwelt* 10, 1982: 328–32.

10 Quoted by Frankl 1960, 461–2 from Friedrich Schlegel's "Grundzüge der gothischen Baukunst, auf einer Reise durch die Niederlande, Rheingegenden, die Schweiz und einen Theil von Frankreich. In dem Jahre 1804, bis 1805," *Friedrich Schlegel Sämmtliche Werke*, vol. 6: Ansichten und Ideen von der christlichen Kunst, (Vienna 1823) 269–70.

11 Quoted from Frankl 1960, 272–3. According to Möbius 1974, 242, the memorandum was addressed to Pope Leo X (1513–21). Compare also Julius Schlosser, *Die Kunstliteratur. Ein Handbuch zur Quellenkunde der neueren Kunstgeschichte* (Vienna 1924) 175, 177.

12 Hermann Hipp, *Studien zur Nachgotik des 16. und 17. Jahrhunderts in Deutschland, Böhmen, Österreich und der Schweiz*, Diss., Tübingen 1974 (Tübingen 1979) 931f with references.

13 Karl Bötticher, *Die Tektonik der Hellenen*, 1843, vol. I: Exkurs p.16. Georg Ungewitter, *Lehrbuch der gotischen Konstruktionen*, (Leipzig 1854). Eugène-Emmanuel Viollet-le-Duc, *Dictionaire raisonnée de L'Architecture française du XI. au XVI. siècle*, 10 vols. (Paris 1858–68) especially vol. 4, chapter "Construction," 1–279.

14 Ernst Gall, *Studien über das Verhältnis der niederrheinischen und französischen Architektur in der ersten Hälfte des 13. Jahrhunderts T.1. Die niederrheinischen Apsidengliederungen nach normännischem Vorbilde*, Diss., Berlin (Halle/Saale 1915). And Gall 1955.

15 Simson 1968. The main theses are summarized in Simson 1953.

16 "German special Gothic" is from Gerstenberg 1913.

17 August Schmarsow, "Reformvorschläge zur Geschichte der deutschen Renaissance," *Berichte der Philologisch-historischen Classe der Königlichen Sächsischen Gesellschaft der Wissenschaften zu Leipzig 1899*: 41–76. Erich Haenel, *Spätgotik und Renaissance*, (Stuttgart 1899). Wilhelm Niemeyer, *Der Formwandel der Spätgotik als das Werden der Renaissance*, Diss., Leipzig (Leipzig 1904).

18 Friedrich Overbeck, *Italia und Germania* (1818/28) in the Bayerische Staatsgemälde-sammlungen Munich.

19 Georg Dehio, "Über die Grenzen der Renaissance gegen die Gotik," *KC, NF.* 11, 1900: columns 273–7 and 305–10.

20 Karl-Heinz Clasen, *Die gotische Baukunst*, in the series *Handbuch der Kunstwissenschaft* (Wildpark-Potsdam 1930). Wolfgang Schenkluhn, *Kritische Berichte* 10, 1982: 61–6 strongly disagrees with Clasen about teleology and the nature-metaphor. Schenkluhn is of the opinion that these peculiarities of Clasen's theory, and his notion of the evolution of Gothic style, reflect the social situation in Germany at the end of the Weimar Republic, and the general desire of the times for deliverance from political chaos. The sociological parameters are perhaps less important than to remember that the theory – that the Gothic style is emmanant in the natural world – is a plainly archaic approach used by cultural historians. Compare Mircea Eliade, *Kosmos und Geschichte. Der Mythos der ewigen Wiederkehr* (Hamburg 1966).

21 J.A. Schmoll gen. Eisenwerth, "Stilpluralismus statt Einheitszwang – Zur Kritik der Stilphasen-Kunstgeschichte," *Argo. Festschrift für Kurt Badt zu seinem 80. Geburtstag*, Martin Gosebruch and L. Dittmann eds. (Cologne 1970), 77–95. Jean Bony, "The Genesis of Gothic: Accident or Necessity," *Australian Journal of Art* 2, 1980, 17–31, here 17 and 20. For a view contrary to Schmoll's see Martin Gosebruch, "Epochenstile – historische Tatsächlichkeit und Wandel des wissenschaftlichen Begriffs," *ZKG* 44, 1981, 9–14.

22 Representative of this approach is Friedhelm Wilhelm Fischer, "Gedanken zur Theoriebildung über Stil und Stilpluralismus," *Beiträge zum Problem des Stilpluralismus*, Werner Hager and Norbert Knopp eds. (Munich 1977) 33–48, in the series *Studien zur Kunst des 19. Jahrhunderts*, vol. 38.

23 Barbara Tuchman, *A Distant Mirror: The Calamitous 14th-Century* (New York 1978).

24 Werner Gross, *Die abendländische Architecktur um 1300*. Stuttgart, n.d. (1948), 50ff.

25 Arnold Hauser, *Soziologie der Kunst und Literatur* (Munich 1975) 127 and 201. Reaching a similar conclusion using the sociological approach is Peter Cornelius Claussen, "Früher Künstlerstolz. Mittelalterliche Signaturen als Quelle der Kunstsoziologie," *Bauwerk und Bildwerk im Hochmittelalter. Anschauliche Beiträge zur Kultur- und Sozialgeschichte*, Karl Clausberg, Dieter Kimpel, Hans Joachim Kunst and Robert Suckale eds., in the series *Kulturwissenschaftliche Untersuchungen des Ulmer Vereins, Verband für Kunst- und Kulturwissenschaft*, vol. 11 (Giessen 1981) 87–102. For historical researchers who have attempted to find modern forms of government and social institutions in the Middle Ages see Joseph R. Strayer, *Die mittelalterlichen Grundlagen des modernen Staates* (Cologne-Vienna 1975) which includes Hanna Vollrath's survey of research being done on the subject.

26 Fernand Braudel, *Die Geschichte der Zivilisation* (Munich 1971) 557.

27 H. Ammann, "Klöster in der städtischen Wirtschaft des ausgehenden Mittelalters," *Festgabe für Otto Mittler*, G. Boner and H. Meng eds., in the series *Argovia*, vol. 72 (Aarau 1960) 102–33.

28 Warnke 1976, 26ff. discusses the development of financing construction projects and patronage.

29 Dehio-Bezold 1901, 257ff.

30 Ibid., 251. Also Gross 1972, 175.

31 Relying on Dehio are, for example, Werner Gross, "Die Hochgotik im deutschen Kirchenbau. Der Stilwandel um das Jahr 1250." *MJK* 7, 1933, 297, and Manfred Fath, "Die Baukunst der frühen Gotik im Mittelrheingebiet," *Mainzer Zeitschift* 63/64, 1968–9, 1–38, here 2.

32 Georg Dehio, *Geschichte der deutschen Kunst*, vol. 1 (Berlin-Leipzig 1919) 218ff.

33 Dehio-Bezold 1901, 251.

34 The mutation theory especially stressed by Simson 1953, 159, and Bony (note 21) 20.

35 This concept was inaugurated by Henry Focillon in reference to that of "premier art roman." Compare to Focillon 1963, 3–32.

36 Compare this to Franz H. Gerhard, *Spätromanik und Frühgotik*, in the series *Kunst der Welt* (Baden-Baden 1969) 231ff. In the same vein is Hans-Erich Kubach, "Die Kirchenbaukunst der Stauferzeit in Deutschland," *Die Zeit der Staufer. Geschichte-Kunst-Kultur*, exhibition catalogue (Stuttgart 1977) vol. 3: 184. Kubach writes "In the royal possessions of France around 1140, various tendencies had been moving towards a standardization of church building techniques, and a stronger and more complete structuring of its visible framework. However, until just prior to 1200 these tendencies remained so intimately bound up with their Romanesque origins that they can be understood as having been Romanesque. It was not

until the 'classic Gothic' of the 1190s that a revolution occurred in the way architectural principles were conceived."

37 The first to speak of a European center of Romanesque architecture that included the areas of the Ile-de-France, Champagne, Picardy, the Rhineland and Franken was Johny Roosval, *Romansk Konst*, in the series *Bonniers Allmänna Konsthistoria* (Stockholm 1930).

38 Hans-Erich Kubach and Peter Bloch, *Früh- und Hochromantik*, in the series *Kunst der Welt* (Baden-Baden 1964) 7, 35f. Compare to a review by Reiner Hausherr, "Überlegungen zum Stand der Kunstgeographie," *Rheinische Vierteljahresblätter* 30, 1965, 351–72. Hans-Erich Kubach and Albert Verbeek, *Romanische Kirchen an Rhein und Maas*, 2nd ed. (Neuss 1972) 11. Compare also Kubach's "Architektur der Romanik," *Weltgeschichte der Architektur* (Stuttgart 1974) 245ff.

39 Hans-Erich Kubach, "Das Triforium. Ein Beitrag zur kunstgeschichtlichen Raumkunde Europas im Mittlealter," *ZKG* 5, 1936, 275–88.

40 The case for the influence of Normandy was made early by Gall (see note 14).

41 Werner Meyer-Barkhusen, *Das große Jahrhundert kölnischer Kirchenbaukunst* (Cologne 1952) 11.

42 For a good survey on this subject see Edith Ennen, *Die europäische Stadt des Mittelalters* (Göttingen 1972) 166ff.

43 Paul Frankl, "Der Beginn der Gotik und das allgemeine Problem des Stilbeginns," *Festschrift Heinrich Wölfflin* (Munich 1924) 107–25, especially 110.

44 Meyer-Barkhausen (note 41) 59ff. observed that the Rhenish Romanesque's "encircling" passageway level should be compared to this standardizing principle with caution. For though occasionally the lateral elevations of the nave resemble those of the choir, their short series of bays hardly forms a balance to the complicated and ornate eastern sections, and the boundaries between the individual spaces remain what they are – major breaks.

45 Compare Dieter Kimpel, "Ökonomie, Technik und Form in der hochgotischen Architektur," *Bauwerk und Bildwerk im Hochmittelalter* (note 25) 103–25. Kimpel, "Die Entfaltung der gotischen Baubetriebe. Ihre sozio-ökonomischen Grundlagen und ihre ästhetisch-künstlerischen Auswirkungen," *Architektur des Mittelalters: Funktion und Gestalt*, Friedrich Möbius and Ernst Schubert eds. (Weimar 1983) 246–72.

46 Differences in the height of the joints of respond elements and wall are visible at Soissons Cathedral (transept begun around 1180, choir 1200–12). Here is the earliest indication we have of the technique of building the piers, then putting up the wall between them. The lodges at the cathedrals of Chartres and Reims appear to have refined the process, but they did not reach the point where they could acceptably apply the technique. It was not until the building of Amiens Cathedral choir (around 1235) that the height of pre-fabricated ashlar blocks was standardized to such a degree that the masons could avoid re-cutting the block to an exact fit just prior to placement in the wall. This avoided the necessity of repairing the seams between the pier elements and the wall that such cuttings would subsequently require. There were other possible solutions to this problem. About the same time as Amiens, the abbey church of St-Denis employed joints that ran vertically between pier element and wall, creating a complete separation of the Gothic framework from the surfaces between it. (Compare also the royal palace chapel at St-Germain-en-Laye, begun around 1238). Kimpel 1983 (see note 45: 252ff.).

47 Frey's thesis deserves mention here regarding this notion – that the Gothic spatial continuum is comprehended in his words "successively-genetically", whereas the spaces of Renaissance buildings are comprehended simultaneously. Dagobert Frey, *Gotik und Renaissance als Grundlagen der modernen Weltanschauung* (Augsburg 1929) 74.

48 For more about the influence of England see Jean Bony, "Tewkesbury et Pershore. Deux Élévations à quatre Étages à la Fin du XIe Siècle" *Bulletin monumental* 96, 1937: 281–90 and 503–4.

49 Compare Gall (note 14) 21ff and Bony (note 21) 24ff.

50 The English cathedrals of the eleventh century are Winchester (1079) Ely (1081) and St. Paul's (1087).

51 The oldest examples of vaults with cross ribs are Durham's choir's side aisles (1101/03), Winchester's transept (after 1107) and Jumièges, Notre-Dame's Chapter Hall (1109). Compare Frankl 1962, 15ff. For a dating of the vaults at Durham see John James, "The Rib Vaults of Durham Cathedral," *Gesta* 22, 1983, 135–45.

52 For more about the reconstruction of the old buttress system at Paris see William Clark and Robert Mark, "The First Flying Buttress: A New Reconstruction of the Nave of Notre Dame de Paris," *Art Bulletin* 66, 1984, 47–65.

53 For more about the causes of, and technical cohesion between, four-part vaulting and the break-up of the clerestory into large window surfaces, see William Taylor and Robert Mark, "The Technology of Transition: Sexpartite to Quadripartite Vaulting in High Gothic Architecture," *Art Bulletin* 64, 1982, 579–87. The authors' main focus is to prove that, as the clerestory's lower section was opened up, it was forced for static reasons to take on the form of a short travée. The primary aim was to heighten the upper nave wall.

54 Bruno Klein, *Saint-Yved in Braine und die Anfänge der hochgotischen Architektur in Frankreich*, in the series *Veröffentlichungen der Abteilung Architektur des Kunsthistorischen Instituts der Universität zu Köln*, vol. 28, (Cologne 1984) 15. Klein assumes the cornerstone was laid before 1188. This assumption is based on a sixteenth century manuscript by Mathieu Herbelin called "Les anciennes et modernes épitaphes. . ." Paris, Library Sainte Génenieve, Ms 855, along with four others containing almost exactly the same information – namely that Robert Count of Dreux before setting out on the Crusade of 1190 bequeathed to his wife Agnes goods and money "pour faire et parfair icelle eglise de l'abbaye de nre dame de Brayne…" (3). Robert must have left no later than 1188, since he died in the Dauphiné that same year. Klein took the expression "faire et parfair" to be unequivocal proof that construction at Braine was already underway. Madeline H. Caviness, "St-Yved of Braine: the Primary Sources for Dating the Gothic Church," *Speculum* 59, 1984, 524–48, dates the begin of construction to 1176, the year that the canons of St-Yved and the construction site are first named. She believes a donation of altar lamp-oil made in April 1208 indicates the church was already completed by that time. This question is not unimportant since Klein – because of his early dating of the start of building at Braine – assumes St-Yved influenced the great churches of Chartres and Soissons (see section beginning 201ff.), whereas the relationship between these churches is usually seen the other way around. The question is also treated by R. Pestell, "The Design Sources of the Cathedrals of Chartres and Soissons," *Art History* 4, 1981, 1–13, note 29. Pestell sees Chartres as the logical continuation of St-Yved, Braine. Regardless of the problems in dating the church, it should be remembered that the differences between Braine and Chartres are greater than Klein describes them to be.

55 Bony traces this type of wall organization from the south of France, through Burgundy into Switzerland and the area of the Rhône River. And in the west through the areas around Paris and all the way to Normandy. Jean Bony, "The Resistance to Chartres in Early Thirteenth-Century Architecture," *Journal of the British Archaeological Association* 3, 1957/8, 20–1, 35–52, here 40f.

56 Pierre Héliot, "L'abbatiale de Saint-Michel-en-Thiérache, modèle de St-Yved de Braine, et l'archi-

ture gothique des 12e et 13e siècles," *Bulletin de la commission royale des Monuments et des Sites* 2, 1972, 13–43, here 28. The chapel at the end of the south aisle of St-Vincent, Laon (destroyed) can be seen as being similar. Klein (note 54) 116f.

57 A survey is made by Klein (note 54) 211ff. Direct descendants of Braine are St-Michel-en-Tiérache, Mons-en-Laonnais, the Ste-Chapelle in Dijon and two churches in Flanders, St-Martin, Ypres and Lisseweghe. Ferrières-en-Brie, Villeneuve-le-Comte, and St-Maximin in southern Provence simplified the plan, as did St-Gengoult in Toul where only one pair of chapels fills the angle between choir and transept. In the Cistercian church at Vaucelles and in St-Niçaise, Reims, diagonal chapels form a transition between transept and choir ambulatory.

58 Bony (note 55) 36ff. provides a map showing the dispersion of the type and its variations.

59 For more on German structures see Götz 1968, 70ff., and Klein (note 54) 211ff.

60 Still one of the best architectural histories of Laon is Hanna Adenauer, "Die Kathedrale von Laon," Diss. Cologne 1932 (Düsseldorf 1934).

61 Robert Branner, "Die Architektur der Kathedrale von Reims im 13. Jahrhundert," *Architectura* 1, 1971, 15–37, here 26.

62 For more on the Gothic of Burgundy see Hans Jantzen, *Burgundische Gotik*, in the series *Sitzungsberichte der Bayerischen Akademie der Wissenschaften, phil.-hist. Klasse 1948*, vol. 5 (Munich 1949). Robert Branner, *Burgundian Architecture, Studies in Architecture*, vol. 3 (London 1960). The difficulties in defining a specific Burgundian Early Gothic, both stylistically and geographically, is dealt with by Bernd Nicolai, "Libido Aedificandi: Walkenried und die monumentalen Kirchenbaukunst der Zisterzienser um 1200." (Diss. Berlin 1986) 411ff. It contains the new notion of a Gothic "de l'Est" which the author claims included large sections of northern Champagne, southern Champagne and that part of Burgundy which belonged to the German Empire at the time.

63 The close resemblance between the structures in these areas is not only because of the passageway motif. Grandjean gives examples of similarities between the cathedrals at Lausanne, Canterbury, Sens, Laon and Soissons. M. Grandjean, "La cathédrale actuelle, sa construction, ses architectes, son architecture," *La cathédrale de Lausanne*, Bibl. de la Société d'Histoire de l'Art en Suisse, vol. 3. (Bern 1975) 45–174, here 159.

64 This geographical dispersion is from Bony (note 55) 42ff.

65 Gall (note 14) 77ff., translates the French stylistic development onto that of the Rhenish Romanesque, and therefore believes St. Aposteln to have been built earlier than St. Martin.

66 The best survey on this subject is Meyer-Barkhausen (note 41).

67 Worth mentioning are the pointed-arch shape of the high vault and the triforium, transverse ribs molded to resemble diagonal ribbing, corbelled-back compound responds in the clerestory which are part of the system of alternating piers, and the crocketed capitals of the small triforium columns and vault responds.

68 Gross 1972, 181.

69 The juxtaposition of Gothic and Romanesque elements in a single structure remained characteristic until long into the second half of the thirteenth century, as was the case with the abbey church at Essen-Werden (consecration in 1275).

70 Panofsky is the preeminent critic of the "mixed style" thesis. In 1963 at the 20th International Congress of the History of Art at Princeton, he breathed new life into the question by proposing that, instead of a transition, perhaps it was a compromise made up of two heterogeneous stylistic attitudes. Jean Bony, "Transition from Romanesque to Gothic, Introduction," *Studies in Western Art: Acts of the*

Twentieth International Congress of the History of Art, vol. I (Princeton 1963) 81–4.

71 Interestingly enough, a similar attitude towards the Gothic form can be seen in the oldest examples of Burgundian Gothic. The wall sections between the chapel windows in the choir ambulatory of the abbey church at Vézelay, for instance, possess a profusion of small columns that have no function other than to create a wall relief, and for a three-dimensional enlivenment of empty zones. Compare to Jantzen (note 62) 9. Smaller structures in the Gothic heartland also seemed to have looked upon Gothic "line tectonics" with indifference at first. The surviving polychromy of the choir walls at St-Quiriace, Provins, Seine-et-Marne (around 1200) articulates the wall elements as a colorful network of responds, small columns and string coursing in a non-systematic exchange, rather than using color to emphasize their structural relationship. Michler 1977: 30ff.

72 Branner (note 61) 27. Pierre Héliot, "Coursières et passages mauraux dans les églises romanes et gothiques de l'Allemagne du Nord," *Festschrift Wolfgang Krönig*, vol. 41 of *Aachener Kunstblätter* (Düsseldorf 1971) 211–23, here 216f.

73 Like the pier buttresses of Notre-Dame-en-Vaux in Châlons-sur-Marne (renovated 1185–1210) and those of the choir at Soissons Cathedral (completed 1212). For more on the development of the Gothic buttress system see Karl-Adolf Knappe, "Die Fiale. Zur Entstehung eines gotischen Architekturgliedes," *Festschrift Wilhelm Messerer* (Cologne 1980) 137–55.

74 Roll-and-fillet was a new kind of molding at the time in France. One of the first structures to employ it was Amiens Cathedral (begun 1220) in the ribs of the nave travées.

75 Dispersion of stepped passageway arcading in the Rhine basin, around the river Maas in Holland and Belgium, and in Normandy and Burgundy, has been examined by Günter Bandmann, "Das Langhaus des Bonner Münsters und seine künstlerische Stellung," *Bonn und sein Münster. Eine Festschrift*, vol. 3 of *Bonner Geschichtsblätter* (Bonn 1947) 109–31. Many parallels are drawn here between the style of Bonn and Roermond.

76 Peter Kurmann, "L'église Saint-Jacques de Reims," *Congrès archéologique de France* 135, 1977: 134–61, here 143ff. However, Kurmann correctly points out that Laon was not the only prototype for Limburg.

77 In 1193 the convent was moved from Mount Petersberg into a valley nearby (today Heisterbach). For more about the excavated ruins of a monastery church on Mount Petersberg see Hans-Eckard Joachim, "Eine Kirchenanlage des 12. Jahrhunderts auf dem Petersberg bei Königswinter," *Zisterzienser und Heisterbach. Spuren und Erinnerungen*, exhibition catalogue Königswinter 1980/81, in the series *Schriften des Rheinischen Museumsamtes*, vol. 15 (Bonn 1980) 45–7. For a history of the monastery see Robert Flink, "Anmerkungen zu einer Geschichte des Kosters Heisterbach," ibid., 17–25.

78 Further examples of Rhenish Romanesque triradial vaulting can be found in Sinzig's nave gallery, and in the surviving bays of St. Kunibert's cloister in Cologne. The triple windows of Heisterbach's west front are similar to those of Great St. Martin in Cologne. For a short stylistic survey, and a selection of the great body of literature on the subject, see Albert Verbeek, "Die Zisterzienser-Abtei Heisterbach," *Zisterzienser und Heisterbach* (note 77) 37–44. For a complete set of drawings of Heisterbach see Supiz Boisserée, "Denkmale der Baukunst vom siebten bis zum dreizehnten Jahrhundert am Niederrhein" (Munich 1833).

79 Simson 1968, *passim*.

80 The early date used here follows that of Matthias Untermann, "Kirchenbauten der Prämonstratenser. Untersuchungen zum Problem einer Ordensbaukunst im 12. Jahrhundert," in the series *Veröffentlichungen*

der Abteilung Architektur des Kunsthistorischen Instituts der Universität zu Köln vol. 26, (Diss. Cologne 1984) 353, note 2044.

81 Structures built in the twelfth century according to the Clairvaux type were Fontenay in 1139, Himmerod in 1138, Eberbach 1140/50, Tre Fontane 1140/50, Fountains I 1135, Kirkstall around 1152?, Withland 1150/60, Clermont 1160/70, Fossanova 1187–1208, Bebenhausen 1190/1200, Boyle end of twelfth century, and Inch around 1190. For more about the development of Cistercian choir forms see Wolfgang Krönig, *Altenberg und die Baukunst der Zisterzienser* (Bergisch Gladbach 1973).

82 According to Guy de Charlieu, Bernhard suggested that he, Charlieu, publish "Regulae de arte musica."

83 St. Augustine, *De trinitate*, 4,2,4. For more concerning the importance of Augustine's Harmonics in St. Bernhard's thought compare Simson 1968, 61ff. and 74ff. Some of this discussion, however, is conducted at a level of interpretation that is not supported by the rather sparse list of primary sources.

84 Hans R. Hahnloser, *Villard de Honnecourt. Kritische Gesamtausgabe des Bauhüttenbuches, ms.fr. 19093 der Pariser Nationalbibliothek*, 2nd ed. (Graz 1972) 65ff., and 355ff., table 28.

85 Compare this to, for instance, the thick arcade profiles of Limburg's choir ambulatory.

86 Chapels reduced to niches by a flat outer wall, as well as twin piers in the inner choir arcading, can be found in a very similar form in the Artois area of France, specifically in the ruins of Thérouanne Cathedral (1133?) and at the Premonstratensian church at Dommartin (1153–63). Whether these were prototypes for Heisterbach or merely similar types of choirs has yet to be established. Eydoux 1952, 80 with bibliography.

87 Walter Hotz, *Der Dom zu Worms* (Darmstadt 1981) 86–100.

88 The polygonal choir termination does not, in and of itself, prove a Gothic influence. The way to Worms Cathedral's polygon was probably prepared by the Romanesque choir polygons in the Lorraine area of France: the Cathedrals at Verdun, at Neuf-Château and Mont-devant-Sassey. See Reiner Slotta, "Romanische Architektur im lothringischen Département Meurthe-et-Moselle" (Bonn 1976).

89 Very similar is the slightly older rose of the southern transept at Braine. For an update, see Klein (note 54).

90 Similar to Ebrach are the choirs at Riddagshausen in Lower Saxony and Schönau in Baden, the last of which represents a noteworthy variation of the Burgundian choir type. Like Heisterbach, its chapels were designed as rounded niches.

91 For more about the history of the building of Ebrach see Wolfgang Wiemer, "Baugeschichte und Bauhütte der Ebracher Klosterkirche 1200–1285," *Jahrbuch für fränkische Landesforschung* 17, 1957, 1–85. The nave was built in the 1250s under a new lodge master, who inaugurated a strict travée system. Dating the nave to the second quarter of the thirteenth century would seem to be too early. See Ilse Bickel, "Die Bedeutung der süddeutschen Zisterzienserbauten für den Stilwandel im 12. Jahrhundert von der Spätromanik zur Gotik" (Munich 1956) 91. A computer-assisted study by Wiemer concerning the proportions of Ebrach concludes that its floor plan is based on a "canon of various forms that can be combined according to certain rules." Whether or not a "canon" of such complexity was actually employed, or whether this conclusion is a construct garnered from a computer program based on probability calculus, is a question that will be answered after measurements of other Cistercian churches have been done. See Wolfgang Wiemer, "Die Geometrie des Ebracher Kirchenplans – Ergebnisse einer Computeranalyse," *Kunstchronik* 35, 1982, 422–43.

92 For more on the history and function of St.

Michael's see Wilhelm Schlink, "Zur liturgischen Bestimmung der Michaelskapelle im Kloster Ebrach," *Architectura* 1, 1971, 116–22. Also Wolfgang Wiemer, "Die Michaelskapelle und ihre mittelalterliche Wandmalerei," *Festschrift 700 Jahre Abteikirche Ebrach 1285–1985*, Wolfgang Wiemer and Gerd Zimmerman eds. (Ebrach 1985) 11–58. The prototype was apparently the Chapelle de Comtes de Flandre in Clarivaux. Nicolai (note 62) 307f. interprets this date as the consecration date of the choir. Based on an analysis of style, he argues for a dating of Ebrach's wall articulation and nave vaulting in the second decade of the thirteenth century.

93 Nicolai (note 62) 415f. believes a relationship between St. Michael's and Laon, which is fifty years older, to be unlikely, preferring instead the choir of the abbey church at Montier-en-Der (Haute-Marne). Nicolai's early dating (construction beginning around 1200) is controversial.

94 For more about Maulbronn see Paul Anstett, "Die Baugeschichte des Klosters," *Kloster Maulbronn 1178–1978* (Maulbronn 1978) 69–76. The stylistic relationship between Ebrach and Maulbronn is handled by Martin Gosebruch, "Vom Bamberger Dom und seiner geschichtlichen Herkunft," *Münchner Jahrbuch der bildenden Kunst*, 3rd ed. 28, 1977, 28–58. Also Dethhard von Winterfeld, *Der Dom in Bamberg*, vol. 1, *Die Baugeschichte bis zur Vollendung im 13. Jahrhundert* (Berlin 1979) 143ff. There is no surviving data concerning the early years of construction on Maulbronn's monastic buildings. The latest attempt at a relative chronology of the individual sections of the monastic buildings was made by Nicolai (note 62) 253–96. It is very revealing that in the Paradise, which was built by the same lodge as the south wing of the cloister, the height of the imposts of the vault supports are varied according to the span of the arches they carry. Evidently, in order to keep the crown of the vault from being too high, the capitals of those ribs crossing the vault at the greatest radius were lowered in relation to those capitals of the shorter transverse and wall arches, resulting in a "springing" impost line – not a homogeneous row of vertical elements, but a system of arches of varying heights that are interlocked like hinges. Irmgard Dörrenberg, *Das Zisterzienserkloster Maulbronn* (Würzburg 1937) 47ff., sees this as completely original to Maulbronn. However, this motif was already in use by the early twelfth century in the bays of the towers at Durham Cathedral. In the architecture of Normandy it is repeated at St-Paul in Rouen. This type of vaulting was repeated later in the Early Gothic western section at St-Denis. It was a motif conspicuously common to Burgundian Gothic: at Auxerre Cathedral (south aisle, and piers between choir ambulatory and apex chapel of choir), at Notre-Dame Dijon (porch) and at St-Pierre in Saint-Julien-du-Sault (side aisles). The Maulbronn Paradise is without doubt the earliest German example. Clearly influenced by Maulbronn's ribbed vaulting was the so-called Bishop's Aisle, part of the choir of Magdeburg Cathedral (after 1225). Even the arched bays of the south choir of Regensburg Cathedral (consecrated 1290) contain springing arch supports.

95 Compare Adalbert Erler, "Das Straßburger Münster im Rechtsleben des Mittelalters" (Frankfurt am Main 1954) 43, and Markus Rafael Ackermann, "Mittelalterliche Kirchen als Gerichtsorte," *Zeitschrift der Savigny-Stiftung für Rechtsgeschichte* 110, 1993, 530–45, here 536.

96 See Ackermann (note 95) 540–1.

97 The originals can be found today in Strasbourg's Frauenhausmuseum. Stylistically similar are the Virgin tympana of the portals, especially the middle figures depicting the Coronation of the Virgin. Willibald Sauerländer, *Von Sens bis Straßburg* (Berlin 1966) 140ff.

98 See Gosebruch (note 94) 43ff. It is doubtful whether this is enough to support the notion that a group of wandering German artisans travelled from Reims via Strasbourg to Bamberg.

99 This observation was made by Winterfeld (note

94) 124 and 128. The dating of the Prince's Portal and the west choir can be found there as well.

100 The connection to Lausanne is made by Urs Boeck. See Wilhelm Boeck, *Der Bamberger Meister, mit Beiträgen von Urs Boeck* (Tübingen 1960) 177 and note 271. Heinrich Mayer's reference to the façade of Mantes seems less impressive. Heinrich Mayer, *Bamberg als Kunststadt* (Bamberg 1955) 56. Furthermore, von Winterfeld (note 94) 156f. proposes the idea that the towers of St-Nicaise in Reims influenced Bamberg's tower design via the tower design of Reims Cathedral, sketches of which may have reached Bamberg.

101 For more on the dispersion of the Cologne passageway in Westphalia and northern Germany see Héliot (note 72) 117ff.

102 The west bays in the south aisle have vaults made of tufa from the Rhine valley. The structure's ornamentation seems to be derived from St. Gereon or St. Aposteln in Cologne. The gallery clerestory and six-part vaulting might have come from the lower Rhine via Westphalia. Rudolf Stein, *Romanische, gotische und Renaissance-Baukunst in Bremen*, in the series *Forschung zur Geschichte der Bau- und Kunstdenkmäler in Bremen*, vol. 2 (Bremen 1962) 38–44.

103 Götz 1968, 88ff., with bibliography.

104 P. Klein, *St. Peter in Sinzig* (Bonn 1932) 30ff. Also belonging to the Sinzig group are Münstermaifeld, Boppard, Wetzlar, Heimersheim and the abbey church at Essen-Werden. Manfred Fath, "Die Baukunst der frühen Gotik im Mittelrheingebiet," *Mainzer Zeitschrift* 65, 1970, 43–92, here 50ff., emphasizes the diagonal placement of bases and capitals, and the interior's blind arcading, as being French. Upon closer inspection, however, we find analogies in western-German architecture as well. An inscription "1232" could at one time be seen bedded into a pier buttress of the choir, and is the only indication of a date for the eastern section. For Gelnhausen see Eduard Schubotz, "Die Marienkirche in Gelnhausen," *Große Baudenkmäler* (Munich-Berlin 1961) 168.

105 This is why all monasteries in greater Poland were occupied by German monks until the fifteenth and sixteenth centuries. Helen Chlopocka and Winfried Stich, Die Ausbreitung des Zisterzienserordens östlich von Elbe und Saale, *Die Zisterzienser* 1980, 93–104, here 101.

106 For the affiliated choirs of Cîteaux and Morimond see Bernd Nicolai, "Lilienfeld und Walkenreid. Zur Genese und Bedeutung eines zisterziensischen Bautyps," *Wiener Jahrbuch für Kunstgeschichte* 41, 1988, 23–39.

107 Wagner-Rieger 1967, 333. She supports this theory once again in Wagner-Rieger, "Die Habsburger und die Zisterzienserarchitektur," in *Die Zisterzienser* 1982, 195–211. For more on the appraisal of Lilienfeld as an early Hall church see Buchowiecki 1952, 413f., with bibliography.

108 That is not to say that Leopold did not make a considerable effort to generously support the construction of his tomb. His intrusion into the management of construction, clues which Nicolai searches for in the change of design in the choir – from the original flat termination, to a polygon – seems to me to be as yet undocumented. See Nicolai (note 62) 161.

109 The large monasteries built prior to the middle of the thirteenth century in the Kingdom of Bohemia bear witness to an architecture bearing a Gothic stamp. The chapter hall of the Cistercian monastery at Osek (around 1240) possesses squat piers on Gothic plate bases, almond-shaped rib molding in the vaults and concave molding of the transverse arches. At the Benedictine monastery church in Trebitsch (1250) the choir apse, both sanctuary bays and the bay between the west towers are covered by eight-part, domed, ribbed vaulting, which allows space for auxiliary ribs in the angles of the bays. The transition from the square bay design to the octagonal did not occur, as it did in the Romanesque, via squinches and pendentives, but via small spandrel-vault cells cut in half by cross ribs.

Crossley sees this domical vault form, which he also reconstructs in the choir vaulting of the destroyed Bohemian Cistercian church in Zbraslav (begun 1297), as being dependent from angevin structures. The same goes for the spandrel-vault cell, which is similar to those of the crossing at Soubise and Charente and the tower at Clussais. Paul Crossley, *Gothic Architecture in the Reign of Kasimir the Great: Church Architecture in Lesser Poland, 1320–1380*, in the series *Panstwowe Zbiory Sztuki na Wawelu, Biblioteka Wawelska*, vol. 7 (Kraków 1985) 68. Similar, but without ribs, were the early thirteenth century spandrel vault cells of the treasury at St. Pantaleon in Cologne.

110 Basel Cathedral bears less of a resemblance to Magdeburg. Both cathedrals probably hail back to the "conch family" of churches at Noyon, Soissons, Cambrai and Valenciennes. Robert Branner, "The transept of the Cambrai Cathedral," *Gedenkschrift Ernst Gall*, Margarete Kühn and Louis Grodecki eds. (Munich 1965) 69–86, here 77ff., sees striking parallels between Cambrai and Magdeburg Cathedral in the termination of the sanctuary and in the alternating sizes of the ambulatory bays.

111 In Tournai the towers originally stood, as at Laon Cathedral, over the bays of the side aisles. Before 1200, however, three of these tower bays were separated by a series of walls and formed into chapel-like spaces.

112 Ernst Schubert, *Der Magdeburger Dom* (Vienna-Cologne 1975) 30.

113 For more information see Wolfgang Götz, "Der Magdeburger Domchor. Zur Bedeutung seiner monumentalen Ausstattung," *ZDVK* 20, 1966, 97–120.

114 The phases of the choir's construction have been systematized anew by Schubert (note 112) 16–32.

115 Except for the bay of the polygon, the north wall possessed no passageway.

116 For more on stylistic and typological groups see Renate Wagner-Rieger, "Gotische Kapellen in Niederösterreich," *Festschrift Karl Maria Swoboda* (Vienna-Wiesbaden 1959) 273–307, here 282ff. Wagner-Rieger 1967, 332 and 369. Pierre Héliot, "Coursières et passages muraux dans les églises gothiques de L'Europe centrale," *ZKG* 33, 1970, 173–210, here 176 and 181ff. Ulrich Stevens, "Burgkapellen im deutschen Sprachraum," in the series *Veröffentlichungen der Abteilung Architektur des Kusthistorischen Instituts der Universität Köln*, vol. 14, (Diss. Cologne 1978) 30f. Besides the constant emphasis put on eastern-French influence, Brucher 1990, 15–16 points out a possible typological connection to the Hall church tradition in western France. (Angers, St-Serge, Poitiers Cathedral).

117 Dating the exact beginning of construction of Our Lady in Trier is one of the most controversial of any Gothic structures in Germany. It is commonly dated between 1227 and 1242, lately after 1233 (by Borger-Keweloh). The earlier date is the most probable. In 1227 Bishop Dietrich created a foundation, supplied by money from sinecure, whose beneficiary was to be Our Lady. In doing so, four "canonici B. Mariae" were named, which indicates the money was already designated for the collegiate church. See Eltester, Görz, Beyer, *Urkundenbuch der jetzt die preußischen Regierungsbezirke Koblenz und Trier bildenden mittelrheinischen Territorien*, vol. 3, No. 315. (Koblenz 1874). The date Our Lady was completed is also unclear. Previous generations of Gothic scholars dated its completion to shortly after 1253, Borger-Keweloh between 1258 and 1283. See Nicola Borger-Keweloh, *Die Liebfrauenkirche in Trier, Studien zur Baugeschichte, Trierer Zeitschrift für Geschichte und Kunst des Trierer Landes und seiner Nachbargebiete*, suppl. 8 (Trier 1986). For a survey of research on the subject see Wolfgang Schenkluhn and Peter van Stipelen, "Architektur als Zitat. Die Trierer Liebfrauenkirche in Marburg," *Elizabethkirche* 1983, 19–53, note 24.

118 Theodor K. Kempf, "Die konstantinische Doppelkirchenanlage in Trier und ihre Baugeschichte von 326–1000," *KC* 4, 1951, 107–9. Also the chapters concerning "double-church" sites from Kempf and Heinz Cüppers, *Der Trierer Dom* in the series *Jahrbuch 1978/79 des Rheinischen Vereins für Denkmalpflege und Landschaftschutz* (Neuss 1980) 112–21.

119 The fact remains that Trier's resemblance to St-Yved, Braine, which is mentioned over and over again by scholars, is in the floor plan. But the chapel walls at Braine are rounded, at Trier polygonal. At Braine the pier buttresses between the chapels stand free of, and at Trier they are melted into, the chapel wall. Trier shares these peculiarities with Saint-Michel-en-Thiérache. See Klein (note 54) 231f.

120 First to interpret it in this way were Schenkluhn and van Stipelen (note 117) 32.

121 Also reminiscent of Reims, besides the style of Trier's foliage-work and the form of its chapel pier buttressing, is the square-cut of its window passageway through the pier buttress of the wall. Other details at Trier can been found in the single-register choir of Toul Cathedral, where forms from Reims' lodge took hold a bit earlier than they did at Trier. Our Lady shares with Toul the six-part foiling in the tracery of the windows – the so-called "standing" foil with one lobe at the bottom – thin mullion-like wall/pier responds, and the molding of the arcade arches. See Reiner Schiffler, *Die Ostteile der Kathedrale von Toul und die davon abhängigen Bauten des 13. Jahrhunderts in Lothringen*, (Diss. Mainz 1974) 120f.

122 Schenkluhn und van Stipelen (note 117) 34–8.

123 The authors of this theory, Schenkluhn and van Stipelen (note 117) 34 agree that the eastern section of Trier stems from Braine. But then, because of a compulsory typological similarity between the two churches' general structural layout, they conclude that "a reform program initiated by Trier's Archbishop was translated into architectural form." By this they mean Dietrich's support for a monastery-like community for the canons, who had only recently taken possession of the newly built monastic buildings east of the choir. The prototype for this was, in an ideological as well as architectural sense, the Premonstratensian chapter at Braine. But Xanten is the only Premonstratensian church, in the considerable list of churches to follow Braine's design, that the authors use as proof for Braine's choir being an example of reform architecture.

124 Richard Krautheimer, "Sancta Maria Rotunda," *idem, Studies in Early Christian, Medieval and Renaissance Art* (London–New York 1969) 107–14, 1st printing 1952.

125 Götz 1968, 55ff., deals extensively with this question and weighs it against other possible influences.

126 Albert Tuczek, "Das Maßwesen der Elisabethkirche in Marburg und der Elisabethkirche in Trier," *Hessisches Jahrbuch für Landesgeschichte* 21, 1971, 1–99.

127 Even the two ground-breaking monographs, both somewhat controversial in their conclusions, have been unable to free themselves completely from this "call to arms" notion. See Richard Hamann and Kurt Wilhelm-Kästner, *Die Elisabethkirche zu Marburg und ihre künstlerische Nachfolge*, 2 vols (Marburg 1924, 1929); and Werner Meyer-Barkhausen, *Die Elisabethkirche in Marburg* (Marburg 1925).

128 See Jürgen Michler, "Die Langhaushalle der Marburger Elisabethkirche," *ZKG* 32, 1969, 104–32, here 124ff.

129 A judicious account of the political situation at the time has been put together by Schenkluhn and van Stipelen (note 117) 19–21.

130 The generally accepted thesis that Marburg's conch owes the form of its three-part division – one that is both functional and symbolic and can be found in the sanctuary of the Teutonic Order, mausoleum of St. Elizabeth and tomb of the Counts of Thuringia – to a scheme that had already been stipulated during

the planning stage of the church does not hold up here. Compare Schenkluhn and van Stipelen (note 117) 21 and 24; See also Uwe Geese, "Die hl.Elisabeth im Kräftefeld zweier konkurrierender Mächte. Zur Ausstattungsphase der Elisabethkirche zwischen 1280 und 1290," *Elisabethkirche* 1983, 55–67.

131 The choirs of St-Léger in Soissons and the Cistercian church Villers-la-Ville in Brabant are similar.

132 Individual details have been identified by Wilhelm-Kästner (note 127) 7ff.

133 Wilhelm-Kästner (note 127) 37ff. and Hans Joachim Kunst, "Die Dreikonchenanlage und das Hallenlanghaus der Elisabethkirche in Marburg," *Hessisches Jahrbuch für Landesgeschichte* 18, 1968: 131–45. Both these scholars believe the northern-French conch scheme to be the prototype. Schenkluhn and van Stipelen argue rather vaguely for Trier as prototype (note 117) 38ff. While Götz 1968, 21ff. gives substantial evidence for the trichora tradition of memorial structures being the prototype, and the form of the Teutonic Order church in Tartlau.

134 Dating taken from the dendrochronological examination of the roof done by Angus Fowler and Ulrich Klein, "Der Dachstuhl der Elisabethkirche – Ergebnisse der dendrochronologischen Untersuchung," *Elisabethkirche* 1983, 163–73.

135 The rib-respond system was changed west of the crossing. Schenkluhn and van Stipelen see it as indicative of the first "Trieresque" nave design with round piers lacking respond shafts. This is, no doubt, because they see the supposed relinquishment of the Trier round pier, in favor of the Reims pier system with four responds, as reflecting the political realignment of the Counts of Thuringia after 1242 from Trier – which had been allied with the House of Hohenstaufen – to that of the anti-Hohenstaufen coalition lead by Cologne and Mainz. With this change, Count Heinrich of Thuringia became an opposing monarch. According to the authors, the choice of the Reims pier-vaulting system in the nave of St. Elizabeth was nothing short of acquiring the same "right of title" as that of the French royal cathedral. Beyond the crossing they continued to build, "with direct reference to Reims, on a monarchical church", 40. If this is true, then why a Hall church, when a basilican form was to be emulated? No contemporary could possibly have recognized Reims in Marburg's nave – especially not in the outer structure which is even more crucial when seen in terms of reflecting a particular ideology. The Hall design of the nave made for a placement of pier buttresses close to the wall. This was so unpretentious it could not have been more unlike the magnificent, open latticework scheme of buttresses and flyers of Reims Cathedral.

136 For more about the influence of the trichora system at Marburg, and its influence in Silesia, see Götz 1968, 33ff. A survey of the most important naves to emulate Marburg is in *Elisabethkirche* 1983, 177ff.

137 The best examples being at Herford's Minster (begun around 1220) and in the Hohnekirche in Soest (around 1220/30).

138 Around 1270 St. Elizabeth's was given an almost monochrome color scheme – a pink background with false joints in white – a style that reflects the French color scheme of the middle of the thirteenth century (see note 180 below).

139 The theory that the collapse of the Hohenstaufen dynasty contributed to a lack of unification in German architectural style was put forth by Werner Gross, "Die Hochgotik im deutschen Kirchenbau. Der Stilwandel um das Jahr 1250," *MJK* 7, 1933, 290–346, here 298f.

140 Quoted (partially corrected) from Heinrich Klotz, *Der Ostbau der Stiftskirche zu Wimpfen im Tal*, in the series *Kunstwissenschaftliche Studien* vol. 39 (Munich 1967) 91.

141 At this point in time the triforia of the east travée, that connects to the flanking towers of the nave, were probably already completed. Lisa

Schürenberg, *Der Dom zu Metz* (Frankfurt-am-Main 1940) 14.

142 Window mullions reaching down as far as the base of the triforium could be found at St-Remi in Reims at this time. About 1220 this motif was adapted for the choir clerestory of Reims Cathedral. Examples of glazed triforia: Beauvais 1225 and Chelles 1226.

143 At Amiens, and in the nave of St-Denis, the side elevations are divided roughly in half by the line formed by the base of the triforium. Only in the choir of St-Denis is the clerestory a little taller than the arcade arches. Just how hard the architect of St-Denis tried to squeeze as much height as possible out of window surfaces can be seen in the positioning and form of the windows of the chapel at St-Germain-en-Laye, whose construction he appears to have taken up in 1238. Here the windows bend outward from the formeret responds and end in straight lintels that are higher than the crowns of the vaults. These glazed surfaces cut in behind the transverse vault cells and hover like a thin, free-standing membrane between the pier buttresses.

144 Though without question St-Denis exercised the dominant influence on Strasbourg, Branner's remark – that Strasbourg's shaft-respond system can otherwise only be found in the Burgundian choirs of Auxerre Cathedral and Notre-Dame Dijon – deserves attention. Robert Branner, "Remarques sur la cathédral de Strasbourg," *Bulletin monumental* 122, 1964, 261–8. At this level of stylistic development, however, it should not be surprising that Strasbourg's design was inspired by diverse sources coming from various Gothic centers.

145 Whether the stylistic character of Strasbourg's pier form was taken directly from St-Denis, as Reinhardt suspects, or is a variation of Freiburg's crossing pier which is square and turned diagonally, as Kurmann thinks, is irrelevant. It is more important to point out that the dimensions of the pier responds here are perhaps a bit more refined and consistently applied than at St-Denis. Hans Reinhardt, *La cathédrale de Strasbourg*, s.l. 1972, 66–9. Peter Kurmann, "Köln und Orleans," *Kölner Domblatt* 24/25, 1979/80, 255–76 (note 7).

146 According to the writer of *Liber de intelligentiis*. Compare Wilhelm Perpeet, *Ästhetik im Mittelalter* (Freiburg-Munich 1977), 96.

147 "Pulchrum id est idem bono – sola ratione differens," Thomas Aquinas, *Summa Theol.*, I.II, qu.27, art. 1 ad 3.

148 *Summa de bono* II.3.IV: "Sicut forma est bonitas cuiuslibet rei, inquantum est perfectio desiderata a perfectibili, sic ipsa etiam est pulchritudo omnis rei inquantum per suam formalem nobilitatem ut lux splendens super formatum...." quotation from the text edition of Martin Grabmann, *Des Ulrich Engelberti von Strassburg O.Pr. (†1277) Abhandlung De pulchro. Untersuchungen und Texte*, in the series *Sitzungsberichte der Bayerischen Akademie der Wissenschaften, philosophisch-philologischen und historische Klasse 1925*, 5. Abh. (Munich 1926) 73–4. For a somewhat abbreviated translation see Perpeet (note 146) 96. For an interpretation see Josef Yoitiro Kumada, *Licht und Schönheit: Eine Interpretation des Artikels "De pulchro" aus der Summa de bono, lib.II, tract.3, cap.4 des Ulrich Engelbert von Strassburg*, (Diss. Würzburg 1966) 32–40. Also Rosario Assunto, *Die Theorie des Schönen im Mittelalter*, 2nd edition (Cologne 1982) 227. Durandus (1230–96) believed stained glass windows to be "holy writings" that kept out wind and rain, but let the light of God, the true sun, into the hearts of the faithful, (from *Rationale divinorum officiorum*, trans. by Frisch 1971, 35).

149 Quoted from Frankl 1960, 829. Also see Erwin Panofsky, "Abt Suger vom St-Denis," idem, *Sinn und Deutung in der bildenden Kunst* (Cologne 1975) 125–66, here 148. First published as *Abbot Suger on the Abbey Church of St-Denis and Its Art Treasures* (Princeton 1946) 1–37.

150 Sauerländer is vehemently against an iconographical system for Gothic architecture that includes all facets of medieval culture because it "would have as prerequisite the modern notion of a systematic, codified relationship between form-vocabulary and architectural content," what he calls a "semantic arrangement" that is not to be read in the unsystematic display of forms in medieval architecture. Willibald Sauerländer, "Abwegige Gedanken über frühgotische Architektur und 'The Renaissance of the Twelfth Century,'" *Études d'art médiéval offertes à Louis Grodecki* (Paris 1981) 167–84, here 169, 171.

151 Other examples of speculative light metaphysics can be found in literature and the pictorial arts, where precious or "illuminated" stones were understood as having allegorically symbolism. A survey can be found in U. Engelen, *Die Edelsteine in der deutschen Dichtung des 12. und 13. Jahrhunderts*, in the series *Münstersche Mittelalter-Schriften*, vol. 27 (Munich 1978) and Christel Meier, *Gemma spiritualis. Methode und Gebrauch der Edelsteinallegorese vom frühen Christentum bis ins 18.Jahrhundert. Teil I*, in the series *Münstersche Mittelalter-Schriften*, vol. 34, 1, 1977 (Diss. Munich 1977). John Gage in his paper entitled "'Lumen,' 'Alluminar,' 'Riant:' Three Central Themes in Gothic Aesthetics" outlined several interesting interpretations of the meaning of light in pictorial arts, at the 25th International Congress of the History of Art in Vienna in 1983. Among other things, he sees a connection between High Gothic sculpture's mimicking of the human face via an "illuminated" smile and the world view of light metaphysics.

152 Denoted here is the chapter entitled "Ein Jahrhundert lichtvoller Geistigkeit," in the volume "Das Hochmittelalter" in *Fischer Weltgeschichte*, vol. 11 (Frankfurt 1965) 256, in which the structuralist Jacques Le Goff summarizes the cultural achievements of the "golden age" of the Late Middle Ages, 1180 to 1270.

153 Examples of Strasbourg-like elements at Freiburg-im-Breisgau are the compound piers, though somewhat altered, the blind arcading on the side-aisle walls, the framing arches of the windows and the tops of the pier buttresses in the eastern bays.

154 Suggested by Volker Osteneck, *Die romanischen Bauteile des Freiburger Münsters und ihre stilgeschichtlichen Voraussetzungen. Studien zur spätromanischen Baukunst am Oberrhein*, Diss. Freiburg (Cologne-Bonn 1973).

155 Georg Dehio, *Handbuch der deutschen Kunstdenkmäler*, vol. 4, 2nd edition (Berlin 1926) 19, 91.

156 Arnold Wolff, *Der Kölner Dom*, 2nd edition (Stuttgart 1977).

157 For chronological comparisons of the building of Amiens and Beauvais see Franz Graf Wolff Metternich, "Zum Problem der Grundriß- und Aufrißgestaltung des Kölner Doms," *KDF*, 51–77. See also Stephen Murray, *Beauvais Cathedral: Architecture of Transcendence* (Princeton 1989) 60ff., who breaks down the earlier building campaigns of the choir of Beauvais this way: in 1225 the side-aisles of the choir and the eastern transept were begun, followed in the late 1230s by the radial chapels and the inner choir arcade up to the string coursing of the triforium, and after that in the 1250s by the choir's clerestory and vaults. Preliminary liturgical regulations for the choir were set down for Amiens Cathedral in 1233. At this time work might already have been underway on the choir.

158 The naves of Tours and Troyes Cathedrals are also five-aisled, though an influence on Cologne cannot be proven. The older pre-Romanesque Cathedral at Cologne was five-aisled, which may have lead to the decision to make the new cathedral the same.

159 For more about Ste-Chapelle, which bears a slight resemblance to the apex chapel of Amiens, see I. Hacker-Stück, "La Sainte Chapelle de Paris et les chapelles palatines du moyen-âge en France," *Cahiers archéologiques*, vol. 13, 1962, 217–57. Also Robert

Branner, *St. Louis and the Court Style* (London 1966) 55ff.

160 A precise comparison of the flying buttress systems of Beauvais, Amiens and Cologne has been done by Wolff Metternich (note 157) 51–77.

161 The unanswered question as to whether medieval architects studied detailing directly from the churches themselves or from sketch material seems especially pertinent here. Were the architects of such projects gone for long periods of time, like it has been proven they were in the fifteenth century?

162 For more on the normative character of Cologne's structural forms see Frankl 1962, 125f. Also Kurmann (note 145) 259. Werner Gross, *Die abendländische Architektur um 1300* (Stuttgart 1948) 17ff., defines Cologne Gothic as "cleansed", an ideal type garnered from the various forms of French Gothic.

163 For a presentation of the cathedral as pushing the limits of science, art and technology see Wolff (note 156) 89.

164 The duties of the so-called "cathedral factory" which administrated the funds for Strasbourg Cathedral were taken over by the town council in 1282/6 not long before the façade's cornerstone was laid. Even before this event, the citizens of Strasbourg were bearing the brunt of financing the project. This is an obvious example of how communities gradually took over the financing and organization of the largest ecclesiastical building projects of the period.

165 Johann Wolfgang Goethe, *Von deutscher Baukunst* (note 2).

166 A new interpretation of the history of Strasbourg's construction, which re-establishes the authority of Erwin von Steinbach in determining the plan of the west façade, can be found in studies done by Reinhard Liess, "Der Riß C der Straßburger Münsterfassade. J.J. Arhardts Nürnberger Kopie eines Originalrisses Erwins von Steinbach," *WRJ* 46/47, 1985/86: 75–117; idem, "Der Riß A 1 der Straßburger Münsterfassade im Kontinuum der Entwürfe Magister Erwins," *Kunsthistorisches Jahrbuch Graz 1986*: 47–121, idem, "Der Riß B der Straßburger Münsterfassade. Eine baugeschichtliche Revision," *Orient und Okzident im Spiegel der Kunst. Festschrift für Heinrich Gerhard Franz* (Graz 1986) 171–202. Idem, "Das Kreßberger Fragment im Hauptstaatsarchiv Stuttgart. Ein Gesamtentwurf der Straßburger Münsterfassade aus der Erwinzeit," *Jahrbuch der Staatlichen Kunstsammlungen in Baden-Württemberg 1986*, 6–31. Idem, "Der Rahnsche Riß A des Freiburger Münsterturms und seine Straßburger Herkunft," *ZDVK* 45, 1991, 7–66. Liess shows that the famous "Sketch B" is not the first plan of the façade, but was a working sketch based on earlier sketches that go back to around 1274. Gothic scholarship has not completely agreed with the theory that the bell-tower level – itself built in the late fourteenth century – was a major part of Erwin's façade design, which included the tower platforms. See Jaroslav Bures, "Die Bedeutung der Magdeburger Hütte in der mitteldeutschen Architektur des ausgehenden 14. Jahrhunderts," *NBK* 29, 1990, 9–33, here 28–9.

167 In this respect, Laon Cathedral's façade was the prototype for both.

168 The south façade of Notre-Dame, Paris, was completed by Pierre de Montreuil. Branner (note 159) 101f. Branner's main thesis – that during the rule of St. Louis (1226–70) a court style patronized by Louis developed in and around Paris, to which Branner relegates the transept fronts of Notre-Dame – cannot be expounded upon here. Paris Gothic, no doubt at its peak around 1240, is so closely bound-up with the stylistic tendencies of Rayonnant architecture that there really is no reason to single out the court style as the ideal of the Paris Gothic.

169 Gross 1969, 87.

170 For the extremely long list of rose windows built in the Paris style see Branner (note 159) 105 and Friedrich Kobler, "Fensterrose," article in *Reallexikon*

zur deutschen Kunstgeschichte, vol. 8 (Munich 1982) cols 65–203. For more about the form of the gabled portal between pinnacles see Heinrich Meckenstock, "Das fialenflankierte Portal. Seine Entstehung und Bedeutung," *Mainzer Zeitschrift* 67/8, 1972/3, 143–6.

171 Because of its distinctive handling of the towers, Erwin von Steinbach's "Sketch B" (Frauenhaus-museum Strasbourg) is usually understood as having been the earliest example of a German façade design that did not follow Paris, Reims and Amiens. As a consequence, it is often held up in sharp contrast to the rectangular, block-like French façades of the same period. Ernst Adam, *Baukunst des Mittelalters*, 2, in the series *Ullstein Kunstgeschichte*, vol. 10 (Frankfurt-Berlin 1963) 158f. overlooks the fact that French Gothic had its own authentic two-towered fronts, the most important of which is Chartres. An interesting structure to place between the Paris transept façades and Sketch B is the south façade of the collegiate church in Wimpfen, where the entire organization of the Paris portal zone has been transfered to the upper registers of the tracery-windowed termination wall of the transept. The "Chronicles" of Burkhard von Hall (around 1300) prove that the managing architect at Wimpfen visited Paris: "…peritisimo in architectoria arte latomo, qui tum noviter de villa Parisiensi e partibus venerat Francie…" Quoted from Klotz (note 140) 9.

172 The sources for Strasbourg's façade are not only to be found in French cathedral Gothic. Liess, "Der Rahnsche Riß A" (note 166) 46–7 rightly points out individual motifs known to have come from Cologne Cathedral's lodge (spiked piers, pinnacles under canopies), which were included in the sketches and are part of the actual façade.

173 This date for Freiburg's spire, not that of the oft-quoted earlier dating (around 1250) follows Liess, "Der Rahnsche Riß A" (note 166) 56–7. The couronnements over the tower portal, to name only one reason for the later dating, are filled with tripartite tracery that is repeated in the spire's tracery panels, whose form could only have come from the triangular gables on the pier buttresses of Strasbourg's portal level. For more about the building of Freiburg see Ernst Adam, "Das Freiburger Münster," in the series *Große Bauten Europas*, vol. 1 (Stuttgart 1968), and Konrad Kunze, *Himmel in Stein. Das Freiburger Münster. Vom Sinn mittelalterlicher Kirchenbauten* (Freiburg 1980).

174 Liess, "Der Rahnsche Riß A" (note 166) 60ff.

175 For a survey of nineteenth-century neo-Gothic spires see Alexander von Knorre, *Turmvollendungen deutscher gotischer Kirchen im 19. Jahrhundert*, in the series *Veröffentlichungen der Abteilung Architektur des Kunsthistorischen Instituts der Universität zu Köln*, vol. 5 (Cologne 1974).

176 The oldest surviving regulations for stonemasons in Germany (from 1459) list both Cologne and Strasbourg in the top four, with Strasbourg listed first.

177 For the individual buildings see Maria Geimer, *Der Kölner Dom und die rheinische Hochgotik* (Bonn 1937).

178 Whether forms from Strasbourg or those specific to the central Rhine region played, besides Cologne Cathedral, a role as Wolff assumes, will have to be more thoroughly investigated. Arnold Wolff, "Gefahr für die Wernerkapelle in Bacharach," *KC*, 35 1982: 277–81. The quadripartite tracery in the couronnements of Werner Chapel's eastern conch can be found in the clerestory of Cologne's choir and in the nave windows at Strasbourg, neither of which contain rounded squares in the spandrels like at Bacharach.

179 Examples from the French are at St-Quiriace in Provins, Seine-et-Marne (around 1200), St-Eliphe in Rampillon, Seine-et-Marne (eastern sections 1225–30), St-Etienne in Brie-Comte-Robert, Seine-et-Marne (eastern sections 1220s), Chambronne, Oise (choir completed 1239). See Michler 1977, 30. Among numerous examples from the Rhine region is the original polychromy system recently discovered at the cathedral of Limburg-an-der-Lahn.

180 Burgundian architecture, with its emphasis on

mullions, seemed especially predisposed towards advanced polychromy, a very early example being in the ambulatory of Auxerre Cathedral (1217–34) where the structural elements were painted white, lacked joints and were set-off against dark-red concave molding and rusticated walls. Michler 1977: 34ff. Confirmed German examples of polychromy identified up until now as belonging to the second half of the thirteenth century – these would be Cologne Cathedral choir and sacristy, St. Elizabeth and its sacristy in Marburg, Marburg Castle chapel, Wetter among others – had basic color schemes comparable to that of Marienstatt. This is especially true of the polychromy at Marburg Castle chapel (consecrated 1288) where flat surfaces were pink with white joints painted on; and columns, responds and ribs were white and set-off against red concave molding. Jürgen Michler, "Zur Farbfassung der Marburger Schloßkapelle. Raumfarbigkeit als Quelle zur Geschichte von Kunst und Denkmalpflege." *DKD*, 36, 1978: 37–52. Decades of research have revealed an exact picture of numerous Gothic polychromy systems in the area of modern day Hessen. Especially interesting is recently completed research on the color scheme used at St. Elizabeth in Marburg. Not only were the wall and vault surfaces pink and enlivened with white joints, but the piers and wall responds were also. The articulated elements of the vaults – ribs, transverse and arcade arches – were set-off in ocher with the transverse and arcade arches alternated with whitened profiling. Ocher-and-white was also the color of the window tracery. The outside walls were pink with white joints, like the surfaces inside. The most remarkable thing about St. Elizabeth's system is that its wall surfaces and articulated elements were monochrome, broken only by vault arches, so that it could not be more different than the pronounced exchange of color between wall and articulated elements found at Marienstatt and Marburg Castle chapel. Michler dates St. Elizabeth's polychromy concurrent with the appearance of Amiens-inspired forms in the west section of the nave (about 1270) and characterizes this propensity for smooth monochrome wall surfacing as a typical stylistical element of the Court Style. Further research, especially concerning pertinent French structures, is necessary to strengthen this theory. Jürgen Michler, "Die Elisabethkirche zu Marburg in ihrer ursprünglichen Farbigkeit," in the series *Quellen und Studien zur Geschichte des Deutschen Ordens*, vol. 92, U. Arnold ed. (Marburg 1984) 92. *Idem* "Zur Farbfassung der Sakristei der Marburger Elisabethkirche," *DKD* 38, 1980, 139–61.

181 An in-depth analysis of the individual forms has been done by Ulrich Schröder, "Royaumont oder Köln? Zum Problem der Ableitung der gotischen Zisterzienserkirche Altenberg," *Kölner Domblatt* 42, 1977: 209–42. Krönig (note 81) 125ff. believes that the major influence for these forms came from French monastic churches.

182 This interpretation is made by Gross (note 139) 327f. Choirs that were more than likely influenced by Ste-Chapelle in Paris are St. Ursula Cologne (consecrated 1287?), Mönchengladbach Abbey Church (1256–1300 in forms from Cologne Cathedral's lodge) St. Servatius Siegburg (last quarter thirteenth century, assumed to be by Cologne Cathedral architect Arnold), Wimpfen's collegiate church (1269–79) and Weissenburg (north arm of crossing consecrated 1289). See also Héliot 1968: 120. Klotz (note 140) 51ff. shows that the choir type of Wimpfen was probably communicated to Mont-Carmel Chapel at Metz Cathedral. Also important is the role played by Toul Cathedral in Wimpfen's rejection of the common three-register elevation system. See Schiffler (note 121).

183 Willibald Sauerländer, "Die Naumburger Stifterfiguren. Rückblick und Fragen," Supplement 5 of exhibition catalogue *Die Zeit der Staufer* (Stuttgart 1979) 169–245, here 170 and 174.

184 Ibid., 228f. Nevertheless, it seems hardly possible to name exact prototypes. Naumburg's Meister developed his own style of sculpture, characterized by

a new kind of realistic figure, powerful in stature.

185 Ibid., 180.

186 For more on the controversial dating of Naumburg see Ernst Schubert, *Der Westchor des Naumburger Domes* (Berlin 1965) and Sauerländer (note 183) 234ff. It is Götz (note 113) 119f. to whom we owe the information that the organization of Naumburg's group of figures was possibly influenced by those in the choir of Magdeburg Cathedral. A clue in dating Naumburg is offered by Meissen Cathedral, much of whose design is based on Naumburg's west choir, and parts of which were already in use in 1268. For more about the dating of Meissen Cathedral choir see Edgar Lehmann and Ernst Schubert, "Der Meißener Dom. Beiträge zur Baugeschichte und Baugestalt bis zum Ende des 13. Jahrhunderts," in the series *Schriften zur Kunstgeschichte* 14 (Berlin 1968) 10ff., 37f.

187 The most important indicator as to the date of Regensburg's construction can be found some eight meters above the floor of the choir, where wooden scaffolding has been found and dendrologically dated to 1283–4. For a history of Regensburg's construction see Manfred Schuller, "Bauforschung," *Der Dom zu Regensburg. Ausgrabung, Restaurierung, Forschung, Ausstellung anläßlich der Beendigung der Innenrestaurierung des Regensburger Domes 1984–88*, in the series *Kunstsammlungen des Bistums Regensburg, Diözesanmuseum Regensburg. Kataloge und Schriften*, vol. 8 (Munich-Zurich 1989) 168–223.

188 More at Héliot 1968, 117ff. A possible link to the choirs of Clermont-Ferrand and Narbonne has been made by Günter Gall, "Zur Baugeschichte des Regensburger Domes," *ZKG* 17, 1954: 61–78, here 76.

189 For the Romanesque Hall structures of the Danube region see H. Thümmler, "Die vorgotischen Hallenkirchen im Regensburger Raum," *KC* 15, 1962, 290–2. Ludwig Stoltze, *Die romanischen Hallenkirchen in Altbayern*, Diss. Aachen (Leipzig 1929). For information about the Romanesque Halls of Westphalia see H.R. Rosemann, "Die westfälische Hallenkirche in der ersten Hälfte des 13. Jahrhunderts," *ZKG* 1, 1932, 203–27. Also F. Badenheurer and H. Thümmler, *Romanik in Westfalen* (Recklinghausen 1964).

190 See note 136. Also Lambert Auer, "Landesherrliche Architecktur. Die Rezeption der Marburger Elisabethkirche in den hessischen Pfarrkirchen," *Elisabethkirche 1983*, 81–123. Theresia Jacobi and Frauke Scherf, "Zur Rezeption der Elisabethkirche in Schlesien," Ibid., 125–34. Perhaps Meissen Cathedral should also be on the list of Marburg-type structures. It was built into a Hall, after a change in design, around 1290. The most likely prototypes for this were probably buildings in Nienburg and Mühlhausen.

191 For a discussion of the term "domical vaults" see Kurt Röckner, *Die münsterländischen Hallenkirchen gebundener Ordnung*, (Diss. Münster 1980) 41–53.

192 The spatial organization of Our Lady in Bremen, built about the same time, is very similar.

193 St. Mary's in Wetzlar (transept and nave 1250–1307), collegiate church of St. Mary's in Wetter near Marburg (begun after 1265), collegiate church of St. Stephan in Mainz (nave begun about 1260).

194 Hans Joachim Kunst, "Der Domchor zu Köln und die hochgotische Kirchenarchitektur in Norddeutschland," *NBK* 8, 1969, 9–40, here 12ff. The side-aisle Halls were completed by the year 1277. Arnold Wolff, "Chronologie der ersten Bauzeit des Kölner Domes 1248–77," *Kölner Domblatt* 28/29, 1968, 23ff.

195 Not long after, Cologne Cathedral's pier-base profile and its characteristic arcade arch/transverse arch system could be found in the west-nave travées of Halberstadt Cathedral in Saxony. See Kunst (note 194) 15ff.

196 In the Our Lady churches of Lemgo, Bielefeld, Osnabrück and Herford (former Stift Berg Church) and at St. Ägidienkirche in Braunschweig.

197 Only three of the windows destroyed during the war were restored.

198 The type of choir with pseudo-basilica and ambulatory common in the west of France in the twelfth century (Notre-Dame-La-Grande in Poitiers, Notre-Dame in Cunaud, Loire) appears not to have influenced German Hall development.

199 The major similarities between them have been forcefully laid out by Hans-Joachim Kunst, "Die Entstehung des Hallenumgangschores. Der Dom zu Verden an der Aller und seine Stellung in der gotischen Architektur," *MJK* 18, 1969, 1–104. Kunst's thesis – that Verden's delineation of the coronation church of Reims bears witness to the House of Welfin's claim to the German crown – seems a bit far-fetched however. Hans Joachim Kunst, "Die Elisabethkirche in Marburg und die Bischofskirchen," *Elisabethkirche* 1983, 69–75, here 72.

200 The first "Verden type" Hall choir in northern Germany was the choir at Lübeck Cathedral, built after a change in the original design. The chapels of its sanctuary (begun 1266, completed about 1335) are spatially fused with the ambulatory of the choir and are as high as the central vessel. The prototypes for Lübeck's piers are from Verden as well.

201 Features from Cologne Cathedral also found in Lower Saxony are the belfry rosettes of Braunschweig Cathedral, and the choir of St. Ägidienkirche in the same town. Kunst "Hallenumgangschor" (note 199) 20.

202 Ibid., 21.

203 For an introduction into the importance of the Mendicants to city culture see Dieter Berg, *Bettelorden und Stadt. Bettelorden und städtisches Leben im Mittelalter und in der Neuzeit*, in the series *Saxonia Franciscana. Beiträge zur Geschichte der Sächsischen Franziskanerprovinz*, vol. 1, Dieter Berg ed. (Werl 1992). Some scholars believe that Mendicant churches were located near the edge of town, close to the town wall, because it offered easy access to the poorer parts of town and cheaper building sites. Meckseper has shown, at least at some locations, that there were other reasons too. The Mendicants built near fortifications at times because public lands were available there, lands turned over to the order by city rulers or the town council. Also, it seems that these lots were not always settled only by the poor. Meckseper 1982, 226f. For a more detailed look at the choice of building sites and the location and placement of churches see Roland Pieper, *Die Kirchen der Bettelorden in Westfalen. Baukunst im Spannungsfeld zwischen Landespolitik, Stadt und Orden im 13. und frühen 14. Jahrhundert*, in the series *Franziskanische Forschungen* 39, (Werl 1993) 257–66. Not all Mendicant churches were built inside the wall. Many of the early Bavarian order's churches stood, at least in the beginning, outside and only became part of the town proper later, following urban expansion. See Friedrich Kobler, "Stadtkirchen der frühen Gotik," *Wittelsbach und Bayern I. Die Zeit der frühen Herzöge. Von Otto I. zu Ludwig dem Bayern*, in the series *Beiträge zur Bayerischen Geschichte und Kunst 1180–1350*, Hubert Glaser ed. (Munich-Zurich 1980) 426–36, here 426.

204 Meckseper 1982, 226.

205 Though flat ceilings were quite common in the southern Rhine region, they had always been a traditional element of south-western German architecture in general. It was probably this factor, rather than the architectural guidelines of the Franciscan General Chapter Meeting in Narbonne, that was behind the large number of flat ceilings here. An indication of this is the fact that other ecclesiastical orders built flat-ceiling naves in the region too. Helma Konow, "Die Baukunst der Bettelorden am Oberrhein," in the series *Forschungen zur Geschichte der Kunst am Oberrhein* vol. 6 (Berlin 1954) 5ff., 13.

206 Early examples of the Mendicant *Langchor* chancel, a chancel that is made up of several bays, can be found in the Franciscan churches at Trier (around 1240) Würzburg (around 1250–80) Freiburg-im-Breisau (choir begun 1262) Pforzheim (begun around

1270) and Schlettstadt (built by 1280, nave destroyed 1881) as well as the Dominican church in Weissenburg (begun 1288). The Franciscans of Brandenburg developed a variation on the *Langchor* chancel too. In their Berlin church (begun about 1290) the narrow sanctuary opens up into a centralized space created by a seven-sided polygon. The Franciscan churches in Stettin (first half of the fourteenth century) and Brandenburg (first decades of the fifteenth century) and, strangely enough, the Augustinian church in far away Vienna have the same choir form. Götz 1968, 168ff.

207 Chancel screens wide enough for three aisles were most common in those naves meant to have flat ceilings, in the south of the Empire: the Dominican churches in Weissenburg (begun 1288) and Gebweiler (begun shortly after 1300), the Franciscan churches in Rothenburg (begun 1285) Esslingen (about 1300) and Colmar (begun 1292), and the Dominican Convent church at Klingental in Basel (begun 1274).

208 Meckseper 1982, 225. For a typological survey of Franciscan churches in German-language regions in the Middle Ages see Günther Binding, "Die Franziskaner-Baukunst im deutschen Sprachgebiet," in exhibition catelogue *Achthundert Jahre Franz von Assisi. Franziskanische Kunst und Kultur des Mittelalters* (Krems 1982) 431–60.

209 The notion here of Italian "archetypes" comes from Ernst Badstübner, *Kirchen der Mönche. Die Baukunst der Reformorden im Mittelalter* (Zurich 1981) 267f.

210 Excavation has confirmed the floor plan of the Franciscan church in Eisenach (destroyed 1597). A church possessing rows of piers was uncovered that probably carried a large room of some kind above it, an arrangement similar to the Dominican church in Eisenach which has survived. Examples of later churches with unvaulted rooms: the Kornmarktkirche in Mühlhausen (second half thirteenth century), the Franciscan churches in Barby (after 1264) and Arnstadt (around 1300–50).

211 Richard Krautheimer, *Die Kirchen der Bettelorden in Deutschland* (Cologne 1925) 16ff. Also Binding (note 208) 433.

212 Among the early Franciscan churches with these characteristics are Seligenthal (building in progress 1247) Duisburg (1272–1315) Trier (last third thirteenth century) Höxter (rebuilt 1281–1320) Angermünde (around 1300) and Fritzlar (first half fourteenth century). Pieper (note 203) 208–24 attributes the asymmetrical, two-aisle nave form of some Mendicant churches in Westphalia to the lecturn, which research has shown was sometimes placed against one of the nave's side walls. This form allowed the congregation to gather in a half circle around the priest as he gave the sermon.

213 The clearest examples being the Dominican churches in Siena (after 1220) Bologna (1236–63) and Santa Croce in Florence (after 1294).

214 For the discussion concerning this question see Konow (note 205) 9f.

215 Krautheimer (note 211) 7ff. sees a pre-Romanesque element in Regensburg's "elastic" wall character. Because of this, it seems to him that Mendicant churches bring together "the early and the late phases of medieval architectural development." He underestimates the completely new, antithetical composition of wall and articulated element. Gross sees in this wall system the intention "to change the emphasis from Gothic's plastic structural articulation to one that is standardized by an abstract, functional character" and understands it as being an enhancement of the Reims style. Gross (note 31) 302ff. For Gross, the central themes of the German High Gothic are functional standardization, "cleansing" of Gothic structural articulation through reduction and unification of form, a sense of clarity that seizes the entire structure, static relief and calm forms. Most of the characteristics particular to Mendicant-order Gothic

are swallowed up by this model to the benefit of an incredibly far-reaching theory that, in the final analysis, is much too general. Gross (note 162) 50ff.

216 H. Bauch, "Innenrestaurierung der Dominkanerkirche in Regensburg, 1.Bauabscnitt," 26. *Bericht des Bayerischen Landesamtes für Denkmalpflege* 1967, 271–6.

217 Kubach writes: "The German 'special Gothic' of the thirteenth century, and in many cases of the fourteenth century as well, has more in common with the simple tangible forms of Late Romanesque architecture than it does with the distinct High Gothic forms of northern France.... Here there are ... large wall surfaces lacking multi-register construction, lacking an overriding verticality, with small windows, simple and clearly arranged proportions ... By combining all these characteristics, the vaulted basilica of the German 'special Gothic' shows itself closely linked to Romanesque and Early Gothic structures. In a certain respect, it seems to have skipped the High Gothic of northern French cathedrals altogether." Hans Erich Kubach, *Architektur der Romanik* (note 38) 330.

218 Krautheimer (note 211) 34 attributes the size and placement of the clerestory windows to the Italian Cistercian churches at Casamari, San Galgano and Fossanova. It might also be possible to trace them to Marienstatt's undated nave. Schenkluhn sees the windows of Cologne's Minorite church, which are organized in a similar way, as having been influenced by San Francisco in Bologna. Wolfgang Schenkluhn, "Die Auswirkungen der Marburger Elisabethkirche auf die Ordensarchitektur in Deutschland," *Elisabethkirche* 1983, 81–101, here 84.

219 See the supports of Lilienfeld choir. Otherwise the octagonal pier is usually found in Cistercian dormitories, chapter halls and refectories, but hardly ever in their churches.

220 The present condition of the church is due to changes in the Baroque style.

221 For more about the complex stages of the construction of the Jacobin Church in Toulouse, which developed out of an earlier double-nave structure with a flat-ceiling and a polygonal choir added later, see M. Prin, "L'Église des Jacobins de Toulouse: Les Étapes de la construction," *Cahiers de Fanjeaux* 9, 1974: 184–208, and Richard A. Sundt, "The Jacobin Church of Toulouse and the Origin of its Double-Nave Plan," *Art Bulletin* 71, 1989, 185–207. The latter also includes a survey of research and the controversial models used to explain the double-nave type.

222 This information is from the year 1263. Ch. Higounet, "La chronologie de la construction de l'église des Jacobins de Toulouse," *Bulletin monumental* 107, 1949, 85–100, here 91.

223 The couronnement tracery is nineteenth-century.

224 The Minorite church in Cologne was badly damaged in the Second World War. From its ruins, Verbeek recognized that the nave was originally planned as a Hall structure. Albert Verbeek, "Zur Baugeschichte der Kölner Minoritenkirche," *Kölner Untersuchungen*, in the series *Die Kunstdenkmäler im Landesteil Nordrhein* supplement 2, Walter Zimmerman ed. (Ratingen 1950) 141–63. More probable is Schenkluhn's observation that the findings indicate a design of a simple crossing without a projecting transept. Wolfgang Schenkluhn, *Ordines Studentes. Aspekte zur Kirchenarchitektur der Dominikaner und Franziskaner im 13. Jahrhundert*, Diss. Marburg 1983 (Berlin 1985) 214ff.; idem (note 218) 82f.

225 The Franciscan curate for Trier, Brabant, Holland, Friesland, Wesphalia and Hessen was seated in Cologne. The influence of Cologne's Minorite church on order churches in Trier, Bonn, Münster and Höxter is therefore not surprising. In these churches we find a balance between Mendicant forms and "classic" Gothic structural articulation as well. Schenkluhn, *Ordines Studentes* (note 224) 221ff. feels free to name San Francisco in Bologna as the source for the Cologne Minorite church's original plan lack-

ing a projecting transept. For further stylistic derivation of its detailing, however, this oberservation is not very helpful.

226 Krautheimer (note 211) 120ff.

227 Badstübner (note 209) 275.

228 See below page 103.

229 Only on the earliest Romanesque buildings do we find tangible wall surfaces with bricks that had been worked with a chisel or the so-called *Fläche* tool before they were fired. These are techiques known from Lombardy and indicates that the Backstein tradition of northern Italy played an important role in the introduction of the technique in northern Germany. Otto Stiehl's "Backstein," chapter in *Reallexikon zur deutschen Kunstgeschichte* vol. 1 (Stuttgart 1937) cols 1340–5.

230 These terms are generally accepted, but do not represent masonry bonds specific to these areas.

231 Well-preserved glazed bricks can be seen in the eastern gable of the Cistercian church in Sonnenkamp, Mecklenburg (around 1245).

232 Such bricks were used in building St. Johannis in Lüneberg. Stiehl (note 229) col. 1343.

233 For a survey of this period and a look at reference material on this subject see *Twelfth Century Europe and the Foundation of Modern Society*, Marshall Glacett, Gaines Post and Robert Reynolds eds. (Madison, Wisconsin 1966).

234 New findings reveal that the Slavic tribes were heavily involved in the domestic colonization of the area. W. Schlesinger ed., *Die Deutsche Ostsiedlung als Problem der europäischen Geschichte. Reichenau-Vorträge 1970–1972*, in the series *Vorträge und Forschungen*, vol. 18 (Sigmaringen 1975).

235 For more about this process see J.A. Schmoll gen.Eisenwerth, *Das Kloster Chorin und die askanische Architektur der Mark Brandenburg* (Berlin 1961) 233.

236 W. Ribbe, "Zur Ordenspolitik der Askanier – Zisterzienser und Landesherrschaft im Elbe-Oder-Raum," *Zisterzienser-Studien* I, in the series *Studien zur europäischen Geschichte*, vol. 11 (Berlin 1975) 77–96. A very similar method of founding monasteries in order to stabilize secular rule was practiced by the Premyslids in Bohemia. Jiri Kuthan, *Die mittelalterliche Baukunst der Zisterzienser in Böhmen und Mähren* (Munich-Berlin 1982) 8, 19ff.

237 Schmoll gen.Eisenwerth (note 235) 106ff. and Aubert 1963) 157.

238 For more on how castle motifs influenced medieval ecclesiastical architecture see Günter Bandmann, *Mittelalterliche Architektur als Bedeutungsträger* 5th edition (Berlin 1978) 84ff. Only a few examples from the Gothic period are included.

239 The dating of Chorin's façade is somewhat controversial. More in Schmoll gen.Eisenwerth (note 235) 162ff., 170. The façade is not symmetrical. The northern section is smaller than the southern because a porch was built on to the reception hall behind it, causing it to jut out of the line of the rest of the façade. Schmoll gen.Eisenwerth believes the aim of this discrepancy was to disconnect the south-façade section from the wall of the lay-brothers' house. This leaves one with the impression that it was done purely for aesthetic reasons, but just the opposite is true. The reception hall is on the weather side of the structure and a porch was built in front of it to prevent wind from blowing in when the outer door was opened. To facilitate this, the builders were forced to make the façade jut out at that point, even though the wall of the reception hall proper is flush with the lay-brothers' house.

240 The oldest Hall structure on the Baltic coast is Riga Cathedral (begun 1211) in Latvia. Its ponderous domical vaults indicate a Westphalian influence as well, as do the choir vaults of Güstrow Cathedral (after 1240). Hall structures were introduced into the Nordelbingen area about 1220 (St. Petri in Lübeck and in Gadebusch). The "three aisles of equal size" arrangement at Gadebusch and St. Petri could have come from

the first Wiesenkirche in Soest. On the other hand, the Hall churches in Holstein built later appear to have been influenced more by the northern-Westphalian Hall type. See Bettina Gnekow, *Der Kirchenbau im heutigen Holstein während des Aufbaus der Pfarrorganisation (1150–1300)*, Diss. Kiel 1989.

241 St. Nicholai in Rostock received a rectangular choir in the fifteenth century, altering the original straight termination.

242 Dating the begining of construction on St. Mary's in Lübeck has been extremely controversial. Primary sources concerning its construction from the 1260s (appropriation of funds in 1261 and 1263, altar consecration 1268) allow one to assume that work on the choir was already underway at this time. See Dietrich Ellger, "Die Baugeschichte der Lübecker Marienkirche 1159–1351," idem and Johanna Kolbe, *St. Marien zu Lübeck und seine Wandmalereien*, in the series *Arbeiten des Kunsthistorischen Instituts der Universität Kiel* (Neumünster 1951) 1–88. Max Hasse, *Die Marienkirche zu Lübeck* (Munich 1983) 34f., believes it is at the very least probable that there were already concrete designs in progress at this time. Be that as it may, the underlying primary sources do not clearly refer to the choir. A political struggle between the town council and the cathedral chapter over the patronage of St. Mary's might have been the reason for the decision to rebuild. Partial victory in this struggle was achieved by the town council in 1286. The later dating of the start of construction coincides with this and was suggested by Hans Joachim Kunst. It is supported by the fact that the arch and tracery molding of St. Mary's derived stylistically from *Cologne Cathedral's lodge*, forms which could not have been communicated to Lübeck in the 1260s, as the early dating would presume. See Hans Joachim Kunst, "Der nordeutsche Backsteinbau. Die Marienkirche in Lübeck und der Dom in Verden an der Aller als Leitbilder der Kirchenarchitektur Norddeutschlands," *Forschung und Information. Baugeschichte und europäische Kultur*, vol. 1 (Berlin 1985) 157–66. Idem, *Die Marienkirche in Lübeck. Die Präsenz bischöflicher Architekturformen in der Bürgerkirche* (Worms 1986). Idem, "Der Chor der Marienkirche in Lübeck – eine Neubestimmung der Herkunft seiner Formen," *Mittelalterliche Backsteinarchitektur und bildende Kunst im Ostseeraum. Wissenschaftliche Beiträge der Ernst-Moritz-Arndt-Universität Greifswald* (Greifswald 1987) 23–30. The later dating would put St. Mary's in the group of churches with Lübeck Cathedral choir types, while the early dating would assume a dependence of Lübeck Cathedral's choir on the eastern sections of St. Mary's. For a look at the current state of research see Manfred Finke, "Die Baugeschichte der Lübecker Marienkirche in neuem Licht?," *Der Wagen, ein lübeckisches Jahrbuch* 1988, 53–88. W. Erdmann, "Zur Diskussion um die Lübecker Marienkirche im 13.Jahrhundert," *ZDVK* 44, 1990, 92–111. Dietrich Ellger, "Zum gotischen Chorbau der Lübecker Marienkirche," *ZKG* 60, 1991, 490–519.

243 Specific to St. Mary's is the apex chapel which was built in the fifteenth century.

244 Götz 168, 78, 146ff.

245 The tracery work at St. Mary's is comparable to that of the Dominican church in Leuven. The framing arches can be found at St. Nicolas and in the choir of St. Bavo in Gent, Flanders.

246 Gross (note 162) 50 writes of St. Mary's "pseudo-Parisian" roof solution in reference to the rebuilding of the choir at Notre-Dame Paris (begun 1296) which included new chapel additions that rounded the choir chevet. This comparison seems a bit stretched.

247 Compare this to the older sections of the Dominican church at Leuven and the engaged piers of the choir ambulatory at St. Nicolas in Gent.

248 These wall paintings were recovered and restored between 1948–54. The cycle of figures on the blind lancets of the nave windows were clearly meant to give the impression that expensive materials were used there. The motif of the figure crowned by a

tabernacle is in imitation of stained-glass figures, as though they were meant to be part of the windows above them.

249 Dietrich von Barth was engaged as master architect at St. Nicholai in 1288. In 1298/99 the master brickmaker Hermann delivered Backstein bricks. Both dates can probably be subcribed to the building of the choir.

250 The conformity of motifs goes so far as to include detailing. For example, all of the churches listed here possess a tall clerestory, the majority of which is blinded by steep ambulatory and side-aisle roofs. Doberan's clerestory posseses a painted-in triforium, which once again underscores northern-German Backstein tendency to substitute painted detailing for Gothic three-dimensionality. Gert Baier, "Anmerkungen zur Rekonstruktion der Architekturfarbigkeit in der Kirche des ehemaligen Zisterzienserklosters Doberan," *Mitteilungen des Instituts für Denkmalpflege – Arbeitsstelle Schwerin* 27, October 1982, 472–81.

251 Pelplin's nave and transept vaulting are later. Clasen 1958, 32f. In Poland, dating the start of construction at Pelplin is controversial. Piotr Skubiszewski, "Architktura Opactwa Cysterskiej w Pelplinie," in the series *Studia Pomorskie* 1 (Wroclaw 1957) 24–102, here 34 believes that the choir was begun in 1276 and complete in 1323. Janusz Ciemolonski, "Ze Studiów nad Bazylika w Pelplinie," *Kwartalnik Architektury i Urbanistyki* 19, 1974: 27–66 argues for a much later date (last quarter of the fourteenth century). Paul Crossley, "Lincoln and the Baltic, the Fortunes of a Theory," *Medieval Architecture and Its Intellectual Context. Studies in Honour of Peter Kidson*, Eric Fernie and Paul Crossley eds. (London 1990) 169–80, here 170–3, convincingly rejects this later dating.

252 Tripartite vaulting, with three groins or rib haunches radiating out from a middle point, was known to the architecture of central Europe as early as pre-Romanesque times (ambulatory of Aachen's Palatine Chapel) and was employed in choir ambulatories, dwarf galleries (St. Kunibert in Cologne – before 1224) and Hall crypts as transition bays over corners. In the thirteenth century, longitudinally placed rooms were covered with rows of tripartite vaults arranged parallel (see side-aisles, Heisterbach 1202–37, gallery, St. Peter's, Sinzig about 1230). During the Late Gothic period the tripartite vault was taken up and developed further into the so-called "zig-zag romboid vault" to which was added a pair of opposing tripartite ribbed vaults (vaulted bays of former cloister, adjacent to north termination wall of choir at St. Kunibert in Cologne, vault built first quarter of the thirteenth century; and Castle Klingenberg in Bohemia, courtyard arcades around 1250). It was not until the building of Pelplin that tripartite ribbed vaulting appeared in conjunction with stellar vaults. Ernst Gall, "Dreistrahlgewölbe," *Reallexikon zur deutschen Kunstgeschichte*, vol. 4 (Stuttgart 1958) cols 545–51. For more about the early "zig-zag romboid vault" of St. Kunibert in Cologne see Clemens Kosch, "Hochmittelalterliche Anbauten und Nebenräume von St. Kunibert," *Colonia Romanica. Jahrbuch des Fördervereins Romanische Kirchen Köln e.V.* 7, 1992, 78–113, here 82–8.

253 It has become accepted when describing English patterned vaults to differentiate decorative ribbing into "tiercerons" (ribs springing from the capitals) and "liernes" (usually shorter ribs that do not spring from the captials). Otherwise there are few, if any, standard terms to describe specific kinds and shapes of vault ribs. This is especially true of the German Gothic, which is rich in vault forms. When applicable, I have here followed the terms introduced by Clasen (1958) and Dambeck. Franz Dambeck, *Spätgotische Kirchenbauten in Ostbayern*, in the series *Veröffentlichungen des Instituts für ostbairische Heimatforschung in Passau* 21, 1939/40, (Diss. Freiburg 1940) 22ff.

254 Clasen 1958, 34 does not doubt that Pelplin's vaulting was built first.

255 Taken from Clasen 1958: 29ff.

256 This older model conceives of cross-rib vault webs which actually do form barrel-vault-like sections, as being made up of a series of parallel arches that exert no horizontal thrust on the formeret wall. In 1890, Mohrmann put forward the hypothesis that in a vault, load is transmitted through the surface of a web compartment to its abutment in a direction that would be followed by a rolling ball. That means that load is always transmitted in the direction of the steepest incline and therefore follows the line of thrust and contour of the pertinent arches. Thrust gathers in the groins in order to then flow into the abutments at the angle of the vault. For more about Mohrmann's model see Georg Gottlob Ungewitter, *Lehrbuch der gotischen Konstruktionen*, vol. 1, 3rd edition (Leipzig 1890) 50–61.

257 Robert Mark has been publishing his photoelastic experiments with two-dimensional models of Gothic cross-rib vaults since 1972. Determining how vaults deflect thrust seems to have been greatly simplified in his experiments, though, because they do not always take the characteristics of the material into consideration. Robert Mark, *Experiments in Gothic Structure* (Cambridge, Mass. 1983) 102–17. He defines the vault shell in the conventional way, as a spatially self-contained, load-bearing structure. His calculated lines of thrust – which differ to a great degree from Mohrmann's line of deflection – get stronger in the direction of the supports as they approach the groins, without ever actually flowing into them. The weakness of this model is that it assumes the vault material will behave linearly/elastically whether under tension or thrust. However, masonry cannot stand much tension at all, which the seemingly inevitable formation of cracks in the building of vaults attests to. Rainer Barthel attempted recently to compensate for this weakness in Mark's model. His graphic representation of the trajectory of tensile forces in the webs of a cylindrical cross-ribbed vault make Mark's results more precise. Rainer Barthel, *Tragverhalten gemauerter Kreuzgewölbe*, in the series *Aus Forschung und Lehre*, ed. Institut für Tragkonstruktionen der Universität Karlsruhe, vol. 26, Diss. Karlsruhe 1991 (Karlsruhe 1993).

258 The question of whether Gothic ribs were meant to deflect thrust, or were only intended to express the transmission of thrust, goes back to the very beginning of Gothic scholarship and is by no means settled. For a survey of research done on the subject see Müller 1990, 184–205. Primary sources describing vault construction are not particulary helpful in answering the question of what role medieval architects assigned to the rib. In most cases these sources are allegorical panegyrics to the ecclesiastics in charge of financing construction and contain little information about the technical side of building. The most information of this type seems to be from an assessment made by building experts from the year 1316 concerning the high vaults of Chartres Cathedral. The people who contracted for this assessment to be undertaken were told: "Seigneurs, nous vous disons que les quatres arcs qui aident à porter les voutes sont bons et fors...." quoted from Victor Mortet, "L'expertise de la cathédrale de Chartres en 1316," *Congrès Archéologique de France. LXIIIe Session. Séances Générales tenues à Chartres en 1900* (Paris 1901) 308–29, here 312. Nonetheless, this passage shows that the building experts did not doubt that the cross ribs of the high vaults contributed to the transmission of thrust.

259 There are numerous indications supporting the assumption that ribbed vaults were employed, not so much for their constructive qualities, as for their aesthetic applicability. A good example would be the choice of cross-ribbed vaults to cover monks' dormitories and refectories, whereas lay-brothers' domiciles in thirteenth century Cistercian monasteries were covered with simple groin vaults (compare the dormitories in Eberbach to the refectories in Maulbronn).

Evidently, ribbed vaulting was seen as a more dignified and exclusive architectural form.

260 For a closer look at the catastrophes of the fourteenth-century Le Goff (note 152); George Duby, *Die Grundlegung eines modernen Humanismus. 1280–1440*, in the series *Kunst, Ideen, Geschichte*, vol. 7 (Geneva 1966) 11ff.; Ruggero Romano and Alerto Tenenti, "Die Grundlegung der modernen Welt," *Fischer Weltgeschichte*, vol. 12 (Frankfurt 1967) 9–47; and Tuchman (note 23). For a survey of the rich amount of literature on the subject see Harry A. Miskimin, *The Economy of Early Renaissance Europe, 1300–1460* (Englewood Cliffs, N.Y. 1969); and Fransisek Graus, "Das Spätmittelalter als Krisenzeit – Literaturbericht als Zwischenbilanz," *Mediaevalia Bohemia* supplement (Prague 1969).

261 Representatives of this theory are Gerstenberg 1913 and Pinder 1952.

262 Grodecki 1976, 26ff.

263 Gross (note 162) 50ff., 61ff.

264 Behling 1937, 50ff. sites Dehio as her authority but does not indicate exactly where in Dehio. Recht characterizes the period after 1310 as "mannerist Gothic" but in the end he bases this on something similar, namely the elegance and subtlety of articulated form. Roland Recht, *L'Alsace gothique de 1300 à 1365* (Colmar 1974) 217. The term "doctrinaire" originated in studies of the presentation of the human figure in the fourteenth-century. It was transfered to architecture by Bachmann, Swoboda and Mencl. See also Jan Bialostocki, "Late Gothic, Disagreements about the Concept," *Journal of the British Archeological Association* 3, s.39 1966, 76–105, here 90.

265 Karl Maria Swoboda, "Klassische Züge in der Kunst des Prager Deutschen Dombaumeisters Peter Parler," idem and Erich Bachmann, *Studien zu Peter Parler* (Brünn-Leipzig 1939) 9–25.

266 Lisa Schürenberg, *Die kirchliche Baukunst in Frankreich zwischen 1270 und 1380* (Berlin 1934). Philippe Chapu, "Architecture," *Les fastes du Gothique. Le siècle de Charles V* exhibition catalogue from Paris 1981: 49–53.

267 Robert Suckale, "Thesen zum Bedeutungswandel der gotischen Fensterrose," *Bauwerk und Bildwerk im Hochmittelalter. Anschauliche Beiträge zur Kultur- und Sozialgeschichte*, Karl Clausberg, Dieter Kimpel, Hans Joachim Kunst eds., in the series *Kunstwissenschaftliche Untersuchungen des Ulmer Vereins*, vol. 11 (Giessen 1981) 259–94.

268 Günther Bandmann, "Ikonologie des Ornaments und der Dekoration," *Jahrbuch für Ästhetik und allgemeine Kunstwissenschaft*, vol. 4, 1958/59, 232–58.

269 Hans Weigert, "Die Stilstufen der deutschen Plastik von 1250 bis 1350," *MJK* 3, 1927, 147–271. For an excellent picture of the gradual move to abstract, non-representational foliage work see Hermann Josef Roth, "Die bauplastischen Pflanzendarstellungen des Mittelalters im Kölner Dom," in *Europäische Hochschulschriften*, series 28, vol. 117 (Franfurt-am-Main 1990). Roth found very few botanical forms in Cologne Cathedral's foliage work that could be clearly identifed as belonging to a known genus or species. Most were abstracted from individual morphological elements of a natural prototype, in order to present the illusion of being based on a recognizable and complete plant. The spatial placement of the foliage work in the Gothic choir seems to be random. As to those plant forms representing theological symbols or medicinal properties, no decorative system inherent in their architectonic organization can be found either. The process by which the foliage work at Cologne Cathedral became more and more abstract evidently did not take place at the Cistercian lodge in nearby Altenberg, which was being built at roughly the same time. The capital zones of its choir (completed end of thirteenth century) are done up in forms as they occur in nature. Roth attributes this to the agricultural activity of Altenberg's monks, and their

intimate knowledge of the plants in the area around the monastery. See Hermann Josef Roth, *Die Pflanzen in der Bauplastik des Altenberger Domes. Ein Beitrag zur Kunstgeschichte und zur mittelalterlichen Botanik* (Bergisch-Gladbach 1976) 81–2. Altenberg's use of the cut-and-fill technique, as well as the articulated structural framework of its choir walls, were executed in a way that was rather traditional for its time. Because of this, it seems more probable that the natural forms of Altenberg's foliage work can be attributed to its conservative lodge, and to the non-innovative attitude it had towards style in general.

270 Michler 1977, 55ff. Also idem, "Gotische Ausmalungssysteme am Bodensee," *Jahrbuch der Staatlichen Kunstsammlungen in Baden-Württemberg*, 23, 1986, 32–57. Idem, "Die Dominikanerkirche in Konstanz und die Farbe in der Bettelordensarchitektur um 1300," *ZKG* 55, 1990, 253–76. Michler traces the white surface color and the ornamental friezes of the clerestory of Constance's Dominican church to northern Italy. From there it was more than likely communicated to Constance via Italian Dominicans.

271 The colors of St. Catherine's choir in Lübeck (in use 1325) survived intact and were restored in 1974. The choir's articulated elements are gray, with raised red and white surface rustication. Regensburg Cathedral was originally all white. It was executed in different phases during the building of the inner structure, after 1300. The white limestone walls were left unmortared and only whitewashed with chalk in locations where sporadic use of sandstone blocks required it. All the vault webs were completely whitewashed and only sparsely accented by the use of colorful bosses partially inlaid with gold, and decorative *manschettes* on the moldings of ribs and transverse arches. Research indicates that the southern side-chapel, the oldest section of Regensburg, diverged a little from this polychromy system in that its vault ribs were painted a roof-tile red, had white joints and were set off from the chalky white of the vault webs by a dark gray strip that ran lengthwise along the rib edge. Colorfully painted *manschettes* decorated the apexes of the vaults there. Air holes in the vault webs were rimmed by red stars and flowers. See Michael Kühlenthal, "Die Innenrestaurierung des Regensburger Doms. Historische Farbigkeit und Restaurierungskonzept," *KC* 42, 1989, 348–53.

272 Böker interprets the decision to build the west façade, before building the nave and transept on to the already completed choir, as being the direct result of the Battle of Worringen in 1288, in whose aftermath the archbishop of Cologne was forced to flee the city and the way paved for creation of a city regiment under the secular control of rich merchant families. The reason the south-façade tower was built first, Böker writes, was because of "a fundamental change in thinking of the major donors, who wanted it to represent something far different than Archbishop Konrad von Hochstaden's choir." The cathedral chapter's construction of a huge cathedral in the west facing the city, Böker goes on, appears to have been "an architectonic statement against the push by the burghers for autonomy.... Compared to the radial chapels of the choir ambulatory that reach out in all directions, and its vertically articulated and extremely slender clerestory, the façade tower's closed stone seeks to express the archbishop's claim to power through his cathedral chapter, via an imposing structure outfitted with a complete system of Gothic forms." Hans Josef Böker, "Prag oder Köln? Das architekturgeschichtliche Beziehungsfeld der süd-niedersächsischen Stadtpfarrkirchen zu Beginn der Spätgotik," *NBK* 22, 1983, 9–27, here 22. It is difficult to agree with what is obviously a historical construct here.

273 Ulrich Back, "Die Domgrabung XXXIII. Die Ausgrabungen im Bereich des Südturms," *Kölner Domblatt* 59, 1994, 193–224. For more about "Plan F" see Arnold Wolff, "Mittelalterliche Planzeichnungen

für das Langhaus des Kölner Domes," *Kölner Domblatt* 30, 1969, 137–78. Idem, *Der gotische Dom in Köln* (Cologne 1986). Reinhard Liess, *Der Rahnsche Riß A* (note 166) note 43, 47 dates "Plan F" around 1280. He arrives at this rather early dating using the same arguments that were employed to compare and date Strasbourg's west-façade sketches.

274 This information comes from Arnold Wolff, *Parler*, vol. 1, 148.

275 Hans Kauffmann, "Die Kölner Domfassade," *KDF* 78–138, here 106f.

276 Other churches from this period to renounce the use of imposts on portals are Freiburg porch portal; Mainz, Our Lady's portal; and the Predigerkirche in Erfurt. For examples of window jambs and mullions without bases or capitals see Hans Joachim Kunst, *Hallenumgangschor* (note 199) 19 and note 99. Other churches to lack these elements are the Minorite church, Cologne, St. Blasius, Mühlhausen (choir), the Cistercian church in Haina (nave), the parish church in Frankenberg, and St. Mary's, Wetzlar.

277 Gross (note 162) 30.

278 This information comes from Berhard Schütz, "Die Katharinenkirche in Oppenheim," in the series *Beiträge zur Kunstgeschichte*, vol. 17 (Berlin–New York 1982).

279 One of the many interesting forms at Salem, much of which has not survived in its original form, was the square termination of its choir with ambulatory, whose clerestory terminated in a polygon. See Jürgen Michler, "Die ursprüngliche Chorform der Zisterzienserkirche in Salem," *ZKG* 47, 1984, 3–46. For more on the history of Salem's construction see *idem*, "Dendrochronologische Datierung des Salemer Münsters," *KC* 38, 1985, 225–8.

280 In the windows of the Wiesenkirche in Soest (probably begun 1313) the transoms are formed by trilobed arches and quatrefoils. The choir windows of St. Paul in Liège (1334) have similar transoms. Harvey 1969, 89, assumes, perhaps correctly, that the prototype for this motif can be found in the windows of the early English perpendicular style.

281 New information about the history of the building of St. Mary's choir and nave can be found in Bruno Kadauke, "Die Architekturzeichnungen in der Reutlinger Marienkirche," *ZKG* 46, 1983, 295–306. Also in *idem, Die Marienkirche in Reutlingen aus kunsthistorischer Sicht. Mit einem Beitrag von Klaus Ehrlich* (Reutlingen 1987).

282 The church was destroyed by fire in 1726 and most of it restored in the second half of the nineteenth century. The majority of the façade, however, is medieval.

283 Gerstenberg 1913, 21, 114.

284 Ibid, 19, 23, 131. Wilhelm Lübke was the first to interpret the Hall form as reflecting the egalitarian values of town life. Wilhelm Lübke, *Die mittelalterliche Kunst in Westfalen. Nach den vorhandenen Denkmälern dargestellt, nebst einem Atlas lithographirter Tafeln* (Leipzig 1883) 37. For a comparison to Lübke's theory see Wolfgang Schenkluhn, "Die Erfindung der Hallenkirche in der Kunstgeschichte," *MJK* 22, 1989, 193–203.

285 Richard Hamann, *Die Elisabethkirche zu Marburg* (Burg, Magdeburg 1938) 7.

286 Karl Heinz Clasen, *Die Baukunst an der Ostseeküste* (Dresden 1955) 46. Nikolaus Zaske, *Gotische Backsteinkirchen Norddeutschlands*, 2nd ed. (Leipzig 1970) 59ff. Ullmann 1981, 43, 69.

287 Hans Joachim Kunst, "Zur Ideologie der deutschen Hallenkirche als Einheitsraum," *Architectura* 1, 1971 38–53. Kunst shows how this interpretation – that the Hall type reflects the ideology of its builders – does not stand up to closer examination by looking closely at the churches built during this period in the town of Lüneburg. It appears that the "non-feudalistic" Hall was preferred by aristocratic builders. St. Nikolai, on the other hand, is based

on the "aristocratic" basilican plan of St. Mary's, Lübeck, yet it was promoted by the burgher-controlled city council and partially paid for the ship builders and coopers' guilds. Hans Joachim Kunst, "Die Kirchen in Lüneburg – Architektur als Abbild," *Architektur des Mittelalters. Funktion und Gestalt*, Friedrich Möbius and Ernst Schubert, eds. (Weimar 1983) 273–85.

288 Longitudinally organized churches of this kind from the fifteenth century are in Stendal – the cathedral and St. Mary's.

289 Georg Rudolph, "Mitteldeutsche Hallen-Kirchen und die erste Stufe der Spätgotik," *Jahrbuch für Kunstwissenschaft* 1930, 137–75.

290 See the clerestory windows (completed in the 1280s) at Soest. A consecration ceremony has survived from 1292, making it possible that construction could have begun there shortly after 1280. Wolff (note 194) and Schenkluhn (note 218) 86ff.

291 Others to have spoken out against the traditionally held notion of Marburg as the prototype here, are Schenkluhn (note 218) 86 and Pieper (note 203) 114–15. The "lying" trefoils of the Franciscan Hall in Münster, which can be found in Altenberg's choir, also indicate a Rhenish influence.

292 Götz 1968: 157ff. Choir solutions in Lower Saxony similar to Maria-zur-Wiese are St. Catherine's, Braunschweig (choir extended eastward, first third of the fourteenth century), Marktkirche St. George in Hannover (begun after 1290, eastern sections completed 1340). For a dating of St. George's see Hans Josef Böker, "Die Marktkirche in Hannover. Zur zeitlichen Stellung der gotischen Backsteinhalle," in *NBK* 25, 1986: 33–46.

293 Besides the relationship of these motifs, Cologne Cathedral's double-aisle south-tower Hall could have provided inspiration for the general Hall form of St. Maria-zur-Wiese. See Böker's review of Richard Hoppe-Sailer, Die Kirche St. Maria-zur-Wiese in Soest. Versuch einer Raumanalyse, in the series *Bochumer Schriften zur Kunstgeschichte*, vol. 2 (Frankfurt am Main – Bern 1983) published in *Westfalen. Hefte für Geschichte, Kunst und Volkskunde*, vol. 63, 1985, 142–4.

294 The inscription cannot be made out. Gross read the date construction began as 1331 (Gross 1972, 209) and Krautheimer as 1343 (note 211) 93.

295 Böker (note 272) 24 suspects that the building of the western sections of Maria zur Wiese was a politically motivated undertaking meant to compete with Cologne Cathedral's façade. The town of Soest was able to leave the protectorate of Cologne-Westphalia in 1444 because of an older pact it had with the Duke of Kleve-Mark. After that the town remained subservient the House of Kleve.

296 The church was partially destroyed by fire in 1396. The vaults are fifteenth century.

297 For more about the somewhat controversial dating of these churches see Eberhard Grunsky, *Doppelgeschossige Johanniterkirchen und verwandte Bauten*, (Diss. Tübingen 1970) 187ff.; Reinhard Weidl, *Die ersten Hallenkirchen der Gotik in Bayern. Ein Beitrag zur Entwicklungsgeschichte des Sakralraumes im 14. Jahrhundert*, MA thesis, Munich University 1987: 11ff., 17ff., 45ff., in the series *Schriften aus dem Institut für Kunstgeschichte der Universität München*, vol. 12; and Emanuel Norbert Braun, *Die mittelalterlichen Spitalkirchen in Altbayern. Studien zur Typologie und zum Verhältnis von Bauaufgabe und Architektur*, Diss. Munich 1980 (Munich 1983) 159ff., 197ff. Braun, idem, 47, 96, 121, suspects the prototype for the flat choir terminations of both hospice churches to have been influenced by monastery architecture, for example the dormitories and hospice Hall structures of the Cistercian order.

298 Richard Kurt Donin, *Die Bettelordenskirchen in Österreich. Zur Entwicklungsgeschichte der österreichischen Gotik* (Baden, Austria 1935) 326, 353ff. See also Rupert Feuchtmüller and Peter Kodera, *Der Wiener Stephansdom* (Vienna 1978) 76ff.

299 The previous church was torn down in 1325 probably at a point in time when, according to medieval practice, the new choir was already consecrated and in use. In any case, the earliest donations for the altar to have survived are from 1323. Böker 1988, 181.

300 Alkmar Freiherr von Ledebur, *Der Chormittelpfeiler. Zur Genese eines Architeturmotivs des Hans von Burghausen*, Diss. Munich 1977.

301 Götz 1968, 77, dates Pasewalk after 1300. Gross 1972, 224 dates it mid-fourteenth century.

302 Gross (note 162) 50.

303 M. Tumler, *Der Deutsche Orden im Werden, Wachsen und Wirken bis 1400* (Vienna 1955).

304 Ernst Gall, *Danzig und das Land an der Weichsel* (Munich 1953); Clasen 1958: 34ff.; Marian Kutzner, "Spoleczne warunki ksztaltowania sie cech indywidualnych sakralnej architektury gotyckiej na Warmii," *Sztuka pobrzeza Battyku* ed. J. Bialolstocki (Warsaw 1978) 49–88; Jósef Tomasz Frazik, "Sklepiena gotyckie w Prusach, na Pomorzu Gdanskim i w Ziemi Chelminskiej," *Kwartalnik Architektury i Ubanistyki* 30, 1985, no. 1, 3–25; and Teresa Mroczko, *Architektura Gotycka na Ziemi Chelminskiej* (Warsaw 1980).

305 These six churches are St. Elizabeth, Holy Cross, Sandkirche, St. Vincenz, Adalbertkirche and Dorotheenkirche.

306 For a survey of this topic see Hans Tintelnot, *Die mittelalterliche Baukunst Schlesiens* (Kitzingen 1951).

307 Götz 1968, 36ff.; and Teresia Jacobi and Frauke Scherf (note 190) 125–34.

308 Copies of vault forms common to the Baltic region might be the four-point rhomboid stars with diagonal ribs over the central vessel of Breslau's Sandkirche, which were completed around mid-century. The same figures can be found in the vaults of the cathedrals of Kulmsee (nave) and Frauenburg (choir). A further source of inspiration for the early figured vaults of Silesia could have been the triradial motifs in the main choir of Krakow Cathedral, which were part of that church's oldest executed plan from 1320. See Jósef Tomasz Frazik, "Sklepienia tak zwane Piastowskie w Katedrze Wawelskiej," *Studia do Dziejów Wawelu* 3, 1968, 127–47; idem, "Zagadnienie sklepien o przestach trójpodporowych w architekturze sredniowiecznej," *Folia Historiae Artium* 4, 1967, 5–91, here 89–91; Crossley (note 109) and idem., "The Vaults of Kraków Cathedral and the Cistercian Tradition," *Podlug Nieba i Zwyczaju Polskiego. Studia z historii Architectury: Sztuki i Kultury Ofiarowane Adamowi Milobedzkiemu* (Warsaw 1988) 63–72.

309 For a survey of the Franciscan *Langchor* chancel see Binding (note 208) 437f.

310 The three western pairs of supports are Romanesque compound piers turned diagonally in relation to the nave. Parts of the central vessel and the northern side-aisles collapsed in 1838. Most of the nave was destroyed in 1944. It has since been completely restored.

311 Either the springers of the vaults rest on an arcade pier or on a console placed above the crown of the arcade arch. In the early vaulted basilican naves of Mendicant Order churches (Dominican churches in Esslingen, Strasbourg and Erfurt) with their short, corbelled responds, we find arcades that do not correspond to the vaulted bays above them. The rooms here are not divided up into vertical sections. The vaulting alone establishes continuity between the various articulated elements. Erfurt's Barfüsser church is in this tradition.

312 According to the *Annalen der Thanner Barfüsser*, Konow (note 205) 28.

313 Compare to Michler (note 270) 272.

314 Konow (note 205) 24.

315 Schenkluhn, "Ordines Studentes" (note 224) 106ff. points out that Colmar's arcade wall, which lacks a clerestory, and the leaning ceiling over its side-aisles can be found in the Dominican church of San

Giovanni in Canale in Piacenza (begun 1230). His reference to Cistercian farm buildings of very similar construction built around 1200 (barns at Moubuisson and Vaulerent, Seine-et-Oise), seems perhaps more pertinent here.

316 Michler (note 279) 46 has written something similar on this theme: "Obviously, architecture around the year 1300 was faced with the decision whether or not to compress the style or to reduce it: whether to fuse the elements of complex articulated systems into a compressed clarity, or seek clarity by reducing articulation to a few emphasized motifs. The decision was for reduction, and development then turned away from complex structural systems." Doubts can be raised about this last sentence, however. The notion that two contradictory options inherently demand that only one of them be chosen is seldom consistent with historical reality. As clear and prominent a period style was, it always occurred within a wider range of possible styles which included reactions against it and grey areas where styles were mixed. For more about differences between contemporary building styles see Chapter I.

317 For more about the correlation between changing notions of piety, and about a decentralization in the organization and celebration of the Liturgy in medieval times, see Anton L. Mayer, "Die Liturgie und der Geist der Gotik," *Jahrbuch für Liturgiewissenschaft* 6, 1926, 68–97; and E. Iserloh, "Der Wert der Messe in der Diskussion der Theologen vom Mittelalter bis zum 16. Jahrhundert," *Zeitschrift für katholische Theologie* 83, 1961, 44–79.

318 Local researchers suspect that it might be the tomb of the House of Wallsee-Drosendorf. Wagner-Rieger (note 116) 293.

319 Donin (note 298) 170f. dates the chapel to the late thirteenth century.

320 For more examples of "spandrel mouchettes" see Behling 1937, 62–3.

321 The most famous design to use this motif, a system of arches whose columns are offset so that one of them stands in front of the arch opening of the other, is Early English – namely, the wall-base arcading in the choir side-aisle of Lincoln Cathedral (begun 1192 by Gaufrido de Noiers). Here an arcade made up of pointed arches is placed before and offset to a somewhat higher blind arcade of trilobed arches. Earlier forms of this kind can be found in the triforium above the east arcades at the Cathedral of Chichester and, even older, the many overlapping rows of arches to be found in Anglo-Norman architecture. Branner (note 62) 59 points out that there are similar arch configurations in Canterbury's transept and Lausanne's north transept (not built). The triforium of the west façade at St-Remi in Reims contains arches whose small columns are placed before the middle of the window. One of the few examples from the Rayonnant style – also a case of two rows of arches, one behind the other – would be the arcading below the north transept rose window at Amiens (first quarter of the fourteenth century). Here the standing tracery is offset in relation to the articulated wall skeleton behind it. Similar configurations can be found in Burgundian High Gothic. The transept terminal walls of Notre-Dame in Dijon, for example, possess a triforium whose sections consist of five lancets outside, and three segmental arches inside arranged so that their small columns stand before the middle of the lancet openings.

322 The west portal of Regensburg Cathedral (1390s) and the two "Prince's Portals" of St. Stephan's in Vienna (around mid-fifteenth century) are very similar to the Erfurt triangle. Furthermore, there are many southern-German portals of a similar motif. See Norbert Nussbaum, *Die Braunauer Bürgerspitalkirche und die spätgotischen Dreistützenbauten in Bayern und Österreich*, Diss. Cologne 1982: 181–6, in the series *Veröffentlichungen der Abteilung Architektur des Kunsthistorischen Instituts der Universität zu Köln*, vol. 21.

323 Nearly contemporary to these are the tracery

strainer arches in the side-aisles of St. Augustine, Bristol, where they play a structural role similar to a flying buttress. They help brace the bays of the side-aisle and carry one of the imposts of the double vaults. Other "flying ribs" in England during this time can be found in the Easter Sepulchre at Lincoln Cathedral (before 1300), in the vestibule of Berkeley Chapel at St. Augustine, Bristol (around 1300) and at the pulpit at Southwell (1320–30). See Frankl 1962, 149f.

324 For more about *baldachin* spatial organization within Gothic spaces see Hans Sedlmayr, *Die Entstehung der gotischen Kathedrale*, 2nd ed. (Graz 1976), *passim*.

325 Müller 1990, 309 rightly points out that, compared to a stellar vault of the same figure, an umbrella vault is a much stronger structure. Its centrally placed pier shortens the distance that the vault ribs must span, and at the same time lowers the vault crown. Whether or not umbrella vaulting can be attributed, first and foremost, to the "realm of technology" as Müller assumes, or whether the umbrella's effect on the space below it was the reason for its employment, has yet to be clarified.

326 The funnel-like appearance of the umbrella vault when seen from above lead Fehr to the concept of the "funnel vault." But the projection of the vault upwards and to all sides like an umbrella cannot, of course, be observed from above. See Götz Fehr, *Benedikt Ried. Ein deutscher Baumeister zwischen Gotik und Renaissance in Böhmen* (Munich 1961) 85.

327 Richard Krautheimer, *Mittelalterliche Synagogen* (Berlin 1927) 100–2; Hans Sedlmayr, "Säulen mitten im Raum," idem, *Epochen und Werke*, vol. 1 (Vienna-Munich 1959) 199–201.

328 A typical Late Romanesque space of this kind can be found in the chapterhouse of the Cistercian monastery at Zwettl (2nd half of the twelfth century). During the Gothic period, this kind of space was typically used for the sacristy. See, for instance, Auxerre Cathedral (end of the twelfth century), Cologne Minorite choir (consecrated 1260), Cologne Cathedral sacristy (consecrated 1277), Marburg St. Elizabeth (shortly before 1283) and Soest Neu-St. Thomas (beginning of the fourteenth century).

329 Words of Abbot Richard de Ware of Westminster (1258–83) concerning the chapterhouse there. Quoted from Götz 1968, 317.

330 Ibid., 317 with bibliography.

331 That there was an independent development of the umbrella vault within continental parameters is at the very least possible. As early as 1235, Villard d'Honnecourt had drawn up a design for a centralized room, the sketch of which is reminiscent of an umbrella-like structure. Admittedly, however, this sketch can also be interpreted as a stellar vault with a large, centrally placed boss. For more about the ambiguity of Villard's floor plan see Roland Bechmann, *Villard de Honnecourt. La pensée technique au XIII siècle et sa communication* (Paris 1991) 118–21. Hahnloser interprets the sketched space as a chapter house. Perhaps the sketch can be traced to English sources. Hahnloser (note 84) 368f. The first large-scale umbrella vault of the French Gothic was built over the choir of the double-nave Dominican church at Toulouse, the so-called Jacobin Church (choir rebuilt between 1275–92). For its history see note 221.

332 Churches lacking diagonal ribs are St. Andreas in Lienz, Tirol (mid-fifteenth century) and St. Ägidienkirche in Oschatz, Saxony (around 1464). Those retaining the diagonal rib are Breisach Minster (rebuilt mid-fifteenth century) and St. Nikolai in Lüneburg (beginning of the fifteenth century) built over a six-sided floor plan.

333 For an iconological study of crypts with a central pier see Götz 1968, 236–52.

334 Crossley (note 251) 179. Böker 1988, 149–51 dates the vaulting of the "Letter Chapel" as belonging to the middle or second half of the fourteenth century

using arguments based on historical records and a comparative study of vault styles that are, alas, not convincing. A survey of research on the chapel can be found in William Steinke, "Die Briefkapelle zu Lübeck: ihre Herkunkft und ihre Beziehung zum Kapitelsaal des Marienburg," *Jahrbuch des St. Marien-Bauvereins* 8, 1974/1975, 55–71. See also Paul Crossley, "Wells, the West Country, and Central European Late Gothic," *Medieval Art and Architecture at Wells and Glastonbury* (Leeds 1981) 81–109, here 82ff., in the series *The British Archeological Association. Conference Transactions for the year 1978*, vol. 4.

335 About 85% of the vaulting of the "Letter Chapel" was renovated in 1834 based on the surviving rudiments of its rib work. The polychromy we find there today – white walls, ocher responds and piers, ribs in an exchange of vermillion and azure blue, colorful capitals against a blue or red background – is based on surviving sections of the original vault surface, and supports the notion that the umbrella vault was organized to aesthetically dominate the walls, which were left white and seen as a bordering foil only. See Stefan Kummer, "Archäologische Aufschlüsse zur Baugeschichte der Briefkapelle an St. Marien in Lübeck," *DKD* 35, 1977, 139–47; and also Eugeniusz Gasierowski, "Die Briefkapelle der St. Marienkirche zu Lübeck," ibid., 148–64.

336 The dating that Clasen 1958, 40ff. gives Marienburg's chapterhouse (*ca.*1300) and refectory (*ca.*1320) is too early. According to the newest findings, the chapterhouse (vaulting restored 1886–90) could not have been built earlier than the 1320s. See Szczesny Skibinski, *Kaplica na Zamku Wysokim w Malborku* (Poznan 1982) 88–89, in the series *Universytet im. AM w Poznaniu, Seria Historia Sztuki*, vol. 14; and Crossley (note 251) 174–7. Frycz believes these buildings were constructed during the period that Luther von Braunschweig was active as head of the Teutonic Order (1331–5). Jerzy Frycz, "Die Burgbauten des Ritterordens in Preussen," *ZEMAU* 29, 1980, 45–56, here 53.

337 Clasen 1958, 48ff.

338 One of the only single-pier rooms with umbrella vaulting built during this period in the area of the Danube River was at the St. Thomas Chapel in Regensburg (early fourteenth century) a private chapel of the patrician House of Auer. Here an eight-point rhomboid star was placed over a four-sided, box-like room, from which a small choir opens to one side. See Götz 1968, 117f.

339 The springers of the older vault can still be seen over the new ones.

340 Quotation from Roland Recht, "Strasbourg et Prague," in *Parler*, vol. 4, 106. Idem (note 264) 54ff.

341 For more about the dating of the Minorite church in Enns, Buchowiecki 1952, 236, Wagner-Rieger (note 116) 294 and Wagner-Rieger 1967, 342. Its forms bear a striking resemblance to those of St. George's Chapel built onto Vienna's Augustinian monastery church between 1337 and 1341.

342 The Minorite church in Enns was prototype for the pilgrimage church in Pöllauberg, in the Austrian state of Steiermark (probably begun around 1370), which translated its spatial concept into much larger dimensions. Wagner-Rieger 1978: 67. Brucher 1990, 116 argues for a much earlier date of construction based on the evidence of a donation from 1339.

343 This was the subtitle of a collection of essays called *Kaiser Karl IV. Staatsman und Mäzen*, Ferdinand Seibt, ed. (Munich 1978).

344 Charles was probably aware of this. The agreement in 1356 between himself and the German Electorate, which resulted in the drawing up of a charter of rights and privileges called the *Goldene Bulle*, exhibited a level of political insight that his predecessors lacked.

345 Charles had been crowned "anti-king" (*Gegenkönig*) in Bonn in 1346, a town with no previous royal function as coronation site, which facilitated the need for his second coronation in Aachen.

346 For more about the late medieval cult of Charlemagne see R. Folz, *Le Souvenir et la Légende de Charlemagne dans l'Empire germanique médiéval*, (Paris 1950) 424ff.

347 The inscription is difficult to read. The passage quoted here concerning Heinrich Parler is from Joseph Neuwirth, *Peter Parler von Gmünd. Dombaumeister in Prag und seine Familie* (Prague 1891) 114. "Petrus henrici arleri de polonia magistri de gemunden in suevia…" ("polonia" has been conventally interpreted as a mispelling of "colonia" or Cologne).

348 City Archives of Cologne, *Schreinsbuch* 465, folio 34.

349 The entry can be found under the dates 16 October 1520 and 1530. Hermann Kissling, *Parler*, vol. 1, 320.

350 Reinhard Wortmann, "Die Heiligkreuzkirche zu Gmünd und die Parlerarchitektur in Schwaben," *Parler*, vol. 1, 315–18, here 315, dates the change in design as having taken place between 1320–5. The other early Hall nave in Swabia, that of Our Lady in Esslingen, was probably not begun until around 1350. See also Hans Koepf, "Die Esslinger Frauenkirche und ihre Meister," *Esslinger Studien* 19, 1980, 1–46, here 4ff.

351 Kissling, *Parler*, vol. 1, 319.

352 Reinhard Wortmann, "Die süddeutsche Wurzel der Langhausarchitektur der Heiligkreuzkirche in Schwäbisch-Gmünd," *Parler*, vol. 4, 118–22 expresses just such doubts. However, at several places in the nave at Gmünd we find the stonemason's square, which is a symbol on the coat of arms of the Parler family.

353 Gerstenberg 1913, 59 describes the singularity of this chapel type in a very perceptive way: "The Gothic chapel is narrow and square, and on the slightly protruding surfaces of its side walls is the pier buttress. In the special Gothic the chapel simply fills the space between the pier buttresses with a straight-wall termination. There it rests, embedded in the wall, looking more like it has been pushed in from the outside, rather than forced out from the inside."

354 To describe this state of affairs, a young Frankl (note 43) came up with the concept of *divisiver Raum* or divisional space which – in contrast to the "additive" and geometric spatial organization of Romanesque, Early and High Gothic structures – came about through the "subdivision of the whole structure, which surely is only to be understood in relation to the structure as a whole." In this respect, in churches displaying a divisional space system the structure as a whole was standing before its parts. A very detailed interpretation of the Hall choir at Gmünd, based on a Late Medieval world view, is presented by Klaus Lange, "Raum und Subjektivität. Strategien der Raumvereinheitlichung im Chor des Heilig-Kreuz-Münsters zu Schwäbisch-Gmünd," Diss. Bochum 1987 (Frankfurt am Main, Bern, New York, Paris 1988) in the series *Bochumer Schriften zu Kunstgeschichte*, vol. 11. Like all analyses of this type, his study exemplifies the danger in over-interpreting what are, after all, only *possible* reasons behind the design.

355 For more on the development of this choir form see von Ledebur (note 300) 57ff.

356 The wall buttresses at Zwettl, however, taper off into spikes thereby lending the chapels a rectangular shape, while the choir chapels at Gmünd are trapezoidal. Furthermore, Gmünd's choir terminates in seven, Zwettl's in nine sides. The windows at Zwettl are so different in form, size and wall-placement that it is hardly possible to trace them to Gmünd. See Hermann Kissling, *Das Münster in Schwäbisch Gmünd. Studien zur Baugeschichte, Plastik und Ausstattung* (Schwäbisch Gmünd 1975) 47–9. Zwettl's ambulatory choir can be traced to the Cistercian church in Sedletz (*ca.*1290–1320), which was the earliest surviving church in eastern-central Europe to possess trapezoidal bays in combination with triangular bays. Also Kunst "Hallenumgangschor" (note 199) 94.

357 For the reconstruction of the ambulatory vaulting I have relied on von Ledebur (note 300) 58.

358 Günter Bräutigam, "Gmünd-Prag-Nürnberg. Die Nürnberger Frauenkirche und der Prager Parlerstil vor 1360," *Jahrbuch der Berliner Museen 3*, 1961, 38–75, *passim*. For a more detailed account see Georg Schmidt, "Peter Parler und Heinrich IV. Parler als Bildhauer," *Wiener Jahrbuch für Kunstgeschichte* 23, 1970, 108–53. The many similarities with Prague allow us to wonder seriously whether or not Peter Parler himself was the decisive influence on his father's choir design in Gmünd. Wortmann (note 351) 317, Robert Suckale, "Peter Parler und das Problem der Stillagen," *Parler*, vol. 4, 175–83, here 182. And while Peter's age upon his arrival in Prague makes this rather improbable, it does not disallow the possiblility that he spent his apprenticeship in the lodge at Gmünd.

359 Gross 1969, 157 is typical for this type of adulation among contemporary Gothic scholars. "For urban church architecture, however, Gmünd's subtly brilliant choir form became prototype for almost all of southern Germany's larger parish churches." Fischer 1971, 80 sees most of southern Germany's ambulatory choirs after 1350 as traceable to Gmünd.

360 For information about these "alternative" choir forms see Kunst "Hallenumgangschor" (note 199) 88ff.

361 Peter Anstett, *Das Martinsmünster zu Colmar. Beiträge zur Geschichte des gotischen Kirchenbaus in Elsass*, in the series *Forschungen zur Geschichte der Kunst am Obberrhein* vol. 8 (Berlin 1966) 53ff.; and Recht (note 264) 198ff. This choir type, lacking chapels, can be found around 1300 at St. Ägidienkirche, Braunschweig.

362 St. Mary's high altar was consecrated in 1367. Destroyed in 1945, the church has remained a ruin ever since. Despite this *primary* source, Böker 1988, 224 argues for the date construction began to be after 1373, the year the city of Frankfurt-an-der-Oder joined the protectorate of Charles IV, and in the years to follow profited from the territorial and trade policies of the House of Luxembourg.

363 Both Günter Schade, "St. Nikolai in Berlin. Ein baugeschichtlicher Deutungsversuch des Hallenchores mit Kapellenkranz," *Jahrbuch für brandenburgische Landesgeschichte 17*, 1966, 52–61, here 55; and Fritz Wochnik, *Ursprung und Entwicklung der Umgangschoranlage im Sakralbau der norddeutschen Backsteingotik*, Diss. Berlin 1982 (summary can be found in the periodical *Das Münster 36*, 1983, 241–2) trace the choir at Frankfurt to St. Sebald's in Nuremberg (1361–79), and arrive at a dating of after 1361. This etymology is disputable. Neither the ratio of the inner to the outer polygon, nor the vault figures are the same, not to mention the stylistic differences of the individual articulated elements which, at least in part, came about due to differences in material.

364 A letter of indulgence indicates a building period from 1379 to 1402. In the year 1460, the nave was still unfinished. Böker 1988, 221.

365 Opinions concerning the exact dating of Berlin's choir have differed over the years. Nikolaus Zaske, "Hinrich Brunsberg, ein ordenspreussischer Baumeister der Spätgotik," *Baltische Studien NF* 44, 1957, 49–72, here 56, feels that the majority of the structure was already standing by 1379. Schade (see note 363: 53ff.) believes the choir, as we know it today, was completed around 1460. A letter of indulgence from 1379 has survived, which strongly supports the earlier dating. Schade and Wochnik (see note 363) allow as prototypes St. Sebald in Nuremberg and Schwäbisch Gmünd. However, questions about Berlin's choir – which was completely destroyed in the Second World War – will remain open as long as nothing new comes to light concerning the year it was begun.

366 Other naves to possess "wall" chapels are St. Johannis (outer side-aisles completed 1372) and St. Michael (begun 1376, consecration 1418) both in the

town of Lüneburg, along with those churches to follow their design example. However, because of its Zwettl-type choir scheme, a southern German or Austrian source as prototype for Berlin's chapel motif appears more likely.

367 Werner Gross, "Mitteldeutsche Chorfassaden um 1400," *Festschrift Wolf Schubert* (Weimar 1967) 117–41, here 122ff. Forms that, for Gross, can clearly be attributed to these churches are the ends of the pier buttress register, its tabernacles and huge crown of crocketed forms (Mantes) and register delineation via triangular gabling (Cologne).

368 Koepf (note 350) 4f regards construction to have begun on the nave at Esslingen around 1350. The three eastern bays were already completed by 1365.

369 The history and dating of this church have been controversial. Brucher 1990, 116–20.

370 Wagner-Rieger 1967, 342 and 1978, 63f., sees the Wallseer Chapel in Enns and the pilgrimage church in Pöllauberg, Steiermark Austria as the most probable prototypes for this feature at St. Lambrecht's choir. On the other hand, neither of these churches possess pier arcading that runs right up to the eastern terminal wall, a motif that dominates the choirs at Heiligenkreuz and Neuberg.

371 Johannes' seal has survived and can be found in the Freiburg City Archives. It is part of a medieval contract dating from 8 January 1359 that engaged Johannes as lodge master for life. No doubt the contract replaced an older contract of shorter duration.

372 Basel, City Archives, *Domstift Urkunde* 100.

373 For more on the lively discussion concerning the construction history of Augsburg Cathedral see Hans Puchta, "Zur Baugeschichte des Ostchores des Augsburger Domes," *Jahrbuch des Vereins für Augsburger Bistumsgeschichte* 14, 1980, 77–86; Hans Josef Böker, "Der Augsburger Dom-Ostchor. Überlegungen zu seiner Planungsgeschichte im 14. Jahrhundert," *Zeitschrift des historischen Vereins für Schwaben* 77, 1983, 90–102; Friedrich Kobler, "Baugeschichte des Ostchores, kunsthistorische Beurteilung der Portalskulpturen," *Das Südportal des Ausburger Domes. Geschichte und Konservierung* in the series *Arbeitshefte des Bayerischen Landesamtes für Denkmalpflege*, vol. 23 (Munich 1984) 7–29; Herbert Hufnagel, "Zur Baugeschichte des Ostchores des Augsburger Domes," *Architectura 1987*, 32–44; and Denis A. Chevalley, *Der Dom zu Augsburg*, in the series *Die Kunstdenkmäler von Bayern*. NF 1 (Munich 1995) 68–120.

374 For an account of the building of Aachen Cathedral choir see Klaus Winands, *Zur Geschichte und Architektur des Chores und der Kapellenanbauten des Aachener Münsters*, Diss. Aachen 1987 (Recklinghausen 1989) 37–50.

375 I rely here on Hans Peter Hilger, "Marginalien zu einer Ikonographie der gotischen Chorhalle des Aachener Domes," *Kunst als Bedeutungsträger. Gedenkschrift für Günter Bandmann* (Berlin 1973) 149–68, here 149.

376 This is the reason given by cathedral chapter documents concerning the building of a new choir structure. Hilger (note 375) 151.

377 In the year 1244 Pope Innocent IV confirmed this newly won prestige with the allegory that Christ had crowned Louis the Holy with his own crown of thorns. Possession of the Crown of Thorns Reliquary increased the power and prestige of the French king as *rex christianissimus, imago Dei* and as *patronus ecclesiae.* Branner (note 159) 55.

378 The sculpture cycle was not in place until 1430, but was part of the design from the beginning of construction. Hans Peter Hilger, *Der Skulpturenzyklus im Chor des Aachener Domes. Ein Beitrag zur Kunstgeschichte des Rhein-Maas-Gebietes*, in the series *Die Kunstdenkmäler des Rheinlandes*, vol. 8 (Essen 1961) 122.

379 Ibid., 75.

380 Hans Sedlmayr, *Die Entstehung der Kathedrale* (Zurich 1950) 376ff.

381 Dorothee Hugot, *Die Erneuerung des mittelalterlichen Ringankersystems der Chorhalle durch Dombaumeister Dr.-Ing.Leo Hugot und die damit verbundene Öffunung der beiden mittelalterlichen Fenster,* Karlsverein zur Wiederherstellung des Aachener Domes publ. (Aachen 1983).

382 Primary sources from 1358–9 concerning the building of the church of Our Lady in Tienen, Brabant mention a "magister Johannes de Aquis." He had come to Tienen to meet with the resident architect Johannes de Osy. Both consulted with the church patrons and clerical administrators about the building of a choir there. Hilger (note 378) 16, and D. Roggen, "Johannes de Osy en Johannes de Aquis," *Gentse Bijdragen tot de Kunstgeschiedenis* 12, 1949/59, 103–10, here 108. Winands (note 374) 85 is sceptical about attributing Aachen's choir rebuilding to "magister Johannes." A comparison of forms of the choirs at Our Lady in Tienen and Aachen, does not reveal many similarities.

383 This was part of a general *Pogrom* against the Jewish population carried out during the plague years. A similar "undertaking" has been confirmed from the very same year in Würzburg, where the Jewish Quarter was leveled in order to build St. Mary's Chapel (after 1377).

384 For more about the building of "St. Michael's Oratory" see Robert Leyh, *Die Frauenkirche zu Nürnberg* (Munich-Zurich 1992).

385 Quoted from Günther Bräutigam, *Parler*, vol. 1: 360. Aachen's Palatinate Chapel is dedicated to the Virgin Mary and Christ (Salvator). Later in the same endowment we find the dedication to Christ named. Günther Bräutigam, "Die Nürnberger Frauenkirche, Idee und Herkunft ihrer Architektur," *Festschrift Peter Metz*, Ursula Schlegel and Claus Zoege von Manteuffel eds. (Berlin 1965) 170–97, here 174. Bräutigam interprets Nüremberg's nave – which was meant as a gathering place for the faithful and organized around a centralized space delineated by a group of four piers – as a direct reference to Aachen's Carolingian system which combines a centralized structure with porch, loft and gallery level to the west.

386 There seems to be a connection between the "St. Michael Oratory" motif of a balcony and the south transept façade at St. Mary's in Mühlhausen in the state of Thuringia, where the oversized figures of the imperial couple, accompanied by two assistant figures (lady in waiting and chamberlain?) look down benevolently from a gallery which has been placed before the windows of the upper register. Obviously this was to strengthen the kaiser's pledge that he would always be there to guarantee Mühlhausen's status as imperial city. See A. Neumeyer, "The Meaning of the Balcony-Scene at the Church of Muehlhausen in Thuringia. A Contribution to the History of 14th-Century Illusionism," *Gazette des Beaux-Arts*, 6.période, tome 50, 99. année, 1957, 305–10. See also Hans Peter Hilger, "Die Skulpturen an der südlichen Querhausfassade von St. Marien in Mühlhausen in Thüringen," in *WRJ* 22, 1960: 159–64. Neumeyer believes this represents a new "illusionism" in the sculptural arts, for the statues turn towards the observer in a life-like way and with human gestures. Sabine Czymmek, "Wirklichkeit und Illusion," *Parler*, vol. 3, 236–40 sees a similar phenomenon in the frescos created during the same period.

387 The concepts put forth in this matter by Bräutigam (note 358) 72 are generally accepted by today's scholars. Compare G.P. Fehring and Anton Ress, *Die Stadt Nürnberg*, 2nd edition by Wilhelm Schwemmer, in the series *Bayerische Kunstdenkmale*, vol. 10 (Munich 1977) 48.

388 Charles also ordered the building of the Karlshof in the Neustadt to house a college of canons. It was consecrated in the name of the Assumption of the Blessed Virgin and dedicated to the memory of Charlemagne. The collegiate church (which was later

destroyed) was octagonal with a central pier connected to a polygonal choir. Several scholars have made a connection between this structural form and Aachen's Palatinate Chapel. Götz 1968, 285–9 disagrees with this, despite Karlshof's patronage, attributing the structure (chapter founded 1350) instead to the Bohemian hospice church tradition of the single pier church.

389 For a reconstruction of the Corpus Christi Chapel from 1382 see Götz 1968, 79–83.

390 For an iconographical analysis of the Kreuzkapelle see Anton Legner, "Wände aus Edelstein und Gefässe aus Kristall," *Parler*, vol. 3, 169–82, and Christel Meier, "Edelsteinallegorese," ibid., 185–7. St. Catherine's Chapel, the *Privatoratorium* for the emperor at Castle Karlstein, is also decorated with precious stones, some of them huge.

391 Líbal and Homolka, going against accepted opinion, believe the whole chapel can be attributed to Peter Parler. Dobroslav Líbal *Parler*, vol. 2, 619, 622. *Idem*, "Grundfragen zur Entwicklung der Baukunst im Böhmischen Staat," *Parler*, vol. 4, 171–2. Jaromír Homolka, "Zu den ikonographischen Programmen Karls IV," *Parler*, vol. 2, 607–18, here 613. For an iconographical analysis of the St. Wenceslaus's Chapel see Viktor Kotrba, "Der Dom zu St. Veit in Prag," *Bohemia Sacra. Das Christentum in Böhmen 973–1973*, Ferdinand Seibt ed., (Düsseldorf 1974) 511–48, here 528–33.

392 Legner (note 390) 171.

393 For a typical account of what impression the similarly decorated Byzantine chapels left on the crusaders see the description of the Boucoleion Palace in Constantinople by Robert de Clari in *La Conquête de Constantinople*, P. Lauer ed., in the series *Les Classiques français du moyen age*, vol. 82 (Paris 1924) 81f. Compare also Legner (note 390) 174.

394 See Chronik of Beneš Krabice (+1375) *Fontes rerum Bohemicarum*, J. Elmer, J. Jirecek, F. Tadra, et al (Prague 1884) 541.

395 This is from the inscription below the bust of Matthew of Arras in the triforium.

396 For this line of thought see Jean Bony, "The English Decorated Style. Gothic Architecture Transformed 1250–1350," in the series *The Wrightsman Lectures*, vol. 10 (Ithaca, N.Y. 1979) 66; and Rainer Haussherr, "Zu Auftrag, Programm und Büstenzyklus des Prager Domchores," *ZKG* 34, 1971: 21–46, here 43.

397 Crossely, *Wells* (note 334) 85ff. makes some important observations concerning this problem. With the exception of the derivation of some individual motifs, the fact should not be overlooked that the moldings in those sections of Prague Cathedral attributed to Peter Parler all seem to have stemmed from central-European sources, especially from the Rhineland (Cologne, Oppenheim).

398 The motif of curtain-like hanging tracery work that fills the spandrels of portal openings was especially common during these years in the architecture of Nuremberg: in the arcade arches between St. Michael's Choir and nave of Our Lady (1352–8), between the vault ribs of the choir central vessel at St. Sebald (1361–79, no longer there) as well as its Bride's Portal. Wilhelm Schwemmer, *Die Sebalduskirche in Nürnberg* (Nuremberg 1979) goes against popular opinion and gives the date of 1360 to the tracery curtain of the Bride's Portal. If this is correct, the hanging tracery of Our Lady would then be the oldest in Nuremberg and should be seen as having been built earlier than the hanging tracery of Prague's St. Wenceslaus Chapel (consecrated 1367) and buttress system (under construction 1371). Might this indicate that Peter Parler was active in Nuremberg before he came to Prague?

399 Matthew of Arras had already given the lower pier-buttress register blind ogee arches. Prior to the Parlers, the lodge at Freiburg Cathedral (St. Peter and Paul's Chapel) had employed the ogee, which had

been known in France and England since the thirteenth century. For the earliest west-European ogee arches see Frankl 1962, 151.

400 Something similar can be found on the flanking towers of Freiburg Cathedral, the so-called *Hahnentürme*, which were given new surface articulation in the years Johannes of Gmünd was building the choir. On the spire, the gallery overlaps the coping, creating a sheath-like structure. Jaroslav Bureš, "Ein unveröffentlichter Choraufriss aus der Ulmer Bauhütte. Zur nachparlerischen Architektur in Süddeutschland und Wien," *ZDVK* 29, 1975, 2–27, here 20f.

401 In a way that is similar to the wall articulation at St. Catherine in Imbach. See Chapter IV, section 5.

402 They do this on the chapel balustrades. This form has been interpreted (in a very creative way) as setting up a kind of movement by Erich Bachmann, "Zu einer Analyse des Prager Veitsdoms," *Studien zu Peter Parler*, Karl Maria Swoboda and Erich Bachmann eds. (Brünn 1939) 36–67, here 41ff.

403 For more about Prague Cathedral's mouchettes see Behling 1937, 73ff. and Nussbaum (note 322) 145f.

404 Earlier examples of tracery mouchettes in England can be found at Oxford, Merton College Chapel (around 1310) and Exeter Cathedral clerestory (around 1335/40). In France tracery mouchettes found in the double chapel on the north side of Amiens Cathedral (west end, mid 1370s) are believed to be the oldest such Flamboyant forms. These were followed by the fireplace wall in the great hall of the Palais de la Justice in Poitiers (Guy de Dammartin 1388).

405 The idea of the "panel-like" wall comes from Gross 1972, 214. Prague's triforium, bent outward like a sharp elbow, is comparable to the form of the outer passageway in front of the nave clerestory at Reims Cathedral. Bock and Haussherr show that Prague's bust cycle, placed in passages through the piers, can also be found at St. Augustine, Bristol, and other west-of-English churches. Henning Bock, "Der Beginn spätgotischer Architektur in Prag (Peter Parler) und die Beziehungen zu England," *WRJ* 23, 1961, 191–210, here 201 and note 21. Also Haussherr (note 396) 31.

406 My notion that the wall is similar to a triptych was inspired by Suckale (note 358) 176.

407 Bachmann (note 402) 45. Strikingly similar to this is the articulation in the choir of Wells Cathedral (1329–45). Also Bock (note 405) 196f.

408 For more about this see Nussbaum (note 322) 173ff. Hans Koepf, *Die gotischen Planrisse der Ulmer Sammlungen*, in the series *Forschungen zur Geschichte der Stadt Ulm*, vol. 18 (Ulm 1977) 17f., puts forward the concept of "inversion" to describe this motif. There are early forms of the motif that can be found in Early Gothic structures, which is significant because they were built at a time prior to the systemization of Gothic wall elevations by the Rayonnant style.

409 Bock (note 405) 202ff.

410 Webs thus reduced could be hung between the ribs without the use of any kind of wooden support whatsoever during construction. This prompted Fehr to see them as being the result of an economically-determined "rational method of vault construction," through which the expensive construction techniques required by the "feudal" Gothic cathedral were tailored to fit the financial parameters of the town burghers building parish churches. Götz Fehr, *Benedikt Ried. Ein deutscher Baumeister zwischen Gotik und Renaissance in Böhmen*, (Munich 1961). Ibid., "Die Wölbekunst der Parler," *Parler*, vol. 3, 45–8. A similar conclusion regarding the emphasis on advancements in the building techniques of vaults was reached by C.A. Meckel, "Die Konstruktion der figurierten Gewölbe in der deutschen Spätgotik," *Architectura* 1, 1933, 107–14; and Werner Müller, "Technik der Wölbung," *Parler*, vol. 3, 48–9. In response, I would point out that

most of these vaults were not developed in urban structures financed by the new merchant classs. Furthermore, the high costs of material, sculpturing and the cut-and-fill technique used for these thick-netted vaults were surely greater than the savings incurred by not having to build a wooden support structure during construction for large vault webs. The German figured vaults that were formally related to the English fan vaults were in any case much more expensive, despite standardized construction techniques, than simple cross-rib vaulting. Walter C. Leedy, *Fan Vaulting. A Study of Form, Technology and Meaning*, (Santa Monica, CA. 1980) 29. Also Nussbaum (note 322) 114f. and note 216.

411 Recht (note 340).

412 Bachmann (note 402) 31ff. sees revealed in the sequence of construction – first sacristy, followed by St. Wenceslaus Chapel, porch and choir vaulting – a step-by-step perfection of the triradial vault. For another opinion see Nussbaum (note 322) 117f.

413 Suckale (note 358) 176 makes a similar judgment of Parler's achievement: "Parler, in building what was a structure firmly entrenched within the tradition of the thirteenth century Gothic cathedral, was not concerned with creating a system in the usual sense. He was not concerned with a strictly logical and artistic standardization of the parts of his choir, nor with their relationship to one another. His main goal was to create movement in architecture."

414 While surviving records indicate choir construction underway in 1400, the choir itself was consecrated earlier, in 1378. In 1366 Parler began All Hallows Chapel on the Hradschin, which was destroyed and rebuilt in a different design (after a fire in 1541). The original chapel was of the French palace-chapel type, and thus another example of Parler being able to employ a rich variety of architectural forms in his work.

415 There were already churches standing in Bohemia at the time that possessed "axial" choir polygons, that is the two halfs of the polygons divided by a buttress, churches Peter Parler must have known – like the Cistercian choir at Sedletz (around 1290– 1320), the choir of the Order of the Maltese Cross (around 1280) and the Karlshof Church (founded 1351) both in Prague. On the other hand, these churches do not possess a pier terminating the *inner* sanctuary.

416 Two new churches were built: Prague Cathedral and St. Nikolai in Berlin. Churches built from west to east with minor or little design change: Augsburg Cathedral and Holy Cross in Schwäbisch Gmünd. Replacement of older choirs by new choirs: Freiburg Minster, St. Sebald in Nuremberg, St. Martin in Colmar, St. Mary's in Frankfurt-an-der-Oder, Aachen Cathedral, St. Lamrecht (?) and St. Bartholomew in Kolin.

417 For a discussion of the single tower as a "burgher" architectural form see Meckseper 1982, 215ff.

418 A good example of this is the Lower Rhine region, where tufa had been almost the only stone used until the thirteenth century. By the early fourteenth century Backstein was being employed in its stead. Many towers were built here that emulated the towers of St. Maria Magdalena in Geldern and St. Lambertus in Düsseldorf. They often possessed a flat, lancet-shaped blind articulation that did not do much by way of dissolving the mass of stone making up the tower.

419 In 1727 J.J. Couven's Baroque design was implemented onto the façade of Aachen's town hall. Between 1840–81 the façade was re-restored to the Gothic original. The *Baldachin* or canopy motif belonged to the usual group of forms of the Town Hall façades in Flanders and the Netherlands (Ghent, Louvain, Brussels, Middelburg). The canopy seems to have migrated from the pairs of pinnacles usually found on the sides of portals, into the window zones where it retained its value as the dominating motif.

420 Son of Johannes von Gmünd who was master of

the lodges at Freiburg and Basel.

421 For a dating of Strasbourg's belfry register see Recht (note 264) 69ff.

422 Similar in its ratio of wall to sculpture is the set of articulated forms decorating the east side of the Moldau Bridge tower in Prague.

423 Gross (note 162). Also Swoboda (note 265).

424 Compare with note 17. Other dates suggested for the beginning of the German Late Gothic are often quite different from those most scholars hold. In 1958, Clasen dated the period as beginning around 1300 based on the development of the figured vault. Georg Hoeltje in *Zeitliche und begriffliche Abgrenzung der Spätgotik innerhalb der Architektur von Deutschland, Frankreich und England* (Weimar 1930) 140, felt that the *Reduktionsgotik* of around 1300 represented a new stylistic direction that would not develop into a classical phase until 1450 with the building of St. George in Dinkelsbühl.

425 Gerstenberg 1913.

426 Ullmann 1981, 106. For a view opposed to the Hall church as a "unified space" see Kunst (note 287).

427 Ullmann 1981, 7f., 42.

428 Much of this can be found in Nussbaum (note 322) 282ff.

429 For an excellent survey of this subject including bibliography see Bialostocki (note 264). Compare also Nussbaum (note 322) note 798.

430 Dehio (note 19).

431 Friedhelm Wilhelm Fischer, *Die spätgotische Kirchenbaukunst am Mittelrhein 1410–1520* (Heidelberg 1961) 248.

432 Suckale (note 358) 178.

433 For the latest on Late Gothic structural geometry see Müller 1990. This volume is a collection of several of Müller's individual studies and offers a critical survey of the large amount of literature on the subject.

434 One of the earliest champions of these theories was Carl Alexander Heideloff, *Der kleine Altdeutsche (Gothe) oder Grundlagen des altdeutschen Baustyles* (Nuremberg 1849–52).

435 For a refutation of neo-Gothic scholarship see Konrad Hecht, "Mass und Zahl in der gotischen Baukunst," *Abhandlungen der Braunschweigischen Wissenschaftlichen Gesellschaft* 21, 1969, 215–36; 22, 1970, 105–263 and 23, 1971, 25–236. For a short survey of the research done on this subject see Paul Naredi-Rainer, *Architektur und Harmonie. Zahl, Mass und Proportion in der abendländischen Baukunst* (Cologne 1982) 201–31. For a detailed and informative report on the latest research on this subject see Müller 1990, 35–120.

436 An attempt to interpret these lodge sketch books as having represented medieval architectural theory has been undertaken by Ulrich Coenen, *Die spätgotischen Werkmeisterbücher in Deutschland als Beitrag zur mittelalterlichen Architekturtheorie. Untersuchung und Edition der Lehrschriften für Entwurf und Ausführung von Sakralbauten*, Diss. Aachen 1988 (Aachen 1989).

437 Meckseper 1982, 220ff., for a report on medieval documents. For more about the many churches that housed courts of law during the period see Ackermann (note 95).

438 A good example would be St. Nikolai in Stralsund. See Nikolaus Zaske, *Die gotischen Kirchen Stralsunds und ihre Kunstwerke* (Berlin 1964) 37.

439 Until 1622, the gallery of Heiligenkreuz in Heidelberg housed the *Bibliotheca Palatina*, famous for its collection of medieval manuscripts.

440 An interesting account of donations made to churches in the town of Stralsund in the late Middle Ages by Horst-Dieter Schroeder, "Bürgerschaft und Pfarrkirchen im mittelalterlichen Stralsund," in Zaske (note 438) 260ff. Detailed information about the late medieval practice of financing great church construc-

tion through the solicitation of chapel donations has survived in the form of a *Stiftungsurkunde*, a Certificate of Endowment dated October 13, 1407 (City Archives–Landshut) concerning the financing of a nave chapel at St. Martin in that city. Only the chapel's foundation between two pulled-in pier buttresses was financed by the general budget. The wall above this was paid for by the Tailor's Guild of Landshut, which was then awarded the right to erect altars in the chapel and to have Mass read. Should the *Donatores* break the terms of the certificate by not paying for construction expenses as stipulated in writing, then church officials were allowed to find a new sponsor for the chapel. Philipp undertook to determine how much the type of some parish churches in Swabia were determined beforehand by the prospect of selling new altars. The results are contradictory. For instance, after the eleven wall chapels off the choir ambulatory at Schwäbisch Gmünd were built, the citizens of the town did not seem to be in any hurry to finance altars to fill them. Obviously, they did not take the opportunity to use the empty space, at least in the beginning. It seems rather unlikely, then, that there was a causal relationship between the type of structure and its function, at least in this area. At the parish church in the town of Schwäbish Hall, on the other hand, there seems to have been a practical reason for the adoption of the Gmünd choir type. When Hall's choir was enlarged in 1493, the Feldner Chapel and the Charnel House had to be torn down, both of which stood in the inner courtyard east of the church. Since three of the seven altars in the new choir are from the old Feldner chapel, it appears a plan-stage decision had been made to build a type of choir structure that put these chapels as close as possible to the location of the older chapels. See Klaus Jan Philipp, *Pfarrkirchen. Funktion, Motivation, Architektur. Eine Studie am Beispiel der Pfarrkirchen der schwäbischen Reichsstädte im Spätmittelalter*, (Diss. Marburg 1986) 35–6.

441 This quote from a report of the building of Ulm Minster in a Treatise on the City of Ulm written by Brother Felix Fabri, translated by Gisela Mönche ed., in *Quellen zur Wirtschafts – und Sozialgeschichte mittel – und oberdeutscher Städte im Spätmittelalter* No. 119. In the series *Ausgewählten Quellen zur deutschen Geschichte des Mittelalters, Freiherr von Stein – Gedächtnisausgabe*, vol. 37 (Darmstadt 1982).

442 Karl Bosl, "Staat, Gesellschaft, Wirtschaft im deutschen Mittelalter," (Bruno) Gebhardt. *Handbuch der deutschen Geschichte*, vol. 1, Herbert Grundmann ed., 9th edition (Stuttgart 1970) 693–835, here 805.

443 For an analysis of eastern Bavaria, which is probably typical for rural church construction of the period, see Nussbaum (note 322) 143. In the lower Rhine region (western and north-western Germany) there were around four hundred churches built between the late fourteenth and early sixteenth centuries. Of these, only forty were city churches, and almost every single one of these were Romanesque structures that were renovated or torn down and rebuilt in the fifteenth century. See Ulrich Reinke, *Spätgotische Kirchen am Niederrhein im Gebiet von Rur, Maas und Issel zwischen 1340 und 1540*, (Diss. Münster 1977) 21ff., 154, 190. The boom in new church construction in the region of Switzerland in and around Zurich after 1470 was directly related to an increase in population which, having steadily fallen until the middle of the fifteenth century, doubled in the next one hundred or so years. Most of these churches were built after a decision of the local town or village council. They usually replaced older churches, most of which had been built around 1200 and were in a state of disrepair of which was written about in several primary sources. See Peter Jezler, *Der spätgotische Kirchenbau in der Zürcher Landschaft. Die Geschichte eines "Baubooms" am Ende des Mittelalters* (Wetzikon 1988) 68–70.

444 For the difficulty in researching the economy of the fifteenth century see Erich Meuthen, *Das 15.*

Jahrhundert, in the series *Oldenbourg Grundriß der Geschichte*, vol. 9 (Munich-Vienna 1980) 3ff.

445 For more on this see Günther Binding with Gabriele Annas, Bettina Jost and Anne Schunicht, *Baubetrieb im Mittelalter* (Darmstadt 1993).

446 Ferdinand Janner, *Die Bauhütten des deutschen Mittelalters* (Leipzig 1876) and Ullmann 1981, 72ff., both see these disputes as reflecting fundamental structural and social differences in medieval society. But the constantly changing relationship between these two organizations, as well as the intense interaction they had with each other over long years, speaks against this.

447 Gerhard Ringshausen, "Die spätgotische Architektur in Deutschland unter besonderer Berücksichtigung ihrer Beziehung zu Burgund im Anfang des 15. Jahrhunderts," in *ZDVK* 27, 1973, 63–78, here 66 assumes the fusions of many of the guilds from neighboring cities in the late Middle Ages came about for the same reasons. The higher social position of the stonemason, and the legal rights that came with the profession, should not be ignored however.

448 Binding (note 445) 151–66.

449 Bern represented Switzerland, Vienna the Habsburg holdings, Cologne northern and Strasbourg southern Germany.

450 Arnold Wolff, "Der Kölner Dombau der Spätgotik," *Beiträge zur Rheinischen Kunstgeschichte und Denkmalpflege* vol. 2, (Düsseldorf 1974) 137–51, here 138f.

451 Inspired by Walter Paatz's study on German sculpture of the fifteenth century, Fischer attempted to prove that forms from the west of the empire found their way to the lodges of the east and exerted a major influence in the field of architectonic style development there. This was in response to Dehio who had maintained just the opposite occurred, that style developed from east to west. Georg Dehio, *Der spätgotische Kirchenbau in Oberdeutschland* (Leipzig 1922) 3. Also Walter Paatz, *Prolegomena zu einer Geschichte der deutschen spätgotischen Skulptur im 15. Jahrhundert*, in the series *AHAW* 2. Abh. (Heidelberg 1956). Wilhelm Friedhelm Fischer, "Unser Bild von der deutschen spätgotishen Architektur des XV. Jahrhunderts (mit Ausnahme der nord- und ostdeutschen Backsteingotik)," in the series *Sitzungsberichte der Heidelberger Akademie der Wissenschften, phil.-hist.KL. 1964*, 1. Abh. Ringshausen (note 447) 64ff., rightly sees that, when explaining the very complex picture we have of style development in post-Parleresque architecture, neither of these views is sufficient.

452 Heinz-Dieter Heimann, *Zwischen Böhmen und Burgund. Zum Ost-West-Verhältnis innerhalb des Territorialsystems des Deutschen Reiches im 15. Jahrhundert*, in the series *Dissertationen zur mittelalterlichen Geschichte*, vol. 2 (Cologne-Vienna 1982) 2f.

453 Walter Paatz, *Verflechtungen in der Kunst der Spätgotik zwischen 1360 und 1530*, in the series *AHAW, 1967*, 1. Abh. (Heidelberg 1967). Fischer (note 431) and *idem* (note 451). Naturally, identifying such western influences on German architecture serves to strengthen the theory both authors hold – that west influenced east during the period. Of the two, Fischer is seldom able to offer proof of this theory. For instance, he sees the Burgundian Court Style in work attributed to Madern Gerthener, but is unable to pinpoint the most important Burgundian prototypes because they are destroyed or have survived in poor condition. Some of Gerthener's structures, especially his vault and portal work, could only have come from Prague Cathedral's lodge. See Nussbaum (note 322) 251ff. Barbara Schock-Werner was unable to identify a single motif that definitely came from the areas west of the empire in those sections built at Strasbourg Cathedral in the fifteenth century. See Schock-Werner, *Das Straßburger Münster im 15. Jahrhundert. Stilistische Entwicklung und Hüttenorganisation eines Bürger-Doms*, Diss. Kiel 1981,

in the series *Veröffentlichungen der Abteilung Architektur des Kunsthistorischen Instituts der Universität Köln*, vol. 23 (Cologne 1983) 226.

454 Herbert Siebenhüner, *Deutsche Künstler am Mailänder Dom*, in the series *Ausstrahlungen der deutschen Kunst. Deutsche Kunst in Italien* (Munich 1944).

455 Joseph Neuwirth, *Die Wochenrechnungen und der Betrieb des Prager Dombaues* (Prague 1890).

456 Jaroslav Bureš, "Die Prager Domfassade," *Acta Historiae Artium* 29, 1983, 3–50 suspects that at the beginning a staired-turret façade was planned, that is a symmetrical copy of the staired turret in the eastern pier buttress of the transept. Bureš interprets the south tower as a relic of a double-tower façade structure that had been planned for the west sections of the cathedral but was never carried out. Peter Parler inserted half of this structure into the south façade. Bureš goes on to say that, everything considered, Prague's original design took Notre-Dame Paris as its prototype. His argument is not without its logic, of course, but the premise is purely hypothetical.

457 See Bachmann (note 402) 51ff. As idiosyncratic as this design is, it seems nonetheless to have been influenced by the great tower projects in south-west Germany. Foremost among these was Ulrich von Ensingen's "Sketch A" (around 1392) for the west tower of Ulm Minster. "Sketch A" not only shows fluted gables (with concave sides) but also a weaving of separate arches into each other, which up to that time had not belonged to the repertoire of any German cathedral lodge. "Concave" gables top the portal porch and a wreath of similar gables surrounds both octagon registers. The wreath of gables of the lower of these two stands upon free-standing shafts of the kind we find holding up the tracery "harps" at Strasbourg, and consist of gables weaving in and out of each other, with the side of each gable encased by two mullions. There are still doubts about the theory that "Sketch A" of Ulm's tower is older than the design for Prague's south façade. The latest to express the opinion that Ulm influenced the lodge at Prague was Jaroslav Bureš, "Der Regensburger Doppelturmplan. Untersuchungen zur Architektur der ersten Nachparlerzeit," *ZKG* 49, 1986, 1–28, here 16ff.

458 These arches are a characteristic of some of the first Parler structures, namely the choir at Schwäbisch Gmünd and St. Michael's Oratory at Our Lady in Nuremberg.

459 More than sixty years ago Otto Kletzl, "Planfragmente aus der deutschen Dombauhütte von Prag in Stuttgart und Ulm," *Veröffentlichungen des Archivs der Stadt Stuttgart*, 3, 1939, 103–19 recognized the prototype for this style of tracery was "Sketch B" of Strasbourg Cathedral façade. Bureš (note 456) 29ff., used this as well to prove his concept that western Gothic influenced everything to the east.

460 Bachmann (note 402) 65ff. Pinder sees a definite connection between the "soft style" and the appearance of what he calls the "painterly" in Gothic articulation, which he sees as characteristic of the entire Late Gothic. Wilhelm Pinder, *Die deutsche Plastik vom ausgehenden Mittelalter bis zum Ende der Renaissance*, in the series *Handbuch der Kunstwissenschaft*, vol. 1 (Potsdam-Wildpark 1924) 148. Surely Pinder was the catalyst for all subsequent attempts at interpreting architecture using the concepts and terms developed in the pictorial arts. In 1937 he came to the conclusion that it would "in principle be possible to represent all of architectural history – starting with the advent of the 'painterly' in architecture – in light of the developments in the pictorial arts, even to understand architectural development in terms of the pictorial arts." Pinder (note 261) 293.

461 The "beautiful style," used by art historians in the Czech Republic, is synonymous with "soft style." See Nussbaum (note 322) 255ff., and *idem* "Stilabfolge und Stilpluralismus in der süddeutschen Sakralarchitektur des 15. Jahrhunderts. Zur Tragfähigkeit kunsthistorischer Ordnungsversuche,"

Archiv für Kulturgeschichte 65, 1983, 43–88.

462 Ernst Petrasch, *Die Entwicklung der spätgotischen Architektur an Beispielen der kirchlichen Baukunst aus Österreich*, (Diss. Vienna 1949). Idem "'Weicher' und 'Eckiger' Stil in der deutschen spätgotischen Architektur," *ZKG* 14, 1951, 7–31.

463 Even Ullmann 1981, 24f, who agrees with Petrasch only concerning the "soft style," sees clear breaks around 1430/40 and around 1470.

464 One study that completely missed the mark when attempting to differentiate the articulation of the inner structures of Gothic churches in a specific area in the Danube River region according to "soft" and "sharp-edged" styles was undertaken by Benno Ulm, *Die Stilentfaltung der Architektur der gotischen Landkirchen in den Bezirken Freistadt und Perg in Oberösterreich*, (Diss. Vienna 1955) 81f. Round wall responds, parallel-rib figures and the ribs connecting to them which lack capitals he attributes to the "soft style," while polygonal responds, piers with elaborate capital zones and stellar vaulting to the "sharp-edged" style. It is easy to show, however, that all these forms were built during the same span of years and often on the same structure. Nussbaum (note 322) 262f.

465 Petrasch 1949 (see also note 462) 97, 135.

466 Petrasch 1951 (note 462) 24f. In describing the Franciscan church in Salzburg – whose entire upper sections, by the way, including the vaulting were not built until the middle of the fifteenth century – Petrasch writes of how "the view is fixed on one spot and calmed" (see Wilhelm Pinder, *Deutsche Dome des Mittelalters*, Düsseldorf-Leipzig 1910, XVI). He writes also of an inner space that "sinks into itself," of a "gradual dulling of the lateral elevations," or of a "soft, lyrical sentimentality." He even talks about an "overly fastidious sensuousness that pulses, in dreamy romantic accord, through all the creations of German art around 1400."

467 Behling 1937, 93ff, sees the mouchette as a typical tracery motif for the "soft style," a classification that is accepted to this day.

468 For example in the choir windows of the Marktkirche in Lippstadt (1478–1506).

469 See the canopied figures at the base of Vienna's main pulpit (from Pilgram), and the windows of St. Nikolaus in Laun, Bohemia (Benedikt Ried 1520–38).

470 Work on Kolin's choir ended before 1400. Prague Cathedral's lodge would not be disbanded until the beginning of 1420, but records show the choir was already closed with a temporary wall in 1399.

471 The first "Freiburg style" west towers were much earlier, at Reutlingen (begun after 1300) and Rottweil (1330/40). Single-tower façades built in the late fourteenth century that were inspired to a greater or lesser degree by Freiburg were St. Nikolas in Freiburg, Switzerland (begun at the end of the fourteenth century), Ulm Minster (probably designed around 1392), Our Lady in Esslingen (begun around 1395), St. Martin in Landshut (tower foundations 1445), Bern Minster (tower begun *ca.* 1455) along with many smaller west-tower structures. Ringshausen (note 447) 78, note 83 sees the "soft style's" constant reference to Freiburg tower in the great tower projects as a conservative trait. In response I will say this: Freiburg's west tower was the only tower of such magnitude to have been completed to its full height at that time, and nothing like it would be built for many years after.

472 V. Flieder, *Stephansdom und Wiener Bistumsgrundung* (Vienna 1968) 174ff. Also Rupert Feuchtmüller, "Herzog Rudolf IV. und die Wiener Stephanskirche," *Parler*, vol. 2, 415–17.

473 Richard Perger, "Die Baumeister des Wiener Stephansdomes im Spätmittelalter," *Wiener Jahrbuch für Kunstgeschichte* 23, 1970, 66–107, here 76.

474 Otto Kletzl, "Zur Identität des Dombaumeisters Wenzel Parler von Prag und Wenzel von Wien," *Wiener Jahrbuch für Kunstgeschichte* 9, 1934, 43–62.

475 The row of gables on the south side of the church belong to the original nave plan, even though only the "Friedrichs Gable" (1440) above the "Singertor" was finished in the Middle Ages.

476 Nussbaum (note 322) 183.

477 The floor plan is similar to that of the Karlshof Palace church in Prague.

478 While the lodge was still under the direction of Master Wenzla, or at a slightly later date between 1409 and 1414, there was a dismantling of the tower wall indicating a change in design at this time. It also seems to have had something to do with a change in stylistic orientation from Strasbourg to Prague and the hiring of two Bohemian architects, Masters Wenzla and Peter von Prachatitz. It is difficult to determine which of these men the upper registers of Vienna's tower should be attributed to. See Perger (note 473) 75ff. Maria Magdalena Zykan, "Zur Baugeschichte des Hochturmes von St. Stephan," *Wiener Jahrbuch für Kunstgeschichte* 23, 1970, 28–65.

479 Bureš (note 400) 22–7.

480 Reinhard Wortmann, "Hallenbau und Basilikaplan der Parler in Ulm," *600 Jahre Ulmer Münster*, in the series *Forschungen zur Geschichte der Stadt Ulm*, vol. 19 (Stuttgart 1977) 101–25. Idem, "Das Ulmer Münster unter den Parlern 1376/77–1391/92," *Parler*, vol. 1, 325.

481 According to Fischer, it was not the decision to build a tower that reflects an effort on the part of Ulm's rich merchant class at aristocratic prestige, but discarding the Hall design in favor of a basilica that glows with "patrician elegance." Fischer 1971, 87f.

482 Especially obvious is Ulm's tendency for axial shifts between the columns of double-layer tracery work ("Harp" tracery, and window tracery in the belfry and lower octagon register) that we saw in the triforium at Prague. Ulm's lively exchange of diverse types of arches can surely be traced to the great number of arch forms found in the blind tracery of Prague Cathedral choir, as well its window tracery.

483 See note 457.

484 Something similar can be found on the kapellenturm at Rottweil.

485 The masthead motif appeared at about the same time on the towers of town halls in the Netherlands. Fischer (note 431) 198, and idem (note 451) 19 concludes from this that the motif first appeared west of the empire. It is to be doubted, however, that the spire of St. Mary's in Reutlingen possessed a masthead *before* it had to be rebuilt in 1494 after being hit by lightning.

486 It is possible to compare the development of Strasbourg's designs from this period at Bern's Historisches Museum, Inv. No. 1962 (*Parler*, vol. 1, illustration p. 282).

487 Franz Dietheuer, "Die Roritzer als Dombaumeister zu Regensburg," *Der Regensburger Dom. Beiträge zu seiner Geschichte*, Georg Schwaiger ed., in the series *Beiträge zur Geschichte des Bistums Regensburg*, vol. 10 (Regensburg 1976) 111–18.

488 Central archives of the episcopate and the Depositorium of the Cathedral Chapter, both in Regensburg.

489 See the window of Martinitz Chapel at Prague Cathedral choir. Heinz Rosemann, "Entstehungszeit und Schulzusammenhänge der Regensburger Turmbaupläne," in *KC* 15, 1962, 259–61.

490 For the latest attempt at dating Regensburg's west towers according to the stylistic tendencies of its design see Jaroslav Bureš, "Der Regensburger Doppelturmplan. Untersuchungen zur Architektur der ersten Nachparlerzeit," in *ZKG* 49, 1986, 1–28. See also Friederich Fuchs, "Zur Westfassade des Regensburger Domes," *Der Dom zu Regensburg* (note 187) 224–30.

491 For more about the Regensburg Triangle see Achim Hubel, *Parler*, vol. 1, 389–92. See also Friedrich Fuchs, "Das mittlere Westportal des Regensburger Doms," MA thesis, Regensburg, sec-

tions publ. in *Das Münster* 34, 1981, 153–4.

492 "Sketch A" is in the collection at Frankfurt's Historisches Museum. Peter Parler erected an open tracery dome above the church of St. Bartholomew in Kolin in 1385. Also similar to Frankfurt are: the cap-like roof of the Fransiscan church in Pressburg (1410/20), the roof above the small staired turret at the church of Deutsch-Altenburg, the open tracery crown of the tower and the canopied portals of St. Maria-am-Gestade in Vienna (1394–1414). All of these similar structures indicate a south-eastern-German architecture strongly influenced by Parler.

493 The vaults over the entrance hall of the Nürnberger Hof and in the choir of Leonhardskirche in Frankfurt, both attributed to Madern Gerthener, have Prague prototypes as well.

494 Tracery vaults in England that were built at an earlier date than Gerthener's were over the choir at St. Augustine in Bristol, at Ottery St. Mary, Wells Cathedral, as well as the south side-aisle vaults of St. Mary Redcliffe in Bristol.

495 Contemporary to these were the first curved-rib vaults at Landshut by Hans von Burghausen – St. Catherine's Chapel (founded 1411) and sacristy (completed 1415) at Heiligenkreuz.

496 The term "branch work" comes from Gerhard Ringshausen in *Parler*, vol. 1, 232.

497 This wall division system might be traceable to the northern choir portal at Freiburg Minster.

498 The whorl rosette appeared very early in Gothic churches in Germany – Kreuzaltar in Doberan (around 1368), western choir stalls at Bamberg and on the throne of the "clay apostle" figures at St. Jakob in Nuremberg (around 1400) – and was already in use some decades before it appeared in English Gothic. See Behling 1937, 98.

499 Churches that do have ornamental western sections: Heiligenkreuz and St. Nikolaus in Landshut, St. Stephan and the hospice church in Braunau, St. Nikolaus in Neuötting, St. Mary's Ascension in Höchstädt-an-der-Donau, and St. Mary's Ascension in Donauwörth.

500 Perger (note 473) 79–82.

501 Gross (note 367) *passim*.

502 For more about the building of Moritzkirche see Hans-Joachim Krause, "Die spätgotischen Neubauten der Moritzkirche und der Marktkirche in Halle," *Denkmale in Sachsen-Anhalt. Ihre Erhaltung und Pflege in den Bezirken Halle und Magdeburg* (Weimar 1983) 225–52. Also Jaroslav Bureš, "Die Bedeutung der Magdeburger Bauhütte in der mitteldeutschen Architektur des ausgehenden 14. Jahrhunderts," in *NBK* 29, 1990, 9–33.

503 For a convincing job of explaining the stylistic derivation of the "stepped" choir see Wolf Schadendorf, "Wien, Prag und Halle. Ein Beitrag zum Einfuß der Dombauhütten von Wien und Prag auf die Baukunst Mitteldeutschlands, dargestellt an Chor und Langhaus von St. Moritz in Halle/Saale," *Hamburger Mittel- und Ostdeutsche Forschungen* 3, 1961, 148–99.

504 Compare Bureš (note 502) 9ff.

505 Fischer (note 451) 28, note 42 feels these motifs to be of western-European descent. He traces Moritzkirche's hanging tracery work, for instance, to the trefoil-tracery curtains hung before the windows of Cologne's town hall tower. However, we should not overlook – besides the hanging tracery of Prague Cathedral's choir buttressing and St. Wenceslaus Chapel – the small tracery curtain of the northern choir portal at Freiburg Minster. Also from Freiburg's lodge under Parler's direction, the combination of blind ogee window arches with panel-like shaft work above. You can find this in the upper registers of the Hahnentürme built, along with the choir, by Johannes von Gmünd. A row of ogee arches frames the windows of the All Hallows Chapel at the Hradschin as well. Due to a fire in 1541 and a subsequent renova-

tion in 1580, it is no longer possible to know for sure if the wall above the windows at All Hallows Chapel (built by Parler *ca.* 1370–5) possessed panel-like mullion work too. For Prague prototypes for the extremely high quality console sculpturing in the Halle area, and its adherents in Saxony, see Wolf Schadendorf, "Mitteldeutsche Kunsträume im 14. und 15. Jahrhundert. Ein Beitrag zur Kunstgeographie und Kunstgeschichte zur Umgrenzung und Bestimmung Mitteldeutschlands," *Berichte zur Deutschen Landeskunde* 20, 1958, 287–319.

506 For more about the influence of Prague architecture on Saxony and the Oberlausitz region see Hans-Joachim Krause, "Zum Einfluß der Prager Architektur auf Sachsen und die Oberlausitz," *Parler*, vol. 2, 552–6.

507 I would venture to say that St. Johannis in Saalfeld (under construction in 1425) probably belongs to this list of choirs as well, since its original Gothic pier buttresses were richly decorated with statues.

508 W. May, *Stadtkirchen in Sachsen/Anhalt* (Berlin 1979) 36ff.

509 Similar to what we found in Schmalkalden, St. Lamberti's southern nave wall forms the north side of Münster's main market square. It was this nave wall, rather than the choir, that got most of the formal decoration. Three portals allow entry into the nave and a choir chapel, the so-called "Alter Chor."

510 Paatz (note 453) 81 interprets the decorative forms on the outer structure of St. Lamberti as southern Dutch. Concerning the same church, Fischer (note 451) 29f., mentions the window ornamentation of Bruges' town hall. Yet, it possesses no panel-like mullion work above its windows, nor does St. Lamberti have canopied figures placed next to the windows like Bruges. Böker (note 272) 11 and idem, *Die Marktpfarrkirche St. Lamberti zu Münster. Die Bau- und Restaurierungsgeschichte einer spätgotischen Stadtkirche* in the series *Denkmalpflege und Forschung in Westfalen*, vol. 18 (Bonn 1989) traces, not very convincingly, Münster's ogee arches to the pointed-arch central-vessel arcades in the ground floor of the south tower at Cologne Cathedral. Bureš (note 502) 20, points out correctly the formal similarities between pier buttress articulation in the "Alter Chor" at St. Lamberti and that of the choir at Moritzkirche in Halle. The evidence seems to indicate that the builders of St. Lamberti were probably more familiar with forms from Prague Cathedral's lodge.

511 Böker (note 510) 41, 48ff., also tries to trace the choir tracery and the forms of St. Lamberti's inner structure back to Cologne Cathedral's lodge.

512 For more about who was the architect of this choir see Nussbaum (note 322) 143 with pertinent literature. Against attributing it to Hans Krumenauer is Peter Kurmann, "Architektur," *St. Martin zu Landshut*, Alfred Fickel ed. (Landshut 1985) 17–52, here 42ff.

513 For a thorough inquiry into the decoration of Passau Cathedral see Bureš (note 400) 12ff.

514 The expression is from Gross (note 367) 131ff., to describe the rows of ogee arches found in Saxony during this period.

515 Behling 1937, 110 writes "In the Backstein Gothic an exchange took place that we do not see anywhere else. In many churches using this material, the tracery work almost disappeared from its original location in the window, and then migrated to other sections of the church. In those cases where this occurred, the window was usually a simple structure subdivided into fields of pointed arches that curve in such a way so as to parallel the pointed arch that framed the window."

516 For a meticulous comparative study of the style used in Backstein gables, and a clear presentation of their formal relationship to the cathedral lodges of western Germany, see Reinhard Liess, "Zur historischen Morphologie der hohen Chorgiebelfassade

von St. Marien in Prenzlau," *NBK* 27, 1988, 9–62.

517 The only mouchettes on the ornamental gabel at Prenzlau can be found under the basket-arch gables of the windows of the lower level. These are not fused into "double-mouchettes" however.

518 The architect of the nave of St. Martin in Landshut was Hans von Burghausen. Its portals, however, might very well have been designed by his nephew, Hans Stethaimer, who was in Landshut for a time in 1434. Theo Herzog, "Die Baugeschichte des St. Martinsmünsters und anderer Landshuter Kirchen im Lichte der Jahrringchronologie," *Verhandlungen des Historischen Vereins für Niederbayern* 95, 1969, 36–53, here 51.

519 It lacks the row of canopied figures on the sides of the framing ogee arch, and the canopies on the sides of the portal are not turned. The upper blind tracery frieze, made up of fused triple and quatrefoils, is an exact copy of the triforium gallery of Prague Cathedral.

520 The ogee-arched canopy that projects out above an opening is, of course, more common to the English Decorated Style. There can be no doubt that here is a motif common to fifteenth-century German Gothic that stems from western Europe. For English examples see Fischer (note 451) note 58.

521 Gerstenberg 1913, *passim*. All of the southern-German inner structures and floor plans used as illustrations in Gerstenberg's book reflect his "unified space" theory. This was a reaction to the negative evaluation of the period as "decadent art" by many scholars who preceded him. His creative vocabulary was an attempt to portray German Late Gothic as a distinctive cultural achievement. Gerstenberg understood the "special Gothic" – as compared to Schmarsow, Haenel and Niemeyer (note 17), who strove to establish the German Late Gothic as a Renaissance phenomenon – as a structural style that still felt itself to be Gothic, but which "had broken off completely from the traditions of the French Gothic. After a first stage in which it reacted against the academic rigidity of the early 14th-Century, it then came to be dominated, beginning around 1350, by a specifically German sense of form that reached its height in the fifteenth century." Applying Alois Riegl's concept of "artistic impulse" as a creative power that grows out of a collective need for artistic representation which then determines a particular style – Alois Riegl, *Spätrömische Kunstindustrie* (Vienna 1901) – Gerstenberg concludes that fundamental differences exist in the "visual perception of form" between various nations. For this reason, he sees the transformation of the French Gothic style in German architecture after 1350 as having been less a development of individual form, and more a transformation of the values to be expressed by those forms. With the German *Volk* as "artistic vehicle" the inherited forms of the Gothic were permeated with a certain kind of sentiment that Gerstenberg not only saw in himself as an individual, but felt to be psychologically representative of the entire German nation. He based this "nationalization" of the Gothic on what he felt was a genuine "germanic" perception of space that manifested itself most clearly in the Gothic Hall tradition. Gerstenberg writes that the French Gothic's functional linearity, which engages the field of vision in only one way, gave way to a painterly disposition that involved the field of vision in a variety of ways. Through the creative effect of what he calls German "active imagination" a process is then described – based this time on Heinrich Wölfflin's theory of the conformity and inevitability of stylistic development – in which a "linear" style at first develops into its purest form then, in the process of its development, is completely remolded into a "painterly" style that enriches the entire repertoire of Gothic forms. The idea that a "national" perception of form can actually call forth an artistic transformation, and that every style delineation contains "not only a problem of history, but also a problem of race" has tainted the concept of the German "special Gothic" ever since. It is now under-

stood as having been the vehicle for a school of art history that was obsessed with, even blinded by, national characteristics. Gerstenberg's descriptions of the different sense of form in Italy and England does not entirely redeem the theory either. The process by which scholars after Gerstenberg have dealt with the German "special Gothic" has not contributed to clarifying the theory's contextual contradictions. The common practice of giving the name "special Gothic" to thirteenth-century churches that deviated from Cathedral Gothic – and there were a lot of these: Mendicant churches, "reductive Gothic" with simplified lateral elevations, along with older Hall traditions and the early Backstein Gothic – is not, by any means, based on methodologic studies. Although Gerstenberg's interpretation of the "special Gothic" Hall space as the major cultural achievement of the germanic "race" was long ago discredited as being one-sided and historically incorrect, much of his expressionistic-seeming terminology has become part of Late Gothic scholarship. Even Marxist-oriented authors, who hold opinions that are opposite to his, have not been able to express their ideas without the use of Gerstenberg's vocabulary. Even his notion of a teleological development of the Hall into a "unified space" can be found here, of course bound-up with the idea that such a sense of artistic form in a time that was "early burgher" or "pre-revolutionary" mirrors a change from a theocentric to a more anthropocentric worldview. See Ullmann 1981: *passim*, where the old theory of the Late Gothic as "nordic Renaissance" resonates once again, this time under the premise of historical materialism.

522 Structures that did not fulfill the requirements of the unified Hall were, strange to report, seen as retrograde and as exhibiting a "relapsed" style. For instance, the nave proportions of the parish church in Weil-der-Stadt, in Swabia brought just such a judgement from Gerstenberg 1913, 35.

523 Quote from Gerstenberg 1913, 36.

524 Ibid., 65.

525 Gerstenberg 1913, *passim*.

526 The nave of Graz Cathedral (a *Staffelhalle* 1438–64); the parish church in Eggenburg, Austria (1482–1515); St. Mauritius in Olmütz, Moravia (1433–83); and St. Jakob in Brünn, Moravia (eastern sections 1456–73). The parish church in Steyr, northeastern Austria – whose floor plan (1443) Hans Puchsbaum drew to follow closely Vienna's floor plan – is also a *Staffelhalle*. Here, like in Vienna, the central-vessel bays are deeper (longitudinally) than those of the choir.

527 The central-vessel bays of the hospice church in Meran (begun around 1425) and Maria Trost in Fernitz, Austria (1506–14) are near rectangles as well. On the other hand, the central-vessel bays at St. Johannis in Dingolfing (begun 1467) are clearly transverse rectangles.

528 St. Jakob in Wasserburg (nave begun 1409, choir 1445) possesses square bays extended slightly, longitudinally over its central vessel. The choir of St. Lorenz in Nuremberg (1439–77) has bays that are almost transverse rectangles, as does the nave of the parish church in Wimpfen (around 1490–1515). The latter structure was probably designed by Anton Pilgram, who had worked at an earlier date at St. Stephan, Vienna. Hans Koepf, "Die Baukunst der Spätgotik in Schwaben," *Zeitschrift für Württembergische Landesgeschichte* 17, 1958, 1–144, here 26ff.

529 Naves with central-vessel bays twice as wide as they are deep – St. Martin in Landshut (begun 1407) and St. Nikolaus in Neuötting (nave is first mentioned in a surviving chapel donation 1429). Heiligenkreuz in Landshut (begun 1407) and St. Jakob in Straubing (under construction 1423) have central-vessel bays that are only a bit deeper.

530 Many scholars would agree with this. Perhaps typical of these would be Baldass who maintains that Hans von Burghausen attempted to realize "the idea

of unified space" in his churches. See Peter Baldass, *Hans Stethaimer. Sein Name, sein Hauptwerk, seine Spätwerke*, (Diss. Vienna 1946) 88.

531 For instance, the most important Bavarian structure in the second half of the fifteenth century, Frauenkirche in Munich (1468–94).

532 Franconia, St. George in Dinkelsbühl (1448–99). Swabia: Heiligenkreuz in Heidelberg (nave 1413–41), St. Michael in Schwäbisch Hall (nave 1427–56, choir begun 1493), St. George in Nördlingen (begun 1427), collegiate church in Tübingen (begun 1470), St. Kilian in Heilbronn (choir begun after 1480), parish church Weil-der-Stadt (begun 1492) and parish church in Weilheim (nave begun 1493). Bohemia: St. Vitus in Krumau (1402–39). Upper Palatine: St. Martin in Amberg (begun 1421).

533 This applies to the churches in Wasserburg, Wimpfen, Meran, Nuremberg and Fernitz. Transversely placed rectangles in the central vessel were even combined with rectangular side-aisle bays set longitudinally: Weilheim, Dinkelsbühl.

534 Of course, we should not forget early-Westphalian and Lower Saxony Halls, which also had square central-vessel bays. See Kunst (note 287) *passim*.

535 St. Martin and Heiligenkreuz in Landshut, Neuötting, Wasserburg, St. Jakob in Straubing, Dingolfing, Munich, Nördlingen, Wimpfen, Dinkelsbühl, Olmütz and Brünn.

536 Churches whose side-aisles have vault figures of four-point stars with transverse arching: St. Martin and Heiligenkreuz in Landshut, Munich, Dingolfing, Meran, Amberg and Fernitz. Munich and Fernitz have stellar vaulting with transverse arches over the central vessel as well. In Krumau and Olmütz, simple cross-rib vaulting covers the side-aisles. Heidelberg has cross-rib vaults with transverse arches throughout its entire nave. The cross-rib vaults in the side-aisles of Neuötting were built in 1622.

537 St. Martin and Heiligenkreuz in Landshut, Dingolfing, Meran and Amberg.

538 Hans von Burghausen's churches in Landshut were also vaulted at a later date – St. Martin's nave in 1475 and Heiligenkreuz in 1461. These vaults, then, were not built earlier than those of churches outside Bavaria with net figures over the side-aisles – the choir in Brünn, the choir of St. Lorenz in Nuremberg, Graz Cathedral and the nave of Schwäbisch Hall. Whether the two Burghausen church vaults possess forms that stem from his own earlier designs has not been established with any certainty.

539 In Swabia: nave in Schwäbisch Hall, choir in Heilbronn. In Franconia: choir of St. Lorenz in Nuremberg. Austria: nave of Eggenburg. Moravia: choir in Brünn. An example from Bavaria would be the curved-rib vaults over the choir in Wasserburg.

540 Swabia: Schwäbisch Gmünd, Nördlingen. Franconia: Dinkelsbühl. Austria: Graz (*Staffelhalle*). Moravia: nave in Brünn.

541 Choir at Schwäbisch Hall, nave in Wimpfen, and nave in Weilheim.

542 For instance at St. Martin in Landshut, Dingolfing, Munich or Nördlingen. Büchner maintains that there was a process by which the cross-section of the vault shell became more pointed in medieval-Bavarian wall-pier churches in general around the year 1450. This would directly contradict Gerstenberg's theory of development. Joachim Büchner, *Die spätgotische Wandpfeilerkirche Bayerns und Österreichs*, Diss. Erlangen-Nuremberg 1958, in the series *Erlanger Beiträge zur Sprach- und Kunstwissenschaft*, (Erlangen 1964) vol. 17.

543 Just to name one, Dinkelsbühl.

544 Central vessel of the choir at St. Lorenz in Nuremberg, choir of Schwäbisch Gmünd.

545 Like those of the high vaults at Wasserburg.

546 This is easy to see in Munich's Frauenkirche. The looping vault figures known in Bohemia and

Saxony, built by Benedikt Reid and Jakob Heilmann, are domed in the center of the bay too (Kuttenberg, Brüx, Annaberg). Yet these vault shells are much flatter in cross-section than those in southern Germany.

547 Gerstenberg 1913, 47, 65. Octagonal piers with fluted (concave) edges did not first appear at the end of the fifteenth century in Upper Saxony, as Gerstenberg maintains. Earlier examples of this pier can be found at St. Nikolai in Lüneberg (begun 1407 combined with thin corner shafting), the parish church in Semriach, Austria (1439–55?), and the Dominican church in Graz (begun 1466).

548 In a manner similar to the pier articulation in the basilican nave of Bern Minster (begun 1421) and Wasserburg (where the responds are corbelled back).

549 Neuötting, Brünn, Olmütz.

550 In Bavaria: St. Martin's (choir) and Heiligenkreuz in Landshut, Neuötting (choir), Dingolfing (since altered). Swabia: Schwäbisch Hall (nave), Nördlingen, Wimpfen, Heilbronn, Weil-der-Stadt (choir), Tübingen (choir), Weilheim, Heidelberg. Franconia: Dinkelsbühl. Moravia: Brünn, Olmütz. Austria: Eggenburg, Graz, Fernitz. Tirol: Meran.

551 Gerstenberg 1913, 32 writes "Instead of the sharp clang of the Gothic cross-rib figure, the vault is now filled with a loud rushing, in the sense of many tonal elements that cannot be distinguished individually."

552 For the history of construction of St. Martin in Landshut see Volker Liedke, "Zur Baugeschichte der kath. Stadtpfarr- und Stiftskirche St. Martin und Kastulus sowie der Spitalkirche Heiliggeist in Landshut," *Ars Bavarica* 39/40, 1986, 1–98. Also Kurmann (note 512).

553 Franz Dambeck, *Hans Stethaimer und die Landshuter Bauschule*, in the series *Verhandlungen des Historischen Vereins für Niederbayern*, vol. 82 (Landshut 1957) 6.

554 His grave on the south side of the church has an inscription that calls him *Meister des Baus*.

555 Büchner (note 542). Important churches belonging to the "Braunau school" are Eggenfelden (consecrated 1444) and Eferding (begun 1451). For more about the general development of the Gothic wall chapel and the importance of the nave chapels at Eichstätt (begun before 1372) as prototypes in Bavarian wall chapel design of the fifteenth century see Jürgen Fabian, *Der Dom zu Eichstätt*, Diss. Heidelberg 1984, in the series *Manuskripte zur Kunstwissenschaft in der Wernerschen Verlagsgesellschaft*, vol. 19 (Worms 1989) 117–27.

556 Überlingen Minster, a five-aisled affair, did not become the structure we know today until the end of the fifteenth century. The original design did not call for windows in the central-vessel walls or chapels between the pier buttresses. See Koepf (note 528) 38.

557 Matthäus Ensinger started building the chapels in the basilican nave of Bern Minster in 1421. Like the chapel walls at Stuttgart, the pier buttresses here stick out of the outer wall. This is different from Bavarian structures.

558 In the towns of Saborov (around 1370), Sobiĕslav (1370–80), Sedlcany (begun 1374). The same triradial vaults at the east end of the nave characterize a group of rectangular, single-pier churches among which are a surprisingly large number of hospice churches. The oldest structure of the group is the church of the Annunciation in Prague, built by a donation from Charles IV in 1359. This is followed by Margarethenkirche in Polin (around 1360?), St. Jakob in Wettel (around 1370), St. Nikolaus in Neuhaus (1365–69), St. Nikolaus in Brünn (second half of the fourteenth century), Loucim (*ca.*1400), Holy Cross in Zittau (around 1400 with a complete umbrella vault) and many churches in the Zips area. See Götz 1968, 107ff. Nikolaus Cusanus, who was in the south-eastern areas of the empire for several months in 1451, as papal nuncio, settled on this structural type for the chapel in his hospice church in Cues (1451–6). Cues

was subsequently the prototype for a group of single-pier churches built in the area of the Moselle River west of modern-day Bonn. See Paul Schotes, *Spätgotische Einstützenbauten und zwieschiffige Hallenkirchen im Rheinland*, Diss. Aachen 1970. This surprising stylistic affiliation shows how a specific type of building could become the prototype for churches a great distance away, and how forms could be communicated directly without being influenced by regional "schools."

559 Other locations where "double-springing rhomboids" were employed were the choir of the Herrenkapelle at Passau Cathedral (1414), the choir and porch of the hospice church in Braunau (1417–30), and the porch of the monastery church in Seeon (1428).

560 A typical Hall church from the time around 1400 is St. Johannis in Königinhof on the Elbe River. Here, four elegant round piers carry cross-rib vaulting with neither transverse nor arcade arches accentuated. With very simple forms, so elegant they are almost fragile, a calm and balanced spatial feel was achieved that is not surpassed by any of the "unified spaces" built later.

561 For a survey see Buchowiecki 1952, 266ff.

562 A Westphalian choir of this type built later is that of the Marktkirche in Lippstadt (1478–1506).

563 There is no known iconographical precedent for building a centralizing wreath of inner piers. Götz 1968, 190 thinks that in the case of Heidelberg the design probably had something to do with the fact that the choir was to hold the grave of Ruprecht III von der Pfalz.

564 Jan Sedlák, "Die Architektur in Mähren in der Zeit der Luxemburger," *Parler*, vol. 5, 123–36, here 133ff.

565 This was not the case in Bozen, where an apex chapel sits in the outer wall at the eastern end of the church.

566 Gerstenberg 1913, 91 writes "Light from the window in the eastern end of the choir falls on the ambulatory pier, which stands like a dark stripe against a flood of light and is robbed of any appearance of plasticity." See also Kunst on the subject of the Hall choir with ambulatory (note 199) 99f., and von Ledebur (note 300) 72f.

567 Dating the construction of St. Jacob, Straubing, which has since been renovated in the Baroque Style, is controversial. There is a surviving donation from 1423 for a procession to have taken place in the Gothic choir.

568 Johann Parler was married in Kuttenberg in 1383. Building on the basilican choir, designed to have wall chapels, was broken off during the Hussite War, then completed according to a different design in the sixteenth century.

569 The vaults were not built until 1461 and probably do not correspond to the original design. See Nussbaum (note 322) 153.

570 Ibid., 164ff.

571 Ledebur was the latest to maintain this (note 300) *passim*.

572 Of the choirs with a centralized apex pier to be built at a later date, the hospice church in Meran (began around 1425) and St. Johannis in Dingolfing (begun 1467) adopted Landshut's pier constellation. The two choirs in the Steiermarkt region of Austria – Maria Trost in Fernitz (1506–14) and St. Nikolaus in Rottenmann (1509, since altered) – take up the solution preferred by Salzburg, but not Krumenauer's sprocket-like arrangement of intertwining rhomboid umbrellas. Rottenmann's reticulated net vault is the only one to approach a similar unifying effect.

573 The outer polygon at Gmünd "breaks" inward at a spot east of the pair of arcade piers in the inner polygon that are placed towards the center of the sanctuary. But in the choirs of the fifteenth century, the outer polygon breaks at the same spot as the inner polygon.

574 Behling 1937, 96.

575 Like at St. Lorenz in Nuremberg, Amberg's gallery balustrade springs over the wall buttresses.

576 The same inner-to-outer choir polygon ratio can be found at Our Lady in Ingolstadt (begun 1425) a *Staffelhalle*. High formeret walls ensure that the central vessel here dominates the side-aisles, ambulatory and low wall chapels. The church has towers placed at the two diagonal sides of its polygonal west termination. The arcades run right up to the west wall. The structure seems to be a longitudinal oval that nonetheless focuses the eye on the choir, since the side-aisles do not circulate in the west.

577 Frauenkirche Munich (1468–92) and St. Michael in Schwäbisch Hall (begun 1495).

578 Basilican structures: St. Salvator in Duisburg (first half of the fifteenth century), parish church in Rheinberg (renovation of the nave second half of the fifteenth century), St. Willibrordi in Wesel (1498–1539). Hall structures: western sections of parish church in Straelen (end of the fourteenth century), parish church in Geldern (1400–18, destroyed), parish church in Kalkar (begun 1409) and the parish church in Dinslaken (mid-fifteenth century, destroyed). *Staffelhallen* structures: Collegiate church in Kleve (1341–1426), parish church in Kranenburg (1409–47), eastern section of parish church in Straelen (after 1498).

579 For a survey see Reinke (note 443).

580 Eckart Mundt, *Die westfälischen Hallenkirchen der Spätgotik (1400–1550)* (Lübeck-Hamburg 1959) 122ff.

581 Ibid., 122.

582 St. Mary's, Wittenberg (1411–39), St. Peter and Paul, Delitzsch (begun 1404), St. Andreas, Eilenburg (begun 1444) and St. Nikolaus. See May (note 508) 40.

583 St. Mary's, Borna (begun 1411), St. Kunigunden, Rochlitz (1417–76), St. Matthäi, Leisnig (completed 1484), St. Catherine, Zwickau, Our Lady in Meissen, St. Mary's, Kamenz (around 1400–80), Our Lady in Görlitz (1449–86). Heinrich Magirius, "Die gotischen Hallenkirchen," *Die Stadtkirchen in Sachsen*, Fritz Löffler ed., 3rd edition (Berlin 1977) 32–42, here 33.

584 For the history of construction on St. Nikolai see the section by Sibylle Harksen in Ingrid Schulze's "Die mittelalterlichen Gewölbemalereien der Nikolai-kirche zu Herzberg (Elster)," *Wissenschaftliche Zeitschrift der Martin-Luther–Universität Halle-Wittenberg. Ges.-sprachw. Reihe* 12, 1963, 693–724.

585 The polygon of St. Nikolai in Luckau (begun 1375) has a somewhat irregular shape.

586 Wilsnack (after 1384), St. Petri, Treptow (early fifteenth century), St. Johannes, Stargard (begun 1408) and others. See Wolfgang Clasen, "Hinrich Brunsberg und die Parler," *Neue Beiträge zur Archäologie und Kunstgeschichte Schwabens. Festschrift für J. Baum* (Stuttgart 1952) 48–58, here 49f.

587 The same method was used to create an ambulatory at St. Lambertus, Düsseldorf.

588 Clasen (note 586) decided on Gmünd as the source for this pier decoration. Against the "Gmünd pier" as the prototype see Zaske (note 286) 57ff. Idem, "Heinrich Brunsberg – Werk und Bedeutung," *Mittelalterliche Backsteinbaukunst. Romanische und gotische Architektur – ihre Rezeption und Restaurierung*, in the series *ZEMAU* 29 (Greifswald 1980) 83–94.

589 See above, page 155.

590 The first mention concerns a chapel consecration in 1388. The Sacristy was built in 1404. Clasen (note 586) 51.

591 Dating of St. Catherine, Brandenburg has been controversial. H. Müther, *Baukunst in Brandenburg* (Dresden 1955) 65 has it between 1407–11. Clasen 1958, 72 has construction begin 1401. Fischer 1971, 102 dates construction begin around 1395. Rudolf Pfefferkorn, *Deutsche Backsteingotik* (Hamburg 1984)

124 dates it between 1387–1411. While it is true that an older church at that site was torn down in 1395, an Indulgence for a new structure has survived and it is dated 1381. See Böker, 1988, 227.

592 Primary sources do not confirm Zaske's suspicion that this double-parallel rib vault over the central vessel could not be from Brunsberg. Zaske (note 286) 145.

593 In the hinterland of the Baltic coast there were many Hall choirs with ambulatory built in the fifteenth century. In general, these did not venture beyond the parameters fixed in Berlin and Frankfurt. Brunsberg's decorative style seemed to have had little influence on smaller parish churches. Kunst, "Hallen-umgangschor" (note 199) 92f. An exception in the Altmark regionto this was the Hall choir of St. Mary's in Stendal (around 1420–47), which adopted the same floor plan as Verden and enriched it by adding wall chapels. Ibid., 88.

594 Single-tower churches with extremely spacious side-aisles on the ground level were known in the cities of the Hanseatic League as early as the thirteenth century (Lübeck, Rostock, Wismar).

595 The transept and choir were financed by the heads of the Drapers Guild of Stralsund. Zaske (note 438) 169.

596 Jürgen Michler, *Gotische Backsteinkirchen um Lüneburg St. Johannis*, Diss. Göttingen 1967.

597 Wille Drost, *Die Marienkirche in Danzig und ihre Kunstschätze*, in the series *Bau- und Kunstdenkmäler des deutschen Ostens*, vol. A.4 (Stuttgart 1963) 51.

598 For a reproduction of such munuscripts see the following: Hans Koepf, *Die gotischen Planrisse der Wiener Sammlungen* (Vienna-Cologne-Graz 1969). Idem (note 408). Also Werner Müller, "Technische Bauzeichnungen der deutschen Spätgotik," *Technikgeschichte* 40, 1973, 281–300. Peter Pause, *Gotische Architekturzeichnungen in Deutschland*, Diss. Bonn 1973.

599 Among the oldest stonemason sketch books, and manuscripts that contain drawings of vaults and vault cut-patterns, are Hans Schmuttemayer's *Fialenbüch-lein* (Nuremberg, Germanisches Nationalmuseum no.36045) and a manscript at the Vienna Albertina (Cim. Kasten, Fach 6 no.55). Both are from the late fifteenth century. These were followed in the sixteenth century by Lorenz Lechner's 1516 *Unterweisungen* (transcript in the stonemason's sketch book of Jacob Facht, 1593, in Cologne City Archives, WF 276; there are fragments in Heidelberg University Library Hs. 3858 and in the Landesbibliotek Karlsruhe, D. Hs. 157). Next was the 1572 stonemason's book "WG 1572" (Frankfurt Städelsches Kunstinstitut, Inv. 2026). For an excellent study on this theme see Naredi-Rainer (note 435) 232–83. See also Müller 1990.

600 Areas like the lower Rhine, Westphalia and Lower Saxony. It was even true in the Altmark and north-eastern Austria, although Vienna played an important role in vault construction in the fifteenth century.

601 Bock argues unconvincingly for an English prototype (over the crossing at Tewkesbury) for this figure. Bock (note 405) 206f.

602 Clasen 1958, 80.

603 These are not fan vaults as Fehr thinks in "Benedikt Ried" (note 410) 96. The English fan vault is a conoid at the edge of the bay, and completely oblate at the vault apex. For a typological study see Leedy (note 410). Hans von Burghausen employed a complicated "creased-rib" vault over the western porch of Heiligenkreuz in Landshut (begun in 1407).

604 Fehr in "Benedikt Ried" (note 410) 96. Very similar to this is the figure over the eastern bay of the sanctuary at St. Nikolaus in Neuötting, that more than likely was built by Hans von Burghausen. The Vienna figuration can be found, slightly altered, in the central bays of the choir at Steyr.

605 Dambeck (note 235) 28 describes these vault figures as "flowing rhomboids."

606 A similar vault is the apex rhomboid figure in St. Peter's in Frankfurt (1417–19), which is attributed to Madern Gerthener by Fischer (note 431) 52.

607 Similar s-shaped ribs can be found beneath the canopies of the west portal at Regensburg.

608 The same figure hangs over the side-aisles of Wells Cathedral (around 1330).

609 In the central vessel of the parish church in Braunau, Krumenauer used the same vault as that of the north porch at Heiligenkreuz, Landshut, but wove it into a new kind of stellar net. Each figure is a six-pointed star, whose short (longitudinal) points are split by a centrally placed rhomboid. Dambeck (note 253) 26 gives this vault motif the name of "Wechsel-berger figure" because it was used at a later date by the Bavarian architect Hans Wechselberger. The motif would be dispersed as far away as the southern Alps of Austria after the mid fifteenth century.

610 For more about Bürkel and his work see Norbert Nussbaum, "Die sogenannte Burghausener Bauschule. Anmerkungen zur ostbayrischen Spätgotik und ihrer Erforschung," *Ostbairische Grenzmarken. Passauer Jahrbuch für Geschichte, Kunst und Volkskunde*, 26, 1984, 82–97. Also Hans Puchta, "Zur Stellung des Hans von Burghausen in der Entwicklung der spätgotischen Gewölbe Süddeutschlands," *Ars Bavarica* 35/36, 1984, 71–82, here 77–9.

611 Nussbaum (note 322). The expression "three-column churches" was first formulated by Erich Bachmann, "Die Wallfahrtkirche St. Maria in Gojau und die bayrisch-österreichischen Dreistützen-räume," *Stifter Jahrbuch*, 4, 1955, 147–75.

612 Representative of this kind of vault are two parish churches in the area of the Inn River: Neukirchen-an-der-Enknach (begun between 1425–36) and Handenberg (altar consecrated 1453).

613 Similar are those Bavarian and Austrian churches with zigzag placement of wall responds and free-standing piers with asymmetrical stellar vaults above them: cloisters of the Domincan church in Regensburg (1424), the Benedictine abbey church at Mondsee (1441–8) and the former Augustinian collegiate church in Beyharting (east and west ends around 1450), collegiate church in Berchtesgaden (*ca.* 1450?), parish church in Rotthalmünster (after 1480?). See Joachim Büchner, "Unsymmetrische Raumformen im spätgotischen Kirchenbau Süddeutschlands und Österreichs," *Festschrift Peter Metz* (Berlin 1965) 256–81. Asymmetrical stellar forms make up the side-aisle vaults of the choir of St. Mauritius in Olmütz, Moravia. These types of vaults were built into many spaces in north-western Austria during the second half of the fifteenth century. See Walther Buchowiecki, "Stephan Wultinger und die gotischen Kirchenbauten im oberösterreichischen Attergau," *Wiener Jahrbuch für Kunstgeschichte*, 11, 1937, 41–58. Also Nussbaum (note 322) 175ff.

614 Friedrich Kobler and Manfred Koller, "Farbigkeit der Architektur," *Reallexikon zur deutschen Kunstgeschichte*, vol. 6 (Munich 1976), cols 274–424, here 349. Franz Dambeck, "Die Farbigkeit der spätgotischen Kirchen Altbayerns," *Bayer. Landesamt für Denkmalpflege*, Bericht 26, 1967, 322–32. The polychromia employed in southern Germany was not used everywhere in the empire. The Rhineland seemed to avoid grey tones around 1400, while in the northern Backstein areas the old method of contrasting red and white continued to be the norm.

615 Like it was, for instance, in the choir vaulting of St. Martin's in Landshut.

616 Karl Oettinger, "Laube, Garten und Wald. Zu einer Theorie der süddeutschen Sakralbaukunst 1470–1520," *Festschrift für Hans Sedlmayr*, (Munich 1962) 201–28. Also Joachim Büchner, "Über die dekorative Ausmalung spätgotisher Kirchenräume in Altbayern," *Mouseion. Studien zur Kunst und Geschichte für Otto H. Förster* (Cologne 1960) 184–93. See also Peter Findeisen, *Studien zur farbigen Fassung spätmittelalterlicher Innenräume*, (Diss., ms Leipzig

1969).

617 Karl Young, *The Drama of the Medieval Church*, vol. I, 1933, 489ff. Orville K. Larson, "Ascension Images in Art and Theatre," *Gazette des Beaux Arts*, 6th pér., tom.54, 101, année 1959, 161–76. For an account concerning devices used to raise and lower things out of apex rings in the late Middle Ages, including an exhaustive bibliography with primary sources, see Karl-Adolf Knappe, "Um 1490. Zur Problematik der Altdeutschen Kunst," *Festschrift Karl Oettinger* (Erlangen 1967) 303–52, here 135. An especially good description of the yearly Ascension Day ceremony at St. Martin in the village of Biberach has survived in the *Chronica Civitatis Biberacensis ante Lutheri Tempora* which says "In this way Our Lord Jesus was pulled upward, and all the Angels did move up with Him, and then down again, and at the end around Him the Angels did gather and All did descend into Heaven.... Once Our Lord was in Heaven, there came from above (over the vault) a rumbling, the Host and fire were thrown down (into the church), water poured down...." From Knappe (note 340).

618 For more about this see Joachim Büchner, "Ast-Laub und Maßwergewölbe in der endenden Spätgotik. Zum Verhältnis von Architektur, dekorativer Malerei und Bauplastik," *Festschrift Karl Oettinger* (Erlangen 1967) 265–302, here 268ff.

619 Ibid., 269.

620 Ibid., 270.

621 The tracery vaults of St. Catherine, Borna (1455–56) are also attributed to Moyses von Altenburg. Clasen 1958, 82.

622 Probably best to compare the tower structures in the Inn-Salzach region (Neuötting; hospice church in Braunau; Eggelsberg) rather than the huge west tower of St. Martin in Landshut.

623 In the painting *Judgement of Verginia by Appius Claudius* (1535) in Munich, Alte Pinakothek Inv.Nr. 13099

624 Schondorf's Gothic choir is the only part of the original church to survive.

625 Koepf (note 528) 45.

626 Aberlin Jörg's vault in the collegiate church at Stuttgart is, like those of the Urach Masters, tightly woven.

627 St. Ulrich and Afra was not the only Benedictine church from the fifteenth century to consciously employ, and thereby emphasize, conservative structural forms. Similar in this respect was also the collegiate church in Melk (consecrated 1429), whose antiquated structural program Wagner-Rieger 1967, 349f., 398 understands as having been a conscious representation of the *Melker Reform* which swept through the Benedictine Order during these years. The new Benedictine church in Blaubeuren, whose monastery joined the order's reform movement in 1451, possesses a tall and narrow chancel, a transept and crossing tower all of which are extremely rare for late fifteenth-century German Gothic.

628 Engelberg was in Ulm starting in 1494 in order to shore-up the weakened tower substructure. It was feared the central-vessel walls might buckle under the weight of the tower, so Engelberg added two rows of piers and doubled the number of side-aisles. Julier points out that the style of the choir clerestory at Freiburg Minster (begun 1471 by Hans Niesenberger, being built 1491 by Hans Niederländer) seems to reflect Engelberg's style. Jürgen Julier, *Studien zur spätgotischen Baukunst am Oberrhein*, in the series *Heidelberger kunstgeschichtliche Abhandlungen*, vol. 13 (Heidelberg 1978) 75–153.

629 Konrad Werner Schulze, *Die Gewölbesysteme im spätgotischen Kirchenbau in Schwaben von 1450–1520*, Diss. Tübingen 1936 (Reutlingen 1939) 9ff.

630 Prominant examples of this kind of vault can be found in Schörfing (1476–96) and St. Georgen-im-Attergau (1490s). Also similar is Allesheiligen-im-

Mürztale, Steiermark. See Nussbaum (note 322) 176ff. Buchowiecki (note 613) attributes most structures with this kind of vault to a certain Stephan Wultinger mentioned in late medieval documents to have lived in the town of Admont. They can be traced back to much older Bavarian vaults as well.

631 Late Gothic churches near the lodge in Steyr: Heiligenstein (second half of the fifteenth century), Sipbachzell (1478), Papneukirchen (1488), Petzenkirchen (end of the fifteenth century). In eastern Austria: Klein-Pöchlarn (1517), Kottes (beginning of the sixteenth century). In Kärnten: Baldramsdorf (1522). In the Steiermark: St. Marein near Knittelfeld (1445–8) and St. Oswald near Oberzeyring (begun 1469), Rottenmann (begun 1488), Gaishorn (1520) and Tiffen (*ca*.1500?). And finally Schladming (1522–32) employed a St. Lambrecht choir type, the last in the group.

632 Records indicate that the dukes of Saxony had roughly a thousand times the available funds for conducting political activities than their western-German counterparts, the electorates of the Rhine and Palantinate. G. Droege, "Die finanzciellen Grundlagen des Territorialstaates in West- und Ostdeutschland and der Wende um Mittelalter zur Neuzeit," *Vierteljahresschrift für Sozial- un Wirtschafisgeschichte* 53, 1966, 145–61, here 155ff.

633 The lower register of the base was probably completed around 1370, while the base's upper register employs blind tracery in the Prague Style and was more than likely finished in the very last years of the fourteenth century.

634 It has always been assumed, but never proven, that Arnold von Westfalen came from Westphalia. This has lead some scholars to look for western-German forms in his work. For a survey on this see Fischer (note 451) 41ff. For a Leipzig origin see Ernst Heinz Lemper, "Arnold von Westfalen. Berufs- und Lebensbild eines deutschen Werkmeisters der Spätgotik," *Die Albrechtsburg zu Meissen*, Hans-Joachim Mrusek ed. (Leipzig 1972) 41–55, here 52.

635 Hermann Meuche, "Das Zellengewölbe. Wesen, Entstehung und Verbreitung einer spätgotischen Wölbweise," Masters thesis Greifswald 1958. Idem, "Die Zellengewölbe und die Albrechtsburg," in Mrusek ed. (note 634) 56–66, 134–8.

636 Two exceptions in the ecclesiastical architecture of Saxony and Thuringia being the folded vaults, with ribs, in the choirs of the parish churches in Neustadt (1502) and Torgau (early sixteenth century). For more about this see Magirius (note 538) 34.

637 Folded vaults can be found in churches in the Bohemian towns of Blatna, Bechin, Soběslav, Nezamyslice, Beltschitz, Slavonice and Tabor. See Meuche on "Das Zellengewölbe" 1958 (note 635) 67ff., Clasen 1958, 86ff., and Fehr on Benedikt Ried (not 410) 64f.

638 Other folded vaults built in eastern Prussia were St. Catherine in Gdansk, the parish church in Marienburg, and churches in Rastenburg, Mohrungen and Labiau. See Clasen 1958, 88.

639 Besides working in Meissen, surviving records indicate Arnold also worked on castles in Rochlitz, Dresden, Torgau, Leipzig and Tharant.

640 See note 94. Rochlitz's rows of piers are braced by arches placed above the vault shell. These are the equivalent to salient arcade arches that support the overall ceiling structure longitudinally. We find this in almost all the great Halls built in Saxony during the Late Gothic period. Heinrich Magirius, "Die Albrechtsburg und die spätgotische Architektur in Obersachsen," Mrusek (note 634) 67–83, here 67.

641 Like several other churches in the region, Merseburg's nave piers are placed to stand in the center of the windows (note 630).

642 The Gothic piers and vault of St. Nikolai were altered beyond recognition in 1784–97.

643 The Hall structure at Görlitz was begun as a three-aisle structure (Hans Knoblauch and Hans

Baumgarten 1423) then expanded by two additional, and lower, side-aisles sometime after 1450. There is a complete four-aisle structure, St. George's Chapel, beneath the nave. The eastern end terminates in a staggered-apse choir. Due to the distance of the former-meret walls of the outer aisles, the central vessel is permanently in shadow.

644 The prominent crease in the middle of the nave at Bauzen is due to the topography of the church site. Its choir with ambulatory – built when the nave was renovated (1492–7) – is the usual three-sided inner and five-sided outer polygon structure. Nonetheless, it seems rather narrow at the end of such a wide nave.

645 H. Batzl, "Amberg St. Martin/Oberpfalz," in the series *Schnell Kunstführer*, vol. 695 (Munich-Zurich 1959) 4.

646 Götz 1968, 142, 172. See also Vera Viertelböck, "St. Salvator in Passau. Historische und baugeschichtliche Untersuchung," *Ostbairische Grenzmarken* 16, 1984, 98–125, here 110–16.

647 Heinrich Magirius, *Der Dom zu Freiberg* (Berlin 1977) 31. Hermann Meuche, "Zur gesellschaftlichen Funktion der Emporen im obersächsischen Kirchenbau um 1500," *Actes du 22e Congrès International d'Historie de l'Art* (Budapest 1972) 551–6, here 553ff., believes that the gallery level at Freiberg Cathedral was reserved for church dignitaries, Duke Albrecht's family and court. Galleries of various types were very popular in churches built during the fifteenth and sixteenth centuries in southern Germany and the Danube River basin. Austrian churches with such galleries compiled by Buchowiecki 1952, 25. Little survived concerning exactly what these galleries were used for, however. The same can be said of Swabia, where concise information concerning the function of galleries in parish churches built during the period has not survived either. See Philipp (note 440) 36.

648 Close economic ties between the rich mining centers of Upper Saxony and the Imperial city of Nuremberg might have inspired Freiberg's employment of Nuremberg's oriel motif. For Nuremberg's economic ties during the Late Gothic period see Theodor Gustav Werner, "Die große Fusion der Zechen um den Rappolt in Schneeberg unter Führung der Nürnberger von 1515," Part I *Mitteilungen des Vereins für Geschichte der Stadt Nürnberg* 56, 1969, 214–50.

649 These are dated by an inscription of 1499.

650 For those churches in Saxony to employ the Freiberg gallery motif see Magirius (note 647) 36.

651 K. Künstle, *Ikonographie der christlichen Kunst*, vol. 1 (Freiburg 1928) 517–21. S. Seeliger, "Das Pfingstbild mit Christus 6.–13. Jahrhundert," *Das Münster* 9, 1956, 146–52.

652 Götz 1968, 175f., 317 compares this structure to English chapterhouses, whose centralized structural form might be interpreted as having been a conscious reference of the builders to Pentacostal iconography.

653 On the other hand, the rounded wall pier – which we find at Alexanderkirche – is a motif that might be traceable to palace church architecture in Halle and Wittenberg. See Gross 1969, 194.

654 Fischer (note 431) 235–7 believes the vaults at Zweibrücken were English influenced because of their strict, what he calls "tangible-rational" formal construction. Yet, there are no major differences between the vaults in Zweibrücken and other Germany tracery vaults either.

655 For more about the complicated history of Willibrordi's construction, and how the church was reconstructed in its original form after major damage during the Second World War, see Hans Merian, "Die Willibrordikirche in Wesel," in the series *Rheinische Kunststätten*, 2nd edition (Neuss 1982) 113.

656 An early looping-rib vault in the Danube River basin to have free-standing tracery placed below the vault shell, when only a little bit, can be seen over the cloisters at Basel Minster (likely before 1485). Fischer (note 431) 61, Büchner (note 618) 275.

657 For a survey of the concept of "Baroque Gothic," its formulation and development, see Bialostocki (note 264) 87–91. The generally accepted chronology of the German *Barockgotik* as having occurred between 1470 and 1520 was probably first put forth in Petrasch's study on the development of Late Gothic architecture (note 462) 196f.

658 François Bucher, "Micro-Architecture as the 'Idea' of Gothic Theory and Style," *Gesta* 15, 1976, 71–89.

659 Early examples of such ornamental objects, the sepulchral canopies, rood screen and main altar at St. Elizabeth, Marburg.

660 For more about late medieval drawings of "micro-architecture" see Koepf, Wiener Sammlungen (note 598). A near inexhaustible compendium of similar drawings and sketches – most of them meant as models for objects of wood or stone – can be found in the so-called *Goldschmiederisse* or "Goldsmith Sketches" of the Kupferstichkabinett in Basel. *Katalog der Zeichnungen des 15. und 16. Jahrhunderts im Kupferstichkabinett Basel* by Tilman Falk, in the series *Kupferstichkabinett der Öffentlichen Kunstsammlung Basel. Beschreibender Katalog der Zeichnungen. 3, 1* (Basel-Stuttgart 1979) 116–40, 155–7, Taf. 89–121, 139–40.

661 Highly ornate pedestals can be found, for instance, on the baptismal font (1467) at St. Severi, Erfurt, and the Eucharist shrines at St. Dionys, Esslingen (by Lorenz Lechner 1486–9) and St. Lorenz, Nuremberg (by Adam Kraft 1493).

662 Early examples of shafts and base structures that were twisted can be found, once again, on the baptismal font at St. Severi, Erfurt and the Eucharist shrine of St. Lambertus in Düsseldorf.

663 Because of this, Bucher's thesis – that the Late Gothic church became a mere protective structure for the ever more complicated forms of micro-architecture – is far too general. Bucher (note 658) 72.

664 Gerstenberg 1913, 48f. See also Hans Josef Böker, "Die spätgotische Nordhalle des Braunschweiger Domes," in *NBK* 26, 1987, 51–62. The first piers with cable molding in French Gothic also appeared in the 1480s, in the ambulatory of St-Séverin in Paris. Frankl 1962, 195f.

665 Because of their fantastic and expressionistic articulation, pier forms from this region have always been seen as very similar to painting and sculpturing of the "Donau School." Indeed, the stone altar structures at Kefermarkt, Pulkau, Mauer and Zwettl have an amazing pictorial quality about them. See Benno Ulm, "Der Begriff 'Donauschule' in der spätgotichen Architektur," *Christliche Kunstblätter*, Deözesan-Kunstverein publ. Linz a.d. Donau, 100, 1962, 82–7.

666 Piers with stellar cross-sections can be found in the churches at Eferding, Göss, Laakirchen, Steinakirchen-am-Forst. Screw-like twisting in Haidershofen, Gaishorn, Göss, and Vöcklamarkt. Cable-molding at Haidershofen. Piers with rhomboid net surface articulation at Frankenburg, Vöcklabruck, and Weissenkirchen. Dates for these poorly documented country churches can be found in Buchowiecki 1952, 262ff., and Nussbaum (note 322) 202ff.

667 Compare the churches in Aschbach, Eisenreichdornach, Kaning, Krenstetten, Papneukirchen, Sindelburg and Steinakirchen-am-Forst. See also Buchowiecki 1952, 98.

668 Heinrich Meckenstock, *Portalarchitektur deutscher Spätgotik*, Diss. Innsbruck 1951, 122ff. Typical examples would be both portals of the cloisters in Hirsau (ca.1493/94, destroyed). For the prototypes of these kinds of shaft constructions see Ringshausen (note 447) chapter IV, note 18.

669 Behling 1937, 100–8.

670 For the French Court Style origins of early branch-work forms see Margot Braun-Reichenbacher, *Das Ast- und Laubwerk*, in the series *Erlanger Beiträge zur Sprach- und Kunstwissenschaft* vol. 24, (Nuremberg 1966) 5ff.

671 Ibid., 40ff. See also Anneliese Seeliger-Zeiss, *Lorenz Lechner von Heidelberg und sein Umkreis. Studien zur Geschichte der spätgotischen Zierarchitektur und Skulptur in der Kurpfalz und in Schwaben*, in the series *Heidelberger kunstgeschichtliche Abhandlungen*, vol. 10 (Heidelberg 1967) *passim*.

672 Even more audacious is the "Simpertus Arch" (by Burkhard Engelberg 1492–6) at St. Ulrich and Afra in Augsburg.

673 Now and then we find simple shaft and buttress work combined with branch work. Such objects appear to have been damaged and then repaired with makeshift materials. An example might be the Eucharist shrine at the collegiate church in Baden-Baden (1490s).

674 For an iconographical study with literature see Magirius (note 647) 38–41.

675 For a different interpretation of Freiberg's "Tulip Pulpit" see Iris Kalden-Rosenfeld, "Einfach traumhaft – traumhaft einfach. Ein Beitrag zur Ikonographie der Kanzel Hans Wittens im Dom zu Freiberg," *Das Münster* 45, 1992, 303–10. Kalden-Rosenfeld believes the stairs illustrate King Nebuchadnezzar's dream and its interpretation by Daniel (Daniel IV, 1–34) during the Babylonian captivity; the seated figure at the base of the pulpit being the king, and the figure with the stairs on his shoulder Daniel.

676 Büchner (note 618) 268ff., bases his analysis of Gothic branch work on a step-by-step development, which does not admit a complete transformation of abstract structural decoration into branch work until the final stage. The early dating of the vault at Eichstätt seems to contradict his theory.

677 Compare the tops of the piers of the Nonnbergkirche in Salzburg (1485–1507) and the tracery of the hospice church in Krems (after 1470).

678 Büchner (note 618) 272ff.

679 Examples can be found at Büchner (note 616) 187ff. *Idem* (note 618) 277.

680 R. Grimm, *Paradisus coelestis – Paradisus terrestris* (Munich 1971) 78.

681 Meffreth, *Opus sermonum tripartitum.... Hortus reginae. Nuerembergae 1496, sermo XLIV*. Dietrich von Gotha wrote "irre garte ist die heilige christenkirche die nüze sin die heilige lüte samenunge," quote by Johannes Erben, *Ostdeutsche Chrestomathie. Problem der frühen Schreib- und Druckersprache des Mitteldeutschen Ostens* (Berlin 1961) 98.

682 Bavarian examples from Büchner (note 616) 190: the cloisters in Altötting, Niedergottsau, the Franciscan church in Berchtesgaden. Vault painting with interesting iconography can be found over choirs in parish churches around Zurich that were built around 1500. The church in Wiesendangen, for instance, has painted half-figure Apostles and prophets growing out of objects that consist of a blossom atop a stem. God and Christ are depicted at the apex of the vault. Above the first two bays of the choir at the parish church in Elgg, the Holy Family along with a number of saints are painted onto the formeret walls. Wise and foolish virgins gesture towards heaven, which opens up over the main altar at the eastern apex of the choir. Over the polygon, two angels stand guard at the gate of heaven with the patron saints of the church, St. George and St. Paul.

683 Folio 72, quote from Marian Kutzner, "Theologische Symbolik deutscher spätgotischer Hallenkirchen," *Mittelalterliche Backsteinkunst. Romanische und gotische Architektur – ihre Rezeption und Restaurierung*, in the series *ZEMAU* 29, 1980 (Griefswald 1980) 37–43. Certain vault paintings done by the school of Michael Pacher during the period express something very similar to this. Here we find busts of saints between tracery ribs and a colorful background, looking out from foil shapes. The tracery vaults have become windows punched through the membrane of this world, which allows a view of the world of the saints on the other side. See Büchner (note 618) 281–4.

684 For more see Oettinger (note 616) and Büchner (note 618) 292–4.

685 For more on this theme see Eva Börsch-Supan, *Garten-, Landshaft-, und Paradiesmotive im Innenraum. Eine ikonographische Untersuchung*, Diss. Cologne 1963 (Berlin 1967) 157–86, and 233–9.

686 Of those who propose this, Oettinger's notion (note 616) 220ff., that the spatial form of the arbor (*Laube*) could be used to describe the entire German Late Gothic period, seems especially questionable.

687 One of the only Gothic structures with its iconographic system still intact, completely untouched since it was built, can be found in the choir of the Benedictine church in Blaubeuren (Peter von Koblenz, under construction 1491). The iconographic system used here has been interpreted by Knappe (note 617).

688 The most important work to promote this thesis is surely the popular cultural history of the late Middle Ages by Johan Huizinga, *Herbst des Mittelalters. Studien über Lebens- und Geistesformen des 14. und 15. Jahrhunderts in Frankreich und in den Niederlanden*, 11th edition 1975 (Stuttgart 1924).

689 Quote from Bernd Moeller, *Deutschland in der Zeit der Reformation*, in the series *Deutsche Geschichte*, vol. 4, Joachim Leuschner ed. (Göttingen 1977) 38.

690 The apex of the vault is warped, as one would expect at the top of a rhomboid umbrella configuration, and herein lies the difference. The English fan vault has flat, not warped, plates placed at the vault apex in those spaces where the inverted cones of the umbrella do not touch. See Leedy (note 410) 21–30.

691 Examples of this can be found at St. Georgen-am-Ybbsfeld, Eisenerz (1504–9) and St. Peter-in-der-Au, Nöchling, Ried in western Austria: Wallmersdorf, Haimburg, Weyer, Aschbach. See Fehr, "Benedikt Ried" (note 410) 115ff. For the central-Rhine vaults of this type that probably have Donau Late Gothic prototypes (choirs at Hexheim and St. Martin, both completed after 1510) see Fischer (note 431) 171ff.

692 For further examples of curved-rib vaults in eastern Austria see Fehr, "Benedikt Ried" (note 410) 117ff., and Ulm (note 665).

693 In fact, most Austrian curved-rib vaults from this period, not just those in Kärnten, tend towards a seamless fusing of all rib courses. We find them employed, for example, in Anton Pilgram's organ base (1511/13) at St. Stephan and over the entrance gate (1513/16) of the "Niederösterreichsches Landhaus" both in Vienna. In the late medieval period vaults of this type were built further west, in southern Germany, which indicates once again just how much Donau Gothic vault-construction influenced the area. A typical example would be the "Laurentius Chapel" (by Jakob von Landshut 1495–1505) at Strasbourg Cathedral. Some curved-rib figurations are capped at a point not far from the rib crossings and seem because of it to be more brittle. They are reminiscent of branch-work vaults that have been made to look chopped off, examples here being choir vaults (by Stephan Weyrer 1497/99) of St. George in Nördlingen, choir vault (1488?) of the parish church in Rosenlengen and the parish church in Kalsching (vaulted after 1507) both in southern Bohemia.

694 See above, page 12

695 Fehr, in "Benedikt Ried" (note 410), gives scant attention to the influence the architecture of Saxony had on Ried's work.

696 Exactly how the statics of this vault prevent it from crashing to the floor, as it seems to want to do, is not known. Perhaps the vault shell's dome-like form provides the necessary support.

697 Other important works by Ried at the Hradschin include the "capped" rib vault over the "Reiterstiege" (shortly after 1500) and the Bohemian Chancellory (ca.1505). The latter structure represents a completely new variation of the architect's work, in

that it is made out of pieces of ribs that look like branches twisted longitudinally. Like Peter Parler before him, it appears that Benedikt Ried was familiar with most of the styles of his times, and able to employ them in new and exciting ways.

698 This flattening of the vault shell, while a defining characteristic of Late Bohemian and Saxon Gothic, is not isolated to them. The curved-rib vault (from Bernhard Nonnenmacher 1547) at St. Catherine's Chapel in Strasbourg Cathedral, for example, possesses webs that recede back from the impost zones just like they do in Kuttenberg.

699 Interestingly, the vaults at Kuttenberg become gradually simpler as you move outward through the aisles from the central vessel: the vaults of the chapels connected to the side-aisle are simple cross-rib vaults, while the spaces under the gallery are net vaults with straight rib courses.

700 Fehr, "Benedikt Ried" (note 410) 40.

701 In ibid., 43f., Fehr says the vault in Laun has a "crystal-like rigidity" that possesses all the characteristics of a mature style. We should not forget, however, that Ried had already employed capped ribs at the Hradschin at the beginning of his career (note 697). We even find the motif on the tips of the looping-rib stellar configuration at "Vladislaw Hall."

702 More about this in Heinz Schönemann, "Die Baugeschichte der Annenkirche in Annaberg," *Wissenschaftliche Zeitschrift der Martin-Luther-Universität Halle-Wittenberg, gesellshafts- und sprach-wiss.*, Reihe 12, 1963, 745–56, here 752f.

703 For a survey ibid., 746, and Bialostocki 1972, 350.

704 Pflüger built St. Peter in Görlitz (1490–7) according to a similar plan.

705 Schönemann (note 702) has done a disciplined, if somewhat less than critical interpretation of these sources.

706 Heinrich Magirius, "Denkmalpflege an Kirchenbauten der obersächsischen Spätgotik," *Denkmale in Sachsen* (Weimar 1978) 160–209, here 173.

707 This according to Heinrich Magirius, "Neue Ergebnisse zur Baugeschichte der Annenkirche in Annaberg," *Sächsische Heimatblätter* 21, 1975, 149–57, here 149.

708 Gerstenberg 1913, 133. Möbius interprets the interaction of pier and what he calls "star blossoms" in Annaberg's vaults as a Tree of Life motif. He sees it reflecting "the popular beliefs of the medieval miner. Different than the heavenly garden, the Tree of Life has its roots in the earth, which then took shape in the cathedral." Friedrich Möbius, "Beobachtungen zur Ikonolgie des spätgotischen Gewölbes in Sachsen und Böhmen," *Actes du 22e Congrès International d'Histoire de l'Art* (Budapest 1972) 557–67, here 565. This interpretation, which is based on the supposed "realism" reflected by Late Gothic iconography, is completely absurd.

709 For a typological study see Magirius (note 707) 153ff.

710 The original text in Schönemann (note 702) 750.

711 Richter, Ad. Dan, *Chronica der freyen Bergstadt Annaberg 1. Teil* (Annaberg 1746) 59.

712 When Heilmann was absent from Brüx, he put a man named Georg von Maulbronn in charge. Heilmann had been dead for twenty-two years when the church was consecrated, but the overall plan for the church should probably be attributed to him.

713 In 1526 Hans von Torgau was replaced by

Fabian Lobwasser, who then completed the church in 1540. The church burned to the ground during the Second World War, and the rebuilt vault is much lower than the original.

714 The term *Flächengerüst* ("surface grid") to describe Pirna's vault is from Hermann Meuche, "Anmerkungen zur Gestalt der sächsischen Hallenkirchen um 1500," *Aspekte zur Kunstgeschichte von Mittelalter und Neuzeit. Festschrift Karl Heinz Clasen* (Weimar 1971) 167–89, here 172.

715 Timothy Husband and G. Gilmore-House, The *Wild Man. Medieval Myth and Symbolism* (New York) 1980.

716 Möbius (note 708) *passim*.

717 Paradigmatic for this school of thought is Hermann Meuche, "Zur sächsischen Architektur in der Zeit der frühbügerlichen Revolution," in *ZEMAU* 11, 1962, 305–21, especially 310. Idem (note 714) 181.

718 Meuche (note 714) 178ff.

719 Paraphrased from a quote in C.Gurlitt, *Kunst und Künstler am Vorabend der Reformation. Ein Bild aus dem Erzgebirge*, in the series *Schriften des Vereins für Reformationsgeschichte*, vol. 7 (Halle 1890) 130f.

720 The expression "revolt of the medievalists" was coined by Wallace K. Ferguson, *The Renaissance in Historical Thought: Five Centuries of Interpretation* (Boston 1948).

721 Paul Oskar Kristeller, *Humanismus und Renaissance*, vol. 2 (Munich 1976) 10. For a closer look at the economic history of the period Stephan Skalweit, *Der Begin der Neuzeit. Epochengrenze und Epochenbegriff*, in the series *Erträge der Forschung*, vol. 178 (Darmstadt 1982) 9–46.

722 Rudolf Wittkower, *Grundlagen der Architektur im Zeitalter des Humanismus* (Munich 1969) *passim*.

723 See, for example, the portal of the "Alte Sakristei" at Annaberg (Jakob Heilmann 1518/19), the inner portal leading to the chapel of Duke Georg's tomb at Meissen Cathedral (1522/24) the design for which should probably be attributed to Adolf and Hans Daucher from Augsburg. Also the sacristy portal (*ca.* 1523) and the south portal (1525, moved to the Moritzburg 1911) at Halle "Cathedral," both of which seem very southern German indeed. Hans-Joachim Krause, "Das erste Auftreten italienischer Renaissance-Motive in der Architektur Mittel-deutschlands," *Acta Historiae Artium Academiae Scientiarium Hungaricae* (Budapest 1967) 99–114.

724 Other examples: the portal of Breslau Cathedral's sacristy (1517) and Salvatorkirche in Vienna (1515).

725 Irmgard Büchner-Suchland, *Hans Hieber. Ein Augsburger Baumeister der Renaissance*, in the series *Kunstwissenschaftliche Studien*, vol. 32 (Munich-Berlin 1962) 86–7. Also Bruno Bushart, *Die Fuggerkapelle bei St. Anna in Augsburg* (Munich 1994) 96–112.

726 San Bernadino in Urbino, Santissima Annunziata in Florence, Santa Maria delle Grazie in Pistoia. Büchner-Suchland (see note 725) 48.

727 Conches also flank the large dome of Florence Cathedral. Büchner-Suchland (note 725) 49, locates prototypes for these round knobs at San Marco and Santa Maria dei Miracoli in Venice. Also similar is the half-round termination of the choir polygon interior, a common Gothic motif of Venetian architecture.

728 Paradigmatic for this view is Hans-Joachim Kadatz, *Deutsche Renaissancebaukunst von der frühbürg-erlichen Revolution bis zum Ausgang des Dreißijährigen Krieges* (Berlin 1983) 103.

729 Important ecclesiastical structures built in

Upper Saxony before 1600: the parish church in Marienberg (1557–64), choir of St. Mary's in Zwickau (renovated 1563–5), St. Johannis, Plauen (1548–56), the parish churches in Dahlen (begun 1595) and Lauenstein (begun 1595). In Sachsen-Anhalt: the ten-bay Hall nave of the Marktkirche in Halle (1529–54).

730 Hermann Hipp, *Studien zur Nachgotik des 16. und 17. Jahrhunderts in Deutschland, Böhmen, Öster-reich und der Schweiz*, Diss. Tübingen 1974 (Tübingen 1979), vol. 1, 314ff.

731 Ibid., 317.

732 The standard work concerning this concept is Engelbert Kirschbaum, *Deutsche Nachgotik. Ein Beitrag zur Geschichte der kirchlichen Architektur von 1550–1800* (Augsburg 1930).

733 Hipp (note 730) 289ff., 308f., 359. Of those mentioned here, the ones in the west also saw branch work dispersed over a wide area during the post-Gothic period until 1630.

734 This according to Erich Hubala in Georg Kaufmann, *Die Kunst des 16. Jahrhunderts*, in the series *Propyläen-Kunstgeschichte*, vol. 8 (Frankfurt-Berlin-Vienna 1970) 332.

735 Even though castle and palace chapels tradition-ally possessed a gallery, regional prototypes probably called forth the type in Protestant Saxony.

736 Chapels in the Altes Schloss in Stuttgart (1560–1662) and the castle in Schwerin (1560–3).

737 Especially the wall-articulation systems of the chapels at the Augustusburg (1568–73) in the Erzgebirge region and the castle in Schmalkalden in Thuringia (1585–90).

738 Kadatz (note 728) 104.

739 One of the earliest to promote the concept of a "Jesuit style" was Franz Kugler, *Kleine Schriften und Studien zur Kunstgeschichte*, vol. 2 (Stuttgart 1854) 247ff.

740 For a specific look at both structures see Hipp (note 730) 136–321.

741 Georg Germann, *Neugotik. Geschichte ihrer Architekturtheorie* (Stuttgart 1974) 16ff. Also Paul Clemen, *Der Dom zu Köln*, in the series *Die Kunstdenkmäler der Rheinprovinz*, vol. 6, III, 2nd ed. (Düsseldorf 1938) 65f.

742 Hans Peter Hilger, "Die ehemalige Jesuiten-kirche St. Mariae Himmelfahrt in Köln, 'monumen-tum Bavaricae pietatis,'" *Die Jesuitenkirche St. Mariae Himmelfahrt in Köln*, in the series *Beiträge zu den Bau-und Kunstdenkmälern im Rheinland*, vol. 28, (Düsseldorf 1982) 9–30.

743 There are two main reasons for the "continuity" school maintaining this. First was the *translatio imperii*, the theory that Roman imperial prerogative and power passed to the Germans during the Middle Ages. And second, that of the *Vier-Monarchien-Lehre* (the Four Monarchies theory) which understood the German Empire as fourth in a line of powerful empires that exerted a strong influence on Christianity. See Roderich Schmidt, "Aetates Mundi. Die Weltalter als Gliederungsprinzip der Geschichte," *Zeitschrift für Kirchengeschichte* 67, 1955/6, 288–317.

744 Especially important was how the thin-shelled ceiling with Gothic ribbed vaulting became symbolic for ecclesiastical space, and even for church building as a whole. Hipp (note 730) 516–93.

745 "Ausgewählte Gedichte deutscher Poeten 1624," *Neudrucke deutscher Litteratur-Werke des 16. und 17. Jahrhunderts*, vol. 17 (Halle 1879) 30.

746 Schlegel (note 10) 260–2.

Selected Bibliography

PUBLICATIONS RELATING TO THE ENTIRE TEXT, CITED IN ABBREVIATED FORM

AHAW	*Abhandlungen der Heidelberger Akademie der Wissenschaften, phil.-hist. Klasse*
DKD	*Deutsche Kunst und Denkmalpflege*
EMAU	*Wissenschaftliche Beiträge der Ernst-Moritz-Arndt-Universität Greifswald*
KC	*Kunstchronik*
KDF	*Der Kölner Dom. Festschrift zur 700-Jahrfeier 1248–1948*, published by the Zentral-Dombauverein (Cologne 1948)
KDV	*Der Kölner Dom im Jahrhundert seiner Vollendung.* Vol. 2, *Essays zur Ausstellung der Historischen Museen in der Josef-Haubrich-Kunsthalle Köln, 16. Oktober 1980 bis 11. Januar 1981*, Hugo Borger ed. Cologne 1980
MJK	*Marburger Jahrbuch für Kunstwissenschaft*
NBK	*Niederdeutsche Beiträge zur Kunstgeschichte*
SWA (Princeton 1963)	*Studies in Western Art. Acts of the Twentieth International Congress of the History of Art* (Princeton 1963)
WRJ	*Wallraf-Richartz-Jahrbuch*
ZDVK	*Zeitschrift des deutschen Vereins für Kunstwissenschaft*
ZEMAU	*Wissenschaftliche Zeitschrift der Ernst-Moritz-Arndt-Universität Greifswald, gesellschafts- und sprachwiss. Reihe*
ZKG	*Zeitschrift für Kunstgeschichte*
Aubert 1963	Aubert, Marcel, *Hochgotik*. In the series *Kunst der Welt*. Baden-Baden 1963.
Bachmann 1969	Bachmann, Erich, "Architektur bis zu den Hussitenkriegen." Swoboda, Karl Maria, *Gotik in Böhmen*. Munich 1969: 34–109.
Behling 1937	Behling, Lottlisa, *Das ungegenständliche Bauornament der Gotik*. Diss. Berlin 1937.
Bialostocki 1972	Bialostocki, Jan, *Spätmittelalter und beginnende Neuzeit*. In the series *Propyläen Kunstgeschichte*, Vol. 7. Frankfurt – Berlin – Vienna 1972.
Böker 1988	Böker, Hans Josef, *Die mittelalterliche Backsteinarchitektur Norddeutschlands*. Darmstadt 1988.
Buchowiecki 1952	Buchowiecki, Walter, *Die gotischen Kirchen Österreichs*. Vienna 1952.
Brucher 1990	Brucher, Günter, *Gotische Baukunst in Österreich*. Salzburg-Vienna 1990.
Clasen 1958	Clasen, Karl Heinz, *Deutsche Gewölbe der Spätgotik*. Berlin 1958.
Dehio-Betzold 1901	Dehio, Georg und Gustav von Bezold, *Die kirchliche Baukunst des Abendlandes*, Vol. 2. Stuttgart 1901.
Elisabethkirche 1983	Kunst, Hans Joachim ed., exhibition handbook *Die Elisabethkirche – Architektur in der Geschichte*. In the series *700 Jahre Elisabethkirche in Marburg 1283–1983*, Vol. 1. Marburg 1983.
Eydoux 1952	Eydoux, Henri-Paul, *L'Architecture des églises cisterciennes d'Allemagne*. Paris 1952.
Fehr 1969	Fehr, Götz, "Architektur der Spätgotik." *Gotik in Böhmen*, Karl Maria Swoboda ed. Munich 1969: 322–40.
Fischer 1971	Fischer, Friedhelm Wilhelm and J.J.M. Timmers, *Spätgotik*. In the series *Kunst der Welt*. Baden-Baden 1971.
Focillon 1963	Focillon, Henri, *The Art of the West in the Middle Ages, Vol. 2 "Gothic Art"*. London 1963.
Frankl 1960	Frankl, Paul, *The Gothic. Literary Sources and Interpretations through Eight Centuries*. Princeton, NJ 1960.
Frankl 1962	Frankl, Paul, *Gothic Architecture*. In the series *The Pelican History of Art*, Vol. 19. London 1962.
Frisch 1971	Frisch, Teresa G., *Gothic Art, 1140–c.1450: Sources and Documents*. In *Sources and Documents in the History of Art Series*. Englewood Cliffs, NJ 1971.
Gall 1955	Gall, Ernst, *Die gotische Baukunst in Frankreich und Deutschland*, Part 1, 2nd ed. Braunschweig 1955.
Gerstenberg 1913	Gerstenberg, Kurt, *Deutsche Sondergotik*. Munich 1913.
Götz 1968	Götz, Wolfgang, *Zentralbau und Zentralbautendenz in der gotischen Architektur*. Berlin 1968.
Grodecki 1976	Grodecki, Louis (with Anne Prache and Roland Recht), *Architektur der Gotik*. In the series *Weltgeschichte der Architektur*. Stuttgart 1976.
Gross 1969	Gross, Werner, *Gotik und Spätgotik*. Frankfurt 1969.
Gross 1972	Gross, Werner, "Deutsche Architektur." In Simson, Otto von, *Das Mittelalter II. Das Hohe Mittelalter*. In the series *Propyläen-Kunstgeschichte*, Vol. 6. Frankfurt – Berlin – Vienna 1972: 174–90.
Harvey 1969	Harvey, John, *The Gothic World*. New York 1969.
Héliot 1968	Héliot, Pierre, "Les origines et les débuts de l'apside vitrée, XIe au XIIIe siècle." *WRJ* 30, 1968: 89–127.
Jantzen 1962	Jantzen, Hans, *Die Gotik des Abendlandes*. Cologne 1962.
Kiesow 1956	Kiesow, Gottfried, *Das Masswerk in der deutschen Kunst bis 1350 (mit Ausnahme des Backsteingebietes)*. Diss., Göttingen 1956.
Kobler 1982	Kobler, Friedrich, "Fensterrose," *Reallexikon zur deutschen Kunstgeschichte*, Vol. 8. Munich 1982, cols. 66–194.
Meckseper 1982	Meckseper, Cord, *Kleine Kunstgeschichte der deutschen Stadt im Mittelalter*. Darmstadt 1982.
Michler 1977	Michler, Jürgen, "Über die Farbfassung hochgotischer Sakralräume," *WRJ* 39, 1977: 29–68.
Meyer 1945	Meyer, P. *Schweizerische Münster und Kathedralen des Mittelalters*. Zurich 1945.
Möbius 1974	Möbius, Friedrich und Helga, *Bauornament im Mittelalter. Symbol und Bedeutung*. Vienna 1974.
Müller 1990	Müller, Werner, *Grundlagen gotischer Bautechnik*. Munich 1990.

Panofsky 1951 — Panofsky, Erwin, *Gothic Architecture and Scholasticism.* Latrobe, Pennsylvania 1951.

Parler Vols. 1–4 — Book of the Schnütgen Museum exhibition *Die Parler und der Schöne Stil 1350–1400. Europäische Kunst unter den Luxemburgern.* Vols. 1–3, Cologne 1978. Vol. 4 and "Resultatband" Cologne 1980.

Pinder 1952 — Pinder, Wilhelm, *Die Kunst der ersten Bürgerzeit bis zur Mitte des 15. Jahrhunderts.* 3rd edition. Frankfurt-am-Main 1952.

Simson 1953 — Simson, Otto von, "Wirkungen des christlichen Platonismus auf die Entstehung der Gotik." *Humanismus, Mystik und Kunst in der Welt des Mittelalters,* Josef Koch ed. In the series *Studien und Texte zur Geistesgeschichte des Mittelalters,* Vol. 3. Leiden-Cologne 1953: 159–79.

Simson 1968 — Simson, Otto von, *Die gotische Kathedrale.* Darmstadt 1968.

Stich 1960 — Stich, Fritz, *Der gotische Kirchenbau in der Pfalz.* In the series *Veröffentlichungen der Pfälzischen Gesellschaft zur Förderung der Wissenschaften in Speyer am Rhein,* Vol. 40. Speyer 1960.

Swiechowski 1972 — Swiechowski, Zygmunt, "Backsteingotik." In Simson, Otto von, *Das Mittelalter II. Das Hohe Mittelalter.* In the series *Propyläen-Kunstgeschichte,* Vol. 6. Frankfurt-Berlin-Vienna 1972: 216–25.

Ullmann 1981 — Ullmann, Ernst ed. *Geschichte der deutschen Kunst 1350–1470.* Leipzig 1981.

Wagner-Rieger 1967 — Wagner-Rieger, Renate, "Architektur." *Gotik in Österreich,* exhibition catalogue. Krems/Donau 1967: 330–68.

Wagner-Rieger 1978 — Wagner-Rieger, Renate, "Gotische Architektur in der Steiermark." *Gotik in der Steiermark,* catalogue of Landesausstellung 1978: 45–93.

Warnke 1976 — Warnke, Martin, *Bau und Überbau. Soziologie der mittelalterlichen Architektur nach den Schriftquellen.* Frankfurt-am-Main 1976.

Die Zisterzienser 1980 — Exhibition catalogue of *Die Zisterzienser. Ordensleben zwischen Ideal und Wirklichkeit,* Caspar Elm ed. Bonn 1980. Supplementary vol. Cologne 1982.

I. GOTHIC ARCHITECTURE: THE CHANGING FOCUS OF RESEARCH FROM THE ROMANTIC PERIOD TO MODERN TIMES

Bony, Jean, "The Genesis of Gothic: Accident or Necessity." *Australian Journal of Art* 2, 1980: 17–31.

Borger-Keweloh, Nicola, *Die mittelalterlichen Dome im 19. Jahrhundert.* Munich 1986.

Diekhoff, Reiner, "Vom Geist geistloser Zustände. Aspekte eines deutschen Jahrhunderts." *KDV,* Vol. 2. Hugo Borger ed. Cologne 1980: 63–105.

Fischer, Friedhelm Wilhelm, "Gedanken zur Theoriebildung über Stil und Stilpluralismus." *Beiträge zum Problem des Stilpluralismus,* Werner Hager and Norbert Knopp eds. In the series *Studien zur Kunst des neunzehnten Jahrhunderts,* Vol. 38. Munich 1977: 33–48.

Gärtner, Hannelore, "Zu einigen Problemen der Gotikrezeption in der Romantik." *Mittelalterliche Backsteinkunst. Romanische und gotische Architektur – ihre Rezeption und Restaurierung.* In *ZEMAU* 29. Greifswald 1980: 117–23.

——"Patriotismus und Gotikrezeption der deutschen Frühromantik." *Studien zur deutschen Kunst und Architektur um 1800.* Peter Bettenhausen ed. Dresden 1981: 34–52.

Germann, Georg, "Der Kölner Dom als Nationaldenkmal." *KDV,* Vol. 2. Hugo Borger ed. Cologne 1980: 161–8.

Gosebruch, Martin, "Epochenstile – historische Tatsächlichkeit und Wandel des wissenschaftlichen Begriffs." *ZKG* 44, 1981: 9–14.

Liess, Reinhard, *Goethe vor dem Strassburger Münster. Zum Wissenschaftsbild der Kunst.* Leipzig 1985.

Lützeler, Heinrich Maria, "Die Deutung der Gotik bei den Romantikern." *WRJ* 2, 1925: 9–33.

——"Der Kölner Dom in der deutschen Geistesgeschichte." *KDF.* Zentral-Dombau-Verein publ. Cologne 1948: 195–250.

Nipperdey, Thomas, "Kirche und Nationaldenkmal. Der Kölner Dom in den 40er Jahren." *Staat und Gesellschaft im politischen Wandel. Beiträge zur Geschichte der modernen Welt. Festschrift für Walter Bussmann.* Stuttgart 1979: 175–202.

Panofsky, Erwin, "Das erste Blatt aus dem "Libro" Giorgio Vasaris: Eine Studie über die Beurteilung der Gotik in der italienischen Renaissance, mit einem Exkurs über zwei Fassadenprojekte Domenico Beccafumis." *Städel-Jahrbuch* 6, 1930: 25–72.

Sauerländer, Willibald, *Das Jahrhundert der grossen Kathedralen 1140–1260.* In the series *Universum der Kunst,* Vol. 36. Munich 1990.

Schmoll gen. Eisenwerth, J.A. "Stilpluralismus statt Einheitszwang – Zur Kritik der Stilepochen-Kunstgeschichte." *Argo. Festschrift für Kurt Badt zu seinem 80. Geburtstag,* Martin Gosebruch and L. Dittmann ed. Cologne 1970: 77–95.

Stremmel, Jochen, "Der deutsche Dom und die deutschen Dichter." *KDV,* Vol. 2. Hugo Borger ed. Cologne 1980: 169–81.

II. THE ORIGINS OF STYLE: GOTHIC AND ROMANESQUE

Anstett, Peter, "Die Baugeschichte des Klosters." *Kloster Maulbronn 1178–1978,* exhibition catelogue. Maulbronn 1978: 69–76.

Bandmann, Günter, "Das Langhaus des Bonner Münsters und seine künstlerische Stellung." *Bonn und sein Münster. Eine Festschrift,* vol. 3 of *Bonner Geschichtsblätter,* Bonn 1947: 109–31.

Bickel, Ilse, *Die Bedeutung der süddeutschen Zisterzienserbauten für den Stilwandel im 12. Jahrhundert von der Spätromanik zur Gotik.* Munich 1956.

Bony, Jean, "The Resistance to Chartres in Early Thirteenth-Century Architecture." *Journal of the British Archaeological Association 3,* 20/21, 1957/58: 35–52.

——"Transition from Romanesque to Gothic," *SWA (Princeton 1963),* Vol. I. Princeton 1963, Vol. I. Intro.: 81–4.

——*French Gothic Architecture of the 12th and 13th Centuries.* Berkeley, Los Angeles–London 1983.

Borger-Keweloh, Nicola, "Die Liebfrauenkirche in Trier. Studien zur Baugeschichte". *Trierer Zeitschrift für Geschichte und Kunst des Trierer Landes und seiner Nachbargebiete,* suppl. 8. Trier 1986.

Branner, Robert, *Burgundian Gothic Architecture.* In the series *Studies in Architecture,* Vol. 3. London 1960.

——"Gothic Architecture 1160–1180 and Its Romanesque Sources." *SWA (Princeton 1963),* Vol. I. Princeton 1963: 92–104.

——"The Transept of Cambrai Cathedral." *Gedenkschrift für Ernst Gall.* Margarete Kühn and Louis Grodecki ed. Munich 1965: 69–86.

——"Die Architektur der Kathedrale in Reims im 13. Jahrhundert." *Architectura* 1, 1971: 15–37.

Caviness, Madeline H. "St-Yved of Braine: the Primary Sources for Dating the Gothic Church." *Speculum* 59, 1984: 524–48.

Crosby, Sumner McK, "Abbot Suger's St.-Denis. The New Gothic." *SWA (Princeton 1963)*, Vol. I. Princeton 1963: 85–91.

Dörrenberg, Irmgard, *Das Zisterzienserkloster Maulbronn*. Würzburg 1937.

Fath, Manfred, "Die Baukunst der frühen Gotik im Mittelrheingebiet." *Mainzer Zeitschrift* 63/64, 1968/69: 1–38. *Idem* 65, 1970: 43–92.

Frankl, Paul, "Der Beginn der Gotik und das allgemeine Problem des Stilbeginns." *Festschrift Heinrich Wölfflin*. Munich 1924: 107–25.

Franz, H. Gerhard, *Spätromanik und Frühgotik*: In the series *Kunst der Welt*. Baden-Baden 1969.

Gall, Ernst, *Studien über das Verhältnis der niederrheinischen und französischen Architektur in der ersten Hälfte des 13. Jahrhunderts. T. 1: Die niederrheinischen Apsidengliederungen nach normännischem Vorbilde*. Diss. Berlin. Halle, Saale 1915.

Götz, Wolfgang, "Der Magdeburger Domchor. Zur Bedeutung seiner monumentalen Ausstattung." *ZDVK* 20, 1966: 97–120.

Gosebruch, Martin, "Vom Bamberger Dom und seiner geschichtlichen Herkunft." *Münchner Jahrbuch für bildende Kunst* 3rd series, 28, 1977: 28–58.

Grandjean, M. "La cathédrale actuelle, sa construction, ses architectes, son architecture." *La cathédrale de Lausanne*. In the series *Bibl. de la Société d'Histoire de l'Art en Suisse*, Vol. 3. Bern 1975: 45–174.

Hahn, Hanno, *Die frühe Kirchenbaukunst der Zisterzienser. Untersuchungen zur Baugeschichte von Kloster Eberbach im Rheingau und ihrer europäischen Analogien im 12. Jahrhundert*. In the series *Frankfurter Forschungen zur Architekturgeschichte*, Vol. 1. Berlin 1957.

Héliot, Pierre, "Coursières et passages muraux dans les églises gothiques de l'Europe centrale." *ZKG* 33, 1970: 123–210.

——"Coursières et passages muraux dans les églises romanes et gothiques de l'Allemagne du Nord." *Festschrift Wolfgang Krönig*. Vol. 41 of *Aachener Kunstblätter* 1971: 211–23.

Hotz, Walter, *Der Dom zu Worms*. Darmstadt 1981.

Kimpel, Dieter, "Ökonomie, Technik und Form in der hochgotischen Architektur." *Bauwerk und Bildwerk im Hochmittelalter. Anschauliche Beiträge zur Kultur- und Sozialgeschichte*. Karl Clausberg, et al ed. Giessen 1981: 103–25.

——"Die Entfaltung der gotischen Baubetriebe. Ihre sozio-ökonomischen Grundlagen und ihre ästhetisch-künstlerischen Auswirkungen." *Architektur des Mittelalters. Funktion und Gestalt*. Friedrich Möbius and Ernst Schubert ed. Weimar 1983: 246–72.

Klein, Bruno, *Saint-Yved in Braine und die Anfänge der hochgotischen Architektur in Frankreich*. In the series *Veröffentlichungen der Abteilung Architektur des Kunsthistorischen Instituts der Universität zu Köln*, Vol. 28. Cologne 1984.

Krönig, Wolfgang, *Altenberg und die Baukunst der Zisterzienser*. Bergisch-Gladbach 1973.

Kubach, Hans Erich, "Das Triforium. Ein Beitrag zur kunstgeschichtlichen Raumkunde Europas im Mittelalter." *ZKG* 5, 1936: 275–88.

——"Die Kirchenbaukunst der Stauferzeit in Deutschland." *Die Zeit der Staufer. Geschichte – Kunst – Kultur*, exhibition catelogue, Vol. 3. Stuttgart 1977: 177–85.

Kunst, Hans Joachim, "Die Dreikonchenanlage und das Hallenlanghaus der Elisabethkirche zu Marburg." *Hessisches Jahrbuch für Landesgeschichte* 18, 1968: 131–45.

Kuthan, Jiri, *Die mittelalterliche Baukunst der Zisterzienser in Böhmen und Mähren*. Munich-Berlin 1982.

——"Die böhmische Architektur der 13. Jahrhunderts als historisches und soziales Phänomen." *Stil und Gesellschaft. Ein Problemaufriss*. Friedrich Möbius ed. Dresden 1984: 319–37.

Meyer-Barkhausen, Werner, *Das grosse Jahrhundert kölnischer Kirchenbaukunst*. Cologne 1952.

Michler, Jürgen, "Die Langhaushalle der Marburger Elisabethkirche." *ZKG* 32, 1969: 104–32.

——*Die Elisabethkirche zu Marburg in ihrer ursprünglichen Farbigkeit*. U. Arnold . ed. In the series *Quellen und Studien zur Geschichte des Deutschen Ordens*. Marburg 1984.

Nicolai, Bernd, *Libido Aedificandi. Walkenried und die monumentale Kirchenbaukunst der Zisterzienser um 1200*. Diss. Berlin 1986.

——"Lilienfeld und Walkenried. Zur Genese und Bedeutung eines zisterziensischen Bautyps." *Wiener Jahrbuch für Kunstgeschichte* 41, 1988: 23–39.

Reinhardt, Hans, "Die Entwicklung der gotischen Travée." *Gedenkschrift Ernst Gall*. Margarete Kühn and Louis Grodecki ed. Munich 1965: 123–42.

Röckener, Kurt, *Die münsterländischen Hallenkirchen gebundener Ordnung*. Diss. Münster 1980.

Rosemann, Heinz Rudolf, "Die westfälische Hallenkirche in der ersten Hälfte des 13. Jahrhunderts." *ZKG* 1, 1932: 203–27.

Sauerländer, Willibald, *Von Sens bis Strassburg*. Berlin 1966.

Schenkluhn, Wolfgang and Peter van Stipelen, "Architektur als Zitat. Die Trierer Liebfrauenkirche in Marburg." *Elisabethkirche* 1983: 19–53.

Schubert, Ernst, *Der Magdeburger Dom*. Vienna-Cologne 1975.

Wagner-Rieger, Renate, "Gotische Kapellen in Niederösterreich." *Festschrift Karl Maria Swoboda*. Vienna-Wiesbaden 1959: 273–307.

——"Die Habsburger und die Zisterzienserarchitektur." *Die Zisterzienser* 1982: 195–211.

Wiemer, Wolfgang, "Baugeschichte und Bauhütte der Ebracher Klosterkirche 1200–1285." *Jahrbuch für fränkische Landesforschung* 17, 1957: 1–85.

——"Die Geometrie des Ebracher Kirchenplans – Ergebnisse einer Computeranalyse." *KC* 35, 1982: 422–43.

——"Die Michaelskapelle und ihre mittelalterliche Wandmalerei." *Festschrift 700 Jahre Abteikirche Ebrach 1285–1985*. Wolfgang Wiemer and Gerd Zimmermann eds. Ebrach 1985: 11–58.

Winterfeld, Dethard von, *Der Dom in Bamberg. Bd. 1: Die Baugeschichte bis zur Vollendung im 13. Jahrhundert*. Berlin 1979.

——"Zum Stande der Baugeschichtsforschung." *Der Dom zu Limburg*. Wolfram Nicol ed. Mainz 1985: 381–896.

Zisterzienser und Heisterbach. Spuren und Erinnerungen. Exhibition catalogue Königswinter 1980/81. In the series *Schriften des Rheinischen Museumsamtes*, Vol. 15. Bonn 1980.

III. THE DEVELOPMENT OF GOTHIC ARCHITECTURE IN GERMANY

Adam, Ernst, *Das Freiburger Münster*. In the series *Grosse Bauten Europas*, Vol. 1, 3rd edition Darmstadt 1981.

Altmann, Lothar, "Die Baugeschichte des gotischen Domes von der Mitte des 13. bis zum Anfang des 16. Jahrhunderts." *Der Regensburger Dom. Beiträge zu seiner Geschichte*. Georg Schwaiger ed. In the series *Beiträge zur Geschichte des Bistums Regensburg*, Vol. 10. Regensburg 1976: 97–109.

Bader, Walter, "Vom ersten Baumeister der gotischen Stiftskirche (1263 bis um 1280)" *Sechzehnhundert Jahre Xantener Dom. Idem* ed. Cologne 1964: 103–40.

Badstübner, Ernst, *Kirchen der Mönche. Die Baukunst der Reformorden im Mittelalter*. Zurich 1981.

Baier, Gerd, "Anmerkungen zur Rekonstruktion der Architekturfarbigkeit in der Kirche des ehemaligen Zisterzienserklosters Doberan." *Mitteilungen des Instituts für Denkmalpflege – Arbeitsstelle Schwerin* 27, Oct. 1982: 472–81.

Berg, Dieter ed. *Bettelorden und Stadt. Bettelorden und städtisches Leben im Mittelalter und in der Neuzeit*. In the series *Saxonia Franciscana. Beiträge zur Geschichte der Sächsischen Franziskanerprovinz*, Vol. 1. Werl 1992.

Beyer, V., J.R. Haeusser, J.D. Ludmann and R. Recht, *La cathédrale de Strasbourg*. Strasbourg 1974.

Binding, Günther, "Die Franziskaner-Baukunst im deutschen Sprachgebiet." *800 Jahre Franz von Assisi. Franziskanische Kunst und Kultur des Mittelalters*, exhibition catalogue. Krems 1982: 431–60.

Börste, Norbert, *Der Paderborner Dombau des 13. Jahrhunderts. Eine baugeschichtliche Untersuchung*. Diss. Münster 1986.

Branner, Robert, *St. Louis and the Court Style*. London 1966.

——"Remarques sur la cathédrale de Strasbourg." *Bulletin monumental* 122, 1964: 261–8.

Ciemolonski, J., "Ze Studiów nad Bazylika w Pelplinie." *Kwartalnik Architektury i Urbanistyki* 19, 1974: 27–66.

Crossley, Paul, "Lincoln and the Baltic, the Fortunes of a Theory." *Medieval Architecture and Its Intellectual Context. Studies in Honour of Peter Kidson*. Eric Fernie and Paul Crossley eds. London 1990: 169–80.

Donin, Richard Kurt, *Die Bettelordenskirchen in Österreich. Zur Entwicklungsgeschichte der österreichischen Gotik*. Baden, near Vienna 1935.

Ellger, Dietrich, "Die Baugeschichte der Lübecker Marienkirche 1159–1351." *Idem* and Johanna Kolbe, *St. Marien zu Lübeck und seine Wandmalereien*. In the series *Arbeiten des Kunsthistorischen Instituts der Universität Kiel*, Vol. 2. Neumünster 1951: 1–88.

—— "Zum gotischen Chorbau der Lübecker Marienkirche." *ZKG* 60, 1991: 490–519.

Erdmann, W., "Zur Diskussion um die Lübecker Marienkirche im 13. Jahrhundert." *ZDVK* 44, 1990: 92–111.

Erlande-Brandenburg, Alain, *Triumph der Gotik 1260–1380*. In the series *Universum der Kunst*, Vol. 34. Munich 1988.

Fait, Joachim, *Die norddeutsche Bettelordensbaukunst zwischen Elbe und Oder*. Diss., manuscript. Greifswald 1954.

Fink, Elisabeth, *Die gotischen Hallenkirchen in Westfalen.* Diss. Munich 1933. Emsdetten 1934.

Finke, Manfred, "Die Baugeschichte der Lübecker Marienkirche in neuem Licht?" *Der Wagen, ein lübeckisches Jahrbuch,* 1988: 53–88.

Gall, Günter, "Zur Baugeschichte des Regensburger Domes," *ZKG* 17, 1954: 61–78.

Geimer, Maria, *Der Kölner Domchor und die rheinische Hochgotik.* Bonn 1937.

Giese, Leopold, "Bettelordenskirchen." *Reallexikon zur deutschen Kunstgeschichte,* Vol. 2. Stuttgart 1948, cols., 394–444.

Gnekow, Bettina, *Der Kirchenbau im heutigen Holstein während des Aufbaus der Pfarrorganisation (von 1150 bis 1300).* Diss. Kiel 1989.

Gross, Werner, "Die Hochgotik im deutschen Kirchenbau. Der Stilwandel um das Jahr 1250." *MJK* 7, 1933: 290–346.

Gross, Werner, *Die abendländische Architektur um 1300.* Stuttgart, s.d. (1948).

Hasse, Max, *Die Marienkirche in Lübeck.* Munich 1983.

Hilger, Hans Peter, *Der Dom zu Xanten.* In the series *Die Blauen Bücher.* Königstein/Taunus 1984.

Jaeger, Falk, *Das Dominikanerkloster in Esslingen. Baumonographie von Kirche und Kloster.* In the series *Esslinger Studien,* Vol. 13. Diss. Hannover 1993. Esslingen 1994.

Kamphausen, Alfred, *Backsteingotik.* Munich 1978.

Kauffmann, Hans, "Die Masswerkhelme des Freiburger Münsters und des Kölner Doms." *Festschrift Kurt Bauch.* Munich-Berlin 1957: 117–25.

Klotz, Heinrich, *Der Ostbau der Stiftskirche zu Wimpfen im Tal.* In the series *Kunstwissenschaftliche Studien,* Vol. 39. Munich 1967.

Kobler, Friedrich, "Stadtkirchen der frühen Gotik." *Wittelsbach und Bayern. Bd. I,1: Die Zeit der frühen Herzöge.* Hubert Glaser ed. In the series *Beiträge zur Bayerischen Geschichte und Kunst 1180–1350.* Munich-Zurich 1980: 426–36.

Konow, Helma, *Die Baukunst der Bettelorden am Oberrhein.* In the series *Forschungen zur Geschichte der Kunst am Oberrhein,* Vol. 6. Berlin 1954.

Krautheimer, Richard, *Die Kirchen der Bettelorden in Deutschland.* Cologne 1925.

Kunst, Hans Joachim, "Die Entstehung des Hallenumgangschores. Der Dom zu Verden an der Aller und seine Stellung in der gotischen Architektur." *MJK* 18, 1969: 1–104.

——"Der Domchor zu Köln und die hochgotische Kirchenarchitektur in Norddeutschland." *NBK* 8, 1969: 9–40.

——"Die Elisabethkirche in Marburg und die Bischofskirchen." *Elisabethkirche* 1983: 69–75.

——"Der norddeutsche Backsteinbau. Die Marienkirche in Lübeck und der Dom in Verden an der Aller als Leitbilder der Kirchenarchitektur Norddeutschlands." *Forschung und Information. Baugeschichte und europäische Kultur,* Vol. 1. Berlin 1985: 157–66.

——*Die Marienkirche in Lübeck. Die Präsenz bischöflicher Architekturformen in der Bürgerkirche.* Worms 1986.

——"Der Chor der Marienkirche in Lübeck – eine Neubestimmung der Herkunft seiner Formen." *Mittelalterliche Backsteinarchitektur und bildende Kunst im Ostseeraum.* In the series *EMAU.* Greifswald 1987: 23–30.

Kurmann, Peter, "Köln und Orleans." *Kölner Domblatt* 24/25, 1979/80: 255–76.

Lehmann, Edgar and Ernst Schubert, *Der Dom zu Meissen.* Berlin 1970.

Liess, Reinhard, "Der Riss C der Strassburger Münsterfassade. J.J. Arhardts Nürnberger Kopie eines Originalrisses Erwins von Steinbach." *WRJ* 46/47, 1985/86: 75–117.

——"Der Riss A 1 der Strassburger Münsterfassade im Kontinuum der Entwürfe Magister Erwins." *Kunsthistorisches Jahrbuch.* Graz 1986: 47–121.

——"Der Riss B der Strassburger Münsterfassade. Eine baugeschichtliche Revision." *Orient und Okzident im Spiegel der Kunst. Festschrift für Heinrich Gerhard Franz.* Graz 1986: 171–202.

——"Das Kressberger Fragment im Hauptstaatsarchiv Stuttgart. Ein Gesamtentwurf der Strassburger Münsterfassade aus der Erwinzeit." *Jahrbuch der Staatlichen Kunstsammlungen in Baden-Württemberg,* 1986: 6–31.

——"Der Rahnsche Riss A des Freiburger Münsterturms und seine Strassburger Herkunft." *ZDVK* 45, 1991: 7–66.

Marnetté, Beatrice, *Die Dominikanerkirche in Regensburg. Studien zur Architektur der Bettelorden des 13. Jahrhunderts in Deutschland.* Diss. Regensburg 1982.

Michler, Jürgen, "Marburg und Köln – Wechselseitige Beziehungen in der Baukunst des 13. Jahrhunderts." *Hessische Heimat* 22, 1972: 73–88.

——"Zur Farbfassung der Marburger Schlosskapelle. Raumfarbigkeit als Quelle zur Geschichte von Kunst und Denkmalpflege." *DKD* 36, 1978: 37–52.

——"Zur Farbfassung der Sakristei der Marburger Elisabethkirche." *DKD* 38, 1980: 139–61.

Murray, Stephen, *Beauvais Cathedral. Architecture of Transcendence.* Princeton 1989.

Noack, Werner, "Das Langhaus des Freiburger Münsters." *Schauinsland* 77, 1959: 32–48.

Pieper, Roland, *Die Kirchen der Bettelorden in Westfalen. Baukunst im Spannungsfeld zwischen Landespolitik, Stadt und Orden im 13. und frühen 14. Jahrhundert.* In the series *Franziskanische Forschungen,* Vol. 39. Werl 1993.

Pfefferkorn, Rudolf, *Norddeutsche Backsteingotik.* Hamburg 1984.

Prin, M., "L'Église des Jacobins de Toulouse: Les Étapes de la construction." *Cahiers de Fanjeaux* 9, 1974: 185–208.

Recht, Roland, *Das Strassburger Münster.* In the series *Grosse Bauten Europas,* Vol. 2. Stuttgart 1971.

Der Dom zu Regensburg. Ausgrabung, Restaurierung, Forschung. Ausstellung anlässlich der Beendigung der Innenrestaurierung des Regensburger Domes 1984–1988. In the series *Kunstsammlungen des Bistums Regensburg, Diözesanmuseum Regensburg. Kataloge und Schriften,* Vol. 8. Munich-Zurich 1989.

Reinhardt, Hans, *La cathédrale de Strasbourg.* Paris 1972.

Roth, Hermann Josef, *Kloster Marienstatt im Westerwald.* In the series *Rheinische Kunststätten.* Vol. 234. Neuss 1980.

Sauerländer, Willibald, "Die Naumburger Stifterfiguren. Rückblick und Fragen." *Die Zeit der Staufer.* Supplement, Vol. 5, exhibition catalogue. Stuttgart 1979: 169–245.

Schenkluhn, Wolfgang, "Die Auswirkungen der Marburger Elisabethkirche auf die Ordensarchitektur in Deutschland." *Elisabethkirche* 1983: 81–101.

Schenkluhn, Wolfgang, *Ordines Studentes. Aspekte zur Kirchenarchitektur der Dominikaner und Franziskaner im 13. Jahrhundert.* Diss. Marburg 1983. Berlin 1985.

Schmoll gen. Eisenwerth, J.A., *Das Kloster Chorin und die askanische Architektur der Mark Brandenburg.* Berlin 1961.

Schröder, Ulrich, "Royaumont oder Köln? Zum Problem der Ableitung der gotischen Zisterzienserkirche Altenberg." *Kölner Domblatt* 42, 1977: 209–42.

Schubert, Ernst, *Der Westchor des Naumburger Domes.* Berlin 1965.

Schürenberg, Lisa, *Die Baugeschichte des Domes in Minden i.W.* Diss. Freiburg 1926.

——*Der Dom zu Metz.* Frankfurt-am-Main 1940.

Skubiszewski, Piotr, *Architektura Opacktwa Cysterskiej w Pelplinie. Studia Pomorskie,* Vol. 1. Wroclaw-Krakow, 1957: 24–102.

Sundt, Richard A., "The Jacobin Church of Toulouse and the Origin of its Double-Nave Plan." *The Art Bulletin* 71, 1989: 185–207.

Verbeek, Albert, "Zur Baugeschichte der Kölner Minoritenkirche." *Kölner Untersuchungen,* Walter Zimmermann ed. In the series *Die Kunstdenkmäler im Landesteil Nordrhein,* supplant 2. Ratingen 1950: 141–63.

Wenzel, Hans and Otto Stiehl, "Backsteinbau." *Reallexikon zur deutschen Kunstgeschichte,* Vol. 1. Stuttgart 1937, cols 1345–72.

Wochnick, Fritz, *Ursprung und Entwicklung der Umgangschoranlage im Sakralbau der norddeutschen Backsteingotik.* Diss. Berlin 1982.

Wolff Metternich, Franz Graf, "Zum Problem der Grundriss-und Raumgestaltung des Kölner Domes." *KDF.* Publ. Zentral-Dombau-Verein. Cologne 1948: 51–77.

Wolff, Arnold, "Chronologie der ersten Bauzeit des Kölner Domes 1248–1277." *Kölner Domblatt* 28/29, 1968: 7–230.

——*Der Kölner Dom,* 2nd edition. Stuttgart 1977.

——"Gefahr für die Wernerkapelle in Bacharach." *KC* 35, 1982: 277–81.

——ed., *Der gotische Dom in Köln.* Cologne 1986.

Wortmann, Reinhard, "Der Westbau des Strassburger Münsters und Meister Erwin." *Bonner Jahrbücher des Rheinischen Landesmuseums Bonn 169,* 1969: 290–318.

Zaske, Nikolaus, *Die gotischen Kirchen Stralsunds und ihre Kunstwerke.* Berlin 1964.

——*Gotische Backsteinkirchen Norddeutschlands,* 2nd edition. Leipzig 1970.

——"Mittelalterliche Backsteinarchitektur. Ergebnisse und Probleme ihrer Erforschung. Mittelalterliche Backsteinbaukunst. Romanische und gotische Architektur – ihre Rezeption und Restaurierung." In *ZEMAU* 29, 1980. Greifswald 1980: 3–18.

——"Stiltypik der bürgerlich-gotischen Backsteinkathedrale." *Stil und Gesellschaft. Ein Problemaufriss.* Friedrich Möbius ed. Dresden 1984: 338–359.

IV. STYLISTIC PLURALISM IN THE FOURTEENTH CENTURY

Arens, Fritz, "Die Katharinenkirche in Oppenheim. Bau und Ausstattung." *St. Katharinen zu Oppenheim. Lebendige Steine. Spiegel der Geschichte.* Carlo Servatius et al. ed. Alzey 1989, 9–37.

Back, Ulrich, "Die Domgrabung XXXIII. Die Ausgrabungen im Bereich des

Südturmes." *Kölner Domblatt* 59, 1994: 193–224.

Böker, Hans Josef, "Prag oder Köln? Das architekturgeschichtliche Beziehungsfeld der südniedersächsischen Stadtpfarrkirchen zu Beginn der Spätgotik." *NBK* 22, 1983: 9–27.

Bölts, Uwe und Matthias Müller, "Klassenkämpferisches Vokabular in der DDR-Kunstwissenschaft: Hallenkirche und Basilika, ihre Interpretation." *Bildende Kunst 1990*, no. 5: 59–63.

Chapu, Philippe, "Architecture." *Les fastes du Gothique. Le siècle de Charles V.* Exhibition catalogue. Paris 1981: 49–53.

Crossley, Paul, "Wells, the West Country, and Central European Late Gothic." *Medieval Art and Architecture at Wells and Glastonbury.* In the series *The British Archaeological Association. Conference Transactions for the Year 1978*, Vol. 4. Leeds 1981: 81–109.

——*Gothic Architecture in the Reign of Kasimir the Great: Church Architecture in Lesser Poland, 1320–1380.* In the series *Panstwowe Zbiory Sztuki na Waweln, Biblioteka Wawelska*, Vol. 7. Kraków 1985.

——"The Vaults of Kraków Cathedral and the Cistercian Tradition." *Podlug Nieba i Zwyczaju Polskiego. Studia z historii Architektury: Sztuki i Kultury Ofiarowane Adamowi Milobedzkiemu.* Warsaw 1988: 63–72.

Duby, Georges, *Die Grundlegung eines neuen Humanismus. 1280–1440.* In the series *Kunst, Ideen, Geschichte*, Vol. 7. Geneva 1966.

Feuchtmüller, Rupert und Peter Kodera, *Der Wiener Stephansdom.* Vienna 1978.

Frazik, Józef Tomasz, "Sklepienia tak zwane Piastowkie w Katedrze Wawelskiej." *Studia do Dziejów Wawelu* 3, 1963: 127–47.

——"Zagadnienie sklepien o przeslach trójpodporowych w architekturze sredniowiecznej." *Folia Historiae Artium* 4, 1967: 5–91.

——"Sklepiena gotyckie w Prusach, na Pomorzu Gdanskim i w Ziemi Chelminskiej." *Kwartalnik Architektury i Urbanistyki* 30, 1985, no. 1: 3–26.

Frycz, Jerzy, "Die Burgbauten des Ritterordens in Preussen." *ZEMAU* 29, 1980: 45–56.

Gardner, A., *L'église des Dominicains de Guebwiller.* Gebweiler 1960.

Gasierowski, Eugeniusz, "Die Briefkapelle der St. Marienkirche zu Lübeck." *DKD* 35, 1977: 148–64.

Hoppe-Sailer, Richard, *Die Kirche St. Maria zur Wiese in Soest. Versuch einer Raumanalyse.* In the series *Bochumer Schriften zur Kunstgeschichte*, Vol. 2. Frankfurt-am-Main – Bern 1983.

Kadauke, Bruno, *Die Marienkirche in Reutlingen aus kunsthistorischer Sicht. Mit einem Beitrag von Klaus Ehrlich.* Reutlingen 1987.

Kauffmann, Hans, "Die Kölner Domfassade." *KDF.* Publ. Zentral-Dombauverein. Cologne 1948: 78–138.

Kühlenthal, Michael, "Die Innenrestaurierung des Regensburger Doms. Historische Farbigkeit und Restaurierungskonzept." *KC* 42, 1989: 348–53.

Kunst, Hans Joachim, "Zur Ideologie des deutschen Hallenkirche als Einheitsraum." *Architectura* 1, 1971: 38–53.

——"Die Kirchen in Lüneburg – Architektur als Abbild." *Architektur des Mittelalters. Funktion und Gestalt.* Friedrich Möbius and Ernst Schubert eds. Weimar 1983: 273–85.

Kurmann, Peter, "Spätgotische Tendenzen in der hochgotischen Architektur um 1300." *Europäische Kunst um 1300. Akten des 25. Internationalen Kongresses für Kunstgeschichte, t.6.* Vienna 1986: 11–18.

Kutzner, Marian: "Spoleczne warunki ksztaltowania sic cech indywidualnych sakralnej architektury gotyckiej na Warmii." *Sztuka, pobrze a Ba tyku*, J. Biatostocki ed. Warsaw 1978: 49–88.

Lehmann, Edgar and Ernst Schubert, *Dom und Severikirche in Erfurt.* Leipzig 1988.

Lübke, Wilhelm, *Die mittelalterliche Kunst in Westfalen. Nach den vorhandenen Denkmälern dargestellt, nebst einem Atlas lithographirter Tafeln.* Leipzig 1883.

Michler, Jürgen, "Die ursprüngliche Chorform der Zisterzienserkirche in Salem." *ZKG* 47, 1984: 3–46.

——"Gotische Ausmalungssysteme am Bodensee." *Jahrbuch der Staatlichen Kunstsammlungen in Baden-Württemberg* 23, 1986: 32–57.

——"Die Dominikanerkirche in Konstanz und die Farbe in der Bettelordensarchitektur um 1300." *ZKG* 55, 1990: 253–76.

Mroczko, Teresa, *Architektura Gotycka na ziemi Chelminskiej.* Warsaw 1980.

Recht, Roland, *L'Alsace gothique de 1300 à 1365.* Colmar 1974.

——"Strasbourg et Prague." *Parler*, Vol. 4: 106–17.

Roth, Hermann Josef, *Die Pflanzen in der Bauplastik des Altenberger Domes. Ein Beitrag zur Kunstgeschichte und zur mittelalterlichen Botanik.* Bergisch-Gladbach 1976.

——*Die bauplastischen Pflanzendarstellungen des Mittelalters im Kölner Dom.* In the series *Europäische Hochschulschriften, Reihe 28*, Vol. 117. Frankfurt-am-Main 1990.

Schenkluhn, Wolfgang, "Die Erfindung der Hallenkirche in der

Kunstgeschichte." MJK *22*, 1989: 193–203.

Schürenberg, Lisa, *Die kirchliche Baukunst in Frankreich zwischen 1270 und 1380.* Berlin 1934.

Schütz, Bernhard, *Die Katharinenkirche in Oppenheim.* In the series *Beiträge zur Kunstgeschichte*, Vol. 17. Berlin-New York 1982.

Skibinski, Szczesny, *Kaplica na Zamku Wysokim w Malborku.* In the series *Universytet im. AM w Poznaniu, Seria Historia Sztuki. 14.* Poznan 1982.

Steincke, William August, "Die Briefkapelle zu Lübeck: ihre Herkunft und ihre Beziehung zum Kapitelsaal der Marienburg." *Jahrbuch des St. Marien-Bauvereins 8*, 1974/75: 55–71.

Stintzi, P., *L'église des Dominicains – Colmar.* Munich-Zurich 1965.

Suckale, Robert, "Thesen zum Bedeutungswandel der gotischen Fensterrose." *Bauwerk und Bildwerk im Hochmittelalter. Anschauliche Beiträge zur Kultur- und Sozialgeschichte.* In the series *Kunstwissenschaftliche Untersuchungen des Ulmer Vereins, Verband für Kunst- und Kulturwiss. 11.* Giessen 1981: 259–94.

Tintelnot, Hans, *Die mittelalterliche Baukunst Schlesiens.* Kitzingen 1951.

Wagner-Rieger, Renate, "Bildende Kunst – Architektur." *Die Zeit der frühen Habsburger. Dome und Klöster 1279–1379.* Exhibition catelogue, Wiener Neustadt. Vienna 1979: 103–26.

Weidl, Reinhard, "Die ersten Hallenkirchen der Gotik in Bayern. Ein Beitrag zur Entwicklungsgeschichte des Sakralraumes im 14. Jahrhundert." In the series *Schriften aus dem Institut für Kunstgeschichte der Universität München.* Vol. 12. MA thesis. Munich 1987.

V. ARCHITECTURE IN THE TIME OF THE PARLERS

Anstett, Peter, *Das Martinsmünster zu Colmar. Beitrag zur Geschichte des gotischen Kirchenbaus im Elsass.* In the series *Forschungen zur Geschichte der Kunst am Oberrhein*, Vol. 8. Berlin 1966.

Bachmann, Erich, "Zu einer Analyse des Prager Veitsdoms." In Swoboda, Karl and Erich Bachmann, *Studien zu Peter Parler.* Brünn-Leipzig 1939: 36–67.

Bock, Henning, "Der Beginn spätgotischer Architektur in Prag (Peter Parler) und die Beziehungen zu England." *WRJ* 23, 1961: 191–210.

Böker, Hans Josef, "Der Augsburger Dom-Ostchor. Überlegungen zu seiner Planungsgeschichte im 14. Jahrhundert." *Zeitschrift des historischen Vereins für Schwaben* 77, 1983: 90–102.

Bräutigam, Günther, "Gmünd-Prag-Nürnberg. Die Nürnberger Frauenkirche und der Prager Parlerstil vor 1360." *Jahrbuch der Berliner Museen* 3, 1961: 38–75.

—— "Die Nürnberger Frauenkirche. Idee und Herkunft ihrer Architektur." *Festschrift für Peter Metz.* Ursula Schlegel and Claus Zoege von Manteuffel ed. Berlin 1965: 170–97.

Chevalley, Denis A., "Der Dom zu Augsburg." In the series *Die Kunstdenkmäler von Bayern. NF 1.* Munich 1995: 68–120.

Crossley, Paul, "Wells, the West Country, and Central European Late Gothic." *Medieval Art and Architecture at Wells and Glastonbury.* In the series *The British Archaeological Association. Conference Transactions for the Year 1978. 4.* Leeds 1981: 81–109.

Fehr, Götz, "Die Wölbekunst der Parler." *Parler*, Vol. 3: 45–8.

Haussherr, Rainer, "Zu Auftrag, Programm und Büstenzyklus des Prager Domchores." *ZKG* 34, 1971: 21–46.

Héliot, Pierre, "Mathias d'Arras, la Cathédrale de Prague et l'evolution stylistique du Gothique Rayonnant en France." *Bulletin de la Commission Departemental des Monuments Historiques du Pas de Calais* 9, 1975: 408–10.

Hilger, Hans Peter, "Marginalien zu einer Ikonographie der gotischen Chorhalle des Aachener Domes." *Kunst als Bedeutungsträger. Gedenkschrift für Günter Bandmann.* Berlin 1978: 149–68.

Himmelheber, Georg, *Der Ostchor des Augsburger Domes.* In the series *Abhandlungen zur Geschichte der Stadt Augsburg. 15.* Augsburg 1963.

Homolka, Jaromír, "Zu den ikonographischen Programmen Karls IV." *Parler*, Vol. 2: 607–18.

Hufnagel, Herbert, "Zur Baugeschichte des Ostchores des Augsburger Domes." *Architectura 1987*: 32–44.

Kissling, Hermann, *Das Münster in Schwäbisch Gmünd. Studien zur Baugeschichte, Plastik und Ausstattung.* Schwäbisch Gmünd 1975.

Kletzl, Otto, *Planfragmente aus der deutschen Dombauhütte von Prag.* In the series *Veröffentlichungen des Archivs der Stadt Stuttgart. 3,* Stuttgart 1939.

Kobler, Friedrich, "Baugeschichte des Ostchores, kunsthistorische Beurteilung der Portalskulpturen." *Das Südportal des Augsburger Domes. Geschichte und Konservierung.* In the series *Arbeitshefte des Bayerischen Landesamtes für Denkmalpflege. 23.* Munich 1984: 7–29.

Kotrba, Viktor, "Der Dom zu St. Veit in Prag." *Bohemia Sacra. Das Christentum in Böhmen 973–1973.* Ferdinand Seibt ed. Düsseldorf 1974: 511–48.

Lange, Klaus, *Raum und Subjektivität. Strategien der Raumvereinheitlichung im*

Chor des Heilig-Kreuz-Münsters zu Schwäbisch-Gmünd. In the series *Bochumer Schriften zur Kunstgeschichte. 11.* Diss. Bochum 1987. Frankfurt-am-Main, Bern, New York, Paris 1988.

Leyh, Robert. *Die Frauenkirche zu Nürnberg.* Munich-Zurich 1992.

Líbal, Dobroslav, "Grundfragen der Entwicklung der Baukunst im Böhmischen Staat." *Parler,* Vol. 4: 171–2.

Marx, Andreas, "Der Ostchor der Sebalduskirche." *Mitteilungen des Vereins für Geschichte der Stadt Nürnberg* 71, 1984: 23–86.

Meckel, C.A., "Untersuchungen über die Baugeschichte des Chores des Münsters zu Freiburg." *Oberrheinische Kunst* 7, 1936: 37–52.

Möseneder, Karl, "Lapides Vivi. Über die Kreuzkapelle der Burg Karlstein." *Wiener Jahrbuch für Kunstgeschichte* 34, 1981: 39–69.

Puchta, Hans, "Zur Baugeschichte des Ostchores des Augsburger Domes." *Jahrbuch des Vereins für Augsburger Bistumsgeschichte* 14, 1980: 77–86.

Reinhardt, Hans, "Johannes von Gmünd, Baumeister an den Münstern von Basel und Freiburg, und sein Sohn Michael von Freiburg, Werkmeister am Strassburger Münster." *Zeitschrift für Schweizerische Archäologie und Kunstgeschichte* 3, 1941: 137–52.

Reinhold, Hans, *Der Chor des Münsters zu Freiburg i.Br. und die Baukunst der Parler-Familie.* In the series *Studien zur deutschen Kunstgeschichte. 263.* Strasbourg 1929.

Schade, Günter, *Der Hallenumgangschor als bestimmende Raumform der bürgerlichen Pfarrkirchenarchitektur in den brandenburgischen Städten von 1355 bis zum Ende des 15. Jahrhunderts.* Diss. Halle 1963.

——"St. Nikolai in Berlin. Ein bauhistorischer Deutungsversuch des Hallenchores mit Kapellenkranz." *Jahrbuch für brandenburgische Landesgeschichte* 17, 1966: 52–61.

Schmitt, Otto, *Das Heiligkreuzmünster in Schwäbisch Gmünd.* Stuttgart 1951.

Schock-Werner, Barbara, "Die Parler." *Parler,* Vol. 3: 7–11.

Schwemmer, Wilhelm, *Die Sebalduskirche in Nürnberg.* Nürnberg 1979.

Sedlák, Jan, "Die Architektur in Mähren in der Zeit der Luxemburger." *Parler Resultatb.:* 123–36.

Stephany, Erich, "Aula celestis particeps – der Halle des Himmels teilhabendes Nachbild. Zur Deutung und Symbolik der Chorhalle des Aachener Domes." *Aachener Kunstblätter* 17/18, 1958/59: 47–57.

Stockhausen, Hans Adalbert von, "Der erste Entwurf zum Strassburger Glockengeschoss und seine künstlerischen Grundlagen." *MJK* 11/12, 1938/39: 579–618.

Suckale, Robert, "Peter Parler und das Problem der Stillagen." *Parler,* Vol. 4, 175–83.

Swoboda, Karl Maria, "Klassische Züge in der Kunst des Prager Deutschen Dombaumeisters Peter Parler." Idem and Erich Bachmann, *Studien zu Peter Parler.* Brünn-Leipzig 1939: 9–25.

——*Peter Parler.* 2nd edition. Vienna 1941.

Winands, Klaus, *Zur Geschichte und Architektur des Chores und der Kapellenanbauten des Aachener Münsters.* Diss. Aachen 1987. Recklinghausen 1989.

Wortmann, Reinhard, "Ein hypothetischer Kathedralchorplan des Augsburger Domostchores." *Kunstgeschichtliche Studien für Kurt Bauch zum 70. Geburtstag.* Munich-Berlin 1967: 43–50.

——"Die Heiligkreuzkirche zu Gmünd und die Parlerarchitektur in Schwaben." *Parler,* Vol. 1: 315–18.

——"Die südwestdeutsche Wurzel der Langhausarchitektur der Heiligkreuzkirche zu Schwäbisch Gmünd." *Parler,* Vol. 4: 118–22.

Wundram, Manfred, "Der Chor des Heiligkreuzmünsters in Schwäbisch Gmünd und sein Meister." *Baukunst des Mittelalters in Europa. Hans Erich Kubach zum 75. Geburtstag.* Franz J.Much ed. Stuttgart 1988: 559–68.

VI. THE FIFTEENTH CENTURY

Bachmann, Erich, "Die Wallfahrtskirche St. Maria in Gojau und die bayrisch-österreichischen Dreistützenräume." *Stifter-Jahrbuch* 4, 1955: 147–75.

Behling, Lottlisa, "Masswerk des weichen Stils." *Pantheon* 32, 1944: 63–8.

Betzner, Klaus, "Zusammenhänge zwischen Konstruktion und Form in gotischer Architektur. Die Ostgiebel der Marienkirchen in Neubrandenburg, Prenzlau und Gransee." *Denkmale in Berlin und in der Mark Brandenburg. Erarbeitet im Institut für Denkmalpflege, Arbeitsstelle Berlin.* Weimar 1987: 211–23.

Bialostocki, Jan, "Late Gothic, Disagreements about the Concept." *Journal of the British Archaeological Association* s.3, 29, 1966: 76–105.

Binding, Günther, *Baubetrieb im Mittelalter.* A collaboration with Gabriele Annas, Bettina Jost and Anne Schunicht. Darmstadt 1993.

Böker, Hans Josef, *Die Marktpfarrkirche St. Lamberti zu Münster. Die Bau- und*

Restaurierungsgeschichte einer spätgotischen Stadtkirche. In the series *Denkmalpflege und Forschung in Westfalen,* Vol. 18. Bonn 1989.

Büchner, Joachim, "Über die dekorative Ausmalung spätgotischer Kirchenräume in Altbayern." *Mouseion. Studien aus Kunst und Geschichte für Otto H. Förster.* Cologne 1960: 184–93.

——*Die spätgotische Wandpfeilerkirche Bayerns und Österreichs.* in the series *Erlanger Beiträge zur Sprach- und Kunstwissenschaft,* Vol. 17. Diss. Erlangen-Nürnberg 1958. Erlangen 1964.

——"Unsymmetrische Raumformen im spätgotischen Kirchenbau Süddeutschlands und Österreichs." *Festschrift Peter Metz.* Berlin 1965: 256–81.

Bureš, Jaroslav, "Ein unveröffentlichter Choraufriss aus der Ulmer Bauhütte. Zur nachparlerischen Architektur in Süddeutschland und Wien." *ZDVK* 29, 1975: 3–27.

——"Die Prager Domfassade." *Acta Historiae Artium* 29, 1983: 3–50.

——"Der Regensburger Doppelturmplan. Untersuchungen zur Architektur der ersten Nachparlerzeit." *ZKG* 49, 1986: 1–28.

——"Die Bedeutung der Magdeburger Hütte in der mitteldeutschen Architektur des ausgehenden 14. Jahrhunderts." *NBK* 29, 1990: 9–33.

Cante, Andreas and Günther Köpping, *Die Katharinenkirche in Brandenburg an der Havel. Zur Bau- und Restaurierungsgeschichte eines Hauptwerkes märkischer Backsteingotik.* In the series *Brandenburgisches Landesamt für Denkmalpflege. Arbeitsheft Nr.6.* Potsdam 1996.

Clasen, Wolfgang, "Hinrich Brunsberg und die Parler." *Neue Beiträge zur Archäologie und Kunstgeschichte Schwabens. Festschrift J. Baum.* Stuttgart 1952: 48–58.

Conradt, Armin, *Ulrich von Ensingen als Ulmer Münsterbaumeister und seine Voraussetzungen.* Diss. Freiburg. 1959.

Cook, John W., *St. Martin, Landshut and the Architecture of Hanns v. Burghausen.* Phil.Th. Yale University. 1975.

Dambeck, Franz, *Hans Stethaimer und die Landshuter Bauschule.* Landshut 1957. In the series *Verhandlungen des Historischen Vereins für Niederbayern,* Vol. 82. Landshut 1957.

Dambeck, Franz, *Spätgotische Kirchenbauten in Ostbayern. Veröffentlichungen des Instituts für Ostbairische Heimatforschung in Passau 21,* 1939/40. Diss. Freiburg 1940. Passau 1940.

Damrich, Nicola, *Die Kirche St. Martin in Amberg/Oberpfalz.* In the series *Schriften aus dem Institut für Kunstgeschichte der Universität München.* Munich 1985.

——*Einstützenkirchen der Spätgotik in Oberösterreich.* Diss. Munich 1989.

Dehio, Georg, "Über die Grenzen der Renaissance gegen die Gotik." *KC NF.*11, 1900, cols. 273–7, 305–10.

Dietheuer, Franz, "Die Roritzer als Dombaumeister zu Regensburg." *Der Regensburger Dom. Beiträge zu seiner Geschichte.* Georg Schwaiger ed. In the series *Beiträge zur Geschichte des Bistums Regensburg.* Vol. 10. Regensburg 1976: 111–18.

Drost, Willi, *Die Marienkirche in Danzig und ihre Kunstschätze.* In the series *Bau- und Kunstdenkmäler des deutschen Ostens, Reihe A,* Vol. 4. Stuttgart 1963.

Fabian, Jürgen, *Der Dom zu Eichstätt.* In the series *Manuskripte zur Kunstwissenschaft in der Wernerschen Verlagsgesellschaft,* Vol. 19. Diss. Heidelberg 1984. Worms 1989.

Kinkel, Walter, *Der Dom Sankt Bartholomäus zu Frankfurt am Main. Seine Geschichte und seine Kunstwerke.* Frankfurt-am-Main 1986.

Kurmann, Peter, "Architektur." *St. Martin zu Landshut.* Alfred Fickel ed. Landshut 1985: 17–52.

Findeisen, Peter, "Studien zur farbigen Fassung spätmittelalterlicher Innenräume." Diss. manuscript. Leipzig 1969.

Fischer, Friedhelm Wilhelm, *Die spätgotische Kirchenbaukunst am Mittelrhein 1410–1520.* Diss. Heidelberg 1960. In the series *Heidelberger kunstgeschichtliche Abhandlungen,* N.F.7. Heidelberg 1962.

——*Unser Bild von der deutschen spätgotischen Architektur des 15. Jahrhunderts. (Mit Ausnahme der nord- und ostdeutschen Backsteingotik).* In the series *AHAW* 1964, 4. Abhandlung. Heidelberg 1964.

Gross, Werner, "Mitteldeutsche Chorfassaden um 1400." *Festschrift Wolf Schubert.* Weimar 1967: 117–41.

Haenel, Erich, *Spätgotik und Renaissance.* Stuttgart 1899.

Helmberger, Werner, *Architektur und Baugeschichte der St. Georgskirche zu Dinkelsbühl (1448–1499). Das Hauptwerk der beiden spätgotischen Baumeister Niclaus Eseler, Vater und Sohn.* In the series *Bamberger Studien zur Kunstgeschichte und Denkmalpflege,* Vol. 2. Diss. Bamberg 1982. Bamberg 1984.

Herzog, Theo, "Meister Hanns von Burghausen genannt Stethaimer. Sein Leben und Wirken." *Verhandlungen des Historischen Vereins für Niederbayern* 84, 1958: 1–83.

——"Die Baugeschichte des St. Martinsmünsters und anderer Landshuter*

Kirchen im Lichte der Jahrring-Chronologie." *Verhandlungen des Historischen Vereins für Niederbayern* 95, 1969: 36–53.

Hoeltje, Georg, *Zeitliche und begriffliche Abgrenzung der Spätgotik innerhalb der Architektur von Deutschland, Frankreich und England.* Diss. Halle/Saale 1929. Weimar 1930.

Jezler, Peter, *Der spätgotische Kirchenbau in der Zürcher Landschaft. Die Geschichte eines "Baubooms" am Ende des Mittelalters.* Wetzikon 1988.

Koch, Rudolf and Bernhard Prokisch, *Stadtpfarrkirche Steyr. Baugeschichte und Kunstgeschichte.* Steyr 1993.

Koepf, Hans, "Die Baukunst der Spätgotik in Schwaben." *Zeitschrift für Württembergische Landesgeschichte* 17, 1958: 1–144.

——"Die Esslinger Frauenkirche und ihre Meister." *Esslinger Studien* 19, 1980: 1–46.

Kotrba, Viktor, "Baukunst und Baumeister der Spätgotik am Prager Hof." *ZKG* 31, 1968: 181–215.

Krämmer, Johannes, *Die spätgotischen Ostteile des Domes in Passau.* Diss. Salzburg 1972.

Krause, Hans-Joachim, "Die spätgotischen Neubauten der Moritzkirche und der Marktkirche in Halle." *Denkmale in Sachsen-Anhalt. Ihre Erhaltung und Pflege in den Bezirken Halle und Magdeburg.* Weimar 1983: 225–52.

Ledebur, Alkmar Freiherr von, *Der Chormittelpfeiler. Zur Genese eines Architekturmotivs des Hanns von Burghausen.* Diss. Munich 1977.

Liedke, Volker, "Anmerkungen zur spätgotischen Architektur in Altbayern." *Idem, Die Baumeister- und Bildhauerfamilie Rottaler (1480–1533).* Ars Bavarica 5/6. Munich 1976: 227–314.

——"Zur Baugeschichte der kath. Stadtpfarr- und Stiftskirche St. Martin und Kastulus sowie der Spitalkirche Heiliggeist in Landshut." *Ars Bavarica* 39/40, 1986: 1–98.

——"Hanns Krumenauer, Werkmeister zu St. Martin in Landhut und Dombaumeister in Passau." *Ars Bavarica* 39/40, 1986: 117–27.

——"Stefan Krumenauer, Dom- und Hofbaumeister zu Salzburg." *Ars Bavarica* 39/40, 1986: 128–41.

Liess, Reinhard, "Zur historischen Morphologie der hohen Chorgiebelfassade von St. Marien in Prenzlau." *NBK* 27, 1988: 9–62.

——"Kunstgeschichtliche Anmerkungen zur Chorgiebelfassade der Prenzlauer Marienkirche." *Kunst im Ostseeraum. Mittelalterliche Architektur und ihre Rezeption.* In the series *EMAU.* Greifswald 1990: 21–35.

Löw, J.P., *Maria am Gestade.* Vienna 1931.

Magirius, Heinrich, "Die gotischen Hallenkirchen." *Die Stadtkirchen in Sachsen.* Fritz Löffler ed., 3rd edition. Berlin 1977: 32–42.

May, W., *Stadtkirchen in Sachsen/Anhalt.* Berlin 1979.

Meulen, Jan van der, "Die baukünstlerische Problematik der Salzburger Franziskanerkirche." *Österreichische Zeitschrift für Kunst und Denkmalpflege* 13, 1959: 52–9.

Michler, Jürgen, *Gotische Backsteinkirchen um Lüneburg St. Johannis.* Diss. Göttingen 1967.

Monjon, Luc, *Der Münsterbaumeister Matthäus Ensinger. Studien zu seinem Werk.* Hans R. Hahnloser ed. In der series *Berner Schriften zur Kunst*, Vol. 10. Bern 1967.

Mundt, Eckart, *Die westfälischen Hallenkirchen der Spätgotik (1400–1550).* Lübeck-Hamburg 1959.

Niemeyer, Wilhelm, *Der Formwandel der Spätgotik als das Werden der Renaissance.* Diss. Leipzig 1904.

Nussbaum, Norbert, *Die Braunauer Bürgerspitalkirche und die spätgotischen Dreistützenbauten in Bayern und Österreich. Ein raumbildnerisches Experiment des 15. Jahrhunderts.* In the series *Veröffentlichungen der Abteilung Architektur des Kunsthistorischen Instituts der Universität zu Köln.* Vol. 21. Diss. Cologne 1982.

——"Stilabfolge und Stilpluralismus in der süddeutschen Sakralarchitektur des 15. Jahrhunderts. Zur Tragfähigkeit kunsthistorischer Ordnungsversuche." *Archiv für Kunturgeschichte* 65, 1983: 43–88.

——"Die sogenannte Burghausener Bauschule. Anmerkungen zur ostbayerischen Spätgotik und ihrer Erforschung." *Ostbairische Grenzmarken. Passauer Jahrbuch für Geschichte, Kunst und Volkskunde* 26, 1984: 82–97.

Paatz, Walter, "Prolegomena zu einer Geschichte der spätgotischen Skulptur im 15. Jahrhundert." In the series *AHAW* 1956, 2. Abhandlung. Heidelberg 1956: 15–96.

——"Verflechtungen in der Kunst der Spätgotik zwischen 1360 und 1530." In the series *AHAW* 1967, 1. Abhandlung. Heidelberg 1967.

Perger, Richard, "Die Baumeister des Wiener Stephansdomes im Spätmittelalter." *Wiener Jahrbuch für Kunstgeschichte* 23, 1970: 66–107.

Petrasch, Ernst, *Die Entwicklung der spätgotischen Architektur an Beispielen der kirchlichen Baukunst aus Österreich.* Diss. manuscript. Vienna 1949.

——"'Weicher' und 'Eckiger' Stil in der deutschen spätgotischen Architektur." *ZKG* 14, 1951: 7–31.

Pilecka, Elzbieta, "Die spätgotische Architektur der Marienkirche zu Danzig." *Kunst im Ostseeraum. Mittelalterliche Architektur und ihre Rezeption.* In the series *EMAU.* Greifswald 1990: 49–57.

Recht, Roland and Albert Châtelet, *Ausklang des Mittelalters 1380–1500.* In the series *Universum der Kunst*, Vol. 35. Munich 1989.

Reinke, Ulrich, *Spätgotische Kirchen am Niederrhein im Gebiet von Rur, Maas und Issel zwischen 1340 und 1540*, 2 Vols. Diss. Münster 1977.

Philipp, Klaus Jan, *Pfarrkirchen. Funktion, Motivation, Architektur. Eine Studie am Beispiel der Pfarrkirchen der schwäbischen Reichsstädte im Spätmittelalter.* Diss. Marburg 1986.

Ringshausen, Gerhard, *Madern Gerthener, Leben und Werk nach den Urkunden.* Diss. manuscript. Göttingen 1968.

——"Die spätgotische Architektur in Deutschland unter besonderer Berücksichtigung ihrer Beziehungen zu Burgund im Anfang des 15. Jahrhunderts." *ZDVK* 27, 1973: 63–78.

Rosemann, Heinz, "Ausstrahlungen der Parler-Bauhütte im südlichen Niedersachsen." *KC* 7, 1954: 284–5.

——"Entstehungszeit und Schulzusammenhang der Regensburger Turmbaupläne." *KC* 15, 1962: 259–61.

Schadendorf, Wulf, "Mitteldeutsche Kunsträume im 14. und 15. Jahrhundert. Ein Beitrag zur Kunstgeographie und Kunstgeschichte zur Umgrenzung und Bestimmung Mitteldeutschlands." *Berichte zur Deutschen Landeskunde* 20, 1958: 287–319.

——"Wien, Prag und Halle. Ein Beitrag zum Einfluss der Dombauhütten von Wien und Prag auf die Baukunst Mitteldeutschlands, dargestellt an Chor und Langhaus von St. Moritz in Halle/Saale." *Hamburger Mittel- und Ostdeutsche Forschungen* 3, 1961: 148–99.

Schahl, Adolf, "Die Herkunft der spätgotischen Staffelhalle in Württemberg. Ein Beitrag zur Geschichte des Einflusses der Bettelordensarchitektur auf den Pfarrkirchenbau des 14.- 15. Jahrhunderts." *Neue Beiträge zur Archäologie und Kunstgeschichte Schwabens.* Stuttgart 1952: 90–7.

Schmarsow, August, "Reformvorschläge zur Geschichte des deutschen Renaissance." *Berichte der phil.-hist. Classe der Königlichen Sächsischen Gesellschaft der Wissenschaften zu Leipzig* 1899: 41–76.

Schock-Werner, Barbara, *Das Strassburger Münster im 15. Jahrhundert. Stilistische Entwicklung und Hüttenorganisation eines Bürger-Domes.* In the series *Veröffentlichungen der Abteilung Architektur des Kunsthistorischen Instituts der Universität zu Köln.* Vol. 23. Cologne 1983.

Schotes, Paul, *Spätgotische Einstützenkirchen und zweischiffige Hallenkirchen im Rheinland.* Diss. Aachen 1970.

Schottner, Alfred, *Das Brauchtum der Steinmetzen in den spätmittelalterlichen Bauhütten und dessen Fortleben und Wandel bis zur heutigen Zeit.* In the series *Volkskunde*, Vol. 6, 2nd edition. Münster-Hamburg 1994.

——*Die "Ordnungen" der mittelalterlichen Dombauhütten. Verschriftlichung und Fortschreibung der mündlich überlieferten Regeln der Steinmetzen.* In the series *Volkskunde*, Vol. 7. Münster-Hamburg 1994.

Schwarz, Heinrich M., *Die kirchliche Baukunst der Spätgotik im Klevischen Raum.* Diss. Bonn 1938.

Sedlak, Jan, "Die Architektur in Mähren in der Zeit der Luxemburger." *Parler Resultatbd.*: 123–36.

Siebenhüner, Herbert, *Deutsche Künstler am Mailänder Dom.* In the series *Ausstrahlungen der deutschen Kunst. Deutsche Kunst in Italien.* Munich 1944.

Weise, Georg, "Stilphasen der architektonischen Entwicklung im Bereich der deutschen Sondergotik." *ZKG* 13, 1950: 68–80.

Wolff, Arnold, "Der Kölner Dombau der Spätgotik." *Beiträge zur Rheinischen Kunstgeschichte und Denkmalpflege. 2.* Düsseldorf 1974: 137–51.

Wortmann, Reinhard, "Zur Baugeschichte der Ulmer Münsterchores." *Zeitschrift für Württembergische Landesgeschichte* 28, 1969: 105–17.

——"Hallenbau und Basilkaplan der Parler in Ulm." *600 Jahre Ulmer Münster.* In the series *Forschungen zur Geschichte der Stadt Ulm*, Vol. 19. Stuttgart 1977: 101–25.

——*Das Ulmer Münster.* In the series *Grosse Bauten Europas*, Vol. 4, 2nd edition. Darmstadt 1981.

Zaske, Nikolaus, "Hinrich Brunsberg, ein ordenspreussischer Baumeister der Spätgotik." *Baltische Studien NF.* 44, 1957: 49–72.

——"Heinrich Brunsberg – Werk und Bedeutung. Mittelalterliche Backsteinbaukunst. Romanische und gotische Architektur – ihre Rezeption und Restaurierung." In *ZEMAU* 29, 1980. Greifswald 1980: 83–94.

Zykan, Marlene, "Zur Baugeschichte des Hochturmes von St. Stephan." *Wiener Jahrbuch für Kunstgeschichte* 23, 1970: 28–65.

VII. MOVEMENT IN STONE. A LATE GOTHIC METAMORPHOSIS

Böker, Hans Josef, "Die spätgotische Nordhalle des Braunschweiger Domes." *NBK* 26, 1987: 51–62.

Börsch-Supan, Eva, *Garten- Landschafts- und Paradiesmotive im Innenraum. Eine ikonografische Untersuchung.* Diss. Cologne 1963. Berlin 1967.

Braun-Reichenbacher, Margot, "Das Ast- und Laubwerk." In the series *Erlanger Beiträge zur Sprach- und Kunstwissenschaft* vol. 24. Nuremberg 1966.

Bucher, François, "Micro-Architecture as the 'Idea' of Gothic Theory and Style." *Gesta* 15, 1976: 71–89.

Büchner, Joachim, "Ast- Laub- und Masswerkgewölbe der endenden Spätgotik. Zum Verhältnis von Architektur, dekorativer Malerei und Bauplastik." *Festschrift Karl Oettinger.* Erlangen 1967: 265–302.

Fehr, Götz, *Benedikt Ried. Ein deutscher Baumeister zwischen Gotik und Renaissance in Böhmen.* Munich 1961.

——"Architektur." *Die Kunst der Donauschule 1400–1540.* Exhibition catalogue. St. Florian-Linz 1965: 202–216.

Feuchtmüller, Rupert, *Die spätgotische Architektur von Anton Pilgram.* Vienna 1951.

——"Architektur des Donaustiles im Raum von Wien, Steyr und Admont." *Die Kunst der Donauschule 1400–1540.* Exhibition catalogue. St. Florian-Linz 1965: 217–34.

Fröhlich, H. and W. Zimmermann, *Die Schlosskirche zu Meisenheim.* Meisenheim 1958.

Griebitsch, H., *Die spätgotischen Kirchen Leipzigs.* Leipzig 1932.

Grieselmayer, Volkmar, "Beobachtungen zur Raumgrenze der obersächsischen Hallenkirche. Ein Beitrag zur Ästhetik des spätgotischen Kirchenraumes." *Das Münster* 46, 1993: 107–13.

Gurlitt, Cornelius, *Die Westtürme des Meissner Doms.* Berlin 1902.

Harksen, Sibylle, *Hallenkirchen in Torgau.* Diss. manuscript. Halle 1958.

Husband, Timothy and G. Gilmore-House, *The Wild Man. Medieval Myth and Symbolism.* New York 1980.

Julier, Jürgen, *Studien zur spätgotischen Baukunst am Oberrhein.* In the series *Heidelberger kunstgeschichtliche Abhandlungen,* vol. 13. Heidelberg 1978.

Kalden-Rosenfeld, Iris, "Einfach traumhaft – traumhaft einfach. Ein Beitrag zur Ikonographie der Kanzel Hans Wittens im Dom zu Freiberg." *Das Münster* 45, 1992: 303–10.

Kaplan, Helene Christine, *The Danzig Churches: A Study in Late Gothic Vault Developement.* Phil.Th.Binghamton, NY 1974.

Knappe, Karl-Adolf, "'Um 1490'. Zur Problematik der Altdeutschen Kunst." *Festschrift Karl Oettinger.* Erlangen 1967: 303–52.

Knopp, Norbert, *Die Frauenkirche zu München und St. Peter.* In the series *Grosse Bauten Europas,* Vol. 3. Stuttgart 1970.

Kutzner, Marian, "Theologische Symbolik deutscher spätgotischer Hallenkirchen." *Mittelalterliche Backsteinbaukunst. Romanische und gotische Architektur – ihre Rezeption und Restaurierung. ZEMAU* 29, 1980: 37–43.

Lemper, Ernst-Heinz, "Arnold von Westfalen. Berufs- und Lebensbild eines deutschen Werkmeisters der Spätgotik." *Die Albrechtsburg zu Meissen.* Hans-Joachim Mrusek ed. Leipzig 1972: 41–55.

Magirius, Heinrich, "Die Albrechtsburg und die spätgotische Architektur in Obersachsen." *Die Albrechtsburg zu Meissen.* H.-J. Mrusek ed. Leipzig 1972: 67–83.

——"Neue Ergebnisse zur Baugeschichte der Annenkirche zu Annaberg." *Sächsische Heimatblätter* 21, 1975: 149–57.

——*Der Dom zu Freiberg.* Berlin 1977.

——"Denkmalpflege an Kirchenbauten der obersächsischen Spätgotik." *Denkmale in Sachsen.* Weimar 1978: 160–209.

——*St. Annen zu Annaberg.* Munich-Zurich 1991.

Meckenstock, Heinrich, *Portalarchitektur deutscher Spätgotik.* Diss. Innsbruck 1951.

Merian, Hans, *Die Willibrordikirche in Wesel.* In the series *Rheinische Kunststätten,* Vol. 113. 2nd edition. Neuss 1982.

——*Das Zellengewölbe. Wesen, Entstehung, Entwicklung und Verbreitung einer spätgotischen Wölbweise.* Diss. Greifswald 1958.

——"Zur sächsischen Architektur in der Zeit der frühbürgerlichen Revolution." *ZEMAU* 11, 1962: 305–21.

——"Architektur in der Zeit der frühbürgerlichen Revolution. Beiträge zur Gestalt und Bedeutung des mittelalterlichen Kirchenraumes um 1500." Diss. manuscript. Greifswald 1968.

——"Anmerkungen zur Gestalt der sächsischen Hallenkirchen um 1500." *Aspekte zur Kunstgeschichte von Mittelalter und Neuzeit. Festschrift Karl Heinz Clasen.* Weimar 1971: 167–89.

——"Die Zellengewölbe und die Albrechtsburg." *Die Albrechtsburg zu Meissen.* Hans-Joachim Mursek ed. Leipzig 1972: 56–66, 134–8.

——"Zur gesellschaftlichen Funktion der Emporen im obersächsischen Kirchenbau um 1500." *Actes du 22e Congrès International d'Histoire de l'Art.* Budapest 1972: 551–6.

Möbius, Friedrich, "Beobachtungen zur Ikonologie des spätgotischen Gewölbes in Sachsen und Böhmen." *Actes du 22e Congrès International d'Histoire de l'Art.* Budapest 1972: 557–67.

Oettinger, Karl, "Laube, Garten und Wald. Zu einer Theorie der süddeutschen Sakralkunst 1470–1520." *Festschrift für Hans Sedlmayr.* Munich 1962: 201–228.

Pfister, Peter and Hans Ramisch, *Die Frauenkirche in München. Geschichte, Baugeschichte und Ausstattung.* Munich 1983.

Schönemann, Heinz, "Die Baugeschichte der Annenkirche in Annaberg." *Wissenschaftliche Zeitschrift der Martin-Luther-Universität Halle-Wittenberg, gesellschafts- und sprachwiss. Reihe* 12, 1963: 745–56.

Schulze, Konrad Werner, *Die Gewölbesysteme im spätgotischen Kirchenbau in Schwaben von 1450–1520.* Diss. Tübingen 1936. Reutlingen 1939.

Seeliger-Zeiss, Anneliese, *Lorenz Lechner von Heidelberg und sein Umkreis. Studien zur Geschichte der spätgotischen Zierarchitektur und Skulptur in der Kurpfalz und in Schwaben.* In the series *Heidelberger kunstgeschichtliche Abhandlungen* NF. 10. Heidelberg 1967.

Seeliger-Zeiss, Anneliese, "Studien zur Architektur der Spätgotik in Hirsau." *Forschungen und Berichte der Archäologie des Mittelalters in Baden-Württemberg* 10, 1991: 265–363.

Ulm, Benno, "Der Begriff 'Donauschule' in der spätgotischen Architektur." *Christliche Kunstblätter.* Diözesan- Kunstverein Linz-an-der-Donau ed. 100, 1962: 82–7.

Viertelböck, Vera, "St. Salvator in Passau. Historische und baugeschichtliche Untersuchung." *Ostbairische Grenzmarken. Passauer Jahrbuch für Geschichte, Kunst und Volkskunde* 26, 1984: 98–125.

Ziessler, Rudolf, *Die Wolfgangkirche zu Schneeberg.* Berlin 1971.

VIII. GOTHIC AND RENAISSANCE

Büchner-Suchland, Irmgard, *Hans Hieber. Ein Augsburger Baumeister der Renaissance.* In the series *Kunstwissenschaftliche Studien,* Vol. 32. Munich-Berlin 1962.

Bushart, Bruno, *Die Fuggerkapelle bei St. Anna in Augsburg.* Munich 1994.

Faber, Karl-Georg, "Epoche und Epochengrenzen in der Geschichtsschreibung." *ZKG* 44, 1981: 105–13.

Frey, Dagobert, *Gotik und Renaissance als Grundlagen der modernen Weltanschauung.* Augsburg 1929.

Guldan, Ernst, "Die Aufnahme italienischer Bau- und Dekorationsformen in Deutschland zu Beginn der Neuzeit." *Arte e Artisti dei Laghi Lombardi I.: Architetti e scultori del Quattrocento.* Como 1959: 381–91.

Hipp, Hermann, *Studien zur Nachgotik des 16. und 17. Jahrhunderts in Deutschland, Böhmen, Österreich und der Schweiz.* 3 Vols. Diss. Tübingen 1974. Tübingen 1979.

Kadatz, Hans-Joachim, *Deutsche Renaissancebaukunst von der frühbürgerlichen Revolution bis zum Ausgang des Dreissigjährigen Krieges.* Berlin 1983.

Kaufmann, Hans, *Die Kunst des 16. Jahrhunderts.* In the series *Propyläen-Kunstgeschichte,* Vol. 8. Frankfurt-am-Main–Berlin–Vienna 1970.

Kirschbaum, Engelbert, *Deutsche Nachgotik. Ein Beitrag zur Geschichte der kirchlichen Architektur von 1550–1800.* Augsburg 1930.

Krause, Hans-Joachim, "Das erste Auftreten italienischer Renaissance-Motive in der Architektur Mitteldeutschlands." *Acta Historiae Artium Academiae Scientiarum Hungaricae.* Budapest 1967: 99–114.

Skalweit, Stephan, *Der Beginn der Neuzeit. Epochengrenze und Epochenbegriff.* In the series *Erträge der Forschung,* Vol. 178. Darmstadt 1982.

GLOSSARY

Aisle
longitudinal spatial unit of a church that, in vaulted structures, consists of numerous bays (central vessel, side-aisles)

Ambulatory
spatial zone that surrounds the sanctuary, usually as a continuation of the side-aisles

Apse
an interior, vaulted termination of hemispherical plan

Arcade, Arcade Arches
either a single arch resting upon a support (pier or column), or a row of such arches that separates one aisle from another

Archivolt
the profile or decoration covering an arch

Arris Pier
a pier embedded in a wall so that a corner projects out from the surface, forming a triangular shape that runs up and down the wall in a line

Base
the projecting, profiled foot of a pier or column

Basilica
in medieval architecture, a multi-aisled interior with raised central vessel lit by a clerestory

Bay
the vault zone of a specific spatial unit, the repetition of which creates aisles

Biforium
a doubled arch or window opening

Blind Articulation
near two-dimensional tracery or profiling applied to arcades, arches and windows. Any kind of articulation flat against a surface

Branch-Work Ornamentation
Ribs and shafts that have been carved or formed to look like leafless branches of trees, often with secondary branches cut off to look like knots

Calotte
a vault whose surface forms the inside of a sphere, employed in the vaults over apses and other spatial zones with a rounded wall surface

Capital
the protruding head or top of a support element that formally reflects the weight carried by the support shaft

Capped Ribs
a rib that ends immediately after intersecting with another rib

Central Vessel
the central space of a multi-aisled church interior bordered on both sides by the arcade arches

Chancel
the area between the triumphal arch and the round or polygonal choir termination

Chapelled Extensions
chapels in the outer walls of a church, framed by pier buttresses pulled inside, that are just as tall as the side-aisle onto which they open

Chapterhouse
place of assembly at monasteries where, among other things, chapters out of the Bible and monastery regulations were read aloud

Chevet
the spaces and/or bays surrounding the sanctuary that terminate the choir, including ambulatory with or without radial chapels

Choir
in the Middle Ages, that part of the church interior allocated for the singing of Mass and prayers of the clergy; usually in the eastern section of the church

Choir Apex
that point where the longitudinal axis of the chevet intersects with the eastern terminating wall of the choir

Choir Polygon
an apse when it is terminated by a collection of straight wall sections, each placed at angles to one another so as to form some kind of polygonal shape

Clerestory
the upper surfaces of the central-vessel wall above the side-aisles, in a basilica mostly of glazing

Cloister Vault
dome-like vault constructed over a polygonal space, consisting of four or more vault webs that are separated by a groin

Cloister
a covered hallway circumventing a square inner courtyard of a monastery, with a wall made up of columns and arches opening to the courtyard

Compound Pier
a pier surrounded on all sides by respond shafts

Conch
a semicircular apse

Couronnement
the tympanum of a window

Creased Rib
a rib bent at an acute angle

Crocket articulation
sculptural leaf-like ornamentation usually found on the edges of finials, gables and spires; sometimes organized to look like a cross

Cross Vault
a vault consisting of those portions of two barrel vaults, sometimes pointed, that intersect at a right angle over the square area that it covers; the lines where the barrels intersect are articulated by groins

Cross Rib
a rib whose course runs diagonally across the vault shell from one support to another and in the apex of the vault intersects with another rib running in the other direction (cross-rib vault)

Cross-rib Vault
cross vault whose groins are covered by ribs that cross in the center of the vault bay

Cross-section Façade
the west façade of a basilica, on whose face the cross-section of the nave is exactly articulated

Crossing
that part of a Gothic church where nave and transept intersect, and the space therein

Crypt
a low room beneath the choir of a church that served both as tomb and the medieval reliquary cult

Curved-rib Vault
a vault consisting of ribs curved to form spherical shapes

Diagonal Rib
a rib that runs diagonally in relation to the longitudinal and transverse axes of an interior

Dome
spherical-shaped vault, usually in the form of a hemisphere over a round floor plan

Domical Vault
an extremely warped, ribbed vault similar in shape to a dome; usually over a square bay and made with ring webbing

Dwarf Gallery
on the outer structure, a low passageway under the eaves

Eaves
the lower edge of a roof

Fan Vault
vault with cone-like compartments that resemble open fans and have horizontal vault apexes

Figured Vault
general term for a vault in which numerous ribs are combined to form a logical figure or pattern

Finial
a thin, ornamental element at the very top of pier buttresses and gables; or as part of a system of crocket ornamentation on portals and galleries

Flamboyant
a tracery style of French Gothic in which curved forms seem flame-like

Flying Buttress, Flyer
arches that slant over the aisles and into the pier buttresses on the outer structure, they are meant to deflect thrust produced by the vaults or by wind load on the clerestory wall of the nave of a basilica

Flying Rib
a rib, free of the vault shell, that rises unattached through the air

Flying-rib vault
a ribbed vault lacking webs, which gives the distinct impression that the ribs are flying through the air

Foil, Foiling
circular tracery figures formed by the cusping of a circle or an arch; usually in groups within a framing circle

Folded Vaults
a ribless vault with deep, prismatic cells that seem folded and thus form sharp-edged groins

Formeret Arch
the arch found where the vault bay meets the wall

Formeret Web
that web of a vault that reaches over to a bordering wall or window; makes windows appear to reach into the vault zone from the sides

Gallery Basilica
basilica with a circumventing gallery over the side-aisles

Gallery
a single structure with balustrade either parallel to or protruding out of a wall, a side-aisle chapel, or in the ambulatory, in the west of a church, and sometimes in the central vessel or above a chapelled extension. It can be a roofed circumventing passageway as well, that often features a rich array of columns opening towards the interior

Gargoyle
a waterspout projecting from the edge of a roof sculpted to resemble a human or animal

Gebundendes System
system of vault organization in a basilica that combines a square high vault with two side-aisle bays each half as large

Hall Church
a church with multiple aisles at the same, or nearly the same height

Hall Choir
a choir where the sanctuary and its aisles are the same or nearly the same height

Hall Nave
a nave built with multiple aisles at the same or nearly the same height

Impost
the zone in which an arch or vault first begins to bend inward

Jambs
in Gothic architecture, the slanting side or base of a portal or window, often stepped or articulated

Keystone
the voissoir at the apex of an arch against which all the other voissoirs push as they rise

Lancet Arches
thin, extremely tall pointed arches with little span whatsoever

Lierne
a secondary rib that connects diagonal ribs, ridge ribs and tiercerons to form stellar shapes

Lintel-like Molding
horizontal wall articulation, such as a cornice or string coursing, that jumps over vertical wall elements like wall piers or responds

Lesene
a shallow, partially embedded pier or column lacking a base or capital, employed to strengthen the outside wall of a church

Longitudinal-ridge Rib
Rib that runs along the longitudinal apex of a vault

Looping Rib
a rib in the form of an arch, that is interwoven with other ribs to form loop-like forms

Looping Stellar Vault
vaults whose individual ribs are looped, and which form stellar figures

Mouchette
a teardrop-shaped tracery figure usually on its side, with a round end and a pointed "tail"

Nave
the single or multi-aisled central space of a church – between the west section and the crossing or, that lacking, the choir – that forms the longitudinal axis of the interior

Net Vault
vault with a net-like rib figure

Octagon
an eight-sided figure

Ogee Arch
a pointed arch with angles concave in the upper sections

One-aisled Church
a church that is not divided into aisles by piers or columns

Oriel
single or multiple-register addition to the outside wall of church, in a raised position, that extends outward from the surface of the wall and is either unsupported or carried by consoles

Ornamental Gable
a triangular gable – usually decorated with tracery, leaf figures or crocketing – over windows or portals

Panel Articulation
fields of vertically oriented wall articulation

Parallel-rib Vault
a rib figure consisting of pairs, or groups, of parallel ribs

Pier Buttress
a pier that abuts the weight of the vault and is partially embedded in the outer wall of a Gothic church; can be visible outside, or pulled inside and used for chapel walls; the pier buttresses of a basilica extend above the eaves of the aisles to receive the flyers

Pilaster
a wall pier with base and capital

Pinnacle
a small turret-like termination of towers, spires, etc.

Plate Frieze
a frieze upon square, inlaid stone plates used in the Rhenish High and Late Romanesque

Plinth
a plate carrying a column or pier base

Polygon
a multi-angled figure

Pseudo-basilica
another name for a *Staffelhalle*

Refectory
dining hall of a monastery

Responds
shaft-like support elements, sometimes very thin, placed upon piers or walls, that rise to archivolts and vault sections above, and which have very different forms in cross-section

Rib
a section or haunch of an arch spanned beneath the stone shell of a vault; combined with other ribs to form various figures

Roll Molding
articulated shaft, respond, or rib with a semicircular or more than semicircular cross-section

Rood Screen, Lectern
a closed screen made of stone, often articulated by arcading, that separated those parts of a church reserved for the clergy and those of the lay congregation in the nave; the lay altar was located on the nave side and the New Testament was read there as well

Rose Window
a round window filled with tracery

Sacrament House
smallish, tower-like construction with a container resembling a tabernacle for the safekeeping of the Blessed Sacrament; sometimes called a tabernacle

Sexpartite Vault
a cross-rib vault, divided through the middle of the bay by an additional transverse arch

Shaft Work
tracery

Side-aisles
spatial units on both sides of the central vessel of a multi-aisled structure: separated from the central vessel by arcade arches

Spiked/Crocketed Pier
a pier, like the pier buttresses sticking up like spikes at the base of Freiburg Minster's spire octagon, that are free-standing and crocketed

Springing or Jumping Vaults
vault with alternating impost placement in the longitudinal plane, causing the ribs to jump back and forth, rather than straight over, to the bordering wall

Staffelhalle, Pseudo-basilica
a Gothic nave type where the outermost aisles are not as tall as those to their insides, the tallest being the central vessel with windowless clerestory

Stellar Vault
a vault whose ribs form a star-like figure overhead

Stilted Arch, stilted
an arch or vault that bends inward at a point above its own imposts, usually accomplished by extending the vertical elements of pier or wall beyond the impost zone

Strainer Arch
an arch in the horizontal plane, rather than the vertical like a flyer, spanned between two parts of a building to help offset horizontal thrust

Tabernacle
an ornamental recess placed on the outer architecture that resembles a finial with open sides, small columns and a pointed roof

Langchor Chancel
a choir form developed by Mendicant Gothic in which the chancel is often several bays deep

Tierceron
an intermediate rib in a vault that rises from the springer to the crown

Tracery
structural ornamentation consisting mostly of abstract, geometric shaft work that serves to articulate – with lattice-like shapes – window openings, closed surfaces (blind tracery), gables, balustrades, and other elements

Tracery Harps, Tracery Sheath
in contrast to blind tracery, a free-standing tracery trellis placed before a wall or opening; used for the first time at Strasbourg Cathedral, the so-called "harps"

Tracery Vault
a ribbed vault formed out of tracery figures, often consisting only of flying ribs

Transept
that section of a church between choir and nave, placed at a 90° angle to both, that can be made up of spaces of different heights

Transverse Arch
an arch set at a right angle to the edges of the vault bay, that separates the individual bays of an aisle from each other

Transverse-ridge Rib
a rib that runs along the apex of a vault at a 90° angle to the longitudinal axis

Travée
the same as bay; also used to describe the structural unit formed by a central-vessel bay and the aisle bays to its immediate sides – including the piers, the wall buttresses and their flyers

Trichora
choir structure consisting of three conches organized like a three-leaf clover

Triforium
passageway in the central vessel wall of a basilica immediately below the clerestory windows; usually articulated by arcade arches opening towards the interior

Triradials
a Y-shaped rib figure, consisting of three ribs that share a common boss, that is used to articulate a triangular vault zone

Triumphal Arch
arch that separates the choir from the crossing or from the nave

Trumeau Pier
the central support of a double-arch portal

Tunnel Vault
a simple vault in the form of half or part of a cylinder with its open side downward, whose cross-section forms a semi-circle, a parabola, a pointed or a segmented arch

Tympanum
the arched area above the lintel of a portal

Umbrella Vault
vault over a freestanding support whose cells and ribs stretch out to all sides like an umbrella

Vault
a bent or warped ceiling over a church interior, that supports itself and is stretched between abutments; in Gothic architecture it is subdivided into webs by groins or ribs

Vault Springers
that part of the vault zone immediately above the impost where the vault shell and/or rib begins to bend inward

Vault Apex
the highest point of a vault bay

Vault Web
those vault surfaces between groins or ribs

Vault Boss
the articulated spot where the ribs meet or cross each other. The bosses of the main ribs are called keystones

Wall-pier Church
a single-aisle church with chapelled extensions between pulled-in pier buttresses in the outer nave wall

Warped Vault
a cross-rib vault with webs of a spherical or warped shape, sometimes due to a difference in height between two ribs

Weathering
a sloping horizontal surface or cornice whose base is deeply concave for the run-off of water

Western Section
the west front of a church comprised of mostly independent structures such as tower, porch or façade

Window Sill
a ledge below the window, sometimes slanting downward, that projects out over the wall below it

Wreath of Chapels
a series of chapels organized like a wreath around a choir chevet

CHRONOLOGY

1140–60

1141–4	Choir of the Abbey Church St. Denis

1160–80

after 1150–72	Trichora choir of Great St. Martin in Cologne
after 1152–74	Second choir of the Cistercian Church at Clairvaux
ca.1155	New choir of the Cistercian Church at Morimond
ca.1155/60	Laon Cathedral begun
1160–65	Transept conches of Noyon Cathedral
1163	Notre-Dame in Paris begun
ca.1165/70	Choir of St-Remi in Reims begun
1171–81	West choir of Worms Cathedral
ca.1175	South transept conch of Cambrai Cathedral begun

1180–1200

ca.1180–93	Third choir of Cistercian Church at Citeaux
1194	Chartres Cathedral begun
ca.1195	Bourges Cathedral begun
ca.1195/1200	St. Yved in Braine begun
before 1200	St. George in Limburg begun

1200–20

1200	Cistercian Church Ebrach begun
1202	Cistercian Church Lilienfeld begun
1202–37	Cistercian Church Heisterbach
1207	Consecration of St. Michael's Chapel in Ebrach
1209	Choir of Magdeburg Cathedral begun
1210	Reims Cathedral begun
1215	Auxerre Cathedral begun
1219–27	Rennovation of the Decagon of St. Gereon in Cologne
1220	Amiens Cathedral begun

1220–40

1220–30	Nave of Bonn Minster
ca.1220–30	Southern cloister wing of the Cistercian Monastery at Maulbronn
1222	Consecration of the Palatine Chapel at Klosterneuburg
ca.1225–7	Cistercian church Marienstatt begun
1227–34	West choir of Bamberg Cathedral
1225	Choir of Beauvais Cathedral begun

ca.1227	Our Lady in Trier begun
ca.1230–40	Transept of Strasbourg Cathedral
ca.1229	Choir of Troyes Cathedral begun
1231	Construction of choir clerestory, transept and nave of Abbey Church St. Denis begun
1235	St. Elizabeth in Marburg begun
1235–40	Nave of Great St. Martin in Cologne rebuilt
ca.1235–75	Nave of Strasbourg Cathedral

1240–60

ca.1240	Nave of Freiburg Minster begun
1241–8	Ste-Chapelle in Paris
ca.1245–8	Dominican Church in Regensburg begun
1246, 1258	Transept fronts of Notre-Dame in Paris begun
1248–1322	Cologne Cathedral choir
ca.1248	Minorite Church in Cologne begun
ca.1250	West choir of Naumburg Cathedral
1259	Cistercian Church Altenberg begun

1260–80

ca.1260	St. Mary's in Greifswald begun
1266	Choir of St. Mary's in Lübeck begun
1263	St. Viktor in Xanten begun
1267–90	Hall Nave of Minden Cathedral
after 1269	Dominican Convent Church in Imbach begun
1273–1313	Hall Ambulatory of Verden Cathedral Choir
after 1273	Choir of Regensburg Cathedral begun
after 1276	Cistercian Church at Pelplin begun
1277	West Façade of Strasbourg Cathedral begun

1280–1300

ca.1280	Octagon of Freiburg Minster Tower begun
ca.1280	Nave of St. Severi in Erfurt begun
after 1287	Wernerkapelle in Bacharach begun
1288–1371	Holy Cross in Breslau
1295	Consecration of the Hall Choir of the Cistercian Church in Heiligenkreuz
1296–1318/20	Choir rennovation at Notre-Dame in Paris
1298	St. Mary's in Neubrandenburg under construction

1300–20

ca.1300	West Façade of St. Mary's in Reutlingen begun
before 1304–40	Choir of St. Stephan in Vienna begun
ca.1306	Dominican Church in Gebweiler begun
1310	"Letter Chapel" of St. Mary's in Lübeck

1313	Wiesenkirche in Soest begun
before 1319	West Façade of the Cistercian Church in Chorin completed

1320–40

ca.1320–35	Nave of St. Mary's in Lübeck
before 1325	West Façade of Cologne Cathedral begun
1325	St. Mary's in Prenzlau under construction
ca.1328	South Façade of St. Catherine in Oppenheim completed
after 1329	"Triangle" of Magdeburg Cathedral
ca.1330	Hall Nave of Holy Cross in Schwäb. Gmünd begun
1334	St. Maria-auf-dem-Sande in Breslau begun

1340–60

1340–6	Nave of Überwasserkirche in Münster
1341–1426	Collegiate Church in Kleve
1343–83	Choir of the Cistercian Church in Zwettl
ca.1343	Wallseer Chapel of the Minorite Church in Enns
1344	Construction of Prague Cathedral begun
1345	Chapterhouse of the Cistercian Monastery at Eberbach receives new vault
1345–80	Marienwerder Cathedral
1348	Castle Karlstein begun
after 1350	Choir of St. Martin in Colmar
1351	Choir of Holy Cross in Schwäb. Gmünd begun
1352	Our Lady in Nuremberg under construction
1354	Choir of Freiburg Minster begun
ca.1355–1415	Choir of Aachen Cathedral
1356–85	Peter Parler completes Prague Cathedral Choir
1356–1431	East Choir of Augsburg Cathedral
1359	Nave of St. Stephan in Vienna begun

1360–80

1360–78	Choir of St. Bartholomew in Kolin
1361–79	Choir of St. Sebald in Nuremberg
1375	Choir of St. Lamberti in Münster begun
1379	Choir of St. Nikolai in Berlin under construction
1379–1502	Hall Church St. Mary's in Danzig

1380–1400

ca.1380–1420	Choir of Parish Church in Bozen
after 1382	St. Mary's in Stralsund begun
1386	Benedictine Church in St. Lambrecht under construction
1387–1411	St. Catherine in Brandenburg
1388	Moritzkirche in Halle begun
1388	Choir of St. Barbara in Kuttenberg begun
ca.1392	South Tower of Prague Cathedral begun
1392	Tower of Ulm Minster begun
1394–1414	Nave of St. Maria-am-Gestade in Vienna
ca.1395	Tower of Our Lady in Esslingen begun
1398–1408	Choir of Heiligenkreuz in Heidelberg
ca.1398	North Tower of Regensburg Cathedral begun

1400–20

1405	Choir of Passau Cathedral begun
1407	Nave of St. Martin in Landshut begun

1407	Heiligenkreuz in Landshut begun
1407–40	St. Nikolai in Lüneburg
after 1408	Choir of Parish Church (today Franciscan) in Salzburg begun
1415	Tower of St. Bartholomew in Frankfurt-am-Main begun
1417–30	Bürgerspitalkirche in Braunau

1420–40

1421–83	St. Martin in Amberg
1427	St. George in Nördlingen begun
1433	South Tower of St. Stephan in Vienna completed
1433	Stuttgart Collegiate Church begun
1433–83	St. Mauritius in Olmütz
1437	Spire of Strasbourg Cathedral completed
1439	Choir of St. Lorenz in Nuremberg begun

1440–60

1443	Parish Church in Steyr begun
1445–8	Choir of St. Jakob in Wasserburg
ca.1450	Nave of St. Lamberti in Münster begun
1456–73	Choir of St. Jakob in Brünn

1460–80

1468–94	Frauenkirche in Munich
1471	Expansion of Albrechtsburg in Meissen begun
1471–81	Window register of Meissen Cathedral Façade
after 1474	Rennovation of St. Ulrich and Afra in Augsburg
1476	St. Kunigunden in Rochlitz completed
before 1478–99	Collegiate Church in Urach
1479	St. Salvator in Passau begun
1479–1503	Palace Church in Meisenheim-am-Glan

1480–1500

ca.1488	Nave of Freiberg Cathedral begun
1489	Parish Church in Weilheim begun
1491–7	Vault built over the choir of Holy Cross in Schwäb. Gmünd
1492–1507	Alexanderkirche in Zweibrücken
1493–1503	"Wladyslaw Hall" on the Hradschin in Prague
1495	Choir of St. Michael in Schwäb. Hall begun
1499–1525	St. Ann in Annaberg

after 1500

1502	St. Mary's in Pirna begun
1509–19	Fugger Chapel in Augsburg
1512–18	Hanging Vault of Willibrordi Church in Wesel
1512	Nave of St. Barbara in Kuttenberg begun
1513	Tower Spire of St. Kilian in Heilbronn begun
1515–40	Wolfgangkirche in Schneeberg
1517	Parish Church in Brüx begun
1518–27	Parish Church in Kötschach
1520	Project for the "Schöne Maria" in Regensburg
ca.1520	Parish Church in Königswiesen

INDEX

PERSONS

PLACES

Photographic Credits

AKG London/ Stefan Drechsel: 47, 134; AKG London/Erich Lessing: 79, 136, 207; Architektur - Bildservice Kandula, Germany: back jacket, 3, 130, 157, 186; Archiv des Verfassers: 11, 15, 51, 65, 148, 158, 167, 169, 177, 195, 197, 222, 227, 239; Archiv der Wissenschaftliche Buchesellschaft: 46, 92, 106 (W. Castelli), 154, 214; Stadt Augsberg, Lichtbildstelle: 127, 204; Bayerisches Landesamt für Denkmalpflege, Munich: 68, 123, 160, 165, 183, 199; U. Bellot: 220; Constantin Beyer: front jacket, 27, 55, 74, 95, 210, 224, 235; Klaus G. Beyer: 83, 90, 105, 187, 198, 243; Bildarchiv Foto Marburg: 4, 6, 8, 20, 21, 29, 31, 33, 35, 36, 37, 39, 44, 45, 56, 57, 63, 64, 73, 85, 88, 100, 102, 118, 122, 149, 151, 155, 180, 191, 225, 232, 240; Brandenburgisches Amt für Denkmalpflege, Meßbildarchiv: 96, 145; Bundesdenkmalamt, Vienna: 25, 152 (I. Kitlitschka-Strempel), 194; Andrew Cowin: 150; Dehio–Bezold, 1901: 89, 112, 147; Donin, 1935: 69; Germanisches Nationalmuseum, Nürnberg: 228; Giraudon: 38; D. Gola, Cologne: 189; H. D. Heckes: 7, 9; *Heidelberge kunstgesichtliche Abhandlungen*, NF 10, Heidelberg, 1967: 217; Michael Jeiter: 50, 59, 60, 87, 128, 170, 213; Landesstelle für AV-Lehrmittel, Salzburg: 179; Ingeborg Limmer: 24; Löbl-Schreyer, Bad Tolz: 219; Wolfgang F. Meier: 2; Werner Neumeister: 43, 104, 114, 116, 132, 135, 137, 138, 139, 140, 143, 173, 181, 201, 206, 208, 218, 229, 230, 233, 236, 241; W. Burmeister, *Norddeutsche Backsteindome*, Berlin, 1930: 188; U. Pfistermeister: 66, 226; Rheinisches Amt für Denkmalpflege, Brauweiler: 11 (Perscheid), 14 (Steinhoff), 18, 34 (Wolf), 42, 48 (Saint-Mont), 54, 70 (Perscheid), 84, 184 (Steinhoff), 216, 221 (Wolf), 244; Rheinisches Bildarchiv, Cologne: 10, 12, 71, 72, 212; Rheinisches Landesmuseum, Cologne: 1; Inge von der Ropp: 215; Sächsische Landesbibliothek. Abt. Deutsche Fotothek, Dresden: 153, 156, 209, 238; Helga Schmidt-Glassner: 223, 231; Schmölz-Huth, Cologne: 245; Westfälisches Amt für Denkmalpflege, Münster: 58 (H. Nieland), 144 (A. Brückner), 185 (A. Brückner); *ZKG* 33, Munich, 1970: 28.

Plans
Ars Bavarica 5/6, 35/36: 159, 161, 164, 176, 199: Bachmann 1969: 142, 163; *Bayerische Kunsdenkmale*, 1958: 121, 126, 182; Buchowiecki 1952; 93, 124, 166, 193, 205; Clasen 1958: 81, 82, 97-99, 107, 108; Elisabethkirche 1983: 32, 101; Dehio-Bezold 1901: 114, 172; Dehio Rheinland, 1967: 41: Dehio Westfalen, 1977: 91; Donin 1935: 103, 110: Frankl 1962: 40, 62, 94, 113, 125, 133: Götz 1968: 5, 30, 77, 78, 131, 168, 195; Hahnloser, *Villard de Honnecourt*, Graz, 1972: 19; Hilger, *Der Skupturenzyklus im Chor des Aachener Doms*, Essen, 1961: 129; Hilger, *Der Dom zu Xanten*, Königsten, 1984: 49; *Kirchen, Klöster und Kunstschätze in der DDR*, Berlin, 1982: 75, 80, 234, 237; *Kölner Domblatt* 42, Cologne, 1977: 52, 53; Kubach-Verbeek, *Romanische Kirchen an Rhein und Maas*, Neuss, 1972: 16; *Die Kunstdenkmäler von Bayer*, IV.3, V4: 175, 211; MJK, 18: 61; *Österreichische Kunsttopographie* 9, 19: 67, 178; *Parler* Vols 1-4: 141; *Propyläen-Kunstgesichte*, Vol.6: 191; Recht 1974: 117; Schubert 1975: 26; Tintelnot 1951: 174; Verbeek, *Heisterbach und Oberdollendorf*, Neuss, 1982: 17; von Winterfeld 1979: 22; Zaske 1970: 76, 119, 120, 189; *Zeitschrift für Württembergische Landesgeschichte* 17, 1958: 146, 162, 202, 203.

Full bibliographic details are given in the bibliography.